ILLUSTRATION INDEX V:

1977-1981

by
Marsha C. Appel

The Scarecrow Press, Inc.
Metuchen, N.J., & London
1984

PREVIOUS VOLUMES:

 Illustration Index, by Lucile E. Vance. New York:
 Scarecrow Press, 1957. Covers 1950 through June
 1956.

 Illustration Index, First Supplement, by Lucile E. Vance.
 New York: Scarecrow Press, 1961. Covers July 1956
 through 1959.

 Illustration Index, Second Edition, by Lucile E. Vance
 and Esther M. Tracey. New York and London: Scare-
 crow Press, 1966. Covers 1950 through June 1963.

 Illustration Index, Third Edition, by Roger C. Greer.
 Metuchen, N.J.: Scarecrow Press, 1973. Covers
 July 1963 through December 1971.

 Illustration Index, Fourth Edition, by Marsha C. Appel.
 Metuchen, N.J., and London: Scarecrow Press, 1980.
 Covers 1972 through 1976.

Library of Congress Cataloging in Publication Data

Appel, Marsha C., 1953-
 Illustration index V, 1977-1981.

 1. Pictures--Indexes. I. Title.
N7525.A66 1984 741.65'2'016 83-15201
ISBN 0-8108-1656-3

Dedicated, with love, to Mark Marcellus,

for it's the least he deserves

PREFACE

This fifth volume of the Illustration Index is entirely new and covers the years 1977-1981. It follows the patterns of scope, style, and arrangement set in the fourth volume.

Though not claiming to be totally comprehensive, the only illustrations methodically excluded are ads. Individual personalities are included, provided that the personality is considered of sufficient historical significance to warrant a separate article in the World Book Encyclopedia. The rationale for this criterion is the fact that photos of people enjoying ephemeral fame abound and can easily be located through the periodical indexes.

Each illustration within each journal article is treated separately, rather than indexing a few illustrations from an article to represent its major theme. This system of handling each picture individually allows better access to more obscure subject matter.

There is an extensive system of cross-references. It should be easy for a user unfamiliar with the volume to be steered to the proper entry by following related term "see also's" and primary "see" references. In the interest of easy and multiple access to each citation, there are frequently three or more entries for one illustration, or several cross-references. Using the format and cross-reference structure of the World Book Encyclopedia, entries tend toward the specific. The Hudson, Amazon, Rio Grande, and Danube rivers can be found under their respective names, but there are "see also" references from RIVERS and from the states or countries in which they're located.

Several main listings operate as key locators to identify every example of a given category to be found alphabetically within the book. The following are the key listings:

v

Amusements	Indians of North America
Animals	Industries
Architectural Structures	Insects
Arms	Minerals
Art Forms	Mountains
Art Works (for art works	Musical Instruments
listed under individual	National Parks
artists' names)	Occupations
Arts & Crafts	Peoples
Birds	Plants
Boats	Rivers
Fish	Sports
Flowering Plants	Transportation
Geological Phenomena	Trees
Housewares	Water Formations
Housing	Weather Phenomena

Publications were selected for their richness of illustration and for the availability of back issues in libraries. All the periodicals indexed in the previous volume have been continued here, and Life magazine, which recommenced publication in 1978, has been added.

A user desiring anything and everything on a specific country will go to the geographical entry. Here will be found general citations to illustrations of the country, perhaps some photographs of doctors or policemen there, maybe a farm or food market. But suppose the user wants pictures of policemen of various nationalities, or would like to see how farmers do their plowing in different parts of the world. The subject breakdowns are geared to yield just this sort of cross-cultural information. There is a major emphasis on historical and sociocultural phenomena, and a quick glance at the entries and cross-references under FESTIVALS, OCCUPATIONS, and RELIGIOUS RITES AND FESTIVALS will show just how extensive this coverage is. MILITARY COSTUME, for example, is indexed not only by different societies, but also by different centuries as well, introducing a valuable historical perspective.

I wish to thank the following for their generosity in making available to me the publications to be indexed: the librarians at Young & Rubicam, J. Walter Thompson, and Doyle Dane Bernbach; the Port Washington Public Library; the Editorial Rights Bureau of Sports Illustrated; and Robert Newman.

Marsha C. Appel

vi

The following is an example of a typical citation under a
subject entry:

Nat Geog 151:588-9 (drawing, c, 1) My '77

Most journal titles are abbreviated; "Nat Geog" refers to
National Geographic. A complete list of journal abbrevia-
tions used follows below in the list of periodicals indexed.
The journal designation is followed by the volume number
of the publication. After the colon comes inclusive pagination.

Most illustrations in the book are photographs. If
the text has identified an illustration as a painting, drawing,
or lithograph, etc., this additional information will appear
as the first item inside the parentheses. If the illustrations
are all photographs or a combination of photographs and other
pictorial forms, no special notation will be made. There is
one exception: if a map accompanies a set of photographs,
"map" will appear in the parentheses. If, however, a map
is the only illustration, the word "map" will appear in the
subject heading (e.g., ITALY--MAPS).

The next item in the sample citation above is a "c,"
which indicates that the illustration is in color. Lack of a
"c" denotes black and white.

Size of illustration is the last item indicated within
the parentheses. There will always be a number from 1 to
4 present:

1	Full page or larger
2	$\frac{1}{2}$ page or larger
3	Larger than $\frac{1}{4}$ page
4	$\frac{1}{4}$ page or smaller

In the case of numerous illustrations in a single citation,
the size of the largest one is indicated.

The date is the final item cited, with months in abbreviated form:

Ja	January	Jl	July
F	February	Ag	August
Mr	March	S	September
Ap	April	O	October
My	May	N	November
Je	June	D	December

PERIODICALS INDEXED

Am Heritage American Heritage. vol. 28-33, January 1977-December 1981

Ebony Ebony. vol. 32-37, January 1977-December 1981

Life Life. vol. 1-4, October 1978-December 1981

Nat Geog National Geographic. vol. 151-160, January 1977-December 1981

Nat Wildlife National Wildlife. vol. 15-20, January 1977-December 1981

Natur Hist Natural History. vol. 86-90, January 1977-December 1981

Smithsonian Smithsonian. vol. 7-12, January 1977-December 1981

Sports Illus Sports Illustrated. vol. 46-55, January 1977-December 1981

Travel Travel. vol. 147-148, January 1977-October 1977

Trav/Holiday Travel/Holiday. vol. 148-156, November 1977-December 1981

Here are the addresses to contact at each publication

regarding reproduction rights to illustrations indexed in this volume. Please note that both National Geographic and Ebony state that their pictures are not generally available to the public for reproduction purposes.

American Heritage
Picture Library
10 Rockefeller Plaza
New York, N.Y. 10020

Smithsonian
Picture Editor
900 Jefferson Drive, S.W.
Washington, D.C. 20560

Life Picture Service
Room 2858
Time & Life Building
Rockefeller Center
New York, N.Y. 10020

Sports Illustrated
Editorial Rights Bureau
Room 1919
Time & Life Building
Rockefeller Center
New York, N.Y. 10020

National Wildlife Magazine
National Wildlife Federation
1412 16th Street, N.W.
Washington, D.C. 20036

Travel/Holiday
Reprints Department
51 Atlantic Avenue
Floral Park, N.Y. 11001

Natural History
Picture Editor
American Museum of Natural
 History
Central Park West at 79th Street
New York, N.Y. 10024

ILLUSTRATION INDEX

ABALONE
--Farming (California)
 Nat Geog 153:499-501 (c, 1) Ap
 '78
Abolitionists. See BROWN, JOHN;
 DOUGLASS, FREDERICK;
 LINCOLN, ABRAHAM; STOWE,
 HARRIET BEECHER; TRUTH,
 SOJOURNER; TUBMAN, HAR-
 RIET
ABORIGINES (AUSTRALIA)
 Nat Geog 153:590-601 (c, 1) My
 '78
 Nat Geog 155:165, 170-1, 224-
 5 (c, 1) F '79
 Nat Geog 158:644-62 (c, 1) N '80
ABORIGINES (AUSTRALIA)--ART
--Bark painting of crocodile
 Nat Geog 153:97 (c, 4) Ja '78
ABU DHABI
 Travel 147:60, 62 (c, 3) Ja '77
ACACIAS
--Eaten by elephants
 Nat Geog 158:574 (c, 1) N '80
ACADIA NATIONAL PARK, MAINE
 Ebony 33:154 (4) My '78
ACAPULCO, MEXICO
 Nat Geog 153:645 (c, 1) My '78
 Ebony 34:121 (3) Ja '79
 Trav/Holiday 152:14-18, 77
 (c, 3) D '79
 Trav/Holiday 156:50 (c, 4) Ag
 '81
--Cliff divers
 Trav/Holiday 153:54-5 (c, 1) Je
 '80
ACCIDENTS
--Car hitting woman (California)
 Life 2:10 (2) F '79
--Collapsed building (Florida)
 Life 4:140 (2) My '81
--Falling grandstand killing people
 at bullfight (Colombia)
 Life 3:142-3 (1) Mr '80
--Falling off building
 Life 2:8-9 (1) Je '79
--Sunken street block (Florida)

 Life 4:42-3 (c, 1) Jl '81
--See also CRASHES; DISASTERS;
 SHIPWRECKS
ACCORDION PLAYING
 Sports Illus 53:66 (c, 4) S 15 '80
--1930
 Am Heritage 29:108 (3) Je '78
--Turkey
 Nat Geog 152:116 (c, 1) Jl '77
ACHESON, DEAN
 Am Heritage 31:44-5 (1) F '80
 Am Heritage 33:79 (4) D '81
Acid rain. See AIR POLLUTION;
 WATER POLLUTION
ACONCAGUA MOUNTAIN, ARGEN-
 TINA
 Sports Illus 52:64-70 (c, 1) Ap 14
 '80
ACORNS
 Natur Hist 88:50-9 (c, 1) F '79
 Nat Wildlife 18:50-4 (c, 1) O '80
ACROBATIC STUNTS
--1980 Olympics (Moscow)
 Sports Illus 53:cov. (c, 1) Jl 28
 '80
--Climbing up the World Trade Cen-
 ter, New York
 Sports Illus 46:24-5 (c, 1) Je 6
 '77
 Sports Illus 48:30 (c, 4) F 9 '78
--Men standing on each other
 Sports Illus 55:75 (4) N 23 '81
--Swinging from trees (New Jersey)
 Sports Illus 52:28 (c, 3) Mr 31 '80
--See also ATHLETIC STUNTS;
 GYMNASTICS
ACROPOLIS, ATHENS, GREECE
 Nat Geog 157:365-7 (c, 1) Mr '80
--See also PARTHENON
ACTORS
--1940's Hollywood
 Life 3:80-9 (1) S '80
--See also BERNHARDT, SARAH;
 BOOTH, EDWIN; CHAPLIN,
 CHARLES; JOLSON, AL; RUS-
 SELL, LILLIAN
ADAM AND EVE

1

Life 3:139-40 (c, 2) Mr '80
Natur Hist 89:64-74 (c, 1) Jl '80
Smithsonian 11:50-9 (c, 1) N '80
--Buzkashi riders
Natur Hist 87:55-62 (c, 1) F '78
--Panthan woman
Smithsonian 11:12 (4) Ja '81
--Pashtoons
Natur Hist 88:128-31 (3) Ag '79
AFRICA--ART
--Museum of African Art, Washington, D. C.
Smithsonian 8:55-6 (c, 3) Ag '77
AFRICA--COSTUME
--African-style village (South Carolina)
Ebony 33:86-94 (c, 2) Ja '78
AFRICA--MAPS
--1375 Timbuktu area
Natur Hist 86:72 (2) My '77
--Aerial photo of northeast Africa
Smithsonian 8:34-5 (c, 1) Je '77
--Elephant population
Nat Geog 158:578-82 (c, 1) N '80
AFRICAN TRIBES
--African Bushmen (1840's)
Am Heritage 28:110 (4) O '77
--Dagombas (Ghana)
Natur Hist 88:69-75 (c, 1) N '79
--Hausa people (Nigeria)
Natur Hist 90:44-53 (c, 1) Je '81
--Kenya
Smithsonian 10:cov., 40-9 (c, 1) Je '79
--Masai ceremonial dance (Kenya)
Trav/Holiday 151:65 (c, 4) Je '79
--Masai children (Kenya)
Travel 148:52-3 (2) Jl '77
--Masai costume and lifestyle (Kenya)
Natur Hist 89:cov., 42-55 (c, 1) Ag '80
--Masai elderhood ritual
Life 3:48-52 (c, 1) S '80
--Masai woman (Kenya)
Natur Hist 86:61 (c, 4) Ag '77
--Matebele tribesman (Zimbabwe)
Trav/Holiday 156:63 (c, 4) N '81
--Murle people (Sudan)
Life 2:65-8 (c, 2) Je '79
--Samburu (Kenya)
Smithsonian 10:cov., 40-7 (c, 1) Je '79
--Samburu warrior hairstyle (Kenya)
Smithsonian 10:10 (c, 4) Ag '79
--Swazi marriage festival (South Africa)

Nat Geog 153:46-61 (c, 1) Ja '78
--Upper Volta
Nat Geog 157:513-25 (c, 1) Ap '80
--Zingili tribal dance (South Africa)
Trav/Holiday 152:56 (c, 3) S '79
--Zulus (1830's; South Africa)
Am Heritage 29:65-76 (painting, c, 2) F '78
--See also BERBER PEOPLE;
BUSHMEN; SWAZIS; ZULUS
AFRICAN TRIBES--RELICS
--Ashanti drum (Ghana)
Smithsonian 10:135 (c, 4) N '79
AGASSIZ, LOUIS
Natur Hist 87:16 (4) Jc '78
Natur Hist 90:8, 12 (3) D '81
Agave plants. See CENTURY
PLANTS
AGED
Nat Geog 151:486 (c, 4) Ap '77
Natur Hist 88:76-85 (1) Mr '79
Ebony 36:58-62 (4) F '81
Smithsonian 12:53 (2) Jl '81
--Arkansas
Nat Geog 151:348-9 (c, 1) Mr '77
Nat Geog 153:421 (c, 1) Mr '78
--Centenarians
Life 4:101-8 (1) O '81
Life 4:33 (4) D '81
--China
Smithsonian 8:117-20 (c, 2) Ap '77
Nat Geog 159:179 (c, 4) F '81
--India
Trav/Holiday 156:cov. (c, 1) Jl '81
--Ireland
Nat Geog 159:458-9 (c, 1) Ap '81
--Kansas
Ebony 36:95 (3) N '80
--Louisiana
Natur Hist 87:100-1 (1) Mr '78
--Maine
Nat Geog 158:400 (c, 4) S '80
--Massachusetts
Smithsonian 8:99 (c, 1) Je '77
--Mississippi
Nat Geog 157:864 (c, 4) Je '80
--North Carolina
Life 2:64 (2) N '79
--Pakistan
Nat Geog 159:701 (c, 1) My '81
--Pennsylvania
Ebony 36:114 (c, 2) Ag '81
--Quebec skier
Sports Illus 51:50-1 (c, 1) D 10 '79
--Senior citizen day care center (Chicago, Illinois)
Ebony 34:74-7 (3) S '79

--Wisconsin
 Nat Geog 152:198 (c, 1) Ag '77
Agra, India. See TAJ MAHAL.
AIR POLLUTION
--1904 cartoon of anti-car en-
 vironmentalist
 Smithsonian 11:146 (drawing, 4)
 S '80
--Acid rain
 Nat Geog 160:652-81 (c, 1) N
 '81
--Effects of acid rain on build-
 ings (Ottawa, Ontario)
 Nat Geog 160:664-5 (c, 1) N
 '81
--Effects of acid rain on Roman
 monuments, Italy
 Life 3:61-4 (c, 2) Je '80
--Idaho
 Smithsonian 12:80-1 (c, 4) S '81
--Indiana power plant
 Nat Geog 151:264-5 (c, 1) F '77
--Israel
 Nat Geog 153:239 (c, 4) F '78
--Midwest
 Natur Hist 87:71-3 (c, 1) Ag
 '78
--New Jersey smoke
 Sports Illus 48:20 (c, 4) Ja 2
 '78
--Ontario
 Sports Illus 55:70 (c, 2) S 21
 '81
--St. Louis, Missouri
 Nat Geog 160:681 (c, 1) N '81
--Tennessee power plant
 Nat Geog 160:654-5 (1) N '81
--Vaporizer to aid horses
 Sports Illus 48:20 (c, 4) Ja 2
 '78
--See also SMOG
AIRPLANE FLYING
 Ebony 32:36 (4) Mr '77
 Ebony 32:88 (3) My '77
 Ebony 34:146-7 (2) Je '79
--Air traffic controllers
 Ebony 34:147 (4) Je '79
--Antique planes at air show
 (Oshkosh, Wisconsin)
 Sports Illus 49:29-32 (c, 1) Jl
 23 '78
 Nat Geog 156:364-75 (c, 1) S
 '79
--Inside Air Force cockpit
 Ebony 34:85 (3) D '78
--Man-powered craft
 Sports Illus 47:18-20 (c, 1) Ag
 1 '77

--Navigating
 Ebony 34:85-6 (4) D '78
--Pedaling across English Channel
 Nat Geog 156:640-51 (c, 1) N '79
--Stewardesses (1930)
 Smithsonian 11:22 (4) Jl '80
--Through Arc de Triomphe, Paris,
 France
 Life 4:196-7 (c, 1) D '81
--Training (Saudi Arabia)
 Nat Geog 158:300 (c, 4) S '80
AIRPLANE INDUSTRY
--Building plane (Northern Ireland)
 Nat Geog 159:493 (c, 4) Ap '81
AIRPLANE PILOTS
 Ebony 33:58-66 (3) Ja '78
 Ebony 33:65 (3) Mr '78
 Ebony 33:58-62 (2) Ag '78
--1919
 Smithsonian 10:102-11 (c, 1) Mr
 '80
--1920's woman pilot
 Ebony 32:89 (3) My '77
--1931
 Smithsonian 12:76 (4) Je '81
--Lincoln Beachey
 Am Heritage 29:92 (2) O '78
--U.S. Air Force
 Ebony 35:46 (4) Mr '80
--U.S. woman Army aviator
 Ebony 35:101-4 (2) Ap '80
--See also EARHART, AMELIA;
 LINDBERGH, CHARLES;
 WRIGHT, WILBUR AND OR-
 VILLE
AIRPLANES
 Nat Geog 154:210-11 (c, 1) Ag
 '78
 Smithsonian 11:42-9 (c, 1) My
 '80
 Nat Geog 158:404-5 (c, 1) S '80
 Nat Geog 159:76-102 (c, 1) Ja
 '81
--Early 20th cent. Wright Brothers
 planes
 Nat Geog 153:824-5 (c, 2) Je '78
 Life 1:62-3 (1) N '78
 Smithsonian 9:44-6 (c, 2) D '78
 Am Heritage 31:45-59 (1) D '79
--1908 biplane
 Nat Geog 151:718-19 (c, 1) My
 '77
--1910's stunt plane
 Am Heritage 29:92 (2) O '78
--1914 Curtiss pusher
 Smithsonian 12:74-5 (c, 3) Je '81
--1919
 Smithsonian 10:102-10 (1) Mr '80

--1920's Arctic expedition
 Natur Hist 89:114 (3) Ap '80
--1920's "Jenny" crashed onto
 Ontario building
 Am Heritage 30:109 (2) Ap '79
--1940's Aeroncas monoplanes
 Am Heritage 32:32-6 (1) O '81
--1942 Stinson Reliant
 Smithsonian 12:77 (c, 2) Je '81
--1947 wooden plane
 Life 4:88 (c, 4) Ja '81
--Antiques and reproductions
 Nat Geog 156:364-75 (c, 1) S
 '79
--Boeing 747 hooked up to space
 shuttle
 Smithsonian 0:cov. , 38-45,
 146 (c, 1) My '77
--C-5 Galaxy
 Ebony 34:98-104 (c, 2) Ap '79
--Cessna twin-engine
 Sports Illus 51:40 (c, 4) D 17
 '79
--Cockpits
 Nat Geog 152:212-13, 233 (c, 1)
 Ag '77
 Life 2:82 (c, 4) Jl '79
 Smithsonian 11:48-9 (c, 4) My
 '80
--Commercial plane
 Nat Geog 160:574-5 (c, 1) N
 '81
--Da Vinci's inventions
 Nat Geog 152:308-9 (c, 1) S '77
--Early planes
 Smithsonian 12:72-7 (c, 1) Je
 '81
--Flight simulator (Smithsonian,
 Wash. , D. C.)
 Smithsonian 9:18 (c, 4) Je '78
--Floatplanes (British Columbia)
 Nat Geog 154:474 (c, 3) O '78
--Grant Spruce Goose
 Smithsonian 11:106-14 (1) D
 '80
--Human-powered aircraft
 Nat Geog 153:130-9 (c, 1) Ja
 '78
 Sports Illus 48:32 (c, 2) F 9
 '78
 Smithsonian 9:34 (c, 4) My '78
 Sports Illus 50:24-6 (c, 1) Je
 25 '79
 Sports Illus 51:127 (c, 3) Ag 13
 '79
 Nat Geog 156:640-51 (c, 1) N
 '79
 Smithsonian 11:71-4 (c, 1) F

 '81
 Natur Hist 90:70-1 (c, 2) Mr '81
--Improving aviation safety
 Nat Geog 152:cov. , 206-35 (c, 1)
 Ag '77
--Interior of corporate jet
 Ebony 34:66 (4) N '78
 Ebony 34:33 (3) Mr '79
--Jet planes
 Nat Geog 152:cov. , 206-8 (c, 1)
 Ag '77
 Nat Geog 158:304-5 (c, 2) S '80
 Smithsonian 11:90 (c, 3) F '81
--Landed on water (Alaska)
 Trav/Holiday 155:55 (c, 2) Mr
 '81
--Landed on water (Brazil)
 Sports Illus 54:81 (c, 4) My 18
 '81
--Military aircraft
 Life 2:12-20 (c, 1) F '79
 Life 3:200-1 (c, 1) D '80
--Military transport plane
 Nat Geog 154:523 (c, 4) O '78
--Mirage fighters (Pakistan)
 Nat Geog 159:673 (c, 3) My '81
--Old fighter planes
 Smithsonian 11:136 (c, 4) Ja '81
--On fire after midair collision
 (California)
 Life 1:8-9 (c, 1) N '78
--Personal planes for commuters
 (1950-78)
 Am Heritage 32:48-55 (c, 1) Ag
 '81
--Powered by houseflies
 Smithsonian 9:18 (3) S '78
--New technologies
 Nat Geog 159:76-102 (c, 1) Ja
 '81
--SST
 Nat Geog 152:216-17 (c, 2) Ag
 '77
 Nat Geog 156:92-3 (c, 2) Jl '79
--SST model
 Travel 147:53 (4) Je '77
--Seaplane
 Smithsonian 12:10 (c, 4) My '81
--747
 Nat Geog 155:410-11 (c, 1) Mr
 '79
--Skiplanes
 Trav/Holiday 156:32-3 (c, 1) D
 '81
--Small jet
 Sports Illus 48:32-3 (c, 3) Je 12
 '78
--Small plane crashed in Alaska

Nat Wildlife 17:20-3 (drawing, 1)
O '79
--Small planes
Ebony 34:107-8 (2) N '78
Ebony 34:35 (3) F '79
Ebony 34:147 (4) Je '79
Trav/Holiday 156:cov. (c, 1) D
'81
--Small U. S. Customs plane
Ebony 32:110 (4) Ap '77
--Solar-powered
Sports Illus 54:34-9 (1) F 16
'81
Smithsonian 11:74-6 (c, 3) F '81
--Solar-powered (California)
Nat Geog 159:41 (c, 3) F '81SR
--Tri-Motor
Nat Geog 154:90-1 (c, 1) Jl '78
--U-2
Am Heritage 28:4-9 (c, 1) O
'77
--Ultralight planes
Sports Illus 53:14-19 (c, 1) Jl
21 '80
Smithsonian 11:113-15 (c, 3) N
'80
--U. S. troop carriers (1943)
Am Heritage 29:46-7 (c, 1) Ap
'78
--World War I
Nat Geog 153:826-9 (c, 1) Je
'78
--World War II
Nat Geog 153:832-3 (c, 2) Je '78
--World War II Allied bombers
Am Heritage 32:cov. , 65, 72-3
(1) Ap '81
--See also AIRSHIPS; CROP
DUSTER PLANES; GLIDERS;
HELICOPTERS; ROCKETS;
SPACECRAFT
AIRPLANES--HISTORY
Life 1:62-75 (c, 1) N '78
--Langley's flight attempt (1903)
Smithsonian 9:36-9 (drawing, c, 2)
D '78
--Smithsonian exhibit of aviation
history
Nat Geog 153:818-37 (c, 1) Je
'78
--Wright Brothers flight (1903)
Smithsonian 9:40-6 (drawing, c, 2)
D '78
AIRPORTS
--Airline ticket counter
Ebony 35:79 (4) Ja '80
--Airplane flipped on top of hangar
Nat Geog 158:353 (c, 2) S '80

--Atlanta, Georgia
Ebony 36:52-8 (3) D '80
Smithsonian 11:90-4 (c, 1) F '81
--Baggage claim (New York)
Sports Illus 47:50-1 (c, 3) Jl 18
'77
--Control tower radar screens
Smithsonian 11:50-1 (c, 1) My
'80
--Dallas/Fort Worth, Texas
Nat Geog 152:235 (c, 1) Ag '77
--Jidda, Saudi Arabia
Nat Geog 154:582-3 (c, 1) N '78
Nat Geog 158:298 (c, 4) S '80
Life 4:91-4 (c, 1) Jl '81
--National, Washington, D. C.
Nat Geog 152:210-11 (c, 1) Ag
'77
--O'Hare, Chicago, Illinois
Nat Geog 153:493 (c, 1) Ap '78
Life 2:96-7 (c, 1) Jl '79
--Wittman Field, Oshkosh, Wis-
consin
Nat Geog 156:366-7 (c, 1) S '79
AIRSHIPS
Smithsonian 8:123-33 (c, 3) Ap
'77
--1919 zeppelin advocating vote for
women
Am Heritage 30:23 (4) D '78
--1937 Hindenburg disaster (New
Jersey)
Smithsonian 8:130-1 (4) Ap '77
--Goodyear blimp
Smithsonian 8:123 (c, 3) Ap '77
Ebony 36:22 (4) Ja '81
--See also BALLOONING
ALABAMA
Nat Geog 151:466-7, 485-99 (c, 1)
Ap '77
--Gulf Shores
Sports Illus 50:43-4 (painting, c, 2)
Ap 23 '79
--Gulf Shores hurricane damage
Nat Geog 158:376-7 (c, 1) S '80
--Helen Keller's birthplace (Tus-
cumbia)
Trav/Holiday 153:68 (c, 4) Mr
'80
--Marion County
Ebony 34:44-5 (3) Ap '79
--See also BIRMINGHAM; MOBILE;
MONTGOMERY
ALAMO, TEXAS
Trav/Holiday 152:68 (c, 4) N '79
--1847 painting
Am Heritage 30:50-1 (c, 3) O '79
ALASKA

Life 2:102-11 (c, 1) F '79
Trav/Holiday 155:50-5 (c, 1) Mr
'81
--Arctic National Wildlife Refuge
Nat Geog 156:cov. , 734-69
(map, c, 1) D '79
--Brooks Range
Nat Wildlife 15:54-5 (c, 1) Ja
'77
Nat Geog 156:744-5, 760 (c, 1)
D '79
--Coast Range
Nat Wildlife 19:25-9 (c, 1) D
'80
--Delta Junction wilderness
Life 4:130-1 (c, 1) Mr '81
--Gulf of Alaska area
Nat Geog 155:236-67 (map, c, 1)
F '79
--Joining U.S. in 1867 treaty
Smithsonian 10:140-2 (painting, 4)
D '79
--Little Diomede Island
Natur Hist 86:55-65 (c, 1) Mr
'77
--Noatak River
Nat Geog 152:52-7 (map, c, 1)
Jl '77
Old Crow River
Nat Geog 150:944-5 (c, 2) S '79
--Prince William Sound
Nat Wildlife 16:50-5 (c, 1) O
'78
--Southeastern region
Travel 148:63-7 (c, 1) Ag '77
--Tikchik Lakes
Sports Illus 47:84-8 (c, 1) D
12 '77
--Wilderness areas
Smithsonian 8:38-49 (map, c, 1)
D '77
--See also ALEUTIAN ISLANDS;
ANCHORAGE; ANIAKCHAK
VOLCANO; JUNEAU; KATMAI
NATIONAL MONUMENT;
MOUNT MCKINLEY; MOUNT
MCKINLEY NATIONAL PARK;
ST. ELIAS RANGE; SITKA
ALASKA--MAPS
Smithsonian 8:40-1 (c, 1) D '77
--Parks and monuments
Nat Geog 156:62-3 (c, 1) Jl '79
ALASKA PIPELINE
Smithsonian 8:41, 49 (map, c, 1)
D '77
Nat Wildlife 17:20 (c, 4) F '79
ALBANIA
Nat Geog 158:530-57 (map, c, 1)

O '80
ALBANIA--COSTUME
Nat Geog 158:530-57 (c, 1) O '80
ALBANY, NEW YORK
Nat Geog 153:75 (c, 1) Ja '78
--Capitol Building
Smithsonian 12:146-53 (c, 1) N
'81
ALBATROSSES
Nat Geog 152:242-3 (c, 2) Ag '77
Nat Geog 153:672-7 (c, 1) My '78
Natur Hist 87:77 (c, 1) My '78
ALBEE, EDWARD
Nat Geog 157:671 (c, 4) My '80
ALBERTA
--Tar-sands plant
Nat Geog 159:cov. , 92 3 (c, 1)
F '81SR
--See also BANFF NATIONAL
PARK; JASPER NATIONAL
PARK; LAKE LOUISE; ROCKY
MOUNTAINS
ALBUQUERQUE, NEW MEXICO
Trav/Holiday 149:34-8 (c, 1) Ja
'78
ALCATRAZ, CALIFORNIA
Nat Geog 156:23-5 (c, 1) Jl '79
Nat Geog 159:842-3 (c, 4) Je '81
ALCOHOLISM
--1st cent. B.C. statuette of drunk
woman (Pompeii)
Trav/Holiday 151:16 (4) My '79
--Anti-drinking poster (Finland)
Nat Geog 160:252 (c, 4) Ag '81
--Derelict (U.S.S.R.)
Life 3:39 (4) My '80
ALEPPO, SYRIA
Nat Geog 154:358-9 (c, 1) S '78
--Citadel
Nat Geog 154:736-7 (c, 2) D '78
ALEUTIAN ISLANDS, ALASKA
--Buldir Island
Nat Wildlife 17:4 (c, 1) F '79
ALEXANDER THE GREAT
Life 3:45 (sculpture, c, 2) Jl '80
Smithsonian 11:cov. , 127 (sculp-
ture, c, 1) N '80
ALEXANDRIA, EGYPT
Nat Geog 151:342-3 (c, 1) Mr
'77
ALFALFA INDUSTRY
--Baling (Illinois)
Nat Geog 157:168 (c, 4) F '80
ALGAE
Smithsonian 8:84-5 (c, 2) Ja '78
Nat Geog 154:93 (c, 2) Jl '78
Smithsonian 9:69 (c, 4) Ag '78
Nat Geog 158:559 (c, 3) O '80

Nat Geog 158:727 (c, 4) D '80
--Antarctic lakes
Smithsonian 12:52-61 (c, 1) N
'81
--Diatoms
Nat Geog 155:870-8 (c, 1) Je '79
ALGER, HORATIO
Smithsonian 8:122-36 (drawing, 4)
N '77
ALGERIA
--Beni-Abbes
Natur Hist 88:66-7 (map, c, 4) F
'79
--Myab region
Travel 147:54-9 (c, 1) F '77
--See also ALGIERS
ALGERIA--COSTUME
Travel 147:58-9, 90 (c, 1) F
'77
ALGIERS, ALGERIA
--Khemisti Gardens
Travel 147:57 (c, 1) F '77
ALLIGATORS
Natur Hist 86:54-61 (c, 1) Je
'77
Nat Wildlife 16:12 (c, 4) D '77
Nat Geog 153:94-115 (c, 1) Ja
'78
Nat Wildlife 16:30 (c, 4) O '78
Nat Wildlife 17:56 (c, 2) D '78
Trav/Holiday 151:102 (4) My
'79
Nat Wildlife 17:47 (c, 4) O '79
Nat Wildlife 18:13 (c, 4) D '79
Nat Wildlife 18:2 (c, 3) O '80
Nat Geog 159:154 (c, 2) F '81
Nat Wildlife 19:41 (c, 2) Ag '81
Trav/Holiday 156:54 (4) N '81
--Comic strip character
Trav/Holiday 149:58 (drawing, 3)
Je '78
ALPACAS
Smithsonian 9:92-3, 98 (c, 3)
Ag '78
ALPHABETS
--3rd millennium, B.C. (Ebla,
Syria)
Nat Geog 154:730-1, 748, 758
(c, 1) D '78
--Ancient Greek Linear A and B
Nat Geog 153:174-5 (c, 2) F '78
--Ancient Ugarit, Syria
Nat Geog 154:754 (c, 4) D '78
--Early inscribed clay bell (Mid-
east)
Life 1:117-18 (c, 1) O '78
--Greek poster (1947)
Am Heritage 29:69 (4) Ap '78

--Russian writing
Nat Geog 152:262-3 (c, 3) Ag '77
--See also CUNEIFORM; HIERO-
GLYPHICS
ALPS, SWITZERLAND
Natur Hist 88:51-6 (c, 3) Ja '79
ALPS, WEST GERMANY
Nat Geog 152:174-5 (c, 1) Ag '77
ALUMINUM
Nat Geog 154:187-211 (c, 1) Ag
'78
ALUMINUM INDUSTRY
--Factory interior (Virginia)
Ebony 35:48 (4) Je '80
--Production process
Nat Geog 154:192-3, 195 (dia-
gram, c, 1) Ag '78
AMARANTH (PLANT)
Nat Geog 159:702-3, 712 (c, 1)
My '81
AMAZON RIVER, SOUTH AMERICA
Smithsonian 8:40-1 (map, c, 1) S
'77
Smithsonian 8:100-5 (c, 2) O '77
--Jari tributary, Brazil
Nat Geog 157:690-1 (c, 1) My '80
AMAZON RIVER, SOUTH AMERICA
--MAPS
Sports Illus 54:89 (c, 4) My 18
'81
AMBER
--Fossils embalmed in amber
Nat Geog 152:422-35 (c, 1) S '77
AMBULANCES
Ebony 36:115 (3) N '80
--1890's
Smithsonian 12:134 (4) My '81
AMERICA--DISCOVERY AND EX-
PLORATION
--6th cent. Irish voyage
Nat Geog 152:cov., 768-97
(map, c, 1) D '77
--1493 woodcut depiction of Colum-
bus voyage
Am Heritage 29:85, 91 (4) Ap
'78
--18th cent. ships' cargoes
Nat Geog 152:724-66 (c, 1) D
'77
--Landing spot of Jamestown set-
tlers (Virginia)
Travel 147:33 (c, 1) Ap '77
--Maps of the new land
Am Heritage 32:4-13 (painting, c, 2)
F '81
--Pueblo Indians repulsing Spanish con-
querors (1680; New Mexico)
Smithsonian 11:86-95 (paint-

ing, c, 1) O '80
AMERICAN MUSEUM OF NATURAL
HISTORY, NEW YORK CITY,
N. Y.
Natur Hist 88:116 (drawing, 4)
Ja '79
Natur Hist 88:110 (drawing, 3)
Mr '79
American Red Cross. See RED
CROSS.
AMISH PEOPLE
Smithsonian 10:79 (c, 4) F '80
--Pennsylvania
Nat Geog 153:764-5 (c, 1) Je
'78
AMMUNITION
--Ammunition belt (Mexico)
Nat Geog 153:618-19 (c, 1) My
'78
--Making buckshot (Missouri)
Travel 148:43 (c, 4) Ag '77
--See also BULLETS
Amphibians. See FROGS; NEWTS;
SALAMANDERS; TOADS;
TURTLES
AMSTERDAM, NETHERLANDS
Life 2:108 (c, 4) Mr '79
Trav/Holiday 151:45-6 (c, 2) Je
'79
Trav/Holiday 152:cov. (c, 1) O
'79
AMUSEMENT PARKS
Trav/Holiday 156:4-7 (4) Jl '81
--1930's sports and pinball ma-
chines
Sports Illus 47:24-8 (c, 1) Jl 4
'77
--Aerial view of Disneyland (Cali-
fornia)
Life 3:10-11 (c, 1) O '80
--California
Trav/Holiday 155:56-9, 80-1
(c, 1) My '81
--Carowinds, North Carolina
Travel 147:53 (c, 2) My '77
--Walt Disney World, Orlando,
Florida
Ebony 34:44 (4) My '79
Life 2:194 (c, 3) D '79
Nat Geog 158:158-9 (c, 2) Ag
'80
Life 4:80-6 (c, 1) S '81
--Dutch swing ride (Michigan)
Trav/Holiday 149:47 (c, 4) My
'78
--Elitch Gardens, Denver, Colorado
Trav/Holiday 153:50-3 (c, 1)
Je '80

--Houston, Texas
Ebony 33:140 (4) Jl '78
--Legoland miniature town, Den-
mark
Trav/Holiday 154:44 (c, 3) Ag '80
--Opryland Park, Nashville, Ten-
nessee
Trav/Holiday 155:55 (c, 4) Ap
'81
--Rides (Monte Carlo)
Trav/Holiday 150:81 (4) Ag '78
--Myrtle Beach, South Carolina
Travel 147:57 (c, 4) Je '77
--Rides
Travel 147:74 (4) Je '77
--Waterslides
Life 2:59-62 (c, 1) S '79
--See also CONEY ISLAND; FERRIS
WHEELS; MERRY-GO-
ROUNDS; ORGANS; PINBALL
MACHINES; ROLLER COAST-
ERS
Amusements. See AMUSEMENT
PARKS; ART GALLERIES;
ART SHOWS; BEACH CLUBS;
BIRD WATCHING; BULL-
FIGHTING; CARD PLAYING;
CAVE EXPLORATION; CIGAR
SMOKING; CIGARETTE SMOK-
ING; CONCERTS; CONTESTS;
FESTIVALS; FIGHTING;
GAMBLING; GAME PLAYING;
GARDENING; GUM CHEWING;
KISSING; MAGIC ACTS;
MERRY-GO-ROUNDS; MOTION
PICTURES; MUSIC; NIGHT
CLUBS; PARTIES; PICNICS;
PINBALL MACHINES; PIPE
SMOKING; READING; RES-
TAURANTS; ROLLER COAST-
ERS; SAUNAS; SPORTS;
SWIMMING; TELEVISION
WATCHING; TOBACCO CHEW-
ING; TOYS; TREASURE
HUNTS; TREE CLIMBING;
WHISTLING; ZOOS
ANABLEPS FISH
Nat Geog 153:390-5 (c, 1) Mr
'78
ANACONDAS
Life 4:183 (c, 4) D '81
ANATOMY
--Early 20th cent. posture diagrams
Am Heritage 32:60-3 (4) Je '81
--Artificial organs and tissues
Smithsonian 9:51-5 (drawings, c, 2)
N '78
--Computer photographs of brain

Nat Geog 153:374-5 (c, 1) Mr
'78
--Da Vinci's sketches
Nat Geog 152:316-17 (c, 2)
S '77
--Diagram of woman's torso de-
formed by corsets
Am Heritage 32:59 (4) Je '81
--Inner ear
Natur Hist 88:67 (c, 3) Ag '79
--Lungs
Life 4:130-4 (1) My '81
--Knees
Sports Illus 47:84-7 (c, 1) O
24 '77
--Stomach lining
Nat Geog 151:289 (2) F '77
--3-D photos of human body
Nat Geog 153:363, 372 (c, 1)
Mr '78
--See also BRAIN; EYES; HEARTS;
TEETH
ANCHORAGE, ALASKA
--1964 earthquake damage
Nat Wildlife 19:34-5 (drawing, 1)
O '81
ANCHOVIES
Nat Geog 152:821 (c, 4) D '77
Ancient civilizations. See BRONZE
AGE; CARTHAGE; CELTIC
CIVILIZATION; EGYPT,
ANCIENT; GREECE, AN-
CIENT; MAN, PREHISTORIC;
PERSIAN EMPIRE; ROMAN
EMPIRE; SELEUCID CIVILI-
ZATION; STONE AGE; SUM-
ERIAN CIVILIZATION
ANDERSEN, HANS CHRISTIAN
--Life and works
Nat Geog 156:824-49 (c, 1) D
'79
ANDERSON, MARIAN
Am Heritage 28:50-7 (1) F '77
ANDES MOUNTAINS, CHILE
Nat Geog 160:64-5 (c, 1) Jl '81
ANDES MOUNTAINS, ECUADOR
Life 2:60-1 (c, 1) Ag '79
ANDES MOUNTAINS, VENEZUELA
Natur Hist 90:50-1 (c, 1) Jl
'81
ANEMONES
Natur Hist 90:80 (c, 4) O '81
ANGELFISH
Natur Hist 87:86-7 (c, 2) F '78
Smithsonian 11:38 (c, 4) Ja '81
ANGELS
--Michael (France)
Nat Geog 151:820 (painting, c, 4)

Je '77
ANGOLA--COSTUME
--Guerrilla fighters
Life 3:43-8 (c, 2) F '80
ANIAKCHAK VOLCANO, ALASKA
Nat Wildlife 15:62 (c, 4) Ja '77
ANIMAL SKINS
--Early 20th cent. fur industry
Natur Hist 89:106-13 (2) Ap '80
--Bobcat and marten skins
Nat Wildlife 17:14 (c, 1) O '79
--Buffalo hides (1884)
Nat Geog 160:92 (4) Jl '81
--Cheetah skins
Nat Geog 159:302-3 (c, 1) Mr
'81
--Crocodile skins drying (Louisiana)
Nat Geog 153:109 (c, 1) Ja '78
--Goods made of endangered species
Nat Wildlife 20:18-19 (1) D '81
--Jaguar skins
Natur Hist 86:66-7 (c, 1) My '77
--Reptile skins
Nat Geog 159:313 (c, 4) Mr '81
--Tiger skins
Nat Geog 159:293 (c, 4) Mr '81
--Vicuna skins
Nat Geog 159:306-7 (c, 1) Mr
'81
ANIMAL TRACKS
Nat Geog 154:852-3 (c, 1) D '78
--Grizzly bear footprints
Smithsonian 12:80 (c, 4) Ag '81
ANIMAL TRAINERS
Ebony 32:104-8 (4) O '77
ANIMALS
--Africa
Sports Illus 48:70-3 (c, 1) My
22 '78
--Amazon River area, South Amer-
ica
Smithsonian 8:100-11 (c, 1) O '77
--Depictions in art
Smithsonian 8:52-61 (c, 1) S '77
Smithsonian 8:108-14 (c, 1) N '77
Smithsonian 12:62-71 (c, 2) N '81
--Endangered species
Nat Wildlife 18:13-16 (c, 2) D
'79
--Fanciful bestiary
Smithsonian 11:40-6 (c, 4) O '80
Smithsonian 12:101-7 (painting, c, 1)
O '81
Natur Hist 90:82-8 (drawing, c, 4)
D '81
--Illegal trade of endangered species
Nat Geog 159:286-315 (c, 1) Mr
'81

--Inhumane treatment of research
and farm animals
Smithsonian 11:50-7 (c, 1) Ap
'80
--Maternal behavior in animals
Nat Wildlife 19:37-47 (c, 1)
Ag '81
--Smuggled animals confiscated
by U. S. Customs
Nat Wildlife 17:3, 32-9 (c, 1)
O '79
--Spain
Smithsonian 9:72-9 (c, 1) Je '78
--Stuffed leopard toy
Nat Geog 159:287 (c, 4) Mr '81
--Vermont mountain life
Nat Geog 158:558-66 (c, 1) O
'80
--See also AMPHIBIANS; APES;
ARACHNIDS; BIRDS; CO-
ELENTERATES; CRUSTACE-
ANS; ECHINODERMS; FISH;
INSECTS; MARINE LIFE;
MARSUPIALS; MOLLUSKS;
POND LIFE; REPTILES;
RODENTS; WORMS
Animals--Mammals. See
ABALONE; ALPACAS; ANT-
EATERS; ANTELOPES;
APES; ARMADILLOS;
BADGERS; BEARS; BISON;
BOARS, WILD; BOBCATS;
BUFFALOES; BURROS;
CARIBOU; CATS; CATTLE;
CHEETAHS; CIVETS; COATIS;
COYOTES; DEER; DOGS;
DONKEYS; DUGONGS; ELE-
PHANTS; ELKS; FOXES;
GAZELLES; GIRAFFES;
GOATS; GUANACOS; HIP-
POPOTAMI; HOGS; HORSES;
HYENAS; JACKALS; JAGUARS;
JERBOAS; KANGAROOS;
KINKAJOUS; KOALAS;
LAMPREYS; LEOPARDS;
LIONS; LLAMAS; LYNXES;
MARTENS; MONGOOSES;
MONKEYS; MOOSE; MUSK
OXEN; OCELOTS; OTTERS;
OXEN; PANDAS; PANTHERS;
PECCARIES; PETS; PIGS;
PIKAS; PLATYPUSES; POR-
POISES; PRONGHORNS;
RABBITS; RACCOONS; REIN-
DEER; RHINOCERI; ROCKY
MOUNTAIN GOATS; SEA ANEMONES; SEA COWS;
SEALS; SHEEP; SHREWS;

SLOTHS; SPONGES; TASMAN-
IAN DEVILS; TASMANIAN
TIGERS; TIGERS; VICUNAS;
WALRUSES; WART HOGS;
WATER BUFFALOES; WEA-
SELS; WHALES; WILDE-
BEESTS; WOLVES; WOOD-
CHUCKS; WORMS; WOMBATS;
YAKS; ZEBRAS
Animals, Extinct. See DINOSAURS;
MAMMOTHS; MASTODONS
ANISE
Ebony 33:154 (c, 4) Je '78
Natur Hist 88:95 (drawing, 4) Je
'79
ANKARA, TURKEY
Nat Geog 152:06-7 (c, 1) Jl '77
ANNAPOLIS, MARYLAND
Travel 147:41-5 (c, 1) Je '77
Nat Geog 158:458-9 (c, 1) O '80
--See also U. S. NAVAL ACADEMY
Anoles. See CHAMELEONS.
ANT LIONS
Natur Hist 86:64-71 (c, 1) Ap '77
Natur Hist 87:67 (c, 4) D '78
ANTARCTIC EXPEDITIONS
--Relics from 1912 Scott expedition
Life 1:102 3 (o, 1) O '78
ANTARCTICA
Nat Geog 152:236-55 (map, c, 1)
Ag '77
Life 1:96-106 (c, 1) O '78
Natur Hist 90:62-4 (map, c, 1)
Ap '81
Smithsonian 12:52-61 (map, c, 1)
N '81
--South Georgia Island
Trav/Holiday 152:61 (c, 4) S '79
ANTEATERS
Smithsonian 8:102 (c, 4) O '77
Natur Hist 89:62-6 (c, 1) O '80
--Tamanduas
Nat Geog 152:709 (c, 2) N '77
ANTELOPES
Natur Hist 86:78 (c, 3) F '77
Natur Hist 87:44-9 (c, 1) My '78
Life 2:65-8 (c, 1) Je '79
Sports Illus 52:76 (c, 4) My 19
'80
--Oryx
Smithsonian 8:46 (c, 4) Mr '78
Sports Illus 48:35 (c, 3) My 29
'78
Smithsonian 11:130-1 (c, 2) My
'80
Trav/Holiday 154:38 (c, 3) Ag '80
--Waterbucks
Sports Illus 48:35 (c, 3) My 29

'78
Trav/Holiday 154:40 (c, 4) N
'80
--See also DIK-DIKS; GAZELLES;
ROCKY MOUNTAIN GOATS;
SPRINGBOKS
ANTENNAS
Smithsonian 9:44-5 (painting, c, 4)
My '78
Ebony 35:75 (4) Je '80
--Radio space antenna
Life 2:46 (c, 4) My '79
--Satellite antennas (Maldives)
Nat Geog 160:435 (c, 4) O '81
Anthropologists. See MEAD,
MARGARET
ANTIMONY
Smithsonian 8:120 (c, 3) O '77
ANTIQUES
--Sold at flea markets
Life 2:47-50 (c, 2) Jl '79
ANTS
Smithsonian 8:108 (c, 4) O '77
Natur Hist 87:67 (c, 4) D '78
Smithsonian 10:39 (c, 4) Ag '79
Nat Geog 157:394-5 (c, 1) Mr
'80
Nat Wildlife 18:18-23 (draw-
ing, 1) Ap '80
Smithsonian 11:50 (c, 4) Je '80
Smithsonian 11:78 (c, 2) S '80
Nat Geog 158:563 (c, 4) O '80
--Fire
Nat Geog 157:170-1 (c, 1) F
'80
--Honey
Nat Geog 156:630-1 (c, 2) N '79
--Seen through microscope
Nat Geog 151:283 (3) F '77
ANTWERP, BELGIUM
--Harbor
Nat Geog 155:329 (c, 1) Mr '79
--Peter Paul Rubens' mansion
Smithsonian 8:48-55 (c, 1) O
'77
APACHE INDIANS (SOUTHWEST)
--Costume, lifestyle
Trav/Holiday 151:65 (4) Ja '79
Nat Geog 157:260-90 (c, 1) F '80
--See also GERONIMO
APACHE INDIANS (SOUTHWEST)--
COSTUME
--1880's
Smithsonian 11:145 (4) Ap '80
Smithsonian 12:74-5 (2) Ap '81
APARTMENT BUILDINGS
--1917 (Washington, D. C.)
Am Heritage 32:82 (c, 4) Ag '81

--China
Nat Geog 159:806-7 (c, 1) Je '81
--Fortress-like (Chicago, Illinois)
Ebony 34:36 (4) Ag '79
--Guilin, China
Nat Geog 156:560-1 (c, 1) O '79
--Harlem, New York City, New
York
Ebony 34:62 (4) Ag '79
--Helsinki, Finland
Nat Geog 160:254 (c, 1) Ag '81
--Model for project (Paris, France)
Smithsonian 8:106 (4) Ja '78
--New York City, New York
Life 2:125 (c, 2) Je '79
--Panama City, Panama
Ebony 33:46 (c, 4) Jl '78
--St. Louis, Missouri
Trav/Holiday 150:26 (c, 4) Ag '78
--Singapore
Life 2:68-9 (c, 1) Ag '79
--Tallinn, Estonia
Nat Geog 157:486-7 (c, 2) Ap '80
--Terraces (Quebec)
Nat Geog 151:445 (c, 1) Ap '77
APARTMENT BUILDINGS--CON-
STRUCTION
--Tunisia
Nat Geog 157:196-7 (c, 2) F '80
APES
--Bush babies
Natur Hist 88:cov. , 76-81 (c, 1)
O '79
--Celebes apes
Smithsonian 12:65 (c, 4) D '81
--Prehistoric
Smithsonian 11:90-103 (drawing, 4)
Je '80
--See also BABOONS; CHIMPAN-
ZEES; GIBBONS; GORILLAS;
MONKEYS; ORANGUTANS
APHIDS
Nat Geog 151:76-7 (1) F '77
Natur Hist 88:87-9 (c, 1) Ja '79
Aphrodite. See VENUS.
APPALACHIAN MOUNTAINS, WEST
VIRGINIA
Nat Geog 153:436-7 (c, 1) Mr '78
APPLE INDUSTRY--HARVESTING
--1856 painting
Am Heritage 29:24 (painting, c, 4)
F '78
--1888 France
Smithsonian 12:53 (painting, c, 2)
Je '81
--Crab apples (Tibet)
Nat Geog 157:230 (c, 1) F '80
APPLE TREES

Nat Geog 154:610-11 (c, 1) N
'78
--Apple blossom
Nat Geog 160:675 (c, 3) N '81
--See also OHIA TREES
APPLES
--1851 lithographs
Am Heritage 31:61-73 (c, 2)
D '79
AQUARIUMS
--California home
Ebony 34:42 (2) Mr '79
--Key Biscayne, Florida
Trav/Holiday 149:56 (4) F '78
--Vancouver, British Columbia
Nat Wildlife 16:8 (c, 4) F '78
AQUEDUCTS
--2nd cent. Roman (Carthage)
Smithsonian 9:52-3 (c, 2) F '79
--Los Angeles, California
Nat Geog 160:511 (c, 3) O '81
--Sluice gates (Los Angeles,
California)
Am Heritage 29:11 (4) D '77
--Venice, Italy
Smithsonian 8:45 (c, 4) N '77
ARAB COUNTRIES--COSTUME
Nat Geog 154:578-607 (c, 1)
N '70
Nat Geog 156:446 (c, 1) O '79
Nat Geog 159:2-3 (c, 1) F '81SR
Arachnids. See ARTHROPODS;
KING CRABS; MITES; SCOR-
PIONS; SPIDERS; TICKS
ARARAT, TURKEY
Nat Geog 152:122-3 (c, 1) Jl '77
Nat Geog 153:848-9 (c, 1) Je '78
Life 4:46-7 (c, 1) Ag '81
ARC DE TRIOMPHE, PARIS,
FRANCE
--Flying plane through it
Life 4:196-7 (c, 1) D '81
ARCHAEOLOGICAL SITES
--17th cent. Virginia settlement
Nat Geog 155:737-66 (map, c, 1)
Je '79
--Abrigo do Sol, Brazil
Nat Geog 155:60-83 (c, 1) Ja
'79
--Afghanistan
Life 2:65-8 (c, 2) Jl '79
--Ancient Bahrain
Nat Geog 156:324-5 (c, 1) S '79
--Ancient Greece
Nat Geog 153:142-87 (map, c, 1)
F '78
--Ancient Indian mound (Arkansas)
Am Heritage 31:69 (painting, c, 2)

O '80
--Anemospilia, Crete
Nat Geog 159:204-21 (c, 1) F '81
--Aphrodisias, Turkey
Nat Geog 160:526-51 (c, 1) O '81
--Arikaree River, Colorado
Nat Geog 155:114-21 (c, 1) Ja
'79
--Bronze Age site in Jordan
Smithsonian 9:82-7 (c, 1) Ag '78
--Bulgaria
Nat Geog 158:112-29 (c, 1) Jl
'80
--Carthage
Smithsonian 9:44-55 (c, 1) F '79
--Dinosaur National Monument
(Utah/Colorado)
Nat Geog 154:172-3 (c, 1) Ag '78
--Dinosaur remains (Dry Mesa
quarry, Colorado)
Nat Geog 154:177 (c, 1) Ag '78
--Dinosaur remains (Montana)
Nat Geog 154:158-9 (c, 1) Ag '78
--Ebla, Syria
Nat Geog 154:730-58 (c, 1) D '78
--Ephesus, Turkey
Trav/Holiday 156:56 (c, 4) Jl '81
--Hierapolis, Turkey
Trav/Holiday 156:55 (c, 3) Jl '81
--Laetoli area, Tanzania
Nat Geog 155:447-57 (c, 1) Ap
'79
--Lake Turkana, Kenya
Smithsonian 8:57 (c, 4) N '77
--Lin-t'ung, China
Nat Geog 153:cov., 441-59 (c, 1)
Ap '78
--Marib, North Yemen
Nat Geog 156:258-9 (c, 1) Ag '79
--Mohenjo Daro, Pakistan
Smithsonian 8:60-5 (c, 1) Jl '77
--Mongolia
Natur Hist 89:79-83 (2) Ap '80
--Monte Alban, Mexico
Smithsonian 10:62-75 (c, 1) F '80
--Mt. Li, China
Smithsonian 10:38-51 (c, 1) N '79
--Palmyra, Syria
Nat Geog 154:350-1 (c, 1) S '78
--Petra, Jordan
Natur Hist 87:42-53 (map, c, 1)
Je '78
--Philip II's tomb (Macedon, Greece)
Nat Geog 154:54-77 (c, 1) Jl '78
--Quebec
Nat Geog 151:442-3 (c, 4) Ap '77
--St. Mary's City, Maryland
Nat Geog 158:445 (c, 4) O '80

--Veracruz, Mexico
 Nat Geog 158:cov., 206-25 (c, 1)
 Ag '80
ARCHAEOLOGISTS
--Cataloging pottery shards (Syria)
 Nat Geog 154:739 (c, 1) D '78
--See also EVANS, ARTHUR;
 SCHLIEMANN, HEINRICH;
 PALEONTOLOGISTS
ARCHAEOPTERYX
 Natur Hist 87:16 (drawing, 4)
 My '78
 Nat Geog 154:168-9 (c, 1) Ag
 '78
ARCHERY
 Sports Illus 49:21 (c, 4) Ag 7
 '78
--4th cent. B.C. Macedonian
 gold quiver
 Life 3:46 (c, 2) Jl '80
 Smithsonian 11:130-1 (c, 3) N
 '80
--Afghanistan
 Smithsonian 11:50 (c, 2) N '80
--Bow and arrow (Kenya)
 Nat Geog 159:288-9 (c, 1) Mr
 '81
--Compound bow
 Sports Illus 47:77 (4) O 31 '77
ARCHERY--EDUCATION
--Oregon
 Nat Geog 155:502 (c, 2) Ap '79
ARCHES NATIONAL PARK,
 UTAH
 Nat Geog 158:792-3 (c, 1) D '80
ARCHITECTS
 Ebony 32:36 (4) Mr '77
 Ebony 32:115 (3) Ag '77
--1886 architect's office (Massa-
 chusetts)
 Am Heritage 32:51 (4) O '81
--Brazil
 Nat Geog 153:277 (c, 3) F '78
--Louis Kahn
 Smithsonian 10:38 (4) Jl '79
--See also LE CORBUSIER;
 RICHARDSON, HENRY HOB-
 SON; WHITE, STANFORD;
 WRIGHT, FRANK LLOYD
Architectural features. See
 BATHROOMS; BEDROOMS;
 CHIMNEYS; DENS; DINING
 ROOMS; DOORS; FENCES;
 FIREPLACES; GATES;
 GAZEBOS; KITCHENS;
 LIVING ROOMS; OUT-
 HOUSES; PARLORS;
 PORCHES; STAIRCASES;

SWINGS; WINDOWS
Architectural structures. See
 AIRPORTS; AQUEDUCTS;
 BARNS; BOATHOUSES; CAPI-
 TOL BUILDING; CAPITOL
 BUILDINGS--STATE; CASTLES;
 CHATEAUS; CHURCHES; CITY
 HALLS; CONVENTION CEN-
 TERS; COURTHOUSES; DAMS;
 FARMHOUSES; FORTRESSES;
 FORTS; FUNERAL HOMES;
 GOVERNMENT BUILDINGS;
 HOTELS; HOUSES; HOUSING;
 INDUSTRIAL PARKS; LI-
 BRARIES; LIGHTHOUSES;
 MUSEUMS; OBSERVATORIES;
 OFFICE BUILDINGS; OIL RE-
 FINERIES; PAGODAS; PLAY-
 GROUNDS; POORHOUSES;
 POWER PLANTS; PYRAMIDS;
 RAILROAD STATIONS;
 SCHOOLS; STABLES; STADI-
 UMS; TEMPLES; THEATERS;
 VIADUCTS; WHITE HOUSE;
 WINDMILLS
ARCHITECTURE
--Buildings influenced by Palladio
 Life 3:107-14 (c, 1) D '80
--Colorful buildings
 Life 4:62-8 (c, 1) Mr '81
--Great Britain
 Smithsonian 7:96-102 (c, 1) F
 '77
ARCHITECTURE--15TH CENT.
--Clamency, France
 Nat Geog 153:807 (c, 1) Je '78
ARCHITECTURE--16TH CENT.
--Decorated house (Prague, Czecho-
 slovakia)
 Nat Geog 155:566 (c, 1) Ap '79
ARCHITECTURE, AMERICAN--
 17TH CENT.
--Recreation of 1642 Boston houses
 Smithsonian 9:89 (c, 3) Mr '79
ARCHITECTURE, AMERICAN--
 18TH CENT.
--Georgian doorway (New England)
 Am Heritage 31:20 (2) Ap '80
--Rhodes Tavern, Washington, D.C.
 (Georgian style)
 Am Heritage 31:106-7 (paint-
 ing, c, 1) F '80
ARCHITECTURE, AMERICAN--
 19TH CENT.
--Late 19th cent. buildings
 Smithsonian 11:11-17 (c, 1) My
 '80
--1880 Victorian house (Iowa)

Nat Geog 157:282 (c, 1) F '80
--Aerial views of Colorado River
 areas
 Life 3:78-82 (c, 1) D '80
--Havasu Falls
 Life 4:102-3 (c, 1) Ag '81
--Historical sites
 Trav/Holiday 151:63-5 (c, 4)
 Ja '79
--Hopi town (1901)
 Natur Hist 88:122-3 (1) N '79
--Huerfano Butte (1902 and 1969)
 Natur Hist 87:61 (4) Ja '78
--Indian lands
 Trav/Holiday 154:57-61 (c, 3) S
 '80
--Kitt Peak Observatory
 Nat Wildlife 18:12 (c, 1) F '80
--Monument Valley
 Nat Wildlife 15:27 (c, 4) Ap '77
 Nat Geog 152:8-9 (c, 1) Jl '77
 Am Heritage 29:cov. , 116
 (c, 1) D '77
 Trav/Holiday 151:63 (c, 4) Ja
 '79
 Nat Wildlife 17:52 (c, 1) Ap '79
 Trav/Holiday 153:108-9 (4) Ap
 '80
--Mt. Hopkins observatory
 Smithsonian 10:42-51 (c, 2) My
 '79
--Oak Creek Canyon
 Life 4:104-5 (c, 1) Ag '81
--Ruins of Hopi town, Tuzigoot
 Smithsonian 9:38 (4) S '78
--Scottsdale
 Trav/Holiday 148:58-63 (c, 1)
 D '77
--Sonoran Desert
 Nat Wildlife 18:40-7 (c, 1) F
 '80
--Sonoran Desert Museum and
 Zoo
 Trav/Holiday 149:48-51, 66-7
 (c, 2) Ap '78
--Sunset scene over cactus
 Smithsonian 11:102-3 (c, 1) D
 '80
--See also GRAND CANYON;
 MESA VERDE NATIONAL
 PARK; NAVAJO NATIONAL
 MONUMENT; PHOENIX;
 TUCSON
ARKANSAS
 Nat Geog 153:396-427 (map, c, 1)
 Mr '78
--Buffalo River area
 Nat Geog 151:344-58 (map, c, 1)

Mr '77
--Ozark region crafts
 Trav/Holiday 153:34-40, 102-4
 (2) Ap '80
--Rosalie House, Eureka Springs
 Trav/Holiday 153:28 (4) My '80
--See also LITTLE ROCK; OZARK
 MOUNTAINS
ARKANSAS RIVER, ARKANSAS
 Nat Geog 153:408-9 (c, 1) Mr
 '78
ARLINGTON NATIONAL CEMETERY,
 VIRGINIA
 Ebony 32:153 (c, 4) Mr '77
ARMADILLOS
 Nat Wildlife 15:34-6 (1) F '77
 Natur Hist 87:108 (c, 3) N '78
ARMENIA, ASIA
 Nat Geog 153:846-67 (map, c, 1)
 Je '78
ARMOR
--15th cent. B. C. (Mycenae,
 Greece)
 Nat Geog 153:182 (c, 4) F '78
--4th cent. B. C. (Macedon, Greece)
 Nat Geog 154:64-71 (c, 1) Jl '78
--16th cent. knight (Germany)
 Nat Geog 154:701-3 (c, 1) N '78
--17th cent. Virginia
 Nat Geog 155:753, 760-1 (paint-
 ing, c, 1) Je '79
--19th cent. Japan
 Smithsonian 12:49 (c, 2) Ap '81
--Celtic civilization
 Nat Geog 151:592-7 (c, 1) My '77
ARMS
--18th cent. grenade launcher (Ger-
 many)
 Nat Geog 154:710 (c, 4) N '78
--Atlatl (Stone Age)
 Nat Geog 155:118-9 (c, 2) Ja '79
--Ice Age knives and spear parts
 Nat Geog 156:cov. , 349-59 (c, 1)
 S '79
--Molotov cocktails
 Life 4:104-5 (c, 1) Jl '81
--New U. S. weapons
 Life 3:32-40 (c, 1) Ap '80
--See also AMMUNITION; ARCH-
 ERY; ARMOR; ARROWS;
 AXES; BOMBS, ATOMIC;
 BULLETS; CANNONS; DAG-
 GERS; EXPLOSIVES; GUNS;
 HARPOONS; HELMETS;
 KNIGHTS; KNIVES; MILITARY
 COSTUME; MISSILES; SLING-
 SHOTS; SWORDS; TANKS,
 ARMORED

ARMSTRONG, LOUIS
 Life 2:145 (c, 2) D '79
Army. See MILITARY COSTUME;
 U.S. ARMY
ARNO RIVER, FLORENCE, ITALY
 Nat Geog 152:304-5 (c, 1) S '77
ARNOLD, BENEDICT
--Medal commemorating 1777 acts
 Am Heritage 29:110 (c, 4) D
 '77
ARROWROOT
 Nat Geog 156:408 (c, 3) S '79
ARROWS
--19th cent. Eskimo (Alaska)
 Nat Geog 156:754 (c, 4) D '79
--Bamboo arrows (Thailand)
 Nat Geog 158:522-3 (c, 1) O '80
Art forms. See CARTOONS;
 CAVE DRAWINGS; CAVE
 PAINTINGS; COLLAGES;
 COMIC STRIPS; DESIGN,
 DECORATIVE; FIGUREHEADS;
 FRESCOES; HOLOGRAPHY;
 MOBILES; MOSAICS; MURALS;
 PAINTINGS; PHOTOGRAPHY;
 POTTERY; PRINTMAKING;
 QUILTS; RESTORATION OF
 ART WORKS; ROCK CARV-
 INGS; ROCK PAINTINGS;
 SCRIMSHAW; SCULPTURE;
 SILHOUETTES; SNOW
 SCULPTURES; STAINED
 GLASS; TAPESTRIES; TOTEM
 POLES; WOOD CARVINGS
ART GALLERIES
--Lugano, Switzerland
 Smithsonian 10:76-85 (c, 1) N
 '79
--Tucson, Arizona
 Sports Illus 51:63 (c, 3) Ag 20
 '79
ART SHOWS
--Outdoor show (Georgia)
 Travel 147:39 (c, 1) F '77
--Outdoor show (Port-au-Prince,
 Haiti)
 Trav/Holiday 151:57 (c, 4) F
 '79
--Outdoor show (St. Augustine,
 Florida)
 Trav/Holiday 148:54, 57 (c, 4)
 N '77
--Outdoor show (San Luis Obispo,
 California)
 Trav/Holiday 155:70 (c, 4) F '81
ART WORKS
--Late 19th cent. U.S.
 Smithsonian 11:108-17 (c, 1)

 My '80
--1920's modern art
 Smithsonian 10:108-15 (c, 2) N
 '79
--Art glass
 Life 2:82-8 (c, 1) Ap '79
--Joseph Cornell's boxes
 Smithsonian 11:44-51 (c, 1) Ja
 '81
--The Dinner Party, by Judy
 Chicago
 Life 2:126-7 (c, 1) My '79
--Gulbenkian collection (Lisbon,
 Portugal)
 Smithsonian 11:42-51 (c, 1) Jl
 '80
--Miniature pictures made of butter-
 fly scales (1880's)
 Smithsonian 11:108-13 (c, 1) O
 '80
--Modern art (New York)
 Life 2:82-93 (c, 2) S '79
--Performance art
 Life 3:83-7 (c, 1) Ja '80
--Photocopier art
 Life 3:9-12 (c, 2) Ja '80
 Smithsonian 11:26-7 (c, 4) O '80
--Pictures made of flowers
 Smithsonian 11:90-101 (c, 1) F
 '81
--Primitive (Rockefeller collection)
 Smithsonian 9:cov., 42-53 (c, 1)
 O '78
--Stolen works
 Life 2:31-6 (c, 3) Mr '79
--Thyssen-Bornemisza collection
 (Switzerland)
 Smithsonian 10:76-85 (c, 1) N
 '79
--U.S. folk art
 Life 3:cov., 112-22 (c, 1) Je '80
--See also AUDUBON, JOHN J.;
 BINGHAM, GEORGE C.;
 BONNARD, PIERRE; BOTTI-
 CELLI, SANDRO; BRANCUSI,
 CONSTANTIN; BREUGHEL,
 PIETER; CALDER, ALEX-
 ANDER; CASSATT, MARY;
 CEZANNE, PAUL; COLE,
 THOMAS; CURRIER & IVES;
 DEGAS, EDGAR; DURER,
 ALBRECHT; EL GRECO; FRA
 ANGELICO; GAUGUIN, PAUL;
 GHIRLANDAIO, DOMENICO;
 GIACOMETTI, ALBERTO;
 GIORGIONE; GOYA, FRAN-
 CISCO; GROSZ, GEORGE;
 HALS, FRANS; HOGARTH,

WILLIAM; HOLBEIN, HANS;
HOMER, WINSLOW; HOP-
PER, EDWARD; KANDINSKY,
WASSILY; KLEE, PAUL;
LEAR, EDWARD; LEGER,
FERNAND; LEONARDO DA
VINCI; LIPPI, FRA FILIPPO;
MAGRITTE, RENE; MANET,
EDOUARD; MATISSE, HENRI;
MIRO, JOAN; MONET,
CLAUDE; MORSE, SAMUEL;
MUNCH, EDVARD; NAST,
THOMAS; PEALE, CHARLES
WILLSON; PICASSO, PABLO;
PISSARRO, CAMILLE;
POUSSIN, NICHOLAS; POW-
ERS, HIRAM; RAPHAEL;
REMBRANDT; REMINGTON,
FREDERIC; RENOIR, PI-
ERRE; RIVERA, DIEGO;
RODIN, AUGUSTE; ROUALT,
GEORGES; ROUSSEAU,
HENRI; RUBENS, PETER
PAUL; RUSSELL, CHARLES;
SARGENT, JOHN SINGER;
SEURAT, GEORGES; SHAHN,
BEN; STUART, GILBERT;
TIFFANY, LOUIS C.;
TITIAN; TOULOUSE-
LAUTREC; TRUMBULL,
JOHN; TURNER, JOSEPH
M. W.; VAN DER WEYDEN,
ROGER; VAN EYCK, JAN;
VAN GOGH, VINCENT;
VERMEER; WATTEAU,
ANTOINE; WATTS, GEORGE
FREDERIC; WHISTLER,
JAMES M.; WOOD, GRANT
ARTHROPODS
--Millipedes
Nat Geog 158:274-5 (c, 1) Ag
'80
--See also KING CRABS; TRILO-
BITES
ARTICHOKES
Ebony 33:154 (c, 4) Je '78
ARTISTS
--18th cent. U. S.
Am Heritage 31:16-17 (paint-
ing, c, 1) Ap '80
--19th cent. studio
Am Heritage 32:34-5 (paint-
ing, c, 1) Ag '81
--Frederic Church
Life 3:100 (4) Ja '80
--John Clymer
Nat Wildlife 17:25, 33 (c, 3)
D '78

--Jasper Cropsey
Smithsonian 10:104 (painting, c, 4)
Ja '80
--Jasper Cropsey's studio (19th
cent.; New York)
Smithsonian 10:104-11 (c, 1) Ja
'80
--Louis Eilshemius
Smithsonian 9:104 (4) N '78
--Etcher at work (1882)
Am Heritage 32:32 (painting, c, 2)
Ag '81
--Geneva, Switzerland
Trav/Holiday 150:64 (4) Jl '78
--Alfred Gilbert
Smithsonian 9:50 (4) D '78
--Marsden Hartley
Smithsonian 10:123 (4) Mr '80
--Japanese craftsmen
Smithsonian 10:50-9 (c, 1) Ja '80
--Lord Leighton
Smithsonian 9:51 (4) D '78
--Modern
Smithsonian 9:82-5 (c, 2) F '79
--Monet's studio (France)
Smithsonian 10:61 (c, 1) F '80
--Albert Moore
Smithsonian 9:51 (4) D '78
--Rubens' studio (Belgium)
Smithsonian 8:49 (c, 4) O '77
--Sidewalk portrait artist (New Or-
leans, Louisiana)
Trav/Holiday 155:57 (c, 3) F '81
--Sketching class (North Carolina)
Smithsonian 11:63 (c, 4) Mr '81
--Sketching Colorado pond
Travel 147:52 (c, 4) Mr '77
--Studios (New York City, New
York)
Life 4:90-1 (c, 4) My '81
--See also BINGHAM, GEORGE;
DALI, SALVADOR; DE
KOONING, WILLEM; GERI-
CAULT, THEODORE; LEAR,
EDWARD; LEONARDO DA
VINCI; MIRO, JOAN; MODIG-
LIANI, AMADEO; MOORE,
HENRY; MUNCH, EDVARD;
O'KEEFFE, GEORGIA; PEALE,
CHARLES WILLSON; PICAS-
SO, PABLO; PISSARRO,
CAMILLE; RIVERA, DIEGO;
ROCKWELL, NORMAN;
RODIN, AUGUSTE; RUBENS,
PETER PAUL; SARGENT,
JOHN SINGER; THURBER,
JAMES; TRUMBULL, JOHN;
WATTS, GEORGE; WEST,

BENJAMIN; WOOD, GRANT
ARTS AND CRAFTS
--17th cent. clay amulets (Latin
America)
Nat Geog 152:742-3 (c, 1) D
'77
--American art (17th-19th cents.)
Am Heritage 31:12-31, 114 (c, 1)
Ap '80
--American folk art
Am Heritage 31:22 (1) F '80
--Bamboo items
Nat Geog 158:508-9, 527 (c, 1)
O '80
--Bread sculpture (Ecuador)
Trav/Holiday 154:48-51 (2) Ag
'80
--Cherokees doing beadwork
Trav/Holiday 154:53 (c, 1) Ag
'80
--Coal sculpture of wagon (Ken-
tucky)
Trav/Holiday 150:51 (4) O '78
--Ecuador
Trav/Holiday 151:69-73 (c, 1)
My '79
--Finger painting
Am Heritage 29:44 (4) Je '78
--Folk art (Mexico)
Nat Geog 153:648-69 (c, 1) My
'78
--Inadan Tuareg people (Niger)
Nat Geog 156:282-97 (c, 1) Ag
'79
--India
Trav/Holiday 153:cov., 58-60
(c, 1) Mr '80
--Indian beadwork (Manitoba)
Trav/Holiday 153:54 (c, 4) My
'80
--Miniature work (U.S.S.R.)
Nat Geog 153:863 (c, 4) Je '78
--Ozarks, Arkansas
Trav/Holiday 153:34-40, 102-4
(2) Ap '80
--Print making
Smithsonian 11:60-4 (c, 2) Ag
'80
--Sand castles (Virginia)
Travel 147:72 (4) Ap '77
--Singapore
Trav/Holiday 148:33-5 (c, 1)
N '77
--Stencil cutting (Japan)
Smithsonian 10:56-7 (c, 4) Ja
'80
--Tie-dyeing
Smithsonian 8:102 (c, 4) S '77

--Virginia crafts
Trav/Holiday 154:44 (c, 4) S '80
--Wooden wheel making (Massachu-
setts)
Nat Geog 155:586 (c, 1) Ap '79
--See also BARREL MAKING;
BASKET WEAVING; BODY
PAINTING; CANDLE MAKING;
CARPENTRY; DOLL MAKING;
EMBROIDERY; GLASSBLOW-
ING; LACE MAKING; LAC-
QUERING; METALWORK;
NEEDLEWORK; PAINTING;
POTTERY MAKING; RUG
MAKING; SAND PAINTING;
SEWING; WEAVING; WOOD
CARVING; WOOL SPINNING
ARUBA
--Harbor area
Trav/Holiday 151:60-1 (c, 1) Ap
'79
ASHEVILLE, NORTH CAROLINA
--Biltmore House
Trav/Holiday 150:50-1 (4) N '78
Asia. See PAMIR REGION; indi-
vidual countries
ASIA--ART
Natur Hist 89:cov., 46-74 (c, 1)
S '80
ASIA--HISTORY
--14th cent. Tamerlane empire
Smithsonian 10:88-97 (c, 1) S '79
--Southeast Asian political history
Nat Geog 157:633-5 (map, c, 1)
My '80
ASIA--MAPS
--1662
Natur Hist 89:50-1 (c, 1) S '80
--Site of ancient Indus civilization
Smithsonian 8:58 (c, 2) Jl '77
--Southeast Asia
Nat Geog 156:712 (c, 1) N '79
Nat Geog 157:634-5 (c, 1) My '80
ASIAN TRIBES
--Hmong people (Laos)
Nat Geog 157:632-61 (c, 1) My
'80
--Kalash People (Pakistan)
Nat Geog 160:458-73 (c, 1) O '81
--Karen People (Thailand)
Trav/Holiday 154:43 (c, 3) N '80
--Long-necked Padaung tribeswomen
(Burma)
Nat Geog 155:798-801 (c, 1) Je
'79
ASPARAGUS
Ebony 33:154 (c, 4) Je '78
ASPEN TREES

Nat Wildlife 15:64 (c, 1) Ja '77
ASTAIRE, FRED
Am Heritage 30:86 (4) Je '79
ASTERS
Nat Geog 159:371 (c, 3) Mr '81
ASTRONAUTS
Ebony 34:39 (4) Ja '79
Ebony 34:54-60 (c, 1) Mr '79
Life 2:77-84 (c, 2) Jl '79
Nat Geog 159:326, 340-2 (c, 2)
Mr '81
Natur Hist 90:cov. , 50-7 (c, 1)
D '81
ASTRONOMY
--17th cent. charts
Smithsonian 12:92-3 (4) Ag '81
--Activities of U. S. Indians
Smithsonian 9:78-85 (c, 1) O
'78
--See also GALILEO; PLANETARI-
UMS; TELESCOPES
ATHENS, GREECE
Trav/Holiday 152:40-5 (c, 1) Ag
'79
Nat Geog 157:365-7 (c, 1) Mr
'80
--See also ACROPOLIS; PARTHE-
NON
ATHLETES
Sports Illus 49:25 (c, 2) Jl 3
'78
Life 2:59-64 (c, 1) O '79
Life 2:121-5 (c, 1) D '79
--Defeated tennis player
Sports Illus 53:18-19 (c, 1) Jl
14 '80
--Paintings of famous athletes
Smithsonian 12:145 (c, 4) Jl '81
--Track stars
Sports Illus 52:70-3 (4) Mr
10 '80
--Victories
Sports Illus 48:54 (3) Mr 20
'78
--Women
Sports Illus 47:33 (c, 1) N 21
'77
--See also BASEBALL PLAYERS;
BASKETBALL PLAYERS;
BOXERS; FOOTBALL PLAY-
ERS; GOLFERS; HOCKEY
PLAYERS; JOCKEYS; SKIERS;
SOCCER PLAYERS; SWIM-
MERS; TENNIS PLAYERS
ATHLETIC STUNTS
--Flying truck over cars
Sports Illus 50:70-1 (4) Mr
12 '79

--Guinness world record holders
Sports Illus 51:56-62 (c, 1) Jl
30 '79
--Jumping over river on motorcycle
(Great Britain)
Life 3:124-5 (c, 3) F '80
--Riding truck on two wheels
Sports Illus 50:72 (c, 4) Mr 12
'79
--See also ACROBATIC STUNTS
ATLANTA, GEORGIA
Sports Illus 46:74-5 (c, 2) Mr 21
'77
Ebony 33:96 (4) F '78
Nat Geog 154:212-13, 218-19,
234 (c, 1) Ag '78
Trav/Holiday 153:56-9, 114
(c, 1) F '80
--Airport
Ebony 36:52-8 (3) D '80
Smithsonian 11:90-4 (c, 1) F '81
--Piedmont Park playground
Smithsonian 9:46-7 (c, 2) Ap '78
ATLANTIC CITY, NEW JERSEY
Travel 148:50-1 (3) O '77
Life 4:66-7 (c, 1) F '81
Nat Geog 160:580-1 (c, 2) N '81
ATLANTIC OCEAN
Smithsonian 10:80-1 (c, 2) Ap
'79
--Continental Shelf
Nat Geog 153:494-531 (map, c, 1)
Ap '78
--Irish coast
Nat Geog 159:441 (c, 2) Ap '81
ATLANTIC OCEAN--MAPS
--Cross-Atlantic boating route
Sports Illus 46:32 (c, 4) Je 27
'77
--Diagram of water masses
Nat Geog 160:812-13 (drawing, 1)
D '81
ATOMS
Nat Geog 151:281 (c, 4) F '77
--Hydrogen
Smithsonian 11:128 (c, 1) D '80
AUCTIONS
Life 2:117-22 (c, 1) N '79
--Art
Smithsonian 12:40-9 (c, 1) Ap
'81
--Art (London, England)
Smithsonian 9:12-16 (3) O '78
--Cattle (Missouri)
Ebony 36:98 (4) N '80
--Cattle (Nebraska)
Nat Geog 154:513 (c, 4) O '78
--Horse

Sports Illus 51:16-17 (c, 3) Ag
6 '79
Sports Illus 55:17 (c, 4) Ag 3
'81
--Horse (Pennsylvania)
Nat Geog 153:764-5 (c, 1) Je '78
--Machinery (Arkansas)
Nat Geog 153:398-9 (c, 1) Mr
'78
--Wild ponies (Virginia)
Nat Geog 157:814-15 (c, 1) Je
'80
AUDIENCES
--1914 vaudeville show (California)
Am Heritage 31:52-3 (1) O '80
--Award ceremony (California)
Ebony 36:50 (3) F '81
--Choral concert (Illinois)
Ebony 35:71 (3) D '79
--Concert
Ebony 35:158 (3) D '79
--Concert (China)
Life 2:102-7 (c, 1) My '79
--Fans mobbing performer
Ebony 33:166 (2) My '78
--Music audience lying down
Smithsonian 11:116 (c, 4) Mr '81
--Outdoor concert (Georgia)
Trav/Holiday 150:50 (c, 4) F
'80
--Outdoor concert (Virginia)
Nat Geog 156:50-1 (c, 1) Jl '79
--Outdoor concert (Washington,
D. C.)
Smithsonian 8:11 (3) Je '77
--Singer (Washington, D. C.)
Ebony 37:146 (4) N '81
--Tanglewood concert, Massachu-
setts
Trav/Holiday 153:cov. , 44 (c, 1)
Je '80
--Theater
Smithsonian 12:134-5 (c, 4) D
'81
AUDUBON, JOHN JAMES
Nat Geog 151:149, 155 (paint-
ings, c, 3) F '77
--Home (New York City, New
York)
Natur Hist 89:96 (painting, 3)
Ap '80
--Paintings by him
Nat Geog 151:148-64 (paint-
ings, c, 1) F '77
Sports Illus 47:20-1 (c, 2) Jl 11
'77
AUKS
Nat Geog 151:162 (painting, c, 3)

F '77
--See also GUILLEMOTS; MURRES
AURORA BOREALIS
Smithsonian 7:64-70 (c, 2) F '77
--Alaska
Nat Geog 156:757 (c, 1) D '79
AURORAS
--Alaska
Natur Hist 86:61-7 (c, 1) O '77
AUSTEN, JANE
--Letter written by her
Smithsonian 10:79 (4) S '79
AUSTRALIA
Nat Geog 155:154-91 (map, c, 1)
F '79
Life 4:95-108 (c, 1) N '81
--Ayres Rock
Trav/Holiday 148:80 (2) D '77
Life 4:96-7 (c, 1) N '81
Trav/Holiday 156:32 (c, 4) D '81
--Desert reclamation
Nat Geog 156:618-19 (c, 1) N '79
--New South Wales
Trav/Holiday 154:57-60 (map, c, 1)
Jl '80
--Outback (Western desert)
Nat Geog 153:580-611 (map, c, 1)
My '78
--Parks
Trav/Holiday 152:cov. , 46 0,
74-8 (c, 1) N '79
--Simpson Desert
Nat Geog 156:590-1 (c, 1) N '79
--See also ABORIGINES; ADE-
LAIDE; GREAT BARRIER
REEF; SYDNEY; TASMANIA
AUSTRALIA--COSTUME
Nat Geog 155:153-87, 210-35
(c, 1) F '79
Life 4:95-108 (c, 1) N '81
--Adelaide
Trav/Holiday 150:28-31 (c, 1) Ag
'78
AUSTRALIA--SOCIAL LIFE AND
CUSTOMS
--Governor of the Rocks election
(Sydney)
Nat Geog 155:226-7 (c, 1) F '79
AUSTRIA
--Countryside
Trav/Holiday 151:26 (4) My '79
--Danube River area
Trav/Holiday 154:38-41 (map, c, 2)
Jl '80
--Schonbuhel
Nat Geog 152:454 (c, 1) O '77
--See also DANUBE RIVER; SALZ-
BURG; VIENNA

AUSTRIA--COSTUME
--Vienna
 Smithsonian 10:78-87 (c, 1) O
 '79
AUTOGRAPH SIGNING
--Authors
 Ebony 32:34-5 (4) Ap '77
 Ebony 32:40 (c, 4) Jl '77
--Baseball players
 Sports Illus 46:23 (c, 4) Je 20
 '77
 Nat Geog 153:485 (c, 4) Ap '78
 Sports Illus 48:38 (c, 4) Ap 10
 '78
 Sports Illus 51:44 (4) Jl 23 '79
 Sports Illus 51:20-1 (c, 2) Jl
 30 '79
 Sports Illus 54:88 (c, 4) My 25
 '81
--Basketball players
 Ebony 35:82 (4) Ap '80
--Boxers
 Ebony 33:89 (3) Ap '78
 Ebony 33:116 (4) S '78
 Ebony 36:140 (4) F '81
--Football players
 Sports Illus 49:88 (c, 4) S 4 '78
 Ebony 34:64 (4) Ja '79
 Sports Illus 53:36 (c, 3) N 3
 '80
 Sports Illus 55:96-7 (c, 1) S 7
 '81
 Sports Illus 55:56 (c, 4) S 21 '81
--Golfers
 Sports Illus 50:21 (c, 4) Mr 12
 '79
 Ebony 35:104 (4) Jl '80
--Runners (Great Britain)
 Sports Illus 52:72-3 (c, 1) Je 23
 '80
--Singers
 Ebony 32:92 (4) S '77
 Ebony 34:38 (4) S '79
 Ebony 35:166 (4) N '79
 Ebony 35:107 (3) Ap '80
 Ebony 35:122 (3) O '80
AUTOMOBILE MECHANICS
 Sports Illus 47:30 (c, 4) O 3 '77
 Sports Illus 48:83-4 (c, 1) My
 15 '78
 Sports Illus 54:42 (c, 4) Mr 2
 '81
--Auto race
 Sports Illus 52:16-17 (c, 1) Je
 2 '80
--Do-it-yourselfers
 Ebony 35:91 (4) Ag '80
AUTOMOBILE RACING

Sports Illus 46:60 (painting, c, 4)
 F 21 '77
Sports Illus 46:31 (c, 4) My 23
 '77
Sports Illus 47:12 (c, 2) Ag 15
 '77
Sports Illus 48:29-32 (drawing, c, 1)
 F 20 '78
Sports Illus 48:55 (c, 4) F 27 '78
Sports Illus 48:20-3 (c, 1) Ap 10
 '78
Sports Illus 49:22-3 (c, 3) S 4
 '78
Sports Illus 49:88-92 (c, 1) O 2
 '78
Sports Illus 50:20-1 (c, 4) My 21
 '79
Sports Illus 51:94 (c, 4) O 15 '79
Sports Illus 52:26 (c, 3) My 19
 '80
Sports Illus 52:94-6 (c, 4) My 26
 '80
Sports Illus 53:80 (c, 4) N 24 '80
--Bonneville Salt Flats, Utah
 Sports Illus 55:50-7 (c, 1) O 5
 '81
--Daytona 500 (1977)
 Sports Illus 46:cov., 16-19 (c, 1)
 F 28 '77
--Daytona 500 (1979)
 Sports Illus 50:18-19 (c, 3) F 26
 '79
--Daytona 500 (1981)
 Sports Illus 54:20-1 (c, 3) F 23
 '81
--Drag racing
 Sports Illus 47:26-7 (c, 2) Jl 18
 '77
 Sports Illus 50:88-91 (c, 1) Ja
 15 '79
 Sports Illus 54:70-3 (c, 1) Je 22
 '81
--Drivers
 Sports Illus 46:27 (c, 1) Ja 17
 '77
 Sports Illus 46:58-61 (painting, c, 1)
 F 21 '77
 Sports Illus 46:cov. (c, 1) F 28
 '77
 Sports Illus 46:30 (c, 3) My 23
 '77
 Sports Illus 47:52 (c, 4) Jl 4 '77
 Sports Illus 48:24-6 (c, 4) My 29
 '78
 Sports Illus 50:91 (c, 2) Ja 15
 '79
 Sports Illus 50:40 (c, 4) F 12 '79
 Sports Illus 51:84-5 (c, 1) D 17

Nat Wildlife 17:4-13, 55 (c, 1)
O '79
Nat Wildlife 18:4-11 (c, 1) O '80
--Birch trees
Nat Wildlife 15:30-2 (c, 1) O '77
--Concord, Massachusetts
Nat Geog 159:383 (c, 2) Mr '81
--Ferns (Vermont)
Nat Wildlife 16:42-7 (c, 1) Ag
'78
--Forest
Nat Wildlife 16:14-16, 25 (c, 1)
O '78
--Louisiana swamp
Nat Geog 156:390-1 (c, 3) S '79
--Minnesota forest
Nat Wildlife 18:54-5 (c, 1) Ap
'80
--Montana park
Nat Geog 156:133 (c, 1) Jl '79
--Mt. Rainier National Park,
Washington
Nat Wildlife 15:12 (c, 2) Ap '77
--New York forest
Sports Illus 47:29 (c, 1) O 3 '77
--Ohio park
Nat Geog 151:254-5 (c, 1) F
'77
--Pennsylvania
Nat Geog 153:755 (c, 1) Je '78
--Raking leaves (Vermont)
Travel 148:77 (3) S '77
--Trees
Nat Wildlife 15:56 (c, 1) O '77
Trav/Holiday 154:43 (c, 1) S '80
--Trees (Michigan)
Nat Geog 155:836-7 (c, 1) Je '79
--Trees (Tennessee)
Nat Geog 156:6, 144 5 (c, 1) Jl
'79
--Trees (Vermont)
Natur Hist 90:82 (c, 1) Mr '81
--Wisconsin
Nat Geog 152:182-3 (c, 1) Ag '77
AUYUITTUQ NATIONAL PARK,
BAFFIN, NORTHWEST TERR.
Sports Illus 50:52-63 (c, 1) F
12 '79
AVALANCHES
--Avalanche control activities
Smithsonian 11:56-65 (c, 1) D
'80
AVOCADOS
Ebony 33:154 (c, 4) Je '78
AVOCETS
Nat Geog 151:164, 176-7 (paint-
ing, c, 2) F '77
Nat Wildlife 15:42-3, 46 (c, 1)

Je '77
Nat Geog 155:372 (c, 1) Mr '79
Nat Wildlife 18:28 (painting, c, 4)
O '80
Nat Wildlife 19:42-3, 48 (c, 1) F
'81
Natur Hist 90:42-7 (c, 1) Ag '81
AWARDS
--American Cancer Society award
Ebony 35:136 (4) N '79
--Black Achievement ceremony
(California)
Ebony 34:130-4 (3) F '79
Ebony 36:44-50 (3) F '81
--Coach of the Year plaque
Ebony 35:51 (4) Ja '80
--College alumni plaque
Ebony 33:131 (3) S '78
--Grammy award
Ebony 33:116 (2) N '77
Ebony 34:40 (4) Ja '79
--NAACP youth awards
Ebony 35:152-4 (3) S '80
--See also TROPHIES
AXES
--Bronze Age (China)
Smithsonian 11:65 (c, 4) Ap '80
--Hatchet used to murder Lizzie
Borden's parents (1893)
Am Heritage 29:42-3 (3) F '78
AZALEAS
Nat Wildlife 16:28 (c, 2) O '78
Sports Illus 54:39 (c, 3) Ap 20
'81
AZTEC INDIANS (MEXICO)
Nat Geog 158:cov., 704-75
(map, c, 1) D '80
AZTEC INDIANS (MEXICO)--
COSTUME
Nat Geog 158:704-53 (c, 1) D '80
AZTEC INDIANS (MEXICO)--
RELICS
Nat Geog 158:cov., 705-75 (c, 1)
D '80
AZTEC INDIANS (MEXICO)--RITES
AND FESTIVALS
--Human sacrifice (16th cent. draw-
ing)
Natur Hist 86:46-51 (c, 1) Ap '77
Smithsonian 8:26 (drawing, c, 3)
Je '77

-B-

BABIES
Ebony 32:60-1 (c, 1) Jl '77
Nat Geog 153:388 (c, 2) Mr '78

Ebony 33:34, 38-9 (c, 4) My
'78
Life 1:44 (c, 2) D '78
Life 2:62-3 (1) N '79
Life 2:164 (c, 1) D '79
Nat Geog 157:853 (c, 1) Je '80
Smithsonian 11:60-8 (1) F '81
Ebony 36:37-44 (2) Jl '81
Natur Hist 90:66-7 (c, 2) Jl '81
Ebony 36:50, 128-30 (4) Ag '81
--1901 (Macedonia)
Am Heritage 32:28 (4) O '81
--Argentina
Nat Geog 158:487 (c, 1) O '80
--Carried on back (Nigeria)
Natur Hist 90:48-9 (c, 2) Je '81
--Cradleboards (Apache Indians;
Arizona)
Nat Geog 157:280-1 (c, 1) F '80
--Feeding baby in high chair
Ebony 36:38 (3) Jl '81
--In aluminum swaddler
Nat Geog 154:188-9 (c, 2) Ag
'78
--Indian papooses
Life 2:86 (4) F '79
--New-born infants
Life 1:5 (4) O '78
Ebony 36:42 (4) Je '81
--Nursing (1930's)
Natur Hist 87:81 (3) F '78
--Nursing (Zimbabwe)
Nat Geog 160:632 (c, 2) N '81
--Premature
Life 2:106 (3) O '79
Life 4:46-54 (1) F '81
--Premature babies on display at
fairs (early 20th cent.)
Am Heritage 32:91 (3) Je '81
--Tossing baby in air
Sports Illus 53:32 (c, 4) S 8 '80
--Warm Springs Indians (Oregon)
Nat Geog 155:494-5 (c, 1) Ap
'79
--See also BABY CARRIAGES;
BABY CRIBS; BABY STROLL-
ERS; CHILDBIRTH; CRADLES;
PREGNANCY
BABOONS
Trav/Holiday 149:63 (c, 4) Je
'78
BABY CARRIAGES
--Austria
Trav/Holiday 151:85 (4) Mr '79
--Spain
Nat Geog 153:330-1 (c, 2) Mr
'78
BABY CRIBS

--Warm Springs Indians (Oregon)
Nat Geog 155:494-5 (c, 1) Ap
'79
BABY STROLLERS
Ebony 35:82 (4) N '79
--U. S. S. R.
Nat Geog 153:42 (c, 3) Ja '78
BACCHUS
--1804 mosaic snuffbox (Italy)
Smithsonian 8:88 (c, 2) My '77
BACHELOR'S-BUTTON PLANTS
Nat Geog 160:700 (c, 4) N '81
BACKPACKS
Sports Illus 47:50-1 (c, 3) Jl 18
'77
Nat Wildlife 17:34-5 (c, 1) D '78
Trav/Holiday 152:47 (c, 1) Jl '79
BACTERIA
Natur Hist 88:44 (3) Ag '79
Natur Hist 88:25 (4) N '79
--Residents of compost piles
Nat Geog 158:272-84 (c, 1) Ag
'80
--Shown on teeth
Life 1:55-8 (1) N '78
BADEN-BADEN, WEST GERMANY
--Race track
Nat Geog 152:160-1 (c, 1) Ag '77
BADGERS
Nat Wildlife 16:36-8 (c, 1) D '77
--Diagram of burrow
Nat Wildlife 16:38 (drawing, 3) D
'77
BADLANDS NATIONAL PARK,
SOUTH DAKOTA
Nat Geog 159:524-39 (c, 1) Ap
'81
BAER, MAX
Sports Illus 48:66-73 (c, 1) Mr
20 '78
Ebony 33:130 (4) Mr '78
BAFFIN ISLAND, NORTHWEST
TERRITORIES
Sports Illus 50:52-63 (c, 1) F 12
'79
--See also AUYUITTUQ NATIONAL
PARK
BAGPIPE PLAYING
--Scotland
Trav/Holiday 152:cov. (c, 1) S
'79
BAGPIPES
--Bagpipe production (Scotland)
Trav/Holiday 152:42 (c, 4) S '79
BAHAMAS
Trav/Holiday 156:cov. , 14-16
(c, 1) D '81
--Beach

Ebony 35:82 (4) Ja '80
--See also NASSAU
BAHRAIN
 Nat Geog 154:816-17 (c, 2) D
 '78
 Trav/Holiday 151:74-9, 90-1
 (c, 1) My '79
 Nat Geog 156:300-29 (map, c, 1)
 S '79
--Mosque
 Travel 147:60 (4) Ja '77
--U. S. officers' recreational center
 Sports Illus 53:92-3 (c, 4) N
 17 '80
--See also MANAMA
BAHRAIN--COSTUME
 Trav/Holiday 151:74-9, 90-1
 (c, 1) My '79
 Nat Geog 156:300-29 (c, 1) S '79
BAINBRIDGE, WILLIAM
 Am Heritage 28:43 (painting, 4)
 Ag '77
BAJA CALIFORNIA, MEXICO
 Trav/Holiday 153:35-9 (c, 1)
 Ja '80
--Mountains
 Nat Geog 158:694-9 (c, 1) N '80
BAKERS
 Life 4:72 (c, 4) Jl '81
Baking. See BREAD MAKING;
 COOKING
BALDNESS
 Life 2:cov. (c, 1) Je '79
--Swimmers
 Sports Illus 48:27-8 (c, 3) Ap
 3 '78
Bali. See INDONESIA
BALLET DANCING
 Nat Geog 151:200-1 (c, 1) F '77
 Sports Illus 47:62-3 (c, 1) Jl 11
 '77
 Travel 148:45 (4) O '77
 Nat Geog 154:392 (c, 4) S '78
 Life 2:37-9 (c, 2) Ag '79
 Life 3:142-6 (c, 1) N '80
--19th cent.
 Smithsonian 8:59 (2) Ag '77
--Australia
 Trav/Holiday 155:cov. (c, 1) F
 '81
--Ballet shoes
 Life 2:9-10 (c, 2) N '79
--Cuba
 Nat Geog 151:60 (c, 1) Ja '77
--New York
 Life 2:61-7 (c, 1) Ja '79
 Life 4:10-20 (c, 1) D '81
--Practicing

Ebony 33:148 (3) Ag '78
Life 2:128 (c, 3) Je '79
Ebony 34:46 (4) S '79
Ebony 36:108 (4) My '81
Sports Illus 54:36 (c, 4) My 11
 '81
--Saratoga, New York
 Trav/Holiday 149:33 (c, 2) My
 '78
--Stop-action photo
 Life 3:98-9 (1) N '80
--U. S. S. R.
 Nat Geog 153:cov., 21, 45 (c, 1)
 Ja '78
 Trav/Holiday 150:8 (4) N '78
--See also DIAGHILEV, SERGEI
BALLET DANCING--EDUCATION
--Albania
 Nat Geog 158:542-3 (c, 1) O '80
BALLOONING
 Ebony 32:88-96 (c, 2) Jl '77
 Life 1:cov., 34-8 (c, 1) O '78
 Nat Geog 154:cov., 858-82 (c, 1)
 D '78
 Sports Illus 50:57 (3) Je 11 '79
--19th cent. France
 Smithsonian 8:124-5 (painting, c, 4)
 Ap '77
--1006
 Smithsonian 9:138 (4) N '78
--California
 Trav/Holiday 148:28-9 (4) N '77
 Nat Geog 155:694 (c, 1) My '79
--Collapsing balloon (Louisiana)
 Sports Illus 54:58 (c, 4) Ja 19
 '81
--Colorado
 Nat Wildlife 16:24 (c, 2) Ap '78
 Nat Geog 155:394-5 (c, 2) Mr '79
 Nat Geog 156:503 (c, 1) O '79
--Cross-Atlantic flight
 Nat Geog 151:cov., 208-17 (c, 1)
 F '77
 Sports Illus 49:cov., 14-19 (c, 1)
 Ag 28 '78
 Life 2:195 (c, 2) D '79
--Cross-country
 Nat Geog 158:260-71 (map, c, 1)
 Ag '80
--New Mexico
 Trav/Holiday 149:37 (c, 2) Ja '78
 Sports Illus 51:60-8 (c, 1) D 24
 '79
--Ohio
 Life 4:144 (c, 2) My '81
--Parasailing (Mexico)
 Trav/Holiday 156:47 (c, 3) N '81
--Pennsylvania

Nat Geog 153:739 (c, 1) Je '78
--Solar balloon
Smithsonian 10:91-4 (c, 2) Je
'79
BALLOONING--HUMOR
--Idealized balloon trips
Sports Illus 53:27-35 (painting, c, 1)
S 29 '80
BALLOONS
Nat Geog 151:212-13 (c, 4) F
'77
--1909 exhibition (France)
Life 3:94 (c, 2) Ap '80
--Inflatable whale
Life 2:138 (c, 4) Je '79
--Lead-foil sky balloon
Smithsonian 12:112 (c, 1) O '81
--Used for aerial photography
(Tunisia)
Smithsonian 9:54 (c, 4) F '79
--Used for research
Smithsonian 9:51 (c, 3) Mr '79
--See also AIRSHIPS
BALLOONS, TOY
Sports Illus 52:25 (c, 4) Je 9
'80
--Bird-shaped (Spain)
Travel 148:26 (c, 4) O '77
--Mexico
Nat Geog 153:612 (c, 3) My '78
BALTIMORE, MARYLAND
Ebony 33:97 (4) F '78
Life 3:90-4 (c, 1) S '80
Trav/Holiday 154:46-8, 72 (c, 1)
S '80
Nat Geog 158:466-7 (c, 1) O '80
Ebony 37:62-3, 68-70 (3) D '81
--Early 19th cent.
Am Heritage 32:18-27 (paint-
ing, c, 1) F '81
--Harbor area
Life 2:60 (4) Mr '79
--Johns Hopkins University
Smithsonian 8:82 (c, 1) O '77
--Street near stadium
Sports Illus 52:95 (painting, c, 3)
Ap 7 '80
BALZAC, HONORE DE
--Tomb (Paris, France)
Smithsonian 9:111 (c, 4) N '78
BAMBOO
Nat Geog 158:502-29 (c, 1) O
'80
BAMBOO INDUSTRY
--Taiwan
Nat Geog 158:518-19 (c, 1) O
'80
BANANA INDUSTRY

--Grenada
Nat Geog 156:419 (c, 4) S '79
--Plantation (Haiti)
Trav/Holiday 151:58 (c, 2) F '79
BANANA INDUSTRY--HARVESTING
--Honduras
Trav/Holiday 155:44 (c, 4) Ja '81
BANANA INDUSTRY--TRANSPORTA-
TION
--Panama
Trav/Holiday 149:42 (c, 4) Ap '78
BANANA PLANTS
Trav/Holiday 149:53 (c, 4) Je '78
BANANAS
Natur Hist 86:80-1 (3) My '77
Nat Geog 155:130 (c, 3) Ja '79
Nat Geog 160:54 (c, 3) Jl '81
BANDS
Ebony 37:148 (4) N '81
--1840's brass band (Missouri)
Am Heritage 31:80 (3) D '79
--Early 20th cent. jazz bands
Smithsonian 11:100-2 (4) N '80
--Japan
Life 4:106-7 (c, 1) F '81
--Jazz
Ebony 34:120 (4) N '78
--Jazz (1920's)
Ebony 34:60 (4) O '79
--Jazz (1930's)
Ebony 34:60 (4) O '79
--Jazz (1940's)
Ebony 32:122 (4) Je '77
--Jazz (New Orleans, Louisiana)
Sports Illus 54:51 (c, 3) Ja 19
'81
--Mariachi (Mexico)
Trav/Holiday 152:53 (c, 4) Jl '79
--Navy band (1945)
Am Heritage 31:38 (3) Je '80
--Night club (Mexico)
Trav/Holiday 153:36 (c, 4) Ja '80
--Prison group (New York)
Ebony 35:105 (4) Mr '80
--Ragtime (St. Louis, Missouri)
Trav/Holiday 150:25 (c, 4) Ag '78
--Steel band (St. Lucia)
Trav/Holiday 151:65 (c, 4) Ap '79
--See also BANDS, MARCHING;
MUSICIANS
BANDS, MARCHING
--1860 (New York)
Am Heritage 32:42 (3) Je '81
--Christmas band (North Carolina)
Trav/Holiday 156:4, 12 (c, 1) D
'81
--Drum and bugle corps (Iowa)
Trav/Holiday 151:62 (c, 2) Je '79

--Drummer (Kansas)
 Life 2:90 (1) Je '79
--Fife and drum corps (1980
 Olympics)
 Sports Illus 52:19 (c, 2) Mr 13
 '80
--Fife and drum corps (Revolu-
 tionary War style)
 Sports Illus 53:cov. (c, 1) D
 1 '80
--Football games
 Sports Illus 48:36, 38, 42 (c, 4)
 Ja 9 '78
--Missouri college band
 Sports Illus 53:72-3 (c, 3) S 1
 '80
--Mummer New Year's parade
 (Philadelphia, Pennsylvania)
 Smithsonian 11:80-1 (c, 2) Ja
 '81
--Munich, West Germany
 Nat Geog 152:172-3 (c, 2) Ag '77
--Ohio State University
 Life 4:58-9 (c, 1) Ja '81
--Presidential inauguration 1981
 Ebony 36:132-3 (c, 3) Mr '81
BANDS, MARCHING--COSTUME
--College
 Sports Illus 51.86 (c, 4) O 22
 '79
--Great Britain
 Sports Illus 52:40 (c, 4) Je 23
 '80
BANFF NATIONAL PARK, AL-
 BERTA
 Nat Geog 157:757-77 (c, 1) Je
 '79
 Trav/Holiday 155:cov. (c, 1)
 My '81
--See also LAKE LOUISE
BANJO PLAYING
--Arkansas
 Trav/Holiday 153:40 (4) Ap '80
--New York
 Nat Geog 153:68-9 (c, 1) Ja '78
--Tennessee
 Trav/Holiday 153:67 (c, 1) Mr
 '80
Banking. See CHECKS, BANKING
BANKS
--19th cent. toy banks
 Am Heritage 32:20-1 (c, 2) D
 '80
--Bahrain
 Nat Geog 156:311 (c, 4) S '79
--Chicago, Illinois
 Ebony 35:42, 104-6 (3) Ag '80
--Line of customers (New York)

Ebony 35:104-5, 107 (3) Ag '80
--Los Angeles, California
 Ebony 35:104, 107 (4) Ag '80
--Richmond, Virginia
 Ebony 35:48 (4) Je '80
--Robberies
 Life 2:142 (4) O '79
--Tellers' windows (Illinois)
 Ebony 35:29 (4) Ja '80
 Ebony 35:104-5 (3) Ag '80
--Vault (Louisiana)
 Ebony 36:68 (3) Jl '81
--Washington, D. C.
 Ebony 35:106, 108 (3) Ag '80
--World Bank activities
 Smithsonian 12:60-9 (c, 1) Je '81
BANYAN TREES
 Trav/Holiday 153:49 (c, 2) Mr
 '80
BAOBAB TREES
 Smithsonian 9:124-5 (c, 2) N '78
 Smithsonian 11:86-7 (c, 1) Ap
 '80
--Leaves
 Nat Geog 157:515 (c, 2) Ap '80
BAPTISMS
--Born again Christians
 Life 2:75 (c, 2) D '79
--Colorado church
 Nat Geog 155:390-1 (c, 1) Mr '79
--Condemned killer (1903; Wyoming)
 Am Heritage 30:29 (4) Ap '79
--St. Vincent
 Nat Geog 156:409 (c, 1) S '79
BARBADOS
 Trav/Holiday 152:50-2 (c, 1) Ag
 '79
--Windmill
 Trav/Holiday 151:52 (c, 1) Ap
 '79
--See also BRIDGETOWN
BARBAROSSA
 Am Heritage 28:36 (c, 1) Ag '77
Barbecues. See COOKING
BARBED WIRE
 Natur Hist 87:84-98 (3) N '78
BARBER POLES
 Nat Geog 158:685 (c, 1) N '80
Barbers. See BEAUTY PARLORS;
 HAIRDRESSING
BARCELONA, SPAIN
--Gothic Cathedral
 Trav/Holiday 150:10 (4) D '78
BARGES
 Nat Geog 152:462 (c, 1) O '77
 Nat Geog 153:84-5 (c, 1) Ja '78
--Vacationing on barges (France)
 Trav/Holiday 151:57-9 (c, 1) My

'79
--Vacationing on barges (Nether-
 lands)
 Trav/Holiday 153:46 (c, 3) F
 '80
BARLEY INDUSTRY
--Barley field (North Dakota)
 Natur Hist 89:38 (c, 4) Jl '80
BARLEY INDUSTRY--HARVESTING
--Peru
 Natur Hist 86:32-3, 41 (c, 1)
 My '77
--Tibet
 Smithsonian 7:83 (c, 3) Ja '77
 Nat Geog 157:256-7 (c, 1) F '80
BARNACLES
 Natur Hist 86:46 (c, 2) My '77
 Nat Geog 155:6-7 (c, 4) Ja '79
BARNS
 Sports Illus 55:51 (drawing, c, 3)
 Jl 6 '81
--19th cent. stone barn (Virginia)
 Life 3:114 (c, 4) D '80
--1850's cantilever barn
 Natur Hist 87:98 (3) Je '78
--Decorated (Wisconsin)
 Trav/Holiday 153:33 (c, 4) Je
 '80
--Maine
 Nat Geog 158:390-1 (c, 1) S '80
--Nebraska
 Nat Geog 154:502-3 (c, 1) O '78
 Trav/Holiday 153:37 (c, 2) Je
 '80
--Old barn wall (Ozarks)
 Am Heritage 29:103 (c, 1) D '77
--Valley Forge, Pennsylvania
 Trav/Holiday 155:105 (4) Ap
 '81
--Vermont
 Nat Wildlife 17:9 (c, 1) D '78
 Nat Wildlife 17:6-7 (c, 1) O '79
--West Virginia
 Travel 148:34 (c, 4) O '77
--See also FARMS; SILOS; STABLES
BARNUM, PHINEAS T.
 Smithsonian 8:59 (2) Ag '77
 Am Heritage 28:99 (4) O '77
 Life 3:67 (4) Jl '80
BARRE, VERMONT
--Early 20th cent. granite quarry
 Am Heritage 32:65-71 (1) D
 '80
BARREL MAKING
--India
 Nat Geog 153:352 (c, 4) Mr
 '78
--Kentucky

Trav/Holiday 155:61 (c, 4) Je '81
BARTON, CLARA
 Smithsonian 8:88 (4) Jl '77
 Am Heritage 32:83 (3) F '81
 Smithsonian 12:126-30 (4) My
 '81
 Nat Geog 159:776 (1) Je '81
--Home (Glen Echo, Maryland)
 Smithsonian 12:140 (4) My '81
BARTRAM, JOHN & WILLIAM
 Smithsonian 8:123 (painting, c, 4)
 O '77
 Nat Wildlife 16:24 (4) O '78
BASEBALL
 Sports Illus 48:80-4 (c, 4) Je 19
 '78
--1888 international tour
 Am Heritage 28:46-9 (c, 3) O '77
--Bat making (Louisville, Kentucky)
 Trav/Holiday 151:55 (2) Mr '79
--Cuba
 Sports Illus 46:68-72 (c, 2) Je 6
 '77
--Dairy Night at Milwaukee stadium
 (Wisconsin)
 Nat Geog 158:180-1 (c, 2) Ag '80
--Dominican Republic
 Nat Geog 152:552-3 (c, 2) O '77
--Japan
 Sports Illus 47:58-63 (c, 1) Ag
 15 '77
 Sports Illus 51:58-62 (painting, c, 1)
 S 24 '79
--Massachusetts
 Sports Illus 55:12-19 (c, 1) Jl 6
 '81
--Running (Mexico)
 Sports Illus 53:26 (c, 4) Ag 18
 '80
--Special days at stadiums
 Sports Illus 47:37-40 (c, 1) Jl 18
 '77
--Umpires
 Sports Illus 55:48-9 (drawing, c, 1)
 Jl 6 '81
--Umpires (Cuba)
 Sports Illus 46:68 (c, 3) Je 6 '77
--World Friendship Series
 Sports Illus 55:40-2 (c, 3) Jl 27
 '81
BASEBALL--COLLEGE
--Celebrating
 Sports Illus 50:47 (c, 4) Je 18
 '79
--Hitting
 Sports Illus 46:47 (4) Je 27 '77
 Sports Illus 54:34-5 (c, 2) Mr 30
 '81

--Pitching
 Sports Illus 54:32 (c, 3) Mr 30
 '81
BASEBALL--HUMOR
 Sports Illus 46:39-44 (paint-
 ing, c, 1) Ap 11 '77
BASEBALL--LITTLE LEAGUE
--Dominican Republic
 Sports Illus 55:62-3, 70 (c, 1)
 Jl 13 '81
--Taiwan
 Sports Illus 47:78 (c, 4) S 5 '77
BASEBALL--PROFESSIONAL
 Sports Illus 46:56 (c, 3) Mr 7
 '77
 Sports Illus 46:24-7 (c, 2) My
 16 '77
 Sports Illus 47:8-13 (c, 3) Jl
 25 '77
 Sports Illus 47:20-4 (c, 4) S 5
 '77
 Sports Illus 47:18 (c, 2) O 3 '77
 Sports Illus 47:18-23 (c, 2) O
 17 '77
 Sports Illus 48:cov., 36-64
 (c, 1) Ap 10 '78
 Sports Illus 48:24-5 (c, 3) Ap
 24 '78
 Sports Illus 49:10-21 (c, 2) Jl
 10 '78
 Sports Illus 49:24-9 (c, 3) O
 16 '78
 Ebony 34:152-6 (c, 3) Je '79
 Sports Illus 51:cov., 12-17
 (c, 1) Jl 23 '79
 Sports Illus 51:20-2 (c, 2) Jl
 30 '79
 Sports Illus 51:36-41 (c, 1) Ag
 13 '79
 Sports Illus 51:18-23 (c, 2) O
 1 '79
 Sports Illus 51:26-31 (c, 1) O
 15 '79
 Sports Illus 52:26-67 (c, 1) Ap
 7 '80
 Sports Illus 53:cov., 20-5
 (c, 1) O 6 '80
 Sports Illus 55:cov., 22-7 (c, 1)
 O 26 '81
--1920's
 Sports Illus 46:88-90 (1) Ap 11
 '77
--1940's
 Ebony 35:104-5 (4) Je '80
--1960's
 Sports Illus 51:71-94 (c, 3) Ag
 13 '79
--1961

 Sports Illus 46:60-1 (1) Je 20
 '77
--Arguing with umpire
 Sports Illus 53:64, 68 (c, 3) O 6
 '80
--Breaking bat while hitting
 Sports Illus 47:17 (c, 4) Ag 1 '77
--Bullpen
 Sports Illus 50:27 (c, 2) My 14
 '79
--Bunting
 Sports Illus 47:23 (c, 4) Jl 18 '77
 Sports Illus 47:38 (4) Ag 1 '77
 Sports Illus 49:14-15 (c, 3) Jl 31
 '78
 Sports Illus 55:35 (c, 4) Ag 24
 '81
 Sports Illus 55:33 (c, 4) Ag 31
 '81
--Catchers
 Sports Illus 49:44 (4) S 25 '78
 Sports Illus 49:20-1 (c, 1) O 23
 '78
 Ebony 34:68 (4) Ja '79
 Sports Illus 54:44 (c, 4) My 11
 '81
 Sports Illus 54:20-1 (c, 1) Je 8
 '81
--Celebrating
 Sports Illus 48:37 (c, 3) Je 5 '78
 Sports Illus 49:50 (c, 4) Jl 24 '78
 Sports Illus 49:27 (c, 4) O 23 '78
 Sports Illus 51:28, 31 (c, 4) O 15
 '79
 Sports Illus 52:92-3 (painting, c, 1)
 Ap 7 '80
 Sports Illus 52:35 (c, 3) Ap 21
 '80
 Sports Illus 52:36 (c, 2) My 5
 '80
 Sports Illus 53:90, 92 (c, 4) O
 13 '80
 Sports Illus 53:20-1 (c, 2) O 20
 '80
 Sports Illus 53:26-7 (c, 2) O 27
 '80
 Sports Illus 55:cov., 12-13 (c, 1)
 Ag 17 '81
 Sports Illus 55:34 (c, 2) O 12 '81
 Sports Illus 55:44 (c, 2) O 19 '81
 Sports Illus 55:28 (c, 2) N 9 '81
--Coaches
 Sports Illus 46:cov., 37-42 (c, 1)
 Mr 14 '77
 Sports Illus 46:30 (c, 2) My 2
 '77
 Sports Illus 46:52 (3) Je 13 '77
 Sports Illus 47:16 (c, 3) Ag 1 '77

Sports Illus 47:16-17 (c, 2) Ag
8 '77
Sports Illus 47:16 (c, 4) Ag
22 '77
Sports Illus 49:cov. , 20 (c, 1)
Jl 31 '78
Sports Illus 49:25 (c, 2) S 25
'78
Sports Illus 49:26 (c, 4) O 23
'78
Sports Illus 50:cov. , 42, 50
(3) Ap 30 '79
Sports Illus 50:cov. , 19 (c, 1)
Je 18 '79
Sports Illus 51:14-15 (c, 2) Jl
2 '79
Sports Illus 52:18-19 (c, 1) Mr
10 '80
Sports Illus 53:53 (c, 2) Je 30
'80
Sports Illus 54:52-63 (c, 1) Ap
13 '81
Sports Illus 55:28-9 (c, 4) S 7
'81
--Crossing home plate
Ebony 35:105 (4) Je '80
--Dugout
Ebony 36:80 (3) Jl '81
--Fielding
Sports Illus 46:cov. (c, 1) Mr
28 '77
Sports Illus 47:52 (2) O 3 '77
Sports Illus 47:22-3 (c, 3) O 24
'77
Sports Illus 48:22-3 (c, 3) My
29 '78
Sports Illus 49:17 (c, 3) Jl 3
'78
Sports Illus 49:19 (c, 3) Jl 10
'78
Sports Illus 49:23-4 (c, 2) Jl
24 '78
Sports Illus 49:27 (c, 3) S 18
'78
Sports Illus 49:32-3 (c, 4) O 9
'78
Sports Illus 49:24-5 (c, 2) O
23 '78
Sports Illus 51:14-15 (c, 2) Jl
23 '79
Sports Illus 51:30-1 (c, 4) O
15 '79
Sports Illus 52:44-6 (c, 2) Mr
10 '80
Sports Illus 52:16-17 (c, 1)
Je 9 '80
Sports Illus 53:cov. (c, 1) Ag
25 '80

Sports Illus 53:24-5 (c, 4) O 20
'80
Sports Illus 53:29 (c, 4) O 27 '80
Sports Illus 54:22 (c, 2) Mr 30
'81
Sports Illus 54:20-4 (c, 2) Ap 13
'81
Sports Illus 54:42-3 (c, 1) Ap 20
'81
Sports Illus 55:14-15 (c, 3) Ag 17
'81
Sports Illus 55:30-40 (c, 1) N 2
'81
--Fighting
Sports Illus 49:26 (c, 4) S 25 '78
--Fighting (1960's)
Sports Illus 49:31 (2) Ag 7 '78
--History montage
Sports Illus 48:92-3 (c, 1) Ap 10
'78
--Hitting
Sports Illus 46:24 (c, 2) Ap 25
'77
Sports Illus 46:cov. , 19 (c, 1)
My 30 '77
Sports Illus 46:22-3 (c, 2) Je 20
'77
Sports Illus 47:21-2 (c, 2) Jl 18
'77
Sports Illus 47:18 (c, 4) Ag 8 '77
Sports Illus 47:18 (c, 3) S 19 '77
Ebony 32:61 (c, 2) O '77
Sports Illus 48:26 (c, 2) My 15
'78
Ebony 33:170-1 (c, 4) Je '78
Sports Illus 49:21 (c, 3) Jl 10
'78
Sports Illus 49:cov. (c, 1) Ag 7
'78
Sports Illus 49:28-9 (c, 2) S 11
'78
Sports Illus 49:26 (c, 4) S 18 '78
Sports Illus 49:41 (c, 4) O 2 '78
Sports Illus 49:23 (c, 4) O 23 '78
Sports Illus 50:18, 20 (c, 3) My
7 '79
Sports Illus 50:cov. , 20-1 (c, 1)
My 28 '79
Sports Illus 51:32 (3) Jl 9 '79
Sports Illus 51:16-17 (c, 4) Jl
23 '79
Sports Illus 51:8-9 (c, 1) Ag 20
'79
Sports Illus 51:26-7 (c, 2) S 3
'79
Ebony 34:88 (4) O '79
Sports Illus 51:21 (c, 3) O 1 '79
Sports Illus 51:39 (c, 2) D 24 '79

Sports Illus 52:26-7 (c, 1) Ap 7
'80
Sports Illus 52:41 (c, 4) Ap 21
'80
Sports Illus 52:21 (c, 3) My 12
'80
Sports Illus 52:25 (c, 4) My 26
'80
Sports Illus 52:29-31 (c, 2) Je
16 '80
Sports Illus 53:26 (c, 2) Jl 14
'80
Sports Illus 53:10-11 (c, 1) Ag
25 '80
Sports Illus 53:31 (c, 3) S 8
'80
Sports Illus 53:cov., 23-4, 74
(c, 1) O 6 '80
Sports Illus 53:cov., 29 (c, 1)
O 27 '80
Sports Illus 54:22, 26 (c, 2)
Mr 16 '81
Sports Illus 54:44 (c, 4) Ap 20
'81
Sports Illus 54:22-3 (c, 4)
Ap 27 '81
Sports Illus 54:cov., 22 (c, 1)
Je 8 '81
Sports Illus 55:20 (c, 4) Ag 31
'81
Sports Illus 55:34 (c, 4) O 5
'81
Sports Illus 55:cov., 27 (c, 1)
O 26 '81
--Hitting home runs
Sports Illus 47:10-15 (c, 1) Jl
4 '77
Sports Illus 47:21 (c, 4) O 24
'77
Sports Illus 47:28-9 (c, 1) O
31 '77
Sports Illus 47:42 (c, 3) D 19
'77
Sports Illus 52:cov. (c, 1) Je
9 '80
Sports Illus 53:cov. (c, 1) Ag 4
'80
Ebony 35:98 (c, 3) O '80
--Illegal doctoring of bats
Sports Illus 54:94-5 (c, 4) Ap
13 '81
--Knocking over catcher
Sports Illus 53:22 (c, 4) O 20
'80
--Mascots
Sports Illus 50:18 (c, 4) Je 18
'79
Sports Illus 51:63-70 (c, 1) S

17 '79
Sports Illus 53:18 (c, 2) S 22 '80
--Minor leagues
Sports Illus 55:22-7 (c, 2) Jl 13
'81
--Pitching
Sports Illus 46:53 (c, 4) Ap 11
'77
Sports Illus 46:26-7 (c, 4) My 16
'77
Sports Illus 46:16-17 (c, 1) My
30 '77
Sports Illus 46:cov. (c, 1) Je 6
'77
Sports Illus 46:44 (4) Je 20 '77
Sports Illus 46:23 (c, 3) Je 27 '77
Sports Illus 47:39-41 (c, 1) Jl 11
'77
Sports Illus 47:11-12 (c, 3) Jl 25
'77
Sports Illus 47:19 (c, 4) Ag 8 '77
Sports Illus 47:72 (4) Ag 29 '77
Sports Illus 47:56 (4) S 12 '77
Sports Illus 47:76 (c, 4) S 19 '77
Sports Illus 47:19-20 (c, 3) O 3
'77
Sports Illus 47:23 (c, 3) O 24 '77
Sports Illus 48:53 (4) Ap 17 '78
Sports Illus 48:50 (3) Je 12 '78
Sports Illus 48:21 (c, 3) Je 26
'78
Sports Illus 49:14-15, 56-7 (c, 1)
Jl 3 '78
Sports Illus 49:20 (c, 4) Jl 10 '78
Sports Illus 49:61 (c, 4) Ag 7 '78
Sports Illus 49:31 (c, 1) Ag 14
'78
Sports Illus 49:28 (c, 4) S 18 '78
Sports Illus 50:62 (c, 4) Ja 22
'79
Sports Illus 50:36-7 (c, 1) F 15
'79
Sports Illus 50:cov. (painting, c, 1)
Mr 5 '79
Sports Illus 50:22-3 (c, 4) My 28
'79
Sports Illus 51:29 (c, 1) Jl 2 '79
Sports Illus 51:cov. (c, 1) Jl 23
'79
Sports Illus 51:40-1 (c, 4) Ag 13
'79
Sports Illus 52:34-6 (c, 2) Ap 21
'80
Sports Illus 52:33 (c, 2) My 5
'80
Sports Illus 52:24 (c, 4) My 26
'80
Sports Illus 53:cov., 22 (c, 1)

J1 21 '80
Sports Illus 53:13 (c, 4) Ag 18
'80
Sports Illus 53:45 (4) S 29 '80
Sports Illus 53:25 (c, 2) N 3
'80
Sports Illus 54:cov. , 38 (c, 1)
Mr 2 '81
Sports Illus 54:24-6 (c, 4) Mr
16 '81
Sports Illus 54:20-1 (c, 4) Ap
27 '81
Sports Illus 54:22-3 (c, 2) My
4 '81
Sports Illus 54:cov. , 24-5 (c, 1)
My 18 '81
Sports Illus 54:45 (c, 4) My 25
'81
Sports Illus 55:59 (c, 4) J1 27
'81
Sports Illus 55:30, 94 (c, 3) Ag
24 '81
Sports Illus 55:64-5 (c, 1) S 28
'81
--Pitching (1950's)
Sports Illus 50:38-9 (2) Ap 2
'79
--Rookies
Sports Illus 50:cov. , 25-31
(c, 1) Mr 19 '79
--Running
Sports Illus 46:23 (c, 4) Je 27
'77
Sports Illus 47:25 (c, 1) Ag 22
'77
Sports Illus 47:25 (c, 4) O 24
'77
Sports Illus 47:31 (c, 3) N 7 '77
Sports Illus 51:11 (c, 4) Ag 20
'79
Sports Illus 51:27 (c, 3) S 10
'79
Ebony 35:104 (4) Je '80
--Scoring run
Sports Illus 49:30-1 (c, 1) O 9
'78
Sports Illus 49:76 (c, 4) O 30
'78
Sports Illus 51:26-7 (c, 1) O 15
'79
--Sliding
Sports Illus 47:18-19 (c, 4) Ag
8 '77
Sports Illus 47:20, 23 (c, 4) S
5 '77
Sports Illus 47:18-19 (c, 2) O
17 '77
Sports Illus 50:40 (c, 3) F 15

'79
Sports Illus 50:38-9 (painting, c, 1)
Mr 5 '79
Sports Illus 50:18-19 (c, 3) Je 18
'79
Sports Illus 51:20 (c, 4) J1 16 '79
Sports Illus 51:123 (c, 2) Ag 13
'79
Sports Illus 51:19 (c, 3) O 1 '79
Sports Illus 51:27 (c, 3) O 22 '79
Sports Illus 52:31 (c, 3) Je 23
'80
Sports Illus 53:20 (c, 4) S 22 '80
Sports Illus 53:62 (c, 2) O 6 '80
Ebony 36:105 (4) N '80
Sports Illus 54:44 (c, 4) Ap 20
'81
Sports Illus 54:49 (c, 4) My 11
'81
Sports Illus 55:29 (c, 4) J1 13 '81
Sports Illus 55:33 (c, 4) S 21 '81
Sports Illus 55:22-3 (c, 1) O 26
'81
--Spring training
Sports Illus 46:32-7 (painting, c, 1)
Mr 7 '77
Sports Illus 48:29-32 (c, 2) Mr 6
'78
Sports Illus 48:29-30 (c, 3) Mr
13 '78
Sports Illus 48:34-7 (painting, c, 3)
Mr 27 '78
Sports Illus 50:cov. , 38-44
(painting, c, 1) Mr 5 '79
Sports Illus 54:36-44 (drawing, c, 1)
Mr 9 '81
--Stealing bases
Life 4:53-6 (c, 2) Ag '81
--Training
Sports Illus 55:14-17 (c, 1) Ag
10 '81
--Umpires
Sports Illus 48:40-9 (painting, c, 1)
Ap 10 '78
Sports Illus 50:18-21 (c, 1) Ap 16
'79
Sports Illus 51:16-17 (c, 2) Ag 20
'79
Ebony 35:105 (4) Je '80
Sports Illus 53:53 (c, 2) Je 30 '80
Sports Illus 53:20-1 (c, 4) O 6 '80
Sports Illus 54:52 (c, 1) Ap 13 '81
Sports Illus 54:78 (4) Ap 20 '81
Ebony 36:47 (4) Je '81
Sports Illus 55:28-9 (c, 2) Ag 24
'81
Ebony 36:92-3 (2) S '81
--Umpires (Japan)

20 '78
Sports Illus 49:cov., 44-7 (c, 1)
N 27 '78
Sports Illus 50:12-15 (c, 2) Mr
5 '79
Sports Illus 50:cov., 26-8 (c, 1)
Mr 12 '79
Sports Illus 50:20-3 (c, 2) Mr
19 '79
Sports Illus 50:cov., 14-19 (c, 1)
Mr 26 '79
Sports Illus 52:18-21 (c, 1) F
18 '80
Sports Illus 52:118-22 (c, 1)
Mr 10 '80
Sports Illus 52:cov., 14-17
(c, 1) Mr 17 '80
Sports Illus 53:30-9 (c, 1) D 1
'80
Sports Illus 54:14-15 (3) F 16
'81
Sports Illus 54:22 (c, 4) F 23
'81
Sports Illus 54:20-4 (c, 2) Mr
9 '81
--Blocking
Sports Illus 46:19 (c, 4) Mr 28
'77
Sports Illus 49.73 (4) D 11 '78
Sports Illus 51:42-5 (c, 3) D 3
'78
Sports Illus 52:14 (c, 2) Ja 21
'80
Sports Illus 54:20 (c, 2) Mr 9
'81
Sports Illus 54:16-17 (c, 1) Mr
16 '81
Sports Illus 54:19 (c, 2) Mr 30
'81
--Celebrating victory
Sports Illus 46:20-1 (c, 2) Mr
28 '77
Sports Illus 50:28 (c, 4) Mr 12
'79
Sports Illus 50:50 (3) Mr 26
'79
Sports Illus 52:10-11 (c, 1) Mr
10 '80
Sports Illus 54:12-13 (c, 1) Mr
23 '81
--Coaches
Ebony 32:44-8 (4) Ap '77
Sports Illus 46:21 (c, 4) Ap 4
'77
Sports Illus 47:24 (c, 3) D 12
'77
Sports Illus 48:26-9 (c, 1) Ja
2 '78

Sports Illus 48:25 (c, 4) Ja 23
'78
Sports Illus 48:42 (4) Ja 30 '78
Sports Illus 48:80-1 (c, 3) F 9
'78
Sports Illus 48:44 (4) F 27 '78
Sports Illus 49:64 (4) D 4 '78
Sports Illus 50:46 (3) Mr 5 '79
Sports Illus 50:28 (c, 4) Mr 12
'79
Sports Illus 51:92-4 (c, 4) D 3
'79
Sports Illus 51:31 (c, 4) D 24 '79
Sports Illus 54:43 (4) Ja 5 '81
Sports Illus 54:cov. (c, 1) Ja 26
'81
Sports Illus 54:23 (c, 4) F 23 '81
Sports Illus 55:33 (c, 4) D 14 '81
--Dribbling
Sports Illus 46:48 (4) F 28 '77
Sports Illus 46:28 (c, 3) Mr 21
'77
Sports Illus 47:87 (4) D 19 '77
Sports Illus 48:12-13 (c, 2) Ja 9
'78
Sports Illus 48:12-13 (c, 2) Mr
20 '78
Sports Illus 49:45 (c, 3) N 27 '78
Sports Illus 50:17 (c, 3) F 5 '79
Sports Illus 50:cov., 53 (c, 1)
Mr 26 '79
Sports Illus 51:32 (c, 4) D 24 '79
Sports Illus 54:28-9 (c, 2) F 9
'81
Sports Illus 54:14-15 (c, 1) Mr
30 '81
--Dunking
Sports Illus 46:cov. (c, 1) Ja 31
'77
Sports Illus 47:50 (3) D 12 '77
Sports Illus 48:18-19 (c, 1) Ap 3
'78
Sports Illus 50:14-15 (c, 3) Ja 22
'79
Sports Illus 50:cov. (c, 1) Mr 12
'79
Sports Illus 50:cov. (c, 1) Ap 2
'79
Sports Illus 52:16-19 (c, 1) F 11
'80
Sports Illus 53:30 (c, 3) D 8 '80
Sports Illus 53:21 (c, 2) D 22 '80
Sports Illus 54:22 (c, 2) F 9 '81
Ebony 36:74, 78 (3) Mr '81
Sports Illus 54:23 (c, 2) Mr 9 '81
Sports Illus 54:33 (c, 4) Je 8 '81
Sports Illus 55:44 (c, 1) N 30 '81
--Informal game

Sports Illus 48:39 (c, 3) My 15
'78
--NCAA Championships 1978 (Ken-
tucky vs. Duke)
Sports Illus 48:cov. , 18-21
(c, 1) Ap 3 '78
Sports Illus 48:78-80 (c, 1) Ap
24 '78
--NCAA Championships 1979
(Michigan vs. Indiana)
Sports Illus 50:cov. , 16-19
(c, 1) Ap 2 '79
--NCAA Championships 1980
(Louisville vs. UCLA)
Sports Illus 52:cov. , 10-13
(c, 1) Mr 31 '80
--NCAA Championships 1981 (Indi-
ana vs. North Carolina)
Sports Illus 54:cov. , 14-21
(c, 1) Mr 30 '81
Sports Illus 54:cov. , 14-19
(c, 1) Ap 6 '81
--Passing
Sports Illus 50:14-15 (c, 1) F
5 '79
Sports Illus 54:12-13 (c, 2) Ja
5 '81
Sports Illus 54:14 (c, 2) Mr 23
'81
Sports Illus 54:19 (c, 2) Ap 6
'81
--Rebounding
Sports Illus 46:20 (c, 3) F 28
'77
Sports Illus 46:20 (c, 2) Ap 4
'77
Sports Illus 48:20 (c, 3) F 13
'78
Sports Illus 48:cov. (c, 1) Mr
13 '78
Sports Illus 50:12-13 (c, 1)
Ja 22 '79
Sports Illus 50:34 (4) Ja 29
'79
Sports Illus 50:12 (c, 2) Mr 5
'79
Sports Illus 53:39 (c, 1) D 8 '80
Sports Illus 53:29 (c, 2) D 15
'80
Ebony 36:75-6 (3) Mr '81
Sports Illus 54:21 (c, 3) Mr 30
'81
Sports Illus 54:26-7 (c, 2) My
18 '81
--Shooting
Sports Illus 46:41 (3) Ja 3
'77
Sports Illus 46:29 (c, 4) Mr 21

'77
Sports Illus 46:18 (c, 3) Mr 28
'77
Sports Illus 46:cov. , 202 (c, 1)
Ap 4 '77
Sports Illus 48:cov. , 46 (c, 1) F
13 '78
Sports Illus 48:26-9 (c, 2) Mr 27
'78
Sports Illus 48:cov. , 20 (c, 1)
Ap 3 '78
Sports Illus 49:cov. , 44-7 (c, 1)
N 27 '78
Sports Illus 49:68 (4) D 25 '78
Sports Illus 50:cov. (c, 1) Ja 22
'79
Sports Illus 50:16 (c, 3) F 5 '79
Sports Illus 50:12, 37 (c, 3) F
12 '79
Sports Illus 50:14-15 (c, 1) Mr
26 '79
Sports Illus 51:cov. , 30 (c, 1)
D 17 '79
Sports Illus 51:30-3 (c, 1) D 24
'79
Sports Illus 52:12-13 (c, 1) Ja 21
'80
Sports Illus 52:12-19 (c, 1) Mr
24 '80
Sports Illus 54:10-11 (c, 1) Ja 5
'81
Sports Illus 54:33 (c, 1) Ja 19
'81
Sports Illus 54:23, 27 (c, 2) F 9
'81
Sports Illus 54:cov. , 15 (c, 1)
Mr 23 '81
Sports Illus 54:cov. , 17-18 (c, 1)
Mr 30 '81
Sports Illus 55:70 (c, 4) D 7 '81
Sports Illus 55:26-8 (c, 2) D 14
'81
Sports Illus 55:30 (c, 2) D 21 '81
--Steps in shooting
Sports Illus 47:38-42 (c, 1) N 28
'77
--Women's coach
Sports Illus 48:34 (2) Mr 20 '78
BASKETBALL--COLLEGE--HUMOR
Sports Illus 49:38-80 (drawing, c, 1)
N 27 '78
Sports Illus 51:54-82 (drawing, c, 4)
D 3 '79
Sports Illus 52:30-5 (drawing, c, 2)
Mr 3 '80
Sports Illus 53:30-3, 44-67 (draw-
ing, c, 1) D 1 '80
Sports Illus 55:36-43 (drawing, c, 1)

N 30 '81
BASKETBALL--COLLEGE--
 WOMEN
 Ebony 32:86-7 (2) F '77
 Sports Illus 48:22-3 (c, 3) Ap
 3 '78
 Sports Illus 51:106-10 (c, 1) D
 3 '79
 Ebony 36:45-6 (4) Ap '81
--Shooting
 Ebony 32:61 (3) Ag '77
 Sports Illus 48:35 (4) Ja 2 '78
BASKETBALL--HIGH SCHOOL
 Sports Illus 47:50 (c, 4) Jl 11
 '77
 Sports Illus 48:35-6, 45 (2)
 Mr 20 '78
--Shooting
 Sports Illus 46:18 (c, 2) F 7
 '77
BASKETBALL--HUMOR
--Dunking
 Sports Illus 46:20-2 (paint-
 ing, c, 1) Mr 14 '77
BASKETBALL--PROFESSIONAL
 Sports Illus 46:cov., 22-5 (c, 1)
 Mr 21 '77
 Ebony 32:127-8 (4) My '77
 Sports Illus 46:cov., 28 0
 (c, 1) My 23 '77
 Sports Illus 47:25 (c, 2) D 19
 '77
 Sports Illus 48:46 (c, 4) Ja 27
 '78
 Sports Illus 48:52-3 (c, 4) Ja
 30 '78
 Sports Illus 48:14-17 (c, 2) F
 13 '78
 Sports Illus 48:cov., 14-17
 (c, 1) F 20 '78
 Sports Illus 48:12-15 (c, 1) Mr
 6 '78
 Sports Illus 48:16-19 (c, 1) Ap
 24 '78
 Sports Illus 48:cov., 20-3
 (c, 1) My 8 '78
 Sports Illus 49:24-7 (c, 2) N
 27 '78
 Sports Illus 49:20-1 (c, 2) D
 18 '78
 Sports Illus 50:20-2 (c, 1) Ja
 15 '79
 Sports Illus 50:26-8 (c, 2) Ap
 16 '79
 Sports Illus 50:34-6 (c, 1) Ap
 23 '79
 Sports Illus 50:24-5 (c, 4) My
 21 '79

Sports Illus 50:28-30 (c, 2) My
 28 '79
Sports Illus 51:38-40 (c, 1) N 5
 '79
Sports Illus 51:cov., 30-3 (c, 1)
 N 19 '79
Sports Illus 51:18-23 (c, 1) D 3
 '79
Sports Illus 52:94-100 (c, 1) Mr
 10 '80
Sports Illus 52:18-24 (c, 1) Ap
 28 '80
Sports Illus 52:16-21 (c, 1) My 5
 '80
Sports Illus 53:36-42 (c, 1) O 20
 '80
Sports Illus 54:14-19 (c, 1) My
 4 '81
Sports Illus 54:cov., 26-31 (c, 1)
 My 11 '81
Sports Illus 55:41-51, 82-5 (c, 1)
 N 9 '81
--Aerial shot of game
 Sports Illus 54:14-15 (c, 1) My
 4 '81
--Blocking
 Sports Illus 46:22 (c, 2) Ja 24
 '77
 Sports Illus 46:22 (c, 2) My 9
 '77
 Sports Illus 46:cov. (c, 1) Je 13
 '77
 Sports Illus 48:21 (c, 3) My 1 '78
 Sports Illus 51:90 (c, 3) N 12 '79
 Sports Illus 51:23 (c, 2) D 3 '79
 Sports Illus 52:20-1 (c, 1) F 11
 '80
 Sports Illus 52:14-15 (c, 1) Mr
 17 '80
 Sports Illus 52:58 (c, 3) Mr 31
 '80
 Sports Illus 53:40-2 (c, 1) O 20
 '80
 Sports Illus 53:17 (c, 4) D 22 '80
 Sports Illus 54:15 (c, 4) Ap 13
 '81
 Sports Illus 55:70 (c, 4) O 12 '81
--Celebrating
 Sports Illus 54:34 (c, 2) My 25
 '81
--Coaches
 Sports Illus 46:14-15 (c, 1) F
 14 '77
 Sports Illus 47:16-17 (c, 2) N
 21 '77
 Sports Illus 48:17 (c, 4) F 13 '78
 Sports Illus 48:100 (4) My 29 '78
 Sports Illus 49:24, 27 (c, 2) N 27

'78
Sports Illus 49:36 (3) D 18 '78
Sports Illus 50:18 (c, 3) F 12
'79
Ebony 34:94-6 (2) Mr '79
Sports Illus 52:26 (c, 3) F 4
'80
Sports Illus 53:47 (4) O 27 '80
Sports Illus 54:56 (4) Mr 23
'81
--Dribbling
Sports Illus 46:54 (c, 4) F 7
'77
Sports Illus 46:cov. (c, 1) Mr
21 '77
Sports Illus 47:74 (c, 4) N 7
'77
Sports Illus 48:28 (c, 3) Ap 10
'78
Sports Illus 48:26 (c, 4) Ap 17
'78
Sports Illus 48:17 (c, 4) Ap 24
'78
Sports Illus 48:12-14 (c, 1) My
22 '78
Sports Illus 49:30 (c, 3) D 11
'78
Sports Illus 51:30-1 (c, 2) N
19 '79
Sports Illus 52:23 (c, 3) Mr 17
'80
Sports Illus 52:20 (c, 2) My 5
'80
Ebony 35:102 (3) My '80
Sports Illus 53:30 (c, 2) D 15
'80
Sports Illus 53:14-15 (c, 1) D
22 '80
Sports Illus 54:cov. (c, 1) Mr
9 '81
Sports Illus 54:59 (c, 4) Mr 23
'81
--Dunking
Ebony 33:56 (4) Ja '78
Sports Illus 48:cov. , 23 (c, 1)
My 8 '78
Ebony 34:150 (3) D '78
Ebony 35:134 (4) F '80
Sports Illus 52:34-5 (c, 2) F
11 '80
Sports Illus 52:57 (c, 2) Mr 31
'80
Sports Illus 52:cov. (c, 1) My
5 '80
Sports Illus 52:21 (c, 2) My 26
'80
Sports Illus 54:29 (c, 1) F 16
'81

Sports Illus 54:78-9, 84 (c, 1)
Ap 6 '81
Sports Illus 54:28 (c, 4) Ap 27
'81
--NBA Playoffs 1977 (Blazers vs.
76ers)
Sports Illus 46:22-3 (c, 3) Je 6
'77
Sports Illus 46:cov. , 30-2 (c, 1)
Je 13 '77
--NBA Playoffs 1978 (Bullets vs.
Supersonics)
Sports Illus 48:24-5 (c, 1) Je 12
'78
--NBA Playoffs 1979 (Sonics vs.
Bullets)
Sports Illus 50:cov. , 16-19 (c, 1)
Je 11 '79
--NBA Playoffs 1980 (Lakers vs.
76ers)
Sports Illus 52:20-3 (c, 1) My 19
'80
Sports Illus 52:cov. , 18-23 (c, 1)
My 26 '80
--NBA Playoffs 1981 (Celtics vs.
Rockets)
Sports Illus 54:26-9 (c, 2) My 18
'81
Sports Illus 54:34-9 (c, 2) My 25
'81
--Passing
Sports Illus 46:63 (c, 4) My 9 '77
Sports Illus 51:43 (c, 3) O 15 '79
Sports Illus 52:21 (c, 3) F 11 '80
Sports Illus 53:16 (c, 4) D 22 '80
Sports Illus 55:20 (c, 3) D 14 '81
--Rebounding
Sports Illus 48:34 (c, 4) F 27 '78
Sports Illus 48:19 (c, 2) Ap 24
'78
Sports Illus 48:20-1 (c, 1) My 8
'78
Sports Illus 48:24-5 (c, 3) My 15
'78
Sports Illus 48:cov. (c, 1) My 22
'78
Sports Illus 48:26-7 (c, 2) Je 5
'78
Sports Illus 49:48-9 (c, 3) O 16
'78
Sports Illus 50:cov. , 60-1 (c, 1)
F 19 '79
Sports Illus 50:25 (c, 3) Ap 9 '79
Sports Illus 50:cov. (c, 1) My 7
'79
Sports Illus 50:cov. , 18 (c, 1) Je
11 '79
Sports Illus 51:41 (c, 1) O 15 '79

BASTILLE DAY
--U. S. soldiers parading (1918;
Paris, France)
Am Heritage 32:cov. (painting,c, 1)
Ag '81
BATHING
--Bath (ancient Pompeii)
Natur Hist 88:76 (c, 1) Ap '79
--Beppu baths, Japan
Smithsonian 11:96-103 (c, 1) Jl
'80
--Budapest, Hungary
Nat Geog 152:474-5 (c, 1) O '77
--Child in small tub (Wyoming)
Nat Geog 160:260 (c, 1) Ag '81
--Children in Bogota fountain,
Colombia
Natur Hist 90:44-5 (c, 2) Ap '81
--Children playing in washtubs
(1953; Illinois)
Life 3:27 (4) S '80
--Hot springs (Jordan)
Nat Geog 153:244-5 (c, 1) F '78
--Hot tubs
Life 2:24-30 (c, 1) Ja '79
Life 2:80 (c, 4) D '79
--In ground coffee (Japanese spa)
Nat Geog 159:390-1 (c, 1) Mr
'81
--In river (Mekranoti Indians;
Brazil)
Natur Hist 87:44-5 (c, 2) N '78
--In St. Louis street, Missouri
Life 3:28 (c, 3) S '80
--Jacuzzi (Idaho)
Trav/Holiday 156:68 (c, 2) N
'81
--Japan
Nat Geog 157:77, 80-1 (c, 1)
Ja '80
Natur Hist 90:55 (c, 3) O '81
--Mud bath (California)
Nat Geog 155:710-11 (c, 1) My
'79
--Outdoor shower at West Ger-
man spa
Trav/Holiday 152:21 (4) S '79
--Outdoors (Montana)
Nat Geog 152:16 (c, 1) Jl '77
--Pig showering
Nat Geog 154:409 (c, 4) S '78
--Sand (Japan)
Nat Geog 152:848 (c, 3) D '77
--Sanitorium (Estonia)
Nat Geog 157:508-9 (c, 1) Ap
'80
--Skinny dipping (Wyoming)
Nat Geog 156:494-5 (c, 1) O

'79
--Sulfur springs (Northwest Terri-
tories)
Nat Geog 160:405 (c, 1) S '81
--Upper Volta desert
Nat Geog 157:524-5 (c, 1) Ap '80
--Western hot springs
Smithsonian 8:90-7 (c, 1) N '77
--Whirlpool
Sports Illus 47:102 (c, 4) D 5 '77
Sports Illus 51:100 (c, 3) S 3 '79
Ebony 37:44 (c, 4) N '81
--See also SAUNAS; SWIMMING
BATHING SUITS
Sports Illus 46:cov., 36-43 (c, 1)
Ja 24 '77
Ebony 32:118 (4) Ap '77
Ebony 33:104-8 (c, 3) Ja '78
Sports Illus 48:cov., 34-45 (c, 1)
Ja 16 '78
Ebony 34:100-4, 120 (c, 3) Ja '79
Sports Illus 50:cov., 37-48 (c, 1)
F 5 '79
Ebony 34:117 (c, 4) Ap '79
Life 2:59-62 (c, 1) S '79
Ebony 35:59, 168 (c, 2) N '79
Ebony 35:100-2 (c, 2) Ja '80
Life 3:112-16 (c, 1) F '80
Sports Illus 52:cov., 40-51 (c, 1)
F 4 '80
Sports Illus 52:134-6 (c, 1) Mr
13 '80
Ebony 35:130-3 (c, 1) Ap '80
Sports Illus 53:50 (4) D 22 '80
Ebony 36:90-4 (c, 2) Ja '81
Life 4:96-100 (c, 1) F '81
Sports Illus 54:cov., 52-65 (c, 1)
F 9 '81
Trav/Holiday 156:14 (c, 1) D '81
--1956
Ebony 33:94-101 (c, 2) Mr '78
--Curaçao
Ebony 32:94 (c, 3) Ja '77
--Paper (Japan)
Nat Geog 159:391 (c, 4) Mr '81
BATHROOMS
--Early 20th cent. outhouse (Pitts-
burgh, Pennsylvania)
Am Heritage 30:7 (4) F '79
--Ancient Pakistan
Smithsonian 8:61 (c, 4) Jl '77
--Composting toilet (California)
Nat Geog 159:47 (c, 4) F '81SR
--Luxurious bathrooms (New York
City, New York)
Life 2:67-70 (c, 2) My '79
--Medicine cabinet
Ebony 32:112 (4) My '77

Ebony 34:156 (4) N '78
--Toilet shaped like fly
Smithsonian 7:78 (c, 4) F '77
--Toilets
Sports Illus 54:78 (c, 4) Je 15
'81
--See also BATHTUBS, OUTHOUSES
BATHTUBS
--Outdoors (Montana)
Nat Geog 152:16 (c, 1) Jl '77
--Round (Texas)
Ebony 33:133 (3) Ag '78
--Shaped like hippo
Smithsonian 7:74-5 (c, 1) F '77
BATON ROUGE, LOUISIANA
Trav/Holiday 152:38-41, 98-9
(c, 2) O '79
BATON TWIRLING
Sports Illus 47:14-15 (c, 3) Ag
15 '77
BATS
Nat Wildlife 15:28-33 (c, 1) Je
'77
Smithsonian 11:49 (c, 3) Je '80
Smithsonian 11:178 (c, 4) S '80
--Embryo
Natur Hist 88:61 (c, 3) Ag '79
--Free-tailed
Natur Hist 87:51-5 (c, 1) Mr
'78
BAUXITE MINING
--Jamaica
Nat Geog 154:194-5 (c, 1) Ag
'78
BAYS
--Florida
Sports Illus 49:32-3 (c, 2) N
27 '78
BEACH CLUBS
--Westhampton, New York
Nat Geog 157:678-9 (c, 1) My
'80
BEACHES
Nat Wildlife 18:4-13 (c, 1) Ap
'80
--California
Nat Geog 152:332-3, 344-5
(c, 1) S '77
--Cornwall, Great Britain
Nat Geog 156:478-9 (c, 1) O '79
--Coronet Island, Florida
Trav/Holiday 154:14 (c, 1) D
'80
--Costa Rica
Nat Geog 160:56-7 (c, 1) Jl '81
--Cumberland Island, Georgia
Nat Geog 152:658-9 (c, 1) N '77
Nat Wildlife 16:56 (c, 2) D '77

--Environmental problems on
coasts
Nat Wildlife 18:4-13 (c, 1) Ap
'80
--France
Sports Illus 50:26 (c, 3) Je 25
'79
--Grenadine Islands
Nat Geog 156:398 (c, 1) S '79
--Hawaii
Ebony 36:118-22 (c, 3) Ja '81
--Lake Michigan, Michigan
Nat Wildlife 16:40 (c, 1) Je '78
--Lumahai, Kauai, Hawaii
Trav/Holiday 150:54 (c, 1) D '78
--Massachusetts
Nat Geog 155:588-9 (c, 1) Ap '79
--Maui, Hawaii
Trav/Holiday 153:52, 55 (c, 2)
Ja '80
--North Carolina
Nat Geog 157:340 (c, 1) Mr '80
--Oahu, Hawaii
Sports Illus 51:96-9 (c, 1) O 8
'77
--Pesaro, Italy
Life 3:62-3 (c, 1) O '80
--St. Thomas, Virgin Islands
Nat Geog 159:224-5 (c, 1) F '81
--Seychelles Islands
Sports Illus 50:58-9 (c, 1) F 5
'79
Nat Geog 160:438-9 (c, 1) O '81
--Sicily, Italy
Travel 148:49 (4) Ag '77
--South Padre Island, Texas
Trav/Holiday 151:10-11 (4) F
'79
--Tobago
Trav/Holiday 153:69 (c, 4) Ap '80
--Waterfront buildings
Smithsonian 11:46-59 (c, 1) S '80
BEACHES, BATHING
Travel 148:68-9, 75 (4) Jl '77
--Acapulco, Mexico
Nat Geog 153:645 (c, 1) My '78
--Agadir, Morocco
Trav/Holiday 150:34 (c, 4) O '78
--Algarve, Portugal
Trav/Holiday 151:42-3, 66 (c, 1)
F '79
--Antalya, Turkey
Trav/Holiday 156:55 (c, 3) Jl '81
--Atlantic City, New Jersey
Travel 148:50-1 (3) O '77
--Benidorm, Spain
Nat Geog 153:304-5 (c, 1) Mr '78
--Bermuda

Travel 147:33-5 (c, 1) Mr '77
--Bulgaria
 Nat Geog 158:108-9 (c, 1) Jl
 '80
--California
 Natur Hist 86:62-5 (c, 1) Je '77
--Cancun, Mexico
 Trav/Holiday 150:43 (c, 3) O '78
--Cape Town, South Africa
 Trav/Holiday 149:64 (c, 2) Je
 '78
--Cartagena, Colombia
 Trav/Holiday 150:54 (c, 4) O
 '78
--Cavendish, Prince Edward Is-
 land
 Trav/Holiday 151:53 (c, 3) My
 '79
--Children playing in sand (Scot-
 land)
 Trav/Holiday 149:47 (4) My '78
--China
 Life 3:108-9 (c, 1) O '80
--Copacabana, Rio de Janeiro,
 Brazil
 Nat Geog 153:249 (c, 1) F '78
 Trav/Holiday 152:27 (4) N '79
 Trav/Holiday 154:60 (c, 4) O
 '80
--Crete
 Trav/Holiday 156:24 (c, 2) D '81
--Dominican Republic
 Trav/Holiday 149:57 (c, 2) Ja
 '78
--Fort Lauderdale, Florida
 Trav/Holiday 150:38 (c, 1) O
 '78
--Grenada
 Trav/Holiday 156:62 (c, 2) S '81
--Hilton Head, South Carolina
 Trav/Holiday 153:58-9 (c, 1)
 Ap '80
--Isla Mujeres, Mexico
 Travel 148:53-6 (c, 1) S '77
--Jacksonville, Florida
 Ebony 36:65 (3) Ap '81
--Jamaica
 Ebony 35:80 (4) Ja '80
 Nat Geog 159:244-5 (c, 1) F '81
--Keauhou, Kona, Hawaii
 Travel 147:42-3 (c, 1) F '77
--Molokai, Hawaii
 Nat Geog 160:212-13 (c, 1) Ag
 '81
--Myrtle Beach, South Carolina
 Travel 147:57 (c, 2) Je '77
--Nazare, Portugal
 Nat Geog 158:804-5 (c, 1) D '80

--Nevis, Caribbean
 Trav/Holiday 155:63 (c, 2) F '81
--Newport Beach, California
 Nat Geog 160:764 (c, 1) D '81
--Old Orchard, Maine
 Nat Geog 151:738-9 (c, 1) Je '77
--Padre Island, Texas
 Nat Geog 159:171 (c, 3) F '81
--Sand castles on Virginia Beach,
 Virginia
 Travel 147:72 (4) Ap '77
--Scheveningen, Netherlands
 Trav/Holiday 155:49 (c, 3) Ap
 '81
--Sylt, West Germany
 Nat Geog 152:168-9 (c, 2) Ag '77
--Tunisia
 Trav/Holiday 149:30 (4) Ja '78
 Nat Geog 157:204-5 (c, 1) F '80
--Virgin Islands
 Trav/Holiday 156:45 (c, 1) O '81
--Waikiki, Honolulu, Hawaii
 Nat Geog 156:654-5 (c, 1) N '79
--See also ATLANTIC CITY,
 CONEY ISLAND
BEAGLES
 Life 1:26 (c, 4) O '78
BEARDS
 Nat Geog 153:421 (c, 1) Mr '78
 Sports Illus 51:52 (c, 2) N 12 '79
 Ebony 35:94-8 (3) Mr '80
 Life 3:19 (2) S '80
--19th cent. mutton chops style
 Smithsonian 12:132 (4) My '81
--19th cent. U. S.
 Smithsonian 9:96-7 (4) My '78
--France
 Natur Hist 90:48-9 (c, 1) Ja '81
--India
 Trav/Holiday 156:cov. (c, 1) Jl
 '81
--See also MUSTACHES
BEARS
 Nat Wildlife 16:21-7 (c, 1) Ag '78
 Trav/Holiday 151:85 (c, 2) Ap
 '79
 Am Heritage 30:12 (painting, c, 4)
 Ag '79
 Sports Illus 51:42 (c, 3) S 10 '79
--Black
 Nat Wildlife 16:22-3 (c, 1) Ag '78
 Nat Geog 156:124 (c, 2) Jl '79
 Natur Hist 90:64-70 (c, 1) O '81
--Brown
 Nat Wildlife 15:26-7 (c, 2) Ap
 '77
 Nat Wildlife 17:50-1 (c, 1) D '78
 Nat Wildlife 17:41 (c, 3) F '79

Nat Geog 155:374-5 (c, 2) Mr
'79
Nat Wildlife 17:51 (c, 3) Ap '79
Nat Wildlife 17:2 (c, 2) Je '79
Nat Geog 156:40-1 (c, 2) Jl '79
Nat Wildlife 18:cov. (c, 1) F
'80
Nat Wildlife 19:25-31 (c, 1)Ap
'81
--Brown bears nursing
Nat Geog 155:244-5 (c, 2) F '79
Nat Wildlife 19:46-7 (c, 1) Ag
'81
--Grizzly
Nat Wildlife 15:4-8 (c, 1) F '77
Natur Hist 86:74-81 (c, 1) Ap
'77
Sports Illus 47:64-7 (painting, c, 1)
Jl 18 '77
Am Heritage 28:cov. , 16-29,
114 (c, 1) O '77
Nat Wildlife 16:21 (c, 3) D '77
Ebony 33:152 (4) My '78
Nat Wildlife 16:9 (c, 3) Ag '78
Nat Wildlife 17:32 (4) Je '79
Nat Wildlife 17:10 (c, 4) O '79
Nat Geog 156:508 (c, 1) O '79
Nat Wildlife 18:43 (4) D '79
Smithsonian 12:78-87 (c, 1) Ag
'81
Smithsonian 12:18 (c, 4) O '81
--Kodiak
Nat Wildlife 15:57 (c, 1) Ja '77
--Misha (1980 Olympic symbol)
Sports Illus 52:18-21 (c, 1) F 4
'80
--Smokey the Bear
Smithsonian 9:40 (4) N '78
--See also POLAR BEARS.
BEARS--HUMOR
--Black bears' dealings with hu-
mans
Sports Illus 48:88-97 (paint-
ing, c, 1) Je 5 '78
BEAUTY CONTESTS
--Contestants (New York City)
Natur Hist 88:80-1 (c, 4) Ag '79
--Homecoming queen (Mississippi
college)
Ebony 32:90 (4) F '77
--College queens
Ebony 32:cov. , 146-8 (c, 4) Ap
'77
Ebony 33:cov. , 64-76 (c, 4) Ap
'78
Ebony 34:144-54 (c, 3) Ap '79
Ebony 35:56-66 (c, 3) Ap '80
Ebony 36:150-4 (c, 4) Ap '81

--Little Miss Pink Tomato (Arkan-
sas)
Nat Geog 153:424-5 (c, 1) Mr '78
BEAUTY PARLORS
Ebony 32:146 (4) Ag '77
--Manicuring nails (California)
Ebony 36:50 (4) N '80
BEAVERS
Nat Wildlife 15:48 (c, 1) F '77
Nat Wildlife 17:26-33 (c, 1) Ap
'79
Natur Hist 88:102 (drawing, 2)
Je '79
Natur Hist 90:44 6 (c, 1) Jl '81
--Dams
Natur Hist 90:44-7 (c, 1) Jl '81
--Freeze-dried
Smithsonian 11:22 (c, 4) Ag '80
BEDOUINS (SAUDI ARABIA)
Nat Geog 158:300-1 (c, 1) S '80
BEDOUINS--COSTUME
--Oman
Nat Geog 160:355 (c, 1) S '81
BEDROOMS
--Atlanta, Georgia
Ebony 35:94 (c, 3) O '80
--Joseph Hirshhorn's
Smithsonian 9:103 (c, 3) N '78
Italian villa
Life 3:108 (c, 4) D '80
--Las Vegas, Nevada
Ebony 36:35 (c, 3) My '81
--Massachusetts mansion
Ebony 36:61 (c, 4) O '81
--Mirrored ceiling
Sports Illus 54:47 (c, 3) Mr 2
'81
--With mirrored walls (New York)
Life 1:87 (c, 3) O '78
BEDS
--17th cent. (Belgium)
Smithsonian 8:52 (c, 3) O '77
--17th cent. (Wales)
Smithsonian 8:95 (c, 4) O '77
--Cast iron
Smithsonian 11:76 (c, 4) N '80
--Eight-foot bed
Sports Illus 54:30 (c, 2) My 4 '81
--Helsinki clinic, Finland
Nat Geog 160:253 (c, 2) Ag '81
--Hospital bed
Life 2:109 (2) My '79
--Versailles, France
Smithsonian 7:40 (c, 2) Mr '77
--See also BABY CRIBS; HAM-
MOCKS
BEECH TREES
Nat Wildlife 19:48 (c, 1) O '81

--Bark
Nat Geog 159:361 (c, 2) Mr '81
BEECHER, HENRY WARD
Smithsonian 8:65 (4) Ag '77
Smithsonian 8:140-1 (cartoon, 4)
O '77
BEEHIVES
--Used as Utah's state symbol
Smithsonian 12:165 (c, 4) Ap '81
BEER
Nat Geog 152:166 (c, 4) Ag '77
BEER INDUSTRY
--Brewery vats (Milwaukee, Wis-
consin)
Ebony 34:32 (c, 2) Mr '79
--Farming hop plants (Washington)
Nat Geog 154:620-1 (c, 1) N
'78
--Milwaukee, Wisconsin
Nat Geog 158:198 (c, 3) Ag '80
BEES
Natur Hist 88:50 (2) N '79
Nat Geog 157:173 (c, 3) F '80
Smithsonian 12:26 (drawing, 4)
Ap '81
Natur Hist 90:79 (c, 4) O '81
--Honeybees
Nat Wildlife 16:34-5 (4) Je '78
Natur Hist 88:cov., 66-74 (c, 1)
Je '79
Nat Wildlife 18:44 (c, 2) F '80
--Killer bees
Life 3:79-84 (c, 1) N '80
--Seen through microscope
Nat Geog 151:281, 286 (1) F
'77
--See also BEEHIVES, HONEY
BEETLES
Nat Geog 151:572 (c, 4) Ap '77
Nat Wildlife 15:40 (c, 4) Ag '77
Smithsonian 8:116-17 (c, 2) O
'77
Nat Geog 153:378 (c, 1) Mr '78
Smithsonian 9:80-1 (c, 4) Ap
'78
Nat Wildlife 16:43 (c, 4) Je '78
Smithsonian 9:120 (c, 4) F '79
Nat Geog 155:781 (c, 4) Je '79
Smithsonian 10:cov., 38 (c, 1)
Ag '79
Nat Geog 157:139 (c, 4) Ja '80
Smithsonian 11:46 (c, 4) Je '80
Natur Hist 89:34-41, 88 (paint-
ing, c, 1) Ag '80
Natur Hist 90:86-7 (drawing, 4)
Mr '81
--Larva
Nat Geog 151:572 (c, 2) Ap '77

BEGGARS
--Jamaica
Nat Geog 159:244-5 (c, 1) F '81
BEIRUT, LEBANON
Life 3:30-4 (c, 1) S '80
--Bomb damage
Nat Geog 153:870 (c, 3) Je '78
Nat Geog 158:343 (c, 3) S '80
BELFAST, NORTHERN IRELAND
Nat Geog 159:470-99 (c, 1) Ap
'81
BELGIUM
Nat Geog 155:314-41 (map, c, 1)
Mr '79
--Binche Carnival
Trav/Holiday 151:41-3, 75 (c, 1)
Ja '79
--See also ANTWERP; ARDENNES
FOREST; BRUSSELS; LIEGE
BELGIUM--COSTUME
--15th cent.
Nat Geog 155:338-9 (painting, c, 2)
Mr '79
BELGIUM--HISTORY
--Embroidered flour sacks as gifts
to U.S. (1915)
Am Heritage 29:72-5 (c, 4) Ap
'78
BELGIUM--SOCIAL LIFE AND
CUSTOMS
--Ommegang pageant (Brussels)
Nat Geog 155:324-5 (c, 1) Mr '79
BELGRADE, YUGOSLAVIA
Nat Geog 152:478-9 (c, 1) O '77
BELL, ALEXANDER GRAHAM
--View of his back
Am Heritage 29:38-9 (1) Ag '78
BELL RINGING
--Montaillou, France
Smithsonian 8:127 (c, 4) Mr '78
BELLBIRDS
Nat Geog 153:120 (c, 4) Ja '78
BELLS
--1710 bronze (Dutch)
Nat Geog 156:870 (c, 3) D '79
--1880 bell toy
Am Heritage 32:114 (c, 2) D '80
--Brass bells for dancers (Ver-
mont)
Smithsonian 12:124 (c, 4) My '81
--Indian ceremonial leg bells
(Washington)
Life 2:83 (4) Ag '79
--Italian
Smithsonian 10:130 (c, 4) O '79
--Japanese temple bell
Smithsonian 10:55 (c, 4) Ja '80
--Tibet

Nat Geog 157:224-5 (c, 1) F
'80
BELLY DANCING
--Vancouver, British Columbia
Nat Geog 154:484 (c, 1) O '78
BELUGAS
Smithsonian 12:68 (c, 4) D '81
BENCHES
--Park (Hamburg, West Germany)
Trav/Holiday 149:28-9 (c, 1)
Mr '78
BENCHLEY, ROBERT
Am Heritage 28:87 (drawing, 2)
Ag '77
BENIN
Trav/Holiday 154:53-7 (map, c, 1)
O '80
BENIN--COSTUME
Trav/Holiday 154:53-7 (c, 1) O
'80
BENIN--HOUSING
--Somba tribe huts
Trav/Holiday 154:54 (c, 2) O
'80
BENNETT, JAMES GORDON, JR.
Smithsonian 9:132-41 (c, 2) N
'78
BERBER PEOPLE (MOROCCO)
Wedding festival
Nat Geog 157:118-29 (c, 1) Ja
'80
BERBER PEOPLE (NIGER)
--Tuareg Inadans
Nat Geog 156:282-97 (c, 1) Ag
'79
BERBER PEOPLE (TUNISIA)
Trav/Holiday 149:cov. (c, 1)
Ja '78
BERGEN, NORWAY
Trav/Holiday 150:44, 86 (c, 2)
N '78
BERKELEY, CALIFORNIA
--Christian Science Church
Am Heritage 32:40-1 (c, 3) Ag
'81
BERLIN, GERMANY
Trav/Holiday 156:58-63 (map, c, 1)
O '81
--1945 ruins
Am Heritage 31:43 (2) Je '80
--Pre-Berlin Wall barbed wire
Am Heritage 28:8-9 (1) Ag
'77
--See also BERLIN WALL
BERLIN WALL, GERMANY
Nat Geog 152:180-1 (c, 2) Ag
'77
Am Heritage 28:22 (2) Ag '77

Life 4:3, 32-3 (c, 3) Ag '81
Life 4:20 (4) O '81
BERMUDA
Travel 147:cov., 32-7 (c, 1) Mr
'77
--19th cent. mansion
Smithsonian 11:11 (c, 3) D '80
--See also HAMILTON
BERN, SWITZERLAND
Trav/Holiday 155:60-2, 78 (c, 2)
My '81
--Old shop sign
Trav/Holiday 154:cov. (c, 1) O
'80
BERNHARDT, SARAH
Smithsonian 9:191 (4) N '78
--Tomb (Paris, France)
Smithsonian 9:110 (c, 4) N '78
BERRIES
--Juniper berries
Nat Wildlife 18:45 (c, 1) O '80
--Mountain ash
Nat Wildlife 15:50 (c, 4) Ja '77
--Salmonberries
Nat Geog 155:244 (c, 4) F '79
See also BLUEBERRIES; CRAN-
BERRIES; GOOSEBERRIES
BHUTAN
Natur Hist 89:39-47 (c, 1) Mr
'80
BHUTAN--COSTUME
--Dancers
Natur Hist 89:cov., 39-47 (c, 1)
Mr '80
BIBLES
Smithsonian 10:74-81 (c, 1) Je
'79
--8th cent. Book of Kells (Ireland)
Smithsonian 8:66-73 (c, 1) O '77
--9th cent. Gospels cover
Smithsonian 10:83 (c, 2) S '79
--13th cent. France
Smithsonian 10:82 (c, 2) S '79
--13th cent. illustrated bible
Nat Geog 152:77 (c, 4) Jl '77
--1450 Gutenberg Bible
Smithsonian 10:74 (c, 4) Je '79
--Dead Sea Scrolls (Israel)
Nat Geog 153:240-1 (c, 1) F '78
--Miniature
Sports Illus 52:47 (4) Je 23 '80
--See also ADAM AND EVE;
CHRISTIANITY; JESUS
CHRIST; JUDAISM; KORAN;
NOAH'S ARK; SAINTS; TEN
COMMANDMENTS
BICYCLE RACES
Sports Illus 55:111 (c, 4) O 19

'81
--Colorado
 Sports Illus 49:62 (c, 4) Jl 24
 '78
--Speed contraptions
 Sports Illus 48:31-3 (c, 1) My
 22 '78
BICYCLE TOURS
 Sports Illus 55:34-5, 38 (c, 2)
 Je 29 '81
 Sports Illus 55:55 (c, 4) Jl 13
 '81
--Iowa
 Smithsonian 12:100-5 (c, 1) Jl
 '81
--Somerville, New Jersey
 Sports Illus 52:33-6 (c, 1) My
 26 '80
BICYCLES
 Nat Geog 152:480-1 (c, 1) O '77
 Nat Geog 156:770-1 (c, 1) D '79
 Nat Wildlife 18:12-14 (c, 2) Je
 '80
 Nat Geog 158:191 (c, 2) Ag '80
--1940's
 Life 4:34 (4) F '81
--Bicycle wheel
 Sports Illus 55:43 (c, 4) Je 29
 '81
--Bike rack (Oxford, England)
 Travel 147:cov. (c, 1) Ap '77
--Covered with ice
 Nat Geog 158:681 (c, 3) N '80
--Custom-made contraption
 Nat Geog 153:140 (c, 3) Ja '78
--Italian bicycle components
 Sports Illus 52:32-7 (c, 1) F
 18 '80
--Tricycle built for two
 Trav/Holiday 156:48 (4) S '81
BICYCLING
 Travel 147:40 (4) Ap '77
 Ebony 33:112 (4) N '77
 Sports Illus 49:55 (c, 4) S 18
 '78
 Ebony 34:39 (4) N '78
 Sports Illus 49:45 (c, 4) D 25
 '78
 Sports Illus 50:88-90 (c, 3) My
 14 '79
 Life 2:53 (c, 2) Ag '79
 Ebony 35:105-6 (3) F '80
 Ebony 35:82, 88 (3) My '80
 Ebony 35:143 (3) Ag '80
 Ebony 35:64 (4) O '80
--19th cent. tricycle
 Smithsonian 11:134 (drawing, 4)
 Mr '81

--Antique highwheeler
 Smithsonian 8:8 (4) S '77
 Smithsonian 8:94 (c, 4) O '77
 Nat Wildlife 16:12 (c, 1) Je '78
--Chased by dogs
 Sports Illus 51:103 (drawing, 4)
 N 5 '79
--China
 Nat Geog 157:322 (c, 2) Mr '80
--Italy
 Nat Geog 159:728 (c, 1) Je '81
--Liechtenstein
 Nat Geog 159:276 (c, 4) F '81
--New York City messengers
 Natur Hist 90:66-73 (1) Ag '81
--New Zealand
 Trav/Holiday 155:37 (c, 2) Ja
 '81
--Puerto Rico
 Trav/Holiday 151:55 (c, 3) Ap
 '79
--Tandem (Texas)
 Nat Geog 153:216 (c, 3) F '78
--Unicycling (California)
 Smithsonian 10:115 (c, 4) Mr '80
--Uphill (California)
 Sports Illus 46:22-3 (c, 2) F 7
 '77
--Zimbabwe
 Nat Geog 160:645 (c, 4) N '81
BIERCE, AMBROSE
 Am Heritage 28:56-63 (1) Ap
 '77
BILLBOARDS
--Celebrating woman basketball
 player (Mississippi)
 Ebony 32:92 (4) F '77
--Housing community ad (Florida)
 Smithsonian 7:76 (c, 4) Ja '77
--Nigeria
 Nat Geog 155:414-5 (c, 1) Mr
 '79
--Promoting record album (New
 York)
 Ebony 32:31 (3) Ja '77
--Soft drink ad (China)
 Nat Geog 158:41 (c, 3) Jl '80
BILLIARD PLAYING
 Sports Illus 46:27 (c, 4) Ja 3 '77
 Ebony 32:56 (4) F '77
 Sports Illus 47:54-6 (painting, c, 1)
 Ag 8 '77
 Sports Illus 47:88-9 (c, 1) S 19
 '77
 Smithsonian 8:106 (c, 4) Mr '78
 Sports Illus 48:78 (4) My 15
 '78
 Ebony 33:40 (4) O '78

Sports Illus 49:59 (4) N 13
'78
Ebony 34:66 (4) My '79
Sports Illus 50:23 (c, 2) Je 18
'79
Sports Illus 51:81 (4) D 10 '79
Ebony 35:42 (4) Ja '80
Ebony 35:76 (4) Ag '80
Sports Illus 54:60 (3) Ap 20 '81
Sports Illus 55:45 (c, 4) Ag 31
'81
--Chalking cue stick
Sports Illus 46:52 (4) Je 27 '77
Sports Illus 49:84 (4) Ag 28 '78
BILLIARD TABLES
Sports Illus 49:120-1 (c, 1) O
9 '78
BILOXI, MISSISSIPPI
--Settlement of Vietnamese boat
people
Nat Geog 160:379-95 (c, 1) S
'81
BINGHAM, GEORGE CALEB
--Fur traders descending the
Missouri
Am Heritage 31:24-5 (paint-
ing, c, 1) Ap '80
--Paintings of election activities
(1840's)
Am Heritage 31:cov., 4 15
(painting, c, 1) O '80
--Self-portrait
Am Heritage 31:5 (painting, c, 4)
O '80
BINOCULARS
Smithsonian 9:83 (c, 4) D '78
Sports Illus 50:31 (c, 4) My 7
'79
Nat Wildlife 18:13 (c, 2) Ap '80
Sports Illus 53:46 (3) O 27 '80
BIOLOGY
--Biotechnology
Life 3:cov., 48-58 (c, 1) My
'80
--Regeneration of limbs in sala-
manders
Natur Hist 86:84-8 (c, 1) O
'77
--See also ANATOMY; GENETICS;
REPRODUCTION
BIRCH TREES
Nat Wildlife 15:30-2 (c, 1) O
'77
Smithsonian 8:72-81 (c, 1) D
'77
--Autumn
Nat Wildlife 18:4-11 (c, 1) O
'80

BIRD CAGES
--Afghanistan
Smithsonian 11:56 (c, 3) N '80
--China
Nat Geog 158:42 (c, 1) Jl '80
--Mexico
Nat Geog 153:634 (c, 1) My '78
--Singapore
Nat Geog 159:553 (c, 2) Ap '81
BIRD FEEDERS
Nat Wildlife 15:34 (4) Ap '77
Nat Wildlife 16:41-5 (c, 1) D '77
--Corn-ear "Iowa"
Nat Geog 159:618 (c, 2) My '81
BIRD HOUSES
Nat Wildlife 15:12-13 (1) F '77
--19th cent. New Orleans, Louisi-
ana
Am Heritage 30:114 (painting, c, 1)
Ag '79
--Martin houses
Natur Hist 90:64-9 (c, 1) My '81
--Nesting boxes
Nat Geog 151:864 (c, 3) Je '77
BIRD WATCHING
Sports Illus 50:31-3 (c, 4) My 7
'79
Nat Geog 156:188-9 (c, 1) Ag '79
Nat Wildlife 19:24-31 (c, 1) O '81
--Early 20th cent.
Natur Hist 88:7-8 (4) D '79
Natur Hist 90:16-23 (3) D '81
--Blind (Korea)
Smithsonian 12:58 (c, 4) O '81
BIRD WATCHING--HUMOR
Nat Wildlife 18:17-19 (draw-
ing, c, 2) Je '80
Nat Wildlife 19:32 (painting, c, 2)
Ap '81
BIRDS
Nat Wildlife 18:24-31 (painting, c, 1)
O '80
--Akepa
Nat Wildlife 15:34 (painting, c, 1)
Ja '77
--Albatross eggs
Nat Geog 153:672-3 (1) My '78
--Anhingas
Nat Wildlife 15:48 (c, 1) Ag '77
Natur Hist 87:108 (c, 4) Ag '78
--Audubon's paintings
Nat Geog 151:150-64 (c, 1) F '77
--Banded and dyed
Nat Geog 156:157, 174-7 (c, 1)
Ag '79
--Banding and studying terns
Nat Wildlife 18:38-9 (c, 1) F '80
Smithsonian 11:28-37 (c, 1) Ag

'80
--Banding eagles
 Sports Illus 53:66 (c, 4) Ag 11
 '80
 Nat Wildlife 19:44 (c, 3) O '81
--Banding geese (Alaska)
 Nat Wildlife 17:5, 8 (c, 3) F
 '79
--Banding hawks
 Nat Wildlife 19:42-9 (c, 1) Ap
 '81
 Nat Wildlife 19:45 (c, 4) O '81
--Bee-eaters
 Smithsonian 9:75 (c, 4) Je '78
 Natur Hist 90:36-9 (c, 1) Ap
 '81
--Bird footprints
 Nat Geog 160:512 (c, 4) O '81
--Carved wooden birds
 Smithsonian 9:34 (c, 4) Ap '78
 Nat Wildlife 19:50-7 (c, 1) D
 '80
--Central American mountains
 Sports Illus 48:56-60 (paint-
 ing, c, 1) F 13 '78
--Chicks
 Nat Wildlife 17:37-43 (c, 1) Ag
 '79
 Smithsonian 11:cov., 33 (c, 1)
 Ag '80
--Cinclodes
 Natur Hist 90:54 (c, 4) Jl '81
--Eagle nests
 Sports Illus 53:64-5 (c, 3) Ag
 11 '80
--Endangered Hawaiian species
 Nat Wildlife 15:29-34 (paint-
 ing, c, 1) Ja '77
--Endangered species
 Nat Wildlife 18:13-16 (c, 2) D
 '79
--Extinct (see also ARCHAEOP-
 TERYX; MOA BIRDS;
 PASSENGER PIGEONS)
 Nat Geog 151:152-173 (c, 1) F
 '77
--Feeding young
 Nat Wildlife 15:cov. (c, 1) Je
 '77
 Nat Wildlife 16:3 (c, 4) Ap '78
--Great potoo
 Smithsonian 11:43 (c, 4) Je '80
--Ground tyrants
 Natur Hist 90:54-5 (c, 3) Jl '81
--Hit by vehicle
 Natur Hist 88:62 (c, 2) Je '79
--Migration research
 Smithsonian 10:52-61 (c, 1) Je

'79
Nat Geog 156:154-93 (map, c, 1)
 Ag '79
--Oo
 Nat Wildlife 15:33 (painting, c, 2)
 Ja '77
 Nat Geog 152:588 (c, 4) N '77
--Nests
 Smithsonian 7:73 (c, 4) Ja '77
 Smithsonian 8:38 (c, 1) S '77
 Nat Geog 152:872 (c, 2) D '77
 Nat Wildlife 17:21-7 (c, 1) Je '79
 Nat Wildlife 18:48 (c, 3) Ap '80
 Nat Geog 159:146-7 (c, 2) F '81
 Nat Wildlife 19:42, 46 (c, 4) Ag
 '81
--Oropendola
 Smithsonian 11:47 (c, 4) Je '80
--Osprey nest
 Nat Geog 157:777 (c, 4) Je '80
 Nat Wildlife 18:10 (c, 4) Ag '80
--Paintings from bird guidebook
 Smithsonian 11:99-101 (c, 2) O '80
--Saddleback
 Natur Hist 88:83-5 (c, 1) O '79
--Screamers
 Smithsonian 8:106-7 (c, 3) O '77
--Silhouettes of most common U. S.
 birds
 Nat Wildlife 18:35 (4) Ap '80
--Songbird market (Brussels, Bel-
 gium)
 Natur Hist 86:58 (c, 1) My '77
--Sparrow's nest
 Nat Wildlife 16:44 (c, 3) Je '78
--Surfbirds
 Nat Geog 156:158-60 (c, 1) Ag '79
--Wekas
 Nat Geog 153:120 (c, 3) Ja '78
--Whiskey jacks
 Sports Illus 51:78 (c, 4) O 29
 '79
--Wilson's phalaropes
 Nat Geog 160:521-5 (c, 1) O '81
--Winter seashore birds
 Nat Wildlife 15:18-19 (drawing, 4)
 Ja '77
--Woodstorks
 Trav/Holiday 151:103 (4) My '79
--See also ALBATROSSES; AUKS;
 AVOCETS; BELLBIRDS; BIRDS
 OF PARADISE; BITTERNS;
 BLACKBIRDS; BLUE JAYS;
 BLUEBIRDS; BOOBY BIRDS;
 BUNTINGS; BUSTARDS; CARA-
 CARAS; CARDINALS; CAS-
 SOWARY BIRDS; CHATS;
 CHICKADEES; CHICKENS;

COCKATOOS; CONDORS;
CORMORANTS; CRANES;
CREEPERS; CROWS; CUR-
LEWS; DARTERS; DOVES;
DUCKS; EAGLES; EGGS;
EGRETS; EMUS; FALCONS;
FINCHES; FLAMINGOS;
FLYCATCHERS; FRIGATE
BIRDS; FULMARS; GEESE;
GOLDFINCHES; GREBES;
GROSBEAKS; GROUSE;
GUANS; GUILLEMOTS;
GULLS; HARRIERS; HAWKS;
HERONS; HOATZINS; HORN-
BILLS; HUMMINGBIRDS;
IBISES; JACANAS; KEAS;
KINGFISHERS; KINGLETS;
KITES; KITTIWAKES; KIWI
BIRDS; LAPWINGS; LARKS;
LOONS; MACAWS; MARTINS;
MEADOW LARKS; MOA
BIRDS; MOCKINGBIRDS;
MURRES; NENES; NUT-
HATCHES; OSPREYS; OS-
TRICHES; OVENBIRDS;
OWLS; PARAKEETS; PAR-
ROTS; PASSENGER PIGEONS;
PEACOCKS; PELICANS;
PENGUINS; PETRELS;
PHALAROPES; PHEASANTS;
PIGEONS; PLOVERS;
PRAIRIE CHICKENS;
PTARMIGANS; PUFFINS;
QUAIL; QUETZALS; RAILS;
REDSTARTS; REDWINGED
BLACKBIRDS; ROAD RUN-
NERS; ROBINS; SAND-
PIPERS; SAPSUCKERS;
SHRIKES; SKIMMERS; SPAR-
ROWS; SPOONBILLS; STILTS;
STORKS; SWALLOWS; SWANS;
TANAGERS; TEALS; TERNS;
THRUSHES; TITMICE; TOU-
CANS; TOWHEES; TRAGO-
PANS; TURKEYS; VIREOS;
VULTURES; WARBLERS;
WATER OUZELS; WHOOPING
CRANES; WILLETS; WOOD
PEWEES; WOODCOCKS;
WOODPECKERS; WRENS;
YELLOWLEGS

BIRDS OF PARADISE
Nat Geog 152:124-5 (c, 2) Jl
'77
Natur Hist 89:94-5 (painting, c, 1)
Ja '80

BIRMINGHAM, ALABAMA
Ebony 35:33-6 (2) F '80

Birth. See CHILDBIRTH; REPRO-
DUCTION

BIRTH CONTROL
--Male contraceptive techniques
Smithsonian 8:36-43 (painting, c, 1)
Jl '77

BIRTHDAY PARTIES
--70th birthday cake
Am Heritage 30:96 (4) O '79
--Blowing out candles
Sports Illus 47:90 (c, 4) D 12
'77
Ebony 37:116 (4) N '81
--Centenarian (Indiana)
Life 4:101 (2) O '81
--Twins (New York)
Ebony 34:95-8 (2) Je '79

BISON
Nat Wildlife 15:42-3 (c, 1) Ja
'77
Am Heritage 28:21 (painting, c, 2)
F '77
Natur Hist 86:cov., 99 (paint-
ing, c, 1) F '77
Travel 148:52-3 (4) Ag '77
Smithsonian 9:68-9 (c, 3) My '78
Nat Wildlife 17:25, 28-9 (paint-
ing, c, 1) D '78
Nat Wildlife 17:5 (c, 4) Je '79
Nat Geog 156:48-9 (c, 1) Jl '79
Am Heritage 30:2, 22-37 (paint-
ing, c, 1) O '79
Smithsonian 10:80-1 (c, 4) Ja '80
Nat Wildlife 18:49 (c, 3) Ap '80
Am Heritage 31:104-5 (paint-
ing, c, 2) Je '80
Trav/Holiday 154:40 (c, 4) N '80
Smithsonian 12:70-9 (c, 1) My
'01
Nat Geog 160:90-3 (c, 1) Jl '81
Natur Hist 90:58-61 (c, 1) D '81

BITTERNS
--Chick
Nat Wildlife 15:9 (c, 4) Je '77
Nat Wildlife 17:3 (c, 4) Ap '79

BITTERSWEETS (PLANTS)
Am Heritage 28:100 (drawing, c, 4)
Je '77

BLACK AMERICANS
--1930's (Alabama)
Life 4:10-12 (2) Mr '81
--Collages of black life
Smithsonian 11:70-7 (c, 1) Mr '81
--Southern life style
Ebony 34:54-60 (2) F '79

BLACK HISTORY
--18th cent. rebel blacks in Suri-
nam

Smithsonian 7:78-83 (drawing, 4)
Mr '77
--Late 19th cent. photos (Mississippi)
Am Heritage 29:26-7 (c, 1) Je
'78
--1955 bus desegregation case
(Alabama)
Ebony 32:54-64 (3) S '77
--Dramatization of post-Civil War
blacks
Ebony 34:102-6 (3) O '79
--Life in early 20th cent. Detroit, Michigan
Am Heritage 30:11 (4) F '79
--Minstrel players (19th cent.)
Am Heritage 29:cov., 93-105,
116 (c, 1) Ap '78
--Voter registration (1860's; Richmond, Virginia)
Ebony 35:45 (engraving, 4) Je
'80
--See also ABOLITIONISTS;
CIVIL RIGHTS; KU KLUX
KLAN; SLAVERY--US; and
list under BLACKS IN
AMERICAN HISTORY
Black Mountains, North Carolina.
See MT. MITCHELL.
BLACKBIRDS
Nat Geog 155:373 (c, 4) Mr
'79
Natur Hist 90:92 (painting, c, 3)
S '81
--Yellow-headed
Nat Wildlife 15:2 (c, 1) F '77
Nat Wildlife 17:9 (c, 4) Je '79
Nat Wildlife 19:46-7 (c, 2) F
'81
BLACKBOARDS
Smithsonian 8:59 (c, 4) Je '77
Ebony 34:98 (4) Ag '79
Ebony 35:158 (4) Ag '80
Smithsonian 11:59 (c, 1) Ja '81
Sports Illus 54:17 (c, 2) Je 22
'81
Sports Illus 55:40 (c, 4) N 9
'81
BLACK-EYED SUSANS
Nat Geog 151:355 (c, 4) Mr '77
Nat Wildlife 15:48 (c, 1) Je '77
Nat Wildlife 16:30-1 (c, 1) Ap
'78
Natur Hist 89:39 (c, 3) D '80
Natur Hist 90:78 (c, 4) Jl '81
BLACKFEET INDIANS (MONTANA)
--1926
Am Heritage 28:57 (4) Je '77

BLACKOUTS
--1977 (New York City, New York)
Natur Hist 87:27 (c, 1) Ap '78
Blacks in American history. See
ARMSTRONG, LOUIS; CARVER, GEORGE WASHINGTON;
DOUGLASS, FREDERICK; DU
BOIS, W. E. B.; GARVEY,
MARCUS; JACKSON, MAHALIA; JOHNSON, JACK; KING,
MARTIN LUTHER, JR.; MALCOLM X; MAYS, WILLIE;
OWENS, JESSE; ROBINSON,
JACKIE; TRUTH, SOJOURNER;
TUBMAN, HARRIET; WASHINGTON, BOOKER T.
BLACKSMITHS
Sports Illus 55:85 (4) O 26 '81
--1878
Am Heritage 31:111 (painting, c, 4)
O '80
--1911 (Ohio)
Am Heritage 32:78 (2) Ag '81
--Ancient Celtic
Nat Geog 151:610-11 (painting, c, 1)
My '77
--Arkansas
Trav/Holiday 153:104 (4) Ap '80
--China
Nat Geog 159:186-7 (c, 2) F '81
--Florida
Trav/Holiday 148:54 (c, 3) N '77
--Ozark Mountains
Travel 148:42 (c, 4) Ag '77
--Vermont
Natur Hist 90:cov. (c, 1) Mr '81
BLADDERWORT PLANTS
Smithsonian 10:91-4 (c, 2) Ag
'79
BLINDNESS
Ebony 36:44-50 (2) D '80
Life 4:17 (3) N '81
--19th cent.
Am Heritage 29:78 (2) Ag '78
--Mexico
Natur Hist 90:26 (3) Mr '81
--Reading machines
Smithsonian 10:52 (c, 4) Mr '80
BLOODROOT (FLOWERS)
Nat Geog 159:360 (c, 4) Mr '81
BLUE JAYS
Nat Wildlife 16:43 (painting, c, 3)
D '77
Nat Wildlife 17:10 (c, 4) D '78
--Chicks in nest
Nat Wildlife 16:26-7 (c, 1) Ap
'78
--Eating poisonous butterfly

Natur Hist 86:50 (c, 4) Je '77
BLUE RIDGE MOUNTAINS, U.S.
 Ebony 33:152 (4) My '78
 Nat Wildlife 16:26-7 (c, 2) O
 '78
 Trav/Holiday 154:54 (c, 4) Ag
 '80
 Smithsonian 12:126-7 (c, 2) Ap
 '81
BLUEBERRIES
 Nat Geog 151:742 (c, 3) Je '77
 Natur Hist 90:116-20 (c, 1)
 Mr '81
 Nat Geog 160:593 (c, 4) N '81
BLUEBERRY INDUSTRY--
 HARVESTING
 Natur Hist 90:118-20 (c, 1) Mr
 '81
BLUEBIRDS
 Nat Geog 151:854-65 (c, 1) Je
 '77
 Nat Wildlife 15:32A B (paint-
 ing, c, 1) O '77
 Nat Wildlife 16:28 (painting, c, 4)
 Je '78
 Smithsonian 10:102 (c, 4) N '79
BLUEBONNETS (FLOWERS)
 Nat Wildlife 18:53 (c, 1) D '79
BOA CONSTRICTORS
 Natur Hist 89:68-9 (c, 1) F
 '80
BOARS, WILD
 Sports Illus 46:59 (painting, c, 3)
 F 7 '77
 Am Heritage 28:49 (c, 4) Je '77
--See also HOGS.
BOAT BUILDING
--Ancient method of building
 canoe (Hawaii)
 Travel 147:47 (c, 1) F '77
--Canoe (Costa Rica)
 Trav/Holiday 150:58 (c, 4) N
 '78
--Mississippi
 Nat Geog 160:384-5 (c, 2) S '81
--Reproducing 6th cent. Irish
 curragh
 Nat Geog 152:774 (c, 2) D '77
--See also SHIP BUILDING
BOAT RACES
--1866 print
 Smithsonian 9:141 (c, 3) N '78
--1870 steamboat race
 Am Heritage 31:96-103 (c, 1)
 F '80
--Drag boat racing
 Sports Illus 47:50 (4) Ag 1 '77
--Hudson River Derby 1976 (New

York)
 Sports Illus 46:39-42 (c, 1) My
 2 '77
--Kinetic sculpture race (Califor-
 nia)
 Smithsonian 10:cov., 66-72 (c, 1)
 Jl '79
--Miami, Florida
 Trav/Holiday 149:57 (4) F '78
--Motorboats
 Sports Illus 55:90 (c, 4) N 23
 '81
--Motorboats (Florida)
 Sports Illus 46:16-17 (c, 4) Mr
 14 '77
 Sports Illus 50:27 (c, 2) My 21
 '79
--Motorboats (Ohio)
 Sports Illus 49:22-3 (c, 3) Ag 14
 '78
--Pirogues (Tahiti)
 Nat Geog 155:856-7 (c, 1) Je '79
--Rowing (Massachusetts)
 Nat Geog 155:573 (c, 4) Ap '79
BOATHOUSES
--Penn Yan, New York
 Trav/Holiday 154:34 (c, 2) Ag
 '80
--See also MARINAS
BOATING
--Colorado River rapids (South-
 west)
 Sports Illus 47:cov., 25-8 (c, 1)
 Ag 1 '77
 Natur Hist 87:81-91 (c, 1) Mr
 '78
--Ice boating (Montreal, Quebec)
 Trav/Holiday 151:53 (c, 4) Ja
 '79
--Lake Minnetonka, Minneapolis,
 Minnesota
 Nat Geog 158:671 (c, 1) N '80
--Moonlight serenade
 Smithsonian 9:104 (drawing, c, 4)
 Ja '79
--Rhine River cruise, West Ger-
 many
 Trav/Holiday 155:35 (4) Mr '81
BOATS
--19th cent. freight boat cabin
 Travel 148:62 (4) Jl '77
--19th cent. Mississippi River
 keelboat
 Smithsonian 10:99 (painting, c, 2)
 Ap '79
--Amphibious toy crafts
 Life 3:38-40 (c, 1) Ag '80
--Ancient Carthage

Smithsonian 9:49 (painting, c, 3)
F '79
--Ancient Egypt
Nat Geog 151:296-7 (c, 1) Mr
'77
--Celtic coracle
Nat Geog 151:618-19 (c, 1) My
'77
--China
Natur Hist 90:70-1 (1) Ja '81
--Dhows (Bahrain)
Trav/Holiday 151:79 (c, 4) My
'79
--Japan
Trav/Holiday 148:28 (c, 3) D
'77
--Malaysia
Trav/Holiday 151:38 (c, 2) Mr
'79
--Model
Sports Illus 55:32 (c, 4) Ag
10 '81
--Outrigger boats (Philippines)
Travel 148:41 (c, 1) Ag '77
--Paddle-wheelers
Sports Illus 51:80 (c, 4) O 29
'79
--Paddle-wheelers (Tennessee)
Trav/Holiday 149:46 (4) Ja '78
--Pirogues (Benin)
Trav/Holiday 154:54 (c, 2) O
'80
--Pirogues (Louisiana)
Nat Geog 156:376-7 (c, 1) S '79
Am Heritage 31:73 (c, 2) Ag
'80
--Pirogues (Tahiti)
Nat Geog 155:856-7 (c, 1) Je '79
--Reed
Smithsonian 11:108 (4) O '80
--Reed (Peru)
Trav/Holiday 152:cov. (c, 1) Ag
'79
--Replica of 6th cent. Irish cur-
ragh
Nat Geog 152:cov., 768-97
(c, 1) D '77
--Replica of 19th cent. woodboat
(New Brunswick)
Trav/Holiday 150:46 (2) Jl '78
--River packet (1860's; Illinois)
Am Heritage 32:52-3 (1) Je
'81
--Rocket-powered
Sports Illus 53:30-3 (c, 1) N 24
'80
--Sightseeing (Lake Michigan)
Ebony 34:74-7 (3) S '79

--Sightseeing (Wisconsin)
Travel 148:68 (3) Ag '77
--Sightseeing airboat (Florida)
Trav/Holiday 156:54 (4) N '81
--Viking (Norway)
Trav/Holiday 153:10, 13 (2) My
'80
Smithsonian 11:69 (c, 1) S '80
--See also BARGES; CANOES;
CRUISES; FERRY BOATS;
FIGUREHEADS; FISHING
BOATS; FLATBOATS; FRI-
GATES; GONDOLAS; GUN-
BOATS; HOUSEBOATS;
HYDROFOILS; HYDROPLANES;
KAYAKS; MARINAS; MOTOR-
BOATS; OCEAN CRAFT;
RAFTS; RIVERBOATS; ROW-
BOATS; SAILBOATS; SAM-
PANS; SHIPS; STEAMBOATS;
SUBMARINES; TANKERS;
TRAWLERS; TUGBOATS;
UMIAKS; WHALING SHIPS;
YACHTS
BOBCATS
Nat Wildlife 16:52 (c, 4) Ap '78
Nat Wildlife 17:cov., 44-7 (c, 1)
Ag '79
Nat Wildlife 18:28E-28F (draw-
ing, 1) O '80
Smithsonian 12:cov., 36-47 (c, 1)
Je '81
Nat Wildlife 19:cov. (c, 1) Ag '81
BOBSLEDDING
Sports Illus 48:13 (c, 4) F 20
'78
Sports Illus 52:44 (c, 4) Ja 7 '80
--1932 Olympics
Sports Illus 52:91-6 (4) Ja 14 '80
--1980 Olympics (Lake Placid)
Sports Illus 52:16-17, 32-3 (c, 1)
F 25 '80
Sports Illus 52:16 (c, 3) Mr 13
'80
--Luge
Sports Illus 50:18-19 (c, 3) Mr 5
'79
Bobwhites. See QUAIL.
BODRUM, TURKEY
Nat Geog 152:92-3 (c, 1) Jl '77
Trav/Holiday 151:111 (4) My '79
BODY PAINTING
--Bahrain
Nat Geog 156:318 (c, 2) S '79
--Seri Indians (Mexico)
Nat Geog 153:664-5 (c, 2) My '78
BODYBUILDING
Sports Illus 47:91 (c, 3) D 5 '77

BODYBUILDING--WOMEN
 Sports Illus 52:64-8 (c, 1) Mr
 17 '80
 Ebony 35:130-3 (c, 1) Ap '80
BOLIVIA
 Trav/Holiday 150:57-60 (c, 1)
 Jl '78
--See also LA PAZ
BOLIVIA--COSTUME
 Trav/Holiday 150:57-60 (c, 1)
 Jl '78
BOLIVIA--POLITICS AND GOV-
 ERNMENT
--Military coup
 Life 3:85 (c, 2) O '80
BOLL WEEVILS
 Smithsonian 7:135-40 (c, 2)
 F '77
 Smithsonian 8:84 (c, 4) N '77
 Nat Geog 157:149, 156 (c, 3)
 F '80
BOMBAY, INDIA
 Nat Geog 160:104-28 (c, 1) Jl
 '81
BOMBS
 Ebony 35:44-5 (4) Mr '80
--Bomb blast (Northern Ireland)
 Life 2:110-11 (1) Ag '79
--Hydrogen bomb test
 Nat Geog 160:813 (c, 4) D '81
BOMBS--DAMAGE
--Beirut, Lebanon
 Nat Geog 153:870 (c, 3) Je '78
--Site of 1945 explosion (Hiro-
 shima, Japan)
 Nat Geog 152.844-5 (c, 1) D
 '77
BONNARD, PIERRE
--Misia aux Roses (1909)
 Smithsonian 10:94-5 (painting, c, 1)
 F '80
--Nude against the Light
 Smithsonian 11:157 (painting, c, 3)
 O '80
BOOBY BIRDS
 Nat Geog 153:690-1 (c, 1) My
 '78
 Nat Wildlife 17:48 (c, 4) Ap '79
 Trav/Holiday 153:45 (c, 4) Ja
 '80
BOOKS
--6th cent. plant handbook
 Natur Hist 90:51-2 (c, 2) Mr
 '81
--8th cent. "Book of Kells" (Ire-
 land)
 Smithsonian 8:66-73 (c, 1) O
 '77

--15th cent. illustrated manuscript
 (Ireland)
 Nat Geog 152:768 (c, 2) D '77
--15th cent. illumination (France)
 Smithsonian 8:122 (3) Mr '78
--16th cent. bejeweled cover
 (U. S. S. R.)
 Nat Geog 153:33 (c, 2) Ja '78
--1796 American cookbook
 Am Heritage 32:104-7 (drawing, 4)
 Ag '81
--19th cent. illustrations
 Nat Geog 154:534-53 (drawing, 1)
 O '78
--Horatio Alger books
 Smithsonian 8:122-36 (drawing, 4)
 N '77
--Alice in Wonderland
 Smithsonian 8:cov., 50-7 (paint-
 ing, c, 1) D '77
--Children's pictorial alphabet
 (1810)
 Am Heritage 31:6-13 (c, 4) Ag
 '80
--Bob Cratchit's Christmas dinner
 (Dickens)
 Natur Hist 88:98 (drawing, 4) D
 '79
--Hidden treasure puzzle book
 (Great Britain)
 Smithsonian 11:118-25 (paint-
 ing, c, 2) D '80
--Chip Hilton sports books
 Sports Illus 52:50-1 (c, 1) Ja 7
 '80
--Illuminated manuscript (Ireland)
 Nat Geog 151:620-1 (c, 2) My '77
--Illustrated (China)
 Nat Geog 153:345 (c, 4) Mr '78
--Illustrations from plant handbooks
 (13th-16th cents.)
 Natur Hist 90:52-6 (c, 1) Mr '81
--Medieval illustration of owls
 Natur Hist 87:100-7 (c, 1) O '78
--Medieval illuminated manuscripts
 Smithsonian 11:cov., 52-9 (c, 1)
 F '81
--Medieval manuscript illustrations
 depicting women
 Natur Hist 87:cov., 56-67 (c, 1)
 Mr '78
--Paperbacks
 Life 4:90 (c, 4) N '81
--Pope Clement XI's collection of
 rare books
 Smithsonian 8:70-7 (c, 1) Ja '78
--Sites connected with Tom Sawyer
 (Hannibal, Missouri)

Smithsonian 9:155-63 (c, 4) O
'78
--Watership Down sites (Isle of
Man)
Smithsonian 10:78-83 (c, 1) Jl
'79
--See also BIBLES; ILIAD; KORAN;
PRINTING INDUSTRY
BOONE, DANIEL
Travel 148:46 (sculpture, 4) Jl
'77
BOOTH, EDWIN
Smithsonian 8:66 (4) Ag '77
BOOTH, JOHN WILKES
Smithsonian 8:66 (4) Ag '77
BORDEAUX, FRANCE
Nat Geog 158:232-59 (map, c, 1)
Ag '80
BORDER CROSSINGS
--California/Mexico
Nat Geog 157:790-1 (c, 1) Je '80
--China/Hong Kong border guard
Nat Geog 156:730-1 (c, 1) N
'79
--Maine/New Brunswick
Nat Geog 158:388-9 (c, 2) S '80
--Mexico/New Mexico
Nat Geog 156:484-5 (c, 2) O '79
BORNEO--COSTUME
Trav/Holiday 151:cov. (c, 1)
Mr '79
BOSPORUS STRAIT, TURKEY
Nat Geog 152:118-19 (c, 1) Jl
'77
BOSTON, MASSACHUSETTS
Trav/Holiday 150:57-60 (c, 2) O
'78
Life 2:52-9 (c, 1) Mr '79
Trav/Holiday 154:48 (c, 4) Jl '80
--1860 aerial view
Life 2:4 (4) Ja '79
--Children's Museum
Smithsonian 12:158-67 (c, 1) O
'81
--Faneuil Hall
Life 2:58-9 (c, 1) Mr '79
Am Heritage 31:31 (c, 2) Ag '80
--Faneuil Hall (1810)
Am Heritage 31:30 (drawing, 4)
Ag '80
--Isabella Stewart Gardner Museum
Am Heritage 29:48 (c, 1) O '78
--Harbor festival
Life 3:40-2 (c, 1) Jl '80
--Haymarket Square
Natur Hist 87:89 (4) My '78
--Museum Wharf
Smithsonian 12:63 (c, 2) Ap '81

--Trinity Church
Am Heritage 32:52-3 (c, 1) O '81
BOSTON MARATHON
Sports Illus 46:40-1 (c, 1) Ap 18
'77
Sports Illus 47:34-5 (c, 3) O 24
'77
Smithsonian 9:22 (4) Je '78
Sports Illus 50:26-9 (c, 1) Ap 23
'79
Sports Illus 52:14-17 (c, 1) Ap 28
'80
--1976
Sports Illus 51:117 (c, 4) Ag 13
'79
BOSTON MASSACRE
--Memorial (Boston, Massachusetts)
Ebony 34:44 (4) My '79
BOSTON TEA PARTY (1773)
--Replica of ship
Trav/Holiday 150:60 (c, 4) O '78
BOTSWANA
--Gaborone
Ebony 34:126 (c, 4) D '78
BOTSWANA--COSTUME
Ebony 34:124-32 (c, 2) D '78
BOTTICELLI, SANDRO
--Inferno XVIII
Smithsonian 7:112 (painting, c, 3)
Ja '77
BOTTLES
--18th cent.
Nat Geog 152:744, 63 (c, 1) D
'77
--See also WINE.
BOURBON INDUSTRY
--Kentucky
Nat Geog 151:268 (c, 1) F '77
BOWFIN FISH
Natur Hist 86:66 (c, 4) F '77
BOWLING
Sports Illus 46:66-9 (c, 1) Mr 7
'77
Ebony 33:46 (4) F '78
Sports Illus 48:134 (c, 4) F 9 '78
Sports Illus 48:42 (c, 1) My 15
'78
Sports Illus 49:58 (4) D 18 '78
Sports Illus 52:71 (4) Ap 21 '80
Sports Illus 53:46 (c, 4) Je 30
'80
Ebony 36:104 (3) Je '81
BOWLING, LAWN
--Isle of Man
Trav/Holiday 151:56 (c, 4) Je '79
--New Zealand
Trav/Holiday 155:38 (4) Mr '81
BOXERS

'77

Sports Illus 46:28-9 (c, 2) My 2 '77

Sports Illus 46:96 (c, 3) My 23 '77

Sports Illus 47:cov., 20 (c, 1) Ag 8 '77

Sports Illus 47:55 (4) Ag 15 '77

Sports Illus 47:cov., 22-5 (c, 1) S 26 '77

Sports Illus 47:cov., 20-3 (c, 1) O 10 '77

Sports Illus 47:36-8 (c, 1) N 14 '77

Sports Illus 47:108-9 (c, 3) D 5 '77

Sports Illus 48:cov., 14-17 (c, 1) Ja 30 '78

Sports Illus 48:96-102 (c, 1) F 9 '78

Sports Illus 48:67 (3) Ap 3 '78

Sports Illus 48:20-1 (c, 3) Je 19 '78

Sports Illus 49:46 (c, 4) Ag 7 '78

Sports Illus 49:82 (c, 4) O 16 '78

Sports Illus 49:48 (c, 2) N 6 '78

Sports Illus 50:16 (c, 3) Ja 22 '79

Sports Illus 50:44, 47 (3) Ja 29 '79

Sports Illus 50:30 (c, 4) F 12 '79

Sports Illus 50:31-4 (c, 1) F 15 '79

Sports Illus 50:16-19 (c, 2) Mr 19 '79

Sports Illus 50:61-2 (c, 4) Je 11 '79

Sports Illus 51:cov., 20-4 (c, 1) Jl 2 '79

Sports Illus 51:16-17 (c, 2) Jl 9 '79

Sports Illus 51:24-5 (c, 2) Ag 27 '79

Sports Illus 51:55-6 (c, 4) S 24 '79

Sports Illus 51:24-7 (c, 1) O 8 '79

Sports Illus 51:67 (4) O 29 '79

Ebony 35:139, 142 (2) N '79

Sports Illus 51:44-6 (c, 2) N 12 '79

Sports Illus 51:98 (c, 3) N 26 '79

Sports Illus 51:cov., 26-31 (c, 1) D 10 '79

Sports Illus 52:58-61 (c, 1) Mr 10 '80

Sports Illus 52:20-1 (c, 2) Ap 14 '80

Sports Illus 52:75-6 (4) Ap 21 '80

Sports Illus 53:18-19 (c, 4) Jl 7 '80

Sports Illus 53:26-9 (c, 1) O 6 '80

Sports Illus 53:22-3 (c, 4) N 3 '80

Sports Illus 53:24-9 (c, 1) D 8 '80

Sports Illus 54:50 (4) Ja 26 '81

Life 4:37 (c, 2) Ja '81

Sports Illus 54:20-1 (c, 3) Ap 6 '81

Sports Illus 54:98 (c, 4) Ap 20 '81

Sports Illus 54:28-9, 44-7 (c, 2) Je 1 '81

Sports Illus 54:22-31 (c, 2) Je 22 '81

Sports Illus 55:48-50 (c, 4) Je 29 '81

Sports Illus 55:cov., 20-3 (c, 1) Jl 6 '81

Sports Illus 55:18-21 (c, 3) Jl 27 '81

Sports Illus 55:16-17 (c, 2) Ag 17 '81

Sports Illus 55:24-5 (c, 2) Ag 31 '81

Sports Illus 55:cov., 18-33 (c, 1) S 28 '81

Sports Illus 55:26-31 (c, 3) O 12 '81

Sports Illus 55:cov., 32-7 (c, 1) N 16 '81

Sports Illus 55:26-9 (c, 3) D 21 '81

Sports Illus 55:26-7, 34-41 (c, 1) D 28 '81

--1930's
 Ebony 36:133-4 (3) Je '81
--1950's
 Ebony 33:131 (2) Je '78
 Sports Illus 51:59-68 (c, 3) Ag 13 '79
--Ali-Foreman fight (1974)
 Sports Illus 51:108 (c, 3) Ag 13 '79
--Ali-Spinks fight (1978)
 Sports Illus 49:cov., 16-20 (c, 1) S 25 '78
 Ebony 34:41 (4) Ja '79
--Black boxing greats
 Ebony 32:68-74, 85 (2) Ja '77
--Celebrating

Sports Illus 51:cov., 26-7
(c, 1) D 10 '79
Sports Illus 53:29 (c, 2) D 8
'80
Ebony 36:137 (2) F '81
Sports Illus 54:94-5 (c, 1) Ap
20 '81
--Championship belt
Sports Illus 54:55 (c, 4) Ja 26
'81
Ebony 36:140 (3) F '81
--Clay-Liston fight (1964)
Sports Illus 51:78 (c, 3) Ag 13
'79
--Decison
Sports Illus 47:52 (3) Ag 15 '77
Ebony 33:131 (c, 2) My '78
Sports Illus 47:54-5 (c, 3) D 19
'77
Sports Illus 50:19 (c, 4) Mr 19
'79
Sports Illus 51:22-4 (c, 3) Jl 2
'79
Sports Illus 51:76 (4) N 5 '79
Ebony 35:142 (4) N '79
Sports Illus 54:21 (c, 4) Ap 6
'81
--Dempsey-Firpo fight (1923)
Am Heritage 28:cov. (paint-
ing, c, 1) Ap '77
--Dempsey-Willard fight (1919)
Am Heritage 28:72-83 (1) Ap
'77
--Duran-Leonard fight (Montreal)
Sports Illus 53:cov., 14-21 (c, 1)
Je 30 '80
--Foreman-Frazier fight (1973)
Ebony 33:43 (2) Ap '78
--Frazier-Ali fight (1971)
Sports Illus 51:100 (c, 4) Ag 13
'79
--Holmes-Ali fight (1980)
Sports Illus 53:cov., 34-44 (c, 1)
O 13 '80
--Johnson Jeffries fight (1908)
Ebony 33:126 (4) Mr '78
--Johnson-Jeffries fight (1910)
Ebony 35:131 (4) F '80
--Knockout
Sports Illus 47:109 (c, 3) D 5
'77
Ebony 33:125 (2) Mr '78
Ebony 35:142 (4) N '79
Ebony 35:67 (3) Mr '80
Ebony 36:138 (3) F '81
--Liston-Patterson fight (1962)
Ebony 33:45 (4) N '77
--Louis-Schmeling fight (1938)

Am Heritage 29:82-91 (1) O '78
Ebony 36:133 (painting, 4) Je '81
--Spinks-Ali fight
Sports Illus 48:14-19 (c, 1) F 27
'78
Ebony 33:130-1 (c, 4) My '78
--Training
Sports Illus 49:21 (c, 2) Jl 24
'78
Ebony 33:113 (4) S '78
Sports Illus 50:37-40 (c, 1) My
28 '79
Sports Illus 52:35-8 (3) Je 16
'80
Sports Illus 53:42-4 (c, 1) N 24
'80
Sports Illus 55:45 (c, 2) Jl 13 '81
Sports Illus 55:34 (c, 4) Jl 20 '81
Sports Illus 55:44 (c, 4) S 14 '81
BOXING--PROFESSIONAL--WOMEN
Ebony 32:61 (4) Ag '77
BOY SCOUTS
--Celebrities in Uniform
Life 1:121 (c, 4) O '78
--Michigan
Natur Hist 89:41 (c, 1) My '80
BOYD, BELLE
Am Heritage 31:95 (3) F '80
BRADLEY, OMAR
Am Heritage 29:94 (3) D '77
BRADY, MATHEW
Smithsonian 8:cov., 24 (1) Jl '77
--Photos by him
Smithsonian 8:cov., 24-35 (1) Jl
'77
Smithsonian 8:59-67 (1) Ag '77
--Photos of Civil War
Smithsonian 8:cov., 24-05 (1)
Jl '77
BRAHMANS
Natur Hist 86:78 (c, 2) F '77
BRAIN
--Diagram of parts
Smithsonian 9:64-71 (c, 1) Je '78
BRANCUSI, CONSTANTIN
--Sculpture
Smithsonian 9:82-3 (c, 1) Jl '78
BRASILIA, BRAZIL
Nat Geog 152:690 (c, 2) N '77
BRASS
--18th cent. medals and crucifixes
Nat Geog 152:732 (c, 1) D '77
BRATISLAVA, CZECHOSLOVAKIA
Nat Geog 152:468-76 (c, 1) O '77
BRAZIL
Nat Geog 152:684-719 (map, c, 1)
N '77
Sports Illus 48:36-45 (c, 1) Ja 16

'78
Nat Geog 153:246-77 (map, c, 1)
F '78
--Amazon paper mill project
Nat Geog 157:686-711 (c, 1) My
'80
--Amazon River regions
Trav/Holiday 149:44-9 (map, c, 2)
Mr '78
--Bahia area
Natur Hist 87:63-73 (c, 1) Je
'78
--Coffee farms
Nat Geog 159:398-9 (c, 2) Mr
'81
--Discovery monument, Santos
Travel 147:38 (4) Je '77
--Lumbering in rain forest
Life 3:76-80 (c, 1) Ja '80
--Mato Grosso area
Nat Geog 155:60-83 (map, c, 1)
Ja '79
--Serra Pelada
Life 3:66-74 (c, 1) D '80
--See also AMAZON RIVER;
BRASILIA; CURITIBA;
MANAUS; RIO DE JANEIRO;
SÃO PAULO
BRAZIL--COSTUME
Nat Geog 152:684-719 (c, 1) N
'77
Nat Geog 153:246-77 (c, 1) F
'78
--Amazonian Indians
Nat Geog 155:61-83 (c, 1) Ja '79
--Bahia
Natur Hist 87:63-73 (c, 1) Je
'78
--Gauchos
Nat Geog 158:482-501 (c, 1) O
'80
--Mehinaku men
Natur Hist 88:18 (2) F '79
--Mekranoti Indians
Natur Hist 87:cov., 43-55 (c, 1)
N '78
--Miners
Life 3:66-74 (c, 1) D '80
--Rio de Janeiro
Trav/Holiday 154:60 (c, 4) O
'80
BREAD
Ebony 34:124-8 (c, 2) F '79
--Carrying bread home (France)
Trav/Holiday 149:34 (c, 4) Ap
'78
--France
Trav/Holiday 151:59 (c, 4) My

'79
BREAD MAKING
--18th cent. Nova Scotia
Trav/Holiday 149:38 (4) My '78
--Bakery (Dominica)
Ebony 36:118 (c, 4) Jl '81
--Cutting dough
Smithsonian 12:115 (c, 4) O '81
--Kurds (Turkey)
Nat Geog 152:101 (c, 1) Jl '77
--Navajo Indians (Arizona)
Nat Geog 156:84-5 (c, 1) Jl '79
--Peru
Natur Hist 86:36-7 (c, 1) My '77
BREUGHEL, PIETER THE ELDER
--The Peasant Dance
Nat Geog 155:339 (painting, c, 4)
Mr '79
BREZHNEV, LEONID
Life 1:89-92 (3) D '78
BRICK MAKING
--Egypt
Nat Geog 151:310 (c, 4) Mr '77
BRIDALVEIL FALLS, YOSEMITE,
CALIFORNIA
Nat Geog 156:cov. (c, 1) Jl '79
Life 2:94 (c, 4) Ag '79
--Climbing frozen falls
Sports Illus 49:cov., 94-100
(c, 1) D 11 '78
BRIDGES
--Amazon Highway, Brazil
Trav/Holiday 149:46 (c, 4) Mr '78
--Bratislava, Czechoslovakia
Nat Geog 152:476 (c, 4) O '77
--Budapest, Hungary
Nat Geog 152:467 (c, 1) O '77
--Charles, Prague, Czechoslovakia
Nat Geog 155:548-9 (c, 1) Ap '79
--Charleston, West Virginia
Am Heritage 28:102 (4) F '77
--Columbia River, Pacific North-
west
Trav/Holiday 152:58 (2) Ag '79
--Cordoba, Spain
Trav/Holiday 152:72 (c, 2) N '79
--Covered (Georgia)
Trav/Holiday 153:79 (c, 4) My '80
--Covered (Indiana)
Travel 148:59 (c, 4) S '77
--Covered (New Hampshire)
Trav/Holiday 150:41 (c, 4) Jl '78
--Covered (New York)
Sports Illus 46:19 (c, 3) Ja 31 '77
--Covered (Pennsylvania)
Travel 148:63 (4) Jl '77
--Covered (Vermont)
Trav/Holiday 149:57 (c, 4) Je '78

--Covered (Zurich, Switzerland)
 Life 2:172 (c, 2) N '79
--Drawbridge (Palm Beach, Florida)
 Trav/Holiday 151:42 (c, 4) Mr
 '79
--Eight-Arch Bridge, Wales
 Sports Illus 51:96-7 (painting, c, 1)
 D 24 '79
--Footbridge (Yugoslavia)
 Life 2:58 (c, 2) Ap '79
--Halfpenny, Dublin, Ireland
 Nat Geog 159:444-5 (c, 1) Ap
 '81
--Japanese (Memphis Botanical
 Garden, Tennessee)
 Trav/Holiday 149:47 (c, 2) Ja
 '78
--Japanese footbridge (France)
 Smithsonian 10:54-5 (c, 4) F
 '80
 Life 3:62-5 (c, 1) My '80
--Kingston, New York
 Nat Geog 153:82-3 (c, 1) Ja '78
--Lion's Gate, Vancouver, British
 Columbia
 Nat Geog 154:486 (c, 1) O '78
--Mackinac Straits, Michigan
 Am Heritage 29:59 (c, 4) Ag
 '78
 Trav/Holiday 154:53 (c, 1) Jl '80
--Milwaukee, Wisconsin
 Smithsonian 8:79 (c, 4) Jl '77
--Newport, Rhode Island
 Sports Illus 53:74 (c, 4) Ag 18
 '80
--Pittsburgh, Pennsylvania
 Nat Geog 153:750-7 (c, 1) Je '78
--Porto, Portugal
 Nat Geog 158:818-19 (c, 1) D
 '80
--Railroad trestle (Isle of Man)
 Smithsonian 10:78 (c, 4) Jl '79
--Sichuan, China
 Life 4:88-9 (c, 1) O '81
--Somerset Drawbridge, Bermuda
 Travel 147:34 (c, 4) Mr '77
--Tappan Zee, New York
 Nat Geog 153:62-3 (c, 1) Ja '78
--Tower, London, England
 Nat Geog 156:454-5 (c, 1) O '79
--See also BROOKLYN BRIDGE;
 CHESAPEAKE BAY BRIDGE-
 TUNNEL; GEORGE WASHING-
 TON BRIDGE; GOLDEN
 GATE BRIDGE; SAN
 FRANCISCO-OAKLAND BAY
 BRIDGE; VERRAZANO NAR-
 ROWS BRIDGE

BRIDGETOWN, BARBADOS
 Ebony 32:96 (c, 3) Ja '77
 Trav/Holiday 152:52 (c, 3) Ag
 '79
BRISTLECONE PINE TREES
 Nat Geog 152:615 (c, 4) N '77
BRITISH COLUMBIA
 Trav/Holiday 155:49-50 (c, 2) My
 '81
--Ogopogo monster
 Smithsonian 9:173-85 (c, 3) N '78
--Shoreline
 Trav/Holiday 155:65-6 (c, 1) Ap
 '81
--Strait of Georgia
 Nat Geog 157:532-3 (c, 1) Ap '80
--See also CASCADE RANGE; VAN-
 COUVER; VICTORIA
BRONX, NEW YORK CITY, NEW
 YORK
--New York Botanical Gardens
 Smithsonian 9:64-73 (c, 1) Jl '78
--Woodlawn Cemetery
 Am Heritage 30:47, 49 (1) Ag
 '79
--Yankee Stadium
 Sports Illus 47:122-4 (c, 1) O 10
 '77
 Sports Illus 52:56-7 (c, 1) Mr 3
 '80
BRONZE AGE
--Ebla, Syria
 Nat Geog 154:730-58 (c, 1) D '78
--Indus Valley ruins (Pakistan)
 Nat Geog 154:822-3 (c, 1) D '78
--Jordanian tombs
 Smithsonian 9:82-7 (c, 1) Ag '78
BRONZE AGE--RELICS
--Bronze art works (China)
 Smithsonian 11:cov., 62-71 (c, 1)
 Ap '80
BROOKLYN, NEW YORK
--Brooklyn Museum
 Smithsonian 11:116-17 (c, 1) My
 '80
--Greenpoint
 Smithsonian 9:74-80 (c, 2) My '78
--Greenwood Cemetery
 Am Heritage 30:42-3, 50, 53
 (c, 1) Ag '79
--West Indian festival
 Natur Hist 88:72-85 (c, 1) Ag '79
--See also CONEY ISLAND
BROOKLYN BRIDGE, NEW YORK
 CITY
 Am Heritage 31:cov., 18-27
 (drawing, c, 1) D '79
--Depicted on 19th cent. cigar label

Am Heritage 30:89 (paint-
ing, c, 3) D '78
BROWN, JOHN
--Tombstone (New York)
Sports Illus 52:74 (4) Ja 28 '80
BRUSSELS, BELGIUM
Travel 148:cov., 26-31 (c, 1)
Ag '77
Nat Geog 155:318-25 (c, 1) Mr
'79
Trav/Holiday 151:43 (4) Ap '79
--Bird market
Natur Hist 86:58 (c, 1) My '77
--Outdoor cafe
Life 3:31 (4) Jl '80
BRYAN, WILLIAM JENNINGS
Am Heritage 31:113 (2) F '80
Am Heritage 31:110 (litho-
graph, c, 4) Je '80
Am Heritage 32:111 (3) Ag '81
Am Heritage 33:80 (4) D '81
--1896 Presidential campaign
Am Heritage 31:4-11 (c, 1) Ap
'80
BRYCE, JAMES
Am Heritage 32:98-9 (1) Ap
'81
BRYCE CANYON NATIONAL
PARK, UTAH
Nat Wildlife 16:22-3 (c, 1) Ap
'78
Ebony 33:148 (c, 2) My '78
Trav/Holiday 149:42 (c, 2) My
'78
Trav/Holiday 151:64 (c, 4) Ja
'79
Nat Geog 156:3-4 (c, 1) Jl '79
Nat Geog 158:780-1 (c, 1) D '80
BUBONIC PLAGUE
--Memorial of 1679 plague (Vienna,
Austria)
Smithsonian 10:79 (c, 3) O '79
--Plague areas
Nat Geog 152:76-7 (c, 1) Jl '77
BUCHAREST, ROMANIA
Trav/Holiday 151:42 (4) Ap '79
BUCKINGHAM PALACE, LON-
DON, ENGLAND
Life 2:194 (c, 3) D '79
BUDAPEST, HUNGARY
Nat Geog 152:467-9 (c, 1) O '77
--Jewish sites and lifestyle
Smithsonian 10:64-73 (c, 1) Ag
'79
Smithsonian 10:12-13 (c, 4) O
'79
--National Museum interior
Smithsonian 10:170 (c, 3) N '79

BUDDHA
--3rd cent. sculpture (Pakistan)
Nat Geog 159:696 (c, 4) My '81
--7th cent. (Tibet)
Nat Geog 157:246-7 (c, 1) F '80
--Ancient sculptures (Yun-king,
China)
Smithsonian 10:54-63 (c, 1) Ap
'79
--Bronze statue (India)
Nat Geog 153:344-5 (c, 1) Mr '78
--Granite (Sri Lanka)
Nat Geog 155:cov., 122 (c, 1) Ja
'79
--Nepal painting
Nat Geog 151:515 (c, 3) Ap '77
--Penang temple, Malaysia
Trav/Holiday 151:38 (c, 2) Mr
'79
--Rock carving (Tibet)
Smithsonian 11:101 (c, 4) Ja '81
--Temple statue (Thailand)
Trav/Holiday 151:34, 38 (c, 1)
Ja '79
--Todaiji Temple, Nara, Japan
Trav/Holiday 152:93 (4) N '79
BUDDHISM
--Deities on votive tablets (Nepal)
Nat Geog 151:511 (c, 1) Ap '77
BUDDHISM--COSTUME
--Dalai Lama
Life 2:117-18 (c, 2) S '79
--Lamas (Ladakh, India)
Travel 147:31 (4) F '77
--Lamas (Mongolia)
Life 3:116-18 (c, 4) D '80
--Monks (Burma)
Trav/Holiday 153:42 (c, 1) Ap '80
--Monks (Colorado)
Nat Geog 155:400 (c, 2) Mr '79
--Monks (Tibet)
Smithsonian 7:85 (c, 2) Ja '77
Trav/Holiday 152:63 (c, 3) Jl '79
Nat Geog 157:242 (c, 3) F '80
--Nepalese saint
Nat Geog 151:516-17 (c, 2) Ap '77
--Pilgrims (Jokhang, Tibet)
Nat Geog 157:242-51 (c, 1) F '80
BUDDHISM--RITES AND FESTIVALS
Life 2:134-42 (c, 2) N '79
--Chopail (South Korea)
Trav/Holiday 153:74-6 (c, 1) My
'80
--Exorcism dance (Sri Lanka)
Natur Hist 87:cov., 43-9 (c, 1)
Ja '78
--Jokhang, Tibet
Nat Geog 157:242-51 (c, 1) F '80

--Ladakh, India
 Nat Geog 153:351-5 (c, 1) Mr
 '78
--Nepal
 Nat Geog 155:276-7 (c, 1) F '79
BUDDHISM--SHRINES AND
 SYMBOLS
--Ganjira (Lhasa, Tibet)
 Smithsonian 11:96-7 (c, 1) Ja
 '81
--Jokhang, Tibet
 Nat Geog 157:242-51 (c, 1) F
 '80
--Ladakh, India
 Nat Geog 153:344-51 (c, 1) Mr
 '78
--Maui, Hawaii
 Ebony 36:120 (c, 4) Ja '81
--Sri Lanka
 Nat Geog 155:122-3 (c, 1) Ja
 '79
--Stupa (Nepal)
 Nat Geog 155:280-1 (c, 1) F '79
 Life 2:140-1 (c, 1) N '79
--Tibet
 Nat Geog 157:224-51 (c, 1) F
 '80
BUFFALO, NEW YORK
--Albright-Knox Museum
 Smithsonian 10:78-84 (c, 2) D
 '79
BUFFALOES
 Nat Geog 151:808-9 (c, 1) Je
 '77
 Nat Geog 154:836-7, 847 (c, 1)
 D '78
BUILDING DEMOLITION
--Atlantic City hotel, New Jersey
 Life 2:33 (2) Ja '79
--Demolition of block (Dallas,
 Texas)
 Life 3:96-7 (c, 1) Ag '80
--Unfinished condominiums (New
 York)
 Nat Geog 156:96-7 (c, 1) Jl '79
BUILDINGS
--Late 18th cent. smokehouse
 (Virginia)
 Natur Hist 88:135 (c, 4) Ag '79
--Made of corn
 Am Heritage 31:28 (c, 4) Ag '80
--See also APARTMENT BUILD-
 INGS; OFFICE BUILDINGS;
 and list of structures under
 ARCHITECTURAL STRUC-
 TURES
BUILDINGS--CONSTRUCTION
--1980 Olympic site (Moscow,

U. S. S. R.)
 Life 2:87-90 (c, 1) Jl '79
--Hospital (Washington, D. C.)
 Ebony 33:136 (4) Ap '78
BULGARIA
 Nat Geog 158:90-111 (map, c, 1)
 Jl '80
--See also PLOVDIV; SOFIA
BULGARIA--COSTUME
 Nat Geog 158:90-107 (c, 1) Jl
 '80
--Military
 Nat Geog 152:485 (c, 3) O '77
BULGARIA, ANCIENT--RELICS
 Nat Geog 158:cov. , 112-29 (c, 1)
 Jl '80
BULLDOGS
 Sports Illus 51:40-1 (c, 4) S 10
 '79
 Sports Illus 54:97 (c, 4) Ap 20
 '81
BULLDOZERS
 Sports Illus 53:80-1 (c, 4) D 15
 '80
 Sports Illus 54:98-9 (c, 1) My
 25 '81
BULLETS
--17th cent. bullet molds (Virginia)
 Nat Geog 155:753 (c, 4) Je '79
BULLFIGHTING
--Bullring (Lisbon, Portugal)
 Nat Geog 158:811 (c, 1) D '80
--Mexico
 Sports Illus 55:31-3 (c, 1) Jl 6
 '81
--Spain
 Nat Geog 163:320 1 (c, 1) Mr '78
--See also MATADORS
BULLFROGS
 Natur Hist 88:30-5 (c, 1) Ap '79
 Nat Wildlife 18:26-7 (c, 2) Je
 '80
 Nat Geog 159:362-3 (c, 1) Mr '81
BUMPER STICKERS
--Pro National Rifle Association
 Am Heritage 29:15 (c, 4) F '78
BUNTINGS (BIRDS)
 Nat Wildlife 18:41 (painting, c, 1)
 Ag '80
BURGUNDY, FRANCE
 Trav/Holiday 149:33-7, 100-1
 (c, 1) Ap '78
 Nat Geog 153:794-817 (c, 1) Je
 '78
BURMA
 Trav/Holiday 153:42-6, 118
 (map, c, 1) Ap '80
BURMA--COSTUME

Trav/Holiday 153:42-4 (c, 1) Ap '80
--Long-necked Padaung tribes-
women
Nat Geog 155:798-801 (c, 1) Je
'79
BURROS
Nat Wildlife 18:14-16 (2) Ag '80
Life 3:117-20 (c, 2) O '80
--Lifting burros by helicopter
Life 3:117 (c, 2) O '80
BURROUGHS, JOHN
Smithsonian 9:88-93 (2) Je '78
Natur Hist 89:85 (2) Ap '80
BUSES
--Cleveland, Ohio
Ebony 37:72 (4) N '81
--Double-decker (Ireland)
Trav/Holiday 153:97 (4) My
'80
--Double-decker sightseeing bus
(British Columbia)
Travel 147:31 (4) My '77
--Elegant motor coaches (1920's)
Am Heritage 31:44-8 (1) Ap
'80
--Houston, Texas
Ebony 37:74 (4) N '81
--Kansas City, Missouri
Ebony 37:70 (4) N '81
--Luxury buses used by touring
stars
Life 2:117-22 (c, 1) O '79
--New York City bus stop
Travel 148:38-9, 73 (1) S '77
--Philippines jeepney
Nat Geog 151:360-1 (c, 1) Mr
'77
--Relics of bus industry history
Smithsonian 12:145-53 (c, 2)
My '81
BUSHMEN (NAMIBIA)
--Costume, lifestyle
Smithsonian 11:86-95 (c, 1) Ap
'80
BUSINESS CARDS
--Paul Revere
Am Heritage 28:34 (4) Ap '77
BUSINESSMEN
Sports Illus 49:18 (c, 3) Jl 3
'78
Sports Illus 49:32 (c, 4) N 20
'78
Smithsonian 9:76 (c, 1) D '78
Sports Illus 50:30 (c, 4) Ja 15
'79
Life 4:116 (c, 2) Ja '81
--1929 assemblage of notables
(Washington, D. C.)

Smithsonian 10:42-3 (painting, c, 1)
S '79
--James Buchanan "Diamond Jim"
Brady
Smithsonian 12:46 (4) Ag '81
--France
Smithsonian 7:47 (c, 1) Mr '77
--Georgia
Nat Geog 154:225 (c, 3) Ag '78
--Michigan
Nat Geog 155:824 (c, 3) Je '79
--Levi Strauss
Am Heritage 29:16 (4) Ap '78
--See also EASTMAN, GEORGE;
FIRESTONE, HARVEY; FORD,
HENRY; GIRARD, STEPHEN;
GOODYEAR, CHARLES;
GOULD, JAY; HEARST,
WILLIAM RANDOLPH; LIP-
TON, SIR THOMAS; MORGAN,
JOHN PIERPONT; ROCKE-
FELLER, JOHN D.; VANDER-
BILT, CORNELIUS; WOOL-
WORTH, FRANK W.
BUSTARDS
Natur Hist 87:76 (c, 4) My '78
Butter-and-eggs flowers. See
TOADFLAX
BUTTERCUPS
Nat Geog 153:120 (c, 3) Ja '78
BUTTERFLIES
Nat Wildlife 15:45 (c, 3) F '77
Nat Wildlife 15:30-1 (c, 1) Ap
'77
Smithsonian 8:108-9, 116-19
(c, 2) O '77
Smithsonian 8:80 (c, 2) N '77
Nat Wildlife 16:30-1 (c, 4) O '78
Nat Wildlife 17:60 (c, 3) D '78
Smithsonian 10:119-35 (c, 3) My
'79
Nat Wildlife 17:cov. (c, 1) Je
'79
Am Heritage 30:12 (painting, c, 4)
Ag '79
Nat Wildlife 17:21-7 (c, 1) Ag '79
Nat Wildlife 17:47 (c, 4) O '79
Natur Hist 88:56-65 (c, 1) N '79
Nat Wildlife 18:15 (c, 4) D '79
Trav/Holiday 153:82 (c, 4) F '80
Nat Geog 157:404-7 (c, 1) Mr '80
Nat Geog 159:155 (c, 4) F '81
Trav/Holiday 156:50 (c, 4) Jl '81
Smithsonian 12:249 (c, 4) N '81
--19th cent. painting
Smithsonian 10:74 (c, 4) Ap '79
--Larvae
Nat Geog 157:402-3 (c, 1) Mr '80

--Monarchs
 Natur Hist 86:cov. , 40-53 (c, 1)
 Je '77
 Nat Wildlife 16:16-19 (1) Ap
 '78
 Smithsonian 9:106-8 (c, 1) F '79
--Papua New Guinea butterfly
 farming
 Smithsonian 10:119-35 (c, 3)
 My '79
BUTTERWORT PLANTS
 Nat Geog 160:404 (c, 3) S '81
BYRD, RICHARD E.
 Natur Hist 89:8 (4) Ap '80
BYZANTINE EMPIRE--ARCHI-
 TECTURE
--Church (Turkey)
 Nat Geog 152:108 (c, 4) Jl '77
BYZANTINE EMPIRE--RELICS
 Smithsonian 12:95 (c, 4) My '81

-C-

Cabbage. See KOHLRABI
CABINS
--Ozark highlands
 Am Heritage 29:97 (c, 1) D '77
--Slave cabins (Georgia)
 Natur Hist 88:8-30 (2) Ja '79
--Summer cabins (Mississippi)
 Nat Geog 157:855, 857-9, 866
 (c, 1) Je '80
--See also LOG CABINS
CABLE CARS (GONDOLAS)
--Colorado Springs, Colorado
 Trav/Holiday 150:62 (4) N '78
--Palm Springs aerial tramway,
 California
 Trav/Holiday 148:30 (1) N '77
--Sandia Peak tram, Albuquerque,
 New Mexico
 Trav/Holiday 149:34 (c, 1) Ja
 '78
--Grenoble, France
 Trav/Holiday 156:29 (c, 1) Ag '81
--Sugarloaf, Rio de Janeiro,
 Brazil
 Trav/Holiday 154:60 (c, 4) O
 '80
--Stone Mountain, Georgia
 Trav/Holiday 153:86 (4) My '80
Cable cars (streetcars). See
 TROLLEY CARS
CACTUS
 Nat Wildlife 15:cov. (c, 1) F
 '77
 Nat Geog 152:506 (c, 2) O '77

 Smithsonian 9:70-1 (c, 4) Jl '78
 Smithsonian 11:94-103 (c, 1) D
 '80
 Trav/Holiday 155:60-2 (c, 4) Ap
 '81
--Cardon
 Trav/Holiday 153:39 (c, 4) Ja '80
--Cereus
 Natur Hist 89:cov. (c, 1) Jl '80
--Cholla
 Nat Geog 156:134 (c, 1) Jl '79
--Saguaro
 Nat Geog 156:636-7 (c, 4) N '79
 Nat Wildlife 18:40-7 (c, 1) F '80
 Sports Illus 52:73 (c, 4) Je 16
 '80
--See also PRICKLY PEARS
Cafes. See COFFEEHOUSES;
 RESTAURANTS
CAIRO, EGYPT
 Nat Geog 151:314-15 (c, 1) Mr
 '77
CALCUTTA, INDIA
--Hospice for poor
 Life 3:54-65 (1) Jl '80
CALDER, ALEXANDER
--Mobile (Washington, D. C.)
 Smithsonian 9:46-9 (c, 1) Je '78
--Sculpture
 Smithsonian 10:62-8 (c, 2) Je '79
--Sculpture of Josephine Baker
 Smithsonian 10:110 (c, 3) N '79
CALENDARS
--Bighorn Medicine Wheel
 Smithsonian 9:80 (c, 4) O '78
CALENDULAS
 Nat Geog 152:cov. (c, 1) O '77
CALHOUN, JOHN
 Smithsonian 8:26 (4) Jl '77
CALIFORNIA
--1846 settlement by Colonel Steven-
 son's expedition
 Am Heritage 30:64-77 (drawing, 1)
 Je '79
--1920's oil industry (Los Angeles)
 Smithsonian 11:187-205 (2) O '80
--Alleghany
 Smithsonian 10:104-14 (c, 1) F
 '80
--Auburn Dam site
 Smithsonian 9:44-5 (c, 1) Ap '78
--Canyon mansions during fire
 Life 1:136-7 (c, 1) D '78
--Daly City
 Life 2:76-7 (c, 1) Ja '79
--Desert areas
 Smithsonian 9:66-75 (c, 1) S '78
--Desert estate

Nat Geog 156:592-3 (c, 1) N '79
--Diablo Canyon nuclear power
 plant
 Life 2:26-7 (c, 2) My '79
--Dunnigan Hills
 Smithsonian 8:74-5 (c, 1) My
 '77
--Effects of drought
 Nat Geog 152:818-21, 828-9
 (c, 1) D '77
--Effects of storm on Malibu beach
 cottages
 Life 3:136-7 (c, 1) Ap '80
--Fort Bragg
 Trav/Holiday 153:54 (c, 3) Mr
 '80
--Los Padres Reservoir, Carmel
 Valley
 Sports Illus 46:54 (3) Ap 4 '77
--Missions
 Trav/Holiday 149:33-7 (c, 1) F
 '78
--Mono Lake
 Smithsonian 11:42-51 (c, 1) F
 '81
 Life 4:cov., 36-7 (c, 1) Jl '81
 Nat Geog 160:505-19 (map, c, 1)
 O '81
--Mural of California history
 (Los Angeles)
 Life 3:87-90 (c, 1) D '80
--Napa Valley
 Nat Geog 155:694-717 (map, c, 1)
 My '79
--Napa Valley farm (1876)
 Am Heritage 30:59 (lithograph, 4)
 D '78
--North coast area
 Nat Geog 152:330-63 (map, c, 1)
 S '77
 Trav/Holiday 153:53-7, 91
 (c, 3) Mr '80
--Orange County
 Nat Geog 160:750-79 (map, c, 1)
 D '81
--Palm Springs
 Trav/Holiday 148:cov., 26-31
 (c, 1) N '77
--Point Reyes Peninsula
 Nat Wildlife 16:49-55 (c, 1) Ap
 '78
--San Andreas Fault
 Nat Geog 152:354-5 (c, 2) S '77
 Life 2:72-86 (c, 1) Ja '79
--San Francisco Bay area
 Nat Geog 159:814-45 (map, c, 1)
 Je '81
--San Luis Obispo

Trav/Holiday 155:67-70 (c, 1) F
 '81
--Santa Clara Valley (aerial view;
 1950 and 1980)
 Life 4:78-9 (c, 2) D '81
--Santa Cruz Island
 Smithsonian 9:78-9 (c, 2) D '78
--17 Mile Drive
 Trav/Holiday 151:91 (4) Mr '79
--Symbolic painting by Diego Rivera
 Am Heritage 29:16 (painting, c, 3)
 D '77
--Venice
 Smithsonian 10:112-21 (c, 1) Mr
 '80
--Venice (1908)
 Smithsonian 10:116 (4) Mr '80
--Westport
 Trav/Holiday 153:54 (c, 3) Mr
 '80
--See also ALCATRAZ; BERKELEY;
 CASCADE RANGE; DEATH
 VALLEY; FARALLON ISLAND;
 FRESNO; GARDEN GROVE;
 GOLDEN GATE NATIONAL
 RECREATION AREA; KLA-
 MATH RIVER; LAKE TAHOE;
 LOS ANGELES; MONTEREY;
 MOUNT SHASTA; NEWPORT
 BEACH; OAKLAND; PASA-
 DENA; REDWOOD NATIONAL
 PARK; SACRAMENTO; SAN
 DIEGO; SAN JOSE; SAN
 FRANCISCO; SIERRA NEVADA;
 YOSEMITE NATIONAL PARK
CALIFORNIA--MAPS
--Los Angeles area
 Nat Geog 155:36 (c, 1) Ja '79
CALISTHENICS
 Ebony 35:132-3 (4) Ap '80
 Sports Illus 55:67 (c, 4) N 23 '81
--1904 West Point cadets
 Am Heritage 29:11 (4) Je '78
--Back bend (U. S. S. R.)
 Life 3:42 (2) My '80
--Bridge exercise
 Ebony 32:168 (4) S '77
 Sports Illus 51:46-7 (1) O 22 '79
--Class
 Ebony 34:52 (4) D '78
--Push-ups (Rhode Island)
 Sports Illus 53:60 (c, 4) Ag 11
 '80
--Senior citizens (Chicago, Illinois)
 Ebony 34:76-7 (4) S '79
--Sit-ups
 Ebony 32:108 (4) My '77
--Tennis player's stretching exer-

cises
Ebony 34:76 (4) Ap '79
--See also EXERCISING; GYM-
NASTICS
CALLIGRAPHY
--16th cent. correspondence
(Great Britain)
Smithsonian 12:106 (4) Ap '81
--Chinese
Smithsonian 11:175 (c, 3) Je '80
--Chinese sign
Nat Geog 157:306-7 (c, 1) Mr
'80
--Hebrew
Natur Hist 89:34-5 (c, 1) D
'80
--Sioux Indian writing
Smithsonian 9:128 (c, 4) D '78
--South Korean
Nat Geog 156:778 (c, 4) D '79
CALLIGRAPHY--EDUCATION
--Shanghai, China
Trav/Holiday 156:36 (c, 2) Jl
'81
CALLIOPES
--19th cent. steam calliope
Am Heritage 30:109 (3) F '79
CAMBODIA--COSTUME
--Refugees in Thailand
Life 3:106-11 (c, 1) Ja '80
CAMBODIA--POLITICS AND
GOVERNMENT
--Bones of Cambodians massa-
cred by the state
Life 3:108-9 (1) Ja '80
--Effects of internal warfare
Life 3:44-56 (c, 1) Mr '80
CAMBODIA--SOCIAL LIFE AND
CUSTOMS
--Traditional dancing
Smithsonian 11:118-25 (c, 1)
S '80
CAMBRIDGE, MASSACHUSETTS
--1860's
Am Heritage 30:104-7 (3) F
'79
--1930 gas station
Life 3:114 (c, 4) D '80
--First Baptist Church
Smithsonian 11:112 (c, 4) Ja '81
--See also HARVARD UNIVERSITY
CAMBRIDGE UNIVERSITY,
GREAT BRITAIN
--Trinity College
Smithsonian 7:98-9 (c, 3) F '77
CAMELS
Nat Geog 152:384-5 (c, 2) S '77
Trav/Holiday 149:33 (c, 2) Ja

'78
Nat Geog 153:cov., 580-611 (c, 1)
My '78
Nat Geog 154:526 (c, 1) O '78
Smithsonian 9:124-5 (c, 3) O '78
Nat Geog 154:666 (c, 3) N '78
Nat Geog 154:799 (c, 1) D '78
Nat Geog 155:154-5 (c, 1) F '79
Nat Geog 156:282 (c, 4) Ag '79
Smithsonian 10:82 (c, 4) Ja '80
Natur Hist 89:83 (2) Ap '80
Nat Geog 158:290-1 (c, 1) S '80
Nat Geog 159:196-7 (c, 1) F '81
Nat Geog 159:766-7, 772-3 (c, 1)
Je '81
Natur Hist 90:86-8 (4) Jl '81
Smithsonian 12:62-3 (c, 1) D '81
--Camel race (Al-Ain)
Travel 147:61 (4) Ja '77
--Camel race (Saudi Arabia)
Nat Geog 158:cov., 306-8 (c, 1)
S '80
--Use in U.S. Civil War
Natur Hist 89:70-4 (2) My '80
--See also CARAVANS
CAMERA INDUSTRY
--Manufacturing (Portugal)
Nat Geog 158:810 (c, 4) D '80
CAMERAS
Ebony 35:120 (4) Ag '80
--Early 20th cent.
Am Heritage 31:2 (3) Ap '80
--Professional portrait camera
Ebony 36:150 (2) My '81
--Television
Sports Illus 49:70-1 (c, 1) Ag 21
'78
Sports Illus 52:23 (c, 4) Je 9 '80
Sports Illus 53:42 (c, 4) Ag 4 '80
Ebony 35:71, 74 (4) O '80
--U-2 aerial spy camera
Am Heritage 28:9 (4) O '77
--Underwater
Smithsonian 10:85 (c, 4) Jl '79
Nat Geog 160:826-7 (c, 1) D '81
--Underwater (1954)
Nat Geog 160:825 (4) D '81
--Worn by pigeons
Smithsonian 10:107 (4) Ap '79
--See also MOTION PICTURE
PHOTOGRAPHY; PHOTOG-
RAPHY
CAMPFIRES
Nat Wildlife 15:12-16 (c, 2) Ap
'77
Nat Geog 154:22 (c, 4) Jl '78
Nat Wildlife 16:53 (c, 4) O '78
Nat Geog 160:398 (c, 1) S '81

--1548 German woodcut
 Natur Hist 90:24 (2) O '81
--1837 painting by Alfred Jacob
 Miller
 Am Heritage 30:52 (c, 4) D '78
--Alberta
 Trav/Holiday 155:44 (c, 4) My
 '81
--France
 Nat Geog 154:558-9 (c, 2) O '78
CAMPING
 Nat Wildlife 15:12-16 (c, 2) Ap
 '77
 Trav/Holiday 149:42, 44 (c, 2)
 My '78
 Nat Wildlife 17:34-7 (drawing, 1)
 Ap '79
--Late 19th cent. (New York)
 Am Heritage 29:98 (4) O '78
--1910's
 Am Heritage 29:84 (3) Je '78
--1916 utensils
 Smithsonian 11:128 (c, 4) F '81
--1918 industrialists
 Smithsonian 9:88-95 (1) Je '78
--Alaska
 Nat Geog 152:54-5 (c, 1) Jl '77
--Australia
 Nat Geog 153:595 (c, 3) My '78
 Trav/Holiday 153:70 (c, 3) F
 '80
--Baffin Island, Northwest Terri-
 tories
 Sports Illus 50:55 (c, 3) F 12
 '79
--In snow
 Nat Wildlife 17:34-9 (c, 1) D
 '78
--Maine
 Nat Geog 151:740 (c, 4) Je '77
--Wyoming
 Trav/Holiday 152:cov. (c, 1)
 Jl '79
--See also BACKPACKS; HIKING;
 SLEEPING BAGS; TENTS
CAMPS
--Summer football camp (Minnesota)
 Nat Geog 158:690-1 (c, 2) N
 '80
CAMPSITES
--Aloha State Park, Michigan
 Nat Geog 155:808-9 (c, 1) Je
 '79
--Arkansas
 Travel 147:51 (c, 4) Ja '77
--Ladakh, India
 Travel 147:28 (c, 3) F '77
--Grand Isle, Louisiana

Trav/Holiday 149:39 (c, 4) Mr '78
--Mississippi
 Trav/Holiday 155:91 (c, 4) Mr '81
--Tennessee park
 Nat Geog 156:146 (c, 2) Jl '79
CANADA
-- Mackenzie River area
 Smithsonian 8:38-51 (map, c, 1)
 S '77
--See also ALBERTA; ARCTIC;
 BRITISH COLUMBIA; MAC-
 KENZIE RIVER; MANITOBA;
 NEW BRUNSWICK; NORTH-
 WEST TERRITORIES; NOVA
 SCOTIA; ONTARIO; PRINCE
 EDWARD ISLAND; QUEBEC;
 ROCKY MOUNTAINS; ST.
 LAWRENCE RIVER; SAS-
 KATCHEWAN; THOUSAND
 ISLANDS; YUKON
CANADA--COSTUME
--19th cent. (Saskatchewan)
 Nat Geog 155:663 (3) My '79
--British Columbia
 Nat Geog 154:466-91 (c, 1) O '78
--Eskimos (Northwest Territories)
 Nat Geog 152:624-47 (c, 1) N '77
--Hutterites
 Natur Hist 90:cov., 34-47 (c, 1)
 F '81
--Ontario
 Nat Geog 154:760-95 (c, 1) D '78
--Quebec
 Nat Geog 157:590-623 (c, 1) My
 '80
--Royal Canadian Mounted Police
 Nat Geog 155:672-3 (c, 2) My
 '79
--Saskatchewan
 Nat Geog 155:652-79 (c, 1) My
 '79
--Yukon
 Nat Geog 153:548-75 (c, 1) Ap
 '78
CANADA--HISTORY
--Fenian invasion (1866)
 Am Heritage 30:56-7 (painting, c, 1)
 Je '79
--Posters inviting Sasketchewan
 settlers (19th cent.)
 Nat Geog 155:650, 670 (c, 1)
 My '79
--Pro British poster (1860's)
 Nat Geog 157:615 (c, 4) My '80
CANADA--MAPS
--Ethnic groups of Saskatchewan
 Nat Geog 155:656-7 (c, 1) My '79
--Provinces by predominant lan-

guage
Nat Geog 151:440 (c, 1) Ap '77
CANADA GEESE
Nat Wildlife 15:2 (c, 2) Ap '77
Nat Wildlife 15:54-5 (painting, c, 1)
O '77
Smithsonian 8:46-7 (c, 3) D '77
Nat Geog 154:490-1 (c, 2) O '78
Nat Geog 156:192-3 (c, 1) Ag '79
Natur Hist 89:30-1, 37 (c, 1) Jl
'80
Nat Geog 158:442-3 (c, 1) O '80
Nat Geog 159:367 (c, 1) Mr '81
Nat Wildlife 19:cov. (c, 1) Je
'81
Nat Wildlife 20:cov. (painting, c, 1)
D '81
--In flight
Nat Wildlife 18:25, 44-7 (c, 1)
O '80
CANALS
--19th cent. U. S.
Travel 148:60-5 (3) Jl '77
--Annecy, France
Trav/Holiday 156:30 (c, 2) Ag
'81
--Belgium
Nat Geog 155:314-5 (c, 1) Mr
'79
--France
Trav/Holiday 151:57-9 (c, 1)
My '79
--Idaho (1904)
Am Heritage 32:29 (4) Ap '81
--Irrigation project (India)
Nat Geog 151:242-3 (c, 1) F '77
--Isle of Man
Trav/Holiday 151:55 (c, 1) Je
'79
--Japan
Nat Geog 152:843 (c, 1) D '77
--Locks (Pacific Northwest)
Trav/Holiday 152:56 (c, 1) Ag
'79
--Ohio-Erie, Ohio
Trav/Holiday 152:55 (c, 4) S
'79
--Scotland
Nat Geog 151:765 (c, 3) Je '77
--See also PANAMA CANAL;
SUEZ CANAL; VENICE,
ITALY
CANARY ISLANDS
--Tenerife
Trav/Holiday 153:38-40 (map, c, 1)
Je '80
--See also LAS PALMAS
CANCER

--Child victims
Life 3:cov. , 128-36 (c, 1) D '80
--Interferon research
Life 2:55-62 (c, 3) Jl '79
--Malignant lung tumor
Life 4:134 (2) My '81
--Treatments
Ebony 33:127-34 (2) Ap '78
Ebony 34:95 (2) N '78
Ebony 35:134 (3) N '79
Life 3:112-18, 128 (c, 1) N '80
--Treatments for children
Life 3:130-6 (c, 1) D '80
--Treatments with pions
Smithsonian 12:80-9 (c, 1) O '81
CANDLE MAKING
--Arkansas
Trav/Holiday 153:38 (4) Ap '80
--Mexico
Nat Geog 151:845 (c, 4) Je '77
--New England
Trav/Holiday 155:69 (c, 1) My '81
CANDLES
Life 4:62 (c, 4) F '81
--Yak-butter (Tibet)
Nat Geog 157:250-1 (c, 1) F '80
CANDLESTICKS
--12th cent. gilt base (Great Britain)
Smithsonian 9:18-19 (c, 4) O '78
--1705 (New York)
Am Heritage 31:19 (4) Ap '80
Canes. See WALKING STICKS.
CANNONS
Life 3:36-7 (c, 1) Ap '80
--Civil War
Travel 148:53 (c, 4) O '77
Trav/Holiday 150:32 (c, 4) Jl '78
Nat Geog 156:106-7 (c, 2) Jl '79
Am Heritage 31:79 (drawing, 4)
O '80
Am Heritage 32:47 (3) Je '81
--Revolutionary War
Am Heritage 32:72 (drawing, 2)
O '81
CANOEING
Sports Illus 46:101 (painting, c, 3)
Ja 10 '77
Nat Wildlife 17:19 (c, 4) F '79
Nat Wildlife 17:9 (c, 3) O '79
Smithsonian 10:125 (c, 4) N '79
--Arkansas
Nat Geog 151:346-7 (c, 1) Mr '77
--Borneo, Indonesia
Nat Geog 157:840-1 (c, 1) Je '80
--Ferry on Niger River, Nigeria
Nat Geog 155:420 (c, 1) Mr '79
--Hawaii
Nat Geog 152:586-7 (c, 1) N '77

--Ice canoe race (Quebec)
Nat Geog 151:454-5 (c, 3) Ap
'77
--Kentucky
Trav/Holiday 155:61 (c, 3) Je
'81
--Maine
Nat Geog 159:381 (c, 4) Mr '81
--Manitoba
Trav/Holiday 153:54 (c, 3) My
'80
--Minnesota
Nat Geog 152:30-1 (c, 1) Jl '77
--Northwest Territories
Nat Geog 160:406-7, 414-15
(c, 3) S '81
--Orchid Island
Nat Geog 151:98-9 (c, 1) Ja
'77
--Shooting Colorado River rapids,
Arizona
Nat Wildlife 16:44 (c, 2) F '78
Sports Illus 48:30-1 (c, 1) F 9
'78
--Shooting rapids (Washington)
Nat Geog 152:38-9 (c, 1) Jl '77
--Shooting rapids (Wyoming)
Nat Geog 151:868-9 (c, 3) Je
'77
--Texas
Nat Geog 152:48-9 (c, 2) Jl '77
--Wisconsin
Travel 148:33-5 (2) Ag '77
CANOES
Nat Wildlife 15:42-3 (c, 3) F
'77
Smithsonian 9:184 (4) O '78
--Ancient method of constructing
canoe (Hawaii)
Travel 147:47 (c, 1) F '77
--Brazil
Nat Geog 157:708 (c, 3) My '80
--Guam
Trav/Holiday 154:47 (c, 3) Jl
'80
--Log canoes (Maryland)
Nat Geog 158:432-3 (c, 2) O
'80
--Maori war canoe (New Zealand)
Trav/Holiday 148:44 (c, 2) D
'77
CANTERBURY, ENGLAND
--Canterbury Cathedral
Life 4:165-76 (c, 2) D '81
CANYONLANDS NATIONAL PARK,
UTAH
Sports Illus 51:23-6 (c, 1) Ag
20 '79

CANYONS
--Hells, Oregon/Idaho
Am Heritage 28:13-23 (c, 1) Ap
'77
--Utah
Nat Geog 158:776-7 (c, 1) D '80
--Waimea, Kauai, Hawaii
Trav/Holiday 154:59 (c, 4) N '80
--See also BRYCE CANYON NA-
TIONAL PARK; CANYON-
LANDS NATIONAL PARK
CAPE CANAVERAL, FLORIDA
Nat Geog 159:318-19 (c, 2) Mr
'81
CAPE COD, MASSACHUSETTS
--Falmouth road race
Sports Illus 49:72, 76 (c, 4) S 4
'78
--Provincetown
Travel 148:42-7 (c, 1) S '77
Trav/Holiday 155:70 (c, 4) My
'81
--Self-sufficient farm (Falmouth)
Nat Wildlife 17:4-11 (c, 1) Ap
'79
--Woods Hole
Life 3:63-6 (c, 1) Ag '80
CAPE HATTERAS, NORTH CARO-
LINA
Nat Geog 157:340 (c, 1) Mr '80
CAPE SOUNION, GREECE
Nat Geog 157:376-7 (c, 1) Mr '80
CAPE TOWN, SOUTH AFRICA
Nat Geog 151:782-3, 802-3 (c, 1)
Je '77
Trav/Holiday 149:63-4 (c, 2) Je
'78
Trav/Holiday 155:23 (4) Ja '81
CAPITAL PUNISHMENT
--71 B.C. crucifixion of Roman
rebel slaves
Nat Geog 159:726-7 (painting, c, 1)
Je '81
--1847 hangings (Mexican War)
Smithsonian 8:100-1 (painting, c, 1)
Mr '78
--1888 crucifixion (Penitentes sect;
New Mexico)
Am Heritage 30:63 (3) Ap '79
--1890's gallows
Smithsonian 12:138 (4) D '81
--1901 hanging (New Mexico)
Am Heritage 30:28 (1) Ap '79
--1910's firing squad (Mexico)
Smithsonian 11:36-7 (3) Jl '80
--1928 electric chair execution (New
York)
Am Heritage 31:31 (2) O '80

--Electric chair
 Ebony 35:44 (4) S '80
--Executing Kurdish rebels by
 firing squad (Iran)
 Life 2:134-5 (1) O '79
--Firing squad victims (Liberia)
 Life 3:50-5 (c, 1) Je '80
 Ebony 36:109 (3) Ja '81
--Hangman's noose
 Travel 147:48 (c, 1) Ja '77
 Am Heritage 28:112 (drawing, 4)
 O '77
--Hangman's noose (Cambodia)
 Life 3:44-5 (c, 1) Mr '80
--See also LYNCHINGS
CAPITOL BUILDING, WASHING-
 TON, D. C.
 Ebony 32:140, 152 (c, 2) Mr
 '77
 Travel 147:59 (c, 4) Je '77
 Ebony 33:102 (4) F '78
 Nat Geog 154:684 (c, 2) N '78
 Ebony 35:45 (3) O '80
 Life 4:59 (c, 2) F '81
 Trav/Holiday 155:10 (c, 2) Ap
 '81
--19th cent. U. S. Capitol toy
 Am Heritage 32:24-5 (c, 1) D
 '80
--Thermogram of escaping heat
 Life 3:144-5 (c, 1) Mr '80
CAPITOL BUILDINGS--STATE
--Albany, New York
 Smithsonian 12:146-53 (c, 1)
 N '81
--Frankfort, Kentucky
 Travel 148:50 (4) Jl '77
--Hartford, Connecticut
 Travel 147:66 (c, 1) Mr '77
 Ebony 33:75 (2) Mr '78
--Madison, Wisconsin
 Ebony 34:74 (2) O '79
--Montgomery, Alabama
 Travel 147:cov. , 28 (c, 1) Ja
 '77
CAPONE, AL
 Am Heritage 30:82-93 (c, 1)
 F '79
CAPYBARAS
 Life 4:181 (c, 2) D '81
CARACARAS (BIRDS)
 Life 4:182 (c, 4) D '81
CARACAS, VENEZUELA
 Trav/Holiday 156:51-5 (c, 1) S
 '81
CARAVANS
--1925 Mongolia
 Natur Hist 89:cov. , 79 (1) Ap

'80
--Afghanistan
 Smithsonian 11:48-9 (c, 1) N '80
--Australia
 Nat Geog 153:580-609 (c, 1) My
 '78
--China
 Nat Geog 159:196-7 (c, 1) F '81
--Pakistan
 Nat Geog 151:116-19 (c, 1) Ja
 '77
--See also CAMELS
CARCASSONNE, FRANCE
 Trav/Holiday 151:66 (c, 1) My
 '79
CARD PLAYING
 Sports Illus 52:86-7 (c, 1) Ap 21
 '80
 Sports Illus 52:68 (c, 4) Je 2 '80
 Ebony 35:58-9 (3) Ag '80
 Trav/Holiday 155:66 (c, 4) Ap '81
--Blackjack (Canada)
 Nat Geog 152:640 (c, 2) N '77
--Blackjack at casino (Tasmania,
 Australia)
 Travel 147:46 (c, 4) Mr '77
--Bridge
 Sports Illus 46:22-3 (painting, c, 1)
 Ap 11 '77
 Smithsonian 8:79 (c, 4) O '77
 Sports Illus 49:44 (3) Ag 28 '78
--Lisbon, Portugal
 Trav/Holiday 148:58-9 (c, 1) N
 '77
--Poker
 Sports Illus 50:56 (4) F 19 '79
 Sports Illus 50:40 (c, 1) My 14
 '79
 Sports Illus 55:80-1 (c, 4) N 30
 '81
--Sheepshead (Wisconsin)
 Nat Geog 152:191 (c, 3) Ag '77
--Solitaire
 Ebony 33:139 (3) S '78
--Spanish cafe
 Natur Hist 89:40-1 (c, 2) Jl '80
--World Series of Poker
 Sports Illus 46:56-8 (4) My 30
 '77
CARD PLAYING--HUMOR
--Bridge
 Sports Illus 51:39 (drawing, c, 3)
 Jl 2 '79
CARDINALS (BIRDS)
 Nat Wildlife 15:50 (c, 4) Ja '77
 Am Heritage 28:49 (c, 4) Je '77
 Nat Wildlife 16:42-4 (c, 1) D '77
 Nat Wildlife 17:cov. (painting, c, 1)

D '78
Nat Wildlife 18:8 (c, 4) D '79
Nat Wildlife 18:49 (c, 4) Ap '80
Nat Wildlife 19:30-1 (c, 1) D
'80
CARDS
--Black South African identity
card
Nat Geog 151:803 (c, 4) Je '77
--See also BUSINESS CARDS;
GREETING CARDS
CARDS, PLAYING
Sports Illus 47:92-3 (drawing, c, 2)
D 19 '77
Life 1:65 (c, 4) O '78
Sports Illus 49:76-7 (drawing, c, 4)
D 25 '78
Sports Illus 51:90-1 (drawing, c, 4)
D 24 '79
--Jacks
Smithsonian 10:63 (c, 4) Ja '80
CARIBBEAN
--Scenes on Caribbean islands
Ebony 32:94-8 (c, 3) Ja '77
Trav/Holiday 151:cov. , 51-66
(map, c, 1) Ap '79
Trav/Holiday 153:67-9 (c, 1) Ap
'80
Trav/Holiday 155:69-71 (c, 2)
Ap '81
--See also WEST INDIES
CARIBBEAN--MAPS
Trav/Holiday 151:61 (4) Ja '79
Trav/Holiday 153:32 (4) Mr '80
CARIBBEAN SEA--MAPS
Nat Geog 159:250-1 (c, 1) F
'81
CARIBOU
Nat Wildlife 15:60 (c, 4) Ja '77
Smithsonian 8:48-9 (c, 1) S '77
Smithsonian 8:46-7 (c, 4) D '77
Nat Wildlife 16:5-7 (c, 4) Ag
'78
Nat Wildlife 17:52 (c, 4) D '78
Nat Wildlife 17:5 (c, 1) O '79
Nat Geog 156:cov. , 734-6
(c, 1) D '79
Natur Hist 90:113-15 (c, 2) N
'81
Nat Wildlife 20:33-41 (c, 1) D
'81
--Calf
Natur Hist 86:92 (painting, c, 2)
Ja '77
Carnivorous plants. See BLAD-
DERWORT PLANTS; BUT-
TERWORT PLANTS; PITCH-
ER PLANTS

Carousels. See MERRY-GO-
ROUNDS
CARP
Smithsonian 11:cov. , 54-63 (c, 1)
My '80
CARPENTRY
--Arkansas
Trav/Holiday 153:39, 102-4 (4)
Ap '80
--Basement workshop (Ohio)
Smithsonian 11:52-3 (3) O '80
--Cabinetmaking (Williamsburg,
Virginia)
Trav/Holiday 156:28 (c, 2) Jl '81
--North Carolina
Nat Geog 157:358-9 (c, 1) Mr '80
CARPETS
--Albania
Nat Geog 158:547 (c, 1) O '80
--See also RUG MAKING
CARRANZA, VENUSTIANO
Smithsonian 11:32 (4) Jl '80
CARRIAGES AND CARTS
--Handcart (China)
Nat Geog 156:562-3 (c, 1) O '79
--Sri Lanka
Nat Geog 155:133 (c, 2) Ja '79
--See also BABY CARRIAGES;
BABY STROLLERS; WAGONS
CARRIAGES AND CARTS--HORSE-
DRAWN
Sports Illus 48:30 (c, 4) Mr 20
'78
Sports Illus 54:108-9 (c, 2) Ja 19
'81
--19th cent. bakery wagon (Con-
necticut)
Am Heritage 31:28 (4) F '80
--Late 19th cent. Utah
Am Heritage 30:64 (4) F '79
--1890 country doctor (Massachu-
setts)
Am Heritage 32:16-17 (paint-
ing, c, 1) Je '81
--1896 New York City, New York
Life 3:26 (4) S '80
--Early 20th cent. (New York)
Smithsonian 9:134-5 (4) N '78
--1900 (Virginia)
Am Heritage 29:30-1 (1) F '78
--1940's Yugoslavia
Smithsonian 10:94-5 (2) D '79
--Albania
Nat Geog 158:556-7 (c, 1) O '80
--Bermuda
Travel 147:cov. (c, 1) Mr '77
--Brewery dray (Great Britain)
Nat Geog 156:458-9 (c, 1) O '79

--Dominican Republic
 Nat Geog 152:559 (c, 2) O '77
--Donkey cart (China)
 Trav/Holiday 150:34 (c, 1) N
 '78
--Donkey cart (Ireland)
 Trav/Holiday 152:70 (c, 2) Jl
 '79
--Gypsy carts (France)
 Travel 147:58-63 (c, 1) Ap '77
--Italy
 Nat Geog 159:714-15 (c, 1) Je
 '81
--Madagascar
 Nat Geog 160:448-9 (c, 1) O '81
--Manitoba race
 Trav/Holiday 153:53 (c, 3) My
 '80
--Michigan
 Natur Hist 89:36-7 (c, 1) My
 '80
 Trav/Holiday 154:54 (c, 4) Jl
 '80
--Morocco
 Trav/Holiday 150:37 (c, 3) O '78
--New Brunswick
 Nat Geog 158:385 (c, 4) S '80
--Ox-drawn carriage (Madeira)
 Trav/Holiday 153:62 (c, 3) F
 '80
--Pakistan
 Nat Geog 159:676 (c, 2) My '81
--Pennsylvania
 Trav/Holiday 152:49 (c, 4) Ag
 '79
--Poland
 Smithsonian 9.117 (c, 1) S '78
 Nat Geog 159:118-19 (c, 1) Ja
 '81
 Trav/Holiday 155:67 (c, 4) Mr
 '81
--Turkey
 Nat Geog 152:102-3, 122-3 (c, 1)
 Jl '77
 Trav/Holiday 149:57 (c, 1) Ap
 '78
--U. S. S. R.
 Nat Geog 155:770, 782-3 (c, 2)
 Je '79
--Vermont
 Nat Wildlife 17:5 (c, 1) D '78
 Nat Wildlife 17:43-7 (c, 1) F
 '79
--Viennese coachman, Austria
 Smithsonian 10:83 (c, 4) O '79
CARROLL, LEWIS
 Smithsonian 8:53, 56 (3) D '77
CARTAGENA, COLOMBIA

Trav/Holiday 150:53-4 (c, 1) O
 '78
CARTER, JIMMY
 Ebony 32:83 (3) Ja '77
 Am Heritage 28:cov., 7 (c, 1)
 Ag '77
 Ebony 33:111 (c, 4) Ap '78
 Ebony 33:54-6 (2) S '78
 Ebony 34:79 (4) N '78
 Ebony 34:38 (4) Ja '79
 Ebony 34:33 (4) F '79
 Ebony 34:185 (4) My '79
 Ebony 34:127 (3) Ag '79
 Ebony 34:61 (4) S '79
 Life 2:142-3 (1) S '79
 Ebony 34:31, 100 (4) O '79
 Life 2:28-31 (2) N '79
 Life 2:48-9, 158 (1) D '79
 Ebony 35:44 (4) Ja '80
 Ebony 35:34, 74 (4) Jl '80
 Life 3:33-44 (c, 1) O '80
 Life 3:138 (4) N '80
 Ebony 36:34, 72, 148 (c, 4) D
 '80
 Life 3:9, 197 (2) D '80
 Ebony 36:27 (2) Jl '81
--Inauguration (1977)
 Ebony 32:139-49 (c, 2) Mr '77
--Running in Maryland race
 Sports Illus 5:16-19 (c, 3) S 24
 '79
CARTHAGE
 Smithsonian 9:42-55 (c, 1) F '79
CARTHAGE--RELICS
 Smithsonian 9:42-53 (c, 1) F '79
CARTHAGE--RUINS
 Smithsonian 9:44-55 (c, 1) F '79
Cartoon characters. See CHARAC-
 TER SYMBOLS; COMIC
 STRIPS
CARTOONS
--19th cent. Grandville's (France)
 Smithsonian 9:134 (drawing, 4) S
 '78
--1858 depictions of dirty Thames
 River, England
 Smithsonian 9:102 (4) My '78
--1867 Alaska joining the U. S.
 Smithsonian 10:142 (4) D '79
--1880's ridiculing of Henry George
 Am Heritage 29:4, 13 (c, 1) Ap
 '78
--1891 rainmaker poster
 Natur Hist 89:94 (3) N '80
--1892 Cecil Rhodes in Africa
 Smithsonian 12:50 (4) My '81
--Early 20th cent. cartoons about
 evolution

Natur Hist 89:118-28 (4) Ap
'80
--1902 origin of "Teddy Bear"
Smithsonian 9:144 (4) D '78
--1904 anti-car environmentalist
Smithsonian 11:146 (drawing, 4)
S '80
--1919 women's suffrage move-
ment
Am Heritage 30:12-13, 21 (c, 2)
D '78
--1920's oil scandal (California)
Smithsonian 11:204-5 (3) O '80
--1920's Prohibition
Smithsonian 10:118 (4) Je '79
--1930's cartoons about Social
Security
Am Heritage 30:42-6 (4) Ap
'79
--1940's gas shortage
Am Heritage 30:10-11 (1) O '79
--1955 Herblock memorial to
Einstein
Smithsonian 9:69 (4) F '79
--Hogarth's "Gin Lane"
Smithsonian 10:16 (3) Ja '80
--Nast's "Country going to the
Dogs"
Smithsonian 10:16 (4) Ja '80
--Osborn's look at human behavior
Smithsonian 10:66-73 (draw-
ing, c, 1) N '79
--Regarding environment
Nat Wildlife 19:29-35 (drawing, 4)
F '81
--James Thurber creations
Smithsonian 7:87-92 (c, 1) Ja
'77
--J. R. Williams' cartoons of
cowboy life
Am Heritage 29:93-9 (4) F '78
--Victoria Woodhull
Smithsonian 8:131-41 (3) O '77
--See also MAULDIN, BILL;
NAST, THOMAS; POLITICAL
CARTOONS
CARUSO, ENRICO
Travel 148:46 (statue, 4) O '77
CARVER, GEORGE WASHINGTON
Ebony 32:102-8 (4) Jl '77
Am Heritage 28:66-73 (2) Ag
'77
Life 4:17 (4) Mr '81
Ebony 36:107 (4) My '81
--Carver Museum, Tuskegee, Ala-
bama
Ebony 32:106 (4) Jl '77
--Sculpture (Missouri)

Ebony 33:150 (2) My '78
CASCADE RANGE, NORTHWEST
Trav/Holiday 154:93 (c, 1) Jl
'80
Life 3:70-9 (c, 1) S '80
Nat Wildlife 19:58-60 (c, 1) D '80
--See also CRATER LAKE; MOUNT
HOOD; MOUNT RAINIER;
MOUNT ST. HELENS; MOUNT
SHASTA
CASSATT, MARY
--Helene de Septenie
Smithsonian 8:134 (painting, 4)
F '78
--Maternal Caress
Smithsonian 11:174 (painting, c, 4)
My '80
--Summertime (1894)
Smithsonian 11:150-1 (painting, c, 1)
O '80
CASSOWARY BIRDS
Smithsonian 11:92-9 (c, 1) Mr '81
CASTLES
Travel 147:54 (drawing, 4) Mr '77
--1880's ice castles (St. Paul,
Minnesota)
Am Heritage 30:60-4 (litho-
graph, c, 1) D '78
--Aggstein, Austria
Trav/Holiday 154:40 (3) Jl '80
--Almansa, Spain
Nat Geog 153:299 (c, 2) Mr '78
--Ashford, Ireland
Sports Illus 48:36-7 (drawing, 1)
F 27 '78
--Balmoral, Scotland
Life 4:50-1 (c, 4) Jl '81
--Barbados
Trav/Holiday 152:50 (c, 4) Ag '79
--Beynac, Bordeaux, France
Nat Geog 158:234-5 (c, 1) Ag '80
--Blair, Scotland
Trav/Holiday 152:42 (c, 4) S '79
--Bluebeard's, St. Thomas, Virgin
Islands
Trav/Holiday 153:69 (c, 4) Ap '80
--Bodrum, Turkey
Nat Geog 152:92-3 (c, 1) Jl '77
--Boldt, Thousand Islands, New
York
Trav/Holiday 150:50-1 (3) N '78
--Casa Loma, Toronto, Ontario
Trav/Holiday 153:32 (4) F '80
--Cawdor, Scotland
Trav/Holiday 152:41 (c, 1) S '79
--Fussen, West Germany
Trav/Holiday 151:52 (c, 3) Je '79
--Gillette, Hadlyme, Connecticut

Trav/Holiday 150:36 (4) Ag '78
--Hearst, California
Trav/Holiday 155:70 (c, 2) F
'80
--Ireland
Nat Geog 159:438-9 (c, 2) Ap
'81
--King John's, Limerick, Ireland
Nat Geog 154:676-7 (c, 1) N
'78
--Linderhof, West Germany
Trav/Holiday 153:64 (c, 4) Mr
'80
--Lyndhurst, Tarrytown, New
York
Trav/Holiday 150:51 (4) N '78
--Moselle River Valley, West
Germany
Travel 147:47 (c, 1) My '77
--Neuschwanstein, West Germany
Nat Geog 152:174-5 (c, 1) Ag
'77
--Palacio da Pena, Sintra, Portu-
gal
Nat Geog 158:828 (c, 4) D '80
Porclada, Gerona, Spain
Trav/Holiday 150:10 (4) D '78
--St. Andrews, Scotland
Sports Illus 49:48-9 (c, 2) Jl
10 '78
--Spain
Trav/Holiday 154:66-70 (map, c, 2)
S '80
--Vezelay, France
Nat Geog 153:813 (c, 1) Je '78
--Warwick, England
Smithsonian 0:52 (c, 3) Ag '78
--See also CHATEAUS; WINDSOR
CASTLE
CASTRO, FIDEL
Nat Geog 151:68-9 (c, 1) Ja '77
Am Heritage 28:7 (4) O '77
Am Heritage 29:26-33 (c, 1) O
'78
CATERPILLARS
Natur Hist 86:42 (c, 1) Je '77
Smithsonian 8:cov., 85 (c, 1)
N '77
Nat Geog 157:142 (c, 4) Ja '80
Natur Hist 89:42-51 (c, 1) Je
'80
Smithsonian 11:51 (c, 4) Je '80
--Gypsy moth
Nat Geog 157:149 (drawing, c, 4)
F '80
Life 4:112-13 (c, 1) Ag '81
--See also BUTTERFLIES;
COCOONS; MEASURING

WORMS; MOTHS
Cathedrals. See CHURCHES
Catholic church. See CHRISTIAN-
ITY
CATS
Ebony 32:51 (4) My '77
Ebony 32:119-20 (4) Jl '77
Sports Illus 47:36 (c, 3) N 21 '77
Smithsonian 9:116 (c, 3) N '78
Nat Geog 154:777 (c, 4) D '78
Life 2:101 (c, 2) Ag '79
Sports Illus 53:47 (2) S 22 '80
Ebony 36:90 (3) Jl '81
--7th cent. B. C. Egyptian statue
Smithsonian 8:55 (c, 4) S '77
--Angora Persian
Ebony 32:119 (4) Jl '77
--Feeding cats
Life 3:134 (2) N '80
--Persian
Life 2:120 (c, 2) Ap '79
--Rare breeds
Life 3:95-102 (c, 1) D '80
--U.S. folk paintings
Life 3:cov., 117 (c, 1) Je '80
--See also BOBCATS; CHEETAHS;
JAGUARS; LEOPARDS; LIONS;
LYNXES; MOUNTAIN LIONS;
OCELOTS; PANTHERS; TIGERS
CAT'S-EYES (GEMS)
Smithsonian 11:70 (c, 4) Je '80
CATTAILS
Natur Hist 87:66 (c, 4) Ag '78
CATTLE
Nat Geog 151:348 (c, 3) Mr '77
Nat Geog 151:746-7 (c, 1) Je '77
Nat Geog 153:567 (c, 4) Ap '78
Nat Geog 153:626-7 (c, 1) My '78
Am Heritage 30:7 (drawing, c, 4)
Je '79
Nat Geog 159:166-7 (c, 1) F '81
Trav/Holiday 155:68 (c, 2) Mr
'81
Life 4:52-3 (c, 1) Jl '81
Smithsonian 12:62 (painting, c, 2)
N '81
--Chillingham white calves
Nat Geog 156:466 (c, 1) O '79
--Cow sculpted from butter (Iowa)
Life 3:132 (c, 2) O '80
--Diagram of parts
Travel 147:12 (4) Ja '77
--Diseased from PBB (Michigan)
Nat Geog 155:810 (c, 4) Je '79
--Drinking water
Nat Wildlife 17:8 (c, 2) Ag '79
--Dying of thirst (Australia)
Nat Geog 153:607 (c, 2) My '78

--India's "Sacred Cow"
 Nat Geog 151:238-9 (c, 1) F '77
--Inhumane treatment
 Smithsonian 11:53-5 (c, 3) Ap
 '80
--Texas longhorn
 Nat Geog 154:513 (c, 4) O '78
--See also BRAHMANS; DAIRYING;
 RANCHING
CATTLE BRANDING
--Chart of Sandhill, Nebraska
 brands
 Nat Geog 154:498 (c, 3) O '78
--Utah
 Nat Geog 158:785 (c, 3) D '80
CATTON, BRUCE
 Am Heritage 30:44, 48-54 (c, 2)
 F '79
CAVE DRAWINGS
--Horse (France)
 Smithsonian 9:66 (c, 3) My '78
CAVE EXPLORATION
--Alabama spelunker
 Nat Wildlife 16:28 (c, 4) Ap '78
CAVE PAINTINGS
--Lascaux cave, France
 Natur Hist 87:94-5 (c, 1) My
 '78
 Natur Hist 87:110-13 (1) O '78
--Mayan (Guatemala)
 Nat Geog 160:220-35 (c, 1) Ag
 '81
--Prehistoric Altamira, Spain
 Natur Hist 87:95 (c, 4) My '78
CAVEMEN
--Brazil
 Nat Geog 155:60-83 (c, 1) Ja '79
CAVES
--Blanchard Springs Cavern,
 Arkansas
 Nat Geog 153:422 (c, 1) Mr '78
--Cappadocia, Turkey
 Trav/Holiday 149:53-7 (c, 1) Ap
 '78
--Devils Island, Wisconsin
 Trav/Holiday 153:33 (c, 4) Je
 '80
--Fern Grotto, Kauai, Hawaii
 Nat Geog 152:606-7 (c, 1) N '77
 Trav/Holiday 156:22 (4) S '81
--Guatemala
 Nat Geog 160:223 (c, 1) Ag '81
--Nevada
 Smithsonian 11:122 (c, 4) F '81
--Northwest Territories
 Nat Geog 160:416-17 (c, 2) S
 '81
--Reed Flute, Guilin, China

 Nat Geog 156:556-7 (c, 1) O '79
--Site of Dead Sea Scrolls, Israel
 Nat Geog 153:240-1 (c, 1) F '78
--See also LURAY CAVERNS
CAVIAR INDUSTRY
--Alaska
 Nat Geog 155:252-3 (c, 2) F '79
CEBU, PHILIPPINES
 Nat Geog 151:386-7 (c, 2) Mr '77
CEDAR TREES
 Nat Geog 154:479 (c, 2) O '78
 Smithsonian 12:93 (c, 3) My '81
CELLO PLAYING
 Smithsonian 8:107 (c, 4) Mr '78
 Smithsonian 11:84-5 (c, 2) F '81
CELLS
--Covered with antibody
 Natur Hist 87:96 (4) Mr '78
--Macrophage lung cleaner cells
 Life 4:130-1 (1) My '81
--Nerve
 Nat Geog 153:373 (1) Mr '78
 Natur Hist 89:10, 18 (diagram, c, 3)
 Ja '80
--Plants
 Natur Hist 87:cov., 74-8 (c, 1)
 Je '78
--White blood cells
 Life 3:52 (3) My '80
CELTIC CIVILIZATION
 Nat Geog 151:582-633 (map, c, 1)
 My '77
CELTIC CIVILIZATION--RELICS
 Nat Geog 151:582-631 (c, 1) My
 '77
--6th cent. B. C. tombs (Germany)
 Nat Geog 157:428-38 (c, 1) Mr
 '80
CEMETERIES
 Natur Hist 86:39 (c, 1) Je '77
--19th cent. Northeast
 Am Heritage 30:2, 42-55 (c, 1)
 Ag '79
--19th cent. Virginia
 Smithsonian 12:136 (c, 4) Ap '81
--Acoma Indians (New Mexico)
 Trav/Holiday 152:29 (c, 4) D '79
--Ancient Bahrain
 Nat Geog 154:816-17 (c, 2) D '78
 Nat Geog 156:324-5 (c, 1) S '79
--Argentina
 Life 4:38-9 (c, 1) S '81
--Chapels (Germany)
 Smithsonian 8:85 (c, 4) F '78
--Civil War (Georgia)
 Nat Geog 159:777 (c, 4) Je '81
--Concord, Massachusetts
 Nat Geog 159:382-3 (c, 2) Mr '81

--Corpses of 14th cent. Indian
massacre (South Dakota)
Smithsonian 11:100-3, 106 (c, 1)
S '80
--Corroded statuary (Kentucky)
Nat Geog 158:160 (c, 3) Ag '80
--Crypts (Sardinia, Italy)
Trav/Holiday 150:47 (c, 2) D
'78
--Flanders Fields, Belgium
Nat Geog 155:337 (c, 1) Mr '79
--Greenwood, Brooklyn, New
York (1852)
Am Heritage 30:42-3 (paint-
ing, c, 1) Ag '79
--Hungary
Life 4:41 (c, 1) Ag '81
--Iceland
Nat Geog 151:692-3 (c, 1) My
'77
--Indiana
Life 4:108 (2) O '81
--Malaysia
Trav/Holiday 151:37 (c, 2) Mr
'79
--Marquesas Islands, Pacific
Trav/Holiday 155:56 (c, 1) Mr
'81
--Muslim (China)
Nat Geog 159:184-5 (c, 1) F '81
--Northern Ireland
Life 4:42-3 (c, 1) O '81
--Old Jewish, Prague, Czecho-
slovakia
Nat Geog 155:563 (c, 2) Ap '79
--Oman
Nat Geog 160:348-9 (c, 1) S '81
--Pere-Lachaise, Paris, France
Smithsonian 9:cov., 108-17
(c, 1) N '78
--Woodlawn, Bronx, New York
Am Heritage 30:47, 49 (1) Ag
'79
--See also ARLINGTON NATIONAL
CEMETERY; TOMBS; TOMB-
STONES
CENSUS
--Taking of Census through U.S.
history
Am Heritage 31:6-17 (c, 1) D
'79
CENSUS--HUMOR
--Taking the U.S. Census
Smithsonian 10:92-100 (draw-
ing, c, 1) Mr '80
CENTRAL AMERICA--MAPS
Trav/Holiday 156:51 (3) Ag '81
CENTRAL INTELLIGENCE

AGENCY
--History
Am Heritage 28:4-12 (c, 2) F '77
CENTURY PLANTS
Trav/Holiday 153:26 (4) Ja '80
Ceremonies. See FUNERAL RITES
AND CEREMONIES; MAR-
RIAGE RITES AND CUSTOMS;
RELIGIOUS RITES AND
FESTIVALS; and individual
religions
Ceylon. See SRI LANKA.
CEZANNE, PAUL
--In the Park of the Chateau Noir
Smithsonian 11:61 (painting, c, 4)
Je '80
--Madame Cezanne
Life 2:34 (painting, c, 4) Mr '79
--Self-portrait
Smithsonian 10:8 (painting, c, 4)
Jl '79
CHAINS
--17th cent. gold (Spain)
Nat Geog 152:736 (c, 1) D '77
CHAIRS
--17th cent. Brewster chair
Am Heritage 31:18 (c, 4) Ap '80
--Constructing (Maine)
Nat Geog 151:732 (c, 1) Je '77
--Designed by Charles Eames
Life 2:86 (c, 2) S '79
--Designed by Frank Lloyd Wright
Smithsonian 12:26 (c, 4) My '81
--Marie Antoinette chairs (Norfolk,
Virginia)
Travel 147:34-5 (4) Ap '77
--Wooden (Ozark Mountains)
Am Heritage 29:109 (c, 1) D '77
--See also THRONES
CHAMELEONS
Smithsonian 8:104 (c, 2) S '77
Natur Hist 88:63 (c, 1) Ag '79
Nat Wildlife 19:20 (4) D '80
CHANDELIERS
--New York Senate Chamber (Albany)
Smithsonian 12:153 (c, 1) N '81
CHANDLER, ZACHARIAH
Am Heritage 32:75 (drawing, 4)
D '80
CHAPLIN, CHARLES
Smithsonian 8:126 (4) D '77
Am Heritage 31:77 (3) Ap '80
--Dressed as "The Tramp"
Life 2:150 (4) D '79
CHARACTER SYMBOLS
--Big Bird (Sesame Street)
Sports Illus 46:cov. (c, 1) Je 6
'77

Smithsonian 10:138 (c, 4) Je
'79
--Donald Duck
Nat Geog 158:330-1 (c, 1) S
'80
--Marlboro Man
Sports Illus 46:58-62 (c, 1) Ja
17 '77
--Victor's Nipper
Smithsonian 9:114 (painting, c, 4)
My '78
--See also COMIC STRIPS;
DRACULA; MICKEY MOUSE;
SUPERMAN; TARZAN
CHARIOTS
--3rd cent. Rome
Nat Geog 159:721 (c, 1) Je '81
--Celtic
Nat Geog 151:586-7, 607-11
(painting, c, 1) My '77
CHARLESTON, SOUTH CAROLINA
Trav/Holiday 149:cov., 26-31,
92 (c, 1) Ap '78
Ebony 36:90-5 (2) My '81
--The Citadel
Trav/Holiday 150:31 (4) O '78
--Market Square (1872)
Am Heritage 28:106 (painting, c, 3)
F '77
CHARLOTTE, NORTH CAROLINA
Travel 147:53 (c, 2) My '77
Nat Geog 157:332-3 (c, 1) Mr
'80
CHARLOTTESVILLE, VIRGINIA
--Remnants of Jefferson's time
Am Heritage 33:110 (4) D '81
--See also JEFFERSON, THOMAS
CHATEAUBRIAND, FRANÇOIS
RENE DE
Smithsonian 9:153 (painting, 4)
S '78
CHATEAUS
--Bordeaux, France
Nat Geog 158:232 (c, 1) Ag '80
--Chateau de Beloeil, Belgium
Nat Geog 155:334 (c, 3) Mr '79
--Chateau de Commarin, France
Trav/Holiday 149:37 (c, 1) Ap
'78
--Chateau de Goulaine, Loire
Valley, France
Trav/Holiday 151:48-50 (c, 2)
F '79
--Chateau de la Clayette, Bur-
gundy, France
Nat Geog 153:799 (c, 3) Je '78
--Talleyrand's Chateau de Valen-
cay, France

Smithsonian 12:76-7 (c, 1) N '81
CHATS (BIRDS)
Sports Illus 52:66 (c, 4) Je 16
'80
CHAUDIERE RIVER, QUEBEC
--Chaudiere Falls (1787)
Am Heritage 29:98-9 (painting, c, 2)
Je '78
CHECKS, BANKING
--1927 illustrated check
Nat Geog 153:824 (c, 4) Je '78
CHEERLEADERS
Sports Illus 47:cov. (c, 1) N 28
'77
Sports Illus 52:28 (c, 4) Mr 13
'80
Sports Illus 55:68 (c, 4) S 7 '81
--Auditioning
Sports Illus 48:18-19 (c, 3) My
22 '78
--College football
Sports Illus 51:35 (c, 4) N 26
'79
--Football half-time show
Sports Illus 54:31-4 (c, 2) Mr
16 '81
--Football team (Texas)
Nat Geog 157:477 (c, 4) Ap '80
--Kansas high school
Life 2:94-5 (1) Je '79
--North Carolina
Nat Geog 157:353 (c, 1) Mr '80
--Pro football
Ebony 37:124-8 (c, 3) D '81
--West Point, New York
Life 3:79 (c, 4) My '80
--See also BATON TWIRLING
CHEERLEADERS--HUMOR
Sports Illus 49:110 (drawing, c, 4)
D 4 '78
CHEESE INDUSTRY
--Straining milk (Poland)
Nat Geog 159:107 (c, 1) Ja '81
CHEESES
Ebony 32:114-16 (c, 2) F '77
--Gouda
Trav/Holiday 153:46 (c, 2) F '80
CHEETAHS
Smithsonian 8:44 (c, 4) Mr '78
Nat Geog 157:cov., 712-27 (c, 1)
My '80
Trav/Holiday 154:38-9 (c, 1) N
'80
Nat Wildlife 20:58-9 (c, 1) D '81
CHEFS
Ebony 32:113 (3) F '77
Travel 147:84 (4) My '77
Life 2:54-8 (c, 1) My '79

Trav/Holiday 156:8-14 (c, 3) S
 '81
Life 4:154-60 (c, 1) N '81
--1780's map
 Ebony 33:64 (2) N '77
--Late 19th cent. Oak Park
 Am Heritage 30:12 (4) F '79
--1910
 Am Heritage 30:4-5 (1) F '79
--Boarded up storefronts (Wood-
 lawn)
 Ebony 33:86 (3) Ag '78
--Commuter train
 Ebony 37:67 (2) N '81
--Edgewater Hospital
 Ebony 33:58 (3) Je '78
--The Glessner House
 Trav/Holiday 154:36, 40 (4) S
 '80
--Items relating to the early his-
 tory of Chicago
 Ebony 33:64-72 (2) N '77
--Museum exhibits
 Trav/Holiday 153:12, 84 (2)
 Ap '80
--Slum
 Ebony 33:73 (2) S '78
--James Woodworth Prairie Pre-
 serve
 Nat Geog 157:44-5 (c, 1) Ja '80
--See also SEARS TOWER
CHICKADEES
 Nat Wildlife 16:42 (painting, c, 4)
 D '77
 Nat Wildlife 16:9 (c, 4) Ag '78
 Nat Wildlife 19:cov., 56 (paint-
 ing, c, 1) D '80
 Nat Wildlife 20:57 (c, 2) D '81
CHICKENS
 Nat Geog 156:265 (c, 1) Ag '79
 Natur Hist 90:50 (c, 1) Ja '81
--Chicken farm (Alabama)
 Sports Illus 55:50 (c, 4) Ag 3
 '81
--Chicks
 Nat Geog 151:756 (c, 1) Je '77
 Life 2:120 (2) F '79
 Smithsonian 11:51 (c, 4) Mr
 '81
--Inhumane treatment
 Smithsonian 11:50-1, 57 (c, 1)
 Ap '80
--Rare prizewinning fowl
 Life 4:75-80 (c, 1) My '81
--See also ROOSTERS
CHIHUAHUAS
 Nat Geog 156:140 (c, 1) Jl '79
CHILDBIRTH

Smithsonian 11:62 (2) F '81
--Birth of horse
 Life 2:93 (c, 3) O '79
--Liberia
 Ebony 32:80 (4) Ap '77
--See also PREGNANCY
CHILDREN
 Smithsonian 8:108 (c, 3) D '77
--1850's street urchins
 Smithsonian 11:34 (painting, 4)
 D '80
--Asleep with teddy bear
 Ebony 36:102 (4) Mr '81
--Fore tribe (Papua, New Guinea)
 Smithsonian 8:106-15 (c, 1) My
 '77
--Playing (1872)
 Am Heritage 32:28-31 (paint-
 ing, c, 2) Ag '81
--Playing (Alabama)
 Nat Geog 151:498-9 (c, 2) Ap '77
--Playing (Harlem, New York)
 Nat Geog 151:178-9, 188-9 (c, 1)
 F '77
--Playing (Siberia, U.S.S.R.)
 Trav/Holiday 149:26 (c, 2) My
 '78
--Playing (Sumatra, Indonesia)
 Nat Geog 159:412, 422-3 (c, 1)
 Mr '81
--Playing (Ust-Ilimsk, U.S.S.R.)
 Smithsonian 8:47 (c, 1) F '78
--Playing in museum (Boston,
 Massachusetts)
 Smithsonian 12:158-67 (c, 1) O
 '81
--Playing in playground (Idaho)
 Smithsonian 12:75 (c, 4) S '81
--See also BABIES; DAY CARE
 CENTERS; FAIRY TALES;
 FAMILY LIFE; PLAY-
 GROUNDS; TOYS; YOUTH
CHILDREN--COSTUME
--1860's (Great Britain)
 Smithsonian 8:53-7 (3) D '77
--Late 19th cent. Mississippi
 Am Heritage 29:33 (4) Je '78
--Early 20th cent.
 Am Heritage 28:73 (4) O '77
--Early 20th cent. (Pittsburgh,
 Pennsylvania)
 Am Heritage 30:8 (4) F '79
--1924
 Am Heritage 30:56 (4) F '79
--1940's (Germany)
 Smithsonian 8:100, 106 (4) F '78
--1940 (New Mexico)
 Am Heritage 31:78-9 (c, 1) F '80

--Colombia
 Natur Hist 90:42-8 (c, 1) Ap '81
--Great Britain
 Sports Illus 52:40-1 (c, 2) Je
 23 '80
--Hutterite community (Canada)
 Natur Hist 90:cov. , 34-47 (c, 1)
 F '81
--Lapps (Norway)
 Nat Geog 152:374-5 (c, 2) S '77
--Mennonites (Ontario)
 Nat Geog 154:774-5 (c, 1) D '78
--Namibia uniforms
 Nat Geog 159:268-9 (c, 1) F '81
--North Yemen
 Nat Geog 156:269 (c, 1) Ag '79
--School outfits (Australia)
 Life 4:98 (c, 2) N '81
--School outfits (Bahrain)
 Trav/Holiday 151:79 (c, 4) My
 '79
--School outfits (Japan)
 Smithsonian 12:129 (c, 1) D '81
--School outfits (Saudi Arabia)
 Nat Geog 158:326 (c, 2) S '80
--School outfits (South Korea)
 Nat Geog 156:782-3 (c, 2) D
 '79
 Trav/Holiday 156:42 (c, 4) S
 '81
--School outfits (Australia)
 Nat Geog 155:210 (c, 1) F '79
--Turkey
 Nat Geog 152:89 (c, 1) Jl '77
CHILE
--Sites of observatories
 Smithsonian 0:40-9 (c, 1) Ap
 '77
--See also ANDES MOUNTAINS
CHIMNEY SWEEPS
 Smithsonian 8:23 (4) Ja '78
--Oregon
 Nat Geog 156:818-19 (c, 1) D
 '79
CHIMNEYS
--Power plant smokestacks
 Natur Hist 90:62 (c, 3) F '81
CHIMPANZEES
 Nat Geog 155:592-621 (c, 1)
 My '79
 Natur Hist 89:32-9 (c, 1) S '80
 Smithsonian 12:cov. , 90-101
 (c, 1) Ap '81
 Natur Hist 90:74 (4) D '81
--Trained chimps
 Ebony 32:104 (4) O '77
--Working with communication

keyboard
 Smithsonian 10:91 (c, 4) Ap '79
CHINA
 Trav/Holiday 150:cov. , 34-8,
 77-82 (c, 1) N '78
 Trav/Holiday 152:32-5, 103 (c, 2)
 O '79
 Life 3:104-13 (c, 1) O '80
--Bridge over Sichuan River
 Life 4:88-9 (c, 1) O '81
--Coastal cities
 Trav/Holiday 156:35-9 (map, c, 2)
 Jl '81
--Guilin area
 Nat Geog 156:536-63 (map, c, 1)
 O '79
--Kunming, Yunnan
 Nat Geog 159:792-813 (map, c, 1)
 Je '81
--Northern region
 Nat Geog 157:292-331 (map, c, 1)
 Mr '80
--Sui River
 Nat Geog 158:506-7 (c, 1) O '80
 Western mountain area
 Nat Geog 159:174-99 (map, c, 1)
 F '81
--See also GREAT WALL OF
 CHINA; LANCHOU; PEKING;
 SHANGHAI
CHINA--ARCHITECTURE
--Chinese garden structures (New
 York)
 Smithsonian 12:66-72 (c, 2) Jl
 '81
CHINA ART
 Natur Hist 89:65-7 (c, 1) S '80
--14th cent. ceramics
 Nat Geog 156:230-43 (c, 1) Ag
 '79
--17th cent. Ming porcelain
 Nat Geog 154:562-75 (c, 1) O '78
--Constructing Chinese garden (New
 York City)
 Life 3:88 (c, 3) Ag '80
--Silk paintings of Tunhuang
 Smithsonian 8:94-103 (c, 2) My
 '77
CHINA--COSTUME
 Smithsonian 8:116-20 (c, 2) Ap
 '77
 Trav/Holiday 150:34-8, 77-82
 (c, 1) N '78
 Life 3:cov. , 104-15 (c, 1) O '80
 Sports Illus 53:42-7 (c, 2) N 17
 '80
 Trav/Holiday 156:34-9 (c, 2) Jl '81

--Early 1900's
 Smithsonian 8:98 (4) My '77
--1916
 Smithsonian 8:116 (4) Ap '77
--Commune workers
 Natur Hist 89:84 (3) S '80
--Guilin region
 Nat Geog 156:536-63 (c, 1) O
 '79
--Northern region
 Nat Geog 157:cov., 292-331
 (c, 1) Mr '80
--Refugees in Hong Kong
 Nat Geog 156:706-31 (c, 1) N
 '79
--Shanghai
 Nat Geog 158:2-41 (c, 1) Jl '80
--Western mountain area
 Nat Geog 159:177-91 (c, 1) F
 '81
--Yunnan province
 Nat Geog 159:792-813 (c, 1) Je
 '81
CHINA--HISTORY
--14th cent. horseback riding
 Smithsonian 10:138 (painting, c, 4)
 O '79
--Naval activities (12th-18th cents.)
 Natur Hist 86:48-63 (c, 1) D
 '77
--See also CHIANG KAI-SHEK;
 KUBLAI KHAN; MAO TSE-
 TUNG
CHINA--SOCIAL LIFE AND CUS-
 TOMS
--Initiation into Young Pioneers
 Nat Geog 156:550-1 (c, 1) O '79
CHINA, ANCIENT
--3rd cent. B.C.
 Nat Geog 153:cov., 441-59
 (map, c, 1) Ap '78
--Tunhuang caves
 Smithsonian 8:102 (4) My '77
CHINA, ANCIENT--COSTUME
--2nd cent. B.C. emperor
 Smithsonian 10:40 (drawing, 4)
 N '79
CHINA, ANCIENT--SCULPTURE
--11th cent. B.C. bronze ele-
 phant
 Smithsonian 9:111 (c, 4) Je '78
--2nd cent. B.C. clay mausoleum
 guards
 Smithsonian 10:cov., 38-51
 (c, 1) N '79
--Bronze Age art works
 Smithsonian 11:cov., 62-71 (c, 1)
 Ap '80

--Buddha sculptures (Yun-king)
 Smithsonian 10:54-63 (c, 1) Ap '79
--Terra cotta figures guarding tomb
 (Shensi Province)
 Life 2:73-6 (c, 2) Ag '79
CHINA SEA
--South
 Nat Geog 151:648-9 (c, 1) My '77
CHINATOWN, BOSTON, MASSA-
 CHUSETTS
 Trav/Holiday 150:59 (c, 4) O '78
CHINATOWN, MALAYSIA
--Kuala Lumpur, Malaysia
 Nat Geog 151:642-3 (c, 1) My '77
CHINATOWN, SAN FRANCISCO,
 CALIFORNIA
 Ebony 34:40 (c, 4) My '79
 Trav/Holiday 152:58 (c, 4) Jl '79
--1900
 Am Heritage 30:cov., 36-46, 114
 (1) D '78
CHINATOWN, SINGAPORE
 Trav/Holiday 148:31 (2) D '77
CHINAWARE
--14th cent. Chinese celadons
 Nat Geog 156:436-9 (c, 1) Ag
 '79
--18th cent. Sèvres bowl (France)
 Smithsonian 8:74 (c, 4) N '77
--19th cent. oyster plates
 Am Heritage 31:69 (c, 4) F '80
CHIPMUNKS
 Nat Wildlife 18:48 (c, 1) Je '80
 Nat Wildlife 18:50 (c, 1) O '80
CHIPPEWA INDIANS (MIDWEST)--
 COSTUME
--1825 chief
 Am Heritage 29:55 (drawing, c, 4)
 Ag '78
--1897
 Natur Hist 89:75 (1) O '80
CHOIRS
--Alabama
 Ebony 32:103 (4) Jl '77
--Estonia
 Nat Geog 157:510-11 (c, 1) Ap
 '80
--Illinois
 Ebony 35:70-2 (2) D '79
--Mississippi
 Ebony 35:34, 36 (3) N '79
--New York
 Ebony 35:82 (3) Ag '80
--Virginia
 Ebony 35:156 (4) My '80
CHOPIN, FREDERIC
--Bust of head (Poland)
 Travel 147:47 (c, 1) Je '77

--Home (Zelazowa Wola, Poland)
 Travel 147:47 (c, 2) Je '77
--Tomb (Paris, France)
 Smithsonian 9:111 (c, 4) N '78
Christian Science. See EDDY,
 MARY BAKER
Christianity. See ANGELS;
 CRUCIFIXES; GREEK ORTHO-
 DOX CHURCH; HELL; JESUS
 CHRIST; MENNONITES;
 MONASTERIES; POPES;
 SAINTS; SANTA CLAUS
CHRISTIANITY--ART
--Early statues (Ireland)
 Nat Geog 159:437 (c, 2) Ap '81
CHRISTIANITY--COSTUME
--14th cent. bishop (France)
 Smithsonian 8:130 (sculpture, 3)
 Mr '78
--Archbishop
 Ebony 33:88 (4) Ap '78
--Archbishop (Great Britain)
 Life 2:79 (2) N '79
 Life 4:174 (c, 3) D '81
--Archbishop (New Mexico)
 Nat Geog 157:794 (c, 4) Je '80
--Baptist pastor
 Ebony 33:98 (4) Ag '78
 Ebony 35:118, 122 (3) F '80
--Benedictine monks through his-
 tory
 Smithsonian 11:80-7 (c, 1) Je
 '80
--Bishop
 Ebony 34:76 (4) Ja '79
 Ebony 35:110-15 (c, 2) Mr '80
 Ebony 35:78-82 (4) O '80
--Cardinal
 Ebony 34:57 (3) O '79
--Church of Ireland bishop
 Nat Geog 154:668 (c, 1) N '78
--Episcopal bishop (Washington,
 D. C.)
 Nat Geog 157:563 (c, 3) Ap '80
--Evangelist preacher
 Life 3:94-100 (1) Je '80
--Female Episcopal priest
 Ebony 34:107-8 (2) S '79
--Female ministers
 Ebony 37:99-104 (3) N '81
--France
 Nat Geog 153:812 (c, 4) Je '78
--Ministers of African Methodist
 Episcopal Church
 Ebony 35:48 (4) Jl '80
--Nuns
 Ebony 34:142-6 (3) S '79
--Nuns (Hawaii)

 Nat Geog 160:188-9 (c, 1) Ag '81
--Nuns (Honduras)
 Trav/Holiday 155:44 (c, 4) Ja '81
--Nuns (India)
 Life 3:55-65 (1) Jl '80
--Nuns (Maryland)
 Ebony 36:98 (4) N '80
--Nuns (New Jersey)
 Nat Geog 160:596 (c, 3) N '81
--Nuns (Ontario)
 Nat Geog 154:794-5 (c, 1) D '78
--Patriarch of Armenian church
 (U. S. S. R.)
 Nat Geog 153:866 (c, 1) Je '78
--Priest
 Ebony 36:31 (c, 2) Je '81
--Priest (Ireland)
 Nat Geog 159:458-9 (c, 1) Ap '81
--Religious club's ceremony (Spain)
 Nat Geog 153:296 (c, 1) Mr '78
--Reverend
 Ebony 34:36 (3) F '79
--Trappist monastery (France)
 Nat Geog 154:548-51 (c, 1) O '78
--See also POPES
CHRISTIANITY--RITES AND FESTI-
 VALS
--Aiding ailing pilgrims (New
 Mexico)
 Nat Geog 154:432 (c, 4) S '78
--All Saints Day kite festival
 (Guatemala)
 Natur Hist 87:68-74 (c, 1) Mr '78
--Blessing fishermen (Mississippi)
 Ebony 35:112 (3) Mr '80
--Candle-lighting (Costa Rica)
 Nat Geog 100.51 (c, 1) Jl '81
--Carnival (Rio de Janeiro, Brazil)
 Nat Geog 153:246, 254-5 (c, 1)
 F '78
--Confession (China)
 Nat Geog 157:331 (c, 4) Mr '80
--Confession (Sri Lanka)
 Nat Geog 155:146 (c, 3) Ja '79
--Crucifixion (1888; New Mexico)
 Am Heritage 30:63 (3) Ap '79
--Day of Candles (Mexico)
 Nat Geog 158:734-5 (c, 1) D '80
--Evangelist revival meeting (North
 Carolina)
 Nat Geog 157:351 (c, 2) Mr '80
--Good Friday celebration (Calanda,
 Spain)
 Natur Hist 86:58-63 (c, 1) Ap '77
--Holy Week (Sevilla, Spain)
 Natur Hist 87:44-55 (c, 1) Ap '78
--Ordaining Episcopal priest
 Ebony 34:108 (4) S '79

Smithsonian 10:68-9 (c, 2) Ag
'79
--Lunch hour sermon (19th cent. ;
Connecticut)
Am Heritage 31:32-3 (1) F '80
--Mass (Chicago, Illinois)
Ebony 36:33-4 (2) Je '81
--Mass (Northern Ireland)
Nat Geog 159:491 (c, 4) Ap '81
--Memphis, Tennessee
Ebony 33:84-8 (3) Mr '78
--New York City, New York
Ebony 33:70 (3) F '78
Life 3:74 (c, 4) Ag '80
--Shakers (Maine)
Nat Geog 151:744 (c, 1) Je '77
--Shanghai, China
Nat Geog 158:8-9 (c, 1) Jl '80
--Spiritualist camp (New York)
Nat Geog 151:712-13 (c, 2) My
'77
--Washington Cathedral, D. C.
Nat Geog 157:553 (c, 1) Ap '80
--See also BAPTISMS; COM-
MUNION
CHURCHES
Am Heritage 28:5-7 (c, 4) Ag
'77
Ebony 36:34 (4) F '81
--18th cent. missions (San An-
tonio, Texas)
Am Heritage 30:50-3 (paint-
ing, c, 3) O '79
--Alexander Nevski, Sofia, Bul-
garia
Nat Geog 158:100-1 (c, 1) Jl
'80
--Anderson, Indiana
Life 3:32 (c, 4) Ag '80
--Antigua, Guatemala
Travel 148:36 (2) S '77
--Assumption, Kremlin, Moscow,
U. S. S. R.
Nat Geog 153:28-9 (c, 1) Ja
'78
--Basilica of Haghia Irene, Istan-
bul, Turkey
Trav/Holiday 151:104-5 (4) My
'79
--Beecher Bible & Rifle, Wabaun-
see, Kansas
Nat Geog 157:53 (c, 1) Ja '80
--Birmingham, Alabama
Ebony 35:35 (4) F '80
--Byzantine (Turkey)
Nat Geog 152:108 (c, 4) Jl '77
--Canterbury Cathedral, England
Life 4:165-76 (c, 2) D '81

--Cape May, New Jersey
Smithsonian 9:128 (c, 4) S '78
--Cathedral of Mexico, Mexico
City, Mexico
Trav/Holiday 154:32-3 (4) S '80
--Chartres Cathedral, France
Natur Hist 89:26 (4) Ja '80
Life 3:102-3 (c, 1) N '80
--Chartres stained glass, France
Smithsonian 10:78-9 (c, 2) Je '79
--Cholula, Mexico
Nat Geog 153:614-15 (c, 1) My
'78
--Christian Science, Berkeley,
California
Am Heritage 32:40-1 (c, 3) Ag
'81
--Columbus, Indiana
Nat Geog 154:384-5, 390-1 (c, 1)
S '78
--Concord, Massachusetts
Nat Geog 159:356-7, 383 (c, 1)
Mr '81
--Crystal Cathedral, Garden Grove,
California
Nat Geog 160:754-5 (c, 1) D '81
--Denmark
Nat Geog 156:827 (c, 1) D '79
--Detroit First Presbyterian,
Michigan
Am Heritage 32:59 (c, 4) O '81
--Drive-in (California)
Nat Geog 159:29 (c, 4) F '81SR
--Duomo, Milan, Italy
Travel 148:47-8 (c, 1) O '77
--First Baptist, Cambridge, Mas-
sachusetts
Smithsonian 11:112 (c, 4) Ja '81
--Fountains Abbey, Yorkshire,
Great Britain
Smithsonian 7:101 (c, 4) F '77
--Galway, Ireland
Nat Geog 159:464-5 (c, 1) Ap '81
--Gaspé Peninsula, Quebec
Nat Geog 157:588-9 (c, 1) My '80
--Gothic Cathedral, Barcelona,
Spain
Trav/Holiday 150:10 (4) D '78
--Greek Orthodox (Wroxton, Sas-
katchewan)
Nat Geog 155:661 (c, 1) My '79
--Halawa Valley, Molokai, Hawaii
Trav/Holiday 149:67 (4) Mr '78
--Hamtramck, Michigan
Nat Geog 155:828-9 (c, 1) Je '79
--Houston, Texas
Ebony 33:134 (4) Jl '78
--Interfaith chapel interior (Houston,

Texas)
Life 3:68-9 (c, 1) Ja '80
--Jerez de los Caballeros, Spain
Trav/Holiday 154:70 (c, 4) S
'80
--Kawaiahao, Honolulu (1860's)
Am Heritage 32:88 (3) O '81
--Khor Virap, Turkey
Nat Geog 153:848-9 (c, 1) Je
'78
--Lake Sevan, Armenia, U.S.S.R.
Nat Geog 153:864-5 (c, 1) Je
'78
--Lexington, Mississippi
Ebony 34:54 (2) F '79
--Lincoln Cathedral, England
Smithsonian 7:98 (c, 3) F '77
--Masi, Norway
Nat Geog 152:372 (c, 2) S '77
--Memorial, Berlin, West Germany
Trav/Holiday 156:60-1 (c, 2)
O '81
--Missions (California)
Trav/Holiday 149:33-7 (c, 1)
F '78
--Missions (San Antonio, Texas)
Trav/Holiday 152:66 (c, 4) N
'79
--Modern (Chicago, Illinois)
Ebony 33:90 (4) Jl '78
--Modern roles and services
Smithsonian 11:107-18 (c, 2)
Ja '81
--Molokai, Hawaii
Trav/Holiday 154:38 (c, 4) Ag
'80
--Mormon temple (1897; Salt
Lake City, Utah)
Am Heritage 28:74-5 (1) Je
'77
--Mormon temple, Washington,
D.C.
Am Heritage 28:83 (c, 4) Je
'77
--Mystic, Connecticut
Am Heritage 31:27 (2) F '80
--Negombo, Sri Lanka
Nat Geog 155:147 (c, 1) Ja '79
--Oaxaca, Mexico
Trav/Holiday 152:52 (c, 4) Jl
'79
--Ozark Mountains
Travel 148:42 (c, 4) Ag '77
--Peruvian altars and offerings
Nat Geog 160:304-5 (c, 2) S '81
--Pew of Harvard Chapel, Cambridge, Massachusetts

Sports Illus 53:51 (2) N 24 '80
--Plasencia Cathedral, Spain
Trav/Holiday 154:69 (c, 2) S '80
--Poland
Nat Geog 152:392-3 (c, 1) S '77
Nat Geog 159:120-1 (c, 1) Ja '81
--Porto, Portugal
Nat Geog 158:816-17 (c, 1) D '80
--Princeton University, New Jersey
Trav/Holiday 156:65 (c, 2) O '81
--Rapid City, South Dakota
Travel 147:30-1 (4) Je '77
--Round Top Church, Providence,
Rhode Island
Trav/Holiday 154:64 (c, 4) S '80
--Russian Orthodox (Alaska)
Smithsonian 8:48 (c, 4) D '77
--St. Andrews, Scotland
Sports Illus 49:48-9 (c, 2) Jl 10
'78
--St. Basil's, Moscow, U.S.S.R.
Nat Geog 153:22-3 (c, 1) Ja '78
Sports Illus 52:24 (c, 4) F 4
'80
--St. Foy, Conques, France
Smithsonian 11:116-25 (c, 1) O
'80
--St. George's Chapel, Windsor
Castle, England
Nat Geog 158:624-5 (c, 1) N '80
--St. John the Divine, New York
City, New York
Travel 148:40-1 (4) S '77
Life 2:100-4 (c, 1) N '79
--St. Patrick's, Toledo, Ohio
Am Heritage 32:30-1 (c, 4) D '80
--St. Paul's Cathedral, London,
England
Life 4:74 (c, 2) Jl '81
--St. Peter's, New York City, New
York
Smithsonian 11:108-10 (c, 4) Ja
'81
--San Giovanni Battista, Turin,
Italy
Nat Geog 157:733 (c, 4) Je '80
--San Marco, Venice, Italy
Trav/Holiday 151:cov., 38 (c, 1)
F '79
--San Miguel, Mexico
Trav/Holiday 152:71 (4) S '79
--San Miguel Mission (Santa Fe,
New Mexico)
Nat Geog 154:433 (c, 1) S '78
Trav/Holiday 154:16 (4) O '80
--Santo Domingo, Dominican Republic
Nat Geog 152:554 (c, 3) O '77

Trav/Holiday 154:63 (c, 1) O '80
--Scale model of St. Paul's Cathe-
dral (Prince Edward Island)
Trav/Holiday 151:54 (c, 4) My
'79
--Shipka Memorial, Bulgaria
Nat Geog 158:106-7 (c, 1) Jl
'80
--Sitka, Alaska
Travel 148:67 (4) Ag '77
--Sod (Iceland)
Trav/Holiday 155:52 (c, 4) Je
'81
--Swedish (Bishop Hill, Illinois)
Trav/Holiday 151:10 (4) Mr '79
--Trinity, Boston, Massachusetts
Trav/Holiday 150:60 (c, 4) O
'78
Am Heritage 32:52-3 (c, 1) O
'81
--Trinity, Newport, Rhode Island
Sports Illus 53:72-3 (c, 1) Ag
18 '80
--Vault of St. Jacques, Liege,
Belgium
Trav/Holiday 155:45 (c, 1) Mr
'81
--Venice, Italy
Smithsonian 8:49-53 (c, 3) N
'77
--Vermont
Smithsonian 10:129 (c, 3) N '79
--Victoria, Texas
Ebony 36:59 (4) Ag '81
--Warsaw, Poland
Smithsonian 9:106-17 (c, 1) S
'78
--Washington Cathedral, Wash-
ington, D.C.
Nat Geog 157:553-73 (c, 1) Ap
'80
--Wawel, Krakow, Poland
Trav/Holiday 155:65 (c, 1) Mr
'81
--Wedding chapel (Kauai, Hawaii)
Trav/Holiday 150:53 (c, 4) D
'78
--West Germany
Nat Geog 152:174-5 (c, 1) Ag
'77
--See also MONASTERIES;
MOSQUES; ST. MARK'S
CATHEDRAL; ST. PETER'S
CHURCH; TEMPLES
CHURCHILL, WINSTON
Am Heritage 28:11 (4) Ag '77
Am Heritage 31:113 (2) Ap '80
Am Heritage 31:40-5 (2) Je

'80
Am Heritage 32:113 (2) F '81
Am Heritage 32:9 (1) Ap '81
--Birthplace (Blenheim, Great
Britain)
Smithsonian 9:50-1 (c, 2) Ag '78
--Sketch by John Singer Sargent
Smithsonian 10:102-3 (3) O '79
Churchill Downs. See HORSE
RACING; RACE TRACKS
CICADAS (INSECTS)
Natur Hist 88:39-45, 94 (c, 1)
My '79
Am Heritage 30:12 (painting, c, 4)
Ag '79
Nat Wildlife 18:26-7 (c, 1) Ag
'80
Nat Geog 159:366 (c, 2) Mr '81
CIGAR MAKING
--19th cent. cigar labels depicting
U.S. history
Am Heritage 30:82-91 (paint-
ing, c, 1) D '78
--By hand (Florida)
Trav/Holiday 148:57 (c, 4) N '77
--Cuba
Nat Geog 151:53 (c, 4) Ja '77
--Dominican Republic
Nat Geog 152:564-5 (c, 1) O '77
CIGAR SMOKING
Nat Geog 151:68-9 (c, 1) Ja '77
Sports Illus 46:23 (c, 4) Ja 24
'77
Smithsonian 7:74 (4) Mr '77
Sports Illus 47:16 (c, 2) Ag 15
'77
Sports Illus 49:18 (c, 3) Jl 17
'78
Sports Illus 49:70-1 (c, 1) Ag
21 '78
Sports Illus 50:40 (c, 1) My 14
'79
Life 3:150 (c, 2) Je '80
Sports Illus 54:38 (c, 3) My 11
'81
--Hawaii
Nat Geog 152:590 (c, 4) N '77
CIGARETTE INDUSTRY
--Cigarette packages (1880-1940)
Am Heritage 32:97-100 (c, 4)
F '81
CIGARETTE SMOKING
Sports Illus 47:82 (c, 1) N 21
'77
Ebony 33:34 (2) Ja '78
Sports Illus 53:36-7 (c, 3) Jl 14
'80
Life 4:118 (2) N '81

--War against smoking (1880-
1980)
Am Heritage 32:94-107 (c, 1)
F '81
--Yukon
Nat Geog 153:559 (c, 4) Ap '78
CINCHONA TREES
--Harvesting bark
Smithsonian 9:99-101 (c, 4) Ag
'78
CINCINNATI, OHIO
Nat Geog 151:253, 258-9 (c, 1)
F '77
Smithsonian 9:70-1 (c, 3) Ja
'79
--1835 lithograph
Am Heritage 29:32 (c, 4) Ap
'78
--Mid 1800's
Am Heritage 29:33 (4) Ap '78
CINQUEFOIL PLANTS
Nat Wildlife 19:58-9 (c, 1) D
'80
Ciphers. See CODES AND
CIPHERS
CIRCUS ACTS
Life 4:114-20 (c, 1) Ap '81
--19th cent. oddities
Life 3:68 (4) Jl '80
--1860's giants
Am Heritage 30:106-7 (1) Ag
'79
--Tightrope walking (India)
Nat Geog 160:122-3 (c, 1) Jl
'81
CIRCUSES
--1904 parade of elephants (Idaho)
Am Heritage 32:34-5 (1) Ap
'81
--1919 performance in hospital
(New York)
Am Heritage 32:108-9 (1)
Ap '81
--Circus toys (1860's-1870's)
Am Heritage 32:18-19 (c, 1)
D '80
--Early ads disparaging com-
petitors
Am Heritage 30:34-7 (2) Ap
'79
--Miniature models of circuses
Ebony 32:90-2 (c, 2) Mr '77
--See also ACROBATIC STUNTS;
BARNUM, PHINEAS T. ;
CLOWNS; FIRE EATERS;
RINGLING BROTHERS
Cisterns. See RESERVOIRS
CITIES

--Early 20th cent. working class
city life
Am Heritage 30:7-12 (4) F '79
--Changes in a city over decades
Natur Hist 86:86 (painting, c, 4)
Je '77
CITIZEN BAND RADIOS
Ebony 35:76 (3) D '79
CITY HALLS
--Bigelow, Minnesota
Nat Geog 157:47 (c, 1) Ja '80
--Brussels, Belgium
Travel 148:29 (1) Ag '77
--Guildhall, Londonderry, Northern
Ireland
Nat Geog 159:484 (c, 1) Ap '81
--Munich, West Germany
Trav/Holiday 148:53 (c, 1) D '77
--Vienna, Austria
Trav/Holiday 151:47 (c, 4) Mr
'79
CIVETS
Natur Hist 86:cov. (c, 1) My '77
CIVIL RIGHTS
--1960's demonstrators attacked by
dogs
Ebony 34:157 (4) D '78
Ebony 35:34 (4) F '80
--1960 lunch counter sit-in (North
Carolina)
Ebony 35:110-11 (3) My '80
--1961 American Nazi pickets
(Washington, D. C.)
Sports Illus 51:77 (4) Jl 2 '79
--1977 occupation of church (Wilm-
ington, North Carolina)
Ebony 34:65-6 (3) Je '79
--Anti-busing demonstration (Boston,
Massachusetts)
Life 2:180 (4) D '79
--Demonstrators sprayed by fire
hose
Ebony 35:34 (4) F '80
--Doctor's segregated waiting rooms
Ebony 34:58 (4) F '79
--See also GARVEY, MARCUS;
KING, MARTIN LUTHER,
JR. ; KU KLUX KLAN; MAL-
COLM X
CIVIL RIGHTS MARCHES
--1960's
Ebony 34:39 (4) Jl '79
Ebony 34:128 (4) Ag '79
Ebony 35:28 (4) Ja '80
Ebony 36:177 (3) N '80
--1960's (Washington, D. C.)
Ebony 34:157 (2) D '78
Ebony 36:108 (4) N '80

Ebony 37:114 (4) N '81
--Alabama
Ebony 36:31 (3) S '81
CIVIL WAR
Am Heritage 32:42-55 (1) Je
'81
--1864 Shenandoah campaign
Am Heritage 31:48-63 (draw-
ing, 1) Ag '80
--1864-65 battle for Fort Fisher,
North Carolina
Am Heritage 31:70-9 (paint-
ing, c, 1) O '80
--1913 reunion of Gettysburg sur-
vivors
Am Heritage 29:2, 56-61 (1)
Je '78
--Andersonville Prison, Georgia
(1864)
Am Heritage 31:100-1 (2) Ap
'80
--Appomattox, Virginia sites
Trav/Holiday 150:32, 66 (c, 4)
Jl '78
--Artifacts of the Confederacy
(Montgomery, Alabama)
Travel 147:30-1 (4) Ja '77
--Black soldiers at Milliken's
Bend
Am Heritage 32:83 (drawing, 3)
D '80
--Blacks serving Confederacy
Smithsonian 9:95-101 (paint-
ing, c, 1) Mr '79
--Mathew Brady photographs
Smithsonian 8:cov., 24-35 (1)
Jl '77
--Color guard of Yankee infantry
Natur Hist 80:32 (4) Je '79
--Confederate memorial (Stone
Mountain, Georgia)
Trav/Holiday 153:79 (c, 1) My
'80
--Depicted on 19th cent. cigar
labels
Am Heritage 30:85 (painting, c, 3)
D '78
--Gunboat battle at Vicksburg
Am Heritage 29:62-4 (draw-
ing, c, 3) Ag '78
--Lincoln's cabinet
Smithsonian 8:60-1 (1) Ag '77
--Memorial (Benzonia, Michigan)
Am Heritage 30:51 (4) F '79
--Recreation of Civil War camps
(Virginia)
Trav/Holiday 150:30-5, 66-7
(c, 1) Jl '78

--Sharpshooter
Smithsonian 10:126 (drawing, 4)
Ja '80
--Sheridan's ride (1864)
Am Heritage 31:62-3 (drawing, 3)
Ag '80
--Sherman's march through Georgia
Am Heritage 30:4-10 (painting, c, 1)
D '78
--Stealing Confederate train "Gen-
eral" (1862)
Am Heritage 29:34-45 (paint-
ing, c, 2) D '77
--Union spies John Scobell and
Carrie Lawton
Ebony 33:73-81 (drawing, 2) O '78
--Use of camels
Natur Hist 89:70-4 (2) My '80
--See also BOYD, BELLE; DAVIS,
JEFFERSON; FARRAGUT,
DAVID GLASGOW; GRANT,
ULYSSES S.; HALLECK,
HENRY WAGER; JACKSON,
STONEWALL; LEE, ROBERT
E.; LINCOLN, ABRAHAM;
SEWARD, WILLIAM H.;
SHERMAN, WILLIAM;
SLAVERY--U. S.
CLAM DIGGING
--Maine
Nat Geog 151:750-1 (c, 3) Je '77
--Massachusetts
Travel 148:42-3 (c, 1) S '77
Nat Geog 155:590 (c, 3) Ap '79
Nat Wildlife 18:8 (c, 2) Ap '80
--Oregon
Trav/Holiday 154:34 (c, 2) Jl '80
--Scotland
Trav/Holiday 152:79 (4) S '79
--Virginia
Nat Geog 157:810-11 (c, 1) Je '80
CLAMS
Nat Geog 152:443-53 (c, 1) O '77
--Giant ocean clams
Nat Geog 156:696-7 (c, 1) N '79
--Reef
Nat Geog 159:660 (c, 3) My '81
CLARINET PLAYING
Smithsonian 8:78 (c, 4) Ag '77
Smithsonian 9:116 (4) Ap '78
CLASSROOMS
Ebony 32:34 (3) Ag '77
Ebony 32:147 (3) O '77
Sports Illus 53:44 (c, 4) O 27
'80
Life 4:82-3 (painting, c, 1) Mr '81
--1871 painting
Am Heritage 31:4-5 (painting, c, 1)

Ag '80
--Early 20th cent. Maine
 Am Heritage 31:100-1 (1) D '79
--Biology class (Illinois)
 Ebony 32:43-6 (2) Mr '77
--Chicago high school, Illinois
 Ebony 34:48 (4) D '78
--Church Bible lesson (Texas)
 Ebony 36:60 (2) Ag '81
--Cuba
 Nat Geog 151:49 (c, 3) Ja '77
--Elementary school (Atlanta,
 Georgia)
 Ebony 35:64 (2) F '80
--Hutterite community (Canada)
 Natur Hist 90:40-1 (c, 3) F '81
--Kindergarten class
 Life 3:8 (4) Ag '80
--Massachusetts
 Ebony 32:134 (4) Ap '77
--Michigan high school
 Life 4:123-7 (3) Mr '81
--Mobile trailer class (California)
 Nat Geog 157:797 (c, 3) Je '80
--Nigeria
 Nat Geog 155:442 (c, 1) Mr '79
--Northern Ireland
 Nat Geog 159:485 (c, 3) Ap '81
--One-room schoolhouse (Nebraska)
 Nat Geog 154:497 (c, 3) O '78
--Outdoor (Afghanistan)
 Natur Hist 89:74 (c, 1) Jl '80
--Outdoor (Zimbabwe)
 Nat Geog 160:628 (c, 2) N '81
--Romania
 Sports Illus 51:90 (c, 4) N 19
 '79
--Somalian refugees
 Nat Geog 159:762-3 (c, 1) Je '81
--Virgin Islands
 Nat Geog 159:239 (c, 3) F '81
--Washington, D. C.
 Ebony 36:81-2 (3) Ag '81
--See also BLACKBOARDS; MEDI-
 CAL EDUCATION
CLASSROOMS--UNIVERSITIES
 Ebony 32:168 (4) O '77
 Ebony 33:66 (4) O '78
 Ebony 34:68 (4) Je '79
 Ebony 34:58 (4) O '79
 Smithsonian 11:80-6 (c, 1) My
 '80
 Ebony 36:45-6 (3) D '80
--1883 (Georgia)
 Ebony 36:109 (4) My '81
--University of Illinois
 Ebony 35:55 (3) S '80
--Turkey

Nat Geog 152:97 (c, 3) Jl '77
CLAY, HENRY
 Am Heritage 28:26 (4) F '77
 Smithsonian 8:26 (4) Jl '77
--Silhouette (1841)
 Smithsonian 9:123 (4) Ap '78
CLEANING
--Stadium after football game
 Sports Illus 55:69 (c, 2) S 7 '81
CLEMENCEAU, GEORGES
 Smithsonian 10:59 (4) F '80
CLEOPATRA
 Smithsonian 11:196 (4) N '80
CLEVELAND, GROVER
--In hunting outfit
 Am Heritage 30:19 (3) Je '79
--Inaugural relic
 Smithsonian 7:109 (c, 4) Ja '77
--On his honeymoon (1886)
 Am Heritage 29:83 (drawing, 4)
 Je '78
CLEVELAND, OHIO
--Cuyahoga River
 Nat Geog 158:156-7 (c, 1) Ag '80
CLIFF DIVING
--Acapulco, Mexico
 Trav/Holiday 152:15 (c, 4) D '79
 Trav/Holiday 153:54-5 (c, 1) Je
 '80
CLIFFS
--California beach
 Nat Geog 152:344-5 (c, 1) S '77
 Life 2:76-7 (c, 1) Ja '79
--Hawaii
 Trav/Holiday 156:55 (c, 1) O '81
--Kauai, Hawaii
 Nat Geog 152:602-3 (c, 1) N '77
--Moher, County Clare, Ireland
 Nat Geog 159:441 (c, 2) Ap '81
--Prince Leopold Island, Northwest
 Territories, Canada
 Natur Hist 88:68-73 (c, 1) Mr '79
--See also PALISADES, NEW JER-
 SEY
CLOCKS
 Nat Geog 151:527 (c, 4) Ap '77
--15th cent. Old Town Hall, Prague,
 Czechoslovakia
 Nat Geog 155:560 (c, 1) Ap '79
--16th cent. Dresden
 Nat Geog 154:716 (c, 1) N '78
--16th cent. "Drumming Bear"
 alarm clock (Dresden)
 Nat Geog 154:717 (c, 4) N '78
--17th cent. Great Britain
 Nat Geog 156:870-1 (c, 1) D '79
--18th cent. Grandfather (Ireland)
 Nat Geog 159:466-7 (c, 2) Ap '81

--19th cent. Italy
 Smithsonian 8:84 (c, 1) My '77
--19th cent. U. S.
 Smithsonian 12:150 (c, 4) N '81
--19th cent. clock tower (Great
 Britain)
 Smithsonian 10:61 (c, 4) Jl '79
--1820 Great Britain
 Nat Geog 158:616 (c, 4) N '80
--1884 Great Historical Clock
 Am Heritage 33:4-9 (c, 1) D
 '81
--Alarm clock
 Life 3:81 (2) Ap '80
--Carriage clock (France)
 Life 2:45 (c, 4) Mr '79
--Derby Clock, Louisville, Kentucky
 Trav/Holiday 151:55 (4) Mr '79
--Great Clock, Rouen, France
 Trav/Holiday 150:15 (4) O '78
--Qatar clock tower
 Travel 147:63 (c, 3) Ja '77
--Renaissance Europe
 Smithsonian 11:cov. , 45-53
 (c, 1) D '80
--Steam (British Columbia)
 Nat Geog 154:477 (c, 1) O '78
--See also SUNDIALS; WATCHES
CLOTHING
--19th cent. woman's man-style
 attire
 Smithsonian 7:113-18 (3) Mr
 '77
--1930's evening gown
 Life 4:106 (2) Ja '81
--1957 vicuna coat ad
 Smithsonian 7:63 (drawing, c, 4)
 Ja '77
--Apron (Ireland)
 Nat Geog 159:447 (c, 2) Ap '81
--Arctic gear
 Nat Geog 154:cov. , 297-325
 (c, 1) S '78
--Formal attire
 Smithsonian 9:68 (c, 4) Jl '78
 Ebony 34:54 (2) Jl '79
 Ebony 36:140-2 (c, 4) Mr '81
--Formal men's wear
 Sports Illus 49:cov. , 42-3, 89
 (c, 1) N 27 '78
--Formal men's wear (South Africa)
 Nat Geog 151:792 (c, 3) Je '77
--History of jeans
 Am Heritage 29:2, 16-21 (c, 1)
 Ap '78
--Homespun shawls
 Nat Wildlife 15:54-5 (c, 1) Ap
 '77

--Protection against chemical war-
 fare
 Life 3:36-7, 40 (c, 1) Ap '80
--Testing insulation of textiles on
 copper man
 Natur Hist 90:91, 96 (c, 1) O '81
--Windbreakers
 Sports Illus 50:34 (c, 1) My 7 '79
--Women's lingerie
 Life 2:72-9 (c, 1) F '79
 Sports Illus 54:44-5 (c, 1) My 4
 '81
--See also BATHING SUITS; COATS;
 COSTUME; FOOTWEAR;
 GLOVES; HATS; HEADGEAR;
 KIMONOS; PURSES; RAIN-
 WEAR; SNOWSHOES; SPORTS-
 WEAR
CLOUDS
 Nat Geog 152:540-1 (c, 1) O '77
 Nat Geog 159:356-7 (c, 1) Mr '81
--Grand Canyon, Arizona
 Nat Wildlife 16:46 (c, 4) F '78
--Over Alaskan mountains
 Nat Wildlife 15:54-5 (c, 1) Ja '77
--Storm clouds
 Smithsonian 10:78-81 (c, 1) Ag
 '79
CLOWNS
 Life 2:112-13 (c, 1) F '79
 Ebony 35:44-6 (c, 3) Jl '80
 Smithsonian 11:cov. , 64-5 (c, 1)
 Mr '81
 Life 4:118-20 (c, 1) Ap '81
 Smithsonian 12:110-11 (c, 2) N '81
 Life 4:20 (c, 2) D '81
--Children in clown make-up (Indi-
 ana)
 Nat Geog 154:392 (c, 3) S '78
CLUBS
--College sorority activities
 (Arkansas)
 Life 2:91-5 (c, 1) Ap '79
--Explorers Club history
 Smithsonian 11:162-79 (c, 2) O
 '80
--History of Bohemian Club, San
 Francisco, California
 Am Heritage 31:2, 81-91 (c, 1)
 Je '80
--See also BEACH CLUBS; BOY
 SCOUTS; COUNTRY CLUBS;
 KU KLUX KLAN; MASONRY;
 TENNIS CLUBS
COAL
 Nat Geog 152:19 (c, 4) Jl '77
 Smithsonian 8:30-7 (c, 1) Ag '77
 Smithsonian 10:103 (c, 1) Ja '80

COAL INDUSTRY
--Drilling rig (Montana)
 Smithsonian 10:79 (c, 1) Mr '80
--Liquefaction plant (South Africa)
 Nat Geog 159:84-5 (c, 1) F
 '81SR
--U. S. resources
 Nat Geog 159:62-3 (map, c, 1)
 F '81SR
COAL INDUSTRY--TRANSPORTA-
 TION
--Coal-filled railroad cars
 Nat Wildlife 17:26 (c, 4) F '79
--Training coal from Wyoming
 Nat Geog 159:96-7 (1) F '81SR
COAL MINES
--New Mexico
 Smithsonian 8:39 (c, 1) Ag '77
 Nat Geog 158:782-3 (c, 2) D
 '80
COAL MINING
--Kentucky
 Smithsonian 8:32-3 (c, 4) Ag '77
--West Germany
 Nat Geog 152:170-1 (c, 2) Ag
 '77
--Wyoming
 Nat Geog 159:100-13 (1) F
 '81SR
COAST GUARD--U. S.
--Putting out fire (New Jersey)
 Nat Geog 160:584-5 (c, 1) N '81
COAT RACKS
 Ebony 36:60 (c, 4) O '81
COATIS
 Nat Wildlife 16:41 (c, 1) F '78
 Sports Illus 52:113 (painting, c, 4)
 Ja 14 '80
COATS
--Aluminum
 Nat Geog 154:186-7 (c, 1) Ag
 '78
--Fur coats
 Life 3:81-4 (c, 2) My '80
--Lynx fur (Japan)
 Nat Geog 159:304 (c, 1) Mr '81
--Men's fur coats
 Ebony 34:106-9 (2) Ja '79
--Parkas
 Smithsonian 11:102 (c, 1) F '81
--Parkas (Canada)
 Nat Geog 152:630-47 (c, 1) N
 '77
 Nat Geog 154:cov., 297-325
 (c, 1) S '78
--Raccoon (1920's)
 Nat Geog 151:180-1 (1) F '77
 Ebony 36:151 (4) My '81

--Straw cape (Japan)
 Natur Hist 90:51 (c, 1) O '81
COBB, TY
 Sports Illus 47:24 (4) Jl 18 '77
 Sports Illus 47:62-4 (2) O 10 '77
 Sports Illus 49:92 (4) O 9 '78
 Life 2:98 (drawing, c, 2) S '79
 Smithsonian 10:155 (c, 4) O '79
 Sports Illus 53:46 (drawing, c, 4)
 Jl 7 '80
COBRAS
 Natur Hist 86:65 (c, 3) My '77
 Smithsonian 10:127 (c, 1) O '79
COCKATOOS
 Nat Geog 153:605 (c, 4) My '78
COCKROACHES
 Natur Hist 89:74 (3) Mr '80
 Nat Geog 159:130-42 (c, 1) Ja
 '81
COCONUT INDUSTRY
--Husking coconuts (Philippines)
 Travel 148:37 (c, 1) Ag '77
--Preparing copra (Maupiti, Society
 Islands)
 Nat Geog 155:867 (c, 4) Je '79
--Turning husks into rope (Sri
 Lanka)
 Nat Geog 155:131 (c, 1) Ja '79
COCONUT PALM TREES
 Travel 148:54 (c, 2) S '77
--Covered with volcanic ash (St.
 Vincent)
 Nat Geog 156:406-7 (c, 1) S '79
COCOONS
 Smithsonian 8:84-5 (c, 4) N '77
COD
 Natur Hist 88:36-7 (4) Mr '79
CODES AND CIPHERS
--1822 number code (Virginia)
 Smithsonian 12:126 (c, 4) Ap '81
--Thomas Jefferson's 1790's cipher
 wheel
 Smithsonian 12:132 (c, 4) Ap '81
CODY, WILLIAM (BUFFALO BILL)
 Nat Geog 158:58 (4) Jl '80
 Nat Geog 160:77-103 (c, 1) Jl '81
--Home (North Platte, Nebraska)
 Trav/Holiday 153:63 (4) Je '80
--On buffalo hunt
 Smithsonian 12:75 (painting, c, 3)
 My '81
--Statue by Whitney (Cody, Wyoming)
 Smithsonian 11:94 (3) Ag '80
COELACANTHS (FISH)
 Smithsonian 12:137 (c, 4) N '81
COELENTERATES
--Siphonophores
 Nat Geog 160:846-7 (c, 1) D '81

--See also CORALS; JELLYFISH;
 SEA ANEMONES
COFFEE
--Pouring cup of coffee
 Nat Geog 159:388 (c, 4) Mr '81
COFFEE INDUSTRY
 Nat Geog 159:388-405 (c, 1)
 Mr '81
--Brazil
 Nat Geog 153:270-1 (c, 1) F '78
--Production and consumption map
 Nat Geog 159:398-9 (c, 2) Mr
 '81
COFFEE INDUSTRY--HARVESTING
--Costa Rica
 Trav/Holiday 150:60 (c, 1) N
 '78
 Nat Geog 160:35 (c, 4) Jl '81
COFFEE POTS
--Early 20th cent.
 Smithsonian 11:138 (c, 4) O '80
COFFEEHOUSES
--1800 (Great Britain)
 Nat Geog 159:404-5 (draw-
 ing, c, 1) Mr '81
--Cafe (Rome, Italy)
 Smithsonian 8:103 (c, 2) Mr '78
--Turkey
 Nat Geog 152:105 (c, 1) Jl '77
COINS
--3rd cent. B. C. Carthage
 Smithsonian 9:43 (c, 4) F '79
--1st cent. B. C. (Phoenician
 silver)
 Nat Geog 160:298 (c, 1) S '81
--11th cent. bronze Byzantine
 coin (Turkey)
 Nat Geog 160:538 (c, 4) O '81
--17th cent. gold (Spain)
 Nat Geog 152:736 (c, 1) D '77
--1613 Harington farthing (Great
 Britain)
 Nat Geog 155:743 (c, 4) Je '79
--1709 silver (Spain)
 Nat Geog 156:852 (c, 4) D '79
--Ancient
 Smithsonian 10:30 (c, 3) My
 '79
--Ancient Celtic
 Nat Geog 151:607 (drawing, 4)
 My '77
--Ancient Macedonia
 Nat Geog 151:607 (drawing, 4)
 My '77
--Byzantine
 Smithsonian 23:95 (c, 4) My '81
--Gold
 Life 2:146 (c, 4) N '79

--South African Krugerrands
 Nat Geog 151:796 (c, 4) Je '77
--Swiss francs
 Nat Geog 159:272 (c, 1) F '81
--Valuable coins
 Smithsonian 10:131-43 (c, 2) Mr
 '80
--See also CURRENCY
COLE, THOMAS
--Manhood, Voyage of Life (1840)
 Am Heritage 28:58-9 (painting, c, 1)
 F '77
COLLAGES
--Black American experience
 Smithsonian 11:70-7 (c, 1) Mr
 '81
COLLEGE LIFE
--College students
 Ebony 35:33 (4) N '79
 Ebony 35:114 (4) Ja '80
 Ebony 35:54-8 (3) S '80
--Sorority activities (Arkansas)
 Life 2:91-5 (c, 1) Ap '79
--Studying (New York)
 Nat Geog 151:716 (c, 4) My '77
COLLEGES AND UNIVERSITIES
--University of Arizona's McKale
 Center
 Ebony 32:44-5 (2) Ap '77
--Boston College gym
 Sports Illus 54:17 (c, 4) F 16
 '81
--Brigham Young University, Provo,
 Utah
 Sports Illus 53:84-7 (c, 1) D 8
 '80
--College of Charleston, South
 Carolina
 Trav/Holiday 149:28 (c, 2) Ap '78
--Fisk University, Nashville, Ten-
 nessee
 Ebony 33:74 (4) Ag '78
--Howard University, Washington,
 D. C.
 Ebony 34:84 (3) F '79
--Johns Hopkins University, Balti-
 more, Maryland
 Smithsonian 8:82 (c, 1) O '77
--Kent State shooting (1970)
 Life 2:37 (1) D '79
--Le Moyne, Memphis, Tennessee
 Ebony 36:128 (4) Je '81
--Lewis & Clark, Portland, Oregon
 Sports Illus 54:72 (c, 4) My 11
 '81
--U. of Minnesota underground
 bookstore
 Smithsonian 9:105 (c, 2) F '79

--Morgan State University,
Baltimore, Maryland
Ebony 37:68 (4) D '81
--Morris Brown, Atlanta, Georgia
Ebony 36:112 (4) My '81
--University of Nevada at Lincoln
Life 3:98 (3) Ja '80
--Northwestern University life
(Chicago, Illinois)
Sports Illus 49:92-5 (c, 2) O
30 '78
--Oxford University, England
Travel 147:25-31 (c, 1) Ap '77
--Pepperdine, California
Sports Illus 46:100-4 (c, 1) My
23 '77
--Princeton University, New
Jersey
Am Heritage 32:58 (c, 4) O '81
--Rand Afrikaans, Johannesburg,
South Africa
Nat Geog 151:806-7 (c, 1) Je
'77
--Recruitment booths at show
Ebony 34:86 (4) F '79
--St. Andrews, Scotland
Sports Illus 49:48 (c, 4) Jl 10
'78
--Spelman, Atlanta, Georgia
Ebony 36:108-9 (3) My '81
--Trinity College library, Dublin,
Ireland
Smithsonian 8:75 (c, 1) O '77
--Tuskegee Institute, Alabama
Ebony 36:105-7 (2) My '81
--Tuskegee Institute lab, Alabama
(late 19th cent.)
Am Heritage 28:68 (3) Ag '77
--Vassar observatory, New York
(1880's)
Natur Hist 88:14 (3) May '79
--U. of Virginia, Charlottesville,
Virginia
Sports Illus 53:66-8 (c, 2) S
15 '80
--Yunnan, China
Nat Geog 159:796-7 (c, 4) Je '81
--University of Zurich, Switzer-
land
Life 3:49, 57-8 (c, 4) My '80
--See also CAMBRIDGE UNIVER-
SITY; COLLEGE LIFE;
DORMITORIES; HARVARD
UNIVERSITY; PRINCETON
UNIVERSITY; YALE UNIVER-
SITY
COLLIES
Smithsonian 8:69 (c, 1) S '77

Ebony 33:164 (c, 3) S '78
COLOGNE, WEST GERMANY
--Countryside outside city
Life 3:70 (c, 3) N '80
COLOMBIA
--Coffee farms
Nat Geog 159:392-3 (c, 1) Mr '81
--Magdalena River valley
Sports Illus 53:86-98 (c, 1) N
24 '80
--See also CARTAGENA
COLOMBIA--ART
--Pre-Hispanic gold works
Natur Hist 88:cov., 36-52 (c, 1)
N '79
COLOMBIA--COSTUME
--Palenque
Sports Illus 53:86-98 (c, 1) N 24
'80
--Street children
Natur Hist 90:40-8 (c, 1) Ap '81
COLOMBIA--MAPS
--Goldworking regions
Natur Hist 88:41 (4) N '79
COLOMBO, SRI LANKA
Nat Geog 155:128-9 (c, 1) Ja '79
COLORADO
Sports Illus 49:62 (c, 4) Jl 24
'78
--Aerial view of Denver-Boulder-
Rockies region
Life 3:77 (c, 2) D '80
--Countryside
Travel 147:38-43 (c, 1) Ap '77
Am Heritage 30:67 (painting, c, 4)
F '79
--Countryside (19th-20th cents.)
Life 2:9-12 (c, 4) Mr '79
--Crested Butte
Sports Illus 50:27-30 (c, 2) F
19 '79
Am Heritage 30:38-9 (c, 1) O '79
--Red Rocks
Smithsonian 10:118 (painting, c, 4)
Ap '79
--Rocky Mountain area
Nat Geog 156:497-509 (c, 1) O '79
--Shale mine
Nat Geog 159:76-7 (c, 1) F '81SR
--Sites of dinosaur remains
Nat Geog 154:172-3, 177 (c, 1)
Ag '78
--Steamboat Springs
Trav/Holiday 154:34 (c, 3) N '80
--Vail
Travel 147:42-3 (c, 1) Ap '77
Trav/Holiday 154:33 (c, 2) N '80
--See also COLORADO SPRINGS;

DENVER; ROCKY MOUNTAIN
NATIONAL PARK; ROCKY
MOUNTAINS
COLORADO--MAPS
--Cripple Creek (1896 aerial view)
Am Heritage 30:22-3 (c, 1) F
'79
COLORADO RIVER, SOUTHWEST
Sports Illus 47:25-8 (c, 1) Ag
1 '77
Nat Wildlife 16:42-7 (c, 1) F
'78
Natur Hist 87:81-91 (c, 1) Mr
'78
Sports Illus 51:23 (c, 1) Ag 20
'79
Nat Geog 158:176-7 (map, c, 2)
Ag '80
Nat Geog 158:803 (c, 3) D '80
--Aerial views
Life 3:77-82 (c, 1) D '80
COLORADO SPRINGS, COLORADO
Trav/Holiday 150:62-4 (c, 1) N
'78
COLOSSEUM, ROME, ITALY
Nat Geog 159:716-17 (c, 1) Je
'81
COLUMBIA RIVER, PACIFIC
NORTHWEST
Trav/Holiday 152:56-61 (c, 1)
Ag '79
Natur Hist 89:52-61 (map, c, 1)
Jl '80
--See also GRAND COULEE DAM
COLUMBINES (FLOWERS)
Nat Wildlife 15:38 (c, 4) Ag '77
Nat Geog 156:505 (c, 3) O '79
Natur Hist 90:78 (c, 3) Jl '81
COLUMBUS, CHRISTOPHER
--1496 woodcut of his ships
Am Heritage 29:110 (4) Je '78
--Settlements in the New World
(1493)
Am Heritage 29:82-91 (c, 1) Ap
'78
COMBINES
Natur Hist 87:76 (3) F '78
Nat Geog 155:658-9 (c, 1) My
'79
Nat Geog 155:772-3 (c, 1) Je
'79
Life 2:11 (2) Ag '79
Natur Hist 90:100-1 (c, 1) Ja
'81
--Tibet
Nat Geog 157:231 (c, 3) F '80
COMBS
--18th cent.

Nat Geog 152:764 (c, 4) D '77
Comedians. See ENTERTAINERS.
COMETS
Natur Hist 87:47 (3) Mr '78
--Historical depictions
Natur Hist 89:54-61 (1) D '80
--Kohoutek (1974)
Natur Hist 90:61 (c, 1) Ap '81
--See also HALLEY'S COMET
COMIC STRIPS
--1904 Verbeek comic
Natur Hist 89:92-3 (3) F '80
--Albert the Alligator
Trav/Holiday 149:58 (drawing, 3)
Je '78
--Asterix
Nat Geog 151:632-3 (c, 1) My '77
--Batman
Sports Illus 52:13 (drawing, c, 4)
My 26 '80
--Doonesbury
Life 2:140 (4) D '79
--Goofy
Natur Hist 88:36 (c, 4) My '79
--Lone Ranger
Smithsonian 8:113-20 (drawing, c, 2)
S '77
--Pogo
Smithsonian 12:143 (c, 4) Jl '81
--Snoopy
Life 1:72 (c, 4) N '78
--See also MICKEY MOUSE;
SUPERMAN; TARZAN
COMMENCEMENTS
--College
Ebony 35:90 (4) Ag '80
--High school graduation (Allagash,
Maine)
Nat Geog 158:406-7 (c, 1) S '80
--Junior high school (Illinois)
Sports Illus 51:56 (c, 4) Jl 9 '79
--Lagos University, Nigeria
Nat Geog 155:443 (c, 3) Mr '79
--National Cathedral School, Wash-
ington, D. C.
Nat Geog 157:572-3 (c, 1) Ap '80
--UCLA
Nat Geog 155:56-7 (c, 2) Ja '79
--U. S. Naval Academy (Annapolis,
Maryland)
Life 4:133 (c, 2) Ja '81
COMMENCEMENTS--COSTUME
--College
Ebony 32:33 (4) Ag '77
Ebony 33:70 (4) Ag '78
Ebony 34:65 (4) D '78
Ebony 34:83 (3) F '79
Ebony 34:75 (4) Mr '79

Life 2:112 (c, 2) Ag '79
Sports Illus 51:100 (c, 4) S 3
'79
Sports Illus 52:57 (4) Ap 28 '80
Sports Illus 52:72 (drawing, c, 2)
My 19 '80
Ebony 36:83 (4) My '81
--College graduation (New York)
Nat Geog 151:717 (c, 1) My '77
--College graduation (Tennessee)
Nat Geog 153:708-9 (c, 1) My
'78
--High school graduation
Ebony 35:92 (4) S '80
--High school graduation (North
Carolina)
Nat Geog 151:475 (c, 4) Ap '77
--LH. D. degree
Ebony 34:57 (4) O '79
COMMUNION
--Peking, China
Nat Geog 157:330 (c, 2) Mr '80
--Poland
Nat Geog 159:124-5 (c, 1) Ja
'81
--Turin, Italy
Nat Geog 157:732-3 (c, 1) Je '80
COMMUNION--COSTUME
--Bonaire, Netherland Antilles
Trav/Holiday 151:58 (c, 4) Ja
'79
--Ireland
Nat Geog 159:458 (c, 4) Ap '81
COMOROS
--Mayotte Island
Nat Geog 160:454-5 (c, 1) O '81
COMPASSES
Smithsonian 10:76 (drawing, 4)
Jl '79
Composers. See CHOPIN, FRED-
ERIC; FOSTER, STEPHEN;
SATIE, ERIK; STRAUSS,
JOHANN
COMPUTER TERMINALS
Sports Illus 47:54-5 (c, 2) Ag
22 '77
Smithsonian 9:35 (c, 3) Jl '78
Ebony 34:136 (3) S '79
Ebony 36:66 (4) N '80
Smithsonian 12:130 (c, 4) Ap '81
Ebony 37:97 (2) D '81
COMPUTERS
Sports Illus 51:54-5 (c, 2) Jl
23 '79
Ebony 35:26 (4) Mr '80
Smithsonian 10:49-57 (c, 1) Mr
'80
--Computer graphics

Smithsonian 12:106-13 (c, 1) Je
'81
--Computer room
Ebony 36:112 (4) Je '81
--High school computer rooms
(Ohio)
Ebony 36:112 (4) Ap '81
--Keypunching
Ebony 32:34 (4) Mr '77
Ebony 33:42 (4) Ag '78
--Personal computers
Life 4:52-8 (c, 1) O '81
--Tape files
Smithsonian 10:51 (c, 3) Mr '80
COMPUTERS--HUMOR
--Computer difficulties with hard
problems
Smithsonian 10:91-6 (drawing, c, 2)
O '79
CONCENTRATION CAMPS
--1940's prisoner's costume (Poland)
Life 2:49 (c, 3) S '79
--Aerial view of Auschwitz, Poland
(1944)
Life 2:8-12 (1) Ap '79
--Auschwitz victims of Dr. Mengele
Life 4:45-52 (c, 1) Je '81
--Treblinka, Poland
Life 3:30 (4) F '80
Concert halls. See THEATERS
CONCERTS
--Chamber group (Tennessee)
Nat Geog 153:705 (c, 1) My '78
--China
Life 2:102-3 (c, 1) My '79
--Female singing group
Ebony 35:137 (c, 4) F '80
--Jazz (Washington, D. C.)
Ebony 33:58-61 (4) S '78
--New Wave band
Life 3:102 (c, 4) Je '80
--Orchestra rehearsal (Dallas,
Texas)
Trav/Holiday 149:60 (c, 4) Ap '78
--Rock and roll
Life 4:60-3 (c, 1) N '81
--String quartet (Washington, D. C.)
Smithsonian 11:43 (c, 4) Ap '80
--Symphony (New Zealand)
Trav/Holiday 155:78 (c, 4) F '81
--Wolf Trap Farm Park, Virginia
Nat Geog 156:50-1 (c, 1) Jl '79
--Woodwind group (London, Eng-
land)
Smithsonian 8:68-9 (c, 3) Je '77
--See also AUDIENCES; BANDS;
CHOIRS; CONDUCTORS;
MUSICIANS

CONCHES
 Nat Geog 159:640 (c, 4) My '81
CONCORD, MASSACHUSETTS
 Nat Geog 159:350-83 (c, 1) Mr
 '81
--19th cent.
 Am Heritage 30:94-105
 (map, drawing, 2) D '78
 Nat Geog 159:356 (4) Mr '81
CONCORD, NEW HAMPSHIRE
--19th cent. house
 Am Heritage 32:56 (1) D '80
Condominiums. See HOUSING
 DEVELOPMENTS
CONDORS
 Nat Geog 151:161 (painting, c, 3)
 F '77
 Nat Wildlife 18:14-15 (c, 2) D
 '79
 Nat Wildlife 19:25-8 (c, 1) Ag
 '81
CONDUCTORS, MUSIC
 Ebony 33:148 (4) Ag '78
 Nat Geog 156:51 (c, 4) Jl '79
 Ebony 35:71 (2) D '79
 Life 3:19 (2) N '80
 Smithsonian 12:105 (c, 4) Ag '81
--Arizona
 Nat Geog 152:492 (c, 3) O '77
--California
 Ebony 35:56 (3) O '80
--Choir (New York)
 Ebony 35:82 (3) Ag '80
--Michigan
 Ebony 33:38 (4) Ap '78
Conductors, Railroad. See
 RAILROAD CONDUCTORS
CONEY ISLAND, NEW YORK
--1880 painting
 Am Heritage 32:24-5 (paint-
 ing, c, 1) Ag '81
--Early 20th cent.
 Smithsonian 8:45-7 (c, 4) Ag '77
--Luna Park (1904)
 Am Heritage 30:79 (1) O '79
CONFERENCES
 Ebony 32:58-9 (3) Ja '77
 Ebony 32:63 (4) Mr '77
 Ebony 32:64 (3) Je '77
 Ebony 33:94 (3) N '77
 Ebony 33:76 (4) Mr '78
 Ebony 34:33 (3) Mr '79
--Boardroom (Alaska)
 Smithsonian 12:31 (c, 4) Ag '81
--Chicago, Illinois
 Ebony 36:36 (4) N '80
--Liechtenstein
 Nat Geog 159:273 (c, 4) F '81

--Moscow, U. S. S. R.
 Nat Geog 153:18-19 (c, 1) Ja '78
--Press conference
 Ebony 32:105 (3) F '77
 Ebony 33:32 (4) Je '78
 Ebony 34:35 (3) D '78
 Ebony 34:75 (3) Ap '79
 Ebony 34:61 (3) S '79
 Ebony 35:54 (3) N '79
 Ebony 35:36 (4) Jl '80
 Ebony 36:101 (3) Ap '81
CONNECTICUT
--Connecticut River area
 Trav/Holiday 150:32-6 (map, c, 1)
 Ag '78
--Goodspeed Opera House, East
 Haddam
 Travel 147:47 (c, 4) Ap '77
 Trav/Holiday 150:35 (c, 4) Ag '78
 Trav/Holiday 154:6 (4) Ag '80
--Housatonic River paper mills
 Smithsonian 8:83, 86-7 (c, 3) S
 '77
--See also CONNECTICUT RIVER;
 HARTFORD; LITCHFIELD;
 NEW LONDON
CONNECTICUT RIVER, NEW ENG-
 LAND
 Natur Hist 87:42 (c, 3) D '78
CONSTELLATIONS
 Natur Hist 88:102-3 (1) Mr '79
 Nat Wildlife 18:36-9 (drawing, 4)
 Ap '80
--Centaurus
 Smithsonian 8:44-7 (c, 3) Ap '77
--Cygnus
 Natur Hist 86:84 (3) My '77
--See also NEBULAE; STARS
CONSTRUCTION
--Bamboo scaffolds (Hong Kong)
 Nat Geog 158:511-13 (c, 1) O '80
--Building oriental garden (New
 York)
 Smithsonian 12:69 (c, 2) Jl '81
--Construction site (Chicago, Illi-
 nois)
 Ebony 34:36 (2) Ap '79
--Construction site (St. Louis,
 Missouri)
 Ebony 34:88 (3) S '79
--Ground-breaking (Atlanta, Georgia)
 Ebony 35:61 (3) Ja '80
--See also specific items--CON-
 STRUCTION (e. g. BUILD-
 INGS--CONSTRUCTION,
 HOUSES--CONSTRUCTION)
CONSTRUCTION EQUIPMENT
--1910's shovel (Panama Canal)

Smithsonian 8:94 (4) Ag '77
--Earth movers
 Smithsonian 12:57 (c, 1) My '81
 Smithsonian 12:30 (c, 1) Ag '81
--Jackhammers
 Smithsonian 9:71 (c, 4) Ja '79
--Widening highway (New York)
 Smithsonian 10:42-3 (c, 1) F '80
--See also BULLDOZERS
CONSTRUCTION WORKERS
--Grenada
 Nat Geog 159:252-3 (c, 2) F '81
--Siberia, U. S. S. R.
 Nat Geog 152:264 (c, 2) Ag '77
CONTACT LENSES
 Ebony 36:54 (4) F '81
CONTESTS
--Cow chip throwing (Oklahoma)
 Natur Hist 89:81 (1) N '80
--Crab-picking (Maryland)
 Nat Geog 158:430 (c, 1) O '80
--Crayfish eating contest (Louisiana)
 Nat Wildlife 19:32 (4) Je '81
--Grape stomping (Michigan)
 Trav/Holiday 156:43 (4) Ag '81
--Horse-pulling contest (Iowa)
 Smithsonian 10:78-9 (c, 1) F
 '80
--Lottery winners
 Ebony 33:161-2 (3) Je '78
--Rock throwing (Iowa)
 Trav/Holiday 151:62 (c, 4) Je
 '79
--Tug-of-war (China)
 Nat Geog 158:35 (c, 3) Jl '80
--Wood-sawing (Quebec)
 Nat Geog 157:618-19 (c, 1) My
 '80
--See also BEAUTY CONTESTS
CONTINENTAL DIVIDE, U. S.
 Nat Geog 156:482-514 (map, c, 1)
 O '79
CONVENTION CENTERS
--Norfolk, Virginia
 Travel 147:36 (4) Ap '77
CONVICTS
--California
 Ebony 36:56-62 (2) Je '81
--Death row
 Ebony 35:44-8 (3) S '80
--Hard labor (Philippines)
 Nat Geog 151:371 (c, 4) Mr '74
--Policemen dressed as inmates
 (1915; New Jersey)
 Am Heritage 32:101 (2) O '81
COOK, JAMES
 Am Heritage 31:2 (painting, c, 1)
 Ag '80

--Memorial (Hawaii)
 Trav/Holiday 154:59 (c, 4) N '80
COOKING
 Life 2:33 (c, 4) Ag '79
 Ebony 36:111 (c, 3) F '81
 Ebony 36:127 (c, 2) Ap '81
--1915 (Ohio)
 Am Heritage 32:81 (2) Ag '81
--Abalone
 Natur Hist 89:104 (4) Mr '80
--American Indians (Florida)
 Travel 147:53 (4) F '77
--At restaurant table (New Orleans,
 Louisiana)
 Trav/Holiday 155:52 (c, 1) F '81
--Baking cake atop Mt. Whitney,
 California
 Natur Hist 86:75 (3) Ja '77
--Baking scones (Northern Ireland)
 Life 4:44-5 (c, 1) O '81
--Barbecue
 Sports Illus 55:68 (c, 2) S 14 '81
--Barbecue (Argentina)
 Nat Geog 158:497 (c, 4) O '80
--Barbecue (Massachusetts)
 Ebony 35:90 (4) S '80
--Barbecue (Pennsylvania)
 Nat Geog 151:250 (c, 4) F '77
--Burgoo (Virginia)
 Natur Hist 89:100 (4) S '80
--Campfire (Alaska)
 Nat Wildlife 16:53 (c, 4) O '78
--Campfire (Arizona)
 Am Heritage 29:104-5 (c, 1) F
 '78
--Campfire (Australia)
 Nat Geog 153:587 (c, 1) My '78
--Campfire (Oregon)
 Trav/Holiday 154:37 (c, 2) Jl '80
--Chinese mountains
 Nat Geog 157:324-5 (c, 1) Mr '80
--Chopping ingredients
 Ebony 36:104 (c, 2) Mr '81
--Creole style fish
 Trav/Holiday 153:53 (c, 4) Ap '80
--Drying walrus meat (Alaska)
 Natur Hist 86:55 (c, 1) Mr '77
--Ecuador Indians
 Natur Hist 87:94-5 (c, 1) O '78
--Fast food hamburger restaurant
 Natur Hist 87:80-1 (2) Ja '78
--Fiji
 Trav/Holiday 155:58, 60 (c, 4)
 Ja '81
--Fish (Ontario)
 Nat Geog 154:785 (c, 4) D '78
--Fish (West Germany)
 Nat Geog 152:463 (c, 3) O '77

--Fish boil (Wisconsin)
Natur Hist 90:94-5 (c, 1) D '81
--Giant pancake (New Brunswick)
Nat Geog 158:398-9 (c, 1) S '80
--Gnocchi
Trav/Holiday 152:62 (c, 4) S
'79
--Grinding corn (1910; California)
Am Heritage 31:24 (painting, c, 2)
Ag '80
--Grinding corn (Yugoslavia)
Nat Geog 152:676 (c, 4) N '77
--India
Natur Hist 88:14 (3) Je '79
--Iron Age style (Great Britain)
Smithsonian 9:82 (c, 4) Je '78
--Japanese restaurant
Nat Geog 152:574 (c, 1) O '77
--Maize (Peru)
Natur Hist 86:38 (c, 2) My '77
--Making omelet aboard balloon
Nat Geog 158:267 (c, 4) Ag
'80
--Making sausage (Louisiana)
Natur Hist 89:92-5 (2) Ag '80
--Maupiti, Polynesia
Trav/Holiday 150:54 (c, 4) N
'78
--Montenegro, Yugoslavia
Nat Geog 152:662 (c, 2) N '77
--Mutton (Falkland Islands)
Smithsonian 12:88 (c, 4) S '81
--Outdoors (Florida hotel)
Trav/Holiday 151:42 (c, 4) Mr
'79
--Outdoors (Guam)
Trav/Holiday 154:47 (c, 4) Jl
'80
--Pancakes (1918)
Smithsonian 9:92 (4) Je '78
--Peking duck (China)
Smithsonian 9:125 (c, 4) N '78
--Pig (Orchid Island)
Nat Geog 151:105 (c, 3) Ja '77
--Poi (Hawaii)
Trav/Holiday 155:62 (c, 4) Mr
'81
--Pounding grain (Gambia)
Ebony 32:40 (4) Ap '77
--Preparing picnic baskets (New
Hampshire)
Smithsonian 8:49 (c, 4) Jl '77
--Qatar
Travel 147:63-5 (c, 2) Ja '77
--Restaurant (Madrid, Spain)
Travel 148:32 (3) O '77
--Roast pig (Philippines)
Trav/Holiday 151:37 (c, 2) Ja

'79
--Roasting oysters (South Carolina)
Natur Hist 90:91 (4) Ag '81
--Salmon
Natur Hist 90:102-4 (c, 1) Jl '81
--Salmon on campfire Indian-style
(Oregon)
Nat Geog 155:497 (c, 3) Ap '79
--Smoking mutton (China)
Nat Geog 160:742 (c, 3) D '81
--Spain
Nat Geog 153:315 (c, 4) Mr '78
--Syria
Nat Geog 154:347 (c, 1) S '78
--Torres Strait, Pacific Islands
Natur Hist 90:58-63 (c, 1) My
'81
--Tortillas (Arizona)
Nat Geog 157:803 (c, 4) Je '80
--Using juicer and blender
Ebony 32:68 (4) F '77
--See also BREAD MAKING; CHEFS
COOKING--EDUCATION
--Early 20th cent. (New Hampshire)
Am Heritage 29:21 (4) O '78
--Hyde Park, New York
Life 2:54-8 (c, 1) My '79
COOLIDGE, CALVIN
Am Heritage 29:78-9 (3) F '78
Coopers. See BARREL MAKING.
COPENHAGEN, DENMARK
--Hans Christian Andersen sites
Nat Geog 156:832-47 (c, 1) D
'79
--Concert hall of Tivoli
Trav/Holiday 153:30 (4) Ap '80
COPPER MINES
--Ancient remains (Oman)
Nat Geog 154:818-19 (c, 1) D '78
--New Mexico
Nat Geog 156:486-7 (c, 1) O '79
--Early 20th cent. cartoons about
Montana copper wars
Am Heritage 29:9 (4) Ag '78
CORAL REEFS
Natur Hist 86:72-4 (c, 2) Ap '77
Nat Geog 154:136-50 (c, 1) Jl
'78
Nat Geog 159:250 (c, 3) F '81
--See also GREAT BARRIER REEF
CORAL SNAKES
Nat Geog 151:160 (painting, c, 1)
F '77
CORALS
Nat Geog 151:675 (c, 4) My '77
Smithsonian 8:117 (c, 4) O '77
Nat Geog 154:136-50 (c, 1) Jl
'78

Nat Geog 154:377 (c, 4) S '78
Nat Geog 155:718-32 (c, 1) My '79
Natur Hist 89:cov., 83-5 (c, 1) F '80
Nat Geog 157:534-5 (c, 1) Ap '80
Natur Hist 89:62-3 (c, 1) Jl '80
--Nauru
Life 2:70-1 (c, 1) Ag '79
CORBETT, JIM
Ebony 33:130 (4) Mr '78
CORDOBA, SPAIN
Trav/Holiday 152:71-2, 96-7 (c, 1) N '79
COREOPSES FLOWERS
Trav/Holiday 155:70 (c, 4) F '81
CORK TREES
Nat Geog 158:821 (c, 3) D '80
CORMORANTS
Natur Hist 87:49 (c, 3) F '78
--Dead from oil spill
Nat Geog 154:135 (c, 4) Jl '78
CORN
Smithsonian 10:68-76 (c, 2) D '79
Am Heritage 31:14-28, 114 (c, 1) Ag '80
--Buildings made of corn
Am Heritage 31:28 (c, 4) Ag '80
--Dishes prepared with corn
Ebony 32:136-40 (c, 2) Ap '77
--Ear of corn
Natur Hist 88:61 (c, 1) F '79
CORN INDUSTRY
--Farming (19th cent.)
Am Heritage 31:18-23 (painting, c, 1) Ag '80
--Pests plaguing corn
Nat Geog 157:158-9 (drawing, c, 4) F '80
--Through U.S. history
Am Heritage 31:14-28 (c, 1) Ag '80
CORN INDUSTRY--HARVESTING
--19th cent. paintings
Am Heritage 31:21-5 (c, 1) Ag '80
CORNFIELDS
--Florida
Sports Illus 52:28-9 (c, 2) Mr 24 '80
--Infected with blight
Smithsonian 10:74-5 (c, 2) D '79
--Iowa
Nat Geog 159:616 (c, 1) My '81

Cornflowers. See BACHELOR'S-BUTTONS
CORNWALLIS, CHARLES
Am Heritage 32:77 (drawing, 2) O '81
CORONET PLAYING
--Dominican Republic
Nat Geog 152:539 (c, 1) O '77
COSMETICS
--Applying make-up
Ebony 33:86 (4) O '78
Life 2:84-5 (c, 4) Je '79
Life 4:123 (4) O '81
--Applying theater make-up
Ebony 32:158 (c, 4) Mr '77
Ebony 36:104 (4) Je '81
Smithsonian 12:83 (c, 4) Je '81
Smithsonian 12:101-2 (c, 4) Ag '81
--King Tut nail polish (California)
Nat Geog 155:45 (c, 4) Ja '79
--Putting on lipstick
Ebony 36:112 (4) Mr '81
COSTA RICA
Trav/Holiday 150:57-61 (c, 2) N '78
Nat Geog 160:32-61 (map, c, 1) Jl '81
--National parks
Smithsonian 10:64-73 (c, 1) S '79
--Rain forest
Smithsonian 9:121-30 (c, 3) Mr '79
Smithsonian 11:cov., 42-53 (c, 1) Je '80
--See also SAN JOSE
COSTA RICA--COSTUME
Trav/Holiday 150:57-61 (c, 2) N '78
Nat Geog 160:35-57 (c, 1) Jl '81
COTTAGES
--Ireland
Nat Geog 154:678-9 (c, 1) N '78
Trav/Holiday 152:68-9 (c, 1) Jl '79
--Madeira
Trav/Holiday 153:65 (c, 3) F '80
--Pine Knot, Virginia
Natur Hist 86:42 (4) N '77
COTTON
Nat Geog 160:648 (c, 1) N '81
COTTON FIELDS
--Mississippi
Ebony 33:56 (4) D '77
COTTON INDUSTRY
--Spinning cotton by hand (Louisiana)
Natur Hist 87:100-1 (1) Mr '78
--Syria

Nat Geog 154:352 (c, 1) S '78
COTTON INDUSTRY--HARVESTING
--1940's (California)
　Ebony 36:94-5 (3) N '80
COTTONWOOD TREES
　Nat Wildlife 16:42-3 (c, 2) Je
　　'78
　Life 1:100-1 (c, 1) D '78
　Smithsonian 10:52-5 (c, 1) D '79
Cougars.　See MOUNTAIN LIONS
COUNSELING
--Psychological cancer therapy
　Smithsonian 11:48-57 (c, 1) Ag
　　'80
COUNTRY CLUBS
--U. S. recreational center (Bahrain)
　Sports Illus 53:92-3 (c, 4) N 17
　　'80
COUNTRY LIFE
--Vermont
　Natur Hist 90:cov. , 72-82 (c, 1)
　　Mr '81
COURTHOUSES
--County courthouses
　Am Heritage 28:50-61 (1) O
　　'77
--Dayton, Tennessee
　Natur Hist 90:18 (2) O '81
--Evansville, Indiana
　Smithsonian 9:186-7 (4) N '78
--Hillsboro, Texas
　Am Heritage 32:59 (c, 4) O '81
--Houston, Texas
　Ebony 34:73 (4) S '79
--Vicksburg, Mississippi
　Travel 148:54 (c, 1) O '77
--See also SUPREME COURT
　　BUILDING
COURTROOMS
　Life 4:9-17 (2) Ap '81
--17th cent. Williamsburg, Vir-
　ginia
　Natur Hist 88:130-1 (3) O '79
--1927 Snyder murder trial (New
　York City)
　Am Heritage 31:25-31 (2) O
　　'80
--Cleveland, Ohio
　Ebony 33:61-3 (2) F '78
--Jurors' chairs (Georgia court-
　room)
　Am Heritage 28:56 (3) O '77
--Miami, Florida
　Ebony 35:140 (4) S '80
--Newark, Ohio
　Am Heritage 28:58 (2) O '77
COURTS-MARTIAL
--Mexican War (1847)

Smithsonian 8:99 (painting, c, 4)
　Mr '78
COVERED WAGONS
　Nat Wildlife 15:44 (c, 4) Ja '77
　Am Heritage 32:58-61 (paint-
　　ing, c, 1) F '81
　Life 4:48-9 (c, 1) S '81
COWARD, NOEL
　Am Heritage 30:86 (4) Je '79
COWBOYS
　Am Heritage 28:55 (4) Je '77
　Am Heritage 29:101-5 (c, 1) F
　　'78
　Ebony 33:58, 62 (2) My '78
--1880's rancher
　Natur Hist 86:9 (4) My '77
--Apache Indians (Arizona)
　Nat Geog 157:272-5 (c, 1) F '80
--Australia
　Nat Geog 155:174-5 (c, 1) F '79
--Depicted in films of "The Vir-
　ginian"
　Am Heritage 32:54-5 (2) F '81
--Idaho
　Nat Geog 156:223 (c, 4) Ag '79
--Marlboro Man
　Sports Illus 46:58-62 (c, 1) Ja
　　17 '77
--Mexico
　Nat Geog 153:626-7 (c, 1) My '78
--South America
　Nat Geog 158:478-501 (c, 1) O '80
--South Dakota
　Nat Geog 159:530 (c, 2) Ap '81
--Texas
　Nat Geog 157:441, 456-7, 480-1
　　(c, 1) Ap '80
--Utah
　Nat Wildlife 17:4-11 (c, 1) Ag '79
--J. R. Williams' cartoons of cow-
　boy life
　Am Heritage 29:93-9 (4) F '78
--Yukon
　Nat Geog 153:566-7 (c, 4) Ap '78
--See also RANCHING; RODEOS;
　　WESTERN FRONTIER LIFE
Cows.　See CATTLE
COWSLIPS
　Nat Wildlife 19:61 (c, 4) D '80
COYOTES
　Nat Wildlife 15:29 (c, 2) O '77
　Nat Wildlife 17:57 (c, 1) D '78
　Smithsonian 9:116 (4) Ja '79
　Nat Geog 156:280-1 (c, 2) Ag '79
　Smithsonian 11:120-1 (c, 3) N '80
　Nat Geog 159:158 (c, 4) F '81
COYPUS (RODENTS)
　Nat Wildlife 15:9 (c, 4) Je '77

CRAB APPLE TREES
 Nat Wildlife 17:48 (c, 1) F '79
CRAB INDUSTRY
--Alaska
 Nat Geog 155:238-9 (c, 1) F '79
--Georgia
 Nat Geog 154:240-1 (c, 2) Ag
 '78
--Maryland
 Nat Geog 158:450-1 (c, 1) O '80
CRABS
 Nat Geog 151:683 (c, 1) My '77
 Nat Wildlife 15:2 (c, 2) Je '77
 Smithsonian 8:100-1 (c, 4) S '77
 Nat Geog 152:440-9 (c, 1) O
 '77
 Trav/Holiday 152:61 (c, 2) Ag
 '79
 Nat Geog 156:692-7 (c, 1) N '79
 Trav/Holiday 153:46 (c, 4) Ja
 '80
 Nat Geog 157:548 (c, 4) Ap '80
 Nat Geog 158:430, 448-9 (c, 1)
 O '80
 Smithsonian 11:38-9 (c, 4) Ja
 '81
 Nat Geog 159:644 (c, 4) My '81
 Natur Hist 90:40 (c, 4) Jl '81
 Smithsonian 12:136 (c, 4) N '81
--Blue
 Nat Geog 151:680-1 (c, 1) My
 '77
 Nat Wildlife 19:12 (c, 4) O '81
--Coconut
 Natur Hist 88:76-82 (c, 1) N '79
--Fiddler
 Smithsonian 7:74-5 (c, 3) Ja '77
 Nat Wildlife 18:18-19 (drawing, 1)
 Ag '80
--Hermit
 Sports Illus 46:46 (c, 4) F 14
 '77
 Natur Hist 87:38 (drawing, 3)
 Ja '78
 Nat Wildlife 16:48 (c, 1) F '78
 Nat Geog 157:548-9 (c, 1) Ap
 '80
 Nat Wildlife 19:40 (c, 1) D '80
CRADLES
--China
 Nat Geog 157:318-19 (c, 1) Mr
 '80
--Pakistan
 Nat Geog 151:138-9 (c, 1) Ja '77
CRANBERRIES
 Nat Wildlife 16:8 (c, 4) Ag '78
CRANBERRY INDUSTRY--HAR-
 VESTING

--Wisconsin
 Nat Geog 152:194 (c, 3) Ag '77
CRANES
 Natur Hist 90:58-61 (c, 1) Mr '81
 Smithsonian 12:57-65 (c, 2) O '81
--Sandhill
 Natur Hist 86:23 (3) Mr '77
 Nat Geog 152:202-3 (c, 2) Ag '77
 Nat Wildlife 16:10-11 (c, 1) Je
 '78
 Smithsonian 9:cov. , 62-3 (c, 1)
 S '78
 Nat Wildlife 16:26 (c, 4) O '78
 Nat Geog 155:680-93 (c, 1) My
 '79
 Nat Wildlife 17:7 (c, 4) Je '79
 Nat Geog 159:156-7 (c, 1) F '81
--Sandhill chicks
 Nat Wildlife 17:40 (c, 4) Ag '79
--See also WHOOPING CRANES
CRAPPIES (FISH)
 Nat Geog 156:389 (c, 4) S '79
CRASHES
--1919 airplane
 Smithsonian 10:110 (3) Mr '80
--1920's airplane on building
 (Ontario)
 Am Heritage 30:109 (2) Ap '79
--1977 airplane (Canary Islands)
 Nat Geog 152:228-9 (c, 1) Ag '77
--Airplane
 Life 4:108-9 (c, 1) Jl '81
--Airplane (California)
 Life 2:182 (c, 4) D '79
--Escape from plane crash (Manila)
 Life 3:140 (1) Ap '80
--Hydroplane crash
 Sports Illus 55:80-1 (4) Ag 24 '81
--Plane on fire after midair collision
 Life 1:8-9 (c, 1) N '78
 Smithsonian 11:44-5 (c, 3) My '80
--Seconds before plane crash
 (Chicago, Illinois)
 Life 2:96-7 (c, 1) Jl '79
--See also ACCIDENTS; SHIP-
 WRECKS
CRATER LAKE, OREGON
 Smithsonian 11:57 (c, 4) Jl '80
 Life 3:74-5 (c, 1) S '80
CRAYFISH
 Natur Hist 87:24 (drawing, 4) O
 '78
 Trav/History 151:52 (c, 4) Ap '79
 Nat Geog 156:389 (c, 4) S '79
 Nat Wildlife 19:28-32 (c, 1) Je
 '81
CRAYFISH INDUSTRY
--Fishing (Louisiana)

Natur Hist 87:102 (3) Mr '78
CREEKS
--Tennessee
 Smithsonian 11:122 (c, 4) Mr
 '81
CREEPERS (BIRDS)
 Nat Wildlife 15:29 (painting, c, 1)
 Ja '77
--Honey creepers
 Nat Wildlife 15:30-2 (paint-
 ing, c, 1) Ja '77
CRESS
--Winter cress
 Nat Wildlife 17:60 (c, 3) D '78
CRETE
 Nat Geog 153:145-77 (map, c, 1)
 F '78
 Nat Geog 157:390-3 (c, 1) Mr
 '80
 Trav/Holiday 156:24, 31 (c, 2)
 D '81
--Ancient Phaistos
 Nat Geog 153:144-77 (c, 1) F
 '78
--Anemospilia ruins
 Nat Geog 159:204-21 (c, 1) F
 '81
--See also GREECE, ANCIENT;
 KNOSSOS
CRETE--COSTUME
 Trav/Holiday 156:24 (c, 4) D '81
CRICKET
--West Indies
 Sports Illus 54:36, 40-2 (c, 2)
 Ap 6 '81
--Children on Grenadine Island
 beach
 Nat Geog 156:398 (c, 1) S '79
CRICKETS
 Natur Hist 87:64-73 (c, 1) Ja
 '78
 Nat Wildlife 16:24 (c, 4) Ap '78
CRIME AND CRIMINALS
 Ebony 34:entire issue (1) Ag
 '79
--19th cent.
 Smithsonian 12:60-5 (c, 3) Ag
 '81
--19th cent. West
 Am Heritage 30:22-31 (1) Ap
 '79
--1884 bank robbers (Kansas)
 Smithsonian 10:130 (3) F '80
--1890's Appalachia
 Smithsonian 12:132-8 (3) D '81
--1963 Great Train Robbery
 (England)
 Smithsonian 11:164-80 (1) N '80

--Abscam sting
 Life 4:38 (2) Ja '81
--Accused murderer in handcuffs
 Life 4:32 (c, 1) F '81
--Bank robberies
 Life 2:142 (4) O '79
--Lizzie Borden and 1893 murder
 case (Massachusetts)
 Am Heritage 29:42-53 (2) F '78
--Capone's activities (1920's; Chi-
 cago)
 Am Heritage 30:84-93 (c, 4) F
 '79
--Car theft operations
 Life 3:44-50 (c, 1) Ag '80
--Criminalist and his lab (New
 York)
 Life 4:29 (2) Je '81
--Depiction of rape attack
 Ebony 33:155 (1) S '78
--Juvenile delinquents
 Ebony 34:76 (4) Ag '79
--Looted stores (1977; New York)
 Ebony 33:90 (4) Ag '78
--Looting
 Ebony 32:133 (2) S '77
--Looting during power shortage
 (New York)
 Smithsonian 8:62-3 (c, 2) N '77
--Looting stores (Mobile, Alabama)
 Nat Geog 158:350-1 (c, 1) S '80
--Man battering wife
 Ebony 36:94 (2) F '81
--Murder
 Ebony 32:100-1 (drawing, 2) S '77
--Murder of James Garfield (1871)
 Am Heritage 32:32 (woodcut, 3)
 Je '81
--Murdered gangsters (New York)
 Life 2:136-7 (1) S '79
--Police pursuing man on roof
 (Rhode Island)
 Life 3:10 (3) Ap '80
--Pope John Paul II assassination
 attempt
 Life 4:102-3 (c, 1) Jl '81
--Reagan assassination attempt
 Life 4:32-40 (c, 1) My '81
--Shootout in bar (Houston, Texas)
 Life 3:70 (c, 4) Ja '80
--Snyder murder case (1927; New
 York City)
 Am Heritage 31:20-31 (2) O '80
--Stolen loot
 Life 4:38-9 (c, 1) F '81
--Stranger luring child into car
 Ebony 36:117 (2) My '81
--Suicide by jumping from building

Ebony 36:36 (3) S '81
--Terrorist blown up in car
(Lebanon)
Life 2:101 (3) Ap '79
--Vandalism of car
Ebony 36:125 (2) Ag '81
--Yorkshire Ripper case (Great
Britain)
Life 2:162-3 (1) N '79
Life 3:64-81 (1) Ap '80
--See also BOOTH, JOHN WILKES;
CAPITAL PUNISHMENT;
CAPONE, AL; JUSTICE,
ADMINISTRATION OF;
LYNCHING; PROSTITUTION;
PUNISHMENT
Crinoids. See SEA LILIES
CROCODILES
Nat Geog 152:556-7 (c, 2) O '77
Nat Geog 153:90-115 (c, 1) Ja
'78
Natur Hist 88:84 (woodcut, 4)
My '79
Nat Wildlife 18:41 (4) D '79
Nat Geog 159:312-13 (c, 1) Mr
'81
Life 4:190-1 (c, 1) D '81
--Open-mouthed
Nat Wildlife 17:19 (c, 4) F '79
--See also ALLIGATORS; GAVIALS
CROCUSES
Nat Geog 153:565 (c, 4) Ap '78
CROP DUSTER PLANES
Natur Hist 87:124 (4) O '78
Smithsonian 9:85 (c, 1) Ja '79
Nat Wildlife 17:18 (c, 4) F '79
Natur Hist 88:41 (c, 2) D '79
Nat Geog 157:146-7, 150-3,
174-5 (c, 1) F '80
--Spraying lime on lake (New
York)
Nat Geog 158:160-1 (c, 3) Ag
'80
CROQUET PLAYING
--1946 (California)
Life 3:83 (3) S '80
--Florida
Trav/Holiday 151:41 (c, 3) Mr
'79
CROSS COUNTRY
Sports Illus 47:28-35 (c, 1) D
5 '77
Sports Illus 49:28-30 (c, 2) D
4 '78
Sports Illus 50:82 (3) Ap 9 '79
Sports Illus 51:98-103 (c, 4)
D 3 '79
Sports Illus 52:32-7 (2) Mr

24 '80
Sports Illus 53:41, 43 (c, 1) O
27 '80
Sports Illus 53:75-6 (c, 3) D 8
'80
Sports Illus 55:82, 85 (c, 4) D
7 '81
--Belgium
Sports Illus 46:28-30 (c, 2) Ap 4
'77
--Crossing finish line
Sports Illus 46:29 (c, 4) Ap 4 '77
Sports Illus 52:24 (c, 3) My 12
'80
--Italy
Sports Illus 52:75 (c, 2) Je 23
'80
--New Jersey race
Sports Illus 52:22-4 (c, 1) My 12
'80
Cross-country skiing. See
SKIING--CROSS-COUNTRY
CROW INDIANS (MONTANA)
--Hunting bison
Nat Wildlife 17:25 (painting, c, 3)
D '78
CROWDS
Ebony 35:27 (2) Ja '80
--Afghanistan
Natur Hist 87:61 (c, 3) F '78
--Commuters (New York City,
N. Y.)
Smithsonian 8:49 (c, 1) Ja '78
--India
Ebony 35:35 (3) Jl '80
--New York City, New York
Nat Geog 160:326-7 (c, 1) S '81
--On line in store (Moscow,
U. S. S. R.)
Life 3:34-5 (1) My '80
--On steps of public library (New
York)
Natur Hist 89:62-3 (c, 1) Ag '80
--Religious meeting (Florida)
Life 2:134-5 (c, 1) Je '79
--Shanghai, China
Nat Geog 158:2-3 (c, 1) Jl '80
--Syria
Nat Geog 154:328 (c, 1) S '78
--Watching Pope (Japan)
Life 4:122-3 (c, 1) Ap '81
--Zimbabwe
Nat Geog 160:633 (c, 1) N '81
--See also SPECTATORS
CROWNS
--11th cent. St. Stephen's (Hungary)
Smithsonian 10:168-70 (c, 3) N
'79

--Huichol Indian governor (Mexico)
 Nat Geog 151:843 (c, 4) Je '77
--Iran
 Nat Geog 155:102-3 (c, 1) Ja
 '79
--Replica of British crown
 Nat Geog 156:453 (c, 3) O '79
--Russian rulers
 Nat Geog 153:26-7 (c, 1) Ja '78
CROWS
 Sports Illus 55:40 (c, 4) Ag 10
 '81
CRUCIFIXES
 Am Heritage 28:5 (c, 4) Ag '77
--18th cent.
 Nat Geog 152:732-3 (c, 1) D '77
--18th cent. gold (Spain)
 Nat Geog 156:868-9 (c, 1) D
 '79
--1920's rotating cross (California)
 Am Heritage 28:62 (2) O '77
--Carved Bulgarian cross
 Nat Geog 158:107 (c, 4) Jl '80
--Cross design
 Smithsonian 10:80 (drawing, 4)
 Je '79
--France
 Nat Geog 154:550-1 (c, 1) O '78
--Marking landing spot of James-
 town settlers (Virginia)
 Travel 147:33 (c, 1) Ap '77
--New Mexico
 Nat Geog 154:423 (c, 3) S '78
--Penitentes sect (New Mexico)
 Am Heritage 30:2 (c, 1) Ap '79
--St. Mark's Cross
 Life 2:36 (c, 4) Mr '79
CRUISES
 Trav/Holiday 148:44 (c, 1) N
 '77
--1890 yacht
 Am Heritage 31:cov. (paint-
 ing, c, 2) Ag '80
--Activities
 Trav/Holiday 154:24-7 (4) D
 '80
--Cruise ship pool
 Trav/Holiday 153:55 (c, 4) Je
 '80
 Trav/Holiday 156:26 (c, 3) O '81
--Cruise ships
 Travel 148:cov., 28-31, 68-9
 (c, 1) S '77
 Travel 148:80 (4) O '77
 Trav/Holiday 149:58-9 (c, 2) F
 '78
 Trav/Holiday 155:50-1 (c, 1) Mr
 '81

Trav/Holiday 156:50 (c, 4) Ag '81
Trav/Holiday 156:26-30, 41 (c, 3)
 O '81
--QE2
 Trav/Holiday 149:113 (4) Mr '78
 Trav/Holiday 150:62-8 (4) O '78
--Shipboard activities
 Travel 147:34-9 (c, 1) Je '77
CRUSTACEANS
--Isopods
 Nat Wildlife 18:15 (c, 4) D '79
--Krills
 Natur Hist 89:66-71 (c, 1) Mr '80
--Ostracods
 Nat Geog 151:567 (c, 2) Ap '77
--See also BARNACLES; CRABS;
 CRAYFISH; LOBSTERS;
 SHRIMPS
CRYSTALS
 Natur Hist 87:64-71 (c, 1) F '78
CUBA
 Nat Geog 151:32-69 (map, c, 1)
 Ja '77
--1962 missiles (aerial view)
 Smithsonian 10:112-13 (c, 1) Ap
 '79
--Baseball
 Sports Illus 46:68-72 (c, 2) Je 6
 '77
--El Torreon de Cojimar fortress
 Sports Illus 47:54-5 (c, 1) Ag 1
 '77
--Guantanamo Bay (1927)
 Am Heritage 29:31 (3) O '78
--See also HAVANA
CUBA--COSTUME
--Military
 Life 3:43-8 (c, 2) F '80
--Refugees in the U. S.
 Life 3:148-9 (c, 1) Je '80
 Life 3:56-62 (c, 1) N '80
 Nat Geog 159:270 (c, 3) F '81
CUBA--HISTORY
--1962 missile crisis
 Am Heritage 28:6-15 (c, 1) O '77
--U. S. involvement in Cuba (20th
 cent.)
 Am Heritage 29:28-33 (c, 2) O
 '78
CUNEIFORM
--Ancient Ebla, Syria
 Nat Geog 154:730-58 (c, 1) D '78
Curaçao. See NETHERLANDS
 ANTILLES
CURITIBA, BRAZIL
 Nat Geog 153:264-5 (c, 1) F '78
CURLEWS
 Am Heritage 30:13 (painting, 3)

Ag '79
Natur Hist 89:31-2 (3) Ag '80
Nat Wildlife 19:45 (c, 4) F '81
--Egg
Nat Wildlife 17:8 (c, 4) Je '79
--Wooden
Nat Wildlife 19:54-5 (c, 1) D
'80
CURLING
Nat Wildlife 19:11 (drawing, c, 4)
D '80
CURRENCY
--Botswana
Ebony 34:124 (c, 4) D '78
--Irish five-pound note
Am Heritage 32:111 (c, 4) D
'80
--Rare $20 bill
Ebony 34:53 (3) Ja '79
--Tossing dollars in the air
Am Heritage 32:72 (4) Ag '81
--United Arab Emirates
Travel 147:64 (c, 4) Ja '77
--U. S. $100 bills
Sports Illus 54:cov. (c, 1) F
16 '81
--See also COINS
CURRIER AND IVES
--18th cent. wilderness life
Nat Wildlife 15:6-7, 10-11
(litho, c, 1) Ja '77
--1866 boat race
Smithsonian 9:141 (c, 3) N '78
--Aerial view of New York City
(1884)
Am Heritage 30:24-5 (c, 1) F
'79
--Depiction of Mason George
Washington
Am Heritage 31:92 (drawing, 4)
O '80
--Flower painting
Am Heritage 29:94-5 (c, 1) Ag
'78
--Oyster (1875)
Am Heritage 31:65 (painting, c, 4)
F '80
CUSCUSES
Natur Hist 86:68-9 (c, 1) Ja
'77
CUSTOMS OFFICIALS
--Arizona airborne border guard
Ebony 32:104-10 (2) Ap '77
--California
Nat Geog 159:310 (c, 4) Mr '81
--New York
Nat Wildlife 17:3, 32-9 (c, 1)
O '79

CUVIER, BARON GEORGES
Natur Hist 88:24 (painting, 4) F
'79
CYCADS
Smithsonian 9:126 (c, 4) N '78
Smithsonian 10:116 (c, 3) O '79
CYCLONES--DAMAGE
--Dead child (1970; Pakistan)
Life 2:182 (c, 4) D '79
CYPRESS TREES
Nat Wildlife 15:6-7 (c, 1) Je '77
Smithsonian 9:48-9 (c, 4) Ja '79
Sports Illus 52:24-5 (c, 2) F 11
'80
CYPRUS
Trav/Holiday 152:68 (c, 4) O '79
Czechoslovakia. See BRATISLAVA;
PRAGUE
CZECHOSLOVAKIA--COSTUME
--Border guards
Life 4:38-9 (c, 1) Ag '81
--Wedding
Nat Geog 152:471 (c, 1) O '77
Nat Geog 155:547 (c, 1) Ap '79
--Workers
Nat Geog 152:470 (c, 4) O '77
CZECHOSLOVAKIA--POLITICS
AND GOVERNMENT
--Communist takeover commemora-
tion (Prague)
Nat Geog 155:564-5 (c, 1) Ap '79

-D-

DADDY LONGLEGS
Nat Geog 158:563-4 (c, 1) O '80
DAGGERS
--14th cent. B. C. (Egypt)
Nat Geog 151:305 (c, 4) Mr '77
--Yemen
Nat Geog 159:301 (c, 1) Mr '81
Dahomey. See BENIN
DAIRYING
--Dairy farming (North Carolina)
Ebony 32:47-52 (3) F '77
--Milking cows (1912; Ohio)
Am Heritage 32:80 (3) Ag '81
--See also CHEESE INDUSTRY;
FARMING; MILK INDUSTRY
DAISIES
Nat Wildlife 17:58-9 (c, 4) D '78
Trav/Holiday 155:8 (4) My '81
DALI, SALVADOR
Life 3:168 (2) N '80
DALLAS, TEXAS
Ebony 33:98 (4) F '78
Trav/Holiday 149:58-60 (c, 1) Ap

'78
Smithsonian 9:60-9 (c,1) N '78
Nat Geog 157:458-9 (c,1) Ap
'80
--Demolition of block
Life 3:96-7 (c,1) Ag '80
DAMASCUS, SYRIA
Nat Geog 154:328-35 (c,1) S
'78
DAMIEN DE VEUSTER, JOSEPH
(FATHER DAMIEN)
Nat Geog 160:205 (4) Ag '81
DAMS
--1976 Teton Dam disaster,
Idaho
Smithsonian 9:36-9 (c,1) Ap '78
--Ancient Yemen
Nat Geog 156:259 (c,3) Ag '79
--Checking for safety
Smithsonian 9:36-45 (c,1) Ap
'78
--Fontana Dam, North Carolina
Am Heritage 28:71 (c,4) F '77
--Glen Canyon, Utah
Nat Geog 158:803 (c,3) D '80
--Great Falls, Lyndon, Vermont
Smithsonian 8:86 (c,4) S '77
--Hells Canyon, Idaho
Am Heritage 28:23 (c,1) Ap
'77
--Logging dam (Wisconsin)
Am Heritage 33:46-7 (c,1) D
'81
--Merrimack, Lawrence, Massa-
chusetts
Smithsonian 8:84-5 (c,3) S '77
--Milner, Snake River, Idaho
Am Heritage 32:28 (3) Ap '81
--Syria
Nat Geog 154:338 (c,3) S '78
--Tellico, Tennessee
Smithsonian 10:100 (c,4) Ja '80
--See also GRAND COULEE DAM
DAMS--CONSTRUCTION
--South Africa
Nat Geog 151:794 (c,3) Je '77
DANCERS
--Bhutan
Life 2:138-9 (c,1) N '79
--Street performers (Great
Britain)
Smithsonian 9:106-7 (c,2) My
'78
--See also ASTAIRE, FRED;
DUNCAN, ISADORA
DANCES
--Ball (Prague, Czechoslovakia)
Nat Geog 155:558-9 (c,2) Ap '79

--Barn dance (Wisconsin)
Nat Geog 152:192 (c,1) Ag '77
--Formal ball (Vienna, Austria)
Smithsonian 10:87 (c,1) O '79
--High school prom (Kansas)
Life 2:96-7 (1) Je '79
DANCING
Nat Geog 151:483 (c,1) Ap '77
Life 2:31 (c,3) Jl '79
--18th cent. courtesan's sword
dance (Korea)
Smithsonian 10:116-17 (paint-
ing, c,2) My '79
--1920's
Smithsonian 9:181 (drawing,4)
O '78
--Acapulco nightclub, Mexico
Trav/Holiday 156:51 (c,3) N '81
--Arakhova, Greece
Nat Geog 157:360-1 (c,1) Mr '80
--Aztec Indians (Mexico)
Nat Geog 158:708-9 (c,1) D '80
--Ballroom championships (New
York)
Life 1:40-1 (c,1) N '78
--Bhutan
Natur Hist 89:cov., 39-47 (c,1)
Mr '80
--Brazil
Nat Geog 152:686-7 (c,1) N '77
--British spring morris dancing
(Vermont)
Smithsonian 12:118-25 (c,1) My
'81
--Cabaret (Estonia)
Nat Geog 157:506-7 (c,1) Ap '80
--Cambodia
Smithsonian 11:118-19, 125 (c,1)
S '80
--Crete
Nat Geog 153:146-7 (c,2) F '78
--Dagomba tribe (Ghana)
Natur Hist 88:70-5 (c,1) N '79
--Disco
Ebony 32:54-60 (c,2) F '77
Ebony 33:64-8 (c,2) Ag '78
Life 1:42-52 (c,1) N '78
Ebony 34:83 (4) Ap '79
Ebony 34:40 (c,4) My '79
Life 2:81 (c,1) D '79
--Disco (Chicago, Illinois)
Nat Geog 153:488 (c,1) Ap '78
--Disco (New York City, New
York)
Life 2:130-1 (c,1) N '79
--Disco (New York street festival)
Natur Hist 88:82 (c,2) Ag '79
--Gauchos (Argentina)

Nat Geog 158:492 (c, 1) O '80
--Grenadine Islands
Nat Geog 156:420-5 (c, 2) S '79
--Hawaii
Trav/Holiday 150:41 (c, 2) D
'78
--Hula (Hawaii)
Nat Geog 152:595 (c, 4) N '77
Trav/Holiday 154:59 (c, 4) N
'80
Ebony 36:119-20 (c, 4) Ja '81
Trav/Holiday 155:61 (c, 1) Mr
'81
Nat Geog 160:209 (c, 1) Ag '81
--Limbo (Caribbean)
Trav/Holiday 151:60 (c, 4) Ap
'79
Trav/Holiday 155:70 (c, 4) Ap
'81
--Limbo (Jamaica)
Ebony 32:96 (c, 4) Ja '77
--Masai tribe (Kenya)
Trav/Holiday 151:65 (c, 4) Je
'79
--Mexico
Trav/Holiday 152:57 (c, 4) Jl
'79
--New Mexico Indians
Trav/Holiday 149:38 (c, 4) Ja
'78
--New Wave
Life 3:102-3 (c, 1) Je '80
--Oglala Indians (Wyoming)
Trav/Holiday 149:41 (c, 4) Je
'78
--Old West dance hall style
(Yukon, Canada)
Nat Geog 153:548-9 (c, 1) Ap
'78
--Oman
Nat Geog 160:344-5 (c, 1) S '81
--On stilts (Nigeria)
Ebony 34:39 (4) Ja '79
--Silhouette of Indian rain dance
Nat Wildlife 17:30-1 (4) Je '79
--Spain
Natur Hist 87:55 (c, 1) Ap '78
--Square dancing (California)
Nat Geog 155:707 (c, 1) My
'79
--Sri Lanka
Natur Hist 87:cov. , 43-9 (c, 1)
Ja '78
--Tahiti
Nat Geog 155:856 (c, 4) Je '79
--Tap dancing
Life 4:95-100 (c, 1) My '81
--Thailand

Trav/Holiday 154:44 (c, 4) N '80
--Virgin Islands night club
Ebony 33:112 (c, 4) Ja '78
Trav/Holiday 149:28 (c, 4) F '78
--Warm Springs Indian (Oregon)
Nat Geog 155:504 (c, 1) Ap '79
--Warming up
Smithsonian 11:54-60 (c, 1) Mr '81
Life 4:109 (4) Je '81
--Zigili tribe (South Africa)
Trav/Holiday 152:56 (c, 3) S '79
--Zulus (1830's; South Africa)
Am Heritage 29:68-9 (painting, c, 3)
F '78
--See also BALLET DANCING;
BELLY DANCING; FOLK
DANCING; NIGHT CLUBS
DANCING--EDUCATION
--Ballroom (Utah)
Sports Illus 53:88 (c, 4) D 8 '80
--Dancing school (Vienna, Austria)
Nat Geog 152:464-5 (c, 1) O '77
DANCING, CONTEMPORARY
Sports Illus 51:37 (c, 4) S 10 '79
--Detroit, Michigan lounge
Nat Geog 155:832-3 (c, 1) Je '79
--Texas
Sports Illus 53:61 (3) N 17 '80
--Wales
Sports Illus 51:99 (painting, c, 3)
D 24 '79
DANCING, MODERN
Ebony 32:149 (c, 3) Mr '77
Natur Hist 86:93 (4) Mr '77
Ebony 34:112 (4) O '79
Ebony 35:68 (4) F '80
Smithsonian 11:cov. , 60-9 (c, 1)
O '80
Smithsonian 12:82 (c, 4) Je '81
--1944
Life 2:7-8 (3) Jl '79
--Practicing
Ebony 34:167 (3) My '79
--Street (Charlotte, North Carolina)
Nat Geog 157:332-3 (c, 1) Mr
'80
--See also DUNCAN, ISADORA
DANDELIONS
Smithsonian 8:93 (painting, c, 4)
Ap '77
Smithsonian 8:14 (4) Ag '77
Smithsonian 9:124, 130 (c, 4) F
'79
Natur Hist 89:38 (c, 2) D '80
Nat Geog 159:372 (c, 4) Mr '81
DANTE
--"Inferno" illustration by Botticelli
Smithsonian 7:112 (painting, c, 3)

Ja '77
DANUBE RIVER, EUROPE
Nat Geog 152:454-85 (map, c, 1)
O '77
Trav/Holiday 154:38-41 (map, c, 2)
Jl '80
Life 4:42-3 (c, 1) Ag '81
DARTERS (BIRDS)
Natur Hist 86:cov. (c, 1) Ag '77
DARTERS (FISH)
Nat Wildlife 20:12-16 (c, 3) D
'81
--Ashy darters
Natur Hist 86:69 (3) F '77
DARWIN, CHARLES
--Sculpture (New York City, New
York)
Smithsonian 11:105 (c, 4) Mr
'81
DATE PALMS
Natur Hist 86:114 (c, 1) O '77
DAVAO, PHILIPPINES
Travel 148:36-41 (c, 1) Ag '77
DAVIS, JEFFERSON
Travel 147:31 (painting, 4) Ja
'77
--Drawing of Minerva by him
Am Heritage 32:96 (drawing, 4)
D '80
DAWSON CITY, YUKON
Travel 148:57 (c, 2) Jl '77
Nat Geog 153:573-5 (c, 1) Ap
'78
Sports Illus 51:80 (c, 4) O 29
'79
DAY CARE CENTERS
--Atlanta, Georgia
Ebony 35:66 (4) Ja '80
--California
Ebony 33:150 (3) Je '78
--Memphis, Tennessee
Ebony 33:90 (3) Mr '78
DEAD SEA, MIDDLE EAST
Nat Geog 153:224-45 (map, c, 1)
F '78
DEARBORN, MICHIGAN
Trav/Holiday 149:60-1 (c, 4)
Mr '78
--Greenfield Village Museum
Am Heritage 32:98-107 (c, 1)
D '80
DEATH
--Dead people in Guyana
Life 2:100-1 (c, 1) Ja '79
--Murdered gangsters (New York)
Life 2:136-7 (1) S '79
--Police moving dead crime
victim

Ebony 34:38 (4) Ag '79
--Poor dead and dying people (India)
Life 3:54-64 (1) Jl '80
--Suicide victim
Life 1:66-7 (painting, c, 1) O '78
--Victim of tiger attack (Nepal)
Smithsonian 11:107 (c, 3) Jl '80
--See also FUNERAL RITES AND
CEREMONIES
DEATH MASKS
--16th cent. B. C. (Mycenae,
Greece)
Nat Geog 153:cov., 142-3 (c, 1)
F '78
--Mayan Indians (Mexico)
Smithsonian 8:82 (c, 4) Ap '77
--Tutankhamun (Egypt)
Nat Geog 151:cov. (c, 1) Mr '77
DEATH VALLEY, CALIFORNIA
--Rocks moving by themselves
Smithsonian 8:11 (4) Ap '77
Decoys. See HUNTING EQUIPMENT
DEER
Nat Wildlife 15:53 (painting, c, 2)
O '77
Sports Illus 48:46 (drawing, c, 4)
Ap 3 '78
Sports Illus 48:44 (drawing, 4) Je
26 '78
Nat Geog 155:358-9 (c, 1) Mr '79
Smithsonian 10:82-3 (c, 4) Ja '80
Smithsonian 11:120 (c, 4) N '80
Natur Hist 90:75 (drawing, 4) My
'81
Natur Hist 90:56 (woodcut, o, 4)
Je '81
Nat Geog 160:194-5 (c, 1) Ag '81
--14th cent. painting
Smithsonian 8:58 (c, 4) S '77
--19th cent. painting of stag
Smithsonian 12:71 (painting, c, 2)
N '81
--Barasingha
Natur Hist 88:47-55 (c, 1) O '79
--Bucks
Nat Wildlife 19:46-7 (c, 2) O '81
--Ezo stag
Nat Geog 157:84 (c, 1) Ja '80
--Fallow
Smithsonian 9:72 (c, 2) Je '78
--Fawns
Nat Wildlife 17:32 (painting, c, 2)
D '78
Nat Wildlife 19:9 (c, 4) Ap '81
Nat Wildlife 19:8 (c, 2) O '81
--Key
Nat Geog 151:687 (c, 4) My '77
Trav/Holiday 154:48 (c, 4) N '80

--Mouse
 Natur Hist 87:46 (c, 4) My '78
--Mule
 Nat Wildlife 15:28 (c, 2) O '77
 Nat Geog 154:21 (c, 1) Jl '78
 Nat Geog 154:504 (c, 2) O '78
 Nat Wildlife 16:4, 8 (map, c, 2)
 O '78
 Nat Geog 156:130 (c, 4) Jl '79
 Natur Hist 89:56-65 (c, 1) Mr
 '80
 Nat Wildlife 18:46-7 (c, 1) Ap
 '80
 Nat Wildlife 19:12 (c, 4) O '81
--Muntjacs
 Smithsonian 10:78-9 (c, 3) Ja
 '80
--Poaching victims
 Sports Illus 50:49 (3) F 26 '79
--Red
 Natur Hist 89:60 (c, 4) Je '80
 Trav/Holiday 155:38 (c, 4) Ja
 '81
 Natur Hist 90:70 (c, 1) F '81
--White-tailed
 Nat Wildlife 15:9 (painting, c, 2)
 Ja '77
 Smithsonian 8:124 (c, 4) My '77
 Nat Wildlife 15:4-5 (c, 1) Je '77
 Nat Wildlife 16:cov. (paint-
 ing, c, 1) D '77
 Nat Wildlife 16:4, 9 (map, c, 2)
 O '78
 Nat Wildlife 17:10 (c, 4) D '78
 Nat Geog 156:388 (c, 2) S '79
 Nat Wildlife 18:53 (c, 4) O '80
 Nat Wildlife 19:3 (c, 1) D '80
 Nat Geog 160:cov., 683 (c, 2)
 N '81
--White-tailed fawns
 Nat Wildlife 16:58-9 (c, 1) D
 '77
 Nat Wildlife 17:7 (c, 4) Je '79
--See also CARIBOU; ELK;
 MOOSE; REINDEER
DEGAS, EDGAR
--Sculpture
 Smithsonian 10:50-1 (c, 2) S
 '79
DEITIES
--19th cent. Ho-tei sculpture
 (China)
 Natur Hist 89:67 (c, 1) S '80
--Ancient Crete
 Nat Geog 153:150, 178-9
 (sculpture, c, 2) F '78
--Aztec gods (Mexico)
 Nat Geog 158:762-7 (c, 4) D '80

--Bahubali (India)
 Life 4:126 (c, 2) Ap '81
--Buddhist (Nepal)
 Nat Geog 151:511 (c, 1) Ap '77
--Pre-Columbian Mexico
 Smithsonian 9:55-9 (sculpture, c, 2)
 My '78
--Tanit (Carthage)
 Smithsonian 9:42-3 (sculpture, c, 1)
 F '79
--See also BUDDHA; JESUS
 CHRIST; MYTHOLOGY
DE KOONING, WILLEM
 Nat Geog 157:670-1 (c, 1) My '80
DELAWARE
--Colonial houses
 Trav/Holiday 150:63, 67 (c, 3)
 D '78
DELAWARE INDIANS--COSTUME
 Nat Geog 151:419 (4) Mr '77
DELFT, NETHERLANDS
--Flower market
 Trav/Holiday 153:44 (c, 4) F '80
DELHI, INDIA
 Travel 148:62-3 (c, 4) O '77
Demolition. See BUILDING DEMO-
 LITION
DEMONSTRATIONS
--1903 nude protest (Saskatchewan)
 Nat Geog 155:672 (3) My '79
--1960 civil rights (Nashville, Ten-
 nessee)
 Ebony 35:112 (3) My '80
--1961 anti-black American Nazis
 (Washington, D. C.)
 Sports Illus 51:77 (4) Jl 2 '79
--1963 civil rights (Alabama)
 Ebony 36:108 (3) N '80
--1967 anti Vietnam War (New
 York)
 Am Heritage 29:22-3 (1) Ap '78
--1973 civil rights (Illinois)
 Ebony 36:158 (4) Je '81
--Anti busing (Boston, Massachu-
 setts)
 Life 2:180 (4) D '79
--Anti developers (Molokai, Hawaii)
 Nat Geog 160:202 (c, 1) Ag '81
--Anti EEC sugar quota (Ireland)
 Nat Geog 159:450 (c, 1) Ap '81
--Anti genetic engineering
 Smithsonian 8:57 (4) Je '77
--Anti Iran (California)
 Life 3:29 (1) Ja '80
--Anti national park (California)
 Nat Geog 152:360-1 (c, 3) S '77
--Anti North Korea (South Korea)
 Nat Geog 156:786-7 (c, 1) D '79

--Anti nuclear energy
 Life 2:28-9 (2) My '79
--Anti nuclear energy (France)
 Nat Geog 155:484-5 (c, 1) Ap
 '79
--Anti nuclear energy (New York)
 Life 2:150-1 (3) N '79
--Anti paraquat
 Smithsonian 9:80 (c, 4) Ja '79
--Anti police brutality
 Ebony 36:46 (3) Mr '81
--Anti Rhodesian politics
 Ebony 34:39 (4) Ja '79
--Anti SST
 Nat Geog 152:216 (c, 4) Ag '77
--Anti U. S. (Iran)
 Life 3:22-7 (1) Ja '80
--Black education (North Carolina)
 Nat Geog 157:355 (c, 1) Mr
 '80
--Burning environmentalist in
 effigy (Utah)
 Nat Geog 158:788 (4) D '80
--Earth Day 1970
 Nat Wildlife 17:17-18 (c, 4) F
 '79
--El Salvador anti-repression
 march (Costa Rica)
 Nat Geog 160:36-7 (c, 3) Jl '81
--Farmers (Georgia)
 Nat Geog 154:234 (c, 1) Ag '78
--Irrigation issue (California)
 Nat Geog 158:168 (c, 4) Ag '80
 Labor (Poland)
 Life 4:34-5 (c, 1) Ja '81
 Life 4:10-18 (1) My '81
--Peasants (Mexico)
 Nat Geog 153:616-17 (c, 2) My
 '78
--Posters (China)
 Nat Geog 158:22-3 (c, 2) Jl '80
--Pro abortion (New York City,
 New York)
 Life 4:45 (3) N '81
--Pro black colleges (Washington,
 D. C.)
 Ebony 36:106 (2) Ja '81
--Pro desegregation (Cleveland,
 Ohio)
 Ebony 35:80 (4) O '80
--Pro national Martin Luther
 King, Jr. holiday (D. C.)
 Ebony 36:126-9 (c, 2) Mr '81
--Pro nuclear energy (New
 Hampshire)
 Nat Geog 155:461 (c, 3) Ap '79
--Protesting job layoffs (Chicago,
 Illinois)

Ebony 34:94 (3) S '79
--Save Mono Lake, California
 Nat Geog 160:514-15 (c, 2) O '81
--Save the Whales
 Nat Wildlife 17:21 (c, 4) F '79
--Saving Harlem hospital (New
 York)
 Nat Geog 151:202-3 (c, 1) F '77
--Striking umpires
 Sports Illus 50:18-21 (c, 4) Ap
 16 '79
--Turkey
 Life 3:129 (c, 2) Ap '80
--Welfare recipients (Michigan)
 Ebony 32:33 (3) Ag '77
--See also CIVIL RIGHTS
 MARCHES; RIOTS
DEMPSEY, JACK
 Am Heritage 28:cov. , 72-83
 (c, 1) Ap '77
 Ebony 33:128 (4) Mr '78
DENMARK
--Hans Christian Andersen sites
 Nat Geog 156:824-49 (c, 1) D '79
--Jutland
 Trav/Holiday 154:cov. , 42-7
 (map, c, 1) Ag '80
--See also COPENHAGEN; FAEROE
 ISLANDS
DENMARK--COSTUME
 Nat Geog 156:824-47 (c, 1) D '79
DENMARK--RELICS
--17th cent. throne
 Smithsonian 10:119 (c, 4) F '80
DENS
 Sports Illus 55:92-3 (c, 1) Ag 24
 '01
--Atlanta, Georgia
 Ebony 35:94 (c, 4) O '80
--Cuba
 Nat Geog 151:45 (c, 3) Ja '77
--Las Vegas, Nevada
 Ebony 36:36 (c, 3) My '81
--Washington, D. C. mansion
 Smithsonian 8:64-5 (c, 3) S '77
DENTISTRY
 Ebony 32:34 (4) Mr '77
 Ebony 32:110 (3) My '77
 Sports Illus 47:64 (c, 4) Jl 11 '77
 Ebony 33:48 (3) O '78
 Ebony 35:139 (4) N '79
 Ebony 35:28 (4) Mr '80
 Sports Illus 54:46 (4) Ap 6 '81
--Administering anesthesia
 Ebony 32:34 (4) S '77
--Braces on teeth
 Sports Illus 51:53 (c, 1) Jl 9 '79
--Fitting athletes' mouthpieces

Sports Illus 52:36-42 (1) Je 2
'80
--Taking X-ray
Ebony 33:138 (4) Ag '78
DENVER, COLORADO
Ebony 33:98 (4) F '78
Nat Geog 155:382-411 (map, c, 1)
Mr '79
--Art museum
Smithsonian 10:115 (c, 4) Ap '79
DES MOINES, IOWA
Nat Geog 159:606-7 (c, 1) My
'81
DESERTS
Nat Geog 156:586-639 (map, c, 1)
N '79
--Chihuahua, Texas
Nat Wildlife 18:50-3 (c, 1) D '79
--Egypt
Smithsonian 10:62-3 (c, 2) My
'79
--Hurt by off-road vehicles
Smithsonian 9:66-75 (c, 1) S
'78
--Kenya
Life 2:66-7 (c, 1) Ag '79
--Northeastern Africa
Smithsonian 8:34-41 (c, 1) Je
'77
--Oman
Nat Geog 160:346 (c, 4) S '81
--Qattara Depression, Egypt
Nat Geog 151:330-1 (c, 2) Mr
'77
--Reclaiming land
Nat Geog 156:618-23 (c, 1) N
'79
--Tengger (China)
Nat Geog 157:308-9 (c, 1) Mr
'80
--Tunisia
Smithsonian 10:cov., 32-41 (c, 1)
Ag '79
--Utah
Nat Geog 156:218-19 (c, 1) Ag
'79
--Western Australia
Nat Geog 153:584-607 (c, 1) My
'78
--Western U. S.
Smithsonian 9:66-75 (c, 1) S '78
--See also MOJAVE DESERT;
SAHARA DESERT
DESIGN, DECORATIVE
--1930's Bauhaus teapot
Life 2:84-5 (c, 2) S '79
--Arizona rock formations
Nat Wildlife 19:20-4 (c, 1) F '81

--Art deco architecture (1926-1940;
Miami, Florida)
Am Heritage 32:50-1 (c, 4) F '81
--Art nouveau lamp (1933)
Life 2:83 (c, 4) S '79
--Computer graphics
Smithsonian 12:106-13 (c, 1) Je
'81
--Maya-Quiche Indian fabrics
(Guatemala)
Travel 148:33-4 (c, 1) S '77
--Pueblo Indian pot decoration
Am Heritage 30:2 (c, 2) F '79
--Stenciled ceilings (West)
Smithsonian 12:138-43 (c, 1) O
'81
--Symmetry of crystals
Natur Hist 87:64-70 (c, 1) F '78
--Treasures of Cooper-Hewitt
Museum, New York
Smithsonian 8:68-77 (c, 1) N '77
--Visual puns
Natur Hist 89:72-7 (c, 1) F '80
--Wallpaper with scenes of U. S.
history
Am Heritage 33:81-9 (c, 1) D '81
DESKS
Smithsonian 8:68 (c, 2) N '77
--18th cent. Italy
Smithsonian 12:76 (c, 4) N '81
--1770's secretary (Rhode Island)
Am Heritage 31:23 (c, 4) Ap '80
--Louis XV style
Smithsonian 11:46-7 (c, 4) Jl '80
--U. S. presidents
Am Heritage 32:63-4 (c, 4) O '81
--Used by world rulers
Life 2:82-9 (c, 1) Mr '79
DETECTIVES
--Dressed as Orthodox Jews (New
York)
Natur Hist 86:48 (2) Ja '77
--19th cent. Pinkerton detectives
Smithsonian 12:60-8 (c, 3) Ag '81
--See also PINKERTON, ALLAN
DETROIT, MICHIGAN
Trav/Holiday 149:59-63 (c, 2) Mr
'78
Ebony 33:29-40 (4) Ap '78
Nat Geog 155:820-33 (c, 1) Je '79
--Early 20th cent. life in the ghetto
Am Heritage 30:11 (4) F '79
DETROIT RIVER, DETROIT,
MICHIGAN
Nat Geog 155:820-1 (c, 1) Je '79
--1920's
Smithsonian 10:116 (4) Je '79
DEVIL

--Beguiling St. Anthony
 Smithsonian 11:118 (painting, c, 4)
 Jl '80
--Woodcuts
 Am Heritage 29:14-23 (c, 2) Ag
 '78
DEWEY, MELVIL
 Am Heritage 32:72 (2) D '80
 Am Heritage 32:112 (4) Je '81
DIABETES
--Taking insulin shot
 Ebony 34:66 (3) Mr '79
DIAGHILEV, SERGEI
 Smithsonian 10:150 (drawing, 4)
 D '79
DIAMOND HEAD VOLCANO,
 HONOLULU, HAWAII
 Nat Geog 156:654 (c, 3) N '79
 Ebony 35:79 (2) Ja '80
DIAMOND INDUSTRY
 Nat Geog 155:92-9 (c, 1) Ja '79
DIAMOND MINES
--Kimberley, South Africa
 Nat Geog 155:88-9 (c, 2) Ja '79
--Namibia
 Nat Geog 155:90-1 (c, 1) Ja '79
DIAMOND MINING
--Diamond hunting (Arkansas)
 Travel 147:50, 53 (c, 4) Ja '77
--Namibia
 Smithsonian 12:48-57 (c, 1) My
 '81
--South Africa
 Trav/Holiday 152:56-9, 68-9
 (c, 2) S '79
--Venezuela
 Natur Hist 88:66-71 (1) D '79
DIAMONDS
 Smithsonian 8:30 (c, 4) D '77
 Nat Geog 155:84-112 (c, 1) Ja
 '79
 Nat Geog 155:327 (c, 4) Mr '79
 Smithsonian 12:49, 54-5 (c, 4)
 My '81
--Hope Diamond
 Nat Geog 155:112 (c, 1) Ja '79
 Smithsonian 12:54 (c, 4) My '81
DIANA
--1780 sculpture by Houdon
 Smithsonian 11:48 (c, 4) Jl '80
DIAZ, PORFIRIO
 Smithsonian 11:31 (4) Jl '80
DICE
 Sports Illus 52:E5 (painting, c, 4)
 Ap 21 '80
--Ancient Pompeii
 Natur Hist 88:74-5 (painting, c, 2)
 Ap '79

DICKENS, CHARLES
--Bob Cratchit's Christmas dinner
 Natur Hist 88:98 (drawing, 4) D
 '79
DIK-DIKS
 Natur Hist 87:44-9 (c, 1) My '78
DIMAGGIO, JOE
 Sports Illus 49:86 (4) O 9 '78
 Life 2:7 (4) Jl '79
DINGOES
 Trav/Holiday 152:74 (4) N '79
DINING ROOMS
--17th cent. Belgian mansion
 Smithsonian 8:52-3 (c, 2) O '77
--Early 20th cent. France
 Smithsonian 10:58 (c, 3) F '80
--Atlanta, Georgia
 Ebony 35:94 (c, 4) O '80
--Country inn (California)
 Sports Illus 52:68 (c, 3) Je 16 '80
--Elegant Harlem, New York room
 Nat Geog 151:184-5 (c, 1) F '77
--Formal (British office)
 Smithsonian 11:88 (c, 3) Mr '81
--Gothic style (Tarrytown, New
 York)
 Trav/Holiday 150:51 (4) N '78
--Las Vegas, Nevada
 Ebony 36:36 (c, 4) My '81
--Massachusetts mansion
 Ebony 36:60 (c, 4) O '81
--Washington, D. C. mansion
 Smithsonian 8:60 (c, 1) S '77
DINNERS AND DINING
--19th cent. banquet (Mexico)
 Smithsonian 9:60-1 (painting, c, 1)
 My '78
--1877 railroad dining car
 Am Heritage 28:18 (drawing, 2)
 F '77
--1918 camping trip
 Smithsonian 9:93 (3) Je '78
--1934 farmhouse
 Smithsonian 11:92-4 (painting, c, 1)
 N '80
--Banquet
 Sports Illus 46:48 (4) My 30 '77
 Sports Illus 48:35 (c, 4) Ap 17
 '78
 Ebony 34:102-6 (3) Jl '79
--Banquet (France)
 Nat Geog 153:814-15 (c, 2) Je '78
--Banquet (Saudi Arabia)
 Life 4:92-3 (c, 1) Jl '81
--Banquet (Virginia)
 Ebony 35:153 (4) My '80
--Baseball players eating sunflower
 seeds

Sports Illus 53:50-4 (drawing, c, 3) O 6 '80
--Breakfast
 Ebony 36:95 (4) S '81
--Breakfast aboard barge (Netherlands)
 Trav/Holiday 153:45 (c, 2) F '80
--Breakfast at poolside (Nevada)
 Ebony 36:35 (c, 3) My '81
--Breakfast in bed (California)
 Ebony 35:33 (c, 3) O '80
--Breakfast in bed (Texas)
 Ebony 36:106 (c, 1) Ag '81
--Buffet
 Ebony 36:138 (c, 4) Mr '81
--Buffet (Guam)
 Ebony 34:34 (4) F '79
 Trav/Holiday 154:43 (c, 4) Jl '80
--Buffet (Las Hadas, Mexico)
 Trav/Holiday 153:55 (c, 4) F '80
--Buffet (St. Lucia)
 Trav/Holiday 151:59 (c, 4) Ap '79
--Buffet (Saudi Arabia)
 Nat Geog 154:602-3 (c, 1) N '78
 Life 2:95 (c, 3) D '79
--Buffet (Shipboard)
 Travel 147:38 (4) Je '77
 Travel 148:69 (4) S '77
--Buffet (South Carolina resort)
 Trav/Holiday 153:63 (c, 3) Ap '80
--Camping trip (Alberta)
 Trav/Holiday 155:46 (c, 2) My '81
--Child eating corn (Manitoba)
 Trav/Holiday 153:53 (c, 4) My '80
--China
 Smithsonian 8:118-19 (c, 3) Ap '77
 Nat Geog 160:740 (c, 4) D '81
--Clambake (Massachusetts)
 Natur Hist 89:96-102 (1) Je '80
--Cookout (Arizona)
 Sports Illus 52:66 (c, 3) Je 16 '80
--Couple eating dinner
 Ebony 36:111 (4) Mr '81
--Dining hall (Saskatchewan)
 Nat Geog 155:676-7 (c, 2) My '79
--Easter dinner (Greece)
 Nat Geog 157:372-3 (c, 1) Mr '80
--Eating oysters (early 19th cent.; Pennsylvania)

Am Heritage 31:68-9 (lithograph, c, 1) F '80
--Eating oysters (South)
 Natur Hist 90:92 (3) Ag '81
--Eating popcorn
 Sports Illus 48:24 (c, 3) Ap 17 '78
--Eating pretzel (Switzerland)
 Trav/Holiday 150:cov. (c, 1) Jl '78
--Eating raw fish (Canada)
 Nat Geog 152:636 (c, 4) N '77
--Eating watermelon
 Sports Illus 47:38 (c, 4) Jl 18 '77
--Elegant restaurant (Wisconsin)
 Sports Illus 52:47 (4) Je 16 '80
--Family dinner
 Sports Illus 50:32 (4) Ja 29 '79
 Ebony 34:78 (4) Ap '79
 Ebony 35:36 (4) My '80
 Ebony 35:70 (4) Ag '80
--Hotel banquet (New York)
 Ebony 36:149 (c, 3) D '80
--Hotel banquet (Washington, D. C.)
 Life 3:102-3 (c, 1) Ap '80
--Iran
 Life 1:27 (c, 4) O '78
--Irish college dinner
 Sports Illus 50:66 (c, 4) Je 25 '79
--Japan
 Sports Illus 51:61 (painting, c, 4) S 24 '79
 Natur Hist 90:53 (c, 4) O '81
--Jordan
 Smithsonian 9:86 (c, 4) Ag '78
--Lobster dinner (Prince Edward Island)
 Trav/Holiday 151:54 (c, 4) My '79
--Louisiana
 Nat Geog 156:380 (c, 2) S '79
--Louisiana crayfish eating contest
 Nat Wildlife 19:32 (4) Je '81
--Lunch in informal restaurant
 Ebony 36:68 (4) Mr '81
--Lunch in school cafeteria
 Ebony 33:106 (4) D '77
--Pizza party
 Sports Illus 54:70 (c, 4) My 11 '81
 Sports Illus 54:65 (c, 4) Je 15 '81
--Puerto Rico inn
 Trav/Holiday 149:53 (c, 4) Je '78
--Restaurant
 Ebony 33:106 (3) F '78
 Ebony 36:102 (4) Jl '81

--Shipboard hors d'oeuvres
 Travel 147:34 (c, 2) Ja '77
--Snack foods
 Ebony 33:35 (2) Ja '78
--Snacking on cookies (Illinois)
 Ebony 34:53 (2) S '79
--South Africa
 Nat Geog 151:785 (c, 3) Je '77
--Sports award banquets
 Sports Illus 46:33-6 (c, 2) F
 28 '77
--Turkey
 Nat Geog 153:773 (c, 3) Je '78
--Vietnamese family (Mississippi)
 Nat Geog 160:390-1 (c, 2) S '81
--West African feast (South Caro-
 lina)
 Ebony 33:87 (c, 3) Ja '78
--See also COOKING; DINING
 ROOMS; DRINKING CUSTOMS;
 FOOD; PICNICS; RESTAURANTS
DINOSAURS
 Nat Geog 154:cov. , 152-85
 (painting, c, 1) Ag '78
 Life 4:163-8 (drawing, c, 1) N '81
 Smithsonian 12:99-114 (c, 1) D
 '81
--Allosaurs
 Smithsonian 9:26 (drawing, 4) Je
 '78
--Brachiosaurus
 Natur Hist 87:9 (drawing, 3) My
 '78
--Brontosaurus
 Nat Geog 154:180-1 (painting, c, 1)
 Ag '78
--Ceratosaurus
 Smithsonian 9:26 (drawing, 4)
 Je '78
--Gorgosaurus skeleton
 Trav/Holiday 153:84 (4) Ap '80
--Ichthyosaur skeleton
 Natur Hist 88:32 (4) Ja '79
--Sauropods
 Smithsonian 9:34 (drawing, 4)
 N '78
--Teeth discovered in Mongolia
 Life 3:117 (c, 2) D '80
--Triceratops
 Natur Hist 87:10 (drawing, 4)
 My '78
--Tyrannosaurus
 Nat Geog 154:162-3 (painting, c, 1)
 Ag '78
--See also ARCHAEOPTERYX
DISASTERS
--Hindenburg airship (1937; New
 Jersey)

Smithsonian 8:130-1 (4) Ap '77
--See also ACCIDENTS; AVA-
 LANCHES; CRASHES; OIL
 SPILLS; SHIPWRECKS; list
 under WEATHER PHENOMENA
DISC JOCKEYS
--China
 Life 3:113 (c, 4) O '80
--Discotheques
 Ebony 32:56, 62 (4) F '77
Discotheques. See DANCING;
 NIGHT CLUBS
DISCUS THROWING
 Sports Illus 46:56 (4) Ap 25 '77
 Sports Illus 47:57 (c, 4) Ag 22
 '77
 Life 3:39 (c, 4) Mr '80
DISEASES
--Mid 19th cent. patients
 Life 3:14 (4) S '80
--Autism
 Life 2:92-6 (1) My '79
--Carried by mosquitos
 Nat Geog 156:430-7 (map, c, 1) S
 '79
--Emphysema-clogged lungs
 Nat Geog 153:375 (4) Mr '78
--Evidence of disease in ancient
 Peruvian mummies
 Natur Hist 88:75-81 (c, 1) F '79
--Eye diseases
 Life 2:75-8 (c, 2) Mr '79
--Lupus
 Ebony 34:127-32 (3) Ap '79
--Mental illness
 Life 4:56-70 (1) My '81
--Multiple sclerosis
 Life 4:78-88 (1) Jl '81
--Pear tree fire blight
 Natur Hist 88:64-7 (c, 2) My '79
--Person suffering from headache
 Ebony 36:85 (2) O '81
--See also ALCOHOLISM; BUBONIC
 PLAGUE; CANCER; DIABETES;
 DRUG ABUSE; LEPROSY;
 MALARIA; MALNUTRITION;
 MEDICINE-PRACTICE; SMALL-
 POX; STROKES; TUBERCULO-
 SIS; VACCINATIONS; VIRUSES
DISEASES--HUMOR
--Occupational hazards
 Smithsonian 10:123-34 (drawing, 4)
 Ap '79
DIVING
 Ebony 33:106 (4) D '77
 Sports Illus 48:24-5 (c, 3) My 8
 '78
 Ebony 33:64 (3) Jl '78

Sports Illus 49:28 (c, 4) S 4
'78
Life 3:103-7 (c, 1) My '80
Sports Illus 52:61-2 (4) My 5
'80
Sports Illus 54:32-5 (c, 1) My
11 '81
DJIBOUTI
Nat Geog 154:518-33 (map, c, 1)
O '78
DJIBOUTI--COSTUME
Nat Geog 154:518-33 (c, 1) O
'78
DNA. See GENETICS
DOCTORS
Ebony 32:34 (4) S '77
Ebony 33:128-30 (3) Ap '78
Sports Illus 48:80 (c, 3) Ap 17
'78
Ebony 33:92, 98 (4) O '78
Ebony 34:46 (4) Ap '79
Ebony 36:100-2 (2) D '80
Ebony 36:41, 64 (c, 2) Je '81
Ebony 36:91-3 (3) O '81
--1664 (Massachusetts)
Am Heritage 32:18 (paint-
ing, c, 4) Je '81
--19th cent. U. S.
Life 3:9 (2) S '80
Am Heritage 32:16-27 (paint-
ing, c, 1) Je '81
--Surgeons
Life 2:cov., 24-7 (c, 1) Ag '79
Ebony 35:62-8 (3) S '80
Life 4:28-36 (c, 1) S '81
--See also MEDICINE--PRACTICE;
PHARMACISTS; PSYCHIA-
TRISTS; PSYCHOLOGISTS;
RUSH, BENJAMIN;
SCHWEITZER, ALBERT;
SHAMANS; VETERINARIANS
DOG RACES
--Greyhounds (Florida)
Sports Illus 46:18-19 (c, 3) Mr
14 '77
DOG SHOWS--HUMOR
--Westminster Kennel Club
Sports Illus 52:66-78 (paint-
ing, c, 1) F 4 '80
DOG SLEDS
Sports Illus 48:33 (c, 4) F 27
'78
Nat Wildlife 19:10-11 (c, 2) D
'80
Sports Illus 53:40 (c, 4) D 8
'80
--1910 Eskimos (Canada)
Natur Hist 89:88-90 (3) Ap '80

--Alaska
Travel 147:57 (4) Ap '77
--Arctic (Canada)
Nat Geog 154:306-24 (c, 1) S '78
--Huskies resting
Travel 148:72 (4) Jl '77
--Yukon
Nat Geog 153:556-7 (c, 1) Ap '78
DOGHOUSES
Ebony 36:59 (4) N '80
DOGS
Nat Geog 151:469-72 (c, 2) Ap '77
Nat Geog 151:716 (c, 4) My '77
Nat Geog 153:580-98 (c, 1) My
'78
Nat Geog 154:208 (c, 4) Ag '78
Nat Geog 154:653 (c, 1) N '78
Life 1:61 (c, 2) D '78
Sports Illus 50:64 (c, 4) Mr 5
'79
Ebony 35:71 (4) Mr '80
Nat Wildlife 18:46 (c, 4) O '80
Life 4:58 (c, 3) F '81
Smithsonian 12:62-9 (painting, c, 3)
N '81
--Begging
Smithsonian 10:80 (c, 4) D '79
--German short-hair
Nat Wildlife 20:22 (drawing, 1)
D '81
--Newborn husky pups
Nat Geog 154:318 (c, 1) S '78
--Playing with frisbees
Life 1:111-12 (c, 2) O '78
--Role in frontier life
Am Heritage 32:58-63 (paint-
ing, c, 1) F '81
--Strays
Life 3:38-43 (2) S '80
--Unusual breeds
Life 2:cov., 3, 42-8 (c, 1) Ja
'79
--Walking dogs
Ebony 33:82 (4) Mr '78
Ebony 34:112 (3) S '79
Ebony 35:139 (4) Ag '80
Ebony 36:59 (c, 4) O '81
--Walking dogs on beach (Italy)
Life 3:62-3 (c, 1) O '80
--Wild dogs
Smithsonian 11:62-71 (c, 1) N '80
--See also AFGHAN HOUNDS;
BEAGLES; BULLDOGS; CHI-
HUAHUAS; COLLIES; DINGOES;
FOXHOUNDS; GERMAN
SHEPHERDS; GREAT DANES;
GREYHOUNDS; HOUNDS;
LABRADOR RETRIEVERS;

MASTIFFS; PEKINGESE
DOGS; POODLES; PUGS; RE-
TRIEVERS; ROTTWEILERS;
ST. BERNARDS; SAMOYED
DOGS; SETTERS; SHEEP
DOGS; SIBERIAN HUSKIES;
TERRIERS; WEIMARANERS
DOGWOOD TREES
 Nat Wildlife 16:26-7 (c, 4) O
 '78
--Blossom
 Trav/Holiday 153:69 (c, 4) Mr
 '80
DOLL HOUSES
 Life 2:53-6 (c, 3) O '79
--Miniature townhouse
 Smithsonian 9:105-8 (c, 2) D '78
--Windsor Castle, Great Britain
 Nat Geog 158:632-43 (c, 1) N
 '80
DOLL MAKING
--South Korea
 Nat Geog 156:784-5 (c, 1) D '79
DOLLS
 Ebony 34:104 (4) N '78
--19th cent. (West Virginia)
 Smithsonian 8:108-13 (c, 4) Je
 '77
--Apple-head doll (Arkansas)
 Trav/Holiday 153:68 (c, 4) Mr
 '80
--Barbie dolls
 Life 2:108-12 (c, 1) N '79
--Celebrity dolls
 Ebony 33:153-6 (2) N '77
--Corn shuck dolls (Kentucky)
 Trav/Holiday 150:50 (4) O '78
--Hopi kachina dolls (Arizona)
 Smithsonian 9:58-60 (c, 1) Ag
 '78
 Trav/Holiday 154:60 (3) S '80
 Smithsonian 12:263 (c, 4) N '81
--Marie Osmond dolls
 Life 1:38-9 (c, 1) D '78
--Paper doll collection
 Life 4:25 (4) D '81
--Sioux souvenirs (South Dakota)
 Nat Geog 159:537 (c, 4) Ap '81
--South Korea
 Nat Geog 156:784 (c, 4) D '79
Dolphins. See PORPOISES
DOMESTIC WORKERS
--South Africa
 Nat Geog 151:793 (c, 1) Je '77
Dominica. See WINDWARD
 ISLANDS
DOMINICAN REPUBLIC
 Nat Geog 152:539-65 (map, c, 1)

O '77
--Damage from hurricane
 Nat Geog 158:348-9, 353-9 (c, 1)
 S '80
--See also SANTO DOMINGO
DOMINICAN REPUBLIC--COSTUME
 Nat Geog 152:539-65 (c, 1) O '77
--Santo Domingo
 Trav/Holiday 149:54 (c, 1) Ja '78
DOMINICAN REPUBLIC--MAPS
 Trav/Holiday 154:65 (4) O '80
DONKEYS
 Nat Geog 153:242-3 (c, 1) F '78
 Nat Geog 153:308-9 (c, 1) Mr '78
 Sports Illus 48:31 (c, 4) Mr 20
 '78
 Nat Geog 154:30-1 (c, 2) Jl '78
 Nat Geog 154:534-59 (c, 1) O '78
 Nat Geog 157:208-9 (c, 1) F '80
 Smithsonian 12:130 (c, 4) O '81
DOORMEN
--Great Britain
 Smithsonian 11:89 (c, 1) Mr '81
--Hotel (London, England)
 Trav/Holiday 151:51 (1) Mr '79
DOORS
--18th cent. brass door (Jaipur,
 India)
 Smithsonian 9:147 (c, 4) O '78
--1821 Georgian doorway (Dublin,
 Ireland)
 Nat Geog 159:447 (c, 2) Ap '81
--Gilded theater door (Costa Rica)
 Nat Geog 160:41 (c, 1) Jl '81
--Revolving (New York)
 Smithsonian 8:44-5 (c, 3) Ja '78
DORMITORIES
--19th cent. Groton boarding school
 Am Heritage 31:101 (4) O '80
--College dorm (Montenegro, Yugo-
 slavia)
 Nat Geog 152:667 (c, 3) N '77
--College dorm room
 Sports Illus 55:45 (c, 4) N 30 '81
DOSTOEVSKY, FYODOR
--Tombstone (Leningrad, U. S. S. R.)
 Smithsonian 9:12 (4) Ja '79
DOUGLAS, STEPHEN
 Am Heritage 31:112 (4) O '80
DOUGLAS FIR TREES
 Natur Hist 90:85-8 (c, 1) Mr '81
 Nat Wildlife 19:4 (c, 4) Ag '81
DOUGLASS, FREDERICK
 Ebony 35:122 (4) Ja '80
 Ebony 36:106 (4) N '80
 Ebony 36:56 (4) Ag '81
--Home (Washington, D. C.)
 Ebony 34:42 (c, 4) My '79

DOURO RIVER, PORTO, PORTU-
GAL
 Nat Geog 158:818-19 (c, 1) D
 '80
DOVES
 Ebony 32:92 (4) Ap '77
 Nat Geog 151:665 (c, 1) My '77
DRACULA
--Depictions on stage and film
 Life 2:94-100 (c, 1) F '79
DRAGONFLIES
 Nat Geog 151:578 (c, 4) Ap '77
 Nat Geog 152:37 (c, 4) Jl '77
 Natur Hist 87:53-5 (c, 1) O '78
 Nat Geog 157:134-5 (c, 1) Ja
 '80
 Nat Geog 160:686 (c, 4) N '81
DRAGONS
--8-9th cent. Korean sculpture
 Smithsonian 10:110-11 (c, 1) My
 '79
--1650 depiction
 Smithsonian 11:87 (4) Jl '80
--Postage stamp mosaic (Taiwan)
 Life 2:52-3 (c, 1) F '79
DRESDEN, GERMANY
 Nat Geog 154:704-5 (c, 1) N '78
DRESSING ROOMS
--Quebec
 Nat Geog 151:460-1 (c, 2) Ap
 '77
--Santa Fe, New Mexico
 Smithsonian 12:101-3 (c, 4) Ag
 '81
DRINKING CUSTOMS
--17th cent. Iran
 Smithsonian 9:146 (drawing, c, 4)
 N '78
--Athlete drinking from squeeze
 bottle
 Sports Illus 55:38-9 (c, 1) Ag
 31 '81
--Beer
 Sports Illus 50:35 (c, 4) Mr 26
 '79
 Sports Illus 50:46 (4) Ap 30 '79
 Sports Illus 55:70 (c, 4) S 28
 '81
--Beer (Ireland)
 Nat Geog 159:448-9 (c, 2) Ap '81
--Beer (Spain)
 Sports Illus 47:32 (c, 4) Ag 8
 '77
--Beer (Texas)
 Sports Illus 53:53 (4) N 17 '80
--Beer (West Germany)
 Nat Geog 152:166, 172-3 (c, 2)
 Ag '77

 Natur Hist 88:92 (4) F '79
--Beer at football game
 Sports Illus 55:67 (c, 4) S 7 '81
--Cocktail party
 Sports Illus 48:63 (c, 4) F 20 '78
--Coffee
 Life 2:8-9 (4) Ja '79
--Couple in bar
 Ebony 32:104 (3) Ag '77
--Drinking coffee at desk
 Ebony 37:50 (4) N '81
--Drinking milk straight from cow's
 udder (Australia)
 Life 4:104-5 (c, 1) N '81
--Locked-arms toast
 Nat Geog 160:821 (c, 4) D '81
--New Jersey bar
 Sports Illus 52:26 (c, 4) Mr 31
 '80
--North Wales tavern
 Trav/Holiday 151:78 (c, 2) Ap '79
--Sherry tasting party (Spain)
 Trav/Holiday 154:70 (c, 4) S '80
--Swimming pool bar at Mexican
 resort
 Nat Geog 153:644 (c, 3) My '78
--Tavern (Pennsylvania)
 Sports Illus 49:104-5 (drawing, c, 3)
 N 27 '78
--Tea (Afghanistan)
 Natur Hist 89:70-1 (c, 1) Jl '80
--Tea (Brazil)
 Nat Geog 158:500-1 (c, 1) O '80
--Tea (China)
 Trav/Holiday 150:38 (c, 4) N '78
--Tea (Japan)
 Trav/Holiday 152:57 (3) N '79
 Nat Geog 158:526 (c, 1) O '80
--Tea (St. Vincent estate)
 Nat Geog 156:402-3 (c, 1) S '79
--Tea ceremony (Dubai)
 Travel 147:61 (4) Ja '77
--Wine (France)
 Nat Geog 153:796 (c, 4) Je '78
--Wine tasting (Australia)
 Trav/Holiday 150:29 (c, 4) Ag '78
--Wine tasting (Spain)
 Nat Geog 153:314 (c, 1) Mr '78
--Yaqona-drinking ceremony (Fiji)
 Trav/Holiday 155:63 (c, 4) Ja '81
--See also TAVERNS
Drinking fountains. See WATER
 FOUNTAINS
DROUGHT
--Australian desert
 Nat Geog 153:607 (c, 2) My '78
--California
 Nat Geog 152:818-21, 828-9 (c, 1)

D '77
--Dried up riverbeds (California)
Nat Wildlife 20:42-3 (1) D '81
--Effects of hot summer (U. S.)
Life 3:22-9 (c, 1) S '80
--Midwest
Natur Hist 89:64-5 (c, 1) Je '80
DRUG ABUSE
--Anti-drug signs
Ebony 34:119 (2) Ag '79
--Anti-drug signs (Harlem, New
York)
Ebony 33:144 (3) Ag '78
--Depiction of Mayan taking hal-
lucinogens
Natur Hist 86:88 (painting, 2)
Mr '77
--Drug industry in New York City,
New York
Life 3:34-42 (c, 1) N '80
--Heroin needle tracks on arm
Ebony 33:146 (4) Ag '78
--Kat (North Yemen)
Nat Geog 156:252-3 (c, 1) Ag '79
--Police raid (New York)
Life 3:40 (3) N '80
--Shooting heroin
Life 3:34-5, 42 (c, 1) N '80
Life 4:18 (4) F '81
--Smuggling marijuana from
Jamaica to the U. S.
Life 4:110-16 (c, 1) O '81
--See also ALCOHOLISM; CIGAR
SMOKING; CIGARETTE
SMOKING; MARIJUANA;
MESCALINE; OPIUM
DRUGS
--1856 machine for producing
medicines (Shakers; New
York)
Am Heritage 31:72-3 (paint-
ing, c, 1) Ap '80
--Interferon
Life 2:55-62 (c, 3) Jl '79
Ebony 35:108-14 (4) S '80
--Medicinal plants
Smithsonian 12:86-97 (c, 1) N
'81
--Medicine bottles
Ebony 34:130 (4) Ap '79
--Rhino horn aphrodisiac pills
(China)
Life 3:56 (c, 4) Ap '80
--Rhino horn chip aphrodisiac
(Japan)
Nat Geog 159:300 (c, 4) Mr '81
--Silver-coated pills (India)
Nat Geog 160:283 (c, 1) S '81

--Steroid pills
Sports Illus 47:92 (c, 4) D 5 '77
DRUM PLAYING
Ebony 32:130-4 (3) Ap '77
Sports Illus 49:40 (c, 3) O 2 '78
Ebony 34:62 (4) My '79
Nat Geog 155:714 (c, 4) My '79
Sports Illus 54:62 (c, 4) My 11
'81
Ebony 37:150 (4) N '81
--1781 British drummer boy
Smithsonian 12:cov. (painting, c, 1)
O '81
--Bongoes
Sports Illus 52:55 (c, 1) Mr 31
'80
--Calanda, Spain Good Friday cele-
bration
Natur Hist 86:58-63 (c, 1) Ap '77
--Conga drums
Sports Illus 52:41 (4) Je 16 '80
--Cuba
Sports Illus 47:56 (c, 4) Ag 1 '77
--Cymbal production
Ebony 32:132 (4) Ap '77
--Steel drums (Caribbean)
Trav/Holiday 155:70 (c, 4) Ap '81
--Uganda
Ebony 35:38 (c, 4) D '79
DRUMS
--Ashanti (Ghana)
Smithsonian 10:135 (c, 4) N '79
--U. S. Indian drums
Smithsonian 9:60-4 (c, 4) Ag '78
DRUSES (SYRIA)
Nat Geog 154:340 (c, 3) S '78
DUBAI
Travel 147:58-64 (c, 1) Ja '77
DUBLIN, IRELAND
Trav/Holiday 153:57-61, 97 (c, 1)
My '80
Nat Geog 159:444-5, 447 (c, 1)
Ap '81
--Trinity College library
Smithsonian 8:75 (c, 1) O '77
DU BOIS, W. E. B.
Ebony 35:122 (4) Ja '80
Ebony 36:38 (4) F '81
--Tombstone (Ghana)
Ebony 34:76 (4) F '79
DUBUQUE, IOWA
Nat Geog 159:626-7 (c, 1) My '81
DUCKS
Nat Geog 151:176 (c, 4) F '77
Nat Wildlife 16:29 (c, 2) Ap '78
Nat Geog 157:677 (c, 2) My '80
Nat Geog 159:375 (c, 2) Mr '81
Natur Hist 90:57 (woodcut, c, 4)

Je '81
--Bird hunting stamps
Nat Wildlife 17:40-3 (c, 1) D '78
--Bottom-up in pond
Nat Wildlife 18:2 (c, 1) F '80
--Feeding ducks in pond (Denmark)
Trav/Holiday 154:47 (c, 3) Ag
'80
--Flock in flight
Life 4:182-3 (c, 2) D '81
--Newly hatched
Nat Wildlife 15:29 (c, 4) Ap '77
--Pintail
Nat Wildlife 16:4-5, 9 (c, 1) Je
'78
--Wooden decoys
Nat Wildlife 17:50-5 (c, 1) O
'79
--See also GADWALLS; MAL-
LARDS; MUD HENS; TEALS;
WOOD DUCKS
DUELS
--1818 engraving
Smithsonian 11:176 (4) D '80
DUGONGS
Natur Hist 90:54-7 (c, 1) My '81
DULCIMERS
--17th cent. German engraving
Smithsonian 8:24 (4) D '77
--19th cent. West Virginia
Smithsonian 8:108 (c, 4) Je '77
DULLES, JOHN FOSTER
Am Heritage 33:80 (4) D '81
DUMPS
--Alaska garbage dump
Nat Wildlife 19:37-9 (c, 1) Je
'81
DUNCAN, ISADORA
Smithsonian 11:61 (4) O '80
DURER, ALBRECHT
--Tuft of Cowslips (1526)
Smithsonian 11:152 (painting, c, 2)
O '80
--Walrus (1521)
Smithsonian 8:59 (drawing, 4) S
'77
DUST STORMS
Nat Geog 152:824-7 (c, 1) D '77
Natur Hist 88:54-9 (c, 1) My '79
--1930's
Am Heritage 28:34-5 (1) Ag '77
--Midwest
Natur Hist 87:72-83 (1) F '78
Smithsonian 11:120-1 (c, 1) Mr
'81
--Phoenix, Arizona
Nat Geog 152:514-15 (c, 1) O
'77

Dutch Guiana. See SURINAM

-E-

EAGLES
Smithsonian 9:75, 78 (c, 4) Je
'78
Nat Wildlife 16:16 (drawing, 4)
Ag '78
Nat Wildlife 18:29 (painting, c, 4)
O '80
--Bald
Nat Wildlife 16:13 (c, 1) D '77
Nat Geog 153:186-99 (c, 1) F '78
Nat Wildlife 16:7 (c, 4) Je '78
Natur Hist 87:63-5 (c, 1) Ag '78
Nat Wildlife 16:17 (4) O '78
Nat Wildlife 17:12-17 (c, 1) D '78
Nat Wildlife 17:32 (c, 4) F '79
Natur Hist 88:30-2 (3) Je '79
Nat Geog 156:212-13 (c, 1) Ag '79
Sports Illus 51:42-3, 84 (c, 1) O
29 '79
Life 2:53-4 (c, 2) N '79
Smithsonian 10:52-6 (c, 1) D '79
Sports Illus 52:76-82 (c, 1) F 25
'80
Nat Wildlife 18:7 (c, 2) Ag '80
Sports Illus 53:62-71 (c, 1) Ag 11
'80
Nat Wildlife 19:37-9 (c, 1) Je '81
Nat Wildlife 20:25-32 (c, 1) D '81
--Bald eagle as U.S. symbol
Nat Wildlife 20:27-32 (c, 4) D '81
--Golden
Sports Illus 46:80-1 (c, 2) My 16
'77
Nat Wildlife 15:2 (painting, c, 2)
Ag '77
Nat Wildlife 18:6-8 (c, 4) Ag '80
Nat Wildlife 18:25 (painting, c, 2)
O '80
--Nest
Smithsonian 9:82 (c, 4) D '78
--Philippine
Nat Geog 159:846-56 (c, 1) Je '81
--Spanish imperial eagle
Natur Hist 90:40-3 (c, 1) Je '81
EARHART, AMELIA
Life 1:75 (4) N '78
EARRINGS
--Gold (Ancient Korea)
Smithsonian 10:112-13 (c, 3) My
'79
--Gold (Ancient Peru)
Smithsonian 8:88-9 (c, 3) D '77
--Made from sandbox tree seeds

(Hawaii)
Nat Geog 160:207 (c, 4) Ag '81
EARTH
Natur Hist 87:84 (4) Ja '78
--Computer photographs
Nat Geog 153:370-1 (c, 1) Mr
'78
--Creation of earth's crust
Natur Hist 90:56-7 (painting, c, 1)
Ap '81
--Photos from Voyager I
Nat Geog 154:52-3 (c, 1) Jl '78
--Prospects for future ice ages
Smithsonian 8:34-9 (painting, c, 1)
Ja '78
EARTH--MAPS
--Volcanic plates
Nat Geog 159:20-1 (c, 1) Ja '81
--World energy resources
Nat Geog 159:20-1 (c, 1) F
'81SR
EARTHQUAKES
Nat Wildlife 19:34-9 (drawing, 1)
O '81
--Configurations of small quakes
(Washington)
Nat Geog 160:729 (drawing, c, 2)
D '81
--Mississippi River (1811-12)
Natur Hist 89:70-3 (map, 1) Ag
'80
EARTHQUAKES--DAMAGE
--Anchorage, Alaska (1964)
Nat Wildlife 19:34-5 (drawing, 1)
O '81
--Balvano, Italy (1980)
Life 4:4 (3) Ja '81
--California
Life 2:82 (4) Ja '79
--Mezzogiorno region, Italy
Life 4:41-4 (c, 1) F '81
EARTHQUAKES--MAPS
--Late 19th cent. Japan
Natur Hist 89:72 (4) Ap '80
--1899-1911 quakes
Natur Hist 89:76 (4) Ap '80
--U. S. high risk areas
Nat Wildlife 19:36 (c, 3) O '81
EARTHWORMS--HUMOR
Sports Illus 51:52-63 (draw-
ing, c, 4) Ag 27 '79
EASTER
--1898 Easter hats
Am Heritage 31:109 (4) Ap '80
--Choosing bonnet (1898 "Puck"
cover)
Am Heritage 32:114 (painting, c, 2)
Ap '81

--Dinner (Greece)
Nat Geog 157:372-3 (c, 1) Mr '80
--Poland
Nat Geog 159:120-1 (c, 1) Ja '81
EASTERN UNITED STATES--MAPS
--Mid-Atlantic coast from satellite
photo
Smithsonian 9:43-5 (c, 1) Mr '79
EASTMAN, GEORGE
Life 3:159 (4) D '80
Eating. See DINNERS AND DINING
Echinoderms. See SEA CUCUM-
BERS; SEA LILIES; SEA
URCHINS; STARFISH
ECLIPSES
--Solar eclipse
Life 2:cov., 11-18 (c, 1) Ap '79
Smithsonian 11:97-9 (c, 2) Ap '80
ECONOMIC CONDITIONS
--Graph of U. S. cost of living
(1800-1980)
Am Heritage 32:14-17 (drawing, 2)
F '81
ECUADOR
--Otavalo
Natur Hist 86:cov., 49-59 (c, 1)
O '77
--See also ANDES MOUNTAINS;
GALAPAGOS ISLANDS
ECUADOR--ART
--Bread sculptures
Trav/Holiday 154:48-51 (2) Ag
'80
--Crafts
Trav/Holiday 151:69-73 (c, 1) My
'79
ECUADOR--COSTUME
Natur Hist 86:cov., 49-59 (c, 1)
O '77
Trav/Holiday 151:70-3 (c, 2) My
'79
--Canelos Quichua Indians
Natur Hist 87:90-9 (c, 1) O '78
--Toucan feather hat (Jivaro Indians)
Smithsonian 8:119 (c, 4) O '77
EDDY, MARY BAKER
Am Heritage 32:56-63 (1) D '80
--Concord, New Hampshire home
Am Heritage 32:56 (1) D '80
EDINBURGH, SCOTLAND
Trav/Holiday 155:47-50, 73 (c, 1)
Ja '81
EDISON, THOMAS ALVA
Smithsonian 9:112 (4) My '78
Smithsonian 9:88-95 (1) Je '78
Smithsonian 10:34-45 (c, 1) S '79
Am Heritage 32:100 (3) D '80
Smithsonian 12:131 (4) Jl '81

Sports Illus 55:86 (4) O 26 '81
--Recreation of his laboratory
(Michigan)
Am Heritage 32:101 (c, 3) D '80
EDUCATION
--Vocational training class
Ebony 33:87 (3) Ag '78
--See also BLACKBOARDS; CLASS-
ROOMS; COLLEGES AND
UNIVERSITIES; MEDICAL
EDUCATION; SCHOOLS;
WASHINGTON, BOOKER T.
EDWARD IV (GREAT BRITAIN)
Smithsonian 12:108 (painting, c, 4)
Ap '81
Natur Hist 90:74 (painting, 4)
My '81
EDWARD VII (GREAT BRITAIN)
Smithsonian 8:64 (4) Ag '77
Smithsonian 12:177-82 (3) O
'81
EELS
Nat Geog 157:621 (c, 1) My '80
--Moray
Nat Geog 158:424-5 (c, 1) S '80
Nat Geog 159:659 (c, 4) My '81
EGG INDUSTRY
--Checking quality (Arkansas)
Nat Geog 153:417 (c, 4) Mr '78
EGGS
--Shell seen under microscope
Natur Hist 87:111-13 (2) Mr
'78
--Turtle eggs
Smithsonian 10:71 (c, 4) S '79
Natur Hist 90:61 (c, 3) My '81
--Whooping cranes
Smithsonian 9:53, 56 (c, 4) S
'78
EGRETS
Sports Illus 47:21-2 (paint-
ing, c, 3) Jl 11 '77
Nat Wildlife 17:52 (c, 3) D '78
Nat Geog 156:397 (c, 1) S '79
Nat Wildlife 17:47 (c, 2) O '79
Nat Geog 157:824-5 (c, 1) Je
'80
Sports Illus 52:61 (c, 2) Je 16
'80
Sports Illus 53:30-1 (draw-
ing, c, 2) S 22 '80
Nat Geog 159:162-3 (c, 1) F '81
Trav/Holiday 156:39 (4) N '81
--Baby cattle egret
Nat Wildlife 16:21 (c, 2) Ap '78
--Cattle
Nat Geog 157:828 (c, 3) Je '80
--Cattle egret eating frog

Nat Geog 155:360-1 (c, 1) Mr '79
--Great egrets
Nat Wildlife 19:14 (c, 4) O '81
Nat Wildlife 20:9 (c, 1) D '81
--Snowy
Nat Wildlife 15:46-7 (c, 1) Je '77
Nat Geog 153:218-19 (c, 1) F '78
Nat Wildlife 16:44 (c, 2) F '78
EGYPT
Nat Geog 151:312-43 (map, c, 1)
Mr '77
Smithsonian 10:54-65 (map, c, 1)
My '79
--See also ALEXANDRIA; CAIRO;
NILE RIVER; SUEZ CANAL
EGYPT--ART
Smithsonian 11:176 (c, 4) Mr '81
EGYPT--COSTUME
Smithsonian 10:54-9 (c, 1) My '79
EGYPT--HISTORY
--1854 painting
Smithsonian 12:110-11 (c, 3) S '81
EGYPT--MAPS
--Satellite view of Sinai Peninsula
Smithsonian 10:148 (c, 4) Mr '80
EGYPT--POLITICS AND GOVERN-
MENT
--Sadat assassination (1981)
Life 4:182-3 (1) N '81
Egypt, Ancient. See CLEOPATRA;
PHARAOHS; PYRAMIDS;
SPHINX
EGYPT, ANCIENT--ART
--2nd millennium B. C. glass head
Smithsonian 11:68 (c, 4) My '80
--7th cent. B. C. cat sculpture
Smithsonian 8:55 (c, 4) S '77
--7th cent. lion textile medallion
Smithsonian 8:111 (c, 4) N '77
EGYPT, ANCIENT--RELICS
Nat Geog 151:cov., 292-311 (c, 1)
Mr '77
--15th cent. B. C. wooden mallet
Smithsonian 7:10 (4) Ja '77
--King Tut's tomb
Nat Geog 151:cov., 304-5 (c, 1)
Mr '77
Life 2:120 (c, 1) D '79
--One-eyed gold ornament from
Tut's tomb
Smithsonian 10:66-7 (c, 4) Ja '80
EIFFEL TOWER, PARIS, FRANCE
Trav/Holiday 152:53 (c, 4) O '79
EINSTEIN, ALBERT
Smithsonian 9:70-4 (4) F '79
Life 2:133 (sculpture, c, 2) Mr '79
Life 2:14 (4) Ap '79
Smithsonian 11:74 (4) Ap '80

--Home (Princeton, New Jersey)
Smithsonian 9:768-71 (drawing, 2)
F '79
--Testing his theories
Smithsonian 11:74-83 (c, 1) Ap
'80
EISENHOWER, DWIGHT D.
Am Heritage 28:54-5 (2) F '77
Am Heritage 29:94 (3) D '77
Ebony 34:185 (4) My '79
Am Heritage 30:24 (4) Je '79
Life 3:138 (4) N '80
Am Heritage 32:73 (4) Je '81
--Throwing out first baseball
(1957)
Sports Illus 51:64 (c, 4) Ag 13
'79
EL GRECO
--Repentent Peter
Smithsonian 10:76-7 (c, 1) My
'79
EL PASO, TEXAS
Nat Geog 157:478-9 (c, 1) Ap '80
EL SALVADOR
--San Salvador riot
Life 3:114-15 (1) My '80
EL SALVADOR--MAPS
Nat Geog 160:59 (c, 2) Jl '81
EL SALVADOR--POLITICS AND
GOVERNMENT
--Fortification of U. S. embassy
Life 4:65-70 (c, 2) Je '81
ELECTIONS
--1880's ballot box (California)
Smithsonian 11:144 (c, 4) Mr '81
--Blacks registering to vote
(1860's, Virginia)
Ebony 35:45 (engraving, 4) Je
'80
--Blacks voting in Alabama (1960's)
Ebony 36:33 (4) O '81
--Blacks voting in Georgia (1867)
Ebony 36:32 (woodcut, 3) O '81
--Scenes of election activities
(1847-55; Missouri)
Am Heritage 31:cov. , 4-15
(painting, c, 1) O '80
--Voting (China)
Nat Geog 159:805 (c, 3) Je '81
--Voting (Tennessee)
Ebony 36:34 (3) S '81
--Voting (U. S. S. R.)
Nat Geog 153:18-19 (c, 4) Ja
'78
--See also POLITICAL CAM-
PAIGNS
ELECTRICITY
--Early 20th cent. street lighting

Am Heritage 30:76-9 (1) O '79
--Benjamin Franklin with kite
Nat Wildlife 18:12 (painting, c, 4)
F '80
--See also EDISON, THOMAS ALVA;
LIGHT BULBS
ELECTRONICS
--Creating integrated circuits
Smithsonian 9:92-3 (c, 2) O '78
--Designing video games
Smithsonian 12:52-61 (c, 1) S '81
--Home entertainment systems
Ebony 35:74-80 (2) D '79
--Hydroelectric complex control
room (U. S. S. R.)
Smithsonian 8:45 (c, 3) F '78
--Semiconductor chip
Life 2:168 (c, 2) D '79
--Silicon chips
Nat Geog 153:383-4 (c, 1) Mr '78
--Walkie-talkies (Tennessee)
Ebony 32:109 (4) Je '77
--See also ANTENNAS; CITIZENS
BAND RADIOS; COMPUTERS;
FIBER OPTICS; PHONO-
GRAPHS; RADAR; RADIOS;
ROBOTS; TELEVISIONS
ELEPHANTS
Nat Geog 151:638 (c, 3) My '77
Smithsonian 8:116-17 (c, 2) My
'77
Sports Illus 48:70 (c, 1) My 22
'78
Smithsonian 9:28, 34-5 (c, 3) Ag
'78
Trav/Holiday 151:22-3 (4) Mr
'79
Nat Wildlife 17:17 (4) Ap '79
Life 3:79-92 (c, 1) Mr '80
Smithsonian 11:115-18 (c, 2) Ap
'80
Nat Geog 158:568-603 (c, 1) N
'80
Trav/Holiday 154:40, 43 (c, 3) N
'80
Natur Hist 90:31-5, 88 (c, 1) Ap
'81
Nat Geog 160:638-9 (c, 1) N '81
Trav/Holiday 156:62 (c, 4) N '81
--11th cent. B. C. bronze sculpture
(China)
Smithsonian 9:111 (c, 4) Je '78
--18th cent. painting (India)
Smithsonian 8:110 (c, 2) N '77
--Bronze Age Chinese sculpture
Smithsonian 11:68 (c, 3) Ap '80
--Carrying royalty (India)
Smithsonian 9:144-5 (painting, c, 3)

O '78
--Cleaning elephant nails for circus
Sports Illus 47:88 (c, 4) S 26
'77
--Evolution chart
Nat Geog 158:582-3 (drawing, c, 2)
N '80
--Fighting (India)
Smithsonian 9:144-5 (painting, c, 3)
O '78
--Riding elephants (Asia)
Trav/Holiday 153:84 (c, 4) F '80
--Stone statue (Indonesia)
Trav/Holiday 151:cov. (c, 1) Ja
'79
--Tusks
Nat Geog 158:598-9 (c, 1) N '80
--See also MAMMOTHS; MASTO-
DONS
ELEVATORS
--19th cent.
Am Heritage 29:40-5 (drawing, 2)
Ag '78
--Fancy hotel and office building
elevators
Am Heritage 29:46-7 (c, 4) Ag
'78
ELIZABETH I (GREAT BRITAIN)
Smithsonian 10:147 (4) O '79
Natur Hist 90:75 (painting, 3)
My '81
ELIZABETH II (GREAT BRITAIN)
Smithsonian 8:156 (4) Ap '77
Life 3:31 (4) Ja '80
Life 3:12 (2) Mr '80
Sports Illus 54:15 (c, 4) Ja 5
'81
Sports Illus 55:15 (c, 4) Ag 3
'81
--Coronation
Life 4:61 (4) Jl '81
--On horseback
Smithsonian 10:146-7 (4) O '79
ELKS
Nat Wildlife 16:5-7 (map, c, 1)
O '78
Nat Wildlife 17:cov., 12-16
(c, 1) Ap '79
Nat Geog 156:9-11 (c, 1) Jl '79
Nat Wildlife 18:6-7 (c, 1) D '79
Nat Geog 157:58 (c, 1) Ja '80
Nat Wildlife 18:54 (c, 4) Ap '80
Nat Wildlife 19:12-17 (c, 1) D
'80
Trav/Holiday 155:54 (c, 4) Ja
'81
Nat Wildlife 19:cov. (c, 1) F
'81

Sports Illus 55:26 (c, 3) Jl 20 '81
--Herd
Nat Wildlife 16:24 (c, 4) D '77
--Wapiti
Smithsonian 12:66-7 (c, 3) D '81
ELLESMERE ISLAND, NORTHWEST
TERRITORIES, CANADA
Nat Geog 159:676-93 (map, c, 1)
My '81
Natur Hist 90:81 (c, 1) O '81
Life 4:72 (c, 3) O '81
ELM TREES
--Diseased (Wisconsin)
Nat Wildlife 16:38 (3) Ap '78
EMBROIDERY
--Embroidered flour sacks from
Belgium to U.S. (1915)
Am Heritage 29:72-5 (c, 4) Ap
'78
--On silk damask
Smithsonian 8:73 (c, 4) N '77
--Polish trousers
Nat Geog 159:123 (c, 4) Ja '81
EMERALDS
Smithsonian 8:30 (c, 4) D '77
EMERSON, RALPH WALDO
Smithsonian 8:65 (4) Ag '77
Am Heritage 31:64 (4) O '80
--Home (Concord, Massachusetts)
Am Heritage 30:102-3 (drawing, 4)
D '78
EMPIRE STATE BUILDING, NEW
YORK CITY, NEW YORK
Ebony 32:68 (3) Ap '77
EMUS
Nat Geog 153:605 (c, 3) My '78
Trav/Holiday 152:45 (c, 1) N '79
Smithsonian 10:83 (c, 1) Ja '80
ENCOUNTER GROUPS
--Esalen inductee
Life 2:76 (c, 2) D '79
ENERGY
Nat Geog 159:entire issue (c, 1)
F '81SR
--Harvesting turf from peat bogs
(Ireland)
Natur Hist 89:50-7 (c, 1) N '80
--Nuclear
Nat Geog 155:458-93 (c, 1) Ap
'79
--Nuclear testing radiation victims
Life 3:32-9 (c, 1) Je '80
--Produced from salt ponds (Israel)
Smithsonian 11:143-6 (c, 2) O '80
--U.S. nuclear warfare facilities
Life 3:24-8 (1) Ag '80
--Using peat as fuel
Smithsonian 12:145-55 (c, 1) O '81

--See also ELECTRICITY; GAS,
NATURAL; GASAHOL; GEO-
THERMAL ENERGY; OIL
INDUSTRY; SOLAR ENERGY
ENERGY SHORTAGE
--1940's efforts to conserve gas
Am Heritage 30:4-16 (c, 1) O
'79
--Alternatives to oil
Life 2:120-8 (c, 1) S '79
--Fanciful gadgets to solve prob-
lem
Am Heritage 28:30-3 (draw-
ing, 1) O '77
--Gas line
Ebony 34:31 (4) O '79
--Gas line (California)
Life 2:131 (2) Je '79
--"No gas" sign
Ebony 34:38 (4) O '79
--See also INSULATION
ENGINEERS
Ebony 32:33-4 (3) Mr '77
ENGINES
--Spacecraft
Nat Geog 159:333-5 (c, 1) Mr
'81
England. See GREAT BRITAIN
ENTERTAINERS
--Black celebrities
Ebony 35:74-90 (3) F '80
--Comedians
Ebony 35:88, 110 (4) Ap '80
Life 3:100 (4) N '80
--In drag
Sports Illus 54:106-7 (c, 1) Ja
19 '01
--Jugglers through history
Natur Hist 88:44-55 (c, 1) D
'79
--Juggling
Life 3:100-1 (1) N '80
--Wax museum images of Laurel
& Hardy (California)
Trav/Holiday 155:59 (c, 3) My
'81
--See also ACTORS; BANDS;
CHAPLIN, CHARLES; CIR-
CUS ACTS; CONCERTS;
DANCERS; MAGIC ACTS;
MARX, GROUCHO; MUSI-
CIANS; ROGERS, WILL;
SINGERS; THEATER; VEN-
TRILOQUISTS
EPHESUS, TURKEY
Nat Geog 152:114-15 (c, 2) Jl
'77
ERMINES

--Leonardo Da Vinci painting
Nat Geog 152:314 (c, 2) S '77
--With mouse in mouth
Nat Wildlife 15:28 (c, 4) Ap '77
EROS
--1891 Gilbert sculpture (Great
Britain)
Smithsonian 9:54 (c, 3) D '78
ESCALATORS
--National Gallery of Art, Washing-
ton, D. C.
Smithsonian 9:56-61 (c, 1) Je '78
--New York
Smithsonian 8:49 (c, 1) Ja '78
--Pompidou Center, Paris, France
Smithsonian 8:cov. (c, 1) Ag '77
--Shopping mall (Singapore)
Nat Geog 159:559 (c, 3) Ap '81
ESKIMOS (ALASKA)
--Costume, lifestyle
Natur Hist 86:55-65 (c, 1) Mr '77
Life 2:111 (c, 4) F '79
--Hunting bowhead whales
Nat Wildlife 16:4-11 (c, 1) Ap '78
--See also IGLOOS; KAYAKS
ESKIMOS (ALASKA)--ART
--Drawings by shaman
Natur Hist 87:96-7 (4) My '78
ESKIMOS (ALASKA)--RELICS
--19th cent. arrows
Nat Geog 156:754 (c, 4) D '79
--Mask
Natur Hist 87:98 (c, 1) My '78
ESKIMOS (CANADA)
--1910
Natur Hist 89:88-93 (2) Ap '80
--Ancient lifestyle
Nat Geog 159:590-1, 596-7
(painting, c, 1) My '81
--Costume, lifestyle
Natur Hist 86:70-5 (2) F '77
Nat Geog 152:624-47 (c, 1) N '77
Natur Hist 88:78-85 (2) Ja '79
Natur Hist 90:42-9 (c, 1) O '81
ESKIMOS (CANADA)--RELICS
--Ancient finds (Ellesmere Island,
Canada)
Nat Geog 159:574-601 (c, 1) My
'81
ESTONIA
Nat Geog 157:484-511 (map, c, 1)
Ap '80
--See also TALLINN
ESTONIA--COSTUME
Nat Geog 157:484-511 (c, 1) Ap
'80
ETHIOPIA
--Danakil Depression salt mines

Nat Geog 152:382-3, 385 (c, 1)
S '77
--Hadar region
Smithsonian 11:94-5 (c, 3) Je
'80
ETHIOPIA--COSTUME
Nat Geog 154:796, 799 (c, 1) D
'78
--Emperor (1954)
Ebony 36:94 (3) N '80
--Refugees in Somalia
Life 4:36-46 (c, 1) Ap '81
EUCALYPTUS TREES
--Bark
Natur Hist 86:37-9 (c, 1) D '77
EUPHRATES RIVER, SYRIA
Nat Geog 154:338 (c, 3) S '78
EUROPE
Trav/Holiday 152:52-81 (c, 4)
O '79
Trav/Holiday 154:67-85 (c, 4)
O '80
Trav/Holiday 156:65 (c, 4) S
'81
--Border between Eastern and
Western Europe
Life 4:3, 32-48 (map, c, 1) Ag
'81
EUROPE--HISTORY
--17th cent. Inquisition (Italy)
Smithsonian 12:90-1 (painting, c, 2)
Ag '81
EUROPE--MAPS
--Danube River
Nat Geog 152:456-7 (c, 1) O '77
--Prehistoric settlements
Nat Geog 152:617 (c, 2) N '77
EVANS, SIR ARTHUR
Nat Geog 153:148 (painting, c, 4)
F '78
Smithsonian 11:164 (4) Mr '81
EVANSVILLE, INDIANA
--Courthouse
Smithsonian 9:186-7 (4) N '78
EVERGLADES NATIONAL PARK,
FLORIDA
Ebony 33:148 (c, 4) My '78
Trav/Holiday 156:cov., 52-5,
78 (c, 1) N '81
Evergreen trees. See HOLLY
EVOLUTION
Smithsonian 11:90-103 (c, 1)
Je '80
--Early 20th cent. cartoons
Natur Hist 89:118-28 (4) Ap '80
--1925 Scopes trial (Tennessee)
Natur Hist 90:12-22 (2) O '81
--Chart of dinosaurs

Smithsonian 12:99-108 (paint-
ing, c, 1) D '81
--Drawings of human evolution
Natur Hist 88:86-91 (c, 1) Ag '79
--Elephant evolution chart
Nat Geog 158:582-3 (drawing, c, 2)
N '80
--See also DARWIN, CHARLES;
MAN, PREHISTORIC
EXERCISING
Ebony 32:72 (4) Mr '77
Ebony 35:103 (3) F '80
Sports Illus 53:37 (4) Ag 4 '80
Ebony 36:64 (c, 3) Je '81
Sports Illus 55:32 (c, 4) Ag 3 '81
Ebony 36:94 (4) S '81
--Airline seat exercises
Trav/Holiday 153:27-8, 73 (draw-
ing, c, 4) Je '80
--Arizona
Nat Geog 157:260-1 (c, 1) F '80
--Basketball player
Sports Illus 53:38 (c, 4) N 17 '80
--Chin-ups (Bahrain)
Sports Illus 53:98 (c, 4) N 17 '80
--Class
Sports Illus 52:28-30 (c, 4) Je 9
'80
Smithsonian 11:52-6 (c, 1) Ja '81
--Class (Alabama)
Ebony 34:48 (3) Ap '79
--Class (Arizona)
Nat Geog 152:492 (c, 3) O '77
--Class (Washington, D. C.)
Ebony 33:44 (4) F '78
--Class relaxation period
Sports Illus 55:38 (c, 3) Ag 3 '81
--Exercise bar
Sports Illus 51:27 (c, 1) Jl 30 '79
--Exercise bicycle
Sports Illus 47:38 (c, 4) D 5 '77
Sports Illus 50:91 (c, 4) My 14
'79
Nat Geog 156:644 (c, 1) N '79
Ebony 37:44 (c, 3) N '81
--Exercise equipment
Sports Illus 51:12 (c, 1) Ag 6
'79
Life 2:126 (2) N '79
Sports Illus 55:55 (c, 4) S 21 '81
--Football players
Sports Illus 53:28-9 (c, 4) N 10
'80
--Japanese ship builders
Nat Geog 154:122-3 (c, 1) Jl '78
--Nautilus equipment
Ebony 35:38 (4) Mr '80
Sports Illus 55:32 (c, 4) Ag 3 '81

Am Heritage 31:74 (c, 4) D '79
--Coal (Norway)
Nat Geog 154:272 (c, 2) Ag '78
--Coal liquefaction plant (South
Africa)
Nat Geog 159:84-5 (c, 1) F
'81SR
--Coke (Zimbabwe)
Nat Geog 160:642-3 (c, 2) N '81
--Columbus, Indiana
Nat Geog 154:387 (c, 1) S '78
--Idaho
Smithsonian 12:74-5 (c, 1) S '81
--Jamestown, New York
Ebony 35:138 (3) Mr '80
--Midwest
Natur Hist 87:72-3 (c, 1) Ag '78
--Nickel (Cuba)
Nat Geog 151:59 (c, 4) Ja '77
--Venice, Italy
Smithsonian 8:44-5 (c, 2) N '77
--See also MANUFACTURING;
MILLS; SAWMILLS
FACTORY WORKERS
--Steel mill (Michigan)
Ebony 32:103 (2) Je '77
FAEROE ISLANDS
Natur Hist 86:40-7 (c, 1) D '77
FAEROE ISLANDS--COSTUME
Natur Hist 86:cov. , 41-6 (c, 1)
D '77
FAIRS
--1905 exposition hall made of
corn (South Dakota)
Am Heritage 31:28 (4) Ag '80
--1940 (Pie Town, New Mexico)
Am Heritage 31:77 (3) F '80
--Ballinasloe, Ireland
Nat Geog 154:662-3 (c, 1) N '78
--Clay County Fair, Iowa
Nat Geog 154:412-13 (c, 2) S
'78
--Exhibits at 1939 World's Fair
(New York)
Smithsonian 10:86-9 (3) N '79
--Iowa
Nat Geog 159:614-15 (c, 2) My
'81
--Neshoba County Fair, Mississippi
Nat Geog 157:855-66 (c, 1) Je
'80
--Sevilla, Spain
Trav/Holiday 149:42-7 (c, 1) F
'78
--Texas
Nat Geog 157:463 (c, 4) Ap '80
FAIRY TALES
--Hans Christian Andersen tales

(Denmark)
Nat Geog 156:824-49 (c, 1) D '79
--Pied Piper of Hamelin
Nat Geog 152:62 (engraving, 3) Jl
'77
FALCONS
Sports Illus 46:78-82 (c, 1) My
16 '77
Natur Hist 88:68-9 (c, 3) F '79
Nat Geog 156:326-7 (c, 1) S '79
Nat Geog 158:320-1 (c, 1) S '80
Sports Illus 53:93 (c, 3) N 17 '80
--Eleonora's
Natur Hist 88:86-92 (c, 1) Ap '79
--Falconry (Bahrain)
Sports Illus 53:93, 100 (c, 3) N
17 '80
--Falconry (Mideast)
Travel 147:63 (4) Ja '77
--Gyrfalcons
Nat Geog 151:151 (painting, c, 3)
F '77
--Peregrine
Nat Geog 151:152 (painting, c, 3)
F '77
Sports Illus 46:79 (c, 2) Mr 16
'77
Smithsonian 8:45 (c, 4) S '77
Smithsonian 9:58-65 (c, 1) D '78
Nat Wildlife 18:13 (c, 4) D '79
Nat Wildlife 18:13 (2) Ag '80
Smithsonian 11:157 (4) Mr '81
--Prairie
Sports Illus 46:82 (c, 3) My 16
'77
Nat Wildlife 16:48 (c, 1) Ag '78
Nat Wildlife 17:11 (c, 4) Je '79
FALKLAND ISLANDS
Smithsonian 12:84-95 (c, 1) S '81
FALKLAND ISLANDS--SOCIAL LIFE
AND CUSTOMS
--Wedding ceremony
Smithsonian 12:16 (4) N '81
FALLOUT SHELTERS
--1961
Am Heritage 31:84-93 (2) F '80
FAMILIES
--Mexican Americans (Texas)
Nat Geog 157:780-1 (c, 1) Je '80
FAMILY LIFE
Ebony 35:116-17 (4) Ap '80
--Family reunion
Life 1:19-23 (c, 1) O '78
--Hugging
Life 3:148-9 (c, 1) Je '80
--New Zealand
Nat Geog 154:256 (c, 1) Ag '78
FANS

Nat Geog 159:406-7 (c, 1) Mr
'81
--Nova Scotia
Sports Illus 47:63 (c, 2) N 14
'77
--Quebec
Nat Geog 151:436-7 (c, 1) Ap
'77
Nat Geog 157:614-15 (c, 1) My
'80
--Spain
Nat Geog 153:308-9 (c, 1) Mr
'78
--U. S. S. R.
Nat Geog 155:768-97 (c, 1) Je
'79
FARMHOUSES
--18th cent. Pennsylvania
Smithsonian 8:124 (c, 4) O '77
--Early 20th cent.
Natur Hist 88:76-81 (1) Je '79
--Farmhouse items (Belgium)
Trav/Holiday 155:46 (c, 4) Mr
'81
--Iowa
Nat Geog 159:620-1 (c, 2) My
'81
FARMING
Am Heritage 29:18-27 (c, 1) F
'78
--Late 19th cent. U. S.
Smithsonian 7:48-55 (1) Mr '77
--1905 (Saskatchewan)
Nat Geog 155:666-7 (1) My '79
--1910's
Am Heritage 30:4-15 (draw-
ing, c, 1) Je '79
--Brazil
Nat Geog 152:702-3, 716-17
(c, 1) N '77
--Crete
Nat Geog 153:172-3 (c, 1) F '78
--Egypt
Nat Geog 151:328, 341 (c, 1)
Mr '77
--Guarding barley crop (India)
Nat Geog 151:240-1 (c, 1) F
'77
--Hoeing potatoes (U. S. S. R.)
Nat Geog 155:776-7 (c, 1) Je
'79
--Hop plants (Washington)
Nat Geog 154:620-1 (c, 1) N '78
--Impoverished land (1939; Ten-
nessee)
Smithsonian 10:96-7 (1) Ja '80
--Inhumane treatment of animals
Smithsonian 11:50-7 (c, 1) Ap

'80
--Lettuce (Arizona)
Nat Geog 152:511 (c, 4) O '77
--Nepal
Nat Geog 155:274 (c, 3) F '79
--Oat-threshing exhibition (Iowa)
Nat Geog 159:614-15 (c, 2) My
'81
--Poland
Nat Geog 159:104-5 (c, 1) Ja '81
--Potatoes (Costa Rica)
Nat Geog 160:50-3 (c, 1) Jl '81
--Problems on U. S. farms
Life 4:74-84 (c, 1) D '81
--Self-sufficient group (Massachu-
setts)
Nat Wildlife 17:4-11 (c, 1) Ap
'79
--Soil erosion problems
Smithsonian 11:120-9 (c, 1) Mr
'81
--Strawberries (Cuba)
Nat Geog 151:48 (c, 4) Ja '77
--Taro (Hawaii)
Nat Geog 156:670-1 (c, 1) N '79
--Terrace (Oman)
Nat Geog 160:347, 368 (c, 1) S
'81
--Tobacco (Indiana)
Nat Geog 151:262 (c, 3) F '77
--See also farmed items listed un-
der INDUSTRIES; IRRIGATION;
PESTICIDES
FARMING--HARVESTING
--Flax (Egypt)
Nat Geog 151:310 (c, 4) Mr '77
--Mustard plants (India)
Nat Geog 153:339 (c, 1) Mr '78
--Ontario
Nat Geog 154:778-9 (c, 1) D '78
--Reeds (Iraq)
Nat Geog 154:808 (c, 3) D '78
--Taro (Hawaii)
Nat Geog 152:590-1 (c, 2) N '77
--Tequilana plants (Mexico)
Nat Geog 153:632-3 (c, 1) My '78
--See also individual agricultural
products--HARVESTING
FARMING--PLANTING
--Maize (Mexico)
Nat Geog 158:202 (c, 1) Ag '80
FARMING--PLOWING
Am Heritage 30:9 (drawing, c, 2)
Je '79
--1905 (Oklahoma)
Am Heritage 29:18 (4) F '78
--By hand (Oman)
Nat Geog 160:366-7 (c, 1) S '81

--By horse (Alaska)
 Nat Geog 155:265 (c, 4) F '79
--China
 Nat Geog 156:541-4 (c, 1) O '79
--France
 Natur Hist 90:52-3 (c, 1) Ja '81
--Mexico
 Nat Geog 151:851 (c, 1) Je '77
--North Carolina
 Nat Geog 157:346 (c, 2) Mr '80
 Ebony 36:98 (4) N '80
--Ox-drawn (China)
 Nat Geog 157:304-5 (c, 3) Mr
 '80
--Strip plowing
 Natur Hist 87:83 (1) F '78
--Syria
 Nat Geog 154:348-9 (c, 1) S '78
--T'ang dynasty era (China)
 Natur Hist 86:94 (painting, 2)
 Ag '77
--Tennessee
 Nat Geog 151:480-1 (c, 1) Ap
 '77
--Using camel (Ethiopia)
 Ebony 33:90 (4) D '77
FARMS
 Natur Hist 86:52 (c, 4) Ag '77
 Smithsonian 11:95-7 (paint-
 ing, c, 1) N '80
 Life 4:74-84 (c, 1) D '81
--1860 (Pennsylvania)
 Am Heritage 29:21 (painting, c, 4)
 F '78
--1897 overworked land (Kansas)
 Am Heritage 29:4-5 (1) D '77
--Arkansas
 Nat Geog 153:400-1 (c, 1) Mr
 '78
--Brazil
 Nat Geog 153:270-3 (c, 1) F '78
--Burgundy, France
 Nat Geog 153:794-5, 800-1 (c, 1)
 Je '78
--China
 Nat Geog 159:182-3 (c, 1) F '81
--Communal (Saskatchewan)
 Nat Geog 155:676-9 (c, 1) My
 '79
--Dominican Republic
 Nat Geog 152:548-9 (c, 2) O '77
--Georgia
 Nat Geog 154:236-7 (c, 1) Ag '78
--Haiti
 Trav/Holiday 151:58 (c, 2) F '79
--Hawaii
 Nat Geog 152:584-5, 598-9 (c, 1)
 N '77

--Indiana
 Nat Geog 151:262-3 (c, 2) F '77
--Iowa
 Smithsonian 11:126-9 (c, 3) Mr
 '81
 Nat Geog 159:604-16 (c, 1) My
 '81
--Ireland
 Nat Geog 154:670-1 (c, 1) N '78
 Nat Geog 159:cov., 433-5, 443,
 468 (c, 1) Ap '81
--Japan
 Natur Hist 89:94-5 (c, 1) Mr '80
--Kentucky
 Smithsonian 11:76-82 (c, 1) Ag
 '80
--Maine
 Nat Geog 158:382-3, 396-7 (c, 1)
 S '80
--Massachusetts
 Nat Wildlife 17:4 (c, 1) Ap '79
--Michigan
 Nat Geog 155:810-11 (c, 1) Je
 '79
 Nat Wildlife 19:50 (c, 1) O '81
--Midwest
 Smithsonian 8:76, 80 (c, 3) My
 '77
 Natur Hist 90:58-9 (c, 2) N '81
--Nebraska
 Nat Geog 158:54-5 (c, 1) Jl '80
--New Brunswick
 Nat Geog 158:396-7 (c, 1) S '80
--New Jersey
 Nat Geog 100:570-1 (c, 1) N '01
--New York
 Nat Geog 151:704-15 (c, 1) My
 '77
 Nat Geog 153:80 (c, 1) Ja '78
--Nigeria
 Nat Geog 155:424-5 (c, 1) Mr '79
--North Carolina
 Ebony 32:47 (3) F '77
 Nat Geog 157:346-7 (c, 1) Mr '80
--North Wales, Great Britain
 Trav/Holiday 151:76-7 (c, 1) Ap
 '79
--Pakistan
 Nat Geog 151:112-13 (c, 1) Ja '77
--Pastureland (Scotland)
 Nat Geog 151:530-1 (c, 1) Ap '77
--Philippines
 Nat Geog 151:362-3 (c, 1) Mr '77
--Santa Clara Valley, California
 (1950 and 1980)
 Life 4:78-9 (c, 2) D '81
--Terraced (Albania)
 Nat Geog 158:550 (c, 3) O '80

--Tobacco (Cuba)
Nat Geog 151:62-3 (c, 1) Ja '77
--Vermont
Nat Wildlife 19:4 (c, 1) Ap '81
--Washington
Nat Geog 151:424-5 (c, 1) Mr
'77
Nat Geog 152:43 (c, 4) Jl '77
--Wisconsin
Nat Geog 160:686-7 (c, 1) N '81
--Yukon
Nat Geog 153:566-7 (c, 1) Ap
'78
--Zimbabwe
Nat Geog 160:618-19 (c, 1) N
'81
--See also BARNS; CORNFIELDS;
FARMHOUSES; GRAIN FIELDS;
HORSE FARMS; ORCHARDS;
PLANTATIONS; SILOS;
STABLES; VINEYARDS;
WHEAT FIELDS
FARRAGUT, DAVID GLASGOW
Smithsonian 10:104 (4) Je '79
FASHION SHOWS
Ebony 32:106-7 (3) Ja '77
Ebony 33:118-22 (c, 2) Mr '78
Ebony 35:92-8 (c, 2) D '79
--Old-fashioned dress (Costa Rica)
Nat Geog 160:42-3 (c, 2) Jl '81
--Paris, France
Life 2:84-8 (c, 2) Je '79
--South Korean fashions
Nat Geog 156:773 (c, 1) D '79
Fat. See OBESITY
Feather stars. See SEA LILIES
FEATHERS
--Used in crafts
Natur Hist 89:150-4 (c, 1) Ap
'80
Federal Bureau of Investigation.
See HOOVER, J. EDGAR
FENCES
--Mending (California)
Nat Wildlife 18:44 (c, 4) O '80
--Ranch (Alaska)
Smithsonian 12:34 (c, 4) Ag '81
--Running Fence (California)
Life 2:197 (c, 2) D '79
--Texas/Mexico border
Nat Geog 157:478 (c, 4) Ap '80
--Whitewashing fence (Falkland
Islands)
Smithsonian 12:90 (c, 4) S '81
--See also BARBED WIRE; GATES
FENCING
Sports Illus 52:46 (4) Ja 7 '80
Ebony 36:58 (3) Jl '81

--Kendo (Japan)
Nat Geog 158:cov., 502-3 (c, 1)
O '80
FENNECS
Natur Hist 88:69 (c, 4) F '79
FENNEL
Natur Hist 88:94 (drawing, 4) Je
'79
FERNS
Nat Geog 151:355 (c, 3) Mr '77
Nat Geog 160:193 (c, 4) Ag '81
--Autumn coloring
Nat Wildlife 16:42-7 (c, 1) Ag '78
--Hapuu
Nat Wildlife 19:22 (c, 3) Je '81
FERRETS
Sports Illus 53:102-3, 110
(painting, c, 1) O 13 '80
FERRIS WHEELS
Trav/Holiday 152:32 (4) Jl '79
Trav/Holiday 156:4 (4) Jl '81
--Atami Korakuen Park, Japan
Travel 147:62 (4) F '77
--Spain
Nat Geog 153:298-9 (c, 1) Mr '78
FERRY BOATS
Smithsonian 8:76-81 (c, 1) Jl '77
--Geogia
Nat Geog 152:654 (c, 3) N '77
--Greece
Nat Geog 157:385 (c, 3) Mr '80
--Kentucky
Travel 148:49 (4) Jl '77
--Ohio
Nat Geog 154:98 (c, 3) Jl '78
--Seattle, Washington
Ebony 36:59 (3) S '81
--Vancouver, British Columbia
Nat Geog 154:466-7 (c, 1) O '78
FESTIVALS
--19th cent. shooting competitions
(New York)
Am Heritage 29:6-8 (drawing, 4)
F '78
--1880's winter carnivals (St. Paul,
Minnesota)
Am Heritage 30:60-4 (c, 1) D '78
--1976 U. S. Bicentennial celebration
Life 2:9-14 (c, 1) D '79
--Air show (Oshkosh, Wisconsin)
Nat Geog 156:364-75 (c, 1) S '79
--Alster Lake Festival, Hamburg,
West Germany
Trav/Holiday 149:35 (c, 1) Mr
'78
--Armadillo festival (Texas)
Nat Wildlife 15:37 (4) F '77
--Arts and culture Festac (Nigeria)

Ebony 32:cov. , 33-49 (c, 1) My
'77
--Bali, Indonesia
Nat Geog 157:416-27 (c, 1) Mr
'80
--Bicentennial celebration at
stadium (Calif.)
Sports Illus 47:38-9 (c, 2) Jl
18 '77
--British spring morris dancing
(Vermont)
Smithsonian 12:118-25 (c, 1) My
'81
--Burning witch dummy (Denmark)
Nat Geog 156:828 (c, 4) D '79
--Carnival (Binche, Belgium)
Trav/Holiday 151:41-3, 75 (c, 1)
Ja '79
--Carnival (Chicoutimi, Quebec)
Nat Geog 151:462-3 (c, 2) Ap '77
--Carnival (Rio de Janeiro, Brazil)
Nat Geog 153:246, 254-5 (c, 1)
F '78
Trav/Holiday 152:24-6 (4) N
'79
--Carnival (St. Thomas, Virgin
Islands)
Nat Geog 159:232-3 (c, 1) F '81
--Charro Days (Brownsville,
Texas)
Trav/Holiday 151:22 (4) F '79
--Chili cookoff (Texas)
Natur Hist 90:96-8 (c, 3) Ap '81
--Confetti at soccer victory
(Argentina)
Sports Illus 50:100-7 (c, 1) F
15 '79
--Czech Communist takeover
commemoration
Nat Geog 155:564-5 (c, 1) Ap
'79
--Edmundston, New Brunswick
Nat Geog 158:398-9 (c, 1) S '80
--Eisteddfod (Wales)
Trav/Holiday 153:110, 120 (3)
Ap '80
--Fasching (Munich, West Ger-
many)
Trav/Holiday 148:54 (c, 2) D '77
--Freedom Week (Philadelphia,
Pennsylvania)
Nat Geog 153:738 (c, 2) Je '78
--Frontier days (Cheyenne,
Wyoming)
Trav/Holiday 149:38-41 (c, 1)
Je '78
--Grand Festival of Nikko, Japan
Trav/Holiday 155:26 (3) Ap '81

--Guadeloupe
Trav/Holiday 153:69 (c, 3) Ap '80
--High school homecoming (Arizona)
Nat Geog 152:516 (c, 2) O '77
--Kite-fighting (Japan)
Nat Geog 151:550-61 (c, 1) Ap
'77
--Nordic Fest (Deborah, Iowa)
Trav/Holiday 151:61-2, 84-5
(c, 1) Je '79
--Oktoberfest (Milwaukee, Wiscon-
sin)
Trav/Holiday 155:37 (4) Je '81
--Oktoberfest (Munich, West Ger-
many)
Nat Geog 152:172-3 (c, 2) Ag '77
Trav/Holiday 148:57 (c, 2) D '77
--Ommegang pageant (Belgium)
Nat Geog 155:324-5 (c, 1) Mr
'79
--Pageant of the Long Canoes
(Hawaii)
Trav/Holiday 152:42-3 (c, 1) O
'79
--Pig race at farm show (Iowa)
Nat Geog 154:408 9 (c, 2) S '78
--Renaissance fair (California)
Travel 147:41 (c, 4) My '77
--San Luis Rey carnival, California
Trav/Holiday 149:37 (c, 2) F '78
--Shooting competition (Ohio)
Am Heritage 29:14-17, 116 (c, 1)
F '78
--Silla (South Korea)
Trav/Holiday 156:46 (c, 4) S '81
--Snow Festival, Sapporo, Japan
Trav/Holiday 154:53-5 (c, 2) N
'80
Life 4:106-7 (c, 1) F '81
--Spartakiade sports event (U. S. S. R.)
Sports Illus 51:18-22 (c, 2) Ag 6
'79
--Summerfest (Milwaukee, Wiscon-
sin)
Nat Geog 158:192-3 (c, 1) Ag '80
--Torchlight run (China)
Nat Geog 157:295-7 (c, 1) Mr '80
--Volksfest (Kelheim, West Ger-
many)
Nat Geog 152:460-1 (c, 1) O '77
--Water show (Wisconsin)
Travel 148:68 (4) Ag '77
--West Indian carnival (Brooklyn,
New York)
Natur Hist 88:72-85 (c, 1) Ag '79
--Winter carnival (Quebec City,
Quebec)
Nat Geog 157:608-9 (c, 1) My '80

--Winter carnival (St. Paul, Minnesota)
Nat Geog 158:680 (c, 4) N '80
--Winterlude, Ottawa, Ontario
Sports Illus 51:46-50 (c, 1) D
24 '79
--See also BEAUTY CONTESTS;
BIRTHDAY PARTIES; BOSTON
MARATHON; COMMENCE-
MENTS; DANCES; DOG SHOWS;
FAIRS; FLEA MARKETS;
HOLIDAYS; HORSE SHOWS;
MARATHONS; OLYMPICS;
PARADES; PARTIES; RACES;
RELIGIOUS RITES AND
FESTIVALS; RODEOS;
SPORTS
FEZ, MOROCCO
Trav/Holiday 156:56-9 (c, 1) S
'81
FIBER OPTICS
Nat Geog 156:517-35 (c, 1) O '79
FIFE PLAYING
Am Heritage 32:78 (drawing, 4)
O '81
FIG TREES
Trav/Holiday 149:33 (c, 1) F
'78
FIGHTING
--19th cent. frontier brawl
Smithsonian 10:104 (drawing, 1)
Ap '79
--Colombian villagers
Sports Illus 53:88-9 (c, 3) N 24
'80
--Couples feuding
Ebony 34:69-70 (2) Ap '79
FIGHTING--HUMOR
Ebony 34:135-6, 142 (draw-
ing, 2) Mr '79
FIGUREHEADS
Nat Geog 152:349 (c, 3) S '77
--1756 frigate
Trav/Holiday 149:38 (c, 1) Ap
'78
--Spanish schooner
Smithsonian 11:125 (c, 1) Je '80
FIGWORT PLANTS
--Louseworts
Smithsonian 9:122 (c, 4) N '78
FIJI
Trav/Holiday 155:cov., 58-63
(map, c, 1) Ja '81
FIJI--COSTUME
Trav/Holiday 155:cov., 58-63
(c, 1) Ja '81
--Children
Trav/Holiday 148:34 (c, 2) D

'77
FILING CABINETS
--Microfilm vaults (Utah)
Smithsonian 12:86-9 (c, 1) D '81
FILLMORE, MILLARD
Am Heritage 30:19 (drawing, 4)
Je '79
FINCHES
Nat Wildlife 16:42-3 (painting, c, 4)
D '77
Nat Geog 153:674 (c, 4) My '78
Smithsonian 10:30 (c, 4) N '79
Natur Hist 90:56-7 (c, 2) Jl '81
Natur Hist 90:62 (c, 1) O '81
--See also GOLDFINCHES
FINGER LAKES, NEW YORK
Nat Geog 151:704-11 (map, c, 1)
My '77
Trav/Holiday 154:33-4 (map, c, 2)
Ag '80
FINLAND
Trav/Holiday 155:47-51 (map, c, 1)
F '81
--Forest
Life 4:34-5 (c, 1) Ag '81
--See also HELSINKI
FINLAND--COSTUME
Trav/Holiday 155:46-51 (c, 1) F
'81
Nat Geog 160:236-55 (c, 1) Ag '81
FINLAND--MAPS
--Helsinki
Nat Geog 160:240 (c, 4) Ag '81
Fir trees. See DOUGLAS FIR
TREES
FIRE EATERS
--Paris, France
Nat Geog 158:476-7 (c, 1) O '80
FIRE FIGHTERS
Ebony 35:124 (3) Ag '80
--1894 Minnesota
Am Heritage 28:93 (3) Ag '77
--Kansas
Life 3:26-7 (2) S '80
FIRE FIGHTING
--1852 hand pumper (Missouri)
Am Heritage 31:76 (c, 4) D '79
--1894 hotel (Hurley, Wisconsin)
Am Heritage 31:109 (2) Je '80
--1910 fire drill (Lake Placid, New
York)
Am Heritage 33:60-1 (1) D '81
--Coast Guard fighting dump site
fire (New Jersey)
Nat Geog 160:584-5 (c, 1) N '81
--Fireboat (Michigan)
Ebony 36:102 (4) N '80
--New York City, New York

BASS; BOWFINS; CARP; COD;
COELECANTHS; CRAPPIES;
DARTERS; EELS; FLOUNDERS;
GARS; LUMPFISH; MARLINS;
PADDLEFISH; PIKE; PIPE-
FISH; PIRANHAS; POMPANO;
PORCUPINE FISH; REMORAS;
SAILFISH; SALMON; SARDINES;
SCULPIN; SEA BATS; SEA
HORSES; SHARKS; SKATES;
SNAPPERS; SUNFISH; TOAD-
FISH; TROUT; TUNA; WHITE-
FISH; WOLF FISH; and
MARINE LIFE; POND LIFE
FISH, HAMILTON
 Am Heritage 33:78 (4) D '81
FISHERMEN
--1920's
 Natur Hist 87:90-1 (1) Ag '78
--Bahamas
 Trav/Holiday 151:62 (c, 4) Ap
 '79
--Bahrain
 Trav/Holiday 151:79 (c, 2) My
 '79
--Dominica
 Ebony 32:95 (c, 3) Ja '77
--Iceland
 Smithsonian 12:174 (c, 4) N '81
--Japan
 Nat Geog 152:847 (c, 4) D '77
--Massachusetts
 Nat Geog 155:572-3 (c, 2) Ap
 '79
--Mexico
 Trav/Holiday 149:48 (c, 4) F
 '78
--New Jersey
 Nat Wildlife 18:5-11 (c, 1) F
 '80
--North Carolina
 Nat Geog 157:341 (c, 4) Mr '80
--Ohio
 Nat Geog 154:92 (c, 4) Jl '78
--Oman
 Nat Geog 160:361 (c, 1) S '81
--Rhode Island
 Sports Illus 53:80 (c, 4) Ag 18
 '80
Fishers. See MARTENS
FISHING
 Travel 148:61 (c, 1) S '77
 Sports Illus 50:40 (drawing, c, 2)
 Mr 12 '79
 Trav/Holiday 151:72-5 (c, 4)
 Ap '79
 Sports Illus 51:70-6 (paint-
 ing, c, 1) Jl 16 '79

Sports Illus 52:62-6 (painting, c, 1)
 My 12 '80
 Ebony 36:143-7 (c, 2) My '81
 Sports Illus 55:66-77 (painting, c, 1)
 Je 29 '81
--Alaska
 Smithsonian 12:42 (c, 3) Ag '81
--Angling (late 19th cent.)
 Am Heritage 29:99 (4) O '78
--Angling (Alaska)
 Nat Geog 156:40-1 (c, 2) Jl '79
--Angling (Montana)
 Sports Illus 51:87 (4) S 3 '79
--Angling for salmon
 Nat Geog 160:602-3, 614-15
 (c, 1) N '81
--Arkansas
 Nat Geog 153:427 (c, 1) Mr '78
--Bass (Louisiana)
 Nat Geog 156:386-7 (c, 1) S '79
--Bass (Massachusetts)
 Sports Illus 49:65 (4) N 13 '78
--Bass (Oregon)
 Trav/Holiday 154:34 (c, 4) Jl '80
--Belgium
 Nat Geog 155:314-5 (c, 1) Mr '79
--Bluefish (Massachusetts)
 Sports Illus 47:42-3 (painting, c, 2)
 N 7 '77
--Bluegills (Alabama)
 Nat Wildlife 15:37-9 (c, 1) Je '77
--Bow and arrows (Brazil Indians)
 Nat Geog 155:81 (c, 4) Ja '79
--Bow and arrows (Surinam)
 Smithsonian 7.82 (c, 4) Mr '77
--Brazil
 Sports Illus 54:78-82 (c, 1) My
 18 '81
--Brazilian Indian
 Smithsonian 9:78-9 (c, 1) Ap '78
--California
 Nat Geog 152:334-5 (c, 2) S '77
--Canadian Eskimos
 Nat Geog 152:624-5, 635 (c, 1)
 N '77
--Catfish (Louisiana)
 Nat Geog 156:381 (c, 3) S '79
--Children
 Nat Wildlife 16:17, 32 (c, 1) F
 '78
--Cod
 Natur Hist 88:34 (painting, 4) Mr
 '79
--Colorado
 Travel 147:44 (4) Ap '77
--Crabs (South Carolina)
 Trav/Holiday 153:cov. (c, 1) Ap
 '80

--Displaying catch
 Trav/Holiday 149:43 (c, 4) Ap
 '78
--Displaying catch (Tahiti)
 Trav/Holiday 153:98 (3) F '80
--Displaying caught tarpon
 Trav/Holiday 150:59 (c, 4) N
 '78
 Sports Illus 52:79 (4) Ap 7 '80
--Dominican Republic
 Nat Geog 152:547 (c, 1) O '77
--Eels (Denmark)
 Nat Geog 156:816-17 (c, 1) D
 '79
--Festival (Nigeria)
 Nat Geog 155:428-9 (c, 1) Mr
 '79
--Finland
 Trav/Holiday 155:51 (c, 2) F
 '81
--Florida
 Nat Geog 152:22-3 (c, 2) Jl '77
 Sports Illus 48:61 (c, 4) F 20
 '78
 Sports Illus 50:32 (c, 1) Mr 19
 '79
--France
 Nat Geog 153:808-9 (c, 1) Je
 '78
--Japan
 Nat Geog 157:92-3 (c, 1) Ja '80
--Kingfish (Florida)
 Sports Illus 54:81 (4) Ap 13
 '81
--Louisiana
 Trav/Holiday 149:36 (c, 4) Mr
 '78
--Measuring caught swordfish
 Sports Illus 47:44 (4) Ag 15 '77
--Mending nets (Japan)
 Travel 147:62 (4) F '77
--New York
 Nat Wildlife 19:13 (c, 2) O '81
--Orchid Island Yamis
 Nat Geog 151:100-1 (c, 1) Ja
 '77
--Oysters (California)
 Nat Wildlife 16:52 (c, 4) Ap '78
--Oysters (France)
 Nat Geog 158:254-5 (c, 1) Ag
 '80
--Ozark highlands
 Am Heritage 29:99 (c, 1) D '77
--Salmon
 Sports Illus 49:82 (painting, c, 3)
 O 23 '78
 Smithsonian 12:174-5 (c, 4) N
 '81

--Salmon (Northwest)
 Nat Geog 154:628-9 (c, 1) N '78
 Smithsonian 9:56-64 (c, 1) F '79
 Natur Hist 89:52-3, 61 (c, 1) Jl
 '80
--Scotland
 Trav/Holiday 152:42 (c, 4) S '79
--Surfcasting
 Sports Illus 54:36-43 (c, 2) Je 1
 '81
--Surinam
 Sports Illus 53:86, 89-90 (draw-
 ing, c, 3) N 10 '80
--Tarpon (Florida)
 Sports Illus 48:33 (c, 2) Je 19
 '78
--Tench (Ireland)
 Nat Geog 154:675 (c, 2) N '78
--Trout
 Nat Wildlife 15:42-7 (c, 1) Ag
 '77
--Trout (19th cent. Minnesota)
 Natur Hist 87:88 (1) Ag '78
--Trout (Arkansas)
 Sports Illus 49:54 (4) D 18 '78
--Trout (Colorado)
 Sports Illus 55:66-7 (c, 2) S 28
 '81
--Trout (Florida)
 Sports Illus 49:34 (c, 4) N 27 '78
--Trout (New York)
 Sports Illus 53:52 (4) D 8 '80
--Trout (New Zealand)
 Trav/Holiday 155:91 (c, 3) Ja '81
--Trout (Northwest)
 Sports Illus 49:78 (painting, c, 3)
 D 4 '78
--Trout (Wyoming)
 Trav/Holiday 152:51 (c, 3) Jl '79
 Sports Illus 52:60 (c, 4) Je 16
 '80
 Nat Geog 160:264-5 (c, 1) Ag '81
--Upper Volta
 Nat Geog 157:518-19 (c, 1) Ap
 '80
--Virgin Islands
 Ebony 33:110-11 (c, 2) Ja '78
 Trav/Holiday 156:46 (c, 4) O '81
--Virginia
 Trav/Holiday 151:49 (4) Je '79
--Washington
 Nat Geog 152:44 (c, 1) Jl '77
--See also CLAM DIGGING; ICE
 FISHING
FISHING--HUMOR
 Sports Illus 48:46-9 (painting, c, 4)
 Ja 16 '78
 Sports Illus 49:44-5 (drawing, c, 1)

O 2 '78
FISHING BOATS
 Travel 147:58-9 (c, 1) Ja '77
 Sports Illus 48:46-7 (painting, c, 1)
 Je 5 '78
 Natur Hist 87:92-4 (c, 1) Ag '78
 Ebony 34:116-22 (2) O '79
--1890's (San Francisco, Califor-
 nia)
 Am Heritage 29:58 (2) O '78
--California
 Nat Geog 152:338-9 (c, 2) S '77
--Denmark
 Natur Hist 86:40 (c, 2) D '77
--Georgia
 Nat Geog 154:240-1 (c, 2) Ag
 '78
--Hauling them ashore (Maldives)
 Nat Geog 160:432-3 (c, 2) O
 '81
--Ernest Hemingway's boat (Cuba)
 Sports Illus 47:58 (c, 4) Ag 1
 '77
--Herring boats (California)
 Nat Geog 159:840-1 (c, 4) Je '81
--Hong Kong
 Trav/Holiday 148:38 (c, 2) D
 '77
--Maine
 Nat Wildlife 15:42-9 (c, 1) Ap
 '77
--Malaysia
 Nat Geog 151:647 (c, 3) My '77
--Massachusetts
 Trav/Holiday 156:40 (c, 2) Jl
 '81
--Poland
 Natur Hist 89:69 (c, 4) Mr '80
--Quebec
 Nat Geog 151:450-1 (c, 1) Ap '77
--Russian ship
 Nat Geog 160:818-21 (c, 1) D
 '81
--Sardines (Monterey, California)
 Trav/Holiday 149:43 (c, 4) Mr
 '78
--Shrimp boats (Louisiana)
 Trav/Holiday 149:37, 86 (1) Mr
 '78
--Shrimp boats (Mississippi)
 Nat Geog 160:380-7 (c, 2) S '81
--Sri Lanka
 Nat Geog 155:148-9 (c, 1) Ja
 '79
--Sumatra, Indonesia
 Nat Geog 159:424-5 (c, 1) Mr
 '81
--Uganda

Life 2:64-5 (c, 1) Ag '79
--Washington
 Smithsonian 9:56-62 (c, 1) F '79
--West Coast
 Natur Hist 87:64-71, 120 (c, 1)
 N '78
FISHING COMPETITIONS
--Cuba
 Sports Illus 47:54-6 (c, 1) Ag 1
 '77
--Weighing in (Kona, Hawaii)
 Trav/Holiday 150:38 (c, 4) D '78
FISHING EQUIPMENT
 Sports Illus 51:36, 40 (c, 1) O 1
 '79
--Angling reels and rods
 Sports Illus 52:74-5 (1) Ap 7 '80
--Lures
 Nat Wildlife 18:3, 37-41 (c, 1) Je
 '80
 Sports Illus 54:46, 51-2 (c, 4)
 My 4 '81
 Sports Illus 55:72 (painting, c, 4)
 Je 29 '81
--Making bamboo fly rod
 Nat Geog 150:524-5 (c, 1) O '80
--Salmon fly
 Nat Geog 160:611 (c, 4) N '81
 Smithsonian 12:174-5 (c, 3) N '81
FISHING INDUSTRY
--1955 (East Coast)
 Ebony 36:95 (4) N '80
--Barracuda (North Yemen)
 Nat Geog 156:255 (c, 1) Ag '79
--Brazil
 Natur Hist 87:63-73 (c, 1) Je '78
--Catfish (Arkansas)
 Nat Geog 153:410 (c, 4) Mr '78
--Cod (Bering Sea)
 Nat Geog 160:818-19 (c, 1) D '81
--Fiji
 Trav/Holiday 155:58-9 (c, 1) Ja
 '81
--Fishermen's sheds (Great Britain)
 Nat Geog 156:462, 468-9 (c, 1)
 O '79
--Fishponds (Philippines)
 Nat Geog 151:376-7 (c, 1) Mr '77
--Flounder (Maine)
 Nat Geog 153:512-13 (c, 1) Ap '78
--Huts in water (Sumatra, Indo-
 nesia)
 Nat Geog 159:428-9 (c, 1) Mr '81
--Japan
 Nat Geog 152:830-8 (c, 1) D '77
 Nat Geog 157:70-1 (c, 1) Ja '80
--Mackerel drying (Portugal)
 Nat Geog 158:826-7 (c, 1) D '80

--Massachusetts
 Nat Geog 155:572-3 (c, 2) Ap
 '79
--Mending nets (Dubai)
 Travel 147:62 (4) Ja '77
--Mending nets (Prince Edward
 Island)
 Trav/Holiday 151:54 (c, 4) My
 '79
--New York
 Nat Geog 153:62-3, 70-1 (c, 1)
 Ja '78
--Ohio
 Nat Geog 154:92 (c, 4) Jl '78
--Oysters (Maryland)
 Nat Geog 152:802-3 (c, 1) D '77
--Pakistan
 Nat Geog 151:128 (c, 1) Ja '77
--Redfish (Maine)
 Nat Geog 153:508-9 (c, 1) Ap
 '78
--Rockfish (California)
 Nat Geog 160:773 (c, 1) D '81
--Salmon (Alaska)
 Smithsonian 12:36 (c, 4) Ag '81
--Salmon (Washington)
 Nat Geog 151:70, 82-9 (c, 1)
 Ja '77
--Salmon hatchery (Connecticut)
 Natur Hist 87:40 (c, 4) D '78
--Shad (New Jersey)
 Nat Wildlife 18:5-11 (c, 1) F
 '80
--Shrimp (France)
 Nat Geog 151:828-9 (c, 1) Je
 '77
--Shrimp (Texas)
 Nat Geog 153:200-1 (c, 1) F '78
--Tuna
 Smithsonian 7:44-53 (c, 1) F '77
 Nat Geog 155:522-4 (c, 1) Ap
 '79
--Tunisia
 Nat Geog 157:207 (c, 4) F '80
--West Coast
 Natur Hist 87:64-71 (c, 1) N '78
FITZGERALD, F. SCOTT
 Am Heritage 28:85 (drawing, 4)
 Ag '77
 Smithsonian 11:172 (drawing, 4)
 Je '80
FITZSIMMONS, ROBERT P.
 Ebony 33:130 (4) Mr '78
FJORDS
--Alaska
 Smithsonian 8:44-5 (c, 4) D '77
--Ellesmere Island, Canada
 Nat Geog 159:576-7 (c, 1) My '81

--Norway
 Trav/Holiday 150:41-3 (c, 1) N
 '78
FLAGS
--Albania
 Nat Geog 158:539 (drawing, c, 4)
 O '80
--All nations
 Ebony 32:33-5 (c, 3) My '77
--Arkansas
 Nat Geog 153:403 (drawing, c, 4)
 Mr '78
--Bahrain
 Nat Geog 156:309 (drawing, c, 4)
 S '79
--Baseball championship banners
 Sports Illus 50:39 (c, 4) My 21
 '79
--Belgium
 Nat Geog 155:316 (drawing, c, 4)
 Mr '79
--British flag clothing (Northern
 Ireland)
 Nat Geog 159:474 (c, 1) Ap '81
--Bulgaria
 Nat Geog 158:95 (drawing, c, 4)
 Jl '80
--Canada
 Nat Geog 154:794-5 (c, 1) D '78
--Comoros
 Nat Geog 160:424 (drawing, c, 4)
 O '81
--Costa Rica
 Nat Geog 160:36, 61 (drawing, c, 4)
 Jl '81
--Cuba
 Nat Geog 151:34 (drawing, c, 4)
 Ja '77
--Diego Garcia
 Nat Geog 160:424 (drawing, c, 4)
 O '81
--Djibouti
 Nat Geog 154:520 (drawing, c, 4)
 O '78
--Dominican Republic
 Nat Geog 152:542 (drawing, c, 4)
 O '77
--Egypt
 Nat Geog 151:316 (drawing, c, 4)
 Mr '77
--El Salvador
 Nat Geog 160:59 (drawing, c, 4)
 Jl '81
--England
 Nat Geog 156:450 (drawing, c, 4)
 O '79
--Georgia
 Nat Geog 154:215 (drawing, c, 4)

FLAGS / 141

Ag '78
--Great Britain
Sports Illus 51:19 (c, 4) Jl 30
'79
Nat Geog 159:478 (drawing, c, 4)
Ap '81
--Greece
Nat Geog 157:371 (drawing, c, 4)
Mr '80
--Guatemala
Nat Geog 160:59 (drawing, c, 4)
Jl '81
--Honduras
Nat Geog 160:60 (drawing, c, 4)
Jl '81
--Iowa
Nat Geog 159:608 (drawing, c, 4)
My '81
--Ireland
Nat Geog 159:446 (c, 4) Ap '81
--Israel
Life 2:138 9 (c, 1) S '79
--Japan
Trav/Holiday 154:52 (draw-
ing, c, 4) N '80
--Liechtenstein
Nat Geog 159:274 (drawing, c, 4)
F '81
--Madagascar
Nat Geog 160:424 (drawing, c, 4)
O '81
--Malaysia
Nat Geog 151:640 (drawing, c, 4)
My '77
--Maldives
Nat Geog 160:424 (drawing, c, 4)
O '01
--Mauritius
Nat Geog 160:424 (drawing, c, 4)
O '81
--Mexico
Nat Geog 153:621 (drawing, c, 4)
My '78
--Michigan
Nat Geog 155:804 (drawing, c, 4)
Je '79
--New Jersey
Nat Geog 160:577 (drawing, c, 4)
N '81
--Nicaragua
Nat Geog 160:61 (drawing, c, 4)
Jl '81
--Nigeria
Nat Geog 155:416 (drawing, c, 4)
Mr '79
--North Carolina
Nat Geog 157:336 (drawing, c, 4)
Mr '80

--Oman
Nat Geog 160:353 (drawing, c, 4)
S '81
--Ontario
Nat Geog 154:764 (drawing, c, 4)
D '78
--Pakistan
Nat Geog 159:681 (drawing, c, 4)
My '81
--Panama
Nat Geog 160:61 (drawing, c, 4)
Jl '81
--Pennsylvania
Nat Geog 153:734 (drawing, c, 4)
Je '78
--Philippines
Nat Geog 151:365 (drawing, c, 4)
Mr '77
--Portugal
Nat Geog 158:806 (drawing, c, 4)
D '80
--Quebec
Nat Geog 151:440 (drawing, c, 4)
Ap '77
Nat Geog 157:599 (c, 4) My '80
--Reunion
Nat Geog 160:424 (drawing, c, 4)
O '81
--Saskatchewan
Nat Geog 155:656 (drawing, c, 4)
My '79
--Saudi Arabia
Nat Geog 158:323 (drawing, c, 4)
S '80
--Seychelles
Nat Geog 160:424 (drawing, c, 4)
O '81
--Singapore
Nat Geog 159:544 (c, 1) Ap '81
--Somalia
Nat Geog 159:754 (drawing, c, 4)
Je '81
--South Africa
Nat Geog 151:786 (drawing, c, 4)
Je '77
--Spain
Nat Geog 153:303 (drawing, c, 4)
Mr '78
--Sri Lanka
Nat Geog 155:126 (drawing, c, 4)
Ja '79
--Syria
Nat Geog 154:332 (drawing, c, 4)
S '78
--Texas
Nat Geog 157:444 (drawing, c, 4)
Ap '80
--Tunisia

Nat Geog 157:193 (drawing, c, 4)
F '80
--Turkey
Nat Geog 152:91 (drawing, c, 4)
Jl '77
--U. S.
Am Heritage 28:55 (4) O '77
Sports Illus 53:13 (c, 4) Jl 28
'80
Nat Geog 158:189-91 (c, 1) Ag
'80
Life 4:50-1 (c, 1) Ja '81
Life 4:26-7 (c, 1) Mr '81
Natur Hist 90:76 (c, 4) Mr '81
Sports Illus 55:41 (c, 4) Ag 3
'81
--U. S. (made to fly from Ver-
razano Narrows Bridge,
N. Y.)
Life 3:112-13 (c, 1) My '80
--U. S. (painting by Jasper Johns)
Life 2:88 (c, 4) S '79
--U. S. Confederacy
Travel 147:27 (drawing, c, 4)
Ja '77
--U. S. flag portrait made of men
Am Heritage 28:93 (4) Je '77
--U. S. flag sculpture by Jasper
Johns
Life 4:124 (c, 4) Ja '81
--Zimbabwe
Nat Geog 160:623, 632 (c, 2) N
'81
FLAMINGOS
Natur Hist 86:72-6 (c, 1) D '77
Natur Hist 87:107 (c, 3) Ag '78
Trav/Holiday 151:60 (c, 2) Ja
'79
Nat Geog 157:202-3 (c, 1) F '80
Trav/Holiday 153:49 (c, 2) Mr
'80
Life 3:44-9 (c, 1) Je '80
Smithsonian 12:117 (painting, c, 2)
S '81
--In flight
Smithsonian 9:76-7 (c, 1) Je '78
FLATBOATS
Nat Geog 151:270-1 (c, 2) F
'77
--1806 Ohio River
Smithsonian 10:102 (drawing, 4)
Ap '79
FLATWORMS
Nat Geog 151:679 (c, 4) My '77
Natur Hist 87:68 (c, 4) D '78
FLEA MARKETS
Life 2:47-50 (c, 2) Jl '79
--Grenoble, France

Trav/Holiday 156:33 (c, 1) Ag '81
--Madrid, Spain
Travel 147:63 (4) Mr '77
--Maryland
Nat Geog 158:456-7 (c, 1) O '80
--Pennsylvania
Smithsonian 11:74 (c, 1) N '80
--Yafo, Israel
Trav/Holiday 149:53 (3) Mr '78
FLEAS
Nat Geog 152:77 (c, 4) Jl '77
Smithsonian 8:86-7 (c, 4) Ja '78
FLEAS--HUMOR
Sports Illus 47:30-3 (painting, c, 2)
Ag 15 '77
FLIES
Nat Geog 151:578-9 (c, 1) Ap '77
Natur Hist 86:58 (c, 2) Ag '77
Smithsonian 8:82-3 (c, 4) N '77
Nat Wildlife 17:2 (c, 1) Ap '79
Natur Hist 88:68-9 (c, 2) Ag '79
Nat Geog 157:412, 414-15 (c, 1)
Mr '80
Nat Wildlife 18:24 (c, 2) Ag '80
Nat Geog 159:166-7 (c, 1) F '81
Smithsonian 11:44 (c, 4) F '81
--Houseflies
Nat Geog 157:154 (c, 4) F '80
--Larvae
Nat Geog 151:563-75 (c, 1) Ap
'77
--Medflies
Life 4:130-1 (c, 1) O '81
--Stable flies
Natur Hist 89:39 (c, 4) My '80
--See also FRUIT FLIES; TSETSE
FLIES
FLOODS
--1920's Tennessee
Am Heritage 28:74 (4) F '77
--1966 Venice, Italy
Smithsonian 8:42 (4) N '77
--California
Nat Geog 159:826-7 (c, 1) Je '81
--Effects on Johnstown, Pennsyl-
vania
Nat Geog 158:164-5 (c, 1) Ag '80
--Kansas City, Missouri
Nat Geog 152:822 (c, 3) D '77
--Texas
Life 4:40-1 (c, 1) Jl '81
FLORENCE, ITALY
Nat Geog 152:304-5 (c, 1) S '77
--Piazza Santa Novella (1560)
Smithsonian 12:40 (painting, c, 4)
S '81
--Renaissance palace
Smithsonian 12:95 (c, 4) Ag '81

--See also ARNO RIVER
FLORIDA
--Bradenton baseball fields
 Sports Illus 48:29-32 (c, 2) Mr
 6 '78
--Environmental problems
 Sports Illus 54:82-93 (map, c, 1)
 F 9 '81
--Florida Bay
 Sports Illus 49:32-3 (c, 2) N
 27 '78
--Fort Jefferson, Florida Keys
 Trav/Holiday 156:36 (4) N '81
--Key Biscayne
 Trav/Holiday 149:54-9 (map, c, 1)
 F '78
--Keys
 Natur Hist 86:74 (4) Ap '77
 Trav/Holiday 154:48-51 (map, c, 1)
 N '80
--Kissimmee River
 Sports Illus 54:82-3 (c, 1) F 9
 '81
--Marco Island
 Smithsonian 7:68-77 (c, 1) Ja '77
--Merritt Island National Wildlife
 Refuge
 Nat Geog 155:350-3 (c, 1) Mr '79
--Naples
 Trav/Holiday 154:14-16 (c, 1) D
 '80
--Palm Beach
 Trav/Holiday 151:41-3, 80-1
 (c, 3) Mr '79
--Sea Island
 Ebony 35:80 (4) My '80
--Wildlife at southern tip
 Nat Geog 151:668-89 (c, 1) My
 '77
--Winter Park sinkhole
 Life 4:42-3 (c, 1) Jl '81
--See also CAPE CANAVERAL;
 EVERGLADES NATIONAL
 PARK; FORT LAUDERDALE;
 JACKSONVILLE; MIAMI;
 MIAMI BEACH; OKEFENOKEE
 SWAMP; ORLANDO; ST.
 AUGUSTINE; SARASOTA;
 SUWANNEE RIVER; TAMPA
FLOUNDERS
 Nat Geog 160:844-5 (c, 2) D '81
FLOWER INDUSTRY
--Arizona
 Nat Geog 152:cov. (c, 1) O '77
--Rose hybridizing (France)
 Smithsonian 10:cov., 44-52 (c, 1)
 Ap '79
--Roses (Bulgaria)

 Nat Geog 158:102-3 (c, 2) Jl '80
--Street vendor (Wisconsin)
 Nat Geog 158:200-1 (c, 1) Ag '80
--Tulips (17th cent. Netherlands)
 Smithsonian 8:70-5 (painting, c, 1)
 Ap '77
--Tulips (Netherlands)
 Nat Geog 153:713-28 (c, 1) My
 '78
 Trav/Holiday 155:49 (c, 3) Ap '81
FLOWER MARKETS
--Brussels, Belgium
 Trav/Holiday 152:52 (c, 4) O '79
--Delft, Netherlands
 Trav/Holiday 153:44 (c, 4) F '80
--Guanajuato, Mexico
 Travel 148:42-3 (c, 1) O '77
--Lisbon, Portugal
 Trav/Holiday 148:63 (c, 4) N '77
--West Germany
 Trav/Holiday 153:64 (c, 4) Mr '80
--Zagreb, Yugoslavia
 Travel 148:33 (c, 2) Jl '77
FLOWERING PLANTS
 Smithsonian 8:129 (painting, c, 1)
 O '77
--Arrowheads
 Natur Hist 87:66 (c, 4) Ag '78
--Avens
 Travel 147:50-1 (c, 1) Mr '77
--Balsamroot
 Am Heritage 28:17 (c, 4) Ap '77
--Bromeliads
 Smithsonian 11:45 (c, 4) Je '80
--Carnivorous. See BLADDERWORT
 PLANTS; BUTTERWORT
 PLANTS; PITCHER PLANTS
--Endangered species
 Smithsonian 9:122-9 (c, 1) N '78
--Garden plants
 Smithsonian 8:90-6 (painting, c, 2)
 Ap '77
--Jewelweed
 Nat Geog 159:371 (c, 4) Mr '81
--King protea
 Trav/Holiday 155:71 (4) Ja '81
--Mountain flowers (Washington)
 Nat Wildlife 19:58-64 (c, 1) D
 '80
--Nabiza (turnip plants)
 Nat Geog 153:308-9 (c, 1) Mr '78
--Poisonous
 Smithsonian 8:48-55 (painting, c, 1)
 My '77
 Nat Wildlife 15:46-7 (painting, c, 4)
 O '77
--Pollination procedures
 Smithsonian 9:119-30 (c, 4) F '79

--Red hot poker
 Trav/Holiday 153:44 (c, 4) Mr
 '80
--Rocky Mountain wildflowers
 Travel 147:48-53 (c, 1) Mr '77
--Senecio
 Nat Wildlife 17:2 (c, 1) Ap '79
--Snow flowers
 Nat Wildlife 16:28 (c, 4) Ap '78
--Wildflowers
 Smithsonian 10:35 (c, 1) Jl '79
 Natur Hist 90:56-7 (c, 2) N '81
--See also ACACIAS; AMARANTH;
 ANEMONES; ASTERS;
 AZALEAS; BACHELOR'S
 BUTTONS; BANANA PLANTS;
 BITTERSWEETS; BLACK-
 EYED SUSANS; BLADDER-
 WORTS; BLOODROOT; BLUE-
 BONNETS; BUTTERCUPS;
 BUTTERWORTS; CACTUS;
 CALENDULAS; CATTAILS;
 CENTURY PLANTS;
 CINQUEFOILS; COLUM-
 BINES; COREOPSES; COW-
 SLIPS; CROCUSES; DAISIES;
 DANDELIONS; FIREWEED;
 FOXGLOVE; GARDENS;
 HEATHER; HIBISCUS; HYA-
 CINTHS; INDIAN PAINT-
 BRUSH; INDIAN PIPES;
 IRISES; JIMSON WEED;
 LADY'S SLIPPERS; LAVEN-
 DER; LILIES; LOBELIAS;
 LUPINES; MARIGOLDS;
 MARIPOSA LILIES; MILK-
 WEED; MISTLETOE; MON-
 KEY FLOWERS; MORNING-
 GLORIES; NIGHTSHADE;
 ORCHIDS; PASQUEFLOWERS;
 PINKS; PITCHER PLANTS;
 POPPIES; PRICKLY PEARS;
 RHODODENDRONS; ROSES;
 RUSHES; SNAPDRAGONS;
 SNOWBALL PLANTS;
 SORREL; SPANISH MOSS;
 SPIDERWORTS; SUNFLOWERS;
 THISTLES; TIGER LILIES;
 TOADFLAX; TOUCH-ME-
 NOTS; TRILLIUM; TULIPS;
 VERBENAS; VIOLETS; WATER
 LILIES; WINTERGREEN;
 YUCCA PLANTS
FLOWERS
--Currier & Ives painting
 Am Heritage 29:94-5 (c, 1) Ag
 '78
--Oriental arrangement (Japan)

 Trav/Holiday 149:42 (c, 2) Je '78
--Paintings made of flowers
 Smithsonian 11:96-101 (c, 1) F
 '81
--See also LEIS
FLUORITE
 Smithsonian 8:120 (c, 3) O '77
 Natur Hist 87:70 (c, 1) F '78
FLUTE PLAYING
 Ebony 32:71 (4) Mr '77
 Ebony 33:96 (4) Je '78
 Nat Geog 156:806-7 (c, 1) Je '79
 Ebony 36:84 (4) Mr '81
--Brazil Indians
 Nat Geog 155:82-3 (c, 1) Ja '79
--Costa Rica
 Trav/Holiday 150:57 (c, 2) N '78
--Gimi tribe (New Guinea)
 Nat Geog 152:144-5 (c, 1) Jl '77
FLYCATCHERS (BIRDS)
 Sports Illus 48:60 (painting, c, 3)
 F 13 '78
 Sports Illus 50:60 (c, 4) F 5 '79
 Nat Wildlife 18:46 (c, 2) F '80
FLYING SQUIRRELS
 Smithsonian 10:191 (drawing, c, 4)
 N '79
 Nat Wildlife 18:54 (c, 4) O '80
FOG
 Nat Geog 154:232 (c, 1) Ag '78
 Nat Geog 159:372 (c, 3) Mr '81
--Arizona
 Nat Wildlife 20:10-11 (c, 1) D '81
--Chicago, Illinois
 Nat Geog 153:460-2 (c, 1) Ap '78
--Cincinnati, Ohio
 Nat Geog 151:258-9 (c, 1) F '77
--Idaho hills
 Nat Geog 160:292 (c, 2) S '81
--Malaysian jungle
 Nat Geog 151:636-7 (c, 1) My '77
--North Yemen farming valley
 Nat Geog 156:262-3 (c, 1) Ag '79
--Oregon
 Nat Geog 156:822-3 (c, 1) D '79
--San Francisco, California
 Nat Geog 159:814-16 (c, 1) Je '81
--South Africa
 Nat Geog 151:798-9 (c, 1) Je '77
--Vancouver, British Columbia
 Nat Geog 154:486 (c, 1) O '78
--Virginia water wheel
 Nat Wildlife 15:30 (c, 4) Ap '77
FOLK DANCING
--Estonia
 Nat Geog 157:498-9 (c, 1) Ap '80
--Greece
 Smithsonian 8:48-9 (c, 1) Ap '77

--Nordic (Iowa)
Trav/Holiday 151:62 (4) Je '79
--Poland
Nat Geog 159:112-13 (c, 1) Ja
'81
FOOD
--Aztec specialties (Mexico)
Nat Geog 158:727 (c, 4) D '80
--Bahamas
Trav/Holiday 156:15 (c, 4) D
'81
--Baltimore seafood
Trav/Holiday 154:47 (c, 4) S '80
--Barbecued dishes
Ebony 32:150-4 (c, 2) My '77
--Bean soups
Ebony 33:140-4 (c, 2) S '78
--Breakfast foods
Ebony 35:87-92 (c, 2) Mr '80
Ebony 36:106-10 (c, 2) Ag '81
--Caviar and sausages (U. S. S. R.)
Nat Geog 155:776 (c, 4) Je '79
--Chinese
Trav/Holiday 150:81 (4) N '78
Ebony 36:135-41 (c, 2) My '81
--Chocolate desserts
Ebony 33:128-32 (c, 2) F '78
--Christmas candy
Ebony 35:132-8 (c, 2) D '79
--Christmas dishes
Ebony 34:144-8 (c, 2) D '78
--Crayfish platter (Louisiana)
Nat Geog 153:210 (c, 2) F '78
--Desserts
Ebony 32:100-4 (c, 2) Ja '77
Ebony 33:124-8 (c, 2) My '78
Ebony 34:148-52 (c, 2) Ag '79
Ebony 35:124-30 (c, 2) My '80
--Dishes made with potatoes
Ebony 35:128-34 (c, 2) S '80
--Fish dishes
Ebony 32:144-8 (c, 2) S '77
--Fish head pie (Great Britain)
Nat Geog 156:480 (c, 4) O '79
--France
Nat Geog 153:810-11 (c, 1) Je
'78
--Israel
Trav/Holiday 149:55 (c, 3) Mr
'78
--Japanese
Life 2:125-8 (c, 1) O '79
--Jelly beans
Life 4:61 (c, 4) F '81
--Lemon desserts
Ebony 33:112-16 (c, 2) Mr '78
--Mexican dishes
Trav/Holiday 152:48 (c, 1) O '79

Ebony 35:124-30 (c, 2) N '79
--Mushroom dishes
Ebony 34:126-30 (c, 2) N '78
--New Year's buffet (Hong Kong)
Trav/Holiday 153:62 (c, 2) Ja '80
--Party snacks
Ebony 33:98-102 (c, 2) Ja '78
--Pasta dishes
Ebony 32:126-34 (c, 2) Mr '77
Natur Hist 88:98-102 (3) Ja '79
--Roast goose
Nat Geog 156:844 (c, 4) D '79
--Salads
Ebony 32:152-6 (c, 2) O '77
--Salmon platter (Norway)
Smithsonian 12:176 (c, 4) N '81
--San Francisco, California spe-
cialties
Nat Geog 159:840-1 (c, 1) Je '81
--Scarsdale diet meals
Life 4:110 (c, 2) Ja '81
--Seafood dishes
Ebony 34:115-20 (c, 2) Jl '79
Ebony 36:106-8 (c, 4) Mr '81
--Shark, Japanese style
Nat Geog 160:178 (c, 4) Ag '81
--Soups
Ebony 37:126-30 (c, 2) N '81
--Specialty food (France)
Life 2:81-2 (c, 2) F '79
--Sushi (Japan)
Nat Geog 152:840-1 (c, 1) D '77
--West African dishes (Mali)
Ebony 33:169 (c, 4) O '78
--See also COOKING; DINNERS
AND DINING
FOOD MARKETS
--15th cent. Italy
Natur Hist 87:59 (fresco, c, 4)
Mr '78
--1930's supermarket
Smithsonian 11:112 (4) Ag '80
--1940's supermarket (New Jersey)
Smithsonian 12:67 (c, 4) Ap '81
--Annapolis, Maryland
Travel 147:43 (c, 4) Je '77
--Armenia, U. S. S. R.
Nat Geog 153:860-1 (c, 2) Je '78
--Aruba
Trav/Holiday 151:60-1 (c, 1) Ap
'79
--Atlanta, Georgia
Natur Hist 90:136-8 (c, 1) O '81
--Barbados
Trav/Holiday 152:52 (c, 4) Ag '79
--Bordeaux, France
Nat Geog 158:253 (c, 4) Ag '80
--Brazil

--Sardine packing (Maine)
 Travel 147:28 (c, 4) My '77
--Sausage (Maryland)
 Ebony 32:100-6 (2) Mr '77
 Ebony 37:70 (4) D '81
--Sausage (Milwaukee, Wisconsin)
 Nat Geog 158:196 (c, 1) Ag '80
--Soup factory (Chicago, Illinois)
 Ebony 32:88 (4) Ag '77
--See also individual food products
 listed under INDUSTRIES
FOOTBALL
--1560 Florence, Italy
 Smithsonian 12:40 (painting, c, 4)
 S '81
--1893 Remington painting
 Am Heritage 32:98-100 (c, 1) O
 '81
--Punting
 Sports Illus 47:40 (painting, c, 4)
 N 21 '77
 Sports Illus 51:44 (c, 2) Ag 13
 '79
 Sports Illus 51:98-100 (c, 4) N
 12 '79
--Strategy
 Sports Illus 47:26-7 (painting, c, 2)
 O 17 '77
 Sports Illus 51:51-4 (drawing, c, 3)
 S 3 '79
--Training
 Sports Illus 49:86-7 (c, 1) S 4
 '78
FOOTBALL--COLLEGE
 Sports Illus 47:29-31, 73-5
 (c, 1) S 5 '77
 Sports Illus 47:20-2 (c, 2) S 19
 '77
 Sports Illus 47:cov., 14-17
 (c, 1) O 3 '77
 Sports Illus 47:28-30 (c, 2) O
 10 '77
 Sports Illus 47:20-3 (c, 1) O
 31 '77
 Sports Illus 47:20-1 (c, 3) N 21
 '77
 Sports Illus 49:35-8 (c, 1) S
 25 '78
 Sports Illus 49:cov., 22-5 (c, 1)
 O 2 '78
 Sports Illus 51:32-4 (c, 2) O 8
 '79
 Sports Illus 51:36-41 (c, 1) N
 12 '79
 Sports Illus 53:74-5 (c, 3) S 1
 '80
 Sports Illus 53:22-4 (c, 1) S 22
 '80

Sports Illus 53:34-41 (c, 2) N 24
 '80
Sports Illus 55:38-44 (c, 3) S 28
 '81
Sports Illus 55:cov., 24-9 (c, 1)
 O 5 '81
Sports Illus 55:32-5 (c, 3) N 9 '81
--1920's
 Sports Illus 51:98-102 (paint-
 ing, c, 1) S 10 '79
 Sports Illus 51:41-2 (painting, c, 2)
 S 17 '79
--1930's
 Sports Illus 55:76-90 (drawing, c, 1)
 Ag 31 '81
--Blocking
 Sports Illus 53:34-5 (c, 2) N 10
 '80
 Sports Illus 55:26 (c, 2) O 5 '81
--Celebrating
 Sports Illus 49:22 (c, 1) N 20 '78
 Sports Illus 49:29 (c, 4) N 27 '78
 Sports Illus 51:30-1 (c, 1) N 26
 '79
--Coaches
 Sports Illus 47:22 (c, 4) N 28 '77
 Sports Illus 49:94 (c, 4) N 20 '78
 Ebony 36:74 (4) S '81
 Sports Illus 55:70-4 (c, 4) S 14
 '81
--Cotton Bowl 1978 (Notre Dame
 vs. Texas)
 Sports Illus 48:cov., 6-9 (c, 1)
 Ja 9 '78
 Sports Illus 48:14-19 (c, 1) F 9
 '78
--Festivities
 Sports Illus 53:70-80 (c, 1) S 1
 '80
--Fumble
 Sports Illus 54:20 (c, 4) Ja 12 '81
--Hiking
 Sports Illus 53:70 (c, 4) D 15 '80
--Huddle
 Sports Illus 54:18 (c, 4) Ap 13
 '81
--Intercepting pass
 Sports Illus 47:22 (c, 4) O 31 '77
 Sports Illus 51:34 (c, 2) O 22 '79
 Sports Illus 54:19 (c, 2) Ja 12
 '81
 Sports Illus 55:32 (c, 4) O 26 '81
--Mascots
 Sports Illus 51:40-2 (c, 2) S 10
 '79
 Life 3:79 (c, 4) My '80
--Orange Bowl 1978 (Arkansas vs.
 Oklahoma)

Sports Illus 48:20 (c, 4) F 9
'78
--Passing
Sports Illus 47:73, 75 (c, 1) S
5 '77
Sports Illus 47:20 (c, 3) O 31
'77
Sports Illus 47:72 (c, 4) N 14 '77
Sports Illus 49:32 (c, 2) O 30 '78
Sports Illus 49:24, 55 (c, 4) N
29 '78
Sports Illus 49:27, 57 (c, 3) D
4 '78
Sports Illus 49:73 (c, 2) D 18
'78
Sports Illus 53:67 (4) N 24 '80
Sports Illus 53:70 (c, 4) D 15
'80
Sports Illus 55:54 (c, 3) N 16
'81
--Place-kicking
Sports Illus 47:27-8 (c, 2) N 7
'77
Sports Illus 49:21 (c, 3) N 13
'78
Sports Illus 49:27 (c, 3) N 20
'78
Sports Illus 55:59 (c, 4) S 14
'81
Sports Illus 55:35 (c, 4) N 30
'81
--Punting
Sports Illus 49:68 (4) O 16 '78
Sports Illus 51:32 (c, 2) O 22 '79
Sports Illus 53:72 (c, 4) D 15 '80
--Receiving
Sports Illus 49:56 (c, 4) S 25
'78
Sports Illus 49:34 (c, 3) O 16
'78
--Rose Bowl 1977 (USC vs. Michi-
gan)
Sports Illus 46:18-19 (c, 3) Ja
10 '77
--Rose Bowl 1978 (Washington vs.
Michigan)
Sports Illus 48:11 (c, 4) Ja 9
'78
Sports Illus 48:20-1 (c, 3) F 9
'78
--Rose Bowl 1979 (USC vs. Michi-
gan)
Sports Illus 50:22-3 (c, 1) F
15 '79
--Rose Bowl 1980 (USC vs. Ohio
State)
Sports Illus 52:29-32 (c, 2) Ja
14 '80

Sports Illus 52:32-3 (c, 1) Mr 13
'80
--Rose Bowl poster (1916)
Am Heritage 29:2 (c, 1) D '77
--Running
Sports Illus 46:14-15 (c, 4) Ja 10
'77
Sports Illus 47:cov. (c, 1) O 3 '77
Sports Illus 47:65 (4) O 17 '77
Sports Illus 47:57 (4) O 24 '77
Sports Illus 47:20-1 (c, 1) N 28
'77
Sports Illus 47:cov., 20-4 (c, 1)
D 5 '77
Sports Illus 48:cov., 6-7 (c, 1)
Ja 9 '78
Sports Illus 49:92-3 (c, 1) S 11
'78
Sports Illus 49:36-8 (c, 2) S 25
'78
Sports Illus 49:cov. (c, 1) O 2 '78
Sports Illus 49:32-3 (c, 2) O 16
'78
Sports Illus 49:33 (c, 3) O 30 '78
Sports Illus 49:cov. (c, 1) N 13
'78
Sports Illus 49:cov., 25, 88-92
(c, 1) N 20 '78
Sports Illus 49:94 (c, 4) N 27 '78
Sports Illus 49:cov., 20-3 (c, 1)
D 4 '78
Sports Illus 49:72 (c, 4) D 18 '78
Sports Illus 51:35 (c, 3) S 10 '79
Sports Illus 51:cov., 12-13 (c, 1)
S 24 '79
Sports Illus 51:36-8 (c, 1) N 12
'79
Sports Illus 51:cov. (c, 1) N 26
'79
Sports Illus 51:24 (c, 3) D 3 '79
Sports Illus 53:cov., 28-33 (c, 1)
N 17 '80
Sports Illus 53:80 (c, 4) D 1 '80
Sports Illus 55:cov., 40 (c, 1)
Ag 31 '81
Sports Illus 55:58 (c, 4) S 21 '81
Sports Illus 55:34-5 (c, 3) S 28
'81
Sports Illus 55:cov., 26-7 (c, 1)
O 5 '81
Sports Illus 55:40-1, 57 (c, 3) N
16 '81
Sports Illus 55:38-41 (c, 1) N 23
'81
Sports Illus 55:36-9 (c, 3) D 7
'81
--Sugar Bowl 1977 (Pittsburgh vs.
Georgia)

Sports Illus 49:12-15 (c, 3) D
25 '78
Sports Illus 50:16-23 (c, 3) Ja
8 '79
Sports Illus 50:cov., 12-19 (c, 1)
Ja 15 '79
Sports Illus 50:29-32 (paint-
ing, c, 1) Ja 22 '79
Sports Illus 51:cov., 24-8 (c, 1)
O 1 '79
Sports Illus 51:30-1 (c, 3) O 8
'79
Sports Illus 51:cov., 30-5 (c, 1)
N 5 '79
Sports Illus 52:cov., 12-21
(c, 1) Ja 7 '80
Sports Illus 52:cov., 14-21
(c, 1) Ja 14 '80
Sports Illus 53:cov., 60-71
(c, 1) S 8 '80
Sports Illus 53:32-4 (c, 2) O 27
'80
Sports Illus 53:cov., 26-31
(c, 1) N 10 '80
Sports Illus 53:26-9 (c, 1) N 24
'80
Sports Illus 53:16-21 (c, 1) D
1 '80
Sports Illus 54:95 (c, 4) Je 8
'81
Sports Illus 55:cov., 20-3 (c, 1)
Ag 24 '81
Sports Illus 55:cov., 32-3, 48-
80, 98-9 (c, 1) S 7 '81
Sports Illus 55:26-31 (c, 2) S
14 '81
Sports Illus 55:36-8 (c, 2) O
12 '81
Sports Illus 55:24-7 (c, 1) N 9
'81
Sports Illus 55:24-7 (c, 1) N 30
'81
Sports Illus 55:20-4 (c, 1) D
28 '81
--1960's
Sports Illus 51:76-95 (c, 2) Ag
13 '79
--Agility training
Sports Illus 53:46 (4) Jl 14 '80
--Blocking
Sports Illus 47:30 (2) Jl 25 '77
Sports Illus 47:33 (c, 3) D 12
'77
Sports Illus 51:15 (c, 3) Ag 6
'79
Sports Illus 52:32 (c, 3) My 12
'80
Sports Illus 53:18 (c, 2) Ag 25

'80
Sports Illus 53:49 (2) N 17 '80
Sports Illus 53:26-7 (c, 1) N 24
'80
--Celebrating
Sports Illus 59:15 (c, 2) Ja 29 '79
Sports Illus 54:12-13 (c, 3) Ja 12
'81
--Coaches
Sports Illus 47:36-8 (2) S 12 '77
Sports Illus 47:90 (4) O 31 '77
Sports Illus 48:24-5 (c, 3) Ja 16
'78
Sports Illus 55:26 (c, 2) Jl 27 '81
--Forecasts for the game
Sports Illus 51:43-8 (painting, c, 1)
S 3 '79
--Fumble
Sports Illus 54:24-5 (c, 4) Ja 19
'81
--Hiking
Sports Illus 49:42-3 (c, 1) D 4
'78
Sports Illus 49:22 (c, 3) D 18 '78
Sports Illus 53:60-1 (c, 1) S 8
'80
Sports Illus 53:46 (2) N 3 '80
--Huddle
Sports Illus 47:22 (c, 4) D 19 '77
--Intercepting pass
Ebony 33:163 (2) N '77
Sports Illus 49:31 (c, 4) O 16 '78
Sports Illus 50:21 (c, 4) Ja 8 '79
Sports Illus 54:18-19 (c, 3) Ja 5
'81
Sports Illus 54:22-3 (c, 4) F 2
'81
--Passing
Sports Illus 47:20 (c, 2) Ag 29
'77
Sports Illus 48:10 (c, 3) Ja 2 '78
Sports Illus 49:30 (c, 4) O 16 '78
Sports Illus 49:32 (c, 1) N 6 '78
Ebony 34:60-2 (3) Ja '79
Sports Illus 50:8 (c, 2) Ja 29 '79
Sports Illus 51:45 (c, 3) Ag 13 '79
Sports Illus 51:14 (c, 4) Ag 20 '79
Sports Illus 51:28 (c, 3) O 1 '79
Sports Illus 51:36 (c, 3) O 15 '79
Sports Illus 51:53 (c, 3) N 12 '79
Sports Illus 51:35 (c, 4) D 3 '79
Sports Illus 51:38 (c, 2) D 24 '79
Sports Illus 52:12, 17 (c, 3) Ja
28 '80
Sports Illus 52:20-1 (c, 2) Ag 18
'80
Sports Illus 53:32 (c, 2) O 27 '80
Sports Illus 53:22-3 (c, 1) D 15

'80
Sports Illus 54:18-19 (c, 1) F 2
'81
Sports Illus 55:20 (c, 2) Jl 20
'81
Sports Illus 55:20-1 (c, 1) Ag
24 '81
Sports Illus 55:26 (c, 2) S 14 '81
Sports Illus 55:36-8 (c, 2) O 12
'81
Sports Illus 55:48 (c, 2) O 19
'81
Sports Illus 55:18-19, 22 (c, 1)
D 21 '81
--Place-kicking
Sports Illus 49:30 (c, 3) O 2 '78
Sports Illus 53:16-17 (c, 4) S
22 '80
Sports Illus 53:56 (c, 4) S 29
'80
Sports Illus 53:20 (c, 3) D 1 '80
--Practicing
Sports Illus 55:20 (c, 4) Ag 3
'81
--Punting
Sports Illus 46:14 (c, 3) Ja 17
'77
Sports Illus 49:58 (4) N 13 '78
Sports Illus 51:26-7 (c, 2) Ag
27 '79
--Receiving
Sports Illus 47:20 (c, 2) D 19
'77
Sports Illus 48:10, 12 (c, 3) Ja
2 '78
Sports Illus 48:19-23 (c, 2) Ja
23 '78
Sports Illus 51:27 (c, 4) O 1 '79
Sports Illus 51:98-9 (c, 1) D
10 '79
Sports Illus 52:cov. (c, 1) Ja
28 '80
Sports Illus 53:45 (2) Jl 14 '80
Sports Illus 53:cov. (c, 1) S 8
'80
Sports Illus 53:32-3 (c, 2) D 8
'80
--Referees
Sports Illus 49:cov., 39 (c, 1)
O 9 '78
Sports Illus 49:13-14 (c, 3) D
25 '78
Ebony 34:62 (4) Ja '79
Sports Illus 52:17 (c, 4) Ja 14
'80
--Running
Sports Illus 47:22 (c, 4) Ag 22
'77

Sports Illus 47:26-7 (c, 3) O 31
'77
Sports Illus 47:32-3 (c, 2) N 14
'77
Sports Illus 47:26 (c, 2) N 28 '77
Sports Illus 48:cov., 11-16 (c, 1)
Ja 2 '78
Sports Illus 48:24-5 (c, 4) Ja 16
'78
Sports Illus 49:25 (c, 2) S 18 '78
Sports Illus 49:67 (c, 4) S 25 '78
Sports Illus 49:31 (c, 2) O 2 '78
Sports Illus 49:28 (c, 2) O 23 '78
Sports Illus 49:30-1 (c, 2) O 30
'78
Sports Illus 49:29 (c, 4) N 20 '78
Sports Illus 50:20 (c, 3) Ja 8 '79
Sports Illus 50:17 (c, 1) Ja 15 '79
Sports Illus 50:10-13 (c, 3) Ja 29
'79
Sports Illus 51:cov. (c, 1) S 3 '79
Sports Illus 51:34-5 (c, 2) O 15
'79
Sports Illus 51:32 (c, 3) O 29 '79
Sports Illus 51:cov., 34-5 (c, 1)
N 5 '79
Ebony 35:102-4 (c, 2) D '79
Sports Illus 51:26-7 (c, 2) D 3
'79
Sports Illus 52:cov. (c, 1) Ja 7
'80
Sports Illus 53:28-9 (c, 4) S 15
'80
Sports Illus 53:14 (c, 1) S 22 '80
Sports Illus 53:34 (c, 3) O 27 '80
Sports Illus 54:16-17, 20 (c, 1)
Ja 5 '81
Sports Illus 54:cov., 16-17 (c, 1)
Ja 12 '81
Sports Illus 54:18-19, 22-3, 26
(c, 1) Ja 19 '81
Sports Illus 55:21-2 (c, 4) Jl 20
'81
Sports Illus 55:30 (c, 4) Jl 27 '81
Sports Illus 55:20-2 (c, 2) Ag 17
'81
Sports Illus 55:cov. (c, 1) Ag 24
'81
Ebony 36:106 (4) S '81
Sports Illus 55:cov., 42-7 (c, 1)
D 7 '81
Sports Illus 55:cov. (c, 1) D 21
'81
--Strategy diagrams
Sports Illus 50:38-64 (draw-
ing, c, 4) Ja 15 '79
Sports Illus 53:40 (c, 3) S 8 '80
--Super Bowl history

Sports Illus 46:35-82 (c, 1) Ja
10 '77
Sports Illus 48:31-68 (c, 4) Ja
9 '78
Sports Illus 50:35-68 (c, 1) Ja
15 '79
Sports Illus 52:41-78 (c, 1) Ja
21 '80
Sports Illus 54:45-82 (c, 1) Ja
19 '81
--Super Bowl 1977 (Oakland vs.
Minnesota)
Sports Illus 46:cov., 10-15
(c, 1) Ja 17 '77
--Super Bowl 1978 (Dallas vs.
Denver)
Sports Illus 48:cov., 16-23
(c, 1) Ja 23 '78
Sports Illus 48:6-13 (c, 1) F 9
'78
--Super Bowl 1979 (Pittsburgh vs.
Dallas)
Sports Illus 59:cov., 8-15 (c, 1)
Ja 29 '79
Sports Illus 50:11-17 (c, 1) F
15 '79
--Super Bowl 1980 (Pittsburgh vs.
Los Angeles)
Sports Illus 52:cov., 10-19
(c, 1) Ja 28 '80
Sports Illus 52:24-5 (c, 1) Mr
13 '80
--Super Bowl 1981 (Oakland vs.
Philadelphia)
Sports Illus 54:18-28 (c, 1) F
2 '81
--Tackling
Sports Illus 46:cov. (c, 1) Ja
3 '77
Sports Illus 46:10-11, 15 (c, 1)
Ja 17 '77
Sports Illus 48:14-16 (c, 3) Ja
9 '78
Sports Illus 49:cov. (paint-
ing, c, 1) Ag 14 '78
Sports Illus 49:33 (c, 1) Ag 21
'78
Sports Illus 49:28 (c, 3) N 20
'78
Sports Illus 49:76 (4) D 4 '78
Sports Illus 51:28 (c, 4) S 17
'79
Ebony 34:124 (2) O '79
Sports Illus 51:cov., 28 (c, 1)
O 1 '79
Sports Illus 51:70 (3) O 22 '79
Sports Illus 51:31 (c, 3) O 29
'79

Sports Illus 52:10-11 (c, 1) Ja 28
'80
Sports Illus 53:30 (c, 3) S 15 '80
Sports Illus 53:15 (c, 3) S 22 '80
Sports Illus 53:24-5 (c, 2) D 15
'80
Sports Illus 54:10-11 (c, 1) Ja 12
'81
Sports Illus 54:cov., 16-17, 25
(c, 1) Ja 19 '81
Sports Illus 55:22 (c, 2) Ag 24
'81
Sports Illus 55:55 (c, 4) O 19 '81
Sports Illus 55:88-9 (c, 2) D 7
'81
--Touchdowns
Sports Illus 46:13 (c, 3) Ja 17 '77
Sports Illus 47:18-19 (c, 1) S 26
'77
Sports Illus 47:22 (c, 2) O 3 '77
Sports Illus 47:20-3 (c, 2) D 19
'77
Sports Illus 49:38-9 (c, 4) O 9
'78
Sports Illus 50:16, 19 (c, 3) Ja 8
'79
Sports Illus 50:15 (c, 2) Ja 15
'79
Sports Illus 51:25 (c, 4) O 1 '79
Ebony 36:58 (3) N '80
Sports Illus 53:20-1 (c, 3) D 1
'80
Sports Illus 54:27 (c, 3) D 15 '80
Sports Illus 53:23 (c, 3) D 22 '80
Sports Illus 54:20-1 (c, 4) F 2 '81
Sports Illus 55:23 (c, 4) D 21 '81
--Training
Sports Illus 47:38-41 (c, 1) S 19
'77
FOOTBALL--PROFESSIONAL--
HUMOR
Sports Illus 49:36-8 (drawing, c, 1)
S 4 '78
Sports Illus 51:36-40 (painting, c, 1)
N 19 '79
Sports Illus 53:48-57, 72-82
(drawing, c, 4) S 8 '80
Sports Illus 55:cov., 34-46
(drawing, c, 4) S 7 '81
--Super Bowl
Sports Illus 52:16-19 (painting, c, 1)
Ja 21 '80
Sports Illus 54:16-19 (drawing, c, 2)
Ja 26 '81.
FOOTBALL PLAYERS
Sports Illus 46:22-3 (c, 2) Ja 10
'77
Sports Illus 47:cov. (c, 1) Jl 25

'77
Sports Illus 47:cov., 73 (c, 1)
S 5 '77
Sports Illus 47:91 (4) O 17 '77
Sports Illus 49:cov. (c, 1) S 11
'78
Sports Illus 49:28-30 (c, 2) O
23 '78
Sports Illus 51:20-3 (c, 2) S 10
'79
Sports Illus 51:38-40 (c, 2) N
26 '79
Sports Illus 51:53-7 (painting, 4)
D 24 '79
Sports Illus 53:20-3 (c, 3) Ag 4
'80
Sports Illus 53:74 (c, 4) O 20
'80
Sports Illus 53:24-6 (c, 3) D 1
'80
Sports Illus 53:cov. (c, 1) D 8
'80
Sports Illus 53:42 (c, 1) D 15
'80
--1950's
Ebony 33:100 (3) My '78
--See also ROCKNE, KNUTE
FOOTBALL PLAYERS--HUMOR
Sports Illus 47:cov., 24-6 (c, 1)
N 21 '77
FOOTBALL TEAMS
Ebony 36:72-3 (1) S '81
--1918
Sports Illus 51:98-9 (paint-
ing, c, 1) S 10 '79
--1930 high school team (Virginia)
Sports Illus 54:98 (4) F 0 '81
FOOTBALLS
Sports Illus 47:28 (c, 4) N 7
'77
Sports Illus 53:44 (4) D 15 '80
Sports Illus 54:67 (c, 4) My 11
'81
--Twirled on finger
Sports Illus 49:75 (c, 4) N 20
'78
Sports Illus 50:16 (c, 2) F 15
'79
FOOTWEAR
--18th cent. (France)
Nat Geog 152:764 (c, 4) D '77
--19th cent. shoes for clubfoot
(France)
Smithsonian 12:83 (c, 1) N '81
--Athletic footwear
Sports Illus 46:42 (c, 3) Mr 28
'77
Sports Illus 54:80-1 (c, 4) Je

8 '81
--Ballet shoes
Life 2:9-10 (c, 2) N '79
--Cowboy boots
Nat Geog 156:206 (c, 4) Ag '79
Sports Illus 53:71 (c, 4) O 27 '80
--Expensive cowboy boots
Life 4:58 (4) F '81
--Farmer (Yugoslavia)
Nat Geog 152:481 (c, 4) O '77
--Hiking boots
Nat Geog 156:211 (c, 3) Ag '79
--Moccasin construction (Maine)
Nat Geog 151:737 (c, 4) Je '77
--Wooden shoes (France)
Nat Geog 154:541 (c, 4) O '78
--Wooden shoes (Netherlands)
Trav/Holiday 151:42 (c, 2) Je '79
--See also SNOWSHOES
FORD, FORD MADOX
Smithsonian 9:76-7 (2) Jl '78
FORD, GERALD
Life 1:11 (2) O '78
Am Heritage 30:48 (4) F '79
Ebony 34:185 (4) My '79
Life 2:31 (c, 3) O '79
Life 2:156 (4) D '79
Life 3:138 (4) N '80
FORD, HENRY
Am Heritage 28:73 (3) Ag '77
Smithsonian 9:88-93 (2) Je '78
Am Heritage 32:98-100 (1) D '80
--Greenfield Village museum, Dear-
born, Michigan
Am Heritage 32:98-107 (c, 1) D
'80
FOREST RANGERS
--Fire lookouts
Nat Wildlife 19.95-8 (2) Ap '81
FORESTS
Natur Hist 86:62-71 (c, 1) N '77
Sports Illus 53:66-7 (painting, c, 1)
D 22 '80
Natur Hist 90:32-9 (c, 1) Je '81
--Big Thicket, Texas
Nat Wildlife 15:4-11 (c, 1) Je '77
Am Heritage 28:45-51 (c, 1) Je
'77
Natur Hist 87:108-10 (c, 1) N '78
--Brazil
Nat Geog 152:714 (c, 3) N '77
Nat Geog 157:692-707 (c, 1) My
'80
--China
Nat Geog 160:734-46 (c, 1) D '81
--Costa Rica
Nat Geog 160:48 (c, 4) Jl '81
--Finland

Life 4:34-5 (c, 1) Ag '81
--Fire lookout
Nat Wildlife 19:35-8 (2) Ap '81
--Flathead National Forest, Montana
Nat Geog 154:285-94 (c, 1) Ag '78
--Hawaii
Sports Illus 49:75 (c, 2) S 25 '78
--India
Natur Hist 88:18 (3) Je '79
--Kentucky
Nat Geog 151:174 (c, 1) F '77
--Michigan
Nat Wildlife 16:41-7 (c, 1) Je '78
--New Zealand
Nat Geog 153:119-26 (c, 1) Ja '78
--Nicolet National Forest, Wisconsin
Nat Wildlife 15:41-3 (c, 2) F '77
--Olympia National Park, Washington
Nat Wildlife 17:48 (c, 1) Je '79
--Rain (Brazil)
Life 3:76-80 (c, 1) Ja '80
--Rain (Costa Rica)
Smithsonian 9:121-30 (c, 3) Mr '79
Smithsonian 11:cov., 42-53 (c, 1) Je '80
--Rain (New Guinea)
Sports Illus 54:68 (c, 4) Mr 2 '81
--Rain (Papua New Guinea)
Smithsonian 10:128 (c, 4) My '79
--Redwood National Park, California
Nat Wildlife 17:48 (c, 1) Ag '79
--South Dakota
Natur Hist 89:67 (c, 4) Je '80
--Spruce (Poland)
Nat Geog 159:108-9 (c, 1) Ja '81
--Washington
Natur Hist 90:85-8 (c, 1) Mr '81
--Wisconsin
Nat Geog 152:186-7 (c, 1) Ag '77
--See also ARDENNES FOREST; AUTUMN; NATIONAL PARKS; TREES
FORRESTAL, JAMES VINCENT

Am Heritage 28:11 (4) F '77
FORT LAUDERDALE, FLORIDA
Trav/Holiday 150:38-41 (c, 1) O '78
FORT WORTH, TEXAS
Trav/Holiday 149:59-60 (c, 4) Ap '78
Nat Geog 157:454-5 (c, 1) Ap '80
FORTRESSES
--13th cent. Tibet
Smithsonian 11:105 (c, 1) Ja '81
--Aleppo, Syria
Nat Geog 154:736-7 (c, 2) D '78
--Beaufort, Luxembourg
Trav/Holiday 154:54 (c, 1) S '80
--Haiti's Citadelle
Trav/Holiday 155:57 (c, 2) Ja '81
--Jiayuguan, China
Nat Geog 157:314-15 (c, 1) Mr '80
--Liechtenstein
Nat Geog 159:280-1 (c, 1) F '81
--Louisbourg, Nova Scotia
Trav/Holiday 149:37-9, 62 (c, 2) My '78
--Mycenae, Greece
Nat Geog 153:185 (c, 1) F '78
--San Juan, Puerto Rico
Travel 148:80 (4) O '77
--Savonlinna, Finland
Trav/Holiday 155:48 (c, 2) F '81
--El Torreon de Cojimar, Cuba
Sports Illus 47:54-5 (c, 1) Ag 1 '77
FORTS
--Battered Fort Sumter (1861)
Am Heritage 32:46-7 (3) Je '81
--Boonesborough, Kentucky
Travel 148:48, 51 (c, 2) Jl '77
--Cartagena, Colombia
Trav/Holiday 150:53 (c, 1) O '78
--Drum, Philippines
Nat Geog 151:380 (c, 4) Mr '77
--George, Ontario
Nat Geog 154:792-3 (c, 1) D '78
--Ground plan of 17th cent. fort (Virginia)
Nat Geog 155:741-3 (c, 1) Je '79
--Jaisalmer, Rajasthan, India
Nat Geog 151:226-7 (c, 1) F '77
--Jefferson, Florida
Trav/Holiday 156:36 (4) N '81
--Laramie, Wyoming
Nat Geog 158:62-3 (c, 1) Jl '80
--Mackinac, Michigan
Am Heritage 29:50-9 (c, 1) Ag '78
--Ross, California

Smithsonian 10:138 (c, 4) D '79
Trav/Holiday 153:57 (c, 3) Mr
'80
FORTUNE TELLERS
--Kalash People (Pakistan)
Nat Geog 160:473 (c, 4) O '81
--New York City, New York
Natur Hist 86:72-3 (c, 1) Ag '77
--See also SEANCES
FOSSILS
--Ammonite
Smithsonian 9:118-20 (c, 3) D
'78
--Cockroach
Nat Geog 159:134-5 (c, 1) Ja '81
--Crinoids
Natur Hist 88:61 (4) Ja '79
--Embalmed in amber
Nat Geog 152:422-35 (c, 1) S
'77
--Embedded in New York City
buildings
Smithsonian 9:143-51 (c, 2) S
'78
--Heterodontosaurus tucki
Smithsonian 7:12 (4) F '77
--King crabs
Nat Geog 159:566 (4) Ap '81
--Preserved in volcanic eruption
(Nebraska)
Nat Geog 159:66-75 (c, 1) Ja
'81
--Stromatolites of algae (Aus-
tralia)
Nat Geog 153:608 (c, 4) My '78
--Trilobites
Natur Hist 89.40-51 (drawing, 3)
Jl '80
FOSTER, STEPHEN
--Manuscript of "Old Folks at
Home"
Nat Geog 152:22 (4) Jl '77
FOUNTAINS
--Bethesda, Central Park, New
York
Am Heritage 32:93 (painting, c, 4)
Ap '81
--Caracas, Venezuela
Trav/Holiday 156:51 (c, 1) S '81
--Dallas, Texas office plaza
Smithsonian 9:61 (c, 3) N '78
--Granada, Nicaragua
Travel 148:41 (c, 2) Jl '77
--Mexico City, Mexico
Trav/Holiday 155:78 (4) Je '81
--Public water garden (Ft. Worth,
Texas)
Nat Geog 157:454-5 (c, 1) Ap '80

--Moscow, U. S. S. R.
Nat Geog 153:35 (c, 1) Ja '78
--Oaxaca, Mexico
Trav/Holiday 152:52 (c, 4) Jl '79
--Scotland
Trav/Holiday 149:54 (c, 2) My '78
--Waterspout in Florida ocean
Nat Geog 160:833 (c, 1) D '81
FOURTH OF JULY
--1795 celebration (Philadelphia,
Pennsylvania)
Am Heritage 28:29 (painting, c, 3)
Je '77
--Fiesta (San Luis Obispo, Califor-
nia)
Trav/Holiday 155:69 (c, 4) F '81
--Milwaukee, Wisconsin
Nat Geog 158:190-1 (c, 1) Ag '80
--Parade (Orleans, Massachusetts)
Sports Illus 55:19 (c, 1) Jl 6 '81
FOX HUNTING
Smithsonian 8:85 (drawing, 2) Ag
'77
FOX HUNTING--COSTUME
--Massachusetts
Nat Geog 155:569 (c, 1) Ap '79
FOXES
Smithsonian 10:90-101 (c, 1) My
'79
Nat Wildlife 19:2 (c, 2) Ap '81
Nat Wildlife 19:44 (c, 4) Ag '81
--Arctic
Nat Wildlife 17:cov., 9 (c, 1) F
'79
Nat Wildlife 17:42-7 (c, 1) Je '79
Nat Geog 156:765 (c, 3) D '79
--Gray
Nat Wildlife 15:21-7 (c, 1) Je '77
Nat Wildlife 16:52 (c, 4) Ap '78
--Red
Nat Geog 152:56-7 (c, 2) Jl '77
Smithsonian 8:46-7 (c, 3) S '77
Nat Wildlife 15:26 (c, 4) O '77
Nat Wildlife 16:9 (c, 4) Ag '78
Nat Wildlife 17:46-7 (c, 1) Ap '79
Nat Geog 156:750 (c, 3) D '79
Nat Wildlife 18:cov. (painting, c, 1)
D '79
Natur Hist 89:94-7 (c, 1) Mr '80
Nat Wildlife 18:25-31 (c, 1) Ap
'80
Natur Hist 89:cov., 60-8 (c, 1)
N '80
Nat Geog 160:409 (c, 4) S '81
--Silver
Smithsonian 10:99 (c, 4) My '79
--See also FENNECS
FOXGLOVE

Smithsonian 8:53 (painting, c, 3)
My '77
FOXHOUNDS
Life 4:46-7 (c, 1) Jl '81
FRA ANGELICO
--Frescoes by him
Life 4:104-10 (c, 2) Ap '81
FRANCE
--Albi
Trav/Holiday 152:13 (4) D '79
--Amboise
Nat Geog 152:328-9 (c, 2) S '77
--Annecy
Sports Illus 55:36 (c, 3) Je 29
'81
Trav/Holiday 156:30 (c, 2) Ag
'81
--Antibes
Smithsonian 10:51 (c, 3) Ap '79
--Belle-Ile-en-Mer
Natur Hist 90:cov. , 48-57
(map, c, 1) Ja '81
--Cevennes Mountains area
Nat Geog 154:534-59 (map, c, 1)
O '78
--Chartres Cathedral
Natur Hist 89:26 (4) Ja '80
Life 3:102-3 (c, 1) N '80
--Chartres Cathedral stained glass
windows
Smithsonian 10:78-9 (c, 2) Je
'79
--Chateau de Goulaine, Loire Val-
ley
Trav/Holiday 151:48-50 (c, 2)
F '79
--Conques
Smithsonian 11:116-25 (c, 1) O
'80
--Giverny
Smithsonian 10:52-61 (c, 1) F
'80
Life 3:62-7 (c, 1) My '80
--Grenoble
Trav/Holiday 156:29-33 (map, c, 1)
Ag '81
--Luc
Nat Geog 154:546-7 (c, 1) O '78
--Monpazier
Nat Geog 158:256 (c, 4) Ag '80
--Montaillou
Smithsonian 8:114-29 (c, 2) Mr
'78
--Riquewihr
Trav/Holiday 153:26 (c, 3) Mr
'80
--Small villages
Smithsonian 12:156-74 (c, 1)

D '81
--Talleyrand's Chateau de Valencay
Smithsonian 12:75-82 (c, 2) N '81
--Wine industry
Trav/Holiday 153:26, 30, 100-2
(c, 3) Mr '80
--See also BORDEAUX; BURGUNDY;
CARCASSONNE; LE HAVRE;
MONT SAINT MICHEL; PARIS;
ROUEN; SAONE RIVER; VER-
SAILLES; VICHY
FRANCE--ARCHITECTURE
--15th cent. house (Clamency)
Nat Geog 153:807 (c, 1) Je '78
FRANCE--COSTUME
--Early 19th cent. women
Smithsonian 12:80-1 (painting, c, 4)
N '81
--Early 20th cent.
Smithsonian 10:96-7 (4) F '80
--1900
Smithsonian 8:69 (painting, c, 3)
Jl '77
--1913 women's fashion
Smithsonian 10:115 (4) Ag '79
--Belle-Ile-en-Mer
Natur Hist 90:cov. , 48-57 (c, 1)
Ja '81
--Brittany
Nat Geog 151:830-1 (c, 1) Je '77
--Burgundy region
Nat Geog 153:794-817 (c, 1) Je
'78
--Cevennes region
Nat Geog 154:540-59 (c, 1) O '78
--French legionnaires
Nat Geog 155:856 (c, 4) Je '79
FRANCE--HISTORY
--1182 expulsion of Jews
Smithsonian 9:38 (c, 2) Je '78
--1719 Mississippi Bubble scandal
Am Heritage 29:29 (c, 1) F '78
--Cartoon of early 20th cent. cele-
brities as dogs
Smithsonian 10:100 (drawing, 4)
F '80
--Empress Eugenie's escape from
France (1870)
Am Heritage 31:65-78 (draw-
ing, c, 3) Je '80
--Life in Paris during 1870-71 siege
Natur Hist 86:68-76 (drawing, c, 2)
O '77
--Revolutionaries seizing Chamber
of Deputies (1870)
Am Heritage 31:65 (drawing, c, 3)
Je '80
--See also CLEMENCEAU, GEORGES;

FRANCO-PRUSSIAN WAR;
LOUIS IX; LOUIS XIV;
NAPOLEON; TALLEYRAND,
CHARLES MAURICE; WORLD
WAR I; WORLD WAR II
FRANCE--MAPS
--Burgundy region
Nat Geog 153:798 (c, 1) Je '78
FRANCO, FRANCISCO
Life 2:146 (4) D '79
FRANCO-PRUSSIAN WAR (1870-
1871)
--Monument (Berlin, Germany)
Trav/Holiday 156:60 (c, 4) O
'81
--Treatment of animals in Paris
during siege
Natur Hist 86:68-76 (draw-
ing, c, 2) O '77
FRANK, ANNE
Life 2:127-30 (c, 4) Mr '79
FRANKFORT, KENTUCKY
--Capitol Building
Travel 148:50 (4) Jl '77
FRANKFURT AM MAIN, WEST
GERMANY
Nat Geog 152:148-9 (c, 1) Ag
'77
FRANKLIN, BENJAMIN
--Flying kite
Nat Wildlife 18:12 (painting, c, 4)
F '80
FREMONT, JOHN C.
Am Heritage 29:30-1 (1) Ag
'78
FRENCH AND INDIAN WAR
Am Heritage 29:100 1 (paint-
ing, c, 2) Je '78
FRENCH HORNS
Smithsonian 11:84 (c, 4) F '81
FRESCOES
--4th cent., B.C. (Macedon,
Greece)
Nat Geog 154:54-74 (c, 1) Jl '78
--5th cent. (Sri Lanka)
Nat Geog 155:145 (c, 2) Ja '79
--Ancient Crete
Nat Geog 153:168-71 (c, 1) F
'78
Trav/Holiday 156:31 (c, 4) D
'81
--Ancient Egypt
Nat Geog 151:298-9, 302-3 (c, 1)
Mr '77
--Ancient Thera, Greece
Nat Geog 153:157-9, 161 (c, 1)
F '78
Natur Hist 87:72-3 (c, 1) Ap '78

--Fra Angelico works
Life 4:104-10 (c, 2) Ap '81
--Avanos, Turkey church
Trav/Holiday 149:54 (c, 4) Ap '78
--Byzantine church (Turkey)
Nat Geog 152:108 (c, 4) Jl '77
--Mira, Italy
Trav/Holiday 151:34 (c, 4) F '79
--Sri Lanka
Trav/Holiday 155:79 (c, 4) F '81
FRESNO, CALIFORNIA
--1910's
Am Heritage 31:50-60 (1) O '80
FRIGATE BIRDS
Nat Geog 153:670-1, 678-9 (c, 1)
My '78
Nat Wildlife 18:38 (painting, c, 1)
Ag '80
FRIGATES
Smithsonian 10:82-8 (c, 1) Mr '80
FROGS
Natur Hist 86:39-45 (c, 1) Ja '77
Smithsonian 7:96 (drawing, c, 4)
Ja '77
Sports Illus 47:37 (c, 1) Jl 18 '77
Natur Hist 86:87 (c, 2) O '77
Nat Geog 153:105 (c, 1) Ja '78
Nat Wildlife 17:12 (c, 4) O '79
Nat Geog 157:140-1 (c, 1) Ja '80
Nat Wildlife 18:56 (c, 1) Ap '80
Nat Wildlife 18:21-7 (c, 1) Je
'80
Life 3:108 (c, 2) N '80
Natur Hist 90:44 (c, 4) My '81
--African clawed frogs
Nat Wildlife 17:34-6 (c, 1) F '79
--Arrow-poison frogs
Nat Wildlife 19:22 (1) D '80
--Being eaten by egret
Nat Geog 155:360-1 (c, 1) Mr '79
--Poison-dart frogs
Smithsonian 11:47 (c, 4) Je '80
--South American
Natur Hist 86:100 (c, 3) N '77
--Tadpoles
Nat Geog 157:132-3 (c, 1) Ja '80
Nat Wildlife 18:26-7 (c, 4) Je '80
Nat Wildlife 18:22-3 (c, 1) Ag '80
--See also BULLFROGS; TREE
FROGS
FROST, ROBERT
Smithsonian 10:194 (4) N '79
FRUIT FLIES
Nat Geog 151:277 (4) F '77
Nat Geog 158:282 (c, 4) Ag '80
Life 4:129 (c, 2) O '81
FRUITS
Life 3:90-1 (c, 1) Ap '80

--19th cent. American still lifes
 Am Heritage 32:2, 14-25
 (painting, c, 1) O '81
--Kiwi
 Natur Hist 86:85 (4) Mr '77
--Persimmons
 Natur Hist 90:102-6 (c, 1) F '81
--See also APPLES; AVOCADOS;
 BANANAS; BERRIES; BLUE-
 BERRIES; COCONUTS;
 CRANBERRIES; GRAPES;
 LIMES; NUTMEG; ORANGES;
 PEARS; PINEAPPLES;
 STRAWBERRIES; TOMATOES;
 WATERMELONS
FULLER, MARGARET
 Smithsonian 9:166 (painting, c, 3)
 N '78
FULMARS
--Chicks
 Natur Hist 88:73 (c, 4) Mr '79
FUND RAISING
--Banquet
 Ebony 34:102-6 (3) Jl '79
FUNERAL HOMES
--Drive-through (Florida)
 Nat Geog 159:28-9 (c, 1) F
 '81SR
FUNERAL RITES AND CERE-
 MONIES
 Ebony 32:94-6 (1) F '77
 Ebony 34:61-2 (2) Ap '79
 Ebony 34:57-8 (2) Ag '79
--17th cent. Virginia
 Nat Geog 155:756-7 (c, 2) Je
 '79
--1905 Japanese funeral pyre
 Am Heritage 28:76 (4) Ag '77
--1917 Queen Lilioukalani funeral
 (Hawaii)
 Am Heritage 28:108 (3) Ap '77
--1951 Spain
 Life 1:53 (4) D '78
--Afghans (Pakistan)
 Nat Geog 159:678-9 (c, 2) My
 '81
--Alabama
 Ebony 35:35 (4) F '80
--Apache Indians (Arizona)
 Nat Geog 157:286-7 (c, 1) F '80
--Bodies on display
 Natur Hist 87:6-9 (3) Je '78
--Body lying in state (Arizona)
 Ebony 35:64-72 (3) Je '80
--Body lying in state (New York)
 Ebony 34:61 (4) Ap '79
--Burial urn (ancient Carthage)
 Smithsonian 9:50-1 (c, 2) F '79

--Burying Union dead (Civil War)
 Am Heritage 31:60-1 (drawing, 4)
 Ag '80
--California
 Ebony 34:95, 98 (4) O '79
 Ebony 35:170 (4) N '79
--Fabric depicting Lord Nelson's
 funeral (1830)
 Smithsonian 8:72 (c, 1) N '77
--Grave digging (Great Britain)
 Life 4:110 (2) Jl '81
--IRA hunger strike victims (North-
 ern Ireland)
 Life 4:40-3, 48 (c, 1) O '81
--Joe Louis (Nevada)
 Ebony 36:133-8 (3) Je '81
--Memorial rally (California)
 Nat Geog 157:788-9 (c, 1) Je '80
--Mexican Indians
 Nat Geog 158:747 (c, 3) D '80
--Murder victim (Georgia)
 Life 4:68-9 (1) Ap '81
--Nez Perce Indians (Washington)
 Nat Geog 151:410-11 (c, 1) Mr
 '77
--Nigeria
 Nat Geog 155:426-7 (c, 2) Mr '79
--Northern Ireland
 Nat Geog 159:496-7 (c, 1) Ap '81
--Palestinian terrorist (Lebanon)
 Life 2:106-8 (2) Ap '79
--Pope Paul VI funeral
 Life 1:124-5 (c, 1) O '78
--Singapore
 Nat Geog 159:554-5 (c, 1) Ap '81
--Surinam
 Smithsonian 7:84-5 (c, 1) Mr '77
--U. S. Congressman
 Ebony 34:38 (4) Ja '79
--U. S. general
 Ebony 34:41 (4) Ja '79
--Vigil for murdered San Francisco
 mayor
 Life 2:82 (c, 2) D '79
--See also CEMETERIES; MUM-
 MIES; TOMBS; TOMBSTONES
FUNGI
 Nat Geog 158:276 (4) Ag '80
 Smithsonian 11:132 (c, 4) O '80
 Nat Wildlife 19:50-1 (c, 4) O '81
--See also MUSHROOMS; SLIME
 MOLDS; TRUFFLES
FUR INDUSTRY
--Early 20th cent.
 Natur Hist 89:106-13 (2) Ap '80
--Indians trading furs
 Nat Wildlife 17:15, 18 (drawing, 4)
 O '79

Trapping
 Nat Wildlife 17:14-19 (c, 1) O
 '79
FURNITURE
--18th cent. George II chest
 (Great Britain)
 Smithsonian 8:87 (c, 2) My '77
--18th cent. Italian sofa
 Smithsonian 12:78-9 (c, 3) D '81
--1760's highboy (Pennsylvania)
 Am Heritage 31:21 (c, 3) Ap '80
--1875 sideboard (New York)
 Smithsonian 11:110-11 (c, 3)
 My '80
--Miniature doll house furniture
 Life 2:53-6 (c, 3) O '79
--See also BABY CRIBS; BATH-
 TUBS; BEDS; BENCHES;
 CHAIRS; CHESTS; DESKS;
 LAMPS; RUGS; TABLES;
 THRONES
FUTURE
--1939 views of future
 Smithsonian 10:86-9 (c, 3) N '79
--Industry expansion into space
 Smithsonian 8:94-9 (painting, c, 1)
 D '77

-G-

GADWALL DUCKS
 Nat Wildlife 16:48 (c, 1) Je '78
GALAPAGOS ISLANDS, ECUADOR
 Life 2:58-9 (c, 1) Ag '79
 Trav/Holiday 153:44-8 (map, c, 1)
 Ja '80
--Marine life
 Nat Geog 154:362-81 (map, c, 1)
 S '78
GALAXIES
--Andromeda
 Natur Hist 89:80-1 (4) Ag '80
--NGC 2903 from electronic
 camera
 Smithsonian 10:48-9 (c, 2) My
 '79
--Ring galaxies
 Natur Hist 86:106 (4) N '77
--See also CONSTELLATIONS;
 MILKY WAY; NEBULAE
GALBRAITH, JOHN KENNETH
 Am Heritage 32:66 (4) Ap '81
GALILEO
 Smithsonian 9:96 (drawing, c, 2)
 Ja '79
--Home (Florence, Italy)
 Smithsonian 12:97 (c, 1) Ag '81

--Interrogated by Inquisition
 Smithsonian 12:90-1 (painting, c, 2)
 Ag '81
--Life and works
 Smithsonian 12:90-7 (c, 1) Ag '81
GALLINULES (BIRDS)
 Smithsonian 7:91 (painting, c, 4)
 Mr '77
 Nat Wildlife 18:2 (c, 1) Ap '80
GALVESTON, TEXAS
 Trav/Holiday 150:47-8, 72 (c, 2)
 N '78
 Smithsonian 11:48-9 (c, 3) S '80
GAMBIA
--Abuko Nature Reserve
 Natur Hist 90:42 (c, 4) S '81
GAMBIA--COSTUME
--Juffure
 Ebony 32:40 (4) Ap '77
 Ebony 32:cov., 31-8 (c, 1) Jl '77
 Ebony 33:164, 170 (c, 4) O '78
GAMBLING
--Blackjack
 Sports Illus 50:66-7 (c, 3) Ap 16
 '79
--Blackjack (Atlantic City, New Jer-
 sey casino)
 Life 2:32-3 (1) Ja '79
--Blackjack (Honduras casino)
 Trav/Holiday 155:43 (c, 4) Ja '81
--Blackjack (Las Vegas, Nevada)
 Sports Illus 50:16-17 (c, 2) F 12
 '79
--Blackjack (Tasmania, Australia
 casino)
 Travel 147:46 (c, 4) Mr '77
--Calculating odds
 Sports Illus 52:30-40 (2) F 25
 '80
--Casino (Atlantic City, New Jersey)
 Nat Geog 160:580-1 (c, 2) N '81
--Casino (Lake Tahoe, California/
 Nevada)
 Trav/Holiday 151:64 (c, 2) Mr '79
--Casino (Las Vegas, Nevada)
 Trav/Holiday 153:40 (c, 1) Ja '80
--Casino exterior
 Smithsonian 12:70 (painting, c, 3)
 O '81
--Roulette wheel (Caribbean)
 Trav/Holiday 151:65 (4) Ap '79
 Trav/Holiday 153:68 (c, 4) Ap '80
 Trav/Holiday 155:70 (c, 4) Ap '81
 Trav/Holiday 156:15 (c, 4) D '81
--School for dealers (New Jersey)
 Life 2:36-7 (2) Ja '79
--Shipboard casino
 Travel 147:39 (4) Je '77

(Padua, Italy)
Natur Hist 90:50-4 (c, 1) Mr '81
--Early 20th cent. rose garden
(Idaho)
Am Heritage 32:33 (2) Ap '81
--Backyard wildlife (Illinois)
Nat Wildlife 15:50-3 (c, 1) Ja
'77
--Baja California, Mexico
Trav/Holiday 153:35 (c, 1) Ja
'80
--Botanical (Bronx, New York)
Smithsonian 9:64-73 (c, 1) Jl
'78
--Botanical (Memphis, Tennessee)
Trav/Holiday 149:47 (c, 2) Ja
'78
--Chinese (Massachusetts)
Smithsonian 8:98 (c, 4) Je '77
--Chinese (New York City mu-
seum)
Life 3:86-8 (c, 1) Ag '80
Smithsonian 12:66-72 (c, 2) Jl
'81
--Estates (Great Britain)
Smithsonian 9:48-55 (c, 1) Ag
'78
--Florida
Trav/Holiday 148:53 (c, 1) N
'77
--Japanese (Singapore)
Trav/Holiday 154:44, 47 (c, 4)
O '80
--Khemisti Gardens, Algiers,
Algeria
Travel 147:57 (c, 1) F '77
Longwood, Pennsylvania
Travel 147:54-7 (c, 1) Ja '77
--Louisiana
Trav/Holiday 152:38 (c, 2) O
'79
--Missouri Botanical Garden
greenhouse
Smithsonian 10:110-11, 119
(c, 1) O '79
--Claude Monet's gardens (Giverny,
France)
Smithsonian 10:62-7 (c, 1) F
'80
Life 3:62-7 (c, 1) My '80
--New Mexico
Am Heritage 31:80 (c, 3) F '80
--New Orleans, Louisiana
Trav/Holiday 155:54 (c, 4) F
'81
--New York
Trav/Holiday 154:37 (c, 1) Ag
'80

--Ohio
Trav/Holiday 152:55 (c, 2) S '79
--Old Westbury, Long Island, New
York
Trav/Holiday 156:24 (c, 4) Ag
'81
--Plant and insect life in lawns
Smithsonian 8:90-6 (painting, c, 2)
Ap '77
--Scotland
Trav/Holiday 149:54, 57 (c, 2)
My '78
Trav/Holiday 152:41 (c, 1) S '79
--Vancouver, British Columbia
Nat Geog 154:488-9 (c, 1) O '78
--Washington, D. C. mansion
Smithsonian 12:cov., 92-101
(c, 1) My '81
--See also FLOWERING PLANTS;
GAZEBOS; GREENHOUSES;
PLANTS; TOPIARY
GARFIELD, JAMES
Am Heritage 32:112 (4) Ag '81
--1881 inaugural parade
Smithsonian 10:66 (2) D '79
--1881 inaugural pitcher
Smithsonian 7:108 (c, 4) Ja '77
--Garfield murder and trial of
Charles Guiteau
Am Heritage 32:30-9 (3) Je '81
GARLIC
Nat Geog 158:253 (c, 4) Ag '80
GARMENT INDUSTRY
--19th cent. factory (Lowell, Mas-
sachusetts)
Life 3:90-1 (c, 1) Jl '80
--1900 fur factory
Natur Hist 89:100 (3) Ap '80
--California factory
Nat Geog 157:798 (c, 4) Je '80
Life 4:30-1 (c, 1) Jl '81
--Designing fur coat (France)
Nat Geog 159:305 (c, 4) Mr '81
--Factory (Miami, Florida)
Ebony 35:140 (4) S '80
--Disposable garments (Illinois)
Ebony 35:140-2 (3) Je '80
--Making parka from caribou skin
(Canada)
Natur Hist 90:44-5 (c, 2) O '81
--Sewing in factory (New York)
Natur Hist 86:51 (3) Ja '77
GARS
--Alligator
Nat Geog 156:198 (c, 2) Ag '79
GARTER SNAKES
Natur Hist 87:56-7 (c, 2) N '78
Nat Wildlife 19:52-5 (c, 3) Ap '81

GARVEY, MARCUS
--Tomb (Jamaica)
Ebony 32:97 (c, 4) Ja '77
GAS, NATURAL
--Collection battery (Texas)
Nat Geog 159:144-5 (c, 1) F '81
--Liquefaction plant (Sumatra,
Indonesia)
Nat Geog 159:428-9 (c, 3) Mr
'81
--Searching for new sources
Nat Geog 154:633-51 (c, 1) N
'78
--U. S. resources
Nat Geog 159:60-1 (map, c, 1) F
'81SR
GAS, NATURAL--TRANSPORTA-
TION
--LNG container
Nat Geog 154:633 (c, 2) N '78
GAS MASKS
Sports Illus 54:97 (c, 4) My
25 '81
Life 4:68-9 (c, 1) Je '81
GASAHOL INDUSTRY
Smithsonian 11:44-53 (c, 1) Mr
'80
Nat Geog 159:88-91 (c, 2) F
'81SR
GASOLINE STATIONS
--1930 (Cambridge, Massachusetts)
Life 3:114 (c, 4) D '80
--1930's
Smithsonian 11:148 (4) S '80
--1930's (Milwaukee, Wisconsin)
Smithsonian 12:67 (c, 4) Ap '81
--1940's gas shortage
Am Heritage 30:4-12 (c, 1) O
'79
--Dewalt, Texas
Sports Illus 53:78 (c, 4) O 27
'80
--Gravity pumps (Alberta)
Nat Geog 157:768 (c, 1) Je '80
--Route 66
Am Heritage 28:27 (c, 1) Ag '77
--Scotland
Nat Geog 151:533 (c, 1) Ap '77
GASPE PENINSULA, QUEBEC
Nat Geog 151:450-1 (c, 1) Ap
'77
Nat Geog 157:588-9, 622-3
(c, 1) My '80
GATES
--Early 20th cent. fashionable gate
(New York)
Am Heritage 29:69 (1) Ag '78
--New York Senate Chamber

(Albany, New York)
Smithsonian 12:153 (c, 1) N '81
--Newport, Rhode Island mansion
Sports Illus 53:74 (c, 4) Ag 18
'80
--Protective steel apartment gates
Ebony 34:36 (4) Ag '79
--Security gate for California man-
sion
Ebony 35:62 (4) Je '80
--Washington, D. C. estate
Smithsonian 12:92, 100 (c, 1) My
'81
GATEWAY NATIONAL RECREA-
TION AREA, NEW YORK
Nat Geog 156:86-97 (c, 1) Jl '79
Gauchos. See COWBOYS
GAUGUIN, PAUL
--Bonjour, M. Gauguin
Smithsonian 11:158 (painting, c, 4)
O '80
--Caribbean woman with sunflowers
Smithsonian 9:78 (painting, c, 4) Jl
'78
--Christmas Night (1896)
Smithsonian 11:60 (painting, c, 2)
Je '80
GAVIALS
Life 2:115-19 (c, 1) My '79
GAZEBOS
--Nashville hotel, Tennessee
Trav/Holiday 155:55 (c, 3) Ap '81
GAZELLES
Smithsonian 11:178 (c, 4) S '80
GECKOS (LIZARDS)
Natur Hist 86:100-1 (c, 2) N '77
Smithsonian 10:39 (c, 4) Ag '79
GEESE
Nat Wildlife 16:10-11 (c, 1) Ag
'78
Nat Wildlife 17:5-8 (c, 1) F '79
Nat Geog 155:378-9 (c, 1) Mr '79
Natur Hist 88:76-9 (c, 3) D '79
Smithsonian 11:79 (c, 4) Ag '80
Nat Wildlife 18:49 (c, 4) O '80
Smithsonian 11:10 (c, 4) Mr '81
Life 4:128 (c, 2) Ap '81
--Being force-fed (France)
Nat Geog 158:237 (c, 1) Ag '80
--Flock in flight
Sports Illus 47:74 (painting, c, 2)
N 21 '77
--Ross' geese stamp
Nat Wildlife 17:40 (painting, c, 1)
D '78
--Snow
Nat Wildlife 15:58-9 (c, 1) Ja '77
Nat Geog 156:737-9 (c, 1) D '79

Natur Hist 89:30-1 (c, 1) Jl '80
--Snow geese in flight
Nat Wildlife 17:10-11 (c, 1) O
'79
Nat Geog 160:588-9 (c, 1) N '81
--See also CANADA GEESE
GEHRIG, LOU
Sports Illus 47:86 (4) O 10 '77
Sports Illus 49:72 (3) O 9 '78
Gems. See JEWELRY; JEWELS;
list under MINERALS
GENEALOGIES
--Family tree
Ebony 32:53-8 (3) Je '77
GENETICS
--DNA
Smithsonian 8:54-63 (c, 1) Je '77
Natur Hist 88:108-9 (4) O '79
Life 3:cov., 48-58 (c, 1) My
'80
--Genes
Ebony 35:31 (4) S '80
--Genetic engineering research
Smithsonian 8:54-63 (c, 1) Je
'77
Ebony 35:31-4 (2) S '80
--Splicing genes
Life 3:cov., 48-58 (c, 1) My '80
GENEVA, SWITZERLAND
Trav/Holiday 150:cov., 63-4
(c, 1) Jl '78
Geological phenomena. See
ANTARCTICA; ARCTIC;
BEACHES; CANYONS; CAVES;
CLIFFS; CONTINENTAL DI-
VIDE; DESERTS; EARTH-
QUAKES; FLOODS; GEYSERS;
GLACIERS; ICEBERGS, IS-
LANDS; MARSHES; MOUN-
TAINS; MUD; NORTH POLE;
PRAIRIE; ROCKS; SAND
DUNES; TUNDRA; VOL-
CANOES; WATER FORMA-
TIONS; WEATHER PHE-
NOMENA
GEORGE, HENRY
Am Heritage 29:4-13 (c, 1) Ap
'78
GEORGE III (GREAT BRITAIN)
Am Heritage 33:73-5 (drawing, 4)
D '81
GEORGE V (GREAT BRITAIN)
Smithsonian 12:174-5, 184-9
(2) O '81
GEORGE VI (GREAT BRITAIN)
Smithsonian 12:174-5 (2) O '81
GEORGE WASHINGTON BRIDGE,
NEW YORK/NEW JERSEY

Nat Wildlife 18:5, 10-11 (c, 1) F
'80
GEORGIA
Nat Geog 154:212-45 (map, c, 1)
Ag '78
--Blue Ridge area
Travel 147:37-41, 90 (c, 1) F '77
--Cumberland Island
Nat Geog 152:648-61 (map, c, 1)
N '77
Nat Wildlife 16:54-60 (c, 1) D '77
--Jekyll Island
Trav/Holiday 155:49 (c, 2) Je '81
--Ossabaw Island
Smithsonian 12:124-33 (c, 1) O
'81
--Stone Mountain
Travel 147:58 (c, 4) Je '77
Trav/Holiday 153:79, 84-6 (c, 1)
My '80
--Wassaw Island
Smithsonian 11:56-7 (c, 2) S '80
--See also ATLANTA; BLUE RIDGE
MOUNTAINS; OKEFENOKEE
SWAMP; SAVANNAH; SUWAN-
NEE RIVER
GEOTHERMAL ENERGY
Nat Geog 152:566-79 (c, 1) O '77
Life 2:126-7 (c, 1) S '79
GERICAULT, THEODORE
--Tomb (Paris, France)
Smithsonian 9:108-9 (c, 2) N '78
GERMAN SHEPHERDS
Ebony 32:56 (4) My '77
Nat Geog 152:197 (c, 3) Ag '77
Ebony 34:92 (4) D '78
Ebony 34:66 (4) My '79
Ebony 36:162 (4) D '79
Life 3:135-6 (2) Je '80
Ebony 37:93 (4) D '81
GERMANY. See also BERLIN
WALL
GERMANY--ART
--16th cent. clocks
Smithsonian 11:cov., 45-53 (c, 1)
D '80
--Early Dresden art works
Smithsonian 9:56-61 (c, 1) Je '78
Nat Geog 154:701-17 (c, 1) N '78
--World War I era expressionist
paintings
Smithsonian 11:88-95 (c, 2) Ja
'81
GERMANY--COSTUME
--1928 formal gowns
Life 4:14 (2) F '81
--1940's children
Smithsonian 8:100, 106 (4) F '78

--World War I soldiers
 Life 4:10 (2) F '81
GERMANY--HISTORY
--1948 Berlin airlift
 Am Heritage 28:12 (4) Ag '77
--See also FRANCO-PRUSSIAN
 WAR; GOERING, HERMANN;
 HITLER, ADOLF; NAZISM;
 WORLD WAR I; WORLD WAR
 II
GERMANY, EAST
--Border with West Germany
 Life 4:36-7 (c, 1) Ag '81
--See also BERLIN; DRESDEN
GERMANY, EAST--COSTUME
--Guard at Tomb of Unknown
 Soldier
 Life 4:12 (3) F '81
--Military
 Nat Geog 152:180-1 (c, 2) Ag '77
GERMANY, WEST
 Nat Geog 152:148-81 (c, 1) Ag
 '77
--Bavaria
 Trav/Holiday 153:63-4 (c, 1)
 Mr '80
--Danube River area
 Nat Geog 152:456-63 (map, c, 1)
 O '77
--Garmisch
 Sports Illus 48:33 (c, 4) Ja 23
 '78
--Koenigshoven
 Life 3:70-2 (c, 2) N '80
--Moselle River Valley
 Travel 147:42-7 (c, 1) My '77
--Oberammergau
 Trav/Holiday 152:6, 94-5 (4)
 N '79
--Romantic Road
 Trav/Holiday 151:50-2 (c, 1) Je
 '79
--Wurzburg
 Trav/Holiday 151:50 (c, 4) Je
 '79
--See also BADEN-BADEN; BER-
 LIN; COLOGNE; FRANK-
 FURT AM MAIN; HAMBURG;
 MUNICH; NUREMBERG
GERMANY, WEST--ART
--Stained glass windows
 Smithsonian 8:82-9 (c, 1) F '78
GERMANY, WEST--COSTUME
 Nat Geog 152:159-81 (c, 1) Ag
 '77
 Nat Geog 152:458-61 (c, 1) O
 '77
--Traditional (Bavaria)

Natur Hist 88:92 (4) F '79
 Trav/Holiday 152:6 (4) N '79
 Trav/Holiday 153:63 (c, 1) Mr '80
--Traditional (Rothenburg)
 Trav/Holiday 151:50 (c, 4) Je '79
GERMANY, WEST--MAPS
 Trav/Holiday 153:65 (4) Mr '80
GERONIMO
 Smithsonian 11:145 (4) Ap '80
GETTYSBURG, PENNSYLVANIA
--1913 reunion of Civil War veterans
 Am Heritage 29:56-61 (1) Je '78
GETTYSBURG NATIONAL MILI-
 TARY PARK, PENNSYL-
 VANIA
 Nat Geog 156:54 (c, 1) Jl '79
GEYSERS
--Lone Star, Yellowstone, Wyoming
 (1883)
 Smithsonian 9:46 (4) Mr '79
--Yellowstone National Park,
 Wyoming
 Nat Geog 154:844-5 (c, 1) D '78
GHANA--ART
--Ashanti tribe sculpture
 Smithsonian 9:52 (c, 4) O '78
GHANA--COSTUME
 Smithsonian 12:87-93 (c, 2) N '81
--Dagomba tribe
 Natur Hist 88:69-75 (c, 1) N '79
--Healers and priests
 Smithsonian 12:87-93 (c, 2) N '81
GHIRLANDAIO, DOMENICO
--Giovanna Tornabuoni (1488)
 Smithsonian 10:85 (painting, c, 4)
 N '79
GHOST TOWNS
--Elkhorn, Montana
 Trav/Holiday 156:49 (c, 4) Jl '81
--Rhyolite, Nevada
 Trav/Holiday 153:46-7, 66-8 (3)
 Je '80
--St. Elmo, Colorado
 Nat Geog 156:490-1 (c, 1) O '79
GHOSTS
--Haunted houses
 Life 3:152-60 (c, 1) N '80
GIACOMETTI, ALBERTO
--Sculpture
 Smithsonian 10:64-5 (c, 1) Je '79
GIBBONS
 Natur Hist 86:55 (c, 1) My '77
 Life 3:50-6 (c, 1) F '80
 Smithsonian 12:65 (c, 4) D '81
GIBRALTAR
 Nat Geog 151:216-17 (c, 1) F '77
GINSENG
 Smithsonian 8:125 (c, 4) O '77

GIORGIONE
--Adoration of the Shepherd
 Smithsonian 9:54-5 (painting, c, 1)
 Ja '79
GIRAFFES
 Nat Geog 151:809 (c, 3) Je '77
 Nat Geog 152:402-21 (c, 1) S
 '77
 Smithsonian 8:44-5, 50-1 (c, 1)
 Mr '78
 Sports Illus 48:72 (c, 3) My 22
 '78
 Sports Illus 48:36 (c, 3) My 29
 '78
 Life 1:88-92 (c, 1) N '78
 Trav/Holiday 151:cov. (c, 2) Je
 '79
 Smithsonian 11:24 (4) Ap '80
 Trav/Holiday 154:40 (c, 4) N '80
GIRARD, STEPHEN
 Am Heritage 29:38-44 (paint-
 ing, c, 1) Je '78
GIRL SCOUTS
--1910's
 Am Heritage 30:23 (4) Je '79
GLACIER NATIONAL PARK,
 MONTANA
 Nat Geog 152:14-15 (c, 1) Jl '77
 Nat Geog 154:285-94 (c, 1) Ag
 '78
 Nat Geog 156:124-33 (c, 1) Jl
 '79
 Nat Geog 156:514 (c, 1) O '79
 Trav/Holiday 156:49 (c, 2) Jl '81
GLACIERS
 Smithsonian 8:33-41 (c, 1) Ja
 '78
--Alaska
 Travel 148:64-5 (4) Ag '77
 Nat Geog 155:242-3 (c, 1) F '79
 Trav/Holiday 155:55 (c, 3) Mr
 '81
--Jasper National Park, Alberta
 Nat Geog 157:754-6, 760-1 (c, 1)
 Je '80
--New Zealand
 Trav/Holiday 155:40 (4) Mr '81
 Trav/Holiday 156:32-3 (c, 1) D
 '81
--Northwest Territories
 Nat Geog 160:411 (c, 1) S '81
--Remains of Ice Age (Wisconsin)
 Nat Geog 152:182-205 (c, 1)
 Ag '77
--Washington
 Nat Geog 152:40 (c, 4) Jl '77
GLADIATORS
--Ancient Rome

 Nat Geog 159:725 (sculpture, c, 4)
 Je '81
GLASGOW, SCOTLAND
--1870's
 Smithsonian 11:40 (4) Ag '80
GLASS INDUSTRY
--Copper engraving on crystal (New
 York)
 Nat Geog 151:724 (c, 4) My '77
--Engraving on glass (Austria)
 Trav/Holiday 151:47 (c, 4) Mr '79
--See also FIBER OPTICS
GLASSBLOWING
--13th cent. Turkey
 Nat Geog 153:774-5 (painting, c, 1)
 Je '78
--Corning, New York
 Trav/Holiday 154:34 (c, 4) Ag '80
--Michigan
 Trav/Holiday 149:48 (c, 4) My
 '78
GLASSWARE
--4th cent. B. C. bronze and silver
 vessels (Macedonia)
 Life 3:47 (c, 2) Jl '80
 Smithsonian 11:128-9, 132 (c, 4)
 N '80
--8th cent. metal chalice (Ireland)
 Smithsonian 8:73 (c, 4) O '77
--9th cent. chalice (Ireland)
 Nat Geog 159:432 (c, 4) Ap '81
--12th cent. porcelain wine cup
 (Korea)
 Smithsonian 10:114 (c, 2) My '79
--13th cent. Turkey
 Nat Geog 153:768-92 (c, 1) Je '78
--14th cent. bottle (Yemen)
 Smithsonian 12:113 (c, 2) Jl '81
--14th cent. brass bowls (Mideast)
 Smithsonian 12:108-11 (c, 3) Jl
 '81
--1664 gold chalice (U. S. S. R.)
 Nat Geog 153:28 (c, 4) Ja '78
--18th cent. Italian porcelain
 Smithsonian 12:75 (c, 3) D '81
--18th cent. Spanish
 Nat Geog 156:872-3 (c, 2) D '79
--18th cent. Spanish wine decanter
 Nat Geog 156:863 (c, 2) D '79
--1788 goblet (Maryland)
 Am Heritage 31:22 (c, 2) Ap '80
--1920's
 Smithsonian 8:74-5 (c, 4) N '77
--Ancient bronze vessels (Nigeria)
 Ebony 35:152-4 (c, 3) O '80
--Ancient Roman glass vial (Aphro-
 disias, Turkey)

Nat Geog 160:538 (c, 4) O '81
--Ancient Thracian gold vessels
 Smithsonian 8:42-50 (c, 1) Je
 '77
--Antiques (Pennsylvania)
 Trav/Holiday 156:46 (c, 4) S '81
--Art glass
 Life 2:82-8 (c, 1) Ap '79
--Beer pitcher
 Sports Illus 47:32 (painting, c, 4)
 S 5 '77
--Bronze Age vessels (China)
 Smithsonian 11:cov. , 62-71
 (c, 1) Ap '80
--Crystal decanters
 Trav/Holiday 156:42 (4) Jl '81
--Crystal goblets (Belgium)
 Nat Geog 155:326 (c, 1) Mr '79
--Decorative (Corning Museum,
 Corning, New York)
 Smithsonian 11:66-77 (c, 1) My
 '80
--Found on 18th cent. shipwrecks
 Nat Geog 152:744-5, 758-9
 (c, 1) D '77
--Gold cup (Ancient Greece)
 Nat Geog 153:184 (c, 4) F '78
--Porcelain Qing jars
 Smithsonian 11:43, 51 (c, 2) Jl
 '80
--Silver water jug (India)
 Nat Geog 160:284-5 (c, 1) S '81
--Venetian glass
 Smithsonian 12:138 (c, 4) Ag '81
--Wine glasses
 Ebony 32:114-20 (c, 2) F '77
 Trav/Holiday 151:81-2 (c, 1) Ap
 '79
--See also BOTTLES
GLIDERS
 Nat Geog 153:428-38 (c, 1) Mr
 '78
--Wright Brothers' planes
 Am Heritage 31:49-51 (2) D
 '79
GLOBES
--Antique
 Smithsonian 11:46 (c, 4) Ap '80
--Daily News Building, New York
 City, New York
 Life 3:76 (c, 1) Ag '80
GLOVES
--Astronaut
 Nat Geog 153:828 (c, 3) Je '78
--Golden (Chimu culture, Peru)
 Natur Hist 86:131 (4) O '77
--Mining gloves (Wyoming)
 Nat Geog 159:108-9 (2) F

'81SR
--Spain
 Nat Geog 153:300-1 (c, 1) Mr '78
--See also BASEBALL GLOVES
GNATS
 Nat Wildlife 15:36 (c, 4) Ag '77
GOATS
 Nat Geog 153:414 (c, 1) Mr '78
 Nat Geog 156:610 (c, 3) N '79
 Natur Hist 88:64 (c, 1) D '79
 Nat Geog 157:520-1 (c, 1) Ap '80
 Nat Geog 158:746 (c, 1) D '80
 Nat Wildlife 19:38-9 (c, 1) Ag '81
 Nat Geog 160:471 (c, 1) O '81
--19th cent. painting
 Smithsonian 8:58-9 (c, 3) S '77
--Kids
 Nat Geog 152:100 (c, 4) Jl '77
 Nat Wildlife 19:38-9 (c, 1) Ag '81
--Tahrs
 Smithsonian 12:70 (c, 4) D '81
--See also IBEXES
GODDARD, ROBERT HUTCHINGS
 Am Heritage 31:24-31 (1) Je '80
Gods and goddesses. See DEITIES;
 MYTHOLOGY
GOERING, HERMANN
 Am Heritage 32:68 (4) Ap '81
GOGGLES
 Sports Illus 51:cov. , 14-15 (c, 1)
 Ag 20 '79
--Made of flashlight lenses (Philip-
 pines)
 Nat Geog 151:379 (c, 1) Mr '77
GOLD
 Smithsonian 10:105, 112 (c, 4)
 F '80
--17th cent. shipwreck relics
 Nat Geog 152:733-54 (c, 1) D '77
--Ancient Egyptian art
 Nat Geog 151:cov. , 304-5 (c, 1)
 Mr '77
--Ancient Peruvian sculptures
 Smithsonian 8:84-9 (c, 1) D '77
--Crystalline
 Smithsonian 11:32 (c, 4) My '80
--Gold bars
 Life 2:146-7 (c, 1) N '79
 Life 4:136-7 (c, 1) D '81
--Pre-Columbian sculpture (Costa
 Rica)
 Nat Geog 160:50 (c, 4) Jl '81
--Pre-Hispanic gold works (Colom-
 bia)
 Natur Hist 88:cov. , 36-52 (c, 1)
 N '79
--South Africa Krugerrands
 Nat Geog 151:796 (c, 4) Je '77

GOLD INDUSTRY
 Life 2:146 (c, 4) N '79
GOLD MINING
--Brazil
 Life 3:66-74 (c, 1) D '80
--California
 Smithsonian 10:108-9 (c, 2) F
 '80
--Stress test for miners (South
 Africa)
 Life 2:144-5 (c, 1) N '79
--See also PROSPECTING
GOLD RUSH
--Travel to Klondike (1897-98)
 Smithsonian 7:106-13 (c, 1) F
 '77
--See also DAWSON CITY; KLON-
 DIKE
GOLDEN GATE BRIDGE, SAN
 FRANCISCO, CALIFORNIA
 Ebony 32:69 (4) Ap '77
 Trav/Holiday 151:99 (4) My '79
 Nat Geog 156:12-14, 98-9 (c, 1)
 Jl '79
 Nat Geog 158:264-5 (c, 1) Ag
 '80
 Nat Geog 159:814-16 (c, 1) Je
 '81
GOLDEN GATE NATIONAL
 RECREATION AREA, S. F.
 Nat Geog 156:12-14, 23 5,
 98-105 (c, 1) Jl '79
GOLDENROD
 Travel 147:53 (4) Mr '77
GOLDFINCHES
 Nat Wildlife 16:41, 44 (c, 1)
 D '77
 Nat Wildlife 17:62-3 (c, 1) D '70
 Nat Wildlife 19:33 (c, 2) D '80
 Natur Hist 90:59-61 (c, 1) O
 '81
GOLF
 Travel 147:40 (3) Ap '77
 Smithsonian 8:79 (c, 4) O '77
 Trav/Holiday 151:41 (c, 3) Mr
 '79
 Sports Illus 51:28-9 (c, 3) Jl 9
 '79
 Ebony 35:75 (2) My '80
 Sports Illus 55:62, 65 (c, 4) S
 14 '81
--18th cent. Great Britain
 Am Heritage 31:2 (painting, c, 1)
 Ag '80
--Australia
 Trav/Holiday 152:46 (c, 3) N
 '79
--Children

Sports Illus 47:44-5 (c, 2) O 10
 '77
--Putting atop office building (Arkan-
 sas)
 Nat Geog 153:404 (c, 1) Mr '78
--Putting indoors
 Sports Illus 54:74-5 (c, 1) Je 5
 '81
--Saudi Arabia
 Sports Illus 53:90-1 (c, 1) N 17
 '80
--Scotland
 Trav/Holiday 151:41, 72 (c, 1)
 F '79
--Virgin Islands
 Trav/Holiday 156:49 (c, 2) O '81
GOLF--AMATEUR
 Sports Illus 47:44 (c, 4) Jl 25
 '77
GOLF--PROFESSIONAL
 Sports Illus 46:56 (c, 4) F 21 '77
 Sports Illus 46:36-7 (1) Je 20
 '77
 Sports Illus 48:20-2 (c, 1) Mr 27
 '78
 Sports Illus 48:cov. (c, 1) My 1
 '78
 Sports Illus 48:26-7 (c, 3) My 8
 '78
 Sports Illus 48:23 (c, 4) Je 19 '78
 Sports Illus 49:27-9 (c, 2) D 25
 '78
 Sports Illus 50:18-19 (c, 3) Ja
 22 '79
 Sports Illus 50:24-6 (c, 2) Ap 2
 '79
 Sports Illus 50:37 (2) Je 18 '79
 Sports Illus 51:20 2 (c, 3) Jl 9
 '79
 Sports Illus 51:27 (c, 3) S 24 '79
 Sports Illus 53:22 (c, 3) S 1 '80
 Sports Illus 54:103-4 (c, 4) Ja 19
 '81
--1940's
 Sports Illus 50:66-7 (4) My 7 '79
--1960's
 Sports Illus 51:70-7 (c, 2) Ag 13
 '79
--Caddies
 Sports Illus 54:38-43 (c, 2) My 4
 '81
--Lining up putt
 Sports Illus 46:28 (c, 4) Ap 18
 '77
 Sports Illus 48:68 (4) Ap 23 '78
 Sports Illus 49:36 (c, 3) O 9 '78
 Sports Illus 50:18-19 (c, 2) Mr
 12 '79

Jersey)
Sports Illus 52:55-6 (4) Je 9
'80
--U. S. Open 1960 (Denver, Colorado)
Sports Illus 48:38-40 (2) Je 19
'78
--U. S. Open 1967 (Springfield, New Jersey)
Sports Illus 52:45-7, 56-8 (c, 1)
Je 9 '80
--U. S. Open 1971 (Merion, Pennsylvania)
Sports Illus 54:55-6, 68-70
(c, 4) Je 8 '81
--U. S. Open 1977 (Tulsa, Oklahoma)
Sports Illus 46:15-19 (c, 1) Je
27 '77
--U. S. Open 1978 (Denver, Colorado)
Sports Illus 48:cov., 15-19
(c, 1) Je 26 '78
--U. S. Open 1979 (Toledo, Ohio)
Sports Illus 50:cov., 20-3 (c, 1)
Je 25 '79
--U. S. Open 1980 (Baltusrol,
New Jersey)
Sports Illus 52:cov., 22-7 (c, 1)
Je 23 '80
--U. S. Open 1981 (Merion, Pennsylvania)
Sports Illus 55:cov., 18-21
(c, 1) Je 29 '81
--U. S. Opens at Baltusrol (New
Jersey)
Sports Illus 52:45-58 (c, 1) Je
9 '80
--Women's U. S. Open 1977
(Chaska, Minnesota)
Sports Illus 47:45-6 (4) Ag 1
'77
--Women's U. S. Open 1978
(Indianapolis, Indiana)
Sports Illus 49:61-2 (3) Jl 31
'78
--Women's U. S. Open 1979 (Fairfield, Connecticut)
Sports Illus 51:32 (c, 3) Jl 23
'79
GOLF TOURNAMENTS--HUMOR
Sports Illus 47:38-40 (painting, c, 1) N 7 '77
Sports Illus 54:72-86 (drawing, c, 4) F 2 '81
GOLFERS
Sports Illus 46:53 (c, 3) Ja 17
'77

Sports Illus 46:22-3 (c, 3) F 28
'77
Sports Illus 46:64-6 (c, 4) Mr 28
'77
Sports Illus 46:40 (c, 4) Ap 4 '77
Sports Illus 46:cov. (c, 1) Ap 18
'77
Sports Illus 47:22-3 (c, 3) D 12
'77
Sports Illus 49:cov. (c, 1) Jl 10
'78
Sports Illus 52:45-58, 80-1 (c, 1)
Je 9 '80
Sports Illus 53:42 (c, 4) Jl 7 '80
--Great Britain
Sports Illus 49:43 (c, 4) O 30 '78
--See also JONES, BOBBY
GOLFERS--WOMEN
Sports Illus 46:30-2 (c, 2) Ap 11
'77
GONDOLAS
--Venice
Trav/Holiday 151:cov., 36, 39
(c, 1) F '79
GONZALES, PANCHO
Sports Illus 51:32 (4) Ag 20 '79
GOODYEAR, CHARLES
Am Heritage 29:63 (2) Ap '78
GOOSEBERRIES
Natur Hist 89:97-8 (3) Jl '80
GOPHERS
Natur Hist 89:37-41 (c, 1) Je '80
GORHAM, NATHANIEL
Smithsonian 8:104 (painting, c, 4)
Ja '78
GORILLAS
Smithsonian 9:58-63 (c, 1) Jl '78
Nat Geog 154:cov., 439-65 (c, 1)
O '78
Nat Wildlife 17:22-3 (2) D '78
Trav/Holiday 153:42-3, 93 (c, 1)
Mr '80
Nat Geog 159:500-23 (c, 1) Ap
'81
Smithsonian 12:138 (c, 4) N '81
GOSHAWKS
Nat Wildlife 18:60 (painting, c, 1)
D '79
Nat Wildlife 18:10-11 (c, 1) Ag
'80
GOULD, JAY
Am Heritage 30:41 (4) F '79
Government. See ELECTIONS;
GOVERNMENT--LEGISLA-
TURES; POLITICAL CAM-
PAIGNS; U. S. --POLITICS
AND GOVERNMENT; U. S.
PRESIDENTS; list under

STATESMEN
GOVERNMENT--LEGISLATURES
--Alderman chambers (St. Louis,
 Missouri)
 Ebony 34:86 (3) S '79
--California
 Ebony 36:102 (3) Ap '81
--New York Senate Chamber
 Smithsonian 12:146-53 (c, 1) N
 '81
--Tennessee legislature (1920)
 Am Heritage 30:26 (2) D '78
--Virginia
 Ebony 34:78 (4) Ap '79
 Ebony 35:46 (4) Je '80
GOVERNMENT BUILDINGS
--Parliament House, Bern, Swit-
 zerland
 Trav/Holiday 155:78 (4) My
 '81
--Restored Reichstag, Berlin,
 West Germany
 Trav/Holiday 156:62 (c, 3) O
 '81
--See also CAPITOL BUILDINGS;
 CITY HALL; COURTHOUSES;
 SUPREME COURT BUILDING
GOYA, FRANCISCO
--Saint Jerome (1799)
 Smithsonian 10:54 (painting, c, 4)
 S '79
GRAFFITI
--New York
 Nat Geog 151:186 (c, 3) F '77
--Northern Ireland
 Nat Geog 159:496 (c, 4) Ap '81
--Quebec woods
 Nat Geog 159:004-6 (c, 1) Mr
 '81
--Spain
 Nat Geog 153:324 (c, 4) Mr '78
GRAIN FIELDS
--California
 Smithsonian 8:81 (c, 1) My '77
--India
 Nat Geog 153:338 (c, 4) Mr '78
GRAIN INDUSTRY
--Grain elevators (Saskatchewan)
 Nat Geog 155:654-5 (c, 1) My
 '79
--Granaries (Canadian prairie)
 Natur Hist 87:40 (c, 4) Ap '78
--See also BARLEY INDUSTRY;
 WHEAT INDUSTRY
GRAIN INDUSTRY--HARVESTING
--1900 Washington
 Smithsonian 7:48-9 (1) Mr '77
--Byelorussia, U. S. S. R.

Nat Geog 155:772-3 (c, 1) Je '79
--China
 Nat Geog 159:808 (c, 4) Je '81
GRAIN INDUSTRY--TRANSPORTA-
 TION
--Ontario
 Nat Geog 154:788-9 (c, 1) D '78
GRANADA, NICARAGUA
 Travel 148:41 (c, 2) Jl '77
GRAND CANYON, ARIZONA
 Sports Illus 47:28 (c, 1) Ag 1 '77
 Nat Wildlife 16:42-7 (c, 1) F '78
 Ebony 33:148-9 (c, 2) My '78
 Nat Geog 154:cov., 2-51 (c, 1)
 Jl '78
 Nat Geog 156:46-7 (c, 1) Jl '79
 Natur Hist 89:40-5 (c, 1) S '80
--1880 sketch for survey
 Smithsonian 9:40-2 (drawing, c, 1)
 Mr '79
--Covered with fog
 Nat Wildlife 20:10-11 (c, 1) D '81
--See also COLORADO RIVER
GRAND COULEE DAM, COLUMBIA
 RIVER, WASHINGTON
 Natur Hist 89:56-7 (c, 1) Jl '80
GRAND TETON NATIONAL PARK,
 WYOMING
 Ebony 33:150 (4) My '78
 Nat Geog 156:148-51 (c, 1) Jl '79
--Jackson Hole
 Trav/Holiday 152:cov., 47-51
 (c, 1) Jl '79
GRANITE QUARRIES
--Early 20th cent. Barre, Vermont
 Am Heritage 32:65-71 (1) D '80
GRANT, ULYSSES S.
 Smithsonian 7:108 (drawing, 4)
 Ja '77
--19th cent. cigar label
 Am Heritage 30:85 (painting, c, 4)
 D '78
--1881 cartoon
 Am Heritage 30:20 (4) Je '79
--Painting by him (1841)
 Am Heritage 32:97 (painting, c, 3)
 D '80
Grape Industry. See VINEYARDS;
 WINE
GRAPE INDUSTRY--HARVESTING
--Bordeaux, France
 Nat Geog 158:240 (c, 2) Ag '80
--Burgundy, France
 Trav/Holiday 149:34 (c, 4) Ap '78
 Nat Geog 153:794-5 (c, 1) Je '78
--California
 Life 4:135-7 (c, 2) N '81
--Crete

Trav/Holiday 156:24 (c, 4) D '81
--France
Trav/Holiday 153:30 (c, 4) Mr
'80
--New York
Nat Geog 151:714-15 (c, 1) My
'77
--South Africa
Nat Geog 151:811 (c, 4) Je '77
--Tasmania, Australia
Travel 147:46 (c, 4) Mr '77
GRAPES
Ebony 32:114 (c, 4) F '77
Nat Geog 152:113 (c, 4) Jl '77
Travel 148:24 (drawing, 4) Ag
'77
Ebony 33:128-32 (c, 2) O '78
Nat Geog 155:696 (c, 3) My '79
Nat Geog 158:233 (c, 4) Ag '80
Trav/Holiday 156:40 (c, 1) Ag
'80
Trav/Holiday 156:39 (4) S '81
--Pinot noir
Trav/Holiday 149:33 (c, 1) Ap
'78
GRASS
Smithsonian 8:51 (c, 2) S '77
Nat Wildlife 16:57 (c, 4) D '77
Smithsonian 10:79 (c, 2) Ja '80
Natur Hist 89:45 (c, 1) D '80
--Beargrass
Nat Wildlife 15:29 (c, 4) Ap '77
Nat Wildlife 19:63 (c, 2) D '80
--Cotton grass (Iceland)
Trav/Holiday 155:55 (c, 3) Je
'81
--Grassland areas of the U. S.
Nat Wildlife 17:11 (map, c, 4)
Je '79
--Pampas grass
Natur Hist 90:54 (c, 1) Mr '81
--Tallgrass (Midwest prairie)
Smithsonian 9:116 (4) Ja '79
Nat Geog 157:36-61 (c, 1) Ja '80
--See also BAMBOO; SORGHUM;
WILD RICE
GRASSE, COMTE DE
Am Heritage 32:70 (drawing, 4)
O '81
GRASSHOPPERS
Natur Hist 86:59 (c, 4) Ag '77
Am Heritage 30:13 (painting, c, 4)
Ag '79
Nat Geog 156:628-9 (c, 2) N
'79
Nat Geog 157:149, 160 (c, 3) F
'80
--See also LOCUSTS

GRAVITY
--Zero gravity in spacecraft
Nat Geog 159:329, 339 (c, 4) Mr
'81
GREAT BARRIER REEF, AUS-
TRALIA
Nat Geog 159:631-63 (c, 1) My
'81
GREAT BRITAIN
--19th cent. shipwreck sites (Corn-
wall)
Smithsonian 9:134-41 (2) O '78
--Bradford, Yorkshire
Life 3:64-6 (1) Ap '80
--England
Nat Geog 156:442-81 (map, c, 1)
O '79
--Estates
Smithsonian 9:48-55 (c, 1) Ag '78
--Homes of British royalty
Life 4:46-54 (c, 1) Jl '81
--Ironbridge, Telford
Smithsonian 10:58-63 (c, 2) Jl '79
--Whitehaven
Smithsonian 11:144-6 (c, 4) D '80
--See also CANTERBURY; GIBRAL-
TAR; LIVERPOOL; LONDON;
MAN, ISLE OF; NORTHERN
IRELAND; OXFORD; SHETLAND
ISLANDS; STONEHENGE;
STRATFORD-ON-AVON; VIR-
GIN ISLANDS; WALES; WIND-
SOR CASTLE; YORK; YORK-
SHIRE
GREAT BRITAIN--ARCHITECTURE
Smithsonian 7:96-102 (c, 1) F '77
--1851 Crystal Palace (London)
Smithsonian 9:82 (4) Ap '78
--Longleat country estate
Smithsonian 9:138 (painting, c, 4)
F '79
GREAT BRITAIN--COSTUME
--Early 17th cent.
Natur Hist 90:59 (painting, c, 2)
Je '81
--1779 portrait
Am Heritage 29:46 (painting, c, 4)
D '77
--1798
Smithsonian 11:80 (c, 3) Mr '81
--19th cent.
Smithsonian 8:68 (painting, c, 2)
Ag '77
--19th cent. women's dress
Smithsonian 12:159 (c, 4) N '81
--1859 man
Smithsonian 9:91 (engraving, 4)
Ag '78

Nat Geog 153:456-7 (paint-
ing, c, 1) Ap '78
GREBES (BIRDS)
Nat Wildlife 17:26-7 (c, 1) Je
'79
Nat Wildlife 18:26 (painting, c, 4)
O '80
Nat Wildlife 19:47 (c, 3) F '81
GREECE
Nat Geog 157:360-93 (map, c, 1)
Mr '80
--Aegae, Macedon
Nat Geog 154:58, 77 (map, c, 1)
Jl '78
--Kalymnos
Smithsonian 8:48-53 (c, 1) Ap
'77
--Kos
Trav/Holiday 151:14 (4) F '79
--Mykonos windmill
Trav/Holiday 148:8 (4) N '77
--Thera
Nat Geog 153:157-62 (c, 1) F
'78
Natur Hist 87:70-6 (map, c, 1)
Ap '78
--See also ATHENS; CAPE
SOUNION; CRETE; OLYMPIA;
RHODES: THESSALY
GREECE--COSTUME
Nat Geog 157:360-93 (c, 1) Mr
'80
--Crete
Nat Geog 153:146-7, 166-7
(c, 2) F '78
GREECE, ANCIENT
--Minoan civilization (Crete)
Nat Geog 153:146-79 (c, 1) F
'78
Nat Geog 159:204-21 (c, 1) F
'81
--Mycenae
Nat Geog 153:149, 182-5 (c, 1)
F '78
--See also ALEXANDER THE
GREAT; ILIAD; MYTHOLOGY;
PHILIP II; ULYSSES
GREECE, ANCIENT--ARCHITEC-
TURE
Nat Geog 153:145-85 (c, 1) F
'78
--See also PARTHENON; TEM-
PLES--ANCIENT
GREECE, ANCIENT--ART
--Frescoes (Crete)
Nat Geog 153:157-71 (c, 1) F
'78
Trav/Holiday 156:31 (c, 4) D '81

--Frescoes (Thera)
Nat Geog 153:157-71 (c, 1) F '78
Natur Hist 87:72-3 (c, 1) Ap '78
--Vase painting of pig sacrifice
Nat Geog 154:405 (c, 4) S '78
GREECE, ANCIENT--RELICS
--Medallion of Philip II of Macedon
Smithsonian 10:67 (4) Ja '80
--Minoan civilization
Nat Geog 153:146-79 (c, 1) F '78
Nat Geog 159:204-21 (c, 1) F '81
--Mycenae
Nat Geog 153:cov., 142-85 (c, 1)
F '78
--Mycenaean funeral stele (18th
cent. B. C.)
Nat Geog 152:619 (c, 4) N '77
--Thracian treasures
Smithsonian 8:cov., 42-51 (c, 1)
Je '77
--Treasures from Philip II's tomb
(Macedon)
Nat Geog 154:54-77 (c, 1) Jl '78
Life 3:46-50 (c, 1) Jl '80
Smithsonian 11:cov., 126-38 (c, 1)
N '80
GREECE, ANCIENT--RUINS
--Ephesus, Turkey
Trav/Holiday 156:56 (c, 4) Jl '81
Greece, Ancient--Sculpture. See
SCULPTURE--ANCIENT
GREEK ORTHODOX CHURCH
--Bishop (Bulgaria)
Nat Geog 158:107 (c, 4) Jl '80
GREEK ORTHODOX CHURCH--
COSTUME
--Bishop (Uganda)
Nat Geog 158:82-3 (c, 1) Jl '80
--Monks
Nat Geog 157:382 (c, 4) Mr '80
GREELEY, HORACE
Smithsonian 8:64 (4) Ag '77
GREENE, NATHANAEL
Am Heritage 32:71 (drawing, 4)
O '81
GREENHOUSES
Smithsonian 10:110-19 (c, 1) O
'79
--Bulgaria
Nat Geog 158:110-11 (c, 1) Jl '80
--Israel
Nat Geog 153:232-3 (c, 2) F '78
Nat Geog 156:634-5 (c, 1) N '79
--Niagara Falls, New York
Life 1:109-12 (c, 2) D '78
GREENLAND--MAPS
Natur Hist 90:52 (c, 4) Ag '81
GREETING CARDS

--Late 19th cent. Christmas
cards
Smithsonian 8:120-5 (c, 3) D '77
--Early 20th cent. Valentine's
Day cards
Smithsonian 11:153 (c, 4) F '81
Grenada. See WINDWARD IS-
LANDS
GREYHOUNDS
Sports Illus 49:79 (4) S 4 '78
--2nd cent. marble sculpture
(Rome)
Smithsonian 8:113 (c, 2) N '77
--See also DOG RACES
GRIFFITH, DAVID W.
Am Heritage 31:27 (4) O '80
GROSBEAKS (BIRDS)
Nat Wildlife 15:8 (c, 4) Je '77
Nat Wildlife 16:42-3 (paint-
ing, c, 1) D '77
Nat Wildlife 17:48 (c, 1) F '79
Nat Wildlife 18:45 (c, 1) O '80
Nat Wildlife 18:37, 41 (paint-
ing, c, 1) Ag '80
--Rose-breasted
Nat Wildlife 15:24A-B (paint-
ing, c, 1) O '77
GROSZ, GEORGE
--The Great City (1917)
Smithsonian 11:88 (painting, c, 2)
Ja '81
Grottoes. See CAVES
Groundhogs. See WOODCHUCKS
GROUSE
Smithsonian 8:60, 153 (c, 3) N
'77
Nat Wildlife 16:42-9 (paint-
ing, c, 1) O '78
Nat Wildlife 17:41 (c, 3) Ag '79
Nat Wildlife 18:53 (c, 2) Ap
'80
Nat Wildlife 19:26-7 (c, 2) O
'81
--See also PRAIRIE CHICKENS;
PTARMIGANS
GRUNTS (FISH)
Nat Geog 154:364-6, 378-9
(c, 1) S '78
GUADELOUPE
Nat Geog 159:266-7 (c, 2) F '81
GUADELOUPE--COSTUME
--Festival
Trav/Holiday 153:69 (c, 3) Ap
'80
GUADALOUPE MOUNTAINS NA-
TIONAL PARK, TEXAS
Nat Geog 156:134-40 (c, 1) Jl
'79

GUAM
Trav/Holiday 154:42-7 (map, c, 2)
Jl '80
GUAM--COSTUME
Trav/Holiday 154:42-7 (c, 2) Jl
'80
GUANACOS
Nat Geog 160:62-75 (c, 1) Jl '81
GUANAJUATO, MEXICO
Travel 148:38-43 (c, 1) O '77
Nat Geog 153:630-1 (c, 1) My '78
GUANS
Sports Illus 48:56-7 (painting, c, 1)
F 13 '78
GUARDS
--East German watchtower
Life 4:37 (c, 4) Ag '81
--Great Britain
Life 4:68 (4) Jl '81
--Museum
Smithsonian 12:49 (c, 2) Ap '81
--Palace (Athens, Greece)
Trav/Holiday 152:45 (c, 4) Ag '79
--School guard (Chicago, Illinois)
Life 4:103 (4) Mr '81
--Scotland
Trav/Holiday 155:47 (c, 1) Ja '81
--Tomb of Unknown Soldier (East
Germany)
Life 4:12 (3) F '81
--Using walkie-talkie (Tennessee)
Ebony 32:109 (4) Je '77
--Wales
Life 1:cov. (c, 1) D '78
--See also DOORMEN; POLICEMEN;
PRISONS
GUATEMALA
Travel 149:33-7 (c, 1) S '77
--Mayan ruins (Tikal)
Natur Hist 90:36-7 (c, 1) Ag '81
--Pacaya volcano
Natur Hist 90:38 (c, 3) Ag '81
--Pyramids (Tikal)
Natur Hist 86:48 (c, 3) Ap '77
--Santiago kite fest
Natur Hist 87:68-74 (c, 1) Mr '78
GUATEMALA--ART
--Mayan cave paintings (Naj Tunich)
Nat Geog 160:cov. , 220-35 (c, 1)
Ag '81
GUATEMALA--COSTUME
--Children
Natur Hist 88:55 (c, 1) Ag '79
GUATEMALA--MAPS
Nat Geog 160:59 (c, 2) Jl '81
GUAYULE (PLANT)
Nat Geog 159:705-7 (c, 3) My '81
GUGGENHEIM MUSEUM, NEW

Sports Illus 48:40-1 (4) My 1
'78
--University of Arizona
Ebony 32:44-5 (2) Ap '77
GYMNASTICS
Sports Illus 48:35-7 (c, 2) Je
26 '78
Life 2:120-4 (c, 1) Mr '79
Sports Illus 50:32-3 (c, 4) Je 18
'79
Sports Illus 51:46-8 (c, 1) Jl 9
'79
Sports Illus 51:92-4 (c, 4) N 19
'79
Sports Illus 51:24-9 (c, 1) D 17
'79
Life 3:40 (c, 3) Mr '80
Ebony 35:45 (2) Ap '80
Life 3:32 (4) N '80
Ebony 36:68 (drawing, 2) My '81
--1976 Olympics (Montreal)
Sports Illus 51:114 (c, 3) Ag 13
'79
--1980 Olympics (Moscow)
Sports Illus 53:17 (c, 2) Ag 4
'80
Life 3:96-7 (c, 2) S '80
--Parallel bars
Life 4:148-9 (c, 1) D '81
--Standing on head
Am Heritage 33:23 (4) D '81

-H-

HAIDA INDIANS (BRITISH COLUM-
BIA)--RELICS
--1840 rattle
Natur Hist 07.01 (c, 1) My '70
HAILSTONES
Smithsonian 10:79-80 (c, 4) Ag
'79
Natur Hist 89:cov., 54-6 (c, 1)
Je '80
HAIRDRESSING--MEN
--At barber shop
Sports Illus 55:100 (c, 4) N 23
'81
--Haircut (Iowa farm)
Nat Geog 159:620 (c, 3) My '81
--Haircut (Nepal)
Trav/Holiday 156:36 (c, 2) Ag
'81
--Haircut (U. S. S. R.)
Nat Geog 155:790 (c, 1) Je '79
--See also BARBER POLES
HAIRDRESSING--WOMEN
Ebony 33:126 (4) Je '78

Ebony 33:88 (4) O '78
Sports Illus 50:36 (c, 3) Mr 26
'79
--China
Nat Geog 158:40-1 (c, 1) Jl '80
--Tuareg people (Niger)
Nat Geog 156:290-1 (c, 2) Ag '79
HAIRSTYLES--MEN
--Corn rows
Ebony 35:cov., 31-6 (c, 1) Ap '80
--Punk styles
Life 3:108 (c, 3) Je '80
--Punks' half-shaved heads (Finland)
Nat Geog 160:248 (c, 4) Ag '81
--Samburu warriors (Kenya)
Smithsonian 10:10 (c, 4) Ag '79
HAIRSTYLES--WOMEN
Ebony 37:132-6 (c, 2) N '81
--1880's long hair
Am Heritage 31:109 (3) Ag '80
--Braids
Life 2:cov. (c, 1) F '79
--Corn rows
Ebony 34:cov. (c, 1) Ja '79
Ebony 34:cov., 103-6 (c, 1) Je
'79
Ebony 35:112-18 (3) N '79
Life 3:111-12 (c, 2) Mr '80
Ebony 35:158 (4) My '80
Ebony 35:64-6 (3) O '80
--Egyptian braiding (California)
Nat Geog 155:44 (c, 1) Ja '79
HAITI
Ebony 32:98 (c, 4) Ja '77
Trav/Holiday 151:66-8, 68 (c, 3)
F '79
Nat Geog 159:246-9 (c, 1) F '81
--Citadelle
Trav/Holiday 155.57 (c, 2) Ja '81
--Countryside
Ebony 35:80 (3) Ja '80
--See also PORT-AU-PRINCE
HAITI--COSTUME
Nat Geog 159:247-9 (c, 4) F '81
--Drowned refugees (Florida)
Life 4:194-5 (c, 1) D '81
HAITI--HOUSING
--Shotgun houses
Natur Hist 86:52-7 (drawing, 1) F
'77
HALLECK, HENRY WAGER
Am Heritage 32:42 (2) F '81
HALLEY'S COMET
--1910
Natur Hist 90:34-7 (4) N '81
HALLOWEEN
--Costuming child as clown
Sports Illus 53:48 (4) N 3 '80

--Mexican talismans
Nat Geog 158:748-9 (c, 1) D '80
HALS, FRANS
--Portrait of a young woman
(1640)
Life 2:32 (painting, 4) Mr '79
HAMBURG, WEST GERMANY
Nat Geog 152:164-5 (c, 1) Ag
'77
Trav/Holiday 149:cov., 28-35
(c, 1) Mr '78
HAMILTON, ALEXANDER
--Drawings depicting events in
his life
Am Heritage 29:70-7 (3) D '77
HAMILTON, BERMUDA
Travel 147:36 (c, 2) Mr '77
HAMMOCKS
Smithsonian 8:102 (c, 4) S '77
Sports Illus 49:18 (c, 2) Jl 24
'78
Sports Illus 53:60-1 (c, 1) S 29
'80
Sports Illus 55:76 (c, 4) Ag 24
'81
Nat Geog 160:392-3 (c, 1) S '81
--Hong Kong
Nat Geog 156:714-15 (c, 1) N
'79
--Mexico
Travel 148:53 (c, 1) S '77
HAMPTON, WADE
Am Heritage 30:80 (2) F '79
HAMPTON ROADS, VIRGINIA
Nat Geog 159:19A-19B (c, 1) F
'81SR
HANCOCK, JOHN
Smithsonian 8:96 (painting, c, 4)
Ja '78
HAND SHAKING
Ebony 34:69 (4) O '79
--Baseball players
Sports Illus 49:30 (c, 2) S 11 '78
--Black Americans
Natur Hist 87:32-4 (3) O '78
--Double hand slap
Ebony 35:160 (4) My '80
--"Giving five"
Sports Illus 46:71 (c, 3) Ap 4
'77
Sports Illus 51:36-7 (c, 1) Ag
13 '79
--Politicians
Sports Illus 47:105 (c, 4) O 31
'77
HAND SHAKING--HUMOR
Sports Illus 54:62-74 (draw-
ing, c, 1) F 16 '81

HANDBALL PLAYING
Sports Illus 46:46 (4) My 2 '77
--Modern decorated court (Indiana)
Nat Geog 154:396 (c, 4) S '78
HANDICAPPED PEOPLE
--19th cent. shoe for clubfoot
(France)
Smithsonian 12:83 (c, 1) N '81
--Brain-damaged child
Life 1:42-54 (1) O '78
--Cerebral palsy victims
Nat Geog 156:88-9 (c, 2) Jl '79
Life 3:90-8 (1) Ja '80
Life 4:13 (4) N '81
--Deaf boy
Life 2:39-40 (2) F '79
--Down's syndrome victims
Ebony 36:44-8 (2) Ag '81
--Exercises for cerebral palsy vic-
tim
Smithsonian 11:54-5 (c, 3) Ja '81
--Legless man
Ebony 33:38 (4) Ag '78
Life 3:38-9 (1) My '80
--One-eyed people
Nat Geog 156:210 (c, 1) Ag '79
Smithsonian 10:63-71 (c, 2) Ja '80
--One-legged boy on crutches
Ebony 36:95-8 (2) Mr '81
--One-legged man
Life 2:100 (c, 4) Mr '79
--One-legged man (Namibia)
Smithsonian 11:90 (c, 4) Ap '80
--Polio victim on crutches
Nat Geog 156:207 (c, 2) Ag '79
--Provisions for handicapped tra-
velers
Trav/Holiday 149:60-2 (3) F '78
--Retarded people
Life 3:34-5 (c, 1) Je '80
--Retarded people using keyboard
communication
Smithsonian 10:90-6 (c, 2) Ap '79
--Riding on motorized scooter (New
York)
Ebony 35:120-2 (3) Jl '80
--Using pets as therapy
Smithsonian 12:48-57 (1) Jl '81
--Victims of agent orange
Life 4:65-70 (1) D '81
--Victim of mercury poisoning
(Japan)
Life 1:54-5 (1) D '78
--Walking with cane
Ebony 35:121 (3) Jl '80
--See also BLINDNESS; HEARING
AIDS; KELLER, HELEN;
MIDGETS; WHEELCHAIRS

HANG GLIDING
 Nat Geog 156:374-5 (c, 2) S '79
 Natur Hist 90:68-9 (c, 2) Mr
 '81
--British Columbia
 Life 1:76-7 (c, 1) N '78
--California
 Nat Geog 156:105 (c, 1) Jl '79
--Hawaii
 Nat Wildlife 15:28 (c, 2) Ap '77
 Trav/Holiday 150:cov. (c, 1) D
 '78
--Pennsylvania
 Nat Geog 153:732-3 (c, 1) Je '78
--Utah
 Sports Illus 51:23-6 (c, 1) Ag
 20 '79
Hanging. See CAPITAL PUNISH-
 MENT; LYNCHING
HANNIBAL, MISSOURI
 Smithsonian 9:155-63 (c, 4) O
 '78
--1869 aerial view
 Am Heritage 30:18-19 (c, 1) F
 '79
HANSON, JOHN
 Smithsonian 8:102 (painting, c, 4)
 Ja '78
HARBORS
--Ancient Carthage
 Smithsonian 9:49 (painting, c, 3)
 F '79
--Annapolis, Maryland
 Nat Geog 158:458-9 (c, 1) O '80
--Antwerp, Belgium
 Nat Geog 155:329 (c, 1) Mr '79
--Baltimore, Maryland
 Life 3:90-1 (c, 1) S '00
--Boston, Massachusetts
 Life 3:40-1 (c, 1) Jl '80
--Charleston, South Carolina
 Ebony 36:92 (4) My '81
--Galveston, Texas
 Trav/Holiday 150:47 (c, 2) N
 '78
--Hamburg, West Germany
 Nat Geog 152:164-5 (c, 1) Ag
 '77
--Helsinki, Finland
 Nat Geog 160:242-3 (c, 1) Ag
 '81
--Hong Kong
 Trav/Holiday 153:4 (4) Mr '80
--Husavik, Iceland
 Trav/Holiday 155:50-1 (c, 1) Je
 '81
--Indonesia
 Trav/Holiday 148:71 (4) D '77

--Juneau, Alaska
 Travel 148:63 (c, 4) Ag '77
--Key Biscayne, Florida
 Trav/Holiday 149:58-9 (c, 2) F
 '78
--Limon, Costa Rica
 Nat Geog 160:55 (c, 1) Jl '81
--Los Angeles-Long Beach, Cali-
 fornia
 Nat Geog 155:48-9 (c, 1) Ja '79
--Marblehead, Massachusetts
 Nat Geog 155:570-1 (c, 1) Ap '79
--Maui, Hawaii
 Trav/Holiday 153:50 (c, 1) Ja '80
--Morro Bay, San Luis Obispo,
 California
 Trav/Holiday 155:68-9 (c, 1) F
 '81
--Port Newark-Elizabeth, New Jer-
 sey
 Nat Geog 160:574-5 (c, 1) N '81
--Savannah, Georgia
 Nat Geog 154:242 (c, 3) Ag '78
--Serce Limani, Turkey
 Nat Geog 153:772-3 (c, 1) Je '78
--Singapore
 Nat Geog 159:556-7 (c, 1) Ap '81
--Sydney, Australia
 Nat Geog 155:212-3 (c, 1) F '79
--Tasmania, Australia
 Travel 147:45 (c, 4) Mr '77
--U. S. waterfront renewals
 Life 2:52-60 (c, 1) Mr '79
HARDING, WARREN G.
 Smithsonian 9:93 (3) Je '78
Hares. See RABBITS
HARP PLAYING
--Illinois
 Nat Geog 153:472 (c, 1) Ap '78
HARPOONS
--Ancient Eskimos (Canada)
 Nat Geog 159:595 (c, 4) My '81
HARRIERS (BIRDS)
--Killing jack rabbit
 Nat Geog 159:160-1 (c, 1) F '81
HARRIMAN, W. AVERELL
 Smithsonian 8:79 (c, 4) Ag '77
HARRISON, BENJAMIN
 Am Heritage 30:25 (drawing, 3)
 Je '79
HARRISON, WILLIAM HENRY
--Memorial quilt
 Smithsonian 7:104-5 (painting, c, 4)
 Ja '77
HARTFORD, CONNECTICUT
 Travel 147:65-8 (c, 1) Mr '77
--Capitol Building
 Travel 147:66 (c, 1) Mr '77

Ebony 33:75 (2) Mr '78
--Collapse of Coliseum
Sports Illus 48:20-1 (c, 2) Ja
30 '78
HARVARD UNIVERSITY, CAM-
BRIDGE, MASSACHUSETTS
Sports Illus 55:84-98 (paint-
ing, c, 1) N 16 '81
HARVESTERS
Nat Geog 151:482 (c, 3) Ap '77
Nat Geog 151:714-15 (c, 1) My
'77
Harvesting. See FARMING--
HARVESTING; individual
agricultural products
Harvestmen. See DADDY LONG-
LEGS
HATS
Smithsonian 8:97 (c, 1) N '77
--19th cent. U. S. cavalryman
Nat Geog 158:63 (c, 4) Jl '80
--1878 design for head measurer
Am Heritage 30:106-7 (draw-
ing, 4) Je '79
--1898 Easter hats
Am Heritage 31:109 (4) Ap '80
--1910's woman's hat
Am Heritage 29:38 (4) F '78
--1920's men's
Am Heritage 29:78-9 (3) F '78
--Bali
Trav/Holiday 151:96 (4) My
'79
--Bamboo
Nat Geog 158:527 (c, 4) O '80
--Baseball caps
Sports Illus 46:cov. (c, 1) Ap
11 '77
Sports Illus 49:34-5 (c, 4) N 6
'78
Sports Illus 55:84 (c, 4) S 7 '81
--Boaters (Australia)
Nat Geog 155:210 (c, 1) F '79
--Construction hard hat
Ebony 32:65 (2) Je '77
--Construction hard hats (Mexico)
Life 2:28 (c, 4) Mr '79
--Cowboy hats
Ebony 32:cov. (c, 1) Ja '77
Nat Wildlife 15:10 (c, 4) Ap '77
Sports Illus 46:68 (c, 2) My 9
'77
Nat Geog 152:490-1, 513 (c, 2)
O '77
Nat Geog 154:492, 512-17 (c, 1)
O '78
Nat Geog 157:441, 480-1 (c, 1)
Ap '80

Nat Geog 158:60 (c, 1) Jl '80
Life 4:66-7 (c, 3) Ja '81
Smithsonian 12:162 (drawing, 4)
S '81
--Derbies
Smithsonian 9:133, 137 (c, 3) N
'78
--Designing women's hats
Life 4:105 (2) Ja '81
--Ecuador
Trav/Holiday 151:69 (c, 1) My
'79
--Farm caps
Nat Geog 155:768-73 (c, 2) Je '79
--Huichol Indians (Mexico)
Natur Hist 88:74-5 (c, 1) O '79
--Korean marine cadets
Life 3:9 (4) Ap '80
--Ladakh, India
Nat Geog 153:cov., 348-9 (c, 1)
Mr '78
--Made of toucan feathers (Ecuador)
Smithsonian 8:119 (c, 4) O '77
--Mexican sombrero
Trav/Holiday 152:68 (c, 4) N '79
Sports Illus 53:24 (c, 2) Ag 18
'80
--Mickey Mouse ears (California)
Sports Illus 52:47 (4) My 26 '80
--Panama straw hat
Sports Illus 48:24 (c, 3) Ap 3 '78
--South Africa
Nat Geog 151:784 (c, 2) Je '77
--Straw (Mexico)
Nat Geog 153:618-19 (c, 1) My '78
--Straw (Panama)
Nat Geog 153:291 (c, 1) F '78
--Straw boaters
Sports Illus 48:32 (c, 4) F 27 '78
--Top hats
Ebony 36:60 (c, 4) O '81
--Top hats (Great Britain)
Sports Illus 51:27 (c, 1) Jl 9 '79
--Winter scarf and hat (Quebec)
Nat Geog 157:604 (c, 4) My '80
--Women's hats
Life 2:69-70 (c, 1) Ja '79
Ebony 34:cov., 138-42 (c, 1) Ap
'79
Ebony 34:154-5 (c, 2) Ag '79
Life 3:84 (c, 2) My '80
--See also HEADGEAR
HAVANA, CUBA
Nat Geog 151:34-41 (c, 1) Ja '77
--Depleted food store shelves
Nat Geog 159:270-1 (c, 2) F '81
HAWAII
Trav/Holiday 150:cov., 34-41,

70 (c, 1) D '78
Ebony 36:118-22 (c, 3) Ja '81
--Mid-19th cent.
Am Heritage 32:81-91 (1) O
'81
--Coral industry
Nat Geog 155:718-32 (map, c, 1)
My '79
--Fern grotto (Kauai)
Trav/Holiday 156:22 (4) S '81
--Forests
Sports Illus 49:72-5 (c, 2) S 25
'78
--Kauai
Nat Geog 152:584-613 (map, c, 1)
N '77
Trav/Holiday 150:53-4 (c, 2) D
'78
Trav/Holiday 154:56-61 (map, c, 1)
N '80
--Kona coast
Travel 147:42-7 (c, 1) F '77
--Lanai
Trav/Holiday 156:55-7 (map, c, 1)
O '81
--Local arts
Trav/Holiday 155:61-2 (c, 1)
Mr '81
--Maui
Sports Illus 46:44 (map, c, 3)
Ja 24 '77
Trav/Holiday 153:50-5 (c, 1) Ja
'80
Nat Wildlife 19:21-7 (c, 1) Je
'81
--Molokai
Trav/Holiday 149:56, 67 (c, 3)
Mr '78
Nat Geog 160:188-219 (map, c, 1)
Ag '81
--Molokai Ranch Wildlife Park
Trav/Holiday 154:38 (c, 3) Ag
'80
--Oahu
Nat Wildlife 15:28 (c, 2) Ap '77
Trav/Holiday 152:42-7 (c, 1)
O '79
Sports Illus 51:96-105 (c, 1) O
8 '79
Nat Geog 156:652-79 (map, c, 1)
N '79
--Waimea Canyon, Kauai
Trav/Holiday 156:32 (c, 4) D '81
--Wildlife refuge
Nat Geog 153:670-91 (c, 1) My
'78
--See also DIAMOND HEAD;
HONOLULU; KILAUEA VOL-

CANO; MAUNA LOA; PEARL
HARBOR; VOLCANOES NA-
TIONAL PARK
HAWAII--COSTUME
--King Kamehameha V and Princess
Victoria (1865)
Am Heritage 32:84-5 (2) O '81
HAWKS
Smithsonian 8:45 (c, 4) S '77
Sports Illus 49:74 (c, 3) S 25 '78
Nat Geog 156:187, 274-5 (c, 2)
Ag '79
Nat Geog 157:55 (c, 2) Ja '80
Nat Wildlife 18:3-13 (c, 1) Ag '80
Nat Wildlife 19:42-3 (c, 1) O '81
Nat Wildlife 20:50-1 (c, 1) D '81
--Red-shouldered
Nat Wildlife 15:21-5 (c, 1) Ag '77
Nat Wildlife 18:9 (c, 4) Ag '80
--Red-tailed
Nat Wildlife 16:52 (c, 4) Ap '78
Natur Hist 87:62-3 (c, 1) O '78
Nat Wildlife 17:39 (drawing, 4)
Ap '79
Nat Wildlife 17:22 (c, 3) Je '79
Natur Hist 90:66-7 (c, 2) Mr '81
--Red-tailed chick
Nat Wildlife 17:42-3 (c, 1) Ag '79
--Sharp-shinned
Nat Wildlife 18:3 (c, 2) Ag '80
Nat Wildlife 18:26-7 (painting, c, 1)
O '80
Nat Wildlife 19:42-9 (c, 1) Ap '81
--See also CARACARAS; FALCONS;
GOSHAWKS; OSPREYS; VUL-
TURES
HAWTHORNE, NATHANIEL
Smithsonian 9:88 (painting, 4) Mr
'79
--Daguerreotype of his children
Smithsonian 9:166 (3) S '78
--Home (Concord, Massachusetts)
Am Heritage 30:98 (drawing, 4)
D '78
--Scenes from the Scarlet Letter
Smithsonian 9:86-93 (c, 1) Mr
'79
HAY, JOHN
Am Heritage 33:79 (4) D '81
--Home (Washington, D. C.)
Smithsonian 8:63 (drawing, c, 3)
Ap '77
HAY
Nat Geog 151:476-7 (c, 2) Ap '77
Nat Geog 151:700 (c, 1) My '77
HAY INDUSTRY
--Baling (China)
Nat Geog 157:312-13 (c, 1) Mr '80

--Baling (Montana)
 Smithsonian 10:74 (c, 4) Mr '80
--Baling (Vermont)
 Natur Hist 90:78-9 (c, 2) Mr
 '81
--Farming (Estonia)
 Nat Geog 157:500-1 (c, 1) Ap
 '80
--Farming (North Carolina)
 Nat Geog 151:476-7 (c, 2) Ap
 '77
--Farming (Yugoslavia)
 Nat Geog 152:670-1 (c, 2) N '77
--France
 Smithsonian 8:114 (c, 2) Mr '78
 Nat Geog 154:552 (c, 2) O '78
HAY INDUSTRY--HARVESTING
--Massachusetts
 Trav/Holiday 153:44 (c, 4) Je
 '80
HAYES, RUTHERFORD B.
 Am Heritage 30:20 (3) Je '79
HAYSTACKS
--Turkey
 Nat Geog 152:106-7 (c, 1) Jl
 '77
HEADGEAR
--Afghanistan
 Travel 148:21 (2) O '77
--Boy's crocheted cap (Oman)
 Nat Geog 160:348 (c, 4) S '81
--Bridal hairpiece (Japan)
 Nat Geog 159:297 (c, 1) Mr '81
--Indian headdresses
 Travel 147:48 (c, 1) F '77
 Smithsonian 9:60 (c, 4) Ag '78
 Sports Illus 50:cov. (c, 1) F 12
 '79
--Jewish skullcaps (Brooklyn,
 New York)
 Natur Hist 86:cov., 46-56 (1)
 Ja '77
--Kapa (Montenegro, Yugoslavia)
 Nat Geog 152:673 (c, 4) N '77
--Lace caps (France)
 Natur Hist 90:57 (c, 1) Ja '81
--Mosquito nets (Alaska)
 Nat Geog 156:766 (c, 3) D '79
--Saudi Arabian headbands
 Nat Geog 158:300-1 (c, 1) S
 '80
--See also CROWNS; HATS; HEL-
 METS; MASKS; TURBANS;
 WIGS
HEADPHONES
 Ebony 33:159 (4) Ag '78
 Ebony 36:142 (4) F '81
 Ebony 36:82 (3) Mr '81

 Ebony 36:108 (4) Ap '81
 Sports Illus 55:51 (c, 4) N 30 '81
HEARING AIDS
 Nat Geog 155:712 (c, 2) My '79
--Testing products
 Smithsonian 9:51 (c, 1) S '78
HEARST, WILLIAM RANDOLPH
 Am Heritage 32:51 (4) Ap '81
--Hearst Castle, California
 Trav/Holiday 155:70 (c, 2) F '81
--His plans for a monastery
 Am Heritage 32:50-9 (2) Ap '81
HEARTS
--Artificial
 Life 4:cov., 28-36 (c, 1) S '81
--Elephant heart
 Sports Illus 46:36 (4) F 14 '77
HEATHER
 Nat Wildlife 19:61 (c, 4) D '80
HEATING
--Collecting buffalo chips (19th
 cent. Kansas)
 Natur Hist 89:76-7 (1) N '80
--Collecting cow dung for fuel
 (India)
 Natur Hist 88:21 (4) Je '79
--Heat produced from recycled
 garbage (Switzerland)
 Smithsonian 11:143-9 (c, 1) N '80
--Stockpiling wood (Vermont)
 Nat Geog 159:34-5 (c, 1) F '81SR
HEBRIDES, SCOTLAND
--St. Kildans (19th cent.)
 Smithsonian 11:143-56 (c, 2) Je
 '80
HEDGEHOGS
--Ancient Egyptian statue
 Nat Geog 151:301 (c, 4) Mr '77
HELEN OF TROY
 Smithsonian 11:197 (4) N '80
HELICOPTERS
 Am Heritage 28:21 (4) Ag '77
 Smithsonian 8:60 (c, 1) O '77
 Smithsonian 8:73 (c, 4) F '78
 Smithsonian 9:28 (c, 4) My '78
 Nat Geog 154:31 (c, 2) Jl '78
 Ebony 35:52-3 (2) F '80
 Ebony 35:101 (2) Ap '80
 Nat Geog 157:773 (c, 2) Je '80
 Ebony 35:44-6 (3) O '80
 Nat Geog 159:32-3, 63 (c, 1) Ja
 '81
 Nat Geog 159:479 (c, 1) Ap '81
 Trav/Holiday 155:49 (c, 2) My '81
 Nat Geog 159:788-9 (c, 2) Je '81
 Smithsonian 12:83 (c, 4) Ag '81
--Interior (Vietnam War)
 Life 2:104 (1) O '79

--Military
 Life 3:34-5 (c, 1) Ap '80
--Military (Cuba)
 Life 3:45 (c, 3) F '80
--U. S. Coast Guard
 Life 4:194-5 (c, 1) D '81
HELL
--Botticelli's "Inferno"
 Smithsonian 7:112 (painting, c, 3)
 Ja '77
HELMETS
--6th cent. B. C. Thracian (Bul-
 garia)
 Nat Geog 158:124 (c, 1) Jl '80
--13th cent. Russian
 Nat Geog 153:30 (c, 3) Ja '78
--17th cent. British
 Nat Geog 155:734, 758-9 (c, 1)
 Je '79
--19th cent. (Denmark)
 Nat Geog 154:198 (c, 4) Ag '78
--Auto racing
 Sports Illus 47:26-7 (c, 4) Jl
 18 '77
--Celtic
 Nat Geog 151:592 (c, 4) My '77
--Football
 Sports Illus 47:cov., 70 (c, 1)
 S 19 '77
 Sports Illus 47:111 (3) O 10
 '77
 Sports Illus 47:cov. (c, 1) O 17
 '77
 Sports Illus 53:37 (c, 4) O 6 '80
 Sports Illus 55:cov (c, 1) Ag 3
 '81
--Hard hats (Wisconsin)
 Nat Wildlife 16:41-0 (c, 0) F
 '77
--Mexican worker
 Nat Geog 153:629 (c, 1) My '78
--Middle Ages style
 Smithsonian 12:102 (c, 4) Je
 '81
--Motorcycle
 Sports Illus 46:31 (c, 1) Mr 14
 '77
 Nat Geog 156:143 (c, 2) Jl '79
--Silver (Orchid Island)
 Nat Geog 151:108-9 (c, 1) Ja
 '77
--World War I (U. S.)
 Nat Geog 153:829 (c, 2) Je '78
HELSINKI, FINLAND
 Trav/Holiday 155:47 (c, 1) F
 '81
 Nat Geog 160:236-55 (c, 1) Ag
 '81

--Outdoor fish market
 Sports Illus 53:36 (c, 3) D 22 '80
HEMINGWAY, ERNEST
 Sports Illus 47:99 (painting, c, 1)
 O 17 '77
 Smithsonian 12:151 (4) Ap '81
--1918 photo
 Am Heritage 32:90 (4) F '81
--Bust (Cuba)
 Sports Illus 47:47 (c, 4) Ag 1 '77
--Home (Cuba)
 Sports Illus 47:47-8 (c, 4) Ag 1
 '77
--Home (Key West, Florida)
 Trav/Holiday 154:48 (c, 4) N '80
HEMLOCK
 Smithsonian 8:51, 55 (painting, c, 1)
 My '77
HENRY VIII (GREAT BRITAIN)
 Smithsonian 12:104-5, 108 (c, 2)
 Ap '81
 Natur Hist 90:76 (painting, 3) My
 '81
HERAT, AFGHANISTAN
 Smithsonian 11:57 (c, 4) N '80
HERBS
--Used as medicine
 Am Heritage 28:97-101 (draw-
 ing, c, 4) Je '77
 Smithsonian 12:86-97 (c, 1) N '81
--See also ANISE; CALENDULAS;
 FENNEL; GINSENG; LAVEN-
 DER; PARSLEY
HERCULES
--Silver chariot ornament (Thrace)
 Smithsonian 8:51 (c, 1) Je '77
HERMITS
 Tahiti
 Nat Geog 155:863 (c, 3) Je '79
--Virginia
 Nat Geog 151:470-1 (c, 2) Ap '77
HERONS
 Nat Geog 151:175 (c, 4) F '77
 Nat Geog 153:107 (c, 4) Ja '78
 Nat Geog 155:361 (c, 3) Mr '79
 Nat Geog 157:450 (c, 4) Ap '80
 Nat Geog 159:148-9 (c, 1) F '81
 Trav/Holiday 156:36 (4) N '81
 Natur Hist 90:23 (3) D '81
 Life 4:184-5 (c, 1) D '81
--Great blue
 Nat Wildlife 16:57 (c, 4) D '77
 Nat Geog 157:824-5 (c, 1) Je '80
 Nat Geog 160:692 (c, 2) N '81
--Great white
 Trav/Holiday 156:52 (c, 1) N '81
--Green
 Nat Wildlife 17:21 (c, 1) Je '79

Nat Wildlife 18:48 (c, 4) Ap
'80
Nat Wildlife 18:42-7 (c, 1) Je
'80
Trav/Holiday 156:cov. (c, 1) N
'81
--Grey
Smithsonian 12:60 (c, 4) O '81
--See also BITTERNS; EGRETS
Herrings. See SARDINES
HEYERDAHL, THOR
Smithsonian 11:168 (4) O '80
HIBISCUS
Nat Geog 152:588 (c, 4) N '77
HIEROGLYPHICS
--Ancient Egypt
Nat Geog 151:293, 301-2 (c, 2)
Mr '77
--Crete
Nat Geog 153:174 (c, 2) F '78
HIGH JUMPING
Sports Illus 46:64-5, 69 (c, 1)
My 30 '77
Sports Illus 46:77 (c, 4) Je 13
'77
Sports Illus 47:20 (c, 4) S 12
'77
Sports Illus 47:55 (c, 4) D 19
'77
Sports Illus 48:16-17 (c, 1) F
6 '78
Sports Illus 48:44 (c, 3) F 13
'78
Ebony 33:82-3 (2) My '78
Sports Illus 49:20 (c, 2) Jl 17
'78
Sports Illus 50:118-19 (c, 4) F
15 '79
Sports Illus 52:70 (c, 4) F 25
'80
Life 3:39 (c, 4) Mr '80
Sports Illus 52:88-9 (c, 2) Mr
13 '80
Sports Illus 53:22-3 (c, 3) Je
30 '80
--1980 Olympics (Moscow)
Sports Illus 53:20-1 (c, 3) Ag
11 '80
HIGHWAYS
--1939 view of the future
Smithsonian 10:87 (3) N '79
--Albany, New York
Nat Geog 153:75 (c, 1) Ja '78
--Alberta
Nat Geog 157:774-5 (c, 2) Je
'80
--Atlanta, Georgia
Nat Geog 154:212-13 (c, 1) Ag

'78
--Brasilia, Brazil
Nat Geog 152:690 (c, 2) N '77
--Dallas, Texas
Smithsonian 9:64 (c, 4) N '78
--Hartford, Connecticut
Travel 147:68 (c, 1) Mr '77
--Miami, Florida
Trav/Holiday 153:38-9 (4) My
'80
--Washington, D. C. area
Smithsonian 8:110 (c, 4) D '77
--Yukon, Canada
Nat Geog 153:551 (c, 1) Ap '78
HIKING
Nat Geog 151:469 (c, 4) Ap '77
Nat Geog 156:cov., 197, 216-17
(c, 1) Ag '79
Sports Illus 52:44 (3) Je 23 '80
Smithsonian 11:119 (c, 2) F '81
--New Zealand
Nat Geog 153:116-22 (c, 1) Ja
'78
--Washington
Nat Wildlife 17:48 (c, 1) Je '79
--Wyoming
Sports Illus 55:66-82 (c, 1) D
14 '81
HIMALAYAN MOUNTAINS, INDIA
Travel 147:25-8 (c, 1) F '77
Nat Geog 153:334-57 (c, 1) Mr
'78
HIMALAYAN MOUNTAINS, NEPAL
Nat Geog 151:502-15 (c, 1) Ap
'77
Natur Hist 88:46-57 (c, 1) Ja '79
Nat Geog 155:270-1 (c, 1) F '79
Nat Geog 155:296-310 (c, 1) Mr
'79
Life 2:136-7 (c, 1) N '79
HIMALAYAN MOUNTAINS, PAKIS-
TAN
--Karakoram Range
Sports Illus 46:92-4 (c, 1) My 2
'77
Nat Geog 155:622-49 (c, 1) My
'79
Trav/Holiday 153:96 (2) F '80
HIMALAYAN MOUNTAINS, TIBET
Smithsonian 11:98 (c, 3) Ja '81
Natur Hist 90:67 (c, 3) S '81
--See also MOUNT EVEREST;
PAMIR REGION
HINDU KUSH MOUNTAINS,
AFGHANISTAN/PAKISTAN
Nat Geog 158:336-7 (c, 1) S '80
Nat Geog 160:463, 471 (c, 1) O
'81

'77
Sports Illus 48:56-8 (c, 1) F 9
'78
--Stanley Cup Playoffs 1978 (Canadians vs. Bruins)
Sports Illus 48:cov., 16-19
(c, 1) My 29 '78
Sports Illus 48:28-9 (c, 2) Je 5
'78
Sports Illus 50:122-4 (c, 1) F
15 '79
--Stanley Cup Playoffs 1979 (Canadiens vs. Rangers)
Sports Illus 50:26-7 (c, 2) My
28 '79
--Stanley Cup Playoffs 1980 (Islanders vs. Flyers)
Sports Illus 52:74-7 (4) My 26
'80
Sports Illus 52:20-3 (c, 1) Je 2
'80
--Stanley Cup Playoffs 1981 (Islanders vs. North Stars)
Sports Illus 54:26-9 (c, 1) My
25 '81
Sports Illus 54:67-8 (c, 4) Je 1
'81
HOCKEY--PROFESSIONAL--
HUMOR
Sports Illus 47:42 (painting, c, 1)
O 17 '77
Sports Illus 49:42-52 (drawing, c, 4) O 23 '78
Sports Illus 50:44-51 (drawing, c, 3) My 28 '79
--Goal-tending
Sports Illus 55:78 (drawing, c, 4)
N 16 '81
HOCKEY PLAYERS
Sports Illus 46:20-1 (c, 3) Ja
24 '77
Sports Illus 49:37-40 (c, 1) O
23 '78
Sports Illus 50:86 (4) Ap 9 '79
Sports Illus 52:cov., 15-16
(c, 1) Mr 10 '80
Sports Illus 55:42-3, 60 (c, 1)
O 12 '81
HOCKEY RINKS
--Dubai
Sports Illus 53:96 (c, 3) N 17
'80
HOCKEY TEAMS
--1932 Olympics
Sports Illus 52:72-81 (3) Ja 14
'80
--U. S. S. R.
Sports Illus 50:24-5 (c, 4) F

12 '79
HOGANS
--Navajos (Arizona)
Nat Geog 156:82-3 (c, 1) Jl '79
HOGARTH, WILLIAM
--Cartoon "Gin Lane"
Smithsonian 10:16 (3) Ja '80
HOGS
Life 2:10 (4) Ja '79
Nat Geog 155:332-3 (c, 1) Mr '79
Trav/Holiday 152:45 (c, 1) S '79
Life 4:114 (4) Je '81
Life 4:84 (c, 3) D '81
--Relaxing in mud
Smithsonian 9:98 (4) Jl '78
HOKKAIDO, JAPAN
Nat Geog 157:62-93 (map, c, 1)
Ja '80
HOLBEIN, HANS
--Portrait of Henry VIII
Smithsonian 12:108 (painting, c, 4)
Ap '81
Holidays. See BASTILLE DAY;
CHRISTMAS; EASTER; FESTIVALS; FOURTH OF JULY;
HALLOWEEN; MAY DAY;
NEW YEAR'S DAY; ST.
PATRICK'S DAY; THANKSGIVING; VALENTINE'S DAY
HOLLY
--Christmas wreaths (Williamsburg,
Virginia)
Trav/Holiday 154:28 (c, 4) D '80
--Usage in Christmas festivities
throughout history
Nat Wildlife 18:22-5 (painting, c, 1)
D '79
HOLMES, OLIVER WENDELL
Am Heritage 30:106 (3) F '79
--19th cent. photos by him
Am Heritage 30:104-7 (3) F '79
--Home (Cambridge, Massachusetts)
Am Heritage 30:104 (3) F '79
HOLMES, OLIVER WENDELL, JR.
Am Heritage 29:68-77 (1) Je '78
Smithsonian 9:14 (4) Ag '78
--Study (Washington, D. C.)
Am Heritage 20:73 (4) Jc '78
HOLOGRAPHY
Smithsonian 10:108, 111 (c, 1) Je
'79
Homer. See ILIAD
HOMER, WINSLOW
--1865 drawing of horse race spectators
Smithsonian 12:46-7 (3) Ag '81
--1870's painting of teacher
Am Heritage 32:26 (painting, c, 1)

Ag '81
--1871 painting of schoolroom
 Am Heritage 31:4-5 (painting, c, 1)
 Ag '80
--Early Evening
 Smithsonian 7:52-3 (painting, c, 1)
 Ja '77
--Northeaster (1895)
 Am Heritage 31:30-1 (paint-
 ing, c, 1) Ap '80
--Winter (1868)
 Smithsonian 9:124 (engraving, 4)
 Ja '79
--Works by him
 Smithsonian 10:126-7 (paint-
 ing, c, 4) Ja '80
HOMES OF FAMOUS PEOPLE
--Black celebrities (California)
 Ebony 33:144-8 (2) O '78
--Governor's mansion (Montgom-
 ery, Alabama)
 Travel 147:26-7 (c, 1) Ja '77
--Movie stars' homes (1920's)
 Smithsonian 12:140-60 (1) S '81
--See also ADAMS, HENRY;
 AUDUBON, JOHN JAMES;
 BARTON, CLARA; CHURCH-
 ILL, WINSTON; CODY, WIL-
 LIAM (BUFFALO BILL);
 DOUGLASS, FREDERICK;
 EDDY, MARY BAKER; EIN-
 STEIN, ALBERT; EMERSON,
 RALPH WALDO; HAW-
 THORNE, NATHANIEL; HAY,
 JOHN; HEARST, WILLIAM
 RANDOLPH; HEMINGWAY,
 ERNEST; HOLMES, OLIVER
 WENDELL; HOLMES, OLIVER
 WENDELL, JR.; IRVING,
 WASHINGTON; JACKSON,
 ANDREW; JEFFERSON,
 THOMAS; JONES, JOHN
 PAUL; KELLER, HELEN;
 KING, MARTIN LUTHER,
 JR.; MADISON, JAMES;
 MONET, CLAUDE; REAGAN,
 RONALD; RUBENS, PETER
 PAUL; SHAKESPEARE,
 WILLIAM; TAFT, WILLIAM
 HOWARD; TALLEYRAND,
 CHARLES MAURICE; THOR-
 EAU, HENRY DAVID;
 THURBER, JAMES; TWAIN,
 MARK; WALPOLE, HORACE
HOMOSEXUALS
--Transvestites in Washington
 prison
 Life 2:79 (1) Ag '79

--Vigil for murdered San Francisco
 mayor
 Life 2:82 (c, 2) D '79
HONDURAS
 Trav/Holiday 155:42-5, 64-7
 (map, c, 1) Ja '81
HONDURAS--COSTUME
 Trav/Holiday 155:42-4 (c, 1) Ja
 '81
HONDURAS--MAPS
 Nat Geog 160:59-60 (c, 2) Jl '81
HONEY INDUSTRY
--Smoking bee trees
 Nat Wildlife 16:14-16 (paint-
 ing, c, 1) O '78
HONG KONG
 Nat Geog 152:215 (c, 1) Ag '77
 Nat Geog 158:508-13 (c, 1) O '80
--New Year's festivities
 Trav/Holiday 153:60-3 (map, c, 1)
 Ja '80
--Refugee camps
 Nat Geog 156:706-31 (c, 1) N '79
--Sung Dynasty Village
 Trav/Holiday 154:41 (c, 2) Ag '80
HONOLULU, HAWAII
 Trav/Holiday 152:42-7 (c, 1) O
 '79
 Nat Geog 156:654-69 (c, 1) N '79
--Mid-19th cent.
 Am Heritage 32:81-9 (1) O '81
HOOVER, HERBERT
 Am Heritage 30:21 (4) Je '79
 Am Heritage 31:38 (4) Ag '80
HOOVER, J. EDGAR
 Life 2:148 (4) D '79
HOPI INDIANS (ARIZONA)
--Ruins of Tuzigoot
 Smithsonian 9:38 (4) S '78
--Shungopavi, Arizona (1901)
 Natur Hist 88:122-3 (1) N '79
HOPI INDIANS (ARIZONA)--COS-
 TUME
--1900
 Natur Hist 88:124-6 (2) N '79
HOPI INDIANS (ARIZONA)--RELICS
--Kachina figures
 Am Heritage 30:77 (c, 3) F '79
 Trav/Holiday 154:60 (3) S '80
 Smithsonian 12:263 (c, 4) N '81
HOPPER, EDWARD
--Bridle Path (1939)
 Am Heritage 32:92 (painting, c, 3)
 Ap '81
--House by the Railroad (1925)
 Life 2:82 (painting, c, 4) S '79
 Smithsonian 10:112-13 (paint-
 ing, c, 2) N '79

--Paintings by him
 Smithsonian 11:126-33 (c, 2) S
 '80
--Self-portrait
 Smithsonian 11:132 (drawing, 4)
 S '80
HORNBILLS (BIRDS)
 Smithsonian 10:102 (c, 4) N '79
HORNS (MUSICAL)
--Ceremonial (Nepal)
 Natur Hist 88:55 (c, 4) Ja '79
--Ceremonial (Switzerland)
 Natur Hist 88:55 (c, 4) Ja '79
HORSE FARMS
--California
 Smithsonian 10:28-9 (c, 2) Jl '79
--Kentucky
 Sports Illus 48:33-4 (c, 2) Ap
 17 '78
 Sports Illus 50:55-60 (3) Ap
 23 '79
--Tennessee
 Nat Geog 153:702-3 (c, 1) My
 '78
--See also STABLES
HORSE JUMPING EVENTS
 Sports Illus 49:70 (c, 3) S 25
 '78
 Sports Illus 49:54 (c, 3) N 6 '78
 Ebony 34:98 (3) Jl '79
--Aintree, Great Britain
 Sports Illus 48:38-9 (c, 2) Mr
 27 '78
--Colorado
 Sports Illus 49:22 (c, 4) Ag 7
 '78
--Horse and rider falling (Ain-
 tree, Great Britain)
 Life 2:124-5 (1) My '79
--Horse falling in water (U. S. S. R.)
 Sports Illus 51:20-1 (c, 3) Ag
 6 '79
--Kentucky
 Sports Illus 50:136 (c, 3) F 15
 '79
--Maryland
 Sports Illus 52:44 (4) My 5 '80
--Massachusetts
 Nat Geog 155:574-5 (c, 2) Ap
 '79
--Rhode Island
 Sports Illus 47:118 (c, 4) O 10
 '77
HORSE RACING
 Sports Illus 46:20 (c, 4) F 21 '77
 Sports Illus 46:37-9 (c, 1) Ap 4
 '77
 Sports Illus 46:68 (3) Ap 25 '77

Sports Illus 46:89 (c, 4) My 2 '77
Sports Illus 46:35 (c, 2) My 9 '77
Sports Illus 47:17 (c, 3) Jl 4 '77
Sports Illus 47:56-7 (c, 4) Ag 15
'77
Sports Illus 47:18 (c, 3) Ag 29 '77
Sports Illus 47:85 (c, 3) S 5 '77
Sports Illus 47:78 (c, 4) S 26 '77
Sports Illus 47:70 (c, 4) O 3 '77
Sports Illus 47:cov. (painting, c, 2)
 N 14 '77
Sports Illus 47:40-1 (c, 3) D 19
'77
Sports Illus 48:18-19 (c, 2) Ja 2
'78
Sports Illus 48:52 (4) Mr 6 '78
Sports Illus 48:20-3 (c, 1) Mr 13
'78
Sports Illus 48:24 (c, 3) Ap 10
'78
Sports Illus 48:28-9 (c, 3) My 8
'78
Sports Illus 49:24 (c, 3) Ag 21
'78
Sports Illus 49:21 (c, 2) Ag 28
'78
Ebony 33:44 (c, 4) S '78
Sports Illus 49:22-3 (c, 3) S 25
'78
Sports Illus 49:88 (c, 4) O 23 '78
Sports Illus 49:38 (c, 4) N 13 '78
Life 2:46-7 (c, 1) F '79
Sports Illus 50:52 (4) F 29 '79
Sports Illus 50:40 (drawing, c, 3)
 Mr 19 '79
Sports Illus 50:25 (c, 3) Ap 30 '79
Sports Illus 50:50-3 (3) My 7 '79
Sports Illus 50:22-3 (c, 3) Je 4
'79
Sports Illus 51:25 (c, 4) S 17 '79
Sports Illus 51:59 (c, 4) O 1 '79
Sports Illus 51:32 (c, 3) O 15 '79
Sports Illus 52:61 (c, 4) Ja 28 '80
Sports Illus 52:124-7 (c, 1) Mr
 13 '80
Sports Illus 52:24 (c, 3) Ap 7 '80
Sports Illus 52:63 (c, 3) Ap 14
'80
Sports Illus 54:52 (c, 4) Mr 23
'81
Sports Illus 54:22 (c, 2) Ap 6 '81
Sports Illus 54:32 (c, 2) Ap 27
'81
Sports Illus 54:32-3 (c, 2) My 25
'81
Sports Illus 54:31 (c, 4) Je 1 '81
Sports Illus 55:14-15 (c, 4) Ag 3
'81

--Nursing
 Sports Illus 50:55 (3) Ap 23 '79
--Palomino pony
 Trav/Holiday 155:54 (c, 3) F
 '81
--Ponies
 Nat Geog 153:752-3 (c, 1) Je '78
 Nat Geog 157:814-15, 822-3,
 828 (c, 1) Je '80
--Pony penning and auctioning
 (Virginia)
 Trav/Holiday 151:49 (c, 4) Je
 '79
--Similar to prehistoric (Poland)
 Smithsonian 9:67-71 (c, 1) My
 '78
--Tibetan pony
 Nat Geog 151:53 (c, 2) Ap '77
--Trading fair (Ireland)
 Nat Geog 154:662-3 (c, 1) N '78
--Treated by sunlamp (New Jersey)
 Nat Geog 160:590 (c, 4) N '81
--Wearing baseball cap
 Sports Illus 55:27 (c, 3) Je 29
 '81
--Wild stallions
 Nat Geog 153:312-13 (c, 1) Mr
 '78
--World's heaviest horse (1955)
 Smithsonian 10:79 (painting, c, 4)
 F '80
--See also CARRIAGES AND
 CARTS--HORSE-DRAWN;
 HORSE FARMS; HORSE
 RACING; HORSEBACK RID-
 ING; STABLES
HORSES, RACING
 Sports Illus 46:44 (c, 4) Ja 31
 '77
 Sports Illus 46:36-8 (c, 3) My 9
 '77
 Sports Illus 47:28-9 (c, 4) N 14
 '77
 Sports Illus 48:73 (4) Ap 3 '78
 Sports Illus 48:33 (c, 2) Ap 17
 '78
 Sports Illus 49:17 (c, 3) Ag 7
 '78
 Sports Illus 49:81-2 (c, 3) S 18
 '78
 Life 2:44-8 (c, 1) F '79
 Sports Illus 50:98-102 (c, 1) Ap
 23 '79
 Sports Illus 52:29-32 (c, 1) Ap
 28 '80
 Sports Illus 54:34-6 (c, 4) Ap 27
 '81
 Trav/Holiday 155:56 (c, 1) Je '81

 Sports Illus 55:12-13, 19 (c, 1)
 Ag 3 '81
 Sports Illus 55:41 (c, 4) Ag 10 '81
--Harness races
 Sports Illus 50:36-7 (1) Je 25 '79
Horseshoe crabs. See KING CRABS
HORSETAILS (PLANTS)
 Nat Geog 152:186 (c, 4) Ag '77
HOSPITALS
 Ebony 34:120 (2) Ag '79
--Beds
 Life 2:109 (2) My '79
 Sports Illus 51:24-5 (c, 2) S 3
 '79
 Life 3:116-17 (1) Mr '80
--Children's (Colorado)
 Sports Illus 47:34 (c, 4) D 12 '77
--Civil War (Maryland)
 Am Heritage 31:61 (drawing, 3)
 Ag '80
--Detroit, Michigan Medical Center
 Ebony 33:37 (4) Ap '78
--Diagnostic equipment (Minnesota)
 Nat Geog 156:518-19 (c, 1) O '79
--Duke U. Medical Center (North
 Carolina)
 Nat Geog 157:344 (c, 1) Mr '80
--Edgewater, Chicago, Illinois
 Ebony 33:58 (3) Je '78
--Exterior architecture (Dacca,
 Bangladesh)
 Smithsonian 10:42-3 (c, 1) Jl '79
--Holmes County, Mississippi
 Ebony 34:58 (4) F '79
--Hospice (Calcutta, India)
 Life 3:54-65 (1) Jl '80
--Hospice de Beaune, France
 Trav/Holiday 149:34 (c, 2) Ap '78
--Howard University, Washington,
 D. C.
 Ebony 32:59-65 (3) Ap '77
--Hydraulic hoist
 Life 4:80 (4) Jl '81
--I. V. equipment
 Nat Geog 159:788 (c, 3) Je '81
--Leprosy (Japan)
 Nat Geog 152:852-3 (c, 1) D '77
--Nursing station (Walter Reed Hos-
 pital, D. C.)
 Ebony 35:46 (2) F '80
--Patients
 Ebony 36:75 (2) Je '81
--Phillips, St. Louis, Missouri
 Ebony 32:164 (4) S '77
--Texas
 Nat Geog 157:476 (c, 3) Ap '80
--Texas Medical Center, Houston,
 Texas

Travel 147:38 (c, 3) My '77
--Uganda
Nat Geog 158:80 (c, 2) Jl '80
--Veterinary operating room
(Pennsylvania)
Nat Geog 153:761 (c, 1) Je '78
--World War I first-aid post
(France)
Life 3:92-3 (c, 1) Ap '80
HOTELS
--19th cent. resort (Cape May,
New Jersey)
Nat Geog 160:572-3 (c, 1) N '81
--1832 inn (Michigan)
Am Heritage 32:104-5 (c, 3) D
'80
--Late 19th cent. Adirondack
club (New York)
Am Heritage 29:97 (4) O '78
--1894 fire (Hurley, Wisconsin)
Am Heritage 31:109 (2) Je '80
--1926-1940 art deco style (Miami,
Florida)
Am Heritage 32:50-1 (c, 4) F
'81
--Acapulco, Mexico
Trav/Holiday 152:14-16 (c, 4) D
'79
--Adirondacks, New York
Smithsonian 10:46-7 (c, 3) F '80
--Algave, Portugal
Nat Geog 158:828-9 (c, 1) D '80
--Anchorage, Alaska
Smithsonian 12:33 (c, 4) Ag '81
--Annapolis, Maryland inn
Travel 147:41 (c, 1) Je '77
--Athens, Texas
Nat Geog 156:202 (c, 1) Ag '79
--Atlanta, Georgia
Ebony 35:66-8 (4) N '79
Trav/Holiday 153:114 (4) F '80
--Bavaria, West Germany
Trav/Holiday 153:64 (c, 4) Mr
'80
--Birdsville, Australia
Nat Geog 155:176-7 (c, 2) F '79
--Boston, Massachusetts
Sports Illus 54:17 (c, 4) F 16
'81
--Bulgarian beach
Nat Geog 158:109 (c, 4) Jl '80
--Chateau Frontenac, Quebec
Nat Geog 151:442-3 (c, 1) Ap
'77
Trav/Holiday 152:32 (4) Ag '79
--Country inn (California)
Sports Illus 52:68, 74 (c, 3) Je
16 '80

--Country inn (New York)
Trav/Holiday 151:80 (c, 3) My
'79
--Delhi, India
Travel 148:62 (4) O '77
--Detroit, Michigan
Trav/Holiday 149:59 (c, 2) Mr
'78
--Fort Bragg, California
Trav/Holiday 153:54 (c, 3) Mr '80
--Garden of Allah, Hollywood,
California
Am Heritage 28:82 (drawing, 1)
Ag '77
--Georgia mansion
Nat Geog 152:651 (c, 2) N '77
--Gideon Putnam, Saratoga, New
York
Trav/Holiday 149:35 (4) My '78
--Grand Hotel, Mackinac Island,
Michigan (1880's)
Am Heritage 29:56 (3) Ag '78
--The Greenbrier, West Virginia
Trav/Holiday 151:106-7 (4) My
'79
--Haiti
Ebony 32:98 (c, 4) Ja '77
--Hawaii
Trav/Holiday 149:73 (4) Ja '78
--Honolulu, Hawaii
Nat Geog 156:654-5 (c, 1) N '79
--Inn (Florida)
Sports Illus 52:63 (c, 4) Je 16
'80
--Lake George, New York (1870)
Am Heritage 28:116 (painting, c, 4)
Je '77
--Luxury (Macau)
Travel 147:33 (c, 1) F '77
--Luxury (Mecca, Saudi Arabia)
Nat Geog 154:602-3 (c, 1) N '78
--Luxury (Miami Beach, Florida)
Trav/Holiday 153:26-7, 31 (4) F
'80
--Machu Picchu, Peru
Travel 147:46 (4) Ja '77
--Manila, Philippines
Trav/Holiday 149:18-21 (4) My
'78
--Miami Beach, Florida
Ebony 34:42 (c, 4) My '79
--Modern (Dallas, Texas)
Trav/Holiday 149:58 (c, 1) Ap
'78
--Modern (Detroit, Michigan)
Nat Geog 155:831 (c, 2) Je '79
--Modern (Los Angeles, California)
Nat Geog 159:36 (c, 4) F '81SR

Trav/Holiday 156:61 (c, 4) N '81
--Modern (Tunisia)
 Nat Geog 157:196-7 (c, 2) F '80
--Montecantini, Italy
 Trav/Holiday 154:20-1 (c, 4) D
 '80
--Montreal, Quebec
 Travel 148:79 (drawing, 4) O '77
--Moscow, U. S. S. R.
 Life 2:88 (c, 4) Jl '79
--New York City, New York
 Trav/Holiday 155:52-5 (2) My
 '81
--Oaxaca, Mexico
 Trav/Holiday 152:57 (c, 4) Jl
 '79
--Old Wisconsin inn
 Trav/Holiday 153:34 (c, 2) Je
 '80
--Pool and gazebo (Nashville,
 Tennessee)
 Trav/Holiday 155:5 (c, 3) Ap
 '81
--Rustic inns (Jutland, Denmark)
 Trav/Holiday 154:42-4 (c, 4)
 Ag '80
--St. Andrews, New Brunswick
 Trav/Holiday 150:47 (c, 4) Jl
 '78
--St. Petersburg, Florida
 Trav/Holiday 153:14-23 (4) Ja
 '80
--San Juan Islands, Washington
 Travel 148:31 (4) Jl '77
--Seychelles Islands
 Sports Illus 50:61 (c, 4) F 5 '79
--Small hotels (London, England)
 Trav/Holiday 151:48-51 (c, 1)
 Mr '79
--Spain
 Nat Geog 153:304 (c, 1) Mr '78
--Tibet
 Trav/Holiday 152:64 (c, 2) Jl
 '79
--Willard, Washington, D. C.
 Am Heritage 30:32-3 (4) Ap '79
--Willard, Washington, D. C. (19th
 cent.)
 Smithsonian 10:62-3 (2) D '79
--Wisconsin Dells, Wisconsin
 Travel 148:34 (4) Ag '77
--See also RESORTS
HOUDON, JEAN ANTOINE
--Diana (1780)
 Smithsonian 11:48 (sculpture, c, 4)
 Jl '80
HOUNDS
 Nat Geog 156:392-3 (c, 4) S '79

Sports Illus 51:42 (c, 4) S 10 '79
--Pharaoh hounds
 Life 2:46 (c, 3) Ja '79
--See also AFGHAN HOUNDS; FOX-
 HOUNDS
HOUSE PLANTS
 Ebony 33:139 (4) Ag '78
 Ebony 35:59 (4) Ag '80
--Spain
 Trav/Holiday 152:71 (c, 1) N '79
HOUSEBOATS
--British Columbia
 Nat Geog 154:474-5 (c, 2) O '78
--India
 Trav/Holiday 148:41 (c, 2) D '77
 Trav/Holiday 149:cov. , 32-7
 (c, 1) Je '78
--Louisiana
 Nat Geog 156:380-1 (c, 1) S '79
--Thatched-roof (Brazil)
 Trav/Holiday 149:44-5 (c, 3) Mr
 '78
--Utah
 Trav/Holiday 153:50 (c, 2) Ap '80
 Trav/Holiday 156:cov. , 45, 57
 (c, 1) Ag '81
--Washington, D. C.
 Ebony 36:44-6 (c, 2) S '81
HOUSEHOLD ACTIVITIES
--Early 20th cent. Maine
 Nat Geog 158:392-3 (sculpture, c, 4)
 S '80
--Carrying well water (U. S. S. R.)
 Nat Geog 155:778 (c, 4) Je '79
--Drying fish for storage (Canada)
 Nat Geog 152:637 (c, 1) N '77
--Rube Goldberg dish-washing in-
 vention
 Am Heritage 28:30-1 (drawing, 1)
 O '77
--Making bed
 Ebony 35:46 (4) Ag '80
--Performed by robot (Illinois)
 Ebony 35:58 (4) Jl '80
--Personal grooming activities
 Ebony 32:117-22 (3) My '77
--Raking leaves (Vermont)
 Travel 148:77 (3) S '77
--Rolling water in barrels (Brazil)
 Nat Geog 152:710-11 (c, 3) N '77
--Shaving
 Ebony 34:117 (c, 4) Ap '79
--Washing dishes
 Life 3:126-7 (1) Je '80
 Sports Illus 55:14 (c, 3) Jl 6 '81
--Washing dishes in river (Nigeria)
 Nat Geog 155:420 (c, 1) Mr '79
--See also BATHING; BREAD

MAKING; COOKING; GARDEN-
ING; LAUNDRY; LOG SPLIT-
TING; SEWING; SHAVING;
SNOW SHOVELING; VACUUM-
ING
HOUSES
--14th cent. (Rome, Italy)
 Smithsonian 8:38-9 (c, 2) Ag '77
--17th cent. (Ulm, West Germany)
 Nat Geog 152:458-9 (c, 1) O '77
--17th cent. (Wales)
 Smithsonian 8:92 (drawing, c, 3)
 O '77
--1775 Talmadge House, Litch-
 field, Connecticut
 Trav/Holiday 151:38 (4) Je '79
--1780's (first Chicago house,
 Illinois)
 Ebony 33:68 (drawing, 3) N '77
--1790 (West Virginia)
 Travel 148:34 (c, 4) O '77
--19th cent.
 Am Heritage 29:8-9 (4) Ap '78
--19th cent. (Concord, New
 Hampshire)
 Am Heritage 32:50 (1) D '80
--19th cent. (Fall River, Massa-
 chusetts)
 Am Heritage 29:48 (2) F '78
--19th cent. (New Orleans,
 Louisiana)
 Am Heritage 30:cov., 66-79,
 114 (painting, c, 1) Ag '79
--19th cent. (San Francisco,
 California)
 Smithsonian 9:136 (4) My '78
--19th cent. (Savannah, Georgia)
 Nat Geog 154:244-5 (c, 1) Ag '78
--19th cent. Gothic (Ohio)
 Nat Geog 154:86 (c, 4) Jl '78
--19th cent. mansard house (Bos-
 ton, Massachusetts)
 Life 2:82 (4) S '79
--1800 symmetrical cottage (Hali-
 fax, North Carolina)
 Life 3:114 (c, 4) D '80
--1840's (Wisconsin)
 Am Heritage 30:48 (3) Je '79
--1886 Glessner House, Chicago,
 Illinois
 Trav/Holiday 154:36, 40 (4) S
 '80
--1889 (Little Rock, Arkansas)
 Nat Geog 153:406 (c, 1) Mr '78
--20th cent. California mansions
 by Maybeck
 Am Heritage 32:39, 45 (c, 4) Ag
 '81

--Abandoned (Maine)
 Nat Geog 151:746-7 (c, 1) Je '77
--Abandoned (Washington)
 Travel 148:28 (c, 1) Jl '77
--Alabama
 Nat Geog 151:496-7 (c, 1) Ap '77
--Alabama shack (1956)
 Ebony 36:102 (3) N '80
--Attached row houses (Baltimore,
 Maryland)
 Ebony 37:63 (3) D '81
--Basement workshop (Ohio)
 Smithsonian 11:52-3 (3) O '80
--Beehive homes (Alberobello, Italy)
 Nat Geog 159:744-5 (c, 1) Je '81
--Burned (Georgia)
 Nat Geog 152:654-5 (c, 2) N '77
--Charleston's old homes, South
 Carolina
 Trav/Holiday 149:cov., 26-30
 (c, 1) Ap '78
--Chestnut Hill, Philadelphia,
 Pennsylvania
 Am Heritage 30:31 (4) Ag '79
--Chicago, Illinois
 Nat Geog 153:480-1 (c, 1) Ap '78
--Cliff dwellings (Arizona)
 Trav/Holiday 151:64 (c, 4) Ja '79
--Destroyed in mud slide (California)
 Nat Geog 155:32-3 (c, 1) Ja '79
--Detroit, Michigan
 Ebony 33:38 (4) Ap '78
--Doorway (Maryland)
 Travel 147:44 (4) Je '77
--Elegant (California)
 Ebony 33:154-60 (c, 2) D '77
--Elegant (Mexico City, Mexico)
 Nat Geog 153:642-3 (c, 1) My '78
--Fenwick, Connecticut
 Life 4:172-3 (c, 1) N '81
--Free-form (Oregon)
 Nat Geog 156:806-7 (c, 1) D '79
--Glass
 Natur Hist 90:118-21 (3) O '81
--Haunted houses
 Life 3:152-60 (c, 1) N '80
--Iowa
 Smithsonian 11:86 (c, 4) N '80
--Iron Age round house recreation
 (Great Britain)
 Smithsonian 9:80, 86 (c, 3) Je
 '78
--Lhasa, Tibet
 Nat Geog 157:226-7 (c, 1) F '80
--Long Island, New York
 Nat Geog 157:672-3, 684-5 (c, 1)
 My '80
--Massachusetts mansion

--Moscow, U. S. S. R.
 Nat Geog 153:36-7 (c, 1) Ja '78
--Philippines
 Nat Geog 151:388-9 (c, 2) Mr
 '77
--Poland
 Nat Geog 159:110 (c, 3) Ja '81
--Thatching roof (Thailand)
 Trav/Holiday 154:46 (4) N '80
HOUSEWARES
--4th cent. , B. C. vessels (Mace-
 don, Greece)
 Nat Geog 154:60-1, 73 (c, 1)
 Jl '78
--2nd cent. B. C. Celtic silver
 caldron (Denmark)
 Nat Geog 151:582, 612-13 (c, 1)
 My '77
--18th cent. shipwreck relics
 Nat Geog 152:734-64 (c, 1) D
 '77
--Late 19th cent. kitchen objects
 Am Heritage 31:50-7 (2) Je
 '80
--1916 camping utensils
 Smithsonian 11:128 (c, 4) F '81
--Clothespins (Australia)
 Nat Geog 152:864 (c, 1) D '77
--Salt shakers
 Nat Geog 152:386 (c, 4) S '77
--Variety store items
 Life 2:54-8 (c, 1) Je '79
--See also BASKETS; BOTTLES;
 CANDLES; CANDLESTICKS;
 CHINAWARE; CLOCKS;
 COFFEE POTS; COMBS;
 FANS; GLASSWARE; SILVER-
 WARE; TEAKETTLES;
 VACUUM CLEANERS;
 WATCHES
Housing. See ADOBE HOUSES;
 APARTMENT BUILDINGS;
 CABINS; CASTLES; CHAT-
 EAUS; COTTAGES; DORMI-
 TORIES; FARMHOUSES;
 HOGANS; HOUSEBOATS;
 HOUSES; HOUSING DEVELOP-
 MENTS; HUTS; IGLOOS;
 KIBBUTZIM; LOG CABINS;
 MANSIONS; MINING CAMPS;
 MOBILE HOMES; SLUMS;
 SOD HOUSES; TENTS; TE-
 PEES; TRAILER CAMPS;
 TREE HOUSES; YURTS; geo-
 graphical entries--HOUSING
 (e. g. NEW GUINEA--
 HOUSING)
HOUSING DEVELOPMENTS

 Nat Wildlife 16:31 (c, 2) F '78
--19th cent. Belfast, Northern Ire-
 land
 Nat Geog 159:480-1 (c, 1) Ap '81
--Arizona
 Nat Geog 152:496-7, 504-5 (c, 1)
 O '77
--California
 Natur Hist 88:82-3 (1) Je '79
 Smithsonian 10:33 (c, 4) Jl '79
--Condominiums (Virgin Islands)
 Nat Geog 159:236-7 (c, 1) F '81
--Construction camp (Brazil)
 Nat Geog 153:260-1 (c, 2) F '78
--Cuba
 Nat Geog 151:44-5 (c, 2) Ja '77
--Demolition of project (St. Louis,
 Missouri)
 Ebony 34:50 (2) Ag '79
--Denver, Colorado
 Nat Geog 155:394-5 (c, 2) Mr '79
--Dominican Republic
 Nat Geog 152:543 (c, 3) O '77
--Florida
 Sports Illus 54:84 (c, 4) F 9 '81
--Houston, Texas
 Nat Geog 157:472-3 (c, 1) Ap '80
--Italy
 Life 4:68 (c, 3) Mr '81
--Memphis, Tennessee
 Ebony 36:124 (4) Je '81
--Namibia
 Smithsonian 12:52 (c, 3) My '81
--Padre Island, Texas
 Nat Geog 153:221 (c, 3) F '78
--Reunion
 Nat Geog 160:456-7 (c, 1) O '81
--Saudi Arabia
 Nat Geog 158:328-9 (c, 2) S '80
 Seoul, South Korea
 Nat Geog 156:790-1 (c, 1) D '79
--Suburbia (Mission Viejo, Califor-
 nia)
 Nat Geog 160:778-9 (c, 1) D '81
--Sydney, Australia
 Nat Geog 155:220 (c, 1) F '79
--Zimbabwe low-income suburb
 Nat Geog 160:644-5 (c, 2) N '81
--See also KIBBUTZIM
HOUSTON, SAM
--Statue (Washington, D. C.)
 Am Heritage 32:7 (4) D '80
HOUSTON, TEXAS
 Travel 147:37-8 (c, 2) My '77
 Ebony 33:100 (4) F '78
 Ebony 33:132-42 (2) Jl '78
 Life 3:64-71 (c, 1) Ja '80
 Nat Geog 157:470-6 (c, 1) Ap '80

--1940
 Am Heritage 28:55 (1) Ap '77
--Courthouse
 Ebony 34:73 (4) S '79
HOWE, JULIA WARD
 Am Heritage 29:36 (4) Ag '78
 Smithsonian 11:178 (4) D '80
HOWELLS, WILLIAM DEAN
 Am Heritage 30:86 (4) O '79
HOWLERS (MONKEYS)
 Smithsonian 7:cov., 58-65 (c, 1)
 Mr '77
 Natur Hist 86:34-41 (c, 1) Mr
 '77
 Life 4:186 (c, 2) D '81
HUDSON BAY, ONTARIO
 Nat Geog 154:784-5 (c, 1) D '78
HUDSON RIVER, NEW YORK
 Sports Illus 46:39-42 (c, 1) My
 2 '77
 Nat Geog 153:62-89 (map, c, 1)
 Ja '78
--West Point area (1778)
 Am Heritage 30:100-1 (paint-
 ing, c, 2) Ag '79
HUGHES, CHARLES EVANS
 Am Heritage 33:79 (4) D '81
Human relations groups. See
 ENCOUNTER GROUPS
HUMMINGBIRDS
 Nat Wildlife 16:28 (c, 4) Ap '78
 Smithsonian 9:126 (c, 4) F '79
 Smithsonian 10:86 (c, 4) Jl '79
 Natur Hist 88:92-7, 122 (c, 1)
 Ag '79
HUMPHREY, HUBERT
 Am Heritage 29:58-67 (c, 1) D
 '77
 Life 2:188 (c, 2) D '79
Hungary. See BUDAPEST
HUNGARY--HISTORY
--1956 revolution
 Am Heritage 28:18-19 (4) Ag
 '77
 Life 4:35-40 (2) N '81
HUNTERS
--Early 20th cent. New York
 Am Heritage 33:64 (1) D '81
--1903
 Natur Hist 89:84-7 (2) Ap '80
--New Jersey club
 Nat Geog 160:590-1 (c, 2) N '81
--Painting by Fernando Botero
 Smithsonian 12:12 (c, 4) Ap '81
--Texas
 Am Heritage 28:51 (c, 1) Je '77
--Trappers in lean-to
 Nat Wildlife 17:30-1 (paint-

 ing, c, 1) D '78
HUNTING
 Sports Illus 49:102-3 (painting, c, 3)
 O 23 '78
--Late 19th cent.
 Am Heritage 29:101-5 (paint-
 ing, c, 1) O '78
--Early 20th cent. hunting lodges
 Am Heritage 29:96-7 (2) O '78
--Animal trophies from hunts
 (Zimbabwe)
 Nat Geog 160:637 (c, 2) N '81
--Indians hunting bears
 Am Heritage 28:20-1 (painting, c, 1)
 O '77
--Birds
 Sports Illus 47:66 (painting, c, 4)
 O 3 '77
--Birds (Montana)
 Nat Geog 160:267 (c, 1) Ag '81
--Bison (19th cent. paintings)
 Smithsonian 12:74-6 (c, 3) My
 '81
--Bison (1858 Indians)
 Am Heritage 30:30-1 (painting, c, 1)
 O '79
--Bison (Crow Indians)
 Nat Wildlife 17:25 (painting, c, 3)
 D '78
--Bison (Ice Age)
 Nat Geog 155:114-21 (drawing, c, 1)
 Ja '79
--Butchering green turtles (Nicara-
 gua)
 Natur Hist 89:8 (3) F '80
--Catching zebras to save them
 (Kenya)
 Smithsonian 9:cov., 34-45 (c, 1)
 Ja '79
--Deer
 Sports Illus 46:98-9 (painting, c, 1)
 Ja 10 '77
--Displaying caught deer (1880;
 Maine)
 Am Heritage 29:98 (2) O '78
--Duck trapping (Virginia)
 Nat Geog 157:827 (c, 3) Je '80
--Ducks (18th cent. U. S.)
 Nat Wildlife 15:10-11 (painting, c, 1)
 Ja '77
--Ducks (Arkansas)
 Nat Geog 153:411 (c, 1) Mr '78
--Eskimos (Alaska)
 Life 2:102-3 (c, 1) F '79
--Fur seals (Alaska)
 Nat Wildlife 18:9 (c, 4) Je '80
--Fur trapping
 Nat Wildlife 17:14-19 (c, 1) O '79

--Geese
 Nat Geog 154:786 (c, 1) D '78
--Grouse (Alberta)
 Nat Geog 157:769 (c, 3) Je '80
--Grouse (Vermont)
 Sports Illus 51:79 (c, 4) D 24 '79
--Handling killed walrus (Alaska)
 Natur Hist 86:55-61 (c, 1) Mr
 '77
--Harpooning dugong (Pacific Is-
 lands)
 Natur Hist 90:55-7 (c, 2) My '81
--Ice Age
 Nat Geog 156:344-57 (painting, c, 1)
 S '79
--Indiana
 Sports Illus 54:56-7 (c, 1) Ja 26
 '81
--Kobs (Sudan)
 Life 2:65-8 (c, 1) Je '79
--Leghold traps
 Sports Illus 47:70 (4) N 7 '77
--Louisiana
 Sports Illus 50:60-1 (c, 1) Ja
 22 '79
--Minnesota
 Sports Illus 51:85 (c, 4) D 10 '79
--Mounted trophies
 Smithsonian 11:163 (c, 2) O '80
--Passenger pigeons (19th cent.)
 Am Heritage 33:33 (engraving, 3)
 D '81
--Pheasants (South Dakota)
 Sports Illus 49:47-50 (paint-
 ing, c, 1) O 9 '78
--Poachers caught in Kenya
 Nat Geog 159:288-9 (c, 1) Mr
 '81
--Reindeer roundup (Lapland)
 Natur Hist 88:48-57 (c, 1) Mr
 '79
--Rheas (19th cent.)
 Natur Hist 90:116 (painting, c, 3)
 N '81
--Riding on elephants (India)
 Trav/Holiday 153:84 (c, 4) F '80
--Seals (1828; Alaska)
 Smithsonian 10:130 (drawing, 3)
 D '79
--Seals (Canada)
 Nat Geog 152:628-9 (c, 2) N '77
 Smithsonian 10:54-63 (c, 1) N
 '79
--Setting duck decoys (New York)
 Sports Illus 53:51 (4) D 8 '80
--Snow geese (Quebec)
 Nat Geog 151:452-3 (c, 1) Ap
 '77

--Stone Age method of killing ele-
 phant
 Smithsonian 9:86-96 (c, 2) Jl '78
--Tortoises (Brazil)
 Natur Hist 87:50-1 (c, 2) N '78
--Trapping pandas (China)
 Nat Geog 160:742-5 (c, 1) D '81
--Turkeys (Florida)
 Sports Illus 46:54, 59 (4) Ap 18
 '77
--Walrus (Alaska)
 Natur Hist 90:48-52 (c, 1) F '81
--Whales
 Life 2:20-5 (c, 1) Jl '79
--Whales (Alaska)
 Nat Wildlife 16:5-11 (c, 1) Ap '78
 Natur Hist 89:52-61 (c, 1) My '80
--Wild boar
 Sports Illus 46:58-61 (painting, c, 3)
 F 7 '77
HUNTING--HUMOR
 Sports Illus 50:32-6 (painting, c, 2)
 Mr 5 '79
Hunting dogs. See HOUNDS
HUNTING EQUIPMENT
--Duck decoys
 Nat Wildlife 17:50-5 (c, 1) O '79
 Nat Geog 157:826-7 (c, 2) Je '80
HUNTINGTON, SAMUEL
 Smithsonian 8:100 (painting, c, 4)
 Ja '78
HURDLING
 Sports Illus 47:34-5 (c, 3) N 21
 '77
 Sports Illus 48:24 (c, 4) Ja 30
 '78
 Sports Illus 48:17 (c, 2) Je 12 '78
 Sports Illus 49:28 (c, 4) Ag 21
 '78
 Sports Illus 50:48 (3) Ja 22 '79
 Sports Illus 50:16 (c, 2) Ja 29
 '79
 Sports Illus 50:16-17 (c, 3) Mr
 5 '79
 Sports Illus 50:37 (c, 3) Ap 30 '79
 Sports Illus 50:37 (c, 3) My 14
 '79
 Ebony 34:110-11 (2) Je '79
 Sports Illus 50:31-3 (c, 2) Je 18
 '79
 Sports Illus 51:22 (c, 3) Ag 6 '79
 Sports Illus 52:105 (4) Ja 14 '80
 Sports Illus 52:16-17 (c, 4) F 18
 '80
 Sports Illus 52:86-7 (c, 1) Mr 13
 '80
 Sports Illus 52:29 (c, 3) Je 16 '80
 Sports Illus 53:22-3 (c, 4) Je 30

'80
Sports Illus 54:14 (c, 3) Jl 7 '80
Sports Illus 54:32 (c, 4) F 9
'81
Sports Illus 54:31 (c, 3) My 18
'81
Sports Illus 55:24 (c, 3) Je 29
'81
Sports Illus 55:18-19 (c, 1) Ag
31 '81
--Crossing finish line
Ebony 35:51 (4) Ja '80
HURLING
--Ireland
Nat Geog 159:452-3 (c, 1) Ap
'81
HURRICANES
Nat Geog 158:346-79 (map, c, 1)
S '80
--David (1980; Caribbean)
Nat Geog 158:346-79 (c, 1) S
'80
HURRICANES--DAMAGE
Nat Geog 158:346-79 (c, 1) S
'80
--Damaged beachfront buildings
Smithsonian 11:48-54 (c, 3) S
'80
--Mississippi (1969)
Nat Geog 153:212-13 (c, 3) F
'78
--Plane atop building (Dominican
Republic)
Life 2:138-9 (1) O '79
Huskies. See SIBERIAN HUSKIES
HUTS
--Gambia
Ebony 32:40 (4) Ap '77
--Grass (Namibia)
Smithsonian 11:89 (c, 3) Ap '80
--Ice fishing huts
Nat Wildlife 19:40-1 (c, 2) F
'81
--Papua New Guinea
Smithsonian 8:107 (c, 4) My '77
--Somalia
Nat Geog 159:cov., 763, 774
(c, 1) Je '81
--Somba tribe (Benin)
Trav/Holiday 154:54 (c, 2) O '80
--Upper Volta
Nat Geog 157:515-17 (c, 1) Ap
'80
HYACINTHS
--Water
Nat Geog 153:626-7 (c, 1) My
'78
HYDERABAD, PAKISTAN

Natur Hist 89:74 (c, 1) N '80
HYDRANTS
--New York
Nat Geog 151:188-9 (c, 1) F '77
HYDROFOILS
--U. S. S. R.
Trav/Holiday 149:27 (c, 4) My
'78
HYDROPLANES
Sports Illus 49:22-3 (c, 2) Jl 10
'78
Sports Illus 55:73-81 (c, 3) Ag
24 '81
HYENAS
Natur Hist 88:65 (c, 2) Je '79
Natur Hist 89:44-53 (c, 1) F '80
HYPNOTISM
Ebony 35:44-50 (2) Ap '80

-I-

IBEXES
Natur Hist 87:51-4 (c, 1) Ja '78
Trav/Holiday 154:38 (c, 3) Ag '80
IBISES
Nat Geog 151:668, 684 (c, 3) My
'77
Trav/Holiday 149:61 (4) Je '78
Smithsonian 12:61 (c, 4) O '81
--Ancient Roman painting (Pompeii)
Natur Hist 88:40 (c, 1) Ap '79
ICE
Nat Geog 152:798-813 (c, 1) D
'77
Trav/Holiday 155:52 (c, 3) Mr
'81
--Arctic region
Life 4:63-74 (c, 1) O '81
--Covering water (Alaska)
Nat Geog 156:742-3, 762 (c, 1) D
'79
--Frozen on plants (Ohio)
Nat Geog 154:101 (c, 2) Jl '78
--Ice sculpture at banquet (Washing-
ton, D. C.)
Trav/Holiday 155:10 (c, 4) Ap '81
--Ice sculpture of penguin at winter
carnival (Canada)
Travel 147:14 (4) F '77
--Ice storage house (Iran)
Trav/Holiday 150:60 (c, 4) D '78
--Icicles on orange trees (Florida)
Nat Geog 152:798 (c, 1) D '77
--Research about cold and ice
Smithsonian 11:102-11 (c, 1) F
'81
ICE AGE

PICCHU
INCA CIVILIZATION--ART
--Silver llama head
Nat Geog 160:303 (c, 4) S '81
INCENSE BURNERS
Life 3:49 (1) N '80
--Mayan Indians (Mexico)
Natur Hist 90:40 (c, 3) Ag '81
--Passing the burner (Oman)
Nat Geog 160:371 (c, 4) S '81
Inch worms. See MEASURING
WORMS
INDEPENDENCE HALL, PHILA-
DELPHIA, PENNSYLVANIA
Ebony 34:41 (c, 4) My '79
INDIA
Nat Geog 152:271-86 (map, c, 1)
Ag '77
--Ladakh
Travel 147:cov., 24-31 (c, 1)
F '77
Nat Geog 153:332-49 (map, c, 1)
Mr '78
--Rajasthan
Nat Geog 151:218-43 (map, c, 1)
F '77
--Rajasthan temple
Nat Geog 152:70-1 (c, 1) Jl '77
--Southern India
Smithsonian 10:98-9 (c, 4) N '79
Trav/Holiday 156:45-7 (map, c, 1)
Jl '81
--See also BOMBAY; CALCUTTA;
DELHI; JAIPUR; KASHMIR;
NEW DELHI; TAJ MAHAL
INDIA--ART
Natur Hist 89:cov., 58-63 (c, 1)
S '80
--16th and 17th cent. drawings
Smithsonian 9:145-9 (c, 2) N '78
--18th cent. elephant painting
Smithsonian 8:110 (c, 2) N '77
--Depictions of god Shiva
Smithsonian 12:58-67 (c, 2) My
'81
INDIA--COSTUME
Nat Geog 152:271-86 (c, 1) Ag
'77
Natur Hist 88:12-21 (3) Je '79
Nat Geog 156:594-5, 602 (c, 2)
N '79
Trav/Holiday 156:cov., 46 (c, 1)
Jl '81
--Bombay
Nat Geog 160:106-28 (c, 1) Jl '81
Nat Geog 160:306 (c, 2) S '81
--Calcutta's poor
Life 3:54-65 (1) Jl '80

--Jain religion worshipers
Life 4:126 (c, 2) Ap '81
--Jaipur
Smithsonian 9:142, 146-7 (c, 1)
O '78
--Kashmir
Trav/Holiday 149:34-7 (c, 2) Je
'78
--Kathakali theater performers
Smithsonian 9:cov., 68-75 (c, 1)
Mr '79
--Ladakh
Travel 147:cov., 25-31 (c, 1) F
'77
Nat Geog 153:cov., 334-59 (c, 1)
Mr '78
--Parsi children (Bombay)
Nat Geog 160:124 (c, 1) Jl '81
--Rajasthan
Nat Geog 151:218-43 (c, 1) F '77
Nat Geog 152:71 (c, 1) Jl '77
INDIA--MAPS
Trav/Holiday 153:61 (4) Mr '80
INDIA--SCULPTURE
--Carved horse
Natur Hist 89:cov. (c, 1) S '80
INDIAN OCEAN
--Small island countries
Nat Geog 160:422-57 (c, 1) O '81
INDIAN OCEAN--MAPS
Nat Geog 160:424-6 (c, 1) O '81
INDIAN PAINTBRUSH (FLOWERS)
Nat Geog 156:505 (c, 3) O '79
INDIAN PIPE FLOWERS
Am Heritage 28:49 (c, 4) Je '77
INDIAN RESERVATIONS
--Gila River, Arizona
Nat Geog 152:499 (c, 2) O '77
--Warm Springs, Oregon
Nat Geog 155:494-504 (c, 1) Ap
'79
INDIAN WARS
--Big Hole, Montana (1877)
Smithsonian 9:92-9 (c, 1) My '78
--Cheyenne drawing of Dodge City
battle
Natur Hist 89:82, 86 (4) O '80
--Medicine Lodge (1867)
Am Heritage 29:66-71 (paint-
ing, c, 1) O '78
--Reenactment of Summit Springs
battle
Nat Geog 160:78-9 (1) Jl '81
--Sites of Nez Percé struggles
Nat Geog 151:408-31 (map, c, 1)
Mr '77
--U.S. cavalry
Am Heritage 31:cov., 98-107

(painting, c, 1) Je '80
--See also GERONIMO; JOSEPH,
 CHIEF; SITTING BULL
INDIANA
--Early 20th cent. life along the
 Wabash
 Nat Wildlife 16:29-35 (paint-
 ing, c, 1) D '77
--Anderson
 Life 3:32-5 (c, 1) Ag '80
--Columbus
 Nat Geog 154:382-97 (c, 1) S
 '78
--Farms
 Nat Geog 151:262-3 (c, 2) F '77
--Madison
 Nat Geog 151:264-5 (c, 1) F '77
--New Harmony
 Travel 148:48 (c, 3) S '77
--New Harmony Museum
 Life 3:60-2 (c, 3) F '80
--See also EVANSVILLE; INDI-
 ANAPOLIS
INDIANA DUNES NATIONAL LAKE-
 SHORE, INDIANA
 Nat Geog 156:56-7 (c, 1) Jl '79
INDIANAPOLIS, INDIANA
 Ebony 33:100 (4) F '78
 Trav/Holiday 151:48-51 (c, 2) Ja
 '79
INDIANS OF LATIN AMERICA
--1493 destruction of Columbus
 settlement, La Navidad
 Am Heritage 29:89 (drawing, 1)
 Ap '78
--Canelos Quichua (Ecuador)
 Natur Hist 87:90-9 (c, 1) O '78
--Erigpactsa tribe (Brasil)
 Nat Geog 152:696-7 (c, 1) N '77
 Huichols (Mexico)
 Nat Geog 151:cov., 833-53
 (c, 1) Je '77
 Natur Hist 88:68-75 (c, 1) O '79
--Mekranoti (Brazil)
 Natur Hist 87:cov., 43-55 (c, 1)
 N '78
--Nambicuara (Brazil)
 Nat Geog 155:61-83 (c, 1) Ja
 '79
--Seri Indians (Mexico)
 Nat Geog 153:664-5 (c, 2) My
 '78
--Totonac
 Nat Geog 158:202-31 (c, 1) Ag
 '80
--See also AZTEC; INCA; JIVARO;
 MAYAN; TARASCAN
INDIANS OF LATIN AMERICA--

ARCHITECTURE
--Toltec pyramid (Mexico)
 Nat Geog 158:712-13 (c, 1) D '80
INDIANS OF LATIN AMERICA--ART
--Huichol Indians (Mexico)
 Nat Geog 151:cov., 845 (c, 1) Je
 '77
 Natur Hist 88:68-75 (c, 1) O '79
--Pre-Columbian gold sculpture
 (Peru)
 Smithsonian 8:84-91 (c, 1) D '77
--Rock paintings (Baja California,
 Mexico)
 Nat Geog 158:692-702 (c, 1) N '80
INDIANS OF LATIN AMERICA--
 COSTUME
--Cuna Indians (Panama)
 Trav/Holiday 149:42-4 (c, 4) Ap
 '78
--Mehinaku men (Brazil)
 Natur Hist 88:18 (2) F '79
INDIANS OF LATIN AMERICA--
 RELICS
--Zapotec Indian sites (Mexico)
 Smithsonian 10:62-75 (c, 1) F '80
INDIANS OF NORTH AMERICA
 Am Heritage 29:43 (drawing, 1)
 O '78
--14th cent. warfare (South Dakota)
 Smithsonian 11:108 (painting, c, 2)
 S '80
--17th cent. attacks on settlers
 (Virginia)
 Nat Geog 155:764-5 (painting, c, 1)
 Je '79
--1680 Pueblo repulsion of Spanish
 conquerors (New Mexico)
 Smithsonian 11:86-95 (painting, c, 1)
 O '80
--18th cent. Detroit area Indians
 Am Heritage 28:96 (drawing, c, 2)
 Ap '77
--18th cent. treatment of enemies
 Am Heritage 28:96-9 (drawing, c, 2)
 Ap '77
--19th cent. photographs
 Natur Hist 89:68-75 (1) O '80
--Late 19th cent.
 Am Heritage 30:72-5 (3) F '79
 Smithsonian 12:72-80 (c, 2) Ap '81
--1877 Ponca Indians
 Smithsonian 12:76-7 (2) Ap '81
--1913 proposed monument to Amer-
 ican Indians (New York)
 Am Heritage 30:96-9 (drawing, 1)
 Ap '79
--Acoma Indian structures (New
 Mexico)

Trav/Holiday 152:28-31 (c, 2)
D '79
--Arizona
Trav/Holiday 154:57-61 (c, 3) S
'80
--Astronomical activities
Smithsonian 9:78-85 (c, 1) O '78
--Ceremonial dance of New Mexico
Indians
Trav/Holiday 149:38 (c, 4) Ja
'78
--Festivals
Travel 147:48-53 (c, 1) F '77
--Oglala ceremonial dance (South
Dakota)
Trav/Holiday 149:41 (c, 4) Je
'78
--Papooses
Life 2:86 (4) F '79
--Posing for souvenir photos (North
Carolina)
Nat Geog 156:34-5 (c, 1) Jl '79
--Silhouette of rain dance
Nat Wildlife 17:30-1 (4) Je '79
--Tanaina (Alaska)
Nat Geog 156:38-9 (c, 1) Jl '79
--Warm Springs (Oregon)
Nat Geog 155:494-505 (c, 1) Ap
'79
--Yakima (Washington)
Nat Geog 154:614, 626 (c, 2) N
'78
--See also APACHE; BLACK-
FEET; CHEROKEE; CHEY-
ENNE; CHIPPEWA; CROW;
DELAWARE; ESKIMOS;
GERONIMO; HAIDA; HOPI;
IOWA; JOSEPH, CHIEF;
KIOWA; KWAKIUTL; MANDAN;
MASSASOIT, CHIEF; NAVA-
JO; NEZ PERCE; OSAGE;
PAWNEE; PUEBLO; SEMI-
NOLE; SIOUX; SITTING BULL;
TEPEES; TLINGIT; TOTEM
POLES; UTE; WINNEBAGO;
ZUNI
INDIANS OF NORTH AMERICA--
COSTUME
--1820 Ottawa Indians
Am Heritage 29:52 (painting, c, 4)
Ag '78
--1830's Snake Indians
Natur Hist 86:98 (painting, c, 2)
F '77
--Fashions based on Indian cos-
tumes
Life 3:81-4 (c, 1) Ag '80
--Feathered headdress of Plains

Indians
Travel 147:48 (c, 1) F '77
--Headdress
Sports Illus 50:cov. (c, 1) F 12
'79
INDIANS OF NORTH AMERICA--
HOUSING
--Mandan lodge
Smithsonian 11:104-5 (painting, c, 2)
S '80
--See also ADOBE HOUSES; HO-
GANS; TEPEES
INDIANS OF NORTH AMERICA--
RELICS
Smithsonian 9:58-65 (c, 1) Ag '78
--Late 19th cent.
Am Heritage 30:76-9 (c, 2) F '79
--Arkansas mound relics (19th cent.
dig)
Am Heritage 31:69 (painting, c, 2)
O '80
--Corpses of 14th cent. massacre
(South Dakota)
Smithsonian 11:100-3, 106 (c, 1)
S '80
--Grand Canyon, Arizona
Nat Geog 154:18-20 (c, 1) Jl '78
--Petroglyphs
Natur Hist 86:43-9 (c, 1) F '77
INDONESIA
Travel 148:56-61 (map, c, 1) Ag
'77
--1963 Mount Agung eruption (Bali)
Natur Hist 86:14 (3) Ja '77
--Bali
Nat Geog 157:416-27 (c, 1) Mr
'80
--Java coffee farm
Nat Geog 159:400-1 (c, 1) Mr '81
--Sumatra
Nat Geog 159:406-29 (map, c, 1)
Mr '81
--Sunda Kelapa harbor
Trav/Holiday 148:71 (4) D '77
INDONESIA--ART
--Bali elephant statue
Trav/Holiday 151:cov. (c, 1) Ja
'79
--Bali wood carvings
Trav/Holiday 155:66, 82 (c, 4)
My '81
--Sumatra
Smithsonian 9:44-5 (c, 2) O '78
INDONESIA--COSTUME
--Bali
Nat Geog 157:416-27 (c, 1) Mr '80
Trav/Holiday 155:65-6 (c, 2) My
'81

--Farmer's hat (Bali)
 Trav/Holiday 151:96 (4) My '79
--Sumatra
 Nat Geog 159:406-29 (c, 1) Mr
 '81
INDONESIA--HOUSING
--Thatched stilt houses (Sulawesi)
 Trav/Holiday 153:90 (3) F '80
INDUSTRIAL PARKS
--Chicago, Illinois
 Nat Geog 153:490-1 (c, 1) Ap '78
Industries. See ALFALFA;
 ALUMINUM; APPLES; AUTO-
 MOTIVE; BAMBOO; BANANAS;
 BARLEY; BEER; BLUEBER-
 RIES; BOURBON; BRICKS;
 CAMERAS; CAVIAR; CHEESE;
 CIGARETTES; CIGARS;
 COAL; COCONUTS; COFFEE;
 CORN; COTTON; CRABS;
 CRANBERRIES; FACTORIES;
 FISHING; FLOWERS; FUR;
 GARMENT INDUSTRY;
 GASAHOL; GLASS; GOLD;
 GRAIN; GRAPES; HONEY;
 INSURANCE; KELP; LEATH-
 ER; LOBSTERS; LUMBER-
 ING; MANUFACTURING;
 MARKETS; MEAT; MILK;
 OIL; OPIUM; ORANGES;
 OYSTERS; PAPER; PEAT;
 PEPPER; PINEAPPLES;
 POTASH; POTTERY; PRINT-
 ING; RANCHING; RICE;
 RUBBER; SALT; SHIPPING;
 SHRIMP; SILK; SORGHUM;
 SOYBEANS; SPONGES; STEEL;
 STOCK EXCHANGES; STORES;
 STRAWBERRIES; SUGAR
 BEETS; SUGAR CANE;
 SUGARING; TEA; TEXTILES;
 TOBACCO; WHALING; WHEAT;
 WINE; WOOL
INJURED PEOPLE
--Arm in cast
 Sports Illus 55:78 (4) S 28 '81
--Baseball player (1955)
 Ebony 33:58 (3) Jl '78
--Baseball players
 Sports Illus 49:20 (c, 4) Ag 14
 '78
--Basketball player's bad knee
 Sports Illus 49:96-7 (c, 3) D 4
 '78
--Basketball players
 Sports Illus 48:20 (c, 3) My 1
 '78
 Sports Illus 52:20 (c, 2) My 26

 '80
--Boxer's cut eye
 Sports Illus 54:26 (c, 4) Je 22 '81
--Boy on crutches
 Life 2:96 (c, 4) Mr '79
--Broken nose
 Sports Illus 49:46-9 (1) N 20 '78
--Burn victim
 Ebony 35:61-4 (2) F '80
--Burned helicopter crash victims
 (Iran)
 Life 4:32-3 (c, 1) Ja '81
--Eyepatch
 Smithsonian 10:107 (c, 4) My '79
--Football player's arm injury
 Sports Illus 47:22 (c, 4) S 19 '77
--Football player's injured knee
 Sports Illus 53:20 (c, 3) Ag 25 '80
--Football players
 Sports Illus 47:24 (c, 4) O 17 '77
 Sports Illus 47:32 (c, 2) D 12 '77
 Sports Illus 48:13 (c, 3) Ja 2 '78
 Sports Illus 49:68-74 (drawing, c, 1)
 Jl 31 '78
 Sports Illus 49:68-72 (painting, c, 1)
 Ag 14 '78
 Sports Illus 49:34-5 (c, 3) Ag 21
 '78
 Ebony 34:42 (4) Ja '79
 Sports Illus 51:20-2 (c, 2) S 10
 '79
 Sports Illus 51:27 (c, 3) S 17 '79
 Sports Illus 51:30 (c, 2) O 29 '79
 Sports Illus 51:33 (c, 4) N 5 '79
 Sports Illus 51:45 (c, 1) N 19 '79
 Sports Illus 52:24-5 (c, 3) Ap 14
 '80
 Sports Illus 53:28-9 (c, 4) N 10
 '80
 Sports Illus 55:32 (c, 3) O 12 '81
--Hockey player
 Sports Illus 47:23 (c, 2) N 21 '77
 Sports Illus 55:50 (c, 4) D 7 '81
--Hurling player (Ireland)
 Nat Geog 159:453 (c, 3) Ap '81
--Knee injuries
 Sports Illus 47:86-7 (c, 4) O 24
 '77
--Leg in cast
 Sports Illus 49:18-19, 23 (c, 1)
 Ag 21 '78
 Sports Illus 50:104 (c, 2) F 15 '79
 Ebony 34:75 (4) Ap '79
 Sports Illus 53:84 (4) O 6 '80
 Ebony 35:68 (4) N '80
--Maimed Nicaraguan children
 Life 2:104-5 (c, 1) Ag '79
--Man on crutches

Ebony 33:46 (4) Ap '78
--Pitchers with bad arms
Sports Illus 49:31-3 (c, 1) Ag
14 '78
--Rescuing avalanche victim
(Colorado)
Nat Wildlife 16:34, 39 (2) F '78
--Soaking arm in ice water
Sports Illus 54:62 (c, 4) Je 15
'81
--Soccer players
Sports Illus 50:30-1 (c, 1) Je
11 '79
--U. S. soldiers (Vietnam)
Am Heritage 29:30-1 (c, 1) Ap
'78
Life 2:104-10 (c, 1) O '79
--Wired jaw
Ebony 34:65 (4) Ja '79
--World War II soldiers
Life 2:72-3, 84 (1) My '79
Am Heritage 31:38-9 (1) D '79
INSECTS
--Assassin bug
Nat Geog 157:168 (c, 4) F '80
Nat Wildlife 18:25 (c, 2) Ag '80
--Camouflaging techniques
Nat Geog 157:394-415 (c, 1) Mr
'80
--Eggs
Nat Geog 151:569 (c, 4) Ap '77
--Fossils embalmed in amber
Nat Geog 152:422-30 (c, 1) S
'77
--Garden residents
Smithsonian 8:90-1 (painting, c, 2)
Ap '77
--Killing prey
Nat Wildlife 18:21-7 (c, 1) Ag
'80
--Lygus bug
Smithsonian 9:78 (c, 3) Ja '79
--Residents of compost piles
Nat Geog 158:272-84 (c, 1) Ag
'80
--Species influenced by smell
Smithsonian 9:78-85 (draw-
ing, c, 2) Mr '79
--Treehoppers
Nat Geog 157:410-11 (c, 1) Mr
'80
Smithsonian 11:50 (c, 4) Je '80
--Vermont mountain life
Nat Geog 158:558-66 (c, 1) O '80
--See also ANT LIONS; ANTS;
APHIDS; BEES; BOLL WEE-
VILS; BUTTERFLIES; CATER-
PILLARS; CICADAS; COCK-

ROACHES; COCOONS;
CRICKETS; DRAGONFLIES;
FIREFLIES; FLEAS; FLIES;
FRUIT FLIES; GNATS; GRASS-
HOPPERS; KATYDIDS; LADY-
BUGS; LICE; MANTIDS; MOS-
QUITOS; MOTHS; NYMPHS;
SCORPION FLIES; STINK-
BUGS; TERMITES; TICKS;
WASPS; WATER BUGS; YEL-
LOW JACKETS
INSECTS--HUMOR
--Foreign pests smuggled into U. S.
Nat Wildlife 17:12-15 (drawing, c, 1)
Je '79
INSTRUMENTS
--Aviation
Nat Geog 159:80-1 (drawing, 4)
Ja '81
--Gravity-measuring device
Life 2:86 (c, 4) Ja '79
--Measuring visibility
Nat Geog 158:781 (c, 4) D '80
--Signature verification system
Smithsonian 9:90 (c, 4) O '78
--See also COMPASSES; MEDICAL
INSTRUMENTS; METAL DE-
TECTORS; MUSICAL INSTRU-
MENTS; NAVIGATION INSTRU-
MENTS; RADAR; SCALES;
SURVEYING EQUIPMENT;
TELESCOPES
INSULATION
--Gauging insulation value of clothing
Nat Geog 159:56 (c, 1) F '81SR
Natur Hist 90:91, 96 (c, 1) O '81
--Insulating home
Natur Hist 90:112-17 (c, 3) O '81
--Thermograms of heat loss
Nat Geog 159:6-15 (c, 1) F '81SR
--Thermograms of White House and
Capitol
Life 3:144-5 (c, 1) Mr '80
INSURANCE INDUSTRY
--Great Britain insurance offices
Smithsonian 11:80-4 (c, 2) Mr '81
INTERIOR DECORATION
Ebony 32:112-21 (c, 2) Ja '77
INUVIK, NORTHWEST TERRI-
TORIES
Sports Illus 51:80 (c, 4) O 29 '79
INVENTIONS
--1878 men's head measurer for
hats
Am Heritage 30:106-7 (drawing, 4)
Je '79
--Leonardo Da Vinci's sketches
Nat Geog 152:300-20 (drawings, c, 1)

LAND; O'CASEY, SEAN;
SHANNON RIVER
IRELAND--ART
--8th cent. "Book of Kells"
Smithsonian 8:66-73 (c, 1) O '77
--8th cent. metalwork
Smithsonian 8:72-3 (c, 1) O '77
IRELAND--COSTUME
Nat Geog 154:653-79 (c, 1) N
'78
Natur Hist 89:50-5 (c, 1) N '80
Nat Geog 159:433, 442-67 (c, 1)
Ap '81
IRELAND--HISTORY
--6th cent. voyage by St. Brendan
to America
Nat Geog 152:cov., 768-97
(map, c, 1) D '77
--19th cent. Irish-American in-
volvement in Irish politics
Am Heritage 30:2, 50-62
(painting, c, 1) Je '79
--1866 Fenian invasion of Canada
Am Heritage 30:56-7 (paint-
ing, c, 1) Je '79
--Sites of Celtic civilization
Nat Geog 151:617-31 (map, c, 1)
My '77
IRELAND--SOCIAL LIFE AND
CUSTOMS
--Harvesting peat for fuel
Smithsonian 12:146-9 (c, 2) O '81
IRELAND, ANCIENT--RELICS
--Ancient wheel and necklace
Natur Hist 89:53, 56 (4) N '80
--Tomb (2300 B. C.)
Nat Geog 152:619 (c, 3) N '77
IRISES
Nat Wildlife 19:cov., 11 (c, 1)
Ap '81
IRISH-AMERICANS
--19th cent. involvement in Irish
politics
Am Heritage 30:2, 50-62
(painting, c, 1) Je '79
IRON MINES
--Michigan
Nat Geog 155:838-9 (c, 3) Je '79
IRRIGATION
--Antiquated African method
Ebony 33:90 (4) D '77
--California strawberry farm
Natur Hist 88:8 (4) N '79
--California's problems
Nat Geog 158:172-3 (c, 2) Ag '80
--Egypt
Nat Geog 151:328 (c, 2) Mr '77
--Farm ruined by salt buildup

(Colorado)
Nat Geog 156:626 (c, 4) N '79
--Nebraska farms
Nat Wildlife 16:6-7 (c, 3) Je '78
--Solar-powered system (Nebraska)
Smithsonian 8:38-9 (c, 1) O '77
--Southwest
Life 4:38-9 (c, 1) Jl '81
--Sprinkler (Montana)
Life 1:100 (c, 4) D '78
--Tunisia
Nat Geog 157:185 (c, 2) F '80
--See also CANALS; RESERVOIRS
IRVING, WASHINGTON
Am Heritage 30:112 (painting, c, 4)
Ag '79
--Home (Sunnyside, New York)
Nat Geog 153:79 (c, 3) Ja '78
Islam. See MOSLEMS
ISLANDS
--Barrier islands
Nat Wildlife 19:9 (c, 4) O '81
--Barro Colorado, Panama
Smithsonian 10:8-10 (c, 4) N '79
--Bass, Ohio
Nat Geog 154:98-9 (c, 2) Jl '78
--Birth of a Solomon Island
Nat Geog 160:782-3 (c, 1) D '81
--Bora Bora
Nat Geog 155:860-1 (c, 1) Je '79
--Canouan, St. Vincent
Nat Geog 156:400-1 (c, 2) S '79
--Carrie Cow Bay, Central America
Smithsonian 11:34-5 (c, 1) Ja '81
--Guyabo, Costa Rica
Smithsonian 10: 66 (c, 4) S '79
--Kojima, Hokkaido, Japan
Nat Geog 157:68-9 (c, 1) Ja '80
--Leewards, Hawaii
Nat Geog 153:673-5 (c, 2) My '78
--Maldive Islands, Indian Ocean
Nat Geog 160:430-1 (c, 1) O '81
--Northern Ireland
Nat Geog 159:482-3 (c, 1) Ap '81
--St. John, Virgin Islands
Nat Geog 159:242-3 (c, 1) F '81
--Smith, Maryland
Nat Geog 158:462-3 (c, 1) O '80
ISRAEL
--Dead Sea area
Nat Geog 153:225-41 (map, c, 1)
F '78
--Masada
Nat Geog 153:234-7 (c, 1) F '78
--Palestinian guerrilla warfare
Life 2:24-31 (c, 1) Je '79
--Salt ponds used for energy
Smithsonian 11:143-6 (c, 2) O '80

--West Bank
 Life 2:138-9 (c, 1) S '79
 Life 4:105-10 (c, 2) My '81
--Yamit, Sinai
 Life 1:22-7 (c, 1) N '78
--See also JERUSALEM; KIB-
 BUTZIM; TEL AVIV
ISRAEL--COSTUME
 Nat Geog 153:232-7 (c, 1) F '78
 Life 1:24-5 (c, 1) N '78
 Life 4:105-13 (c, 2) My '81
ISTANBUL, TURKEY
 Nat Geog 152:116-19 (c, 1) Jl
 '77
--18th cent. Constantinople
 Smithsonian 9:50-1 (painting, c, 3)
 Jl '78
--Basilica of Haghia Irene
 Trav/Holiday 151:104 (4) My '79
ITALY
--Alberobello
 Nat Geog 159:744-5 (c, 1) Je '81
--Ancient Appian Way
 Nat Geog 159:714-46 (map, c, 1)
 Je '81
--Artena
 Smithsonian 10:188 (4) N '79
--Bagnara
 Trav/Holiday 153:101 (4) Ap '80
--Balvano after 1980 earthquake
 Life 4:4 (3) Ja '81
--Canale d'Agordio
 Life 1:128 (c, 3) O '78
--Earthquake damage in Mezzo-
 giorno region
 Life 4:41-4 (c, 1) F '81
--Gravina di Puglia
 Nat Geog 159:742-3 (c, 1) Je '81
--Marostica's human chess match
 Trav/Holiday 149:48-51 (c, 2)
 Je '78
--Monetecantini
 Trav/Holiday 154:20-1 (c, 2) D
 '80
--Vinci
 Nat Geog 152:298-9 (c, 1) S '77
--See also FLORENCE; LEANING
 TOWER OF PISA; MILAN;
 MOUNT ETNA; PADUA;
 PALERMO; PISA; POMPEII;
 ROMAN EMPIRE; ROME;
 SARDINIA; SICILY; TURIN;
 VENICE; VESUVIUS
ITALY--ART
--17th cent. Venetian glass
 Smithsonian 11:71 (c, 4) My '80
--18th cent. Naples
 Smithsonian 12:74-83 (c, 1) D '81

ITALY--COSTUME
--1525 fresco of wedding (Saronno)
 Smithsonian 12:48 (painting, c, 4)
 O '81
--17th cent.
 Smithsonian 12:90-1 (painting, c, 2)
 Ag '81
--18th cent. paintings
 Smithsonian 12:76-81 (c, 2) D '81
--Children (Sardinia)
 Trav/Holiday 150:44, 69 (c, 1) D
 '78
ITALY--HISTORY
--1560 football game (Florence)
 Smithsonian 12:40 (painting, c, 4)
 S '81
--17th cent. Inquisition
 Smithsonian 12:90-1 (painting, c, 2)
 Ag '81
--World War II battle for Cassino
 Am Heritage 32:33-45 (1) O '81
ITALY--HOUSING
--Villas
 Life 3:108-12 (c, 1) D '80
ITALY--MAPS
 Trav/Holiday 156:53 (4) O '81
--Bay of Naples (1754)
 Natur Hist 88:41 (4) Ap '79
Italy, Ancient. See ROMAN EM-
 PIRE
IVORY
--Carving (Alaska)
 Travel 148:64-5 (4) Ag '77
--Carving (Singapore)
 Trav/Holiday 148:34 (c, 4) N '77
--Carving elephant tusks (Hong
 Kong)
 Nat Geog 159:200-1 (o, 1) Mr '81
--Japanese carving
 Natur Hist 89:46-7, 69 (c, 1) S
 '80
--Narwhal tusks
 Natur Hist 90:57 (c, 1) Ag '81
--Smuggled pieces confiscated by
 U. S. Customs
 Nat Wildlife 17:34 (2) O '79
IVORY COAST--ART
--Helmet mask
 Smithsonian 9:51 (c, 3) O '78
IVY
--English
 Smithsonian 9:73 (c, 1) Jl '78
IWO JIMA
--1945 battle
 Am Heritage 32:92-101 (c, 2) Je
 '81

-J-

JACANAS (BIRDS)
 Smithsonian 10:20 (c, 4) S '79
JACK RABBITS
 Nat Wildlife 17:10-13 (1) F
 '79
 Nat Wildlife 18:54-5 (paint-
 ing, c, 1) D '79
 Nat Geog 159:155 (c, 4) F '81
 Nat Wildlife 20:2 (c, 1) D '81
--Rear view
 Nat Geog 160:694 (c, 4) N '81
JACKALS
 Natur Hist 89:44-9 (c, 1) F '80
 Nat Geog 158:840-50 (c, 1) D
 '80
JACKSON, ANDREW
 Smithsonian 8:26 (4) Jl '77
--Hermitage home, Nashville,
 Tennessee
 Travel 148:56, 68 (4) O '77
--Inaugural print
 Smithsonian 7:102 (painting, c, 4)
 Ja '77
JACKSON, MAHALIA
 Ebony 32:140 (4) Ag '77
JACKSON, STONEWALL
--Tombstone (Lexington, Virginia)
 Trav/Holiday 150:34 (4) Jl '78
JACKSON, MISSISSIPPI
 Ebony 35:147 (2) S '80
JACKSONVILLE, FLORIDA
 Ebony 36:64-74 (2) Ap '81
JADE
 Smithsonian 8:80-7 (c, 1) Ap '77
JAGUARS
 Smithsonian 8:103 (c, 4) O '77
 Nat Geog 152:cov. (c, 2) N '77
 Smithsonian 9:20 (c, 4) O '78
JAI ALAI
 Ebony 34:170-2 (3) My '79
 Sports Illus 50:22-3 (c, 4) Je 11
 '79
JAIPUR, RAJASTHAN, INDIA
 Nat Geog 151:234-5 (c, 1) F '77
 Smithsonian 9:142-9 (c, 1) O '78
JAMAICA
 Nat Geog 159:244-5, 256-7 (c, 1)
 F '81
--Montego Bay beach
 Ebony 35:80 (4) Ja '80
--See also KINGSTON
JAMAICA--COSTUME
--Marijuana smokers
 Life 4:110-12 (c, 2) O '81
JAMES, HENRY
 Smithsonian 10:140 (painting, c, 3)

 Je '79
JAMES, WILLIAM
 Am Heritage 31:18-19 (c, 2) O
 '80
JANITORS
--1910 scrubwomen (New York
 City, New York)
 Am Heritage 31:20 (painting, c, 2)
 Je '80
JAPAN
 Nat Geog 152:830-63 (map, c, 1)
 D '77
--Beppu baths
 Smithsonian 11:96-103 (c, 1) Jl
 '80
--Chiyoda
 Nat Geog 154:78-85 (c, 1) Jl '78
--Inland Sea
 Nat Geog 152:830-63 (map, c, 1)
 D '77
--Izu Peninsula
 Travel 147:60-5 (c, 1) F '77
--Mount Usu Volcano
 Life 3:58-60 (c, 1) Mr '80
--Waterway area
 Trav/Holiday 148:28 (c, 3) D '77
--See also HIROSHIMA; HOKKAIDO;
 KYOTO; OSAKA; SAPPORO;
 TOKYO
JAPAN--ART
 Smithsonian 8:84-91 (painting, c, 1)
 Je '77
--1491 painting
 Natur Hist 89:70 (c, 3) S '80
--17th cent. screen
 Smithsonian 8:96-7 (c, 2) O '77
--Arts and crafts
 Smithsonian 10:50-9 (c, 1) Ja '80
JAPAN--COSTUME
 Nat Geog 151:550-61 (c, 1) Ap '77
 Nat Geog 152:835-61 (c, 1) D '77
 Natur Hist 90:51-5 (c, 1) O '81
--Artists
 Smithsonian 10:50-9 (c, 1) Ja '80
--Bride
 Nat Geog 159:297 (c, 1) Mr '81
--Fencers
 Nat Geog 158:cov., 502-3 (c, 1)
 O '80
--Festival apparel
 Nat Geog 154:78-85 (c, 1) Jl '78
--Geishas
 Life 1:10-12 (2) O '78
--Hokkaido
 Nat Geog 157:64-93 (c, 1) Ja '80
--Kindergartners
 Smithsonian 12:129 (c, 1) D '81
--Winter apparel

Trav/Holiday 154:53-5, 69 (c, 2)
N '80
--See also KIMONOS
JAPAN--HISTORY
--13th cent. invasions by Mongol
armada
Smithsonian 12:118-29 (c, 1) D
'81
--1592 naval warfare with China
Natur Hist 86:48 (painting, c, 2)
D '77
--See also RUSSO-JAPANESE
WAR; WORLD WAR II
JAPAN--HOUSING
Natur Hist 90:52-3 (c, 4) O '81
JAPAN--SCULPTURE
--Ivory carving
Natur Hist 89:46-7, 69 (c, 1)
S '80
JAPAN--SOCIAL LIFE AND
CUSTOMS
--Grand Festival of Nikko
Trav/Holiday 155:26 (3) Ap '81
--Kite-fighting (Hamamatsu)
Nat Geog 151:550-61 (c, 1) Ap
'77
--Manhood ceremony for prince
Life 3:138-9 (c, 1) Ap '80
JASPER NATIONAL PARK, AL-
BERTA
Nat Geog 157:754-79 (map, c, 1)
Je '80
Trav/Holiday 155:50 (c, 2) My
'81
JAVELIN THROWING
--1931 Germany
Life 4:12 (3) F '81
--1080 Olympico (Moooow)
Sports Illus 53.29 (c, 4) Ag 11
'80
--Mexico
Nat Geog 153:624 (c, 4) My '78
Javelinas. See PECCARIES
JAY, JOHN
Am Heritage 28:39 (painting, 4)
Ag '77
Smithsonian 8:100 (painting, c, 4)
Ja '78
JEEPS
--Decorated (Philippines)
Trav/Holiday 149:43 (c, 4) Ja '78
--World War II
Am Heritage 32:11 (3) Ap '81
JEFFERSON, THOMAS
Am Heritage 28:38 (sculpture, 4)
Ag '77
Trav/Holiday 156:28 (engrav-
ing, 4) Jl '81

Life 4:7 (4) Ag '81
Am Heritage 33:73-6, 79 (draw-
ing, 4) D '81
--Cipher wheel invented by him
Smithsonian 12:132 (c, 4) Ap '81
--Invention of music stand for
quintets
Smithsonian 12:160 (4) Ap '81
--Monticello, Charlottesville, Vir-
ginia
Am Heritage 29:30-8 (c, 1) F '78
Life 3:114 (c, 4) D '80
Trav/Holiday 156:28-33 (c, 2) Jl
'81
--Mount Rushmore sculpture
Am Heritage 28:18, 27 (c, 4) Je
'77
--Portrait by Trumbull
Am Heritage 29:112 (4) Ap '78
JEFFERSON MEMORIAL, WASH-
INGTON, D. C.
Trav/Holiday 151:67 (4) My '79
JEFFRIES, JIM
Ebony 33:126, 132 (4) Mr '78
JELLYFISH
Natur Hist 88:87 (lithograph, c, 1)
My '79
Nat Geog 157:539 (c, 4) Ap '80
Nat Wildlife 19:39 (c, 4) D '80
Nat Geog 159:642 (c, 3) My '81
Smithsonian 12:123 (c, 4) S '81
Nat Geog 160:837 (c, 1) D '81
JERBOAS
Natur Hist 87:78 (c, 2) My '78
JERSEY CITY, NEW JERSEY
--Liberty Park
Smithsonian 9:151-2 (c, 3) O '78
JERUSALEM, ISRAEL
Nat Geog 158:340-1 (c, 2) S '80
JESUS CHRIST
Nat Geog 160:289 (painting, c, 1)
S '81
--8th cent. "Book of Kells" (Ireland)
Smithsonian 8:66-73 (c, 1) O '77
--15th cent. cassock (U. S. S. R.)
Nat Geog 153:32 (c, 1) Ja '78
--17th cent. Rubens painting
Smithsonian 8:50 (c, 3) O '77
--17th cent. statue (Warsaw,
Poland)
Smithsonian 9:110 (c, 4) S '78
--All-black birth of Christ sculpture
(Tanzania)
Ebony 33:44-6 (c, 2) D '77
--Celtic plaque (Ireland)
Nat Geog 151:627 (c, 4) My '77
--Creches (Naples, Italy)
Life 3:176-84 (c, 1) D '80

--Depicted on grave marker
(Poland)
Nat Geog 159:106 (c, 4) Ja '81
--Depiction in Penitente sect art
(New Mexico)
Am Heritage 30:58-67 (c, 1) Ap
'79
--Golden sculpture (Seville, Spain)
Trav/Holiday 154:67 (c, 2) S '80
--Leonardo Da Vinci's "Last Sup-
per"
Nat Geog 152:322-3 (painting, c, 2)
S '77
--Reenactment of Crucifixion
(Philippines)
Nat Geog 151:375 (c, 1) Mr '77
--Shroud of Turin
Life 1:31-4 (c, 2) D '78
Nat Geog 157:730-53 (c, 1) Je
'80
--Statue (Ozarks)
Travel 148:43 (c, 4) Ag '77
--Van der Weyden's "Last Judg-
ment"
Smithsonian 10:80-1 (painting, c, 2)
Je '79
--Victorian paintings
Life 1:128-34 (c, 2) D '78
JEWELRY
Smithsonian 8:30 (c, 4) D '77
--3500 B. C. gold (Bulgaria)
Nat Geog 152:621 (c, 4) N '77
--4th cent. B. C. Thracian silver
fibula
Smithsonian 8:47 (c, 4) Je '77
--1st cent. gold nose ornament
(Peru)
Smithsonian 9:46-7 (c, 1) O '78
--8th cent. Irish brooch
Smithsonian 8:72-3 (c, 1) O '77
--18th cent. copper arm bracelets
Nat Geog 152:725 (c, 1) D '77
--18th cent. gold chain (Spain)
Am Heritage 31:32 (c, 1) O '80
--18th cent. Spanish
Nat Geog 156:866-76 (c, 1) D
'79
--Late 19th cent. (California)
Am Heritage 30:70-1 (painting, c, 1)
D '78
--Ancient Celtic
Nat Geog 151:608, 614 (c, 3)
My '77
--Ancient Crete
Nat Geog 159:216-21 (c, 3) F '81
--Diamond pieces
Nat Geog 155:86-112 (c, 1) Ja
'79

--Gold (ancient Afghanistan)
Life 2:65-8 (c, 4) Jl '79
--Inadan Tuareg people (Niger)
Nat Geog 156:282-95 (c, 1) Ag
'79
--India
Nat Geog 152:278 (c, 1) Ag '77
--Mexican Indians
Nat Geog 153:652-3 (c, 1) My '78
--Modern
Smithsonian 12:204 (c, 4) D '81
--Nose hoops (India)
Nat Geog 152:278 (c, 1) Ag '77
--Silver (Southwest)
Nat Geog 160:311 (c, 1) S '81
--Vikings
Smithsonian 11:cov. , 64-8 (c, 1)
S '80
--See also EARRINGS; MINERALS;
NECKLACES; RINGS
JEWELS
Smithsonian 11:68-74 (c, 1) Je
'80
--16th cent. Dresden treasures
Nat Geog 154:703-17 (c, 1) N '78
--Royal azel
Smithsonian 12:28 (c, 4) D '81
--Treasures of the czars (U. S. S. R.)
Nat Geog 153:25-33 (c, 1) Ja '78
--See also list under MINERALS
Jews. See JUDAISM
JIMSON WEED
Smithsonian 8:52 (painting, c, 4)
My '77
JIVARO INDIANS (ECUADOR)--
COSTUME
--Toucan feather hat
Smithsonian 8:119 (c, 4) O '77
JOCKEYS
Sports Illus 46:19 (c, 2) Ja 3 '77
Sports Illus 46:19 (c, 3) Ja 31 '77
Sports Illus 46:cov. , 16-21 (c, 1)
Mr 7 '77
Sports Illus 47:cov. , 39-41 (c, 1)
D 19 '77
Sports Illus 48:55 (c, 4) F 20 '78
Natur Hist 87:98-9 (2) Mr '78
Sports Illus 48:80 (c, 4) Mr 27
'78
Trav/Holiday 149:33 (drawing, 4)
My '78
Sports Illus 49:53-4 (c, 4) Jl 3
'78
Sports Illus 49:27-9 (c, 2) Ag 7
'78
Sports Illus 49:29 (c, 4) N 6 '78
Sports Illus 50:14-15 (c, 3) F 12
'79

Sports Illus 51:24 (c, 4) S 17
'79
Sports Illus 52:64-8 (c, 1) Je 2
'80
--Children
Sports Illus 50:24-6 (c, 2) Ja 8
'79
JOGGING
Ebony 32:62 (4) Jl '77
Ebony 32:148 (4) Ag '77
Sports Illus 47:33 (c, 4) O 24 '77
Ebony 33:104 (3) D '77
Ebony 33:93 (c, 2) Je '78
Sports Illus 49:24 (c, 4) Jl 31
'78
Sports Illus 49:23 (c, 3) S 11
'78
Ebony 33:70 (3) O '78
Sports Illus 49:49 (c, 3) N 6 '78
Sports Illus 49:41-3 (c, 1) D 25
'78
Ebony 34:130 (3) Ap '79
Ebony 34:44 (3) S '79
Ebony 35:103, 106 (3) F '80
Ebony 35:59 (4) Ag '80
Ebony 36:48 (1) N '80
Ebony 36:131 (4) O '81
--1914 bathers
Am Heritage 29:4 (painting, c, 1)
O '78
--Charity run (Milwaukee, Wisconsin)
Nat Geog 158:188 (c, 1) Ag '80
--President Carter
Sports Illus 49:32 (c, 1) D 18
'78
JOGGING--HUMOR
Sports Illus 50:50 6 (drawing, c, 1)
Ja 29 '79
Sports Illus 53:72-82 (drawing, c, 1) Jl 14 '80
JOHANNESBURG, SOUTH AFRICA
Nat Geog 151:798-9, 806-7
(c, 1) Je '77
JOHNSON, JACK
Ebony 33:126 (4) Mr '78
--Tombstone (Chicago, Illinois)
Ebony 34:77 (4) F '79
JOHNSON, LYNDON BAINES
Am Heritage 28:54-5 (2) F '77
Ebony 33:74 (4) D '77
Ebony 34:185 (4) My '79
Am Heritage 30:17 (4) Je '79
Life 3:138 (4) N '80
Am Heritage 32:4-15 (c, 2) D '80
--Lady Bird Johnson
Am Heritage 32:4-17 (c, 2) D '80
JOHNSON, WALTER

Sports Illus 47:72 (4) O 10 '77
JOLSON, AL
Am Heritage 28:85 (drawing, 4)
Ag '77
Am Heritage 29:104, 116 (4) Ap
'78
Ebony 35:159 (4) My '80
JONES, BOBBY
Am Heritage 31:76-85 (c, 1) Ag
'80
JONES, JOHN PAUL
Smithsonian 11:139 (painting, c, 3)
D '80
--Birthplace (Scotland)
Smithsonian 11:140 (c, 4) D '80
--Dead body
Smithsonian 11:127 (4) My '80
--Sites connected with him (Great
Britain)
Smithsonian 11:139-54 (c, 3) D
'80
JORDAN
--Bab edh-Dhra Bronze Age site
Smithsonian 9:82-7 (c, 1) Ag '78
--Dead Sea area
Nat Geog 153:224-45 (map, c, 1)
F '78
--Petra
Natur Hist 87:42-53 (map, c, 1)
Je '78
JORDAN--COSTUME
Nat Geog 153:224-45 (c, 1) F '78
JOSEPH, CHIEF (NEZ PERCE INDIAN)
Nat Geog 151:408, 429 (1) Mr
'77
Smithsonian 9:94 (4) My '78
JOURNALISTS
--Early 20th cent.
Sports Illus 47:82 (painting, c, 3)
Ag 29 '77
--1900 (Colorado)
Am Heritage 30:30-1 (1) Ap '79
--1910's Palestine
Am Heritage 31:36 (2) Ag '80
Smithsonian 11:178-9 (3) O '80
--Civil War
Am Heritage 31:49-59 (drawing, 3)
Ag '80
--See also GREELEY, HORACE;
HEARST, WILLIAM RANDOLPH; PYLE, ERNIE; STANLEY, HENRY M.; TELEVISION
NEWSCASTERS; THOMAS,
LOWELL; WHITE, WILLIAM
ALLEN
JOUSTING
--16th cent. Germany

Smithsonian 9:58-9 (c, 1) Je '78
Nat Geog 154:701 (c, 3) N '78
--Hertfordshire, Great Britain
Nat Geog 156:460-1 (c, 1) O '79
--Middle Ages style (Arizona)
Smithsonian 12:94-103 (c, 1) Je
'81
--Turkey
Nat Geog 152:94-5 (c, 1) Jl '77
JOYCE, JAMES
Smithsonian 9:76-7 (2) Jl '78
JUDAISM--COSTUME
--12th cent. France
Smithsonian 9:38 (c, 2) Je '78
--Bronx, New York
Natur Hist 89:26-35 (c, 1) D '80
--Hasidim (Brooklyn, New York)
Natur Hist 86:cov., 46-59 (1)
Ja '77
--Hungary
Smithsonian 10:68-73 (c, 1) Ag
'79
--Phylacteries (New York)
Natur Hist 86:57 (3) Ja '77
--Prayer shawl (Hungary)
Smithsonian 10:68 (c, 4) Ag '79
--Rabbi
Am Heritage 28:5 (c, 4) Ag '77
--Rabbi (Ancient Babylonia)
Smithsonian 9:36-7 (c, 4) Je '78
--U. S. S. R.
Life 4:88-98 (c, 1) D '81
JUDAISM--HISTORY
--1182 expulsion from France
Smithsonian 9:38 (c, 2) Je '78
--1941 shooting by Nazis (Latvia)
Life 3:24-5 (2) F '80
--Memorial to Ghetto Heroes
(Warsaw, Poland)
Smithsonian 9:20 (4) N '78
--Scenes of the Diaspora
Smithsonia 9:cov., 32-43 (c, 1)
Je '78
--Symbolic paintings of death camp
Am Heritage 30:72-9 (paint-
ing, c, 1) D '78
--See also CONCENTRATION
CAMPS; FRANK, ANNE;
MAIMONIDES
JUDAISM--RITES AND CERE-
MONIES
--11th cent. betrothal (Kairouan,
North Africa)
Smithsonian 9:36-7 (c, 2) Je '78
--Circumcision (U. S. S. R.)
Life 4:96 (c, 4) D '81
JUDAISM--SHRINES AND SYMBOLS
--Arch of Titus detail of menorah

Smithsonian 9:35 (c, 3) Je '78
--Old Jewish Cemetery, Prague,
Czechoslovakia
Nat Geog 155:563 (c, 2) Ap '79
--Star of David tattoo
Sports Illus 49:28 (c, 4) D 18 '78
JUDAISM--SOCIAL LIFE AND
CUSTOMS
--Bronx, New York
Natur Hist 89:26-35 (c, 1) D '80
--Budapest, Hungary
Smithsonian 10:64-73 (c, 1) Ag
'79
--Hasidim (Brooklyn, New York)
Natur Hist 86:cov., 46-59 (1) Ja
'77
JUDGES
Nat Geog 151:197 (c, 4) F '77
Ebony 33:61-3 (2) F '78
Ebony 36:52 (3) Ap '81
--Australia
Life 4:100-1 (1) N '81
--U. S. Supreme Court Marshall's
mallet
Smithsonian 7:39 (c, 4) Ja '77
--See also SUPREME COURT JUS-
TICES
JUDO
Life 2:96 (1) My '79
Sports Illus 53:65-6 (4) D 15 '80
JUKEBOXES
Trav/Holiday 155:81 (4) My '81
JUMPING
Sports Illus 47:21 (c, 4) S 12 '77
Sports Illus 47:34 (c, 4) N 21 '77
Sports Illus 51:28-9 (c, 1) Jl 30
'79
Sports Illus 51:20-1 (c, 2) S 3 '79
Sports Illus 52:50 (4) Mr 10 '80
Sports Illus 53:17 (c, 2) Jl 7 '80
Sports Illus 53:28 (c, 4) Jl 21 '80
Sports Illus 54:74-7 (c, 2) Je '81
--1980 Olympics (Moscow)
Sports Illus 53:23 (c, 4) Ag 11 '80
--Contest (Indonesia)
Travel 148:80 (c, 1) Ag '77
--See also HIGH JUMPING; ROPE
JUMPING
JUNEAU, ALASKA
Travel 148:63-4 (c, 4) Ag '77
Jungle. See FORESTS
JUNKYARDS
--Automobiles (New York)
Nat Geog 153:72-3 (c, 1) Ja '78
--Automobiles (Iowa)
Am Heritage 29:13 (c, 1) D '77
--Automobiles (Quebec)
Nat Geog 159:26-7 (c, 1) F '81SR

JUPITER
Life 2:44-7 (c, 1) My '79
Life 2:161 (c, 1) D '79
Nat Geog 157:cov. , 2-29 (c, 1)
Ja '80
Natur Hist 89:62-9 (c, 1) My '80
--Moons
Smithsonian 10:cov. , 36-45 (c, 1)
Ja '80
JUSTICE, ADMINISTRATION OF
--1871 trial of Garfield's murderer
Guiteau
Am Heritage 32:34-9 (3) Je '81
--1893 trial of Lizzie Borden
(Massachusetts)
Am Heritage 29:40 (drawing, 4)
F '78
--1925 Scopes trial (Tennessee)
Natur Hist 90:12-22 (2) O '81
--1926 Halls-Mills case
Life 4:10 (2) Ap '81
--Booking murder suspects (New
York)
Ebony 34:59 (3) Ag '79
--Determining guilt (Gimis, New
Guinea)
Nat Geog 152:142-3 (c, 1) Jl '77
--Hearing of James Earl Ray
Ebony 36:77-8 (4) Ap '81
--Taking mug shot (1860's engrav-
ing)
Smithsonian 12:66 (4) Ag '81
--Trials
Life 4:9-17 (2) Ap '81
Western travel therapy for
juvenile offenders
Life 4:48-56 (c, 1) S '81
--See also CAPITAL PUNISHMENT;
COURTHOUSES; COURTROOMS;
COURTS-MARTIAL; CRIME
AND CRIMINALS; JUDGES;
LAWYERS; PUNISHMENT;
SUPREME COURT

-K-

KABUKI
--Japan
Trav/Holiday 155:79 (c, 4) F '81
KABUKI--COSTUME
--Japan
Smithsonian 10:50-1 (c, 1) Ja '80
KABUL, AFGHANISTAN
Life 3:139 (c, 4) Mr '80
Natur Hist 89:72-3 (c, 2) Jl '80
KAFKA, FRANZ
Smithsonian 8:132 (painting, 4)

Mr '78
KANDINSKY, WASSILY
--Small Pleasures
Smithsonian 11:94 (painting, c, 4)
Ja '81
KANGAROOS
Travel 147:42 (c, 1) Mr '77
Nat Geog 155:cov. , 193-209 (c, 1)
F '79
Trav/Holiday 152:46 (c, 3) N '79
Trav/Holiday 153:97 (4) F '80
Trav/Holiday 154:58 (c, 4) Jl '80
KANSAS
--Caldwell (1880's)
Smithsonian 10:129 (2) F '80
--Emporia (1920's)
Am Heritage 30:84 (4) O '79
--Junction City (1900)
Am Heritage 32:85 (2) D '80
--Prairie land
Nat Geog 157:36-53 (c, 1) Ja '80
KANSAS--MAPS
--Sumner (1857 aerial view)
Am Heritage 30:20-1 (c, 1) F '79
KANSAS CITY, MISSOURI
Ebony 35:80-2 (3) N '80
--Flooded
Nat Geog 152:822 (c, 3) D '77
--Giralda Tower
Trav/Holiday 1 53:64 (c, 1) Ap '80
KARATE
Natur Hist 86:49 (2) Ja '77
Sports Illus 46:83 (4) My 2 '77
Ebony 32:cov. , 78-9 (c, 1) S '77
Ebony 33:76 (4) Je '78
Ebony 34:86 (2) Ag '79
KASHMIR, INDIA
Dal Lake
Trav/Holiday 148:41 (c, 2) D '77
--Srinagar
Travel 147:28 (c, 2) F '77
KASHMIR, INDIA/PAKISTAN
Trav/Holiday 149:cov. , 32-7 (c, 1)
Je '78
KASHMIR, PAKISTAN
--Hunza
Nat Geog 159:698-9 (c, 1) My '81
KATMAI NATIONAL MONUMENT,
ALASKA
Smithsonian 8:42-3 (c, 1) D '77
Nat Geog 156:40-1 (c, 2) Jl '79
Am Heritage 31:82-9 (c, 1) O '80
--1912 volcanic eruption
Am Heritage 31:85-7 (4) O '80
KATMANDU, NEPAL
Nat Geog 155:268-85 (map, c, 1)
F '79
Trav/Holiday 156:34-9 (c, 1) Ag

'81
--Market
Natur Hist 88:104-5 (4) O '79
--Monkey residents
Nat Geog 157:574-84 (c, 1) Ap
'80
KATYDIDS
Nat Wildlife 17:25 (c, 4) Ag '79
Nat Geog 157:410 (c, 4) Mr '80
Smithsonian 10:166 (c, 4) Mr '80
KAYAKING
Sports Illus 48:71 (c, 4) Je 12
'78
Sports Illus 49:56 (c, 2) S 18
'78
--Alaska
Nat Wildlife 16:50-5 (c, 1) O '78
--Capsizing (Switzerland)
Life 2:172 (c, 2) N '79
--Wales competition
Sports Illus 55:14-17 (c, 1) Jl
27 '81
--Western Arkansas river
Nat Wildlife 18:52 (c, 2) Ap '80
KAYAKS
Natur Hist 90:46 (c, 3) O '81
--Colorado
Nat Wildlife 15:30 (c, 4) Ap '77
--Montana
Nat Geog 152:12 (c, 1) Jl '77
--New York
Sports Illus 46:40-1 (c, 1) My
2 '77
KEAS (BIRDS)
Nat Geog 153:120 (c, 4) Ja '78
KELLER, HELEN
Am Heritage 31:77, 81-5 (3)
Ap '80
--Home (Tuscumbia, Alabama)
Travel 148:57 (c, 4) O '77
Trav/Holiday 153:68 (c, 4) Mr
'80
KELP
Nat Wildlife 15:12-16 (c, 1) O
'77
Nat Geog 153:526-7 (c, 1) Ap
'78
Life 2:138 (c, 2) S '79
Nat Geog 158:410-25 (c, 1) S '80
KELP INDUSTRY--HARVESTING
--China
Nat Geog 160:822-3 (c, 1) D '81
KENNAN, GEORGE
Smithsonian 8:79 (4) Ag '77
KENNEBEC RIVER, MAINE
Nat Geog 151:735 (c, 1) Je '77
KENNEDY, JOHN FITZGERALD
Am Heritage 28:7 (4) O '77

Ebony 33:74 (4) D '77
Ebony 34:185 (4) My '79
Life 3:138 (4) N '80
Am Heritage 32:64 (4) O '81
Ebony 36:33 (3) O '81
Life 4:111 (c, 4) N '81
--1961 inauguration
Am Heritage 28:54-5 (2) F '77
KENNY, SISTER ELIZABETH
Smithsonian 12:180-200 (1) N '81
KENTUCKY
Travel 148:46-51 (c, 1) Jl '77
--Eastern region
Trav/Holiday 150:48 (c, 1) O '78
--Farm
Smithsonian 11:76-82 (c, 1) Ag
'80
--Forest
Nat Geog 151:174 (c, 1) F '77
--Heartland
Trav/Holiday 155:56-61 (c, 1) Je
'81
--See also FRANKFORT; LOUIS-
VILLE
KENYA
Trav/Holiday 151:cov., 64-8 (c, 1)
Je '79
Smithsonian 10:40-51 (c, 1) Je '79
--Samburu Game Reserve
Smithsonian 9:cov., 34-45 (c, 1)
Ja '79
--Tana River
Natur Hist 90:33 (map, c, 4) Ap
'81
--Tsavo
Smithsonian 8:116-17 (c, 2) My
'77
Nat Geog 158:598-600 (c, 1) N '80
--Wildlife parks
Trav/Holiday 154:38-41 (map, c, 2)
N '80
--See also LAKE VICTORIA;
MOUNT KENYA; NAIROBI
KENYA--COSTUME
Smithsonian 8:54-5 (c, 2) Ap '77
--Masai tribe
Natur Hist 89:cov., 42-55 (c, 1)
Ag '80
--Masai woman
Natur Hist 86:61 (c, 4) Ag '77
--Nomads
Life 2:66-7 (c, 1) Ag '79
--Park guards
Nat Geog 159:288-9, 298-9 (c, 1)
Mr '81
--Samburu tribe
Smithsonian 10:cov., 40-7 (c, 1)
Je '79

--Samburu warrior hairstyle
 Smithsonian 10:10 (c, 4) Ag '79
--Tribes
 Smithsonian 10:cov., 40-9
 (map, c, 1) Je '79
KHRUSHCHEV, NIKITA
 Am Heritage 28:19, 88 (3) Ag
 '77
 Am Heritage 29:33 (c, 4) O '78
 Life 1:90-2 (3) D '78
 Life 2:146 (4) D '79
KHYBER PASS, PAKISTAN
 Nat Geog 151:124-5 (c, 1) Ja '77
 Nat Geog 159:668-9 (c, 1) My
 '81
KIBBUTZIM
--En Gedi, Israel
 Nat Geog 153:232-3 (c, 2) F '78
KILAUEA VOLCANO, HAWAII
--Eruption
 Natur Hist 86:36, 45 (c, 1) Ap
 '77
--Lava field
 Travel 147:44 (c, 1) F '77
--Researching temperature
 Smithsonian 9:53 (c, 1) Mr '79
KILLER WHALES
 Nat Wildlife 16:5-9 (c, 1) F '78
 Life 1:100-1 (c, 1) O '78
--Attacking blue whale
 Nat Geog 155:542-5 (c, 1) Ap
 '79
--In show (California)
 Trav/Holiday 151:86 (c, 4) Ap
 '79
KILNS
--Japan
 Nat Geog 152:850 (c, 4) D '77
--Outdoor (Mexico)
 Nat Geog 153:651 (c, 3) My '78
KIMBERLEY, SOUTH AFRICA
 Trav/Holiday 152:56-9, 68-9
 (c, 2) S '79
KIMONOS
 Sports Illus 53:37 (c, 4) Jl 14
 '80
KING, MARTIN LUTHER, JR.
 Ebony 34:148 (4) S '79
 Ebony 35:33 (4) F '80
 Ebony 35:110 (4) O '80
 Ebony 36:108 (4) N '80
 Ebony 36:33 (3) O '81
--1956
 Ebony 32:56, 60 (4) S '77
--Birthplace (Atlanta, Georgia)
 Ebony 35:62 (3) Ja '80
--Center for Social Change
 (Atlanta, Georgia)

 Ebony 35:60-4 (3) Ja '80
--Funeral
 Ebony 32:96 (4) F '77
 Ebony 36:95 (4) N '80
--Hearing of James Earl Ray
 Ebony 36:77-8 (4) Ap '81
--Memorial (Memphis, Tennessee)
 Ebony 36:130 (4) Je '81
--Rally for national King holiday
 Ebony 36:126-9 (c, 2) Mr '81
--Tombstone (Atlanta, Georgia)
 Ebony 34:75 (2) F '79
 Ebony 35:61 (4) Ja '80
KING ARTHUR
--Depicted in "Camelot"
 Life 4:86 (c, 4) Ja '81
--Lancelot and Guinevere (14th
 cent. painting)
 Natur Hist 87:66-7 (c, 2) Mr '78
KING CRABS
 Nat Geog 151:680 (c, 4) My '77
 Nat Geog 159:562-72 (c, 1) Ap
 '81
 Smithsonian 12:136 (c, 4) N '81
KING SNAKES
 Nat Wildlife 19:50-1 (c, 1) Ap '81
--Killed by fire
 Nat Geog 159:159 (c, 3) F '81
KINGFISHERS (BIRDS)
 Natur Hist 86:59-63 (c, 1) F '77
 Natur Hist 87:72 (painting, c, 4)
 My '78
 Nat Wildlife 17:24 (c, 4) Je '79
KINGLETS (BIRDS)
 Smithsonian 9:172-3 (c, 4) O '78
KINGSTON, JAMAICA
 Nat Geog 159:264-5 (c, 2) F '81
KINKAJOUS
 Trav/Holiday 149:42 (c, 4) Ap '78
KIOWA INDIANS (SOUTHWEST)
--Chief Satanta (1867)
 Am Heritage 29:70 (4) O '78
KISSING
 Sports Illus 51:60 (c, 4) Jl 30 '79
 Smithsonian 11:54-5 (4) O '80
--College graduation (New York)
 Nat Geog 151:717 (c, 1) My '77
KITCHENS
 Smithsonian 9:44 (c, 4) S '78
 Ebony 36:96 (4) F '81
 Ebony 36:140 (c, 2) Je '81
--19th cent. stove (Cape May, New
 Jersey)
 Trav/Holiday 153:64 (c, 3) My '80
--1800 (North Carolina)
 Travel 147:50 (4) My '77
--Early 20th cent. France
 Smithsonian 10:58 (c, 3) F '80

--1930's Midwest farm
 Natur Hist 87:79 (4) F '78
 Smithsonian 11:92-4 (painting, c, 1)
 N '80
--Jefferson's home (Monticello,
 Virginia)
 Trav/Holiday 156:28 (c, 2) Jl '81
--Ladakh, India
 Nat Geog 153:340-1 (c, 1) Mr
 '78
--Old home (Netherlands)
 Trav/Holiday 153:44 (c, 4) F '80
--Pakistan
 Natur Hist 88:19 (4) O '79
--Restaurant (Atlanta, Georgia)
 Ebony 35:63 (4) N '79
--South Carolina
 Ebony 32:92 (c, 4) Je '77
 Natur Hist 90:90-1 (2) Ag '81
--Wood-burning stoves
 Smithsonian 9:54-63 (c, 1) O '78
 Natur Hist 90:104, 110-11 (c, 1)
 O '81
KITE FLYING
 Nat Geog 151:73 (c, 3) Ja '77
 Smithsonian 11:48 (c, 1) Ag '80
--Guatemala
 Natur Hist 87:68-74 (c, 1) Mr '78
--Kite-fighting (Japan)
 Nat Geog 151:550-61 (c, 1) Ap
 '77
--Malaysia
 Trav/Holiday 151:34 (c, 2) Mr
 '79
--Singapore
 Nat Geog 159:552 (c, 1) Ap '81
KITES
--Japan
 Smithsonian 11:58 (c, 4) My '80
KITES (BIRDS)
 Nat Wildlife 15:34 (4) Ap '77
 Smithsonian 12:109 (painting, c, 4)
 S '81
KITTIWAKES (BIRDS)
 Natur Hist 87:47-52 (c, 1) F '78
 Natur Hist 88:72 (c, 3) Mr '79
KIWI BIRDS
 Natur Hist 89:28 (3) O '80
KLAMATH RIVER, CALIFORNIA
 Sports Illus 50:32-4 (c, 3) Je 4
 '79
KLEE, PAUL
--Twittering Machine (1922)
 Smithsonian 10:111 (painting, c, 4)
 N '79
KLONDIKE, YUKON, ALASKA/
 CANADA
--1898

 Am Heritage 31:90-9 (1) Ap '80
--Traveling in 1897-98 gold rush
 Smithsonian 7:106-13 (c, 1) F '77
--See also DAWSON CITY; GOLD
 RUSH
KLUANE NATIONAL PARK,
 YUKON, CANADA
 Nat Geog 153:564-5 (c, 1) Ap '78
KNIGHTS
--16th cent. Germany
 Nat Geog 154:701-3 (c, 1) N '78
--Cartoon of basketball teams as
 jousters
 Sports Illus 46:32-3 (c, 1) Ap 18
 '77
--Modern jousting tournament
 (Arizona)
 Smithsonian 12:94-103 (c, 1) Je
 '81
KNIVES
 Sports Illus 53:35, 42 (c, 2) Jl
 14 '80
--1850 scissors grinder
 Am Heritage 31:114 (painting, c, 2)
 Je '80
--Ancient Eskimo blade (Canada)
 Nat Geog 159:583 (c, 1) My '81
--Aztec ritual obsidian knife (Mexi-
 co)
 Nat Geog 158:cov. (c, 1) D '80
--Ceremonial (Ancient Peru)
 Smithsonian 8:90 (c, 4) D '77
--See also DAGGERS
KNIVES--CONSTRUCTION
 Sports Illus 53:36-7 (c, 3) Jl 14
 '80
KNOSSOS, CRETE
 Nat Geog 153:144-71 (c, 1) F '78
--Fresco
 Trav/Holiday 156:31 (c, 4) D '81
KNOX, HENRY
 Am Heritage 30:102 (drawing, 4)
 Ag '79
KOALAS
 Travel 147:43 (4) Mr '77
 Trav/Holiday 150:31 (c, 4) Ag '78
 Trav/Holiday 152:cov. (c, 1) N
 '79
KOHLRABI
 Ebony 33:154 (c, 4) Je '78
KORAN
--1369 frontispiece (Egypt)
 Smithsonian 12:110 (c, 4) Jl '81
KOREA
--1950's battlefield
 Smithsonian 12:56 (2) O '81
KOREA--ART
--2nd cent. B.C.--18th cent. A.D.

Smithsonian 10:110-17 (c, 1) My
'79
KOREA (SOUTH)
--Countryside
Trav/Holiday 148:37 (c, 1) D '77
--Kyongju
Trav/Holiday 156:40-5 (map, c, 1)
S '81
KOREA (SOUTH)--COSTUME
Nat Geog 156:770-97 (c, 1) D
'79
Trav/Holiday 153:74-6 (c, 1) My
'80
Trav/Holiday 156:40-5 (c, 1) S
'81
KOREA (SOUTH)--SOCIAL LIFE
AND CUSTOMS
--Masked dance drama
Natur Hist 86:cov., 43-6 (c, 1)
Mr '77
--Saluting the flag
Nat Geog 156:794-5 (c, 2) D '79
KOREAN WAR
Life 3:47-8 (2) D '80
--1950's Korean battlefield
Smithsonian 12:56 (2) O '81
KRAKATOA
--1883 eruption
Natur Hist 86:8 (painting, 4)
Ja '77
KRAKOW, POLAND
Trav/Holiday 155:65-9 (map, c, 1)
Mr '81
KREMLIN, MOSCOW, U. S. S. R.
Nat Geog 153:4-5, 22-3 (c, 1)
Ja '78
KU KLUX KLAN
Ebony 34:160 (4) D '78
Ebony 34:39 (4) Ja '79
Ebony 34:164-79 (2) O '79
Life 4:3, 32-40 (c, 1) Je '81
Ebony 36:34 (4) O '81
--1860's
Ebony 36:34 (engraving, 4) O '81
--1925 induction ceremony
(Fresno, California)
Am Heritage 31:58 (4) O '80
--Cross burning
Ebony 34:69 (4) Ag '79
Life 4:3 (c, 4) Je '81
--Parade (Alabama)
Ebony 35:55 (2) D '79
--Recruitment poster (Alabama)
Ebony 34:54 (4) F '79
--Summer camp (Alabama)
Life 2:108-9 (c, 1) Ag '79
KUALA LUMPUR, MALAYSIA
Nat Geog 151:640-3 (c, 1) My '77

KUBLAI KHAN
Natur Hist 90:72 (painting, 2) My
'81
Smithsonian 12:120 (painting, c, 4)
D '81
KURD PEOPLE (TURKEY)
--Baking bread
Nat Geog 152:101 (c, 1) Jl '77
KWAKIUTL INDIANS--ART
--Carved posts (British Columbia)
Nat Geog 154:481 (c, 1) O '78
KYOTO, JAPAN
Trav/Holiday 149:42-7 (map, c, 1)
Je '78
--Ryoanji temple
Smithsonian 9:132 (4) F '79

-L-

LA PAZ, BOLIVIA
Trav/Holiday 152:65 (c, 4) Ag '79
LABOR UNIONS
--Meeting (West Germany)
Nat Geog 152:162-3 (c, 2) Ag '77
--United Farm Workers (California)
Nat Geog 157:788-0 (c, 1) Jc '80
--See also DEMONSTRATIONS;
MOLLY MAGUIRES
LABOR UNIONS--HISTORY
--19th cent. strike
Am Heritage 31:17-19 (paint-
ing, c, 1) Je '80
--1922 textile workers strike (New
Hampshire)
Am Heritage 29:23 (2) O '78
--Union activity depicted on 19th
cent. cigar labels
Am Heritage 30:88 (painting, c, 4)
D '78
LABORATORIES
Smithsonian 8:54-63 (c, 1) Je '77
Ebony 34:64-5 (3) Mr '79
Ebony 35:112 (4) S '80
Smithsonian 11:51 (c, 4) Mr '81
Ebony 36:110 (4) My '81
--1930's (Alabama)
Life 4:17 (4) Mr '81
--California
Nat Geog 160:762 (c, 1) D '81
--Thomas Edison's (New Jersey)
Smithsonian 10:36-7 (c, 2) S '79
--Recreation of Edison's lab (Michi-
gan)
Am Heritage 32:101 (c, 3) D '80
--Switzerland
Life 3:57-8 (c, 3) My '80
--Tuskegee Institute, Alabama (late

19th cent.)
Am Heritage 28:68 (3) Ag '77
LABORERS
Ebony 32:106 (3) Je '77
--1904 Idaho
Am Heritage 32:28-9 (2) Ap '81
--1930's
Smithsonian 10:94-5 (2) Ja '80
--Clearing road (India)
Nat Geog 156:594-5 (c, 2) N '79
--Lunch hour (Ireland)
Nat Geog 159:454 (c, 3) Ap '81
--Mexico
Nat Geog 153:629 (c, 1) My '78
--Mill (Pittsburgh, Pennsylvania)
Sports Illus 51:36-7 (c, 1) D 24
'79
--Railroad workers (U. S. S. R.)
Smithsonian 8:36-9 (c, 1) F '78
--See also FACTORY WORKERS;
FARM WORKERS
LABRADOR RETRIEVERS
Life 1:112 (c, 2) O '78
LACE MAKING
--Belgium
Nat Geog 155:327 (c, 4) Mr '79
--Monastier, France
Nat Geog 154:541 (c, 4) O '78
LACQUER WARE
--14th cent. China
Nat Geog 156:241 (c, 2) Ag '79
--Japan
Smithsonian 10:57 (c, 4) Ja '80
LACQUERING
--Mexico
Nat Geog 153:668-9 (c, 1) My
'78
LACROSSE
--British Columbia
Nat Geog 154:480 (c, 4) O '78
LACROSSE--COLLEGE
Sports Illus 46:35-8 (c, 1) Ap
25 '77
Sports Illus 46:63 (4) Je 6 '77
Sports Illus 48:26-7 (c, 3) Ap
10 '78
Sports Illus 48:24-5 (c, 3) Je 5
'78
Sports Illus 50:20-1 (c, 3) Je 4
'79
Sports Illus 52:66-9 (4) Je 9 '80
Sports Illus 54:50, 53 (c, 4) Mr
30 '81
Sports Illus 54:26-7 (c, 2) Je 8
'81
Sports Illus 55:80 (c, 4) N 9 '81
--Faceoff
Sports Illus 50:59 (c, 4) Ap 16

'79
LACROSSE PLAYERS
Life 2:61 (c, 2) O '79
LADYBUGS
Nat Wildlife 17:58-9 (c, 4) D '78
Nat Wildlife 19:2 (c, 2) Je '81
LADY'S SLIPPERS (FLOWERS)
Am Heritage 28:101 (drawing, c, 4)
Je '77
Nat Wildlife 16:44 (c, 4) Je '78
Nat Wildlife 17:61 (c, 1) D '78
Nat Wildlife 17:56 (c, 1) Ap '79
Natur Hist 88:69 (c, 3) Ag '79
Nat Wildlife 18:3 (c, 4) Ap '80
LAFAYETTE, MARQUIS DE
Am Heritage 32:67 (drawing, 3)
O '81
--Painting by Samuel Morse (1825)
Smithsonian 12:24 (4) S '81
LAGOS, NIGERIA
Nat Geog 155:418-19 (c, 1) Mr '79
--Theater
Ebony 32:36 (c, 4) My '77
LA GUARDIA, FIORELLO
Ebony 32:129 (4) F '77
LAHORE, PAKISTAN
Nat Geog 159:688-9 (c, 1) My '81
--Badshahi Mosque
Trav/Holiday 153:94 (4) F '80
LAKE BAYKAL, SIBERIA, U. S. S. R.
Natur Hist 89:56-61 (c, 1) Ag '80
LAKE ERIE, NORTH AMERICA
Nat Geog 154:86-101 (c, 1) Jl '78
LAKE GEORGE, NEW YORK
--19th cent. painting
Am Heritage 31:28-9 (c, 2) Ap
'80
--1870
Am Heritage 28:116 (painting, c, 4)
Je '77
LAKE LOUISE, ALBERTA
Trav/Holiday 155:cov. (c, 1) My
'81
LAKE MICHIGAN, NORTH AMERICA
Smithsonian 8:79 (c, 4) Jl '77
Nat Wildlife 16:40 (c, 1) Je '78
Nat Geog 158:186-7 (c, 1) Ag '80
LAKE PLACID, NEW YORK
--Early 20th cent.
Life 3:8-10 (1) F '80
Am Heritage 33:57-69 (1) D '81
--1926
Sports Illus 52:37-8, 44, 48 (3)
Ja 14 '80
--1932 Olympics
Sports Illus 52:35-96 (2) Ja 14
'80
--1980 Olympic site

--Reindeer-pulled sled
 Nat Wildlife 16:50-2 (c, 3) D
 '77
LAPWINGS
 Smithsonian 12:60 (c, 4) O '81
LARKS
--Skylarks
 Smithsonian 9:170 (c, 4) O '78
LAS PALMAS, CANARY ISLANDS
 Smithsonian 8:99 (c, 3) S '77
LAS VEGAS, NEVADA
 Trav/Holiday 152:32 (4) Jl '79
 Trav/Holiday 153:cov., 40-3
 (c, 1) Ja '80
--Grand Prix race course
 Sports Illus 55:28-9 (c, 2) O 26
 '81
LASERS
 Nat Geog 152:510-11 (c, 2) O
 '77
 Smithsonian 9:44-5 (c, 3) S '78
 Smithsonian 9:94-5 (c, 3) O '78
--Fiber optics
 Nat Geog 156:517-35 (c, 1) O
 '79
LATIN AMERICA--MAPS
--Central America
 Nat Geog 160:59-61 (c, 1) Jl '81
--Maya Civilization region (Cen-
 tral America)
 Natur Hist 90:34-5 (2) Ag '81
LAUNDRY
--19th cent. loggers
 Smithsonian 11:125 (4) Ja '81
--Beating wash (India)
 Trav/Holiday 156:46 (c, 4) Jl
 '81
--Brazil
 Nat Geog 157:709 (c, 2) My '80
--By hand (U. S. S. R.)
 Nat Geog 155:779 (c, 1) Je '79
--Clotheslines (Faeroe Islands)
 Natur Hist 86:42 (c, 4) D '77
--Clotheslines (Oregon)
 Life 4:76 (c, 4) N '81
--Clotheslines (Pakistan)
 Nat Geog 159:694-5 (c, 1) My
 '81
--Clotheslines (Portugal)
 Trav/Holiday 148:63 (c, 4) N '77
--Clotheslines (Singapore)
 Life 2:68-9 (c, 1) Ag '79
 Nat Geog 159:541 (c, 2) Ap '81
--Hand washing (Virginia)
 Natur Hist 90:49 (c, 3) Je '81
--Hanging on line (Brazil)
 Nat Geog 152:704-5 (c, 1) N '77
--Using washboard (Alaska)

 Nat Geog 155:265 (c, 4) F '79
--Washing machines
 Ebony 34:118 (4) D '78
LAUREL TREES
 Nat Wildlife 17:58-9 (c, 1) D '78
LAVA
 Natur Hist 88:43 (4) O '79
--Kilauea, Hawaii
 Travel 147:44 (c, 1) F '77
--Lava pillows in seafloor rifts
 Nat Geog 156:700-1 (c, 2) N '79
--Lava rocks (Washington)
 Smithsonian 10:109 (c, 4) Ap '79
--Rock from Vesuvius, Italy
 Smithsonian 9:124 (4) Je '78
LAVENDER
 Smithsonian 12:156 (c, 1) D '81
Law. See JUSTICE, ADMINISTRA-
 TION OF
LAWRENCE, THOMAS E.
 Am Heritage 31:38 (4) Ag '80
 Smithsonian 11:164-5 (4) O '80
LAWYERS
 Ebony 33:33-42 (2) D '77
--19th cent. female lawyer
 Smithsonian 11:133 (painting, c, 2)
 Mr '81
--See also JUDGES; JUSTICE, AD-
 MINISTRATION OF; SUPREME
 COURT JUSTICES
LE CORBUSIER
--Villa Savoye, designed by him
 Life 2:83 (c, 4) S '79
LE HAVRE, FRANCE
 Nat Geog 154:872-3 (c, 1) D '78
LEAR, EDWARD
 Smithsonian 12:107-9 (drawing, 4)
 S '81
--Illustrations by him for limericks
 Smithsonian 12:112-16 (4) S '81
LEANING TOWER OF PISA, ITALY
 Trav/Holiday 156:50 (c, 1) O '81
LEATHER INDUSTRY
--Massachusetts
 Nat Geog 155:580-1 (c, 2) Ap '79
--Protecting reindeer skin (Norway)
 Nat Geog 152:369 (c, 4) S '77
LEAVES
 Nat Geog 151:478-9 (c, 1) Ap '77
 Nat Wildlife 15:2 (c, 1) O '77
 Natur Hist 89:42 (c, 1) Jl '80
--Fallen autumn leaves
 Natur Hist 88:64-5 (c, 1) Ag '79
 Nat Wildlife 19:32 (c, 1) O '81
--Green spring leaves
 Nat Wildlife 16:46-7 (c, 3) Ap '78
--Maple
 Nat Geog 154:237 (c, 4) Ag '78

LEBANON
--Anjar
 Nat Geog 153:868-9 (c, 1) Je '78
--See also BEIRUT
LEBANON--COSTUME
--Beirut's elite
 Life 3:30-4 (c, 1) S '80
LEE, RICHARD HENRY
 Smithsonian 8:103 (painting, c, 4)
 Ja '78
LEE, ROBERT E.
 Smithsonian 8:27 (4) Jl '77
LEECHES
 Nat Geog 157:139 (c, 4) Ja '80
LEEWARD ISLANDS
--St. Kitts and Nevis
 Trav/Holiday 155:63-5, 72-4
 (map, c, 2) F '81
LEGER, FERNAND
--Study for "the City" (1919)
 Smithsonian 10:108 (painting, c, 2)
 N '79
--Woman with a Book
 Life 2:92 (painting, c, 4) S '79
Legislatures. See GOVERNMENT
 LEGISLATURES
LEIS
 Sports Illus 52:29 (c, 1) My 12
 '80
--Lei making (Hawaii)
 Trav/Holiday 154:60 (c, 3) N '80
 Trav/Holiday 155:62 (c, 3) Mr
 '81
LEMURS
 Smithsonian 8:48 (c, 4) Mr '78
 Natur Hist 87:74, 81 (c, 1) My
 '78
 Smithsonian 9:72-81 (c, 1) N '78
 Smithsonian 11:178 (c, 4) S '80
 Natur Hist 90:94 (3) Mr '81
--See also LORISES
LENIN, NIKOLAI
--Billboard
 Nat Geog 157:484 (c, 1) Ap '80
LENINGRAD, U.S.S.R.
 Trav/Holiday 151:109 (4) My '79
--1851 palace drawing room
 Smithsonian 10:56 (painting, c, 4)
 Ag '79
--Silhouette of skyline
 Travel 147:50-1 (c, 2) Ap '77
LEON, NICARAGUA
 Travel 148:44 (2) Jl '77
LEONARDO DA VINCI
--Mona Lisa recreated in pasture
 grass (California)
 Life 2:104 (c, 2) Jl '79
--Paintings and drawings

 Nat Geog 152:296-329 (c, 1) S '77
--Self-portrait
 Nat Geog 152:297, 329 (paint-
 ing, c, 1) S '77
--Statue (Milan, Italy)
 Travel 148:44 (c, 1) O '77
LEOPARDS
 Natur Hist 86:63 (c, 2) My '77
 Natur Hist 86:75 (c, 2) N '77
 Trav/Holiday 154:16 (4) S '80
 Nat Geog 159:286 (c, 1) Mr '81
--Postage stamp mosaic (Taiwan)
 Life 2:51 (c, 2) F '79
LEPROSY
 Nat Geog 160:205-6 (c, 2) Ag '81
--Japanese hospital
 Nat Geog 152:852-3 (c, 1) D '77
--Leper colony (Molokai, Hawaii)
 Nat Geog 160:204-5 (c, 2) Ag '81
LEWIS, MERIWETHER
--Wax effigy
 Am Heritage 30:10 (drawing, c, 4)
 Ag '79
LEWIS AND CLARK EXPEDITION
 (1804-1805)
--Indian relics obtained by them
 Am Heritage 30:10 (c, 4) Ag '79
LHASA, TIBET
 Smithsonian 7:78-84 (c, 3) Ja '77
 Nat Geog 157:218-27, 235-41 (c, 1)
 F '80
 Nat Geog 160:554-5 (c, 1) O '81
LIBERIA
--Kakata
 Ebony 32:80-6 (2) Ap '77
LIBERIA--COSTUME
--Military
 Life 3:52-6 (c, 1) Je '80
--President
 Ebony 35:32 (c, 4) D '79
LIBERIA--POLITICS AND GOVERN-
 MENT
--Coup d'état
 Life 3:50-6 (c, 1) Je '80
--Execution of officials by firing
 squad
 Ebony 36:109 (3) Ja '81
LIBERTY, STATUE OF, NEW
 YORK
 Nat Geog 156:58 (c, 1) Jl '79
 Life 2:10-11, 14 (c, 1) D '79
 Nat Geog 160:599 (c, 1) N '81
 Nat Wildlife 20:17 (3) D '81
--Close-up of face
 Am Heritage 32:cov. (c, 1) O '81
--Living portrait composed of men
 Am Heritage 28:92 (4) Je '77
--Model (Wisconsin)

Natur Hist 90:74-5 (c, 1) Jl '81
--Unassembled (1885)
Am Heritage 28:100 (3) F '77
LIBERTY BELL
Ebony 34:41 (c, 4) My '79
--Living portrait composed of men
Am Heritage 28:92 (4) Je '77
LIBRARIES
--12th cent. monastery (Prague,
Czechoslovakia)
Nat Geog 155:550-2 (c, 1) Ap '79
--Asheville, North Carolina mansion
Trav/Holiday 150:50 (4) N '78
--Bookshelves
Ebony 33:45 (4) Je '78
--Burndy Collection, Connecticut
Smithsonian 10:128-35 (c, 2) O
'79
--California
Smithsonian 12:63 (c, 4) Jl '81
--Card catalog drawer
Smithsonian 12:90 (c, 4) D '81
--College
Ebony 34:82 (3) Ap '79
--Columbus, Indiana
Nat Geog 154:388-9 (c, 1) S '78
--Georgia college
Ebony 36:112 (4) My '81
--Home
Smithsonian 11:81 (c, 1) N '80
--Home (California)
Ebony 33:149 (c, 2) F '78
--Home (Connecticut)
Smithsonian 10:102-3, 108 (c, 3)
My '79
--Home (New York)
Sports Illus 50:72 (c, 4) Je 4
'79
Ebony 35:85 (3) D '79
--Italian mansion
Smithsonian 9:52 (c, 4) Ja '79
--Martin Luther King, Jr.
archives (Atlanta, Georgia)
Ebony 35:62 (4) Ja '80
--Menomonie, Wisconsin
Am Heritage 32:59 (4) O '81
--Morgan Library, New York City,
New York
Smithsonian 10:76-83 (c, 1) S
'79
--Pompidou Center, Paris, France
Smithsonian 8:22-3 (c, 2) Ag '77
--Public (Atlanta, Georgia)
Ebony 35:64 (4) Ja '80
--Rockefeller Archives, New York
Smithsonian 8:90-7 (c, 1) S '77
--Salt Lake City, Utah

Smithsonian 12:86-94 (c, 1) D '81
--Shanghai, China
Nat Geog 158:36-7 (c, 2) Jl '80
--Staircase of LBJ library (Austin,
Texas)
Am Heritage 32:10 (c, 4) D '80
--Trinity College, Dublin, Ireland
Smithsonian 8:75 (c, 1) O '77
--Washington, D. C.
Ebony 32:54, 60 (4) Je '77
--Washington, D. C. research library
Smithsonian 12:94-6 (c, 4) My '81
--Yale University's Sterling Library, New Haven, Ct.
Sports Illus 54:35 (c, 4) Mr 30
'81
--See also DEWEY, MELVIL; LIBARY OF CONGRESS; NEW
YORK PUBLIC LIBRARY
LIBRARY OF CONGRESS, WASHINGTON, D. C.
Ebony 33:78-80 (2) Ja '78
Smithsonian 11:38-49 (c, 1) Ap
'80
LIBYA--COSTUME
Life 3:102-8 (c, 1) F '80
LICE
--Delousing in the Middle Ages
Natur Hist 86:88-9 (drawing, 2)
My '77
LICENSE PLATES
--Mississippi
Nat Geog 160:387 (c, 4) S '81
LICHENS
Smithsonian 8:50 (c, 4) S '77
Nat Geog 156:764 (c, 1) D '79
--Covering koa trees
Nat Wildlife 19:24 (c, 3) Je '81
LICORICE PLANTS
Natur Hist 88:96 (drawing, 4) Je
'79
LIECHTENSTEIN
Nat Geog 159:272-83 (map, c, 1)
F '81
LIECHTENSTEIN--COSTUME
Nat Geog 159:272-83 (c, 1) F '81
LIEGE, BELGIUM
Trav/Holiday 155:45-9 (c, 1) Mr
'81
LIFFEY RIVER, DUBLIN, IRELAND
Nat Geog 159:444-5 (c, 1) Ap '81
LIGHT BULBS
--19th cent. Edison's bulbs
Smithsonian 10:34-8 (c, 2) S '79
--Bamboo filament
Nat Geog 158:529 (c, 1) O '80
LIGHTHOUSES

LIND, JENNY
 Am Heritage 28:2, 98-107 (c, 1)
 O '77
LINDBERGH, CHARLES
 Life 2:148 (4) D '79
 Smithsonian 11:152-3 (4) My '80
 Am Heritage 31:31 (4) Je '80
 Life 4:10 (4) Ap '81
LINNAEUS, CAROLUS
 Natur Hist 90:40 (4) Ja '81
LION TAMING
 Sports Illus 47:82-5 (c, 1) S 26
 '77
LIONS
 Trav/Holiday 149:114 (4) Mr '78
 Trav/Holiday 149:96 (4) Ap '78
 Sports Illus 48:71 (c, 4) My 22
 '78
 Trav/Holiday 151:19 (4) Mr '79
 Trav Holiday 154:40 (c, 4) N '80
 Trav/Holiday 155:18 (4) Ja '81
 Trav/Holiday 155:28 (4) Mr '81
 Natur Hist 90:82 (c, 4) Jl '81
--Cubs
 Smithsonian 8:92 (4) Jl '77
 Sports Illus 48:38 (c, 2) My 29
 '78
--Sculpture in front of New York
 Public Library (N.Y.)
 Smithsonian 12:16 (4) My '81
--See also MOUNTAIN LIONS
LIPPI, FRA FILIPPO
--Painting of St. Benedict miracle
 Smithsonian 11:80-1 (c, 2) Je
 '80
LIPTON, SIR THOMAS
 Smithsonian 11:38-47 (c, 1) Ag
 '80
LIQUOR
--Glasses of liqueurs
 Ebony 35:86-92 (c, 2) Ja '80
--Sake
 Trav/Holiday 153:18-20 (4) My
 '80
LIQUOR INDUSTRY
--1920's distillery (Michigan)
 Smithsonian 10:124-5 (4) Je '79
--Fermenting tanks (Kentucky)
 Travel 148:49 (4) Jl '77
--First government bonded ware-
 house
 Natur Hist 89:90 (4) D '80
--Harvesting tequilana plants
 (Mexico)
 Nat Geog 153:632-3 (c, 1) My
 '78
--Kentucky moonshiners
 Natur Hist 89:86-7 (2) D '80

--Tapping cacti (Mexico)
 Nat Geog 158:730 (c, 4) D '80
--Virginia still
 Natur Hist 89:88-9 (1) D '80
--See also PROHIBITION MOVE-
 MENT
LISBON, PORTUGAL
 Trav/Holiday 148:58-63, 90 (c, 1)
 N '77
 Nat Geog 158:811-13, 831 (c, 1)
 D '80
--Gulbenkian's museum
 Smithsonian 11:42-51 (c, 1) Jl '80
LITCHFIELD, CONNECTICUT
--Talmadge House
 Trav/Holiday 151:38 (4) Je '79
LITTLE ROCK, ARKANSAS
 Nat Geog 153:404-6 (c, 1) Mr '78
LIVERPOOL, ENGLAND
--Edge Hill Station
 Smithsonian 10:106-7 (c, 1) S '79
LIVING ROOMS
 Sports Illus 53:70 (c, 2) S 29 '80
--Atlanta, Georgia
 Ebony 35:92-3 (c, 2) O '80
--California
 Ebony 35:41 (c, 3) My '80
--Elegant (Pakistan)
 Nat Geog 159:688 (c, 3) My '81
--Las Vegas, Nevada
 Ebony 36:34 (c, 3) My '81
--Mansion (California)
 Ebony 35:126 (c, 3) Mr '80
--Mansion (Italy)
 Smithsonian 9:50-1 (c, 2) Ja '79
Lizards. See REPTILES
LLAMAS
 Travel 147:45, 47 (c, 3) Ja '77
 Smithsonian 8:47 (c, 3) Mr '78
 Smithsonian 10:118-26 (c, 2) D
 '79
 Smithsonian 10:12 (4) F '80
 Natur Hist 90:72-3 (c, 1) N '81
 Natur Hist 90:62-73 (c, 1) D '81
--Ancient gold sculpture (Peru)
 Smithsonian 8:91 (c, 2) D '77
LOBELIAS
 Am Heritage 28:97 (drawing, c, 4)
 Je '77
LOBSTER INDUSTRY
--Lobster pots (Maine)
 Travel 147:cov., 26-8 (c, 1) My
 '77
--Maine
 Nat Wildlife 15:42-9 (c, 1) Ap '77
--Raised in aquaculture project
 Life 3:62 (c, 2) Ja '80
LOBSTERS

Nat Wildlife 15:45 (c, 4) Ap '77
Nat Geog 153:501 (c, 4) Ap '78
Nat Geog 154:374 (c, 4) S '78
LOCH NESS, SCOTLAND
Nat Geog 151:758-79 (c, 1) Je
'77
LOCH NESS MONSTER (SCOTLAND)
Nat Geog 151:758-79 (c, 1) Je
'77
Nat Wildlife 16:13 (drawing, c, 2)
Ap '78
Natur Hist 89:130-1 (painting, 2)
Ap '80
LOCKER ROOMS
Sports Illus 52:6 (4) Ap 7 '80
--Baseball
Ebony 34:85 (2) O '79
Sports Illus 54:16-17 (c, 1) Je
22 '81
--Basketball
Sports Illus 53:88-9 (c, 1) D 1
'80
--Football
Sports Illus 53:60 (4) N 3 '80
Sports Illus 53:48 (4) N 17 '80
LOCKS
--Padlock
Ebony 34:49 (4) Ag '79
Ebony 36:96 (4) N '80
--Steel gates on apartment door
Ebony 34:36 (4) Ag '79
LOCKWOOD, BELVA
Smithsonian 11:133-50 (c, 1) Mr
'81
LOCOMOTIVES
--1831 "John Bull"
Am Heritage 32:98-103 (c, 1) Ag
'81
Smithsonian 12:18 (c, 4) Ag '81
Smithsonian 12:151-4 (c, 1) D
'81
--1852 (Missouri)
Am Heritage 31:86-7 (1) D '79
--1883 steam locomotive
Smithsonian 8:89 (4) Ag '77
--1894
Am Heritage 28:93 (3) Ag '77
--Abandoned (Norway)
Nat Geog 154:274-5 (c, 1) Ag '78
--China
Nat Geog 157:302-3 (c, 1) Mr
'80
--Diesel engine (U. S. S. R.)
Smithsonian 8:44-5 (c, 4) F '78
--Steam (Florida)
Smithsonian 11:151 (c, 2) My '80
--See also RAILROADS; TRAINS
LOCUSTS

Natur Hist 87:6-18 (3) D '78
Nat Geog 156:628-9 (c, 2) N '79
Nat Geog 158:566 (c, 4) O '80
--1958 plague (Ethiopia)
Natur Hist 87:6-7 (2) D '78
LOG CABINS
Natur Hist 87:100-1 (4) Je '78
--18th cent. U. S.
Nat Wildlife 15:6-7 (painting, c, 1)
Ja '77
--1836 Midwest
Natur Hist 87:80 (drawing, 4) Ag
'78
--Japan
Nat Geog 157:85 (c, 3) Ja '80
--Maine
Nat Geog 151:733 (c, 3) Je '77
--Midwest prairie
Nat Wildlife 17:6-7 (c, 1) Je '79
--Montana
Nat Geog 152:17 (c, 4) Jl '77
--Ontario
Nat Geog 154:780-1 (c, 4) D '78
--Raised food storage cabin (Alaska)
Travel 147:56 (3) Ap '77
LOG SPLITTING
--France
Nat Geog 154:540-1 (c, 2) O '78
--New Brunswick
Nat Geog 158:385 (c, 3) S '80
--Sawing wood (1842)
Am Heritage 31:11 (painting, c, 2)
Je '80
Logging. See LUMBERING
LOGROLLING
--Wisconsin
Nat Geog 152:32 (c, 4) Jl '77
LONDON, JACK
Am Heritage 28:98-105 (c, 1) Ag
'77
LONDON, ENGLAND
Trav/Holiday 151:96-7 (4) Mr '79
Nat Geog 156:454-5 (c, 1) O '79
--19th cent. Egyptian Hall
Smithsonian 9:68-77 (drawing, 1)
Ap '78
--Bond Street
Life 3:98-9 (1) Ag '80
--Crystal Palace
Smithsonian 9:82 (4) Ap '78
--Model landscape (Christchurch,
England)
Travel 147:50-3 (2) Je '77
--National Theater
Smithsonian 8:66-71 (c, 1) Je '77
--Natural History Museum
Natur Hist 90:38-47 (c, 1) Ja '81
--Office building

Smithsonian 7:99 (c, 3) F '77
--Paddington Station
Smithsonian 10:102-3 (c, 3) S '79
--Royal Cottage (Kew Gardens)
Trav/Holiday 151:16 (4) F '79
--St. Paul's Cathedral
Life 4:74 (c, 2) Jl '81
--Soane Museum
Smithsonian 8:100-7 (c, 1) Ap
'77
--Small hotels
Trav/Holiday 151:48-51 (c, 1)
Mr '79
--Tower Bridge
Smithsonian 9:102-3 (c, 3) My
'78
--Whitehall diorama
Smithsonian 9:40-1 (c, 2) Je '78
--Wine bars
Trav/Holiday 153:16-18, 24 (4)
F '80
--See also BUCKINGHAM PALACE;
THAMES RIVER; TOWER
OF LONDON
LONG, HUEY
Am Heritage 30:42 (4) Ap '79
LONG ISLAND, NEW YORK
--Eastern Suffolk
Nat Geog 157:662-85 (map, c, 1)
My '80
--Montauk Point Lighthouse
Trav/Holiday 154:5 (3) Jl '80
Am Heritage 32:29 (c, 2) Je '81
--Old Westbury Gardens
Trav/Holiday 156:24 (c, 4) Ag
'81
LONG ISLAND SOUND, NEW YORK
Nat Geog 157:668 (c, 3) My '80
LOONS (BIRDS)
Nat Wildlife 17:38-9 (c, 1) Ag
'79
--Covered with oil from spill
Sports Illus 46:97 (c, 4) Ja 10
'77
Loopers. See MEASURING WORMS
LORISES
Natur Hist 86:70 (c, 1) Ja '77
Natur Hist 86:82 (painting, c, 2)
Mr '77
Smithsonian 10:100-1 (c, 3) N
'79
LOS ANGELES, CALIFORNIA
Ebony 33:100 (4) F '78
Nat Geog 155:26-58 (c, 1) Ja '79
Trav/Holiday 156:57-61 (c, 1) N
'81
--1920's oil industry
Smithsonian 11:187-205 (2) O '80

--East Los Angeles
Nat Geog 157:787, 800-1 (c, 1)
Je '80
--East Los Angeles street murals
Smithsonian 9:105-11 (c, 1) O
'78
--Mural of California history
Life 3:87-90 (c, 1) D '80
--Restaurants
Trav/Holiday 152:46-9 (c, 2) S
'79
--Santa Monica Mountains National
Recreation Area
Smithsonian 10:26-35 (c, 1) Jl '79
LOUIS, JOE
Ebony 33:126 (3) Mr '78
Am Heritage 29:84-9 (1) O '78
Ebony 34:43-50 (2) N '78
Ebony 36:132-8 (1) Je '81
--Funeral (Nevada)
Ebony 36:133-8 (3) Je '81
LOUIS IX (FRANCE)
--Statue (St. Louis, Missouri)
Trav/Holiday 150:26 (4) Ag '78
LOUIS XIV (FRANCE)
Smithsonian 7:45 (sculpture, c, 4)
Mr '77
LOUISIANA
--Atchafalaya Basin
Nat Geog 156:378-97 (map, c, 1)
S '79
Nat Wildlife 17:42-9 (c, 1) O '79
Nat Wildlife 19:14-15 (c, 1) O
'81
--Barataria region
Am Heritage 31:65-75 (map, c, 2)
Ag '80
--Bayou Lafourche area
Trav/Holiday 149:36-9, 86 (c, 1)
Mr '78
--Gulf of Mexico area
Nat Geog 153:205-15 (c, 1) F '78
--See also BATON ROUGE; LONG,
HUEY; NEW ORLEANS
LOUISVILLE, KENTUCKY
Nat Geog 151:269 (c, 3) F '77
Trav/Holiday 151:53-5, 66-70
(c, 1) Mr '79
LOUVRE, PARIS, FRANCE
Natur Hist 89:32-3 (c, 1) Jl '80
LOWELL, JAMES RUSSELL
Am Heritage 30:106 (4) F '79
Smithsonian 11:214 (4) N '80
LOWELL, MASSACHUSETTS
Life 3:89-91 (c, 1) Jl '80
LUBLIN, POLAND
--17th cent. Jewish quarter
Smithsonian 9:42 (c, 4) Je '78

Luge. See BOBSLEDDING
LUGGAGE
 Ebony 32:143-5 (c, 2) Ap '77
--On rolling cart
 Ebony 34:78 (2) N '78
--Sports gear bags
 Sports Illus 47:50-1 (c, 3) Jl 18
 '77
--Suitcases
 Trav/Holiday 149:50 (4) My '78
--See also BACKPACKS
LUMBERING
--1884 log jam (Minnesota)
 Nat Geog 152:32-3 (2) Jl '77
--1886 redwoods (California)
 Am Heritage 29:9 (2) D '77
--Alaska
 Smithsonian 12:36 (c, 4) Ag '81
--Arkansas
 Nat Geog 153:417 (c, 3) Mr '78
--Brazil
 Nat Geog 152:714-15 (c, 1) N
 '77
 Life 3:76-80 (c, 1) Ja '80
--California
 Nat Geog 152:358-9 (c, 1) S '77
 Smithsonian 9:38-41 (c, 1) Jl '78
--Clear-cut area (Alaska)
 Life 2:108-9 (c, 1) F '79
--Feeding logs into mill (Washing-
 ton)
 Nat Geog 154:618 (c, 3) N '78
--Harvesting timber felled in
 Mount St. Helens eruption
 (1980; Washington)
 Nat Geog 160:720-1 (c, 1) D '81
--Maine
 Nat Geog 151:734-5 (c, 4) Je '77
--Oregon
 Nat Wildlife 19:4-11 (c, 1) Ag
 '81
--Pulpwood (Quebec)
 Nat Geog 151:458-9 (c, 1) Ap '77
--Washington
 Nat Geog 151:84-5 (c, 1) Ja '77
--Washington millpond
 Smithsonian 8:78-9 (c, 1) My '77
--See also SAWMILLS
LUMBERING--TRANSPORTATION
--1855 Michigan
 Natur Hist 87:83 (painting, c, 2)
 Ag '78
--1886 lumber raft trip (Wisconsin)
 Am Heritage 30:100-7 (3) O '79
--Chips for pulp mill (British
 Columbia)
 Nat Geog 154:472-3 (c, 1) O '78
--Georgia

 Nat Geog 154:243 (c, 1) Ag '78
--Trucking redwoods (California)
 Nat Wildlife 17:20 (c, 4) F '79
--Washington
 Nat Geog 152:42-3 (c, 2) Jl '77
LUMBERJACKS
--19th cent.
 Smithsonian 11:125 (4) Ja '81
--Alaska
 Nat Geog 155:247 (c, 3) F '79
--California
 Nat Geog 152:331 (c, 1) S '77
--Oregon
 Nat Geog 155:498 (c, 1) Ap '79
 Nat Wildlife 19:5-9 (c, 1) Ag '81
LUMPFISH
 Nat Wildlife 19:36 (c, 4) D '80
LUPINES
 Natur Hist 86:43 (c, 4) Je '77
 Natur Hist 89:42 (c, 3) S '80
LURAY CAVERNS, VIRGINIA
 Trav/Holiday 152:6 (4) Ag '79
LUTE PLAYING
--Nepal
 Nat Geog 151:505 (c, 4) Ap '77
LUXEMBOURG
 Trav/Holiday 154:51-5 (map, c, 1)
 S '80
LYNCHINGS
 Ebony 34:164 (4) O '79
--1930 (Indiana)
 Ebony 35:148 (3) Ap '80
LYNXES
 Nat Geog 151:161 (painting, c, 3)
 F '77
 Smithsonian 8:14 (4) D '77
 Smithsonian 9:75 (c, 4) Je '78
 Nat Geog 156:765 (c, 4) D '79
 Nat Wildlife 18:28C-28D (draw-
 ing, 1) O '80
 Natur Hist 90:52 (c, 4) N '81
 Smithsonian 12:71 (c, 1) D '81

-M-

MacARTHUR, DOUGLAS
--Memorial (Norfolk, Virginia)
 Travel 147:35 (4) Ap '77
MACAU
 Travel 147:33-5 (c, 1) F '77
MACAWS
 Smithsonian 8:107 (c, 3) O '77
 Trav/Holiday 149:44 (c, 2) Mr
 '78
 Smithsonian 10:73 (c, 1) S '79
 Trav/Holiday 152:44 (c, 4) O '79
 Smithsonian 12:108 (painting, c, 4)

S '81
Nat Geog 150:764 (c, 2) D '81
McCARTHY, JOSEPH
Am Heritage 28:14 (4) Ag '77
Macedonia. See GREECE,
ANCIENT
MACHINERY
--Medieval designs for advanced
machinery
Smithsonian 9:114-23 (c, 2) O
'78
MACHU PICCHU, PERU
Travel 147:42-7 (c, 1) Ja '77
McKEAN, THOMAS
Smithsonian 8:102 (painting, c, 4)
Ja '78
MACKENZIE RIVER, CANADA
Smithsonian 8:38-43 (map, c, 1)
S '77
MACKINAC ISLAND, MICHIGAN
Am Heritage 29:50-9 (c, 1) Ag
'78
Nat Geog 155:838-9 (c, 2) Je '79
Natur Hist 89:35-41 (c, 1) My
'80
McKINLEY, WILLIAM
--1896 presidential campaign
Am Heritage 31:6-8 (c, 3) Ap '80
--1901 inaugural badge
Smithsonian 7:110 (c, 4) Ja '77
McLOUGHLIN, JOHN
Am Heritage 28:65 (2) Je '77
McPHERSON, AIMEE SEMPLE
Am Heritage 28:62 (2) O '77
MADAGASCAR
Nat Geog 160:424-6, 448-51
(map, c, 1) O '81
MADAGASCAR--COSTUME
Nat Geog 160:448-51 (c, 1) O '81
MADEIRA
Trav/Holiday 153:60-5 (map, c, 1)
F '80
MADEIRA--COSTUME
Trav/Holiday 153:65 (c, 2) F '80
MADISON, DOLLEY
Smithsonian 8:26 (4) Jl '77
Smithsonian 10:173-85 (paint-
ing, c, 4) N '79
MADISON, JAMES
Am Heritage 28:112 (painting, c, 4)
Ap '77
Am Heritage 28:42 (painting, 4)
Ag '77
Smithsonian 10:174 (painting, c, 4)
N '79
--Virginia estate
Smithsonian 10:176-7 (4) N '79
MADISON, WISCONSIN

--State Capitol
Ebony 34:74 (2) O '79
MADISON SQUARE GARDEN, NEW
YORK CITY, NEW YORK
--1879-1979 events
Sports Illus 51:supplement (c, 4)
N 5 '79
MADRID, SPAIN
Travel 148:cov., 26-33 (c, 1) O
'77
Nat Geog 153:318-19 (c, 1) Mr
'78
MADRONA TREES
Nat Geog 156:138 (c, 4) Jl '79
MAGAZINES
--Early 20th cent. movie magazine
covers
Life 3:89 (c, 4) F '80
--Early 20th cent. Physical Culture
cover
Am Heritage 33:25 (c, 4) D '81
--1920's cover of "Smart Set"
Smithsonian 11:154 (c, 4) S '80
MAGELLAN, FERDINAND
--Map of 1519 voyage
Smithsonian 11:120 (c, 3) Je '80
MAGIC ACTS
Ebony 32:88-94 (2) Ap '77
--18th cent. projection effects
Smithsonian 12:120-4 (4) Jl '81
--Magic show (Massachusetts)
Smithsonian 12:110-19 (c, 1) N
'81
MAGRITTE, RENE
--The Therapeutist sculpture
Smithsonian 11:166 (4) Ap '80
MAILBOXES
--Georgia
Nat Geog 152:648 (c, 2) N '77
MAIMONIDES
--Statue of him (Spain)
Smithsonian 9:10 (4) Ag '78
MAINE
Nat Geog 151:726-56 (map, c, 1)
Je '77
--Allagash Waterway
Nat Geog 159:381 (c, 4) Mr '81
--Baxter State Park
Am Heritage 29:49-53 (map, c, 1)
Je '78
--Deer Island
Travel 147:cov., 24-8 (map, c, 1)
My '77
--Eastport area
Nat Wildlife 19:34, 42 (map, c, 4)
D '80
--Madawaska area
Nat Geog 158:380-409 (map, c, 1)

S '80
--Northeast harbor
Sports Illus 52:64-5, 72 (c, 1)
Je 16 '80
--Pemaquid Lighthouse
Trav/Holiday 155:70 (c, 4) My
'81
--Snow scenes
Nat Wildlife 16:14-19 (c, 1) D
'77
--Stonington
Nat Wildlife 15:46-7 (c, 1) Ap
'77
--See also ACADIA NATIONAL
PARK; KENNEBEC RIVER;
PENOBSCOT RIVER; PORT-
LAND
MALARIA
Nat Geog 156:430-1 (map, c, 2)
S '79
MALAYSIA
Nat Geog 151:634-67 (map, c, 1)
My '77
Trav/Holiday 151:34-8 (c, 2) Mr
'79
--See also KUALA LUMPUR
MALAYSIA--ART
--Temple statue
Trav/Holiday 148:41 (c, 2) D '77
--Wooden sculpture
Trav/Holiday 155:79 (c, 4) F '81
MALAYSIA--COSTUME
Nat Geog 151:634-67 (c, 1) My
'77
Trav/Holiday 151:34-8 (c, 2) Mr
'79
MALAYSIA--HISTORY
--1909 photo of rulers
Natur Hist 87:36-7 (3) My '78
MALCOLM X
Nat Geog 151:191 (4) F '77
Ebony 32:75 (4) Je '77
--Tombstone (New York)
Ebony 34:76 (4) F '79
MALDIVE ISLANDS
Nat Geog 160:424-35 (map, c, 1)
O '81
MALDIVE ISLANDS--COSTUME
Nat Geog 160:432-35 (c, 2) O
'81
MALI
Ebony 33:166 (c, 4) O '78
--See also TIMBUKTU
MALI--COSTUME
Natur Hist 86:68-75 (c, 1) My
'77
Ebony 33:166 (c, 4) O '78
MALI--HISTORY

--Timbuktu's history
Natur Hist 86:68-75 (c, 1) My '77
MALLARDS
Nat Wildlife 15:50-1 (painting, c, 1)
O '77
Nat Wildlife 17:50 (c, 4) D '78
Nat Geog 155:344-5 (c, 1) Mr '79
Nat Wildlife 18:61 (painting, c, 4)
D '79
Nat Wildlife 18:49 (c, 4) O '80
Nat Wildlife 20:54-5 (c, 1) D '81
--In flight
Life 2:106-7 (c, 1) F '79
Smithsonian 10:61 (c, 1) Je '79
Nat Wildlife 18:30-1 (painting, c, 1)
O '80
MALNUTRITION
--Africa
Ebony 33:81 (2) D '77
--Ethiopian refugees (Somalia)
Life 4:40-1 (c, 2) Ap '81
--Laotian refugees (Thailand)
Nat Geog 157:636 (c, 1) My '80
--Somalia
Nat Geog 159:760-1 (c, 1) Je '81
Life 4:21 (4) Je '81
--Uganda
Life 2:133 (3) Je '79
Nat Geog 158:81 (c, 1) Jl '80
Life 3:126-7 (c, 1) O '80
MALTA, ANCIENT--RELICS
--ca. 3500 B. C.
Nat Geog 152:614-19 (c, 1) N '77
MAMMOTHS
Smithsonian 10:125-6 (c, 3) S '79
--Preserved in ice (U. S. S. R.)
Smithsonian 8:60-9 (c, 1) D '77
MAN (ISLE OF), GREAT BRITAIN
Trav/Holiday 151:54-6 (map, c, 1)
Je '79
Smithsonian 10:77-83 (c, 1) Jl '79
MAN (ISLE OF), GREAT BRITAIN
--Mansion
Sports Illus 49:37 (c, 1) N 13 '78
MAN, PREHISTORIC
Smithsonian 11:90-103 (c, 1) Je
'80
--Australopithecus afarensis (Tan-
zania)
Nat Geog 155:448-52 (painting, c, 1)
Ap '79
--Australopithecus Lucy's skeleton
Natur Hist 90:90-2 (3) Ap '81
--Australopithecus skull
Smithsonian 8:18 (drawing, 4) Jl
'77
--Bones and skulls
Life 4:109-20 (c, 1) D '81

--Bronze Age skulls (Athens)
 Smithsonian 7:122 (c, 3) F '77
--Del Mar man's skull (Ice Age)
 Nat Geog 156:332 (c, 3) S '79
--Neanderthal bones
 Natur Hist 87:59-63 (c, 1) D '78
--Peking man
 Natur Hist 89:97-101 (4) F '80
 Natur Hist 89:10 (3) Ag '80
--Ramapithecus
 Smithsonian 10:22 (drawing, 4)
 F '80
--Ramapithecus skull
 Smithsonian 8:18 (drawing, 4) Jl
 '77
--Recreation of Iron Age lifestyle
 (England)
 Smithsonian 9:80-7 (c, 1) Je '78
--See also BRONZE AGE; FOSSILS;
 ICE AGE; PILTDOWN MAN;
 STONE AGE; STONEHENGE
MAN, PREHISTORIC--ART
--Cave paintings (Europe)
 Natur Hist 87:94-5 (c, 1) My '78
 Natur Hist 87:110-13 (1) O '78
MAN, PREHISTORIC--RELICS
--3500 B. C. (Europe)
 Nat Geog 152:614-23 (map, c, 1)
 N '77
--Bulgaria
 Nat Geog 158:cov., 112-29
 (c, 1) Jl '80
--Commerce tokens (Middle East)
 Smithsonian 10:16 (4) Ag '79
--Indus people sculpture (Pakistan)
 Smithsonian 8:56-8 (c, 4) Jl '77
MANAMA, BAHRAIN
 Trav/Holiday 151:74 (c, 2) My
 '79
 Nat Geog 156:302-3 (c, 1) S '79
Manatees. See SEA COWS
MANAUS, BRAZIL
 Trav/Holiday 149:44-6 (c, 3) Mr
 '78
MANCHESTER, NEW HAMPSHIRE
--Early 20th cent. textile mills
 Am Heritage 29:14-25 (c, 1) O
 '78
MANDAN INDIANS (NORTH
 DAKOTA)
--1830's village
 Natur Hist 86:96-7 (painting, c, 1)
 F '77
MANDAN INDIANS (NORTH
 DAKOTA)--COSTUME
--1830's
 Natur Hist 86:95 (painting, c, 1)
 F '77

MANDAN INDIANS (NORTH
 DAKOTA)--HOUSING
--Lodge
 Smithsonian 11:104-5 (painting, c, 2)
 S '80
MANDAN INDIANS (NORTH
 DAKOTA)--RELICS
--19th cent. painted buffalo robe
 Am Heritage 30:10 (c, 1) Ag '79
MANDOLIN PLAYING
--Nebraska
 Nat Geog 154:516-17 (c, 1) O '78
MANET, EDOUARD
--The Ragpicker (1869)
 Smithsonian 10:55 (painting, c, 4)
 S '79
MANGANESE
 Nat Geog 160:814 (c, 3) D '81
MANGROVE TREES
 Smithsonian 7:68-9 (c, 1) Ja '77
 Nat Geog 151:668-89 (c, 1) My
 '77
Manhattan. See NEW YORK CITY,
 NEW YORK
MANILA, PHILIPPINES
 Nat Geog 151:366-74 (c, 1) Mr
 '77
 Trav/Holiday 149:41-3, 64 (c, 1)
 Ja '78
--Hotels
 Trav/Holiday 149:18, 21 (4) My
 '78
MANILA BAY, PHILIPPINES
 Nat Geog 151:366-7 (c, 1) Mr '77
--World War II gun emplacement
 Trav/Holiday 149:64 (4) Ja '78
MANITOBA
 Trav/Holiday 153:cov., 50-4, 91
 (map, c, 1) My '80
--See also WINNIPEG
MANNEQUINS
 Life 2:33-4 (c, 2) F '79
MANSIONS
--19th cent. (Fort Smith, Arkansas)
 Travel 147:50 (4) Ja '77
--1856 (St. Louis, Missouri)
 Am Heritage 31:90-1 (1) D '79
--1894 (California)
 Nat Geog 152:348-9 (c, 1) S '77
--Early 20th cent. (Tuxedo, New
 York)
 Am Heritage 29:72-3 (4) Ag '78
--Early 20th cent. cottages (Lake
 Placid, New York)
 Am Heritage 33:62-3 (3) D '81
--1927 Swan House, Atlanta, Georgia
 Trav/Holiday 153:59 (c, 4) F '80
--Bermuda

Nat Geog 159:546 (c, 4) Ap '81
--Carpets (Albania)
Nat Geog 158:547 (c, 1) O '80
--Carpets (China)
Nat Geog 159:180-1 (c, 2) F '81
--China
Trav/Holiday 156:39 (c, 4) Jl
'81
--Control panels (New Jersey)
Ebony 32:72-4 (3) F '77
--Cosmetics (South Korea)
Nat Geog 156:778 (c, 4) D '79
--Electronics (Egypt)
Nat Geog 151:313 (c, 1) Mr '77
--Frisbees (China)
Nat Geog 159:798 (c, 1) Je '81
--Gears (Wisconsin)
Nat Geog 158:197 (c, 3) Ag '80
--Hair care products (California)
Ebony 35:128 (3) Ag '80
--Inside plant
Ebony 35:34 (4) Ja '80
Ebony 35:52-6 (4) F '80
--Jeans (California)
Nat Geog 159:832 (c, 3) Je '81
--Jet planes (Arkansas)
Nat Geog 153:405 (c, 3) Mr '78
--Metal products (New York)
Ebony 35:138 (3) Mr '80
--Motorcycles (Spain)
Nat Geog 153:316 (c, 4) Mr '78
--Radios (Cuba)
Nat Geog 151:48 (c, 4) Ja '77
--Shoes (Ireland)
Nat Geog 159:455 (c, 4) Ap '81
--Shoes (Maine)
Nat Geog 151:737 (c, 4) Je '77
--Steel (China)
Nat Geog 158:12-13 (c, 1) Jl '80
--Textiles (Pennsylvania)
Ebony 35:53 (4) F '80
--Textiles (early 20th cent. New
Hampshire)
Am Heritage 29:14-25 (c, 1) O
'78
--Weapons (Liege, Belgium)
Nat Geog 155:328 (c, 4) Mr '79
--See also FACTORIES; specific
products (e. g. , STEEL,
TEXTILES, POTTERY); list
under INDUSTRIES
MAO TSE-TUNG
Life 2:146 (4) D '79
Life 4:90 (4) O '81
MAORI PEOPLE (NEW ZEALAND)
--ART
--Wooden carving
Trav/Holiday 155:41 (4) Mr '81

MAPLE TREES
Nat Wildlife 17:42-7 (c, 1) F '79
Nat Geog 157:674-5 (c, 1) My '80
--Autumn colors
Nat Wildlife 16:25 (c, 1) O '78
Nat Wildlife 17:4-7 (c, 4) O '79
Nat Wildlife 19:52-5 (c, 1) O '81
--Leaves
Nat Geog 151:478 (c, 2) Ap '77
--Seeds
Natur Hist 88:54 (c, 1) F '79
MAPS
--16th-17th cent. maps of America
Am Heritage 32:4-13 (painting, c, 2)
F '81
--1500 map of New World (Spain)
Am Heritage 29:82-3 (c, 1) Ap
'78
--1662 Asia
Natur Hist 89:50-1 (c, 1) S '80
--Bird migration routes
Nat Geog 156:172-3 (c, 1) Ag '79
--Contour map of California moun-
tain
Am Heritage 30:70-1 (c, 3) F '79
--Detroit, Michigan street map
Ebony 37:68 (4) N '81
--Nuclear plant sites
Nat Geog 155:462-3 (c, 1) Ap '79
--Oceans
Smithsonian 10:116-22 (c, 2) N
'79
--Reading maps
Nat Geog 159:198 (c, 4) F '81
--Revising large relief map of U. S.
Smithsonian 12:94-8 (c, 1) Jl '81
--World's largest relief map (Mas-
sachusetts)
Smithsonian 12:94-8 (c, 1) Jl '81
--See also GLOBES
MARATHONS
Sports Illus 47:34-5 (c, 4) O 24
'77
--Chicago, Illinois
Life 1:38-9 (c, 1) N '78
--Hawaii
Sports Illus 48:58-64 (c, 4) F 27
'78
Sports Illus 51:96-105 (c, 1) O 8
'79
--Los Angeles, California
Sports Illus 54:57 (4) Ap 6 '81
--Maryland
Sports Illus 51:16-19 (c, 3) S 24
'79
--Mile High Marathon, Denver,
Colorado
Nat Geog 155:399 (c, 4) Mr '79

--Minnesota
 Sports Illus 51:31-2 (c, 2) Jl 16
 '79
--New York
 Sports Illus 47:24-5 (c, 1) O 31
 '77
 Sports Illus 49:cov., 24-9 (c, 1)
 O 30 '78
 Sports Illus 51:42-3 (c, 2) O 22
 '79
 Sports Illus 51:cov., 22-5 (c, 1)
 O 29 '79
 Life 2:78-9 (c, 1) D '79
 Sports Illus 53:cov., 4, 16-21
 (c, 1) N 3 '80
 Sports Illus 55:46-9 (c, 2) N 2
 '81
--New York preparations
 Sports Illus 55:44-57 (c, 1) O 26
 '81
--Oregon
 Sports Illus 51:56 (4) S 17 '79
--Women (Georgia)
 Sports Illus 48:24-5 (c, 3) Mr
 27 '78
--See also BOSTON MARATHON
Marching Bands. See BANDS,
 MARCHING
MARIGOLDS
 Smithsonian 9:128-9 (c, 4) F '79
 Nat Wildlife 19:61 (c, 4) D '80
 Natur Hist 90:78-9 (c, 1) O '81
MARIJUANA
--Burning marijuana field (Chicago,
 Illinois)
 Ebony 33:144 (4) Ag '78
--Children smoking (Colombia)
 Natur Hist 90:42 (c, 2) Ap '01
--Leaf seen through microscope
 Nat Geog 151:285 (1) F '77
--Smoking marijuana
 Ebony 33:78, 145 (4) Ag '78
--Smoking marijuana (India)
 Smithsonian 10:120 (c, 2) O '79
--Smoking marijuana (Jamaica)
 Life 4:110-12 (c, 1) O '81
MARINAS
 Nat Wildlife 16:25 (c, 2) F '78
--Annapolis, Maryland
 Travel 147:42 (c, 4) Je '77
--La Rochelle, France
 Trav/Holiday 154:14 (c, 4) Ag
 '80
--Macuto, Venezuela
 Trav/Holiday 156:55 (c, 4) S '81
--St. John, Virgin Islands
 Trav/Holiday 153:68 (c, 3) Ap
 '80

--Tiburon, California
 Nat Geog 150:846 (c, 1) Je '81
--Washington
 Travel 148:cov. (c, 1) Jl '77
--See also BOATHOUSES; HARBORS
MARINE LIFE
 Nat Wildlife 19:21-3 (drawing, c, 4)
 Ag '81
--Coral reef creatures (Central
 America)
 Smithsonian 11:34-43 (c, 1) Ja '81
--Galapagos Islands, Ecuador
 Nat Geog 152:440-53 (c, 1) O '77
 Nat Geog 154:362-81 (c, 1) S '78
--Life in seafloor rifts
 Nat Geog 156:680-705 (c, 1) N '79
--Maine waters
 Nat Wildlife 19:34-9 (c, 1) D '80
--Night creatures (Hawaii)
 Nat Geog 160:834-47 (c, 1) D '81
--Strait of Georgia, British Colum-
 bia
 Nat Geog 157:526-51 (c, 1) Ap '80
--See also POND LIFE; SEA
 LILIES
MARIPOSA LILIES
 Nat Wildlife 17:2 (c, 2) D '78
MARKETS
--Ancient Rome
 Nat Geog 159:736-7 (painting, c, 2)
 Je '81
--Aztec Indians (Mexico)
 Nat Geog 158:728-9 (painting, c, 1)
 D '80
--Bahrain
 Trav/Holiday 151:74-6, 90-1
 (c, 2) My '79
--Baskets (Mexico)
 Trav/Holiday 153:36 (c, 4) Ja '80
--Bazaar (Iran)
 Trav/Holiday 150:57 (c, 1) D '78
--Birds (Belgium)
 Natur Hist 86:58 (c, 1) My '77
--Caribbean
 Trav/Holiday 151:56-66 (c, 1) Ap
 '79
--Carrying goods on back (Guate-
 mala)
 Travel 148:37 (3) S '77
--Cattle (France)
 Nat Geog 154:542-3 (c, 1) O '78
--Crafts sale (New York City, New
 York)
 Trav/Holiday 152:28 (c, 2) O '79
--Damascus, Syria
 Nat Geog 154:334-5 (c, 1) S '78
--Delhi, India
 Travel 148:63 (c, 4) O '77

Trav/Holiday 153:59-60 (c, 4)
Mr '80
--Ethiopia
Nat Geog 152:385 (c, 4) S '77
--Fiji
Trav/Holiday 153:95 (4) F '80
--Guam
Trav/Holiday 154:44 (c, 4) Jl
'80
--Haiti
Trav/Holiday 151:56-7 (c, 3) F
'79
--India
Nat Geog 152:73 (c, 1) Jl '77
--Kathmandu, Nepal
Natur Hist 88:104-5 (4) O '79
--Liege, Belgium
Trav/Holiday 155:49 (c, 2) Mr
'81
--Mali
Natur Hist 86:92 (4) F '77
--Medicinal plant market (West
Africa)
Smithsonian 12:93-7 (c, 2) N
'81
--Mexican (San Antonio, Texas)
Trav/Holiday 152:68 (c, 4) N '79
--Mexico
Trav/Holiday 152:52-3 (c, 4) Jl
'79
--Nepal
Nat Geog 155:272-3 (c, 1) F '79
--Nowy Targ, Poland
Nat Geog 159:114-15 (c, 1) Ja
'81
--Pakistan
Nat Geog 151:132 (c, 1) Ja '77
--Papeete, Tahiti
Nat Geog 155:852-3 (c, 1) Je '79
--Pottery (Afghanistan)
Smithsonian 11:56 (c, 3) N '80
--Pottery (Guanajuato, Mexico)
Travel 148:40-1 (2) O '77
--Quincy Market, Boston, Massa-
chusetts
Trav/Holiday 150:58, 81 (c, 4)
O '78
--Sharjah
Travel 147:60 (4) Ja '77
--Singapore
Trav/Holiday 148:31 (2) D '77
--Souvenir shops (Athens, Greece)
Trav/Holiday 152:45 (c, 2) Ag
'79
--Street markets (Paris, France)
Trav/Holiday 155:45-6, 72-3
(c, 1) Je '81
--Veracruz, Mexico

Nat Geog 158:224 (c, 1) Ag '80
--Vietnamese (California)
Nat Geog 160:760-1 (c, 1) D '81
--See also FLEA MARKETS;
FLOWER MARKETS; FOOD
MARKETS; SHOPPING CEN-
TERS; STORES
MARLINS
Sports Illus 46:32-3 (painting, c, 2)
Ja 10 '77
Sports Illus 47:23-8 (painting, c, 1)
Jl 25 '77
MARMOSETS
Smithsonian 8:49 (c, 4) Mr '78
Natur Hist 87:81 (drawing, 3) My
'78
Smithsonian 11:178 (c, 4) S '80
Smithsonian 12:138 (c, 4) N '81
--Newborn
Smithsonian 9:132 (c, 2) O '78
--Pygmy marmosets
Life 2:140 (c, 2) Je '79
MARMOTS
Nat Wildlife 15:26-7 (c, 1) O '77
Sports Illus 51:78 (c, 4) O 29
'79
MARQUESAS ISLANDS, PACIFIC
Trav/Holiday 155:56-9 (map, c, 1)
Mr '81
MARRAKECH, MOROCCO
Trav/Holiday 156:56-9, 79 (c, 2)
S '81
MARRIAGE RITES AND CUSTOMS
Ebony 33:106-12 (3) Jl '78
Ebony 36:132-8 (c, 2) Ag '81
--11th cent. Jewish (Kairouan,
North Africa)
Smithsonian 9:36-7 (c, 2) Je '78
--1525 (Saronno, Italy)
Smithsonian 12:48 (painting, c, 4)
O '81
--1920's mock nuptials using chil-
dren
Am Heritage 32:110-11 (1) Je '81
--1949 fitting for bridal gown
(California)
Life 3:84-5 (1) S '80
--Albania
Nat Geog 158:532-3 (c, 1) O '80
--Berbers (Morocco)
Nat Geog 157:118-29 (c, 1) Ja '80
--Bridal procession (Hong Kong)
Trav/Holiday 154:41 (c, 2) Ag '80
--Bridesmaids from Prince Charles'
wedding (Great Britain)
Life 4:110-11 (c, 1) S '81
--British Columbia
Nat Geog 154:488-9 (c, 1) O '78

--Byelorussia, U. S. S. R.
 Nat Geog 155:794-5 (c, 1) Je '79
--China
 Nat Geog 158:32 (c, 2) Jl '80
--City Hall (Indiana)
 Nat Geog 154:385 (c, 4) S '78
--Cuba
 Nat Geog 151:66-7 (c, 1) Ja '77
--Czechoslovakia
 Nat Geog 152:471 (c, 1) O '77
--Falkland Islands
 Smithsonian 12:16 (4) N '81
--Gimi people (New Guinea)
 Nat Geog 152:134-9 (c, 1) Jl '77
--Hawaii
 Nat Geog 160:211 (c, 2) Ag '81
--History of the honeymoon
 Am Heritage 29:80-6 (c, 1) Je
 '78
--India
 Nat Geog 151:236-7 (c, 1) F '77
 Nat Geog 152:271-83 (c, 1) Ag
 '77
--Indonesia
 Nat Geog 159:426 (c, 1) Mr '81
--Liechtenstein
 Nat Geog 159:275 (c, 4) F '81
--Osage Indian wedding dress
 (Oklahoma)
 Smithsonian 9:62 (c, 3) Ag '78
--Pakistan
 Natur Hist 88:12-14 (3) O '79
--Poland
 Nat Geog 159:128-9 (c, 1) Ja '81
--Romania
 Life 4:132-3 (c, 1) Ja '81
--St. Nicholas giving dowry to
 woman (11th cent. Italy)
 Smithsonian 12:42 (painting, c, 2)
 D '81
--Saskatchewan
 Nat Geog 155:662 (c, 1) My '79
--Television soap opera
 Ebony 34:cov., 148 (c, 1) O '79
--Vows atop balloon (Ohio)
 Life 4:144 (c, 2) My '81
--Wedding cake (Great Britain)
 Life 4:140-1 (c, 1) Je '81
--Woodrow and Edith Wilson (1915)
 Am Heritage 30:75 (2) Ap '79
--Yugoslavia
 Nat Geog 152:672-3 (c, 2) N '77
MARRIAGE RITES AND CUSTOMS
 --COSTUME
 Sports Illus 53:60 (4) O 13 '80
 Sports Illus 54:74 (c, 4) Ap 27
 '81
 Life 4:82 (c, 4) Jl '81

--1904
 Am Heritage 29:84 (4) Ag '78
--1953
 Life 3:81 (4) Jl '80
--Bridal hairpiece (Japan)
 Nat Geog 159:297 (c, 1) Mr '81
--Bridesmaid (Alabama)
 Nat Geog 153:209 (c, 3) F '78
--Czechoslovakia
 Nat Geog 155:547 (c, 1) Ap '79
--France
 Natur Hist 89:32-3 (c, 1) Jl '80
--Men's formal wear (South Africa)
 Nat Geog 151:792 (c, 3) Je '77
--Ontario
 Nat Geog 154:760-1 (c, 1) D '78
--Orphans (India)
 Life 3:64 (2) Jl '80
--Sri Lanka
 Nat Geog 155:136-7 (c, 1) Ja '79
MARS
 Nat Geog 151:cov., 2-31 (c, 1)
 Ja '77
 Natur Hist 86:48-53 (2) Mr '77
 Natur Hist 87:85-9 (1) Ja '78
 Life 2:48-51 (c, 1) My '79
 Natur Hist 90:91 (4) F '81
--Computer photographs
 Nat Geog 153:386-7 (c, 1) Mr '78
--Viking photos
 Smithsonian 9:38-9 (c, 2) My '78
 Smithsonian 12:56-7 (4) N '81
MARSHALL, GEORGE C.
 Am Heritage 33:79 (4) D '81
MARSHES
--Atchafalaya, Louisiana
 Nat Geog 156:376-97 (c, 1) S '79
 Nat Wildlife 17:42-9 (c, 1) O '79
--Barataria, Louisiana
 Am Heritage 31:65, 73 (c, 2) Ag
 '80
--Brazil
 Nat Geog 152:694-5 (c, 1) N '77
--Georgia
 Nat Geog 152:656-7 (c, 2) N '77
--Midwest
 Nat Wildlife 19:6-7 (c, 1) O '81
--New York
 Nat Geog 153:76-7 (c, 2) Ja '78
--St. Phillips Island, South Carolina
 Life 3:76 (c, 4) Jl '80
--See also OKEFENOKEE SWAMP
Marsupials. See CUSCUSES;
 KANGAROOS; KOALAS; OPOS-
 SUMS; TASMANIAN DEVILS;
 TASMANIAN TIGERS; WOM-
 BATS
MARTENS

Nat Wildlife 15:19-20 (1) Ap '77
Nat Wildlife 16:24 (c, 4) D '77
MARTHA'S VINEYARD, MASSA-
CHUSETTS
--19th cent. general store
Natur Hist 89:10 (4) Je '80
MARTINS (BIRDS)
--Purple martins
Natur Hist 90:64-5 (c, 1) My '81
MARX, GROUCHO
Smithsonian 12:220-1 (draw-
ing, c, 4) N '81
MARYLAND
--Chesapeake Bay area
Nat Geog 158:428-67 (map, c, 1)
O '80
--Eastern shore
Trav/Holiday 153:70-3 (map, c, 1)
My '80
--See also ANNAPOLIS; BALTI-
MORE; CHESAPEAKE BAY
MASKS
--1850 (Mexico)
Smithsonian 9:142 (c, 4) Mr '79
--Ancient Peru
Smithsonian 8:87 (c, 4) D '77
--Chinese opera masks (Singapore)
Trav/Holiday 148:33 (c, 1) N '77
--Eskimo (Alaska)
Natur Hist 87:98 (c, 1) My '78
--Iatmul double image mask (New
Guinea)
Natur Hist 89:77 (c, 1) F '80
--Mexico
Nat Geog 153:660 (c, 1) My '78
Natur Hist 89:84-6 (c, 2) Ag '80
--Nepal
Trav/Holiday 156:34 (c, 3) Ag
'81
--Papua New Guinea
Natur Hist 90:104 (4) N '81
--Primitive
Smithsonian 9:cov., 48-51 (c, 1)
O '78
--U. S. Indians
Smithsonian 9:64-5 (c, 1) Ag '78
--See also DEATH MASKS; GAS
MASKS
MASONRY
Ebony 36:97-9 (3) S '81
--1868 Masons (Connecticut)
Am Heritage 31:24 (1) F '80
--Symbols of the Masonic Order
Am Heritage 31:91-7 (c, 1) O
'80
MASS TRANSIT
--Chicago, Illinois commuter
train

Ebony 37:67 (2) N '81
--Commuters on train (Bombay,
India)
Nat Geog 160:106 (c, 1) Jl '81
--Monorail (Seattle, Washington)
Trav/Holiday 153:115 (4) F '80
--People-mover tram (Dearborn,
Michigan)
Trav/Holiday 149:61 (c, 4) Mr
'78
--See also BUSES; SUBWAYS;
TAXICABS; TRANSIT WORK-
ERS; TROLLEY CARS
MASSACHUSETTS
--Berkshire Mountain area
Trav/Holiday 153:cov., 43-5
(map, c, 1) Je '80
--Crane Wildlife Refuge
Smithsonian 8:92-8 (c, 2) Je '77
--Marblehead
Trav/Holiday 154:48 (c, 4) Jl '80
--North shore area
Nat Geog 155:569-90 (map, c, 1)
Ap '79
--Waterfalls
Smithsonian 8:cov., 82 (c, 1) S
'77
--See also BOSTON; CAMBRIDGE;
CAPE COD; CONCORD; CON-
NECTICUT RIVER; LOWELL;
MARTHA'S VINEYARD; NAN-
TUCKET; NEW BEDFORD;
PLYMOUTH; SALEM; WOR-
CESTER
MASSAGES
Ebony 36:111 (4) Mr '81
Ebony 36:42 (4) Ap '81
Sports Illus 54:71 (c, 4) Ap 27
'81
--California
Ebony 35:168 (4) N '79
--West Virginia hotel
Trav/Holiday 151:107 (4) My '79
MASSASOIT, CHIEF
--Statue (Plymouth, Massachusetts)
Ebony 34:41 (c, 4) My '79
MASTIFFS
Sports Illus 47:66 (c, 4) N 14 '77
Life 2:48 (c, 2) Ja '79
MASTODONS
--Skeleton
Am Heritage 30:17-21 (engrav-
ing, 4) Ag '79
--Platybelodon model
Natur Hist 89:80-2 (4) Ap '80
MATADORS
Sports Illus 55:26-39 (c, 1) Jl 6
'81

--Goring of matador (Spain)
 Life 1:134-5 (1) O '78
MATISSE, HENRI
--Art works
 Smithsonian 8:72-9 (c, 1) S '77
--White Feathers (1919)
 Life 2:32 (painting, 4) Mr '79
--Young Sailor I (1906)
 Smithsonian 11:65 (painting, c, 2)
 Je '80
MAULDIN, BILL
--Cartoons about Revolution and
 World War II
 Smithsonian 8:48-57 (drawing, 1)
 F '78
MAUNA LOA, HAWAII
 Natur Hist 86:44 (c, 3) Ap '77
MAURITANIA
--Desert
 Nat Geog 156:586-7 (c, 1) N '79
--See also NOUAKCHOTT
MAURITIUS
 Nat Geog 160:424-6, 441-3
 (map, c, 1) O '81
MAURITIUS--COSTUME
 Nat Geog 160:441-2 (c, 1) O '81
MAY DAY
--Moscow festival (U. S. S. R.)
 Nat Geog 153:22-3 (c, 1) Ja '78
--Parade (Portugal)
 Nat Geog 158:812 (c, 1) D '80
--Pine Bluff, Arkansas
 Nat Geog 153:412 (c, 2) Mr '78
MAYAN CIVILIZATION (GUATE-
 MALA)
--Tikal
 Natur Hist 90:36-7 (c, 1) Ag '81
MAYAN CIVILIZATION (MEXICO)
 Nat Geog 151:868-9 (c, 3) Je
 '77
--See also PYRAMIDS
MAYAN CIVILIZATION--ARCHITEC-
 TURE
--6th cent. farmhouse (El Salvador)
 Natur Hist 90:39 (c, 3) Ag '81
MAYAN CIVILIZATION--ART
--7th cent. vase
 Natur Hist 86:88 (2) Mr '77
--Cave paintings (Guatemala)
 Nat Geog 160:cov. , 220-35 (c, 1)
 Ag '81
--Crafts
 Nat Geog 153:651-5 (c, 1) My
 '78
MAYAN CIVILIZATION--RELICS
 Natur Hist 90:cov. , 33-41 (c, 1)
 Ag '81
MAYAN CIVILIZATION--RUINS

--Chichen-Itza, Mexico
 Trav/Holiday 150:44, 46 (c, 4) O
 '78
MAYAN CIVILIZATION--SCULPTURE
 Smithsonian 9:56-9 (c, 3) My '78
MAYER, LOUIS B.
 Am Heritage 31:16 (4) F '80
MAYS, WILLIE
 Sports Illus 49:32 (4) Ag 7 '78
 Sports Illus 51:59 (c, 4) Ag 13
 '79
 Life 2:100 (c, 3) S '79
MAZATLAN, MEXICO
--Beach
 Trav/Holiday 156:47-8 (c, 4) N '81
MC.... See MAC...
MEAD, MARGARET
 Smithsonian 9:24 (4) Ja '79
 Life 2:148 (4) D '79
MEADOW LARKS
--Wooden
 Nat Wildlife 19:52 (c, 4) D '80
MEASURING WORMS
 Nat Geog 157:162 (c, 4) F '80
 Nat Geog 157:398-9 (c, 2) Mr '80
MEAT INDUSTRY
--Gates of old stockyard (Chicago,
 Illinois)
 Nat Geog 153:470-1 (c, 2) Ap '78
MECCA, SAUDI ARABIA
 Nat Geog 154:cov. , 578-607 (c, 1)
 N '78
 Life 2:20-7 (c, 1) Ap '79
--Repairing Sacred Mosque
 Nat Geog 158:312 (c, 1) S '80
MEDALS
 Nat Geog 153:291 (c, 1) F '78
--18th-19th cent. France
 Smithsonian 12:76 (c, 4) N '81
--1860's Congressional Medal of
 Honor
 Am Heritage 29:112 (4) O '78
--1893 oyster-eating prize (Texas)
 Am Heritage 31:66 (4) F '80
--1905 inauguration of Theodore
 Roosevelt
 Smithsonian 11:26 (4) Ja '81
--1980 Olympics (Lake Placid)
 Sports Illus 52:cov. (c, 1) F 25
 '80
 Sports Illus 52:26 (c, 3) Mr 3 '80
--Australia
 Nat Geog 155:223 (c, 3) F '79
--Carnegie Hero Fund medal
 Life 2:94 (c, 4) Mr '79
--Commemorating Benedict Arnold
 in 1777
 Am Heritage 29:110 (c, 4) D '77

--Monitoring signs while on tread-
mill
Ebony 32:98 (4) Je '77
--Numbing an ankle with medica-
tion
Sports Illus 54:34-5 (c, 1) Je 15
'81
--Paramedics working on heat vic-
tim (Texas)
Life 3:24-5 (c, 1) S '80
--Podiatry
Ebony 33:106-10 (4) S '78
--Putting pigskin on burn victim
Nat Geog 154:406 (c, 3) S '78
--Radiation therapy
Ebony 33:127, 130 (2) Ap '78
Ebony 34:95 (2) N '78
Ebony 35:134 (3) N '79
--Results of intestinal bypass sur-
gery for obesity
Ebony 32:124-8 (3) O '77
--South Africa
Nat Geog 151:799 (c, 4) Je '77
--Taking blood pressure
Ebony 33:32 (4) Ja '78
Ebony 34 106 (2) My '79
Sports Illus 53:27 (c, 4) Jl 21
'80
--Taking blood sample
Ebony 34:112 (2) My '79
--Taking stress test
Sports Illus 52:43 (4) Ja 28 '80
--Testing lung capacity with spiro-
meter
Life 2:46 (3) O '79
--Therapy for troubled teenagers
Life 3:124-32 (1) Je '80
Nat Wildlife 19:16-19 (c, 1) Ap
'81
Life 4:48-56 (c, 1) S '81
--Therapy with brain-damaged
child
Life 1:42-50 (1) O '78
--Through U. S. history
Am Heritage 32:16-27, 114
(painting, c, 1) Je '81
--Trauma care (Maryland)
Life 3:22-9 (c, 1) O '80
--Treating burn victims
Life 3:114-23 (1) Mr '80
--Treating burn victims (Texas)
Nat Geog 160:298-9 (c, 2) S
'81
--Treating headaches
Ebony 36:86-8 (3) O '81
--Using marijuana to treat glaucoma
Ebony 32:108-12 (3) S '77
--Working with medicinal herbs

(Ghana)
Smithsonian 12:87-93 (c, 2) N '81
--World War I first-aid post
(France)
Life 3:92-3 (c, 1) Ap '80
--See also CHILDBIRTH; DEN-
TISTRY; DISEASES; DOCTORS;
HYPNOTISM; INJURED PEO-
PLE; MEDICAL EDUCATION;
MEDICAL INSTRUMENTS;
MEDICAL RESEARCH;
NURSES; PLASTIC SURGERY;
SHAMANS; SURGERY; VAC-
CINATIONS; VETERINARIANS;
X-RAYS
Medicines. See DRUGS
MEDITATING
Ebony 33:93 (4) Ag '78
Sports Illus 49:61 (c, 3) Ag 7 '78
Sports Illus 52:61 (c, 4) Mr 10
'80
--Chanting
Life 2:77 (c, 3) D '79
MEGAPHONES
Ebony 34:134 (4) Ag '79
Memorials. See MONUMENTS
MEMPHIS, TENNESSEE
Trav/Holiday 149:44-7 (c, 2) Ja
'78
Ebony 36:120-30 (c, 2) Je '81
--Beale Street (1920's)
Am Heritage 30:53 (c, 2) F '79
MENCKEN, H. L.
Smithsonian 9:156 (4) S '78
Smithsonian 11:151-62 (c, 3) S '80
MENNONITES
--Ontario
Nat Geog 154:774-5 (c, 1) D '78
MERMAIDS
--"Little Mermaid" (Copenhagen,
Denmark)
Nat Geog 156:847 (c, 4) D '79
MERRY-GO-ROUNDS
Smithsonian 8:9 (4) Ag '77
Life 3:86 (4) Je '80
--1880 (Rockaway Beach, New York
City)
Am Heritage 31:75 (painting, c, 2)
D '79
--1911 factory (New York)
Am Heritage 31:74 (drawing, 4) D
'79
--Spain
Trav/Holiday 149:43 (c, 4) F '78
MESA VERDE NATIONAL PARK,
ARIZONA
--Cliff dwellings
Trav/Holiday 151:64 (c, 4) Ja '79

MESCALINE
--Peyote use (Mexico)
 Nat Geog 151:837-43 (c, 1) Je
 '77
MESSENGERS
--On bicycle (New York City, New
 York)
 Natur Hist 90:66-73 (1) Ag '81
METAL DETECTORS
 Smithsonian 12:142 (c, 4) Ap '81
METALWORK
--Celtic civilization relics
 Nat Geog 151:582-627 (c, 1) My
 '77
METALWORKING
--Foundry worker (Alabama)
 Nat Geog 151:489 (c, 1) Ap '77
--Knife making (Crete)
 Nat Geog 153:183 (c, 4) F '78
--Pennsylvania
 Nat Geog 153:744-5 (c, 1) Je '78
--Pewter vases (Malaysia)
 Nat Geog 151:666 (c, 4) My '77
--Silver working (India)
 Nat Geog 160:282 (c, 4) S '81
--Silver working (Southwest)
 Nat Geog 160:310-11 (c, 1) S '81
--Welding (Alaska)
 Smithsonian 12:32 (c, 3) Ag '81
--Welding (Pennsylvania)
 Ebony 35:143 (4) Ag '80
--Welding (Zimbabwe)
 Nat Geog 160:642-3 (c, 2) N '81
METEORITES
 Smithsonian 11:133-48 (c, 4) My
 '80
 Natur Hist 90:52-81 (c, 1) Ap
 '81
--Craters in planets
 Life 4:86-7 (c, 1) Je '81
--Hypothetical collision with earth
 Natur Hist 90:cov. (painting, c, 1)
 Ap '81
METRIC SYSTEM
 Nat Geog 152:287-94 (charts, c, 2)
 Ag '77
METROPOLITAN MUSEUM OF
 ART, NEW YORK CITY,
 NEW YORK
 Life 1:116-17 (c, 1) N '78
--American Wing
 Am Heritage 31:12-31, 114 (c, 1)
 Ap '80
 Life 4:123 (c, 2) Ja '81
--Astor Court Chinese garden
 Smithsonian 12:66-72 (c, 2) Jl
 '81
--Cloisters

Trav/Holiday 153:8 (4) Ja '80
--Ming Garden
 Life 3:86-8 (c, 1) Ag '80
MEXICAN AMERICANS
 Nat Geog 157:780-809 (c, 1) Je
 '80
--Illegal aliens
 Ebony 34:34-40 (3) Ap '79
 Ebony 34:93-4 (3) S '79
 Life 4:24-32 (c, 1) Jl '81
--Riding in low slung cars (Cali-
 fornia)
 Life 3:88-94 (c, 1) My '80
MEXICAN WAR
 Smithsonian 8:94-101 (paint-
 ing, c, 1) Mr '78
--See also ALAMO; SCOTT, WIN-
 FIELD
MEXICO
 Nat Geog 153:612-56 (map, c, 1)
 My '78
 Nat Geog 158:704-75 (c, 1) D '80
--Cancun
 Trav/Holiday 150:42-7, 69 (c, 2)
 O '78
--Chichen Itza pyramid
 Trav/Holiday 150:44, 46 (c, 4) O
 '78
 Smithsonian 9:16 (c, 4) D '78
--Huichol Indian region
 Nat Geog 151:834-53 (map, c, 1)
 Je '77
--Isla Mujeres
 Travel 148:53-7 (c, 1) S '77
--Las Hadas
 Trav/Holiday 153:55, 101 (c, 3)
 F '80
--Maruata beach
 Nat Wildlife 19:6-11 (c, 1) Je '81
--Oil industry
 Life 2:22-8 (c, 1) Mr '79
--Patzcuaro Lake area
 Trav/Holiday 149:48-50 (map, c, 2)
 F '78
--Resorts
 Trav/Holiday 156:46-51 (c, 3) N
 '81
--San Miguel church
 Trav/Holiday 152:71 (4) S '79
--Tikal
 Nat Geog 151:869 (c, 3) Je '77
--Tzintzuntzan
 Trav/Holiday 149:48 (c, 2) F '78
--Western coast
 Trav/Holiday 153:54-6 (map, c, 1)
 Je '80
--See also ACAPULCO; BAJA
 CALIFORNIA; GUANAJUATO;

MAZATLAN; MEXICO CITY;
OAXACA; POPOCATEPETL;
VERACRUZ
MEXICO--ARCHITECTURE
--Buildings by Luis Barragan
Smithsonian 11:152-6 (c, 1) N
'80
MEXICO--ART
Smithsonian 9:cov., 52-63 (c, 1)
My '78
--1850 mask
Smithsonian 9:142 (c, 4) Mr '79
--Folk arts
Nat Geog 153:648-69 (c, 1) My
'78
--Masks
Natur Hist 89:84-6 (c, 2) Ag
'80
--Pre-Columbian sculpture
Smithsonian 9:cov., 52, 55-9
(c, 1) My '78
MEXICO--COSTUME
Nat Geog 153:612-69 (c, 1) My
'78
Trav/Holiday 152:52-7 (c, 1) Jl
'79
Nat Geog 158:202-31 (c, 1) Ag
'80
Nat Geog 158:718-74 (c, 1) D
'80
Natur Hist 90:69 (c, 1) Ap '81
--1840's
Smithsonian 9:60-1 (painting, c, 1)
My '78
--1910's soldiers
Smithsonian 11:cov., 30-41 (1)
Jl '80
--Huichol Indians
Nat Geog 151:833-53 (c, 1) Je
'77
Natur Hist 88:68-75 (c, 1) O '79
--Marines
Nat Wildlife 19:6-7 (c, 1) Je '81
MEXICO--HISTORY
--1910's Revolution
Am Heritage 28:78-9 (1) Ag '77
Smithsonian 11:cov., 30-41 (1)
Jl '80
--See also AZTEC INDIANS;
CARRANZA, VENUSTIANO;
DIAZ, PORFIRIO; MAYAN
CIVILIZATION; MEXICAN
WAR; OBREGON, ALVARO;
VILLA, PANCHO; ZAPATA,
EMILIANO
MEXICO--SOCIAL LIFE AND
CUSTOMS
--Paintings by Diego Rivera

Am Heritage 29:16-29 (paint-
ing, c, 1) D '77
MEXICO, ANCIENT
--Ruins of Zapotec civilization
(Monte Alban)
Smithsonian 10:62-75 (c, 1) F '80
MEXICO, ANCIENT--ART
--Stone head
Smithsonian 9:cov. (c, 1) My '78
MEXICO, ANCIENT--RELICS
--Earth Mother sculpture
Trav/Holiday 154:30-1 (c, 1) D
'80
--Veracruz
Nat Geog 158:cov., 216-25 (c, 1)
Ag '80
MEXICO CITY, MEXICO
Nat Geog 153:612, 622-3, 637-43
(c, 1) My '78
Trav/Holiday 155:62-7, 78 (c, 1)
Je '81
--Aztec relics
Nat Geog 158:706-7, 718-19,
764-75 (c, 1) D '80
--Cathedral of Mexico
Trav/Holiday 154:32-3 (4) S '80
MIAMI, FLORIDA
Trav/Holiday 153:38-9 (4) My '80
Ebony 35:136-45 (c, 2) S '80
--1926-1940 art deco architecture
Am Heritage 32:50-1 (c, 4) F '81
MIAMI BEACH, FLORIDA
Smithsonian 11:55 (c, 4) S '80
Sports Illus 54:86 (c, 4) F '81
--Luxury hotels
Ebony 34:42 (c, 4) My '79
Trav/Holiday 153:26-7, 31 (4)
F '80
MICE
Natur Hist 87:38-43 (c, 1) Ap '78
Smithsonian 11:178 (c, 4) S '80
Life 4:108-9 (1) F '81
Nat Wildlife 20:56 (c, 4) D '81
--See also MUSKRATS; RATS;
WHITE-FOOTED MICE
MICHIGAN
Nat Geog 155:804-42 (map, c, 1)
Je '79
--Holland
Trav/Holiday 149:47-9 (c, 1) My
'78
--Mackinac area
Trav/Holiday 154:53-4 (c, 1) Jl
'80
--Mackinac Straits Bridge
Am Heritage 29:59 (c, 4) Ag '78
Trav/Holiday 154:53 (c, 1) Jl '80
--Shores of Lake Michigan

Nat Wildlife 16:40-7 (c, 1) Je
'78
--See also DEARBORN; DETROIT;
KALAMAZOO; LAKE MICHI-
GAN; LAKE SUPERIOR;
MACKINAC ISLAND
MICKEY MOUSE
Trav/Holiday 149:96 (4) Mr '78
Life 1:cov., 96-100 (c, 1) N '78
Trav/Holiday 151:71 (c, 4) Ap
'79
Natur Hist 88:cov., 30-2 (c, 1)
My '79
Trav/Holiday 155:80 (4) My '81
Nat Geog 160:757 (c, 4) D '81
--Mouseketeers' 25th reunion
Life 4:88 (c, 4) Ja '81
MICROFILM READERS
Ebony 32:52-4 (3) Je '77
MICROPHONES
Sports Illus 47:45 (4) S 19 '77
Ebony 33:31 (4) Ap '78
Ebony 33:153 (2) Ag '78
Ebony 35:44, 108 (3) N '79
Sports Illus 51:32 (c, 3) D 10
'79
Am Heritage 31:12 (3) F '80
Sports Illus 52:81 (c, 4) Je 9
'80
Sports Illus 53:35 (c, 4) O 20
'80
MICROSCOPES
Nat Geog 151:280-1 (diagram, c, 4)
F '77
Smithsonian 9:72 (c, 3) Ag '78
Natur Hist 88:5 (4) N '79
Smithsonian 10:101 (c, 4) Ja '80
Life 3:54 (c, 4) My '80
Ebony 35:31, 110 (2) S '80
Ebony 36:108, 110 (4) My '81
--Electron microscope images
Nat Geog 151:274-90 (1) F '77
MIDDLE AGES
--Depictions of women's roles
Natur Hist 87:cov., 56-67
(painting, c, 1) Mr '78
--Modern woman "roughing it"
(France)
Smithsonian 12:156-74 (c, 1) D
'82
--People delousing each other
Natur Hist 86:88-9 (drawing, 2)
My '77
--See also CASTLES; DRAGONS;
FORTRESSES; JOUSTING;
KNIGHTS
MIDDLE AGES--ART
--16th cent. Dresden treasures

Nat Geog 154:701-17 (c, 1) N '78
--Depictions of owls
Natur Hist 87:100-7 (c, 1) O '78
--Designs for advanced machinery
Smithsonian 9:114-23 (c, 2) O '78
--Illuminated manuscripts
Smithsonian 11:cov., 52-9 (c, 1)
F '81
MIDDLE AGES--COSTUME
Smithsonian 12:168 (painting, c, 4)
D '81
MIDDLE EAST--ART
--Ancient art works
Natur Hist 89:53-7 (c, 1) S '80
MIDDLE EAST--COSTUME
--Palestinian guerrillas
Life 2:24-31 (c, 1) Je '79
MIDDLE EAST--HISTORY
--14th cent. Mamluk art works
Smithsonian 12:108-13 (c, 2) Jl
'81
MIDDLE EAST--MAPS
--History
Nat Geog 156:250-1 (c, 1) Ag '79
--Persian Gulf
Life 3:26-7 (c, 1) Mr '80
--Satellite view of Sinai Peninsula
Smithsonian 10:148 (c, 4) Mr '80
--Saudi Arabia and vicinity
Sports Illus 53:98 (c, 4) N 17 '80
MIDGETS
Life 4:126-32 (c, 1) Je '81
MIDWEST
--Dust storms
Natur Hist 87:72-83 (1) F '78
--Ohio River valley
Nat Geog 151:244-73 (map, c, 1)
F '77
--Prairie land
Nat Wildlife 17:4-11 (c, 1) Je '79
Nat Geog 157:36-61 (map, c, 1) Ja
'80
MIDWEST--MAPS
--Winery locations
Trav/Holiday 156:42 (4) Ag '81
MIFFLIN, THOMAS
Smithsonian 8:103 (painting, c, 4)
Ja '78
Migrant workers. See FARM
WORKERS
MILAN, ITALY
Nat Geog 152:306, 319 (c, 2) S '77
Travel 148:44-9 (c, 1) O '77
MILITARY COSTUME
Life 2:36 (c, 3) Je '79
--5-6th cent. Korean statue
Smithsonian 10:113 (c, 4) My '79
--16th cent. Spain

Nat Geog 159:248-9 (c, 3) F '81
--Hessians
 Am Heritage 30:97-9 (engrav-
 ing, c, 3) Ag '79
--Israel
 Nat Geog 153:237 (c, 1) F '78
--Liberia
 Life 3:52-6 (c, 1) Je '80
--Malaysian guerrillas
 Nat Geog 151:637 (c, 4) My '77
--Mexican guerrillas
 Nat Geog 153:618-19 (c, 1) My
 '78
--Mexican marines
 Nat Wildlife 19:8-7 (c, 1) Je
 '81
--North Vietnam
 Life 3:49-50 (c, 1) Mr '80
--Oman
 Life 3:30 (c, 2) Mr '80
 Nat Geog 160:356, 362-3 (c, 1)
 S '81
--Palace guard (Peru)
 Travel 147:37 (c, 1) Ja '77
--Palestine Liberation Organization
 guerrillas
 Life 2:24-31 (c, 1) Je '79
 Nat Geog 158:342 (c, 4) S '80
--Saudi Arabian National Guard
 Nat Geog 158:300-1 (c, 1) S '80
--South Carolina's Oyotunji (Afri-
 can village)
 Ebony 33:88 (c, 3) Ja '78
--Spain
 Nat Geog 153:300-1, 328-9
 (c, 1) Mr '78
--Syria
 Nat Geog 154:356 (c, 1) S '78
--Tanzania
 Nat Geog 158:77 (c, 4) Jl '80
--Tibetan militia
 Nat Geog 157:232-3 (c, 1) F '80
--Toy soldiers depicting historical
 armies
 Am Heritage 29:48-57 (c, 3) D
 '77
 Smithsonian 11:68-75 (c, 2) Ag
 '80
--Turkey
 Nat Geog 152:120-1 (c, 1) Jl '77
--Uganda
 Life 2:132-3 (1) Je '79
--U. S. S. R.
 Nat Geog 152:262-3 (c, 3) Ag '77
--U. S.
 Nat Geog 153:292-3 (c, 2) F '78
 Life 4:66-9, 78 (painting, c, 1) S
 '81

--U. S. Air Force
 Ebony 33:87-92 (2) F '78
 Ebony 34:85-90 (3) D '78
--U. S. Army
 Ebony 32:34-6 (4) Je '77
 Ebony 33:68 (4) Jl '78
 Am Heritage 33:20 (3) D '81
--U. S. Army aviator
 Ebony 35:101-4 (2) Ap '80
--U. S. Army colonel
 Smithsonian 7:70 (c, 4) Ja '77
--U. S. Army major general
 Ebony 37:118 (4) N '81
--U. S. Army sergeant
 Ebony 34:72 (4) N '78
--U. S. cadets (19th cent.)
 Smithsonian 9:96 (4) My '78
--U. S. cadets (Citadel Military
 Academy, S. C.)
 Trav/Holiday 150:31 (4) O '78
 Ebony 36:94 (4) My '81
--U. S. cadets (West Point)
 Life 3:70-1 (c, 1) My '80
--U. S. cadets (West Point; 1840)
 Am Heritage 29:8 (drawing, 4)
 Je '78
--U. S. generals
 Ebony 33:40-50 (4) My '78
 Ebony 34:44-50 (3) Jl '79
 Ebony 35:45 (2) F '80
--U. S. naval cadets
 Nat Geog 158:459 (c, 4) O '80
--U. S. Navy captain
 Am Heritage 29:29 (2) Ag '78
--U. S. Navy lieutenant (1942)
 Am Heritage 32:42 (4) D '80
--U. S. Navy rear admiral
 Ebony 37:118-20 (4) N '81
--U. S. Navy vice admiral
 Ebony 32:66-74 (c, 1) S '77
 Ebony 33:40 (4) My '78
--Zimbabwe
 Nat Geog 160:630-1 (c, 1) N '81
Military Leaders. See ALEXANDER
 THE GREAT; ARNOLD, BENE-
 DICT; BAINBRIDGE, WILLIAM;
 BRADLEY, OMAR; CORN-
 WALLIS, CHARLES; FARRA-
 GUT, DAVID GLASGOW;
 GOERING, HERMANN;
 GRANT, ULYSSES S. ;
 GRASSE, COMTE DE;
 GREENE, NATHANAEL; HAL-
 LECK, HENRY WAGER;
 HAMPTON, WADE; HITLER,
 ADOLF; JACKSON, STONE-
 WALL; JONES, JOHN PAUL;
 KNOX, HENRY; LAFAYETTE,

MARQUIS DE; LAWRENCE,
THOMAS E.; LEE, ROBERT
E.; MacARTHUR, DOUGLAS;
MARSHALL, GEORGE;
MITCHELL, BILLY; NAPO-
LEON; NELSON, HORATIO;
PATTON, GEORGE; PHILIP
II; ROCHAMBEAU, COMTE
DE; SCOTT, WINFIELD;
SHERMAN, WILLIAM TECUM-
SEH; TAMERLANE; TAYLOR,
MAXWELL; VILLA, PANCHO;
WALKER, WILLIAM; YORK,
ALVIN C.; ZAPATA, EMIL-
IANO
MILITARY TRAINING
--Cuba
 Nat Geog 151:64-5 (c, 2) Ja '77
--Cubans teaching Angolans
 Life 3:43-8 (c, 2) F '80
--Ku Klux Klan (Alabama)
 Life 4:34-5 (c, 1) Je '81
--Palestinian guerrillas
 Life 2:24-7 (c, 1) Je '79
--U. S. S. R.
 Life 3:36-7 (1) My '80
--See also U. S. NAVAL ACADEMY;
 WEST POINT
MILK INDUSTRY
--Wisconsin
 Nat Geog 152:191 (c, 4) Ag '77
MILK INDUSTRY--TRANSPORTA-
 TION
--Milkman (Poland)
 Nat Geog 159:118-19 (c, 1) Ja
 '81
MILKWEED
 Am Heritage 28:17 (c, 4) Ap '77
 Natur Hist 86:40-2 (c, 1) Je '77
--Seed pod
 Nat Wildlife 17:9 (c, 4) Je '79
MILKY WAY
 Natur Hist 87:142 (c, 4) O '78
 Natur Hist 88:86-9 (3) Je '79
MILLS
--19th cent. copper mill (Massa-
 chusetts)
 Am Heritage 28:37 (painting, c, 3)
 Ap '77
--Paper (Brazil)
 Nat Geog 157:686-711 (c, 1) My
 '80
--Paper (Connecticut)
 Smithsonian 8:83-7 (c, 3) S '77
--Paper (Virginia)
 Smithsonian 9:63 (c, 1) O '78
--Steel (Ohio)
 Nat Geog 151:251 (c, 1) F '77

Ebony 35:63 (2) Ag '80
--Steel (Pakistan)
 Nat Geog 159:672-3 (c, 1) My '81
--Steel (Utah)
 Smithsonian 8:32 (c, 4) Ag '77
--Water mill (Georgia)
 Travel 147:38 (c, 1) F '77
--Water mill (Kentucky)
 Trav/Holiday 155:58 (3) Je '81
--Water mill (Michigan)
 Am Heritage 32:111 (c, 3) F '81
--See also FACTORIES; SAWMILLS
MILWAUKEE, WISCONSIN
 Nat Geog 158:180-201 (map, c, 1)
 Ag '80
--Festivals
 Trav/Holiday 155:37-8 (4) Je '81
--Residential street
 Nat Wildlife 16:38 (3) Ap '78
MINERALS
 Smithsonian 8:120 (c, 3) O '77
--Ocean nodules of metals
 Smithsonian 12:50 (c, 1) Ap '81
--See also ALUMINUM; ANTIMONY;
 BAUXITE; BRASS; CAT'S
 EYES; COAL; COPPER;
 CRYSTALS; DIAMONDS;
 EMERALDS; FLUORITE;
 GOLD; GRANITE; JADE;
 JEWELRY; JEWELS; LIME-
 STONE; MANGANESE; MOON-
 STONES; OPALS; QUARTZ;
 ROCKS; SALT; SANDSTONE;
 SAPPHIRES; SILVER; STEEL;
 TIN; TOPAZ; TOURMALINE;
 TURQUOISE
MINERS
--19th cent. California
 Am Heritage 29:93 (1) D '77
--Coal (Ireland)
 Nat Geog 154:660 (c, 2) N '78
--Japan
 Nat Geog 157:80 (c, 4) Ja '80
--Pennsylvania
 Nat Geog 153:752-3 (c, 1) Je '78
 Life 4:142 (2) My '81
--South Africa
 Nat Geog 151:796-7 (c, 1) Je '77
--Sri Lanka
 Smithsonian 11:69, 72 (c, 4) Je
 '80
--Wyoming
 Nat Geog 159:100-1 (2) F '81SR
MINERVA
--4th cent. B. C. terra cotta figure
 (Greece)
 Smithsonian 11:134 (c, 4) N '80
MINES

--1918 shale mine (Colorado)
Nat Geog 159:81 (3) F '81SR
--Idaho
Smithsonian 12:78-9 (c, 4) S '81
--Kentucky strip mine
Life 3:75 (c, 4) N '80
--Lead and zinc (Yukon)
Nat Geog 153:560-1 (c, 1) Ap '78
--Montana
Trav/Holiday 156:51 (c, 4) Jl
'81
--Phosphate strip mines (Florida)
Sports Illus 54:90 (c, 4) F 9
'81
MINING
--Amber (Dominican Republic)
Nat Geog 152:428 (c, 2) S '77
--Prototype for mining manganese
underwater
Nat Geog 160:815 (drawing, c, 1)
D '81
--Shale (Colorado)
Nat Geog 159:76-7 (c, 1) F
'81SR
--Strip mining (West Germany)
Life 3:66-9 (c, 1) N '80
--Underwater
Smithsonian 12:53-9 (c, 1) Ap
'81
--See also BAUXITE; COAL;
COPPER; DIAMONDS; GOLD;
GRANITE; IRON; MOLLY
MAGUIRES; NICKEL; OPALS;
PROSPECTING; SALT; SIL-
VER; TIN
MINING CAMPS
--Namibia
Nat Geog 155:90 (c, 1) Ja '79
MINING EQUIPMENT
--Strip mining (West Germany)
Life 3:66-9 (c, 1) N '80
--Ore hauler (Yukon)
Nat Geog 153:562-3 (c, 1) Ap '78
MINNEAPOLIS, MINNESOTA
Ebony 33:102 (4) F '78
Smithsonian 9:102-5 (c, 1) Mr
'79
Nat Geog 158:664-91 (map, c, 1)
N '80
--See also MINNEHAHA FALLS
MINNEHAHA FALLS, MINNEAPOLIS,
MINNESOTA
Nat Geog 158:675 (c, 4) N '80
MINNESOTA
--1884 log jam at Taylors Falls
Nat Geog 152:32-3 (2) Jl '77
--1894 Hinckley fire
Am Heritage 28:90-5 (c, 1) Ag

'77
--Bigelow Town Hall
Nat Geog 157:47 (c, 1) Ja '80
--Red Wing bluff
Nat Geog 159:387 (c, 2) Mr '81
--Temperance River in autumn
Nat Wildlife 18:54-5 (c, 1) Ap '80
--See also MINNEAPOLIS; ST.
PAUL
Minoan Civilization. See GREECE,
ANCIENT
MIRO, JOAN
Smithsonian 11:102 (c, 4) Ap '80
--Tapestry in World Trade Center,
New York
Smithsonian 8:48 (c, 4) Ja '78
--Works by him
Smithsonian 10:66-9 (c, 1) Je '79
Smithsonian 11:102-11 (c, 1) Ap
'80
MIRRORS
--Ancient Celtic
Nat Geog 151:614 (c, 4) My '77
--Distorting mirrors (Florida)
Trav/Holiday 153:50 (c, 2) Mr '80
--Versailles, France
Smithsonian 7:45 (c, 1) Mr '77
--Walk-in kaleidoscope (California)
Smithsonian 9:80 (c, 2) S '78
MISSILES
Life 2:157-60 (c, 1) N '79
Life 3:38 (c, 4) Ap '80
--1962 Cuba (aerial view)
Am Heritage 28:10-11 (1) O '77
Smithsonian 10:112-13 (c, 1) Ap
'79
--Cruise missile
Life 2:16-17 (c, 1) F '79
--Egypt
Nat Geog 151:325 (c, 4) Mr '77
--Missile carrier
Life 2:158-60 (c, 1) N '79
MISSISSIPPI
--Lexington
Ebony 34:54 (3) F '79
--Mayersville
Ebony 33:53-6 (3) D '77
--Neshoba County Fair
Nat Geog 157:855-66 (c, 1) Je '80
--See also BILOXI; JACKSON;
NATCHEZ; VICKSBURG
MISSISSIPPI--MAPS
--1878 aerial view of Quincy
Am Heritage 30:16-17 (c, 2) F
'79
MISSISSIPPI RIVER, MIDWEST
--1811-1812 earthquakes
Natur Hist 89:70-3 (map, 1) Ag '80

--1850's map of lower river
Natur Hist 90:36 (c, 2) Je '81
MISSISSIPPI RIVER, ILLINOIS
Nat Geog 151:272-3 (c, 1) F '77
MISSISSIPPI RIVER, IOWA
--Dubuque
Nat Geog 159:626-7 (c, 1) My
'81
MISSISSIPPI RIVER, LOUISIANA
Smithsonian 8:78-9 (c, 3) Jl '77
Nat Geog 156:384 (c, 4) S '79
MISSISSIPPI RIVER, MINNESOTA
--St. Paul
Nat Geog 158:686-7 (c, 1) N
'80
MISSISSIPPI RIVER, MISSISSIPPI
--Scene of Civil War gunboat
battle (Vicksburg)
Am Heritage 29:62-4 (draw-
ing, c, 3) Ag '78
MISSISSIPPI RIVER, MISSOURI
--1869 view at Hannibal
Am Heritage 30:18-19 (map, c, 1)
F '79
MISSISSIPPI RIVER, TENNESSEE
--Memphis
Ebony 36:122 (4) Je '81
MISSOURI
--Missouri River bluffs
Travel 148:59 (c, 4) S '77
--See also HANNIBAL; OZARK
MOUNTAINS; ST. JOSEPH;
ST. LOUIS
MISSOURI RIVER, MIDWEST
Life 1:122 (c, 2) D '78
--1860
Nat Geog 158:48 (4) Jl '80
MISTLETOE
Nat Wildlife 17:19-21 (2) D '78
MITCHELL, BILLY
--Court-martial
Life 1:72 (4) N '78
MITES
Smithsonian 7:139-40 (c, 2) F
'77
Nat Geog 151:568 (c, 2) Ap '77
Natur Hist 86:90 (4) My '77
Natur Hist 88:75 (2) My '79
Natur Geog 157:149 (drawing, c, 4)
F '80
Nat Geog 158:275 (c, 3) Ag '80
Nat Geog 158:559 (c, 4) O '80
--Humorous drawings of chiggers
Smithsonian 12:77-80 (c, 2) Jl
'81
MOA BIRDS
Natur Hist 89:28, 36 (3) O '80
MOBILE, ALABAMA

Nat Geog 151:496-7 (c, 1) Ap '77
--1979 hurricane damage
Smithsonian 11:50-1 (c, 3) S '80
--Post-hurricane looting
Nat Geog 158:350-1 (c, 1) S '80
MOBILE HOMES
Travel 147:8 (4) Ja '77
Travel 147:58-63 (c, 3) Je '77
--Interior
Sports Illus 50:38 (4) Je 18 '79
--San Francisco, California develop-
ment
Nat Geog 159:820 (c, 4) Je '81
MOBILES
--Calder (Washington, D. C.)
Smithsonian 9:46-9 (c, 1) Je '78
MOCKINGBIRDS
Nat Geog 151:153 (painting, c, 1)
F '77
MODELING
Life 1:115-20 (c, 2) D '78
--Male model
Ebony 32:70-84 (3) Mr '77
--Ugly models (Great Britain)
Ebony 33:52-6 (2) My '78
MODIGLIANI, AMADEO
--Tomb (Paris, France)
Smithsonian 9:111 (c, 4) N '78
MOJAVE DESERT, CALIFORNIA
--Antelope Valley in bloom
Nat Geog 156:607-8 (c, 1) N '79
MOLDS
Natur Hist 88:61 (c, 1) Je '79
--See also FUNGI; SLIME MOLDS
MOLLUSKS
Nat Geog 153.085 (c, 3) My '78
Nat Geog 159:637 (c, 1) My '81
--See also ABALONE; CLAMS;
CONCHES; MUSSELS; NAUTI-
LUSES; OCTOPI; OYSTERS;
SCALLOPS; SLUGS; SNAILS;
SQUID
MOLLY MAGUIRES
--Initiating new members
Smithsonian 12:68 (woodcut, 3)
Ag '81
MONACO
Trav/Holiday 152:72 (4) O '79
MONASTERIES
--13th cent. Spain
Am Heritage 32:53-9 (2) Ap '81
--Drepung, Tibet
Smithsonian 7:79, 85 (c, 2) Ja '77
--Greece
Nat Geog 157:362-4, 382-3 (c, 1)
Mr '80
--Lamaseries (Ladakh, India)
Travel 147:26-7 (c, 1) F '77

Nat Geog 153:343, 356-7 (c, 1)
Mr '78
--Model of abbey (Washington,
D. C.)
Smithsonian 11:84-5 (c, 3) Je '80
--Strahov library, Prague, Czecho-
slovakia
Nat Geog 155:550-2 (c, 1) Ap
'79
--Tagtshang, Bhutan
Natur Hist 89:40 (c, 4) Mr '80
--See also MONT SAINT MICHEL
MONET, CLAUDE
Smithsonian 10:53, 59-60 (4)
F '80
--Home in Giverny, France
Smithsonian 10:52-61 (c, 1) F
'80
Life 3:62-7 (c, 1) My '80
--Paintings at Giverny
Life 3:62-7 (painting, c, 4) My
'80
--Painting of Gare Saint-Lazare,
Paris, France
Smithsonian 10:100-1 (c, 1) S
'79
MONGOLIA
Travel 147:cov., 26-9, 66 (c, 1)
Je '77
Life 3:116-26 (c, 2) D '80
--Archaeological sites
Natur Hist 89:79-83 (2) Ap '80
--See also ULAN BATOR
MONGOLIA--COSTUME
Travel 147:cov., 26-7 (c, 1) Je
'77
Life 3:116-26 (c, 2) D '80
--1920's
Natur Hist 90:108 (4) Mr '81
MONGOLIA--HISTORY
--13th cent. naval invasions of
Japan
Smithsonian 12:118-29 (c, 1) D
'81
MONGOOSES
--Ancient Egyptian statue
Nat Geog 151:301 (c, 4) Mr '77
MONKEY FLOWERS
Nat Wildlife 16:46 (c, 4) F '78
MONKEYS
Life 2:200 (c, 2) D '79
Natur Hist 90:cov., 36-43 (c, 1)
S '81
Smithsonian 12:143 (c, 1) N '81
--Langurs
Smithsonian 10:100-1, 104 (c, 4)
N '79
--Macaques

Smithsonian 10:78 (c, 1) O '79
Smithsonian 10:96-105 (c, 1) N
'79
Nat Wildlife 19:4 (c, 3) D '80
Smithsonian 12:cov. (c, 1) D '81
--Rhesus
Nat Geog 157:574-84 (c, 1) Ap '80
Life 4:200 (c, 2) D '81
--Spider monkeys
Smithsonian 10:70 (c, 4) S '79
--See also BABOONS; HOWLERS;
LEMURS; MARMOSETS
Monks. See BUDDHISM--COSTUME
Monorails. See MASS TRANSIT
MONSTERS
Nat Wildlife 16:12-14 (draw-
ing, c, 2) Ap '78
--Ogopogo (British Columbia)
Smithsonian 9:173-85 (c, 3) N '78
--South American drawing (1621)
Am Heritage 28:60 (4) F '77
--Werewolf costumes
Life 4:61-4 (c, 1) S '81
--See also DRAGONS; LOCH NESS
MONSTER
MONT SAINT MICHEL, FRANCE
Nat Geog 151:820-31 (c, 1) Je '77
Trav/Holiday 155:12 (4) Ja '81
MONTANA
Trav/Holiday 156:49-51 (c, 2) Jl
'81
--Early 20th cent. cartoons about
copper wars
Am Heritage 29:9 (4) Ag '78
--Continental Divide
Nat Geog 156:482-3 (c, 1) O '79
--Countryside
Smithsonian 10:70-9 (c, 1) Mr '80
--Dinosaur remains site
Nat Geog 154:158-9 (c, 1) Ag '78
--Flathead Lake
Travel 147:57 (c, 4) My '77
--Flathead National Forest
Nat Geog 154:285-94 (c, 1) Ag '78
--Flathead River
Nat Geog 152:12-19 (c, 1) Jl '77
--Hunter's Hot Springs
Smithsonian 8:94-5 (c, 2) N '77
--People of the land
Am Heritage 29:11-13 (c, 1) Ag
'78
--Ranch resorts
Travel 147:54-7, 80 (c, 3) My '77
--Reclaimed coalfield
Life 3:75 (c, 3) N '80
--Site of 1877 Big Hole Indian battle
Smithsonian 9:98-9 (c, 1) My '78
--Stillwater River

Life 4:132-3 (c, 1) Mr '81
--See also GLACIER NATIONAL
PARK
MONTE CARLO
Trav/Holiday 150:80-3 (2) Ag '78
Trav/Holiday 152:74 (4) O '79
Life 3:70-1 (c, 1) Je '80
MONTENEGRO, YUGOSLAVIA
Nat Geog 152:662-83 (map, c, 1)
N '77
MONTEREY, CALIFORNIA
Trav/Holiday 149:40-3 (map, c, 1)
Mr '78
MONTGOMERY, ALABAMA
Travel 147:cov., 26-31 (c, 1) Ja
'77
Monticello. See JEFFERSON,
THOMAS
MONTMORENCY RIVER, QUEBEC
--Waterfall at merge with St.
Lawrence River
Nat Geog 157:611 (c, 1) My '80
MONTREAL, QUEBEC
Nat Geog 151:446-7, 465 (c, 1)
Ap '77
Trav/Holiday 151:53-5 (c, 3) Ja
'79
Nat Geog 157:596-9 (c, 1) My '80
--1812
Am Heritage 29:106-7 (paint-
ing, c, 2) Je '78
MONUMENTS
--1904 "Slocum" steamer fire
victims (New York City)
Am Heritage 30:75 (2) O '79
--1913 proposed monument to
American Indians (New York)
Am Heritage 30:96-9 (draw-
ing, 1) Ap '79
--Car crash victims (Yugoslavia)
Nat Geog 152:674 (c, 4) N '77
--Eternal flame (Bratsk, Siberia,
U. S. S. R.)
Trav/Holiday 149:26-7 (c, 2) My
'78
--Father Marquette Memorial,
Michigan
Trav/Holiday 154:53 (c, 1) Jl '80
--Franco-Prussian War (Berlin,
Germany)
Trav/Holiday 156:60 (c, 4) O '81
--Ghetto heroes (Warsaw, Poland)
Smithsonian 9:20 (4) N '78
--Memorial to wife of Henry Adams
(Washington, D. C.)
Smithsonian 8:58-9 (sculp-
ture, c, 4) Ap '77
--Monument to the Confederacy

(Montgomery, Alabama)
Travel 147:30 (4) Ja '77
--Peace
Travel 148:38 (4) Jl '77
--Pearl Harbor, Hawaii
Trav/Holiday 152:43 (c, 4) O '79
Nat Geog 156:664-5 (c, 1) N '79
--Plague Column, Vienna, Austria
Smithsonian 10:79 (c, 3) O '79
--Plaques to Jewish Nazi victims
(Hungary)
Smithsonian 10:67 (c, 3) Ag '79
--World War II (Corregidor,
Philippines)
Trav/Holiday 149:42-3 (4) Ja '78
--World War II (Czechoslovakia)
Nat Geog 152:468-9 (c, 1) O '77
--World War II (Hungary)
Nat Geog 152:469 (c, 3) O '77
--World War II Nazi victims (Paris,
France)
Smithsonian 9:117 (c, 1) N '78
--See also ARC DE TRIOMPHE;
JEFFERSON MEMORIAL;
LINCOLN MEMORIAL; MOUNT
RUSHMORE; TRAJAN'S
COLUMN; WASHINGTON
MONUMENT
MOON
Smithsonian 8:18 (4) S '77
--1969 Apollo II mission
Natur Hist 90:50-1 (c, 1) D '81
--Computer photographs
Nat Geog 153:384-5 (c, 2) Mr '78
--Lunar crater
Natur Hist 90:59 (c, 3) Ap '81
--Photos from Voyager I
Nat Geog 154:52-3 (c, 1) Jl '78
MOONS
--Jupiter
Smithsonian 10:cov., 36-45 (c, 1)
Ja '80
--Saturn
Smithsonian 10:46-7 (c, 1) Ja '80
MOONSTONES
Smithsonian 11:70 (c, 4) Je '80
MOORE, HENRY
Smithsonian 9:75, 80 (c, 3) Ag '78
--Sculptures by him
Smithsonian 9:74-81 (c, 2) Ag '78
MOOSE
Nat Wildlife 15:62-3 (c, 1) Ja '77
Nat Wildlife 15:29 (c, 4) Ap '77
Nat Geog 151:740-1 (c, 2) Je '77
Travel 148:66 (4) Ag '77
Nat Geog 152:532-3 (c, 2) O '77
Nat Wildlife 15:4-11 (c, 1) O '77
Nat Wildlife 16:cov. (c, 1) Ag '78

PRAYING
MOSLEMS--ART
--14th cent. Mamluk works
Smithsonian 12:108-13 (c, 2) Jl
'81
MOSLEMS--COSTUME
--Uighur people (China)
Nat Geog 157:292-4, 316-19
(c, 1) Mr '80
MOSQUES
--Abu Dhabi
Travel 147:62 (4) Ja '77
--Afghanistan
Life 3:140 (c, 2) Mr '80
--Bahrain
Travel 147:60 (4) Ja '77
Nat Geog 156:323 (c, 4) S '79
--Dakar, Senegal
Trav/Holiday 148:41 (c, 4) N '77
--Isfahan, Iran
Trav/Holiday 150:60 (c, 4) D
'78
--Kuching, Malaysia
Trav/Holiday 151:37 (c, 2) Mr
'79
--Mecca, Saudi Arabia
Life 2:20-7 (c, 1) Ap '79
--Nairobi, Kenya
Travel 148:54 (c, 4) Jl '77
--Oman
Nat Geog 160:348-9 (c, 1) S '81
--Pakistan
Trav/Holiday 153:94 (4) F '80
--Repairing of Sacred Mosque,
Mecca
Nat Geog 158:312 (c, 1) S '80
--Sacred, Mecca, Saudi Arabia
Nat Geog 154:cov., 580-007
(c, 1) N '78
--Sankore, Timbuktu, Mali
Natur Hist 86:70 (c, 1) My '77
--U. S. S. R.
Nat Geog 158:344 (c, 3) S '80
MOSQUITOS
Nat Geog 156:426-40 (c, 1) S
'79
Natur Hist 90:cov., 70-1 (c, 1)
Jl '81
--Seen through microscope
Nat Geog 151:287 (1) F '77
Life 3:7-10 (1) Jl '80
MOSQUITOS--HUMOR
Nat Wildlife 16:28 (painting, c, 1)
Ag '78
MOSSES
Nat Wildlife 16:64 (c, 1) D '77
MOTHS
Nat Wildlife 15:38, 41 (c, 1)

Ag '77
Nat Wildlife 16:2 (c, 1) Je '78
Smithsonian 10:68-9 (c, 3) S '79
Smithsonian 11:51 (c, 4) Je '80
Nat Wildlife 19:2 (c, 1) F '81
Natur Hist 90:78 (c, 3) Jl '81
--Larvae
Nat Wildlife 16:56 (c, 1) Ap '78
Nat Geog 153:586 (c, 4) My '78
--Metamorphosis
Natur Hist 86:54 (c, 3) Ag '77
--See also CATERPILLARS
MOTION PICTURE PHOTOGRAPHY
Ebony 32:35 (4) Ag '77
Smithsonian 8:10 (4) F '78
Trav/Holiday 151:57 (c, 4) Mr '79
Nat Wildlife 18:36-45 (c, 1) D '79
Ebony 35:88 (3) Je '80
Ebony 36:73 (4) Ja '81
Ebony 36:156-7 (4) My '81
--1937 movie camera
Am Heritage 31:76 (4) Ap '80
--Creating science fiction space
special effects
Smithsonian 9:56-65 (c, 1) Ap '78
--Film cans
Life 4:120-1 (c, 1) My '81
--Film editing
Ebony 34:30 (4) Ja '79
--Movie camera
Ebony 33:53-4 (c, 2) N '77
--Movie projector
Sports Illus 54:29 (c, 4) Ja 26 '81
MOTION PICTURES
--Early 20th cent. special effects
films
Smithsonian 12:114-28 (c, 2) Jl
'81
--1978 films
Life 1:123-6 (c, 4) D '78
--"All That Jazz"
Life 2:88-92 (c, 1) N '79
--"An American Werewolf in Lon-
don"
Life 4:61-4 (c, 1) S '81
--Animated films
Life 1:96-100 (c, 1) N '78
--"Apocalypse Now"
Life 2:110-20 (c, 1) Je '79
--Artifacts from early film history
Life 4:136-46 (c, 1) O '81
--Black-oriented films
Ebony 35:34-6 (4) Mr '80
--"Cannonball Run"
Sports Illus 55:65 (c, 4) Je 29 '81
--"Casablanca" (1942)
Smithsonian 8:140 (4) Ap '77
--"Catonsville Nine"

Ebony 36:49-50 (3) S '81
--"Chariots of Fire"
Life 4:81-3 (c, 2) O '81
--"Coal Miner's Daughter"
Life 3:123 (c, 4) Ap '80
--"The Electric Horseman"
Life 2:131-3 (c, 1) O '79
--"The Empire Strikes Back"
Life 4:113 (c, 2) Ja '81
Ebony 36:32, 39 (c, 4) Ja '81
--Films of Francis Ford Coppola
Life 4:64, 68 (c, 4) Ag '81
--Films of The Virginian
Am Heritage 32:54-5 (2) F '81
--"French Lieutenant's Woman"
Life 4:80-1 (c, 1) Ap '81
--"Gone with the Wind"
Smithsonian 11:106 (4) Ag '80
--"Guess Who's Coming to Din-
ner?"
Ebony 35:88 (4) Je '80
--"Hair"
Life 2:40-4 (c, 1) Mr '79
--"Heaven's Gate"
Life 3:186-94 (c, 1) D '80
--History of sex in cinema
Am Heritage 31:13-21 (2) F '80
--"Hurry Sundown"
Ebony 35:34 (4) Mr '80
--"Knock on Any Door"
Ebony 36:49-50 (4) S '81
--"Lady Sings the Blues"
Ebony 37:142 (3) D '81
--"Last Days of Pompeii" (1913)
Natur Hist 88:116 (4) Ap '79
--"Lilies of the Field"
Ebony 35:86 (4) Je '80
--"Mommie Dearest"
Life 4:10-16 (c, 1) Jl '81
--"Moonraker"
Life 2:93-5 (c, 1) Jl '79
Ebony 35:58 (c, 4) N '79
--"Norma Rae"
Life 2:97 (2) Ap '79
--"Popeye"
Life 3:91-4 (c, 2) O '80
--"Porgy & Bess"
Ebony 35:86 (4) Je '80
--"Raging Bull"
Life 3:89-94 (c, 1) N '80
Sports Illus 53:87 (c, 4) D 1 '80
--"A Raisin in the Sun"
Ebony 34:42 (4) Je '79
--Remakes of old films
Life 2:89-93 (c, 1) Ja '79
--Scenes from German films
Life 4:116-28 (c, 1) My '81
--Scenes from Danny Kaye films

Sports Illus 46:78-9 (4) Ap 4 '77
--Scenes from Sidney Poitier films
Ebony 33:56, 62 (4) N '77
--Scenes from Tim McCoy cowboy
films
Am Heritage 28:52, 59 (c, 1) Je
'77
--"Semi-Tough"
Sports Illus 47:cov., 78-82 (c, 1)
N 7 '77
--"Sergeant York"
Am Heritage 32:60 (3) Ag '81
--Sex in movie ads
Am Heritage 31:18-19 (4) F '80
--Silent cowboy movie poster
Am Heritage 28:52 (c, 1) Je '77
--"Sounder"
Ebony 35:36 (4) Mr '80
--"Stage Door" (1937)
Life 2:126 (4) Je '79
--"Star Wars" robots
Life 2:130 (c, 4) D '79
--"Stir Crazy"
Ebony 37:146 (4) D '81
--"The Tin Drum"
Life 4:116-17, 128 (c, 1) My '81
--"Under the Rainbow"
Life 4:126-32 (c, 1) Je '81
--"The Wiz"
Life 1:56-60 (c, 1) O '78
Ebony 34:112-18 (c, 1) N '78
--"Ziegfeld Follies" (1945)
Ebony 36:53 (4) N '80
--See also GRIFFITH, DAVID W.;
MAYER, LOUIS B.
MOTORBOATS
Sports Illus 46:30-1 (c, 2) Je 27
'77
Life 2:30-1 (c, 2) O '79
Sports Illus 53:30-2 (3) Ag 4 '80
--"Cup and saucer" shape (Japan)
Travel 147:60 (c, 4) F '77
MOTORCYCLE RACING
Sports Illus 48:47 (3) Je 19 '78
Sports Illus 50:58 (c, 2) F 15 '79
--British Grand Prix 1979
Sports Illus 51:59 (c, 4) Ag 20
'79
--Daytona 200 (Florida)
Sports Illus 46:31-5 (c, 1) Mr 14
'77
Sports Illus 46:26 (c, 3) Mr 21
'77
MOTORCYCLE RIDING
Life 2:81 (2) Ag '79
Ebony 35:100 (3) Jl '80
Life 3:104 (c, 2) Jl '80
Ebony 37:38 (c, 1) N '81

Sports Illus 55:86-7 (c, 1) D 7
'81
--Indonesia
Nat Geog 159:417 (c, 3) Mr '81
--Spain
Nat Geog 153:316-17 (c, 2) Mr
'78
--Yukon
Nat Geog 153:562 (c, 4) Ap '78
MOTORCYCLES
Ebony 33:132 (4) Ag '78
Nat Geog 154:434 (c, 3) S '78
Ebony 34:116 (c, 3) Ap '79
Nat Geog 158:790-1 (c, 3) D '80
Nat Geog 159:230 (c, 2) F '81
--Dirt motorbikes
Smithsonian 9:66-75 (c, 1) S '78
--North Yemen
Nat Geog 156:249 (c, 1) Ag '79
--Three-wheelers
Ebony 36:32 (3) Mr '81
Smithsonian 12:38-9 (c, 1) Ag
'81
MOUNT ETNA, SICILY, ITALY
Travel 148:47 (c, 4) Ag '77
Life 3:59-61 (c, 1) Mr '80
MOUNT EVEREST, NEPAL
Natur Hist 90:64-5 (c, 1) S '81
Nat Geog 160:552-65 (c, 1) O
'81
--View from satellite
Natur Hist 88:126-7 (c, 1) O '79
MOUNT HOOD, OREGON
Smithsonian 11:56-7 (c, 3) Jl '80
Life 3:73 (c, 4) S '80
MOUNT KENYA, KENYA
Sports Illus 48:40 (c, 4) My 29
'78
MOUNT LOGAN, YUKON
Nat Geog 153:576-7 (c, 1) Ap
'78
MOUNT McKINLEY, ALASKA
Smithsonian 8:38-9 (c, 1) D '77
Nat Wildlife 16:4-5 (c, 1) Ag '78
Trav/Holiday 151:100 (4) My '79
Nat Geog 156:66-79 (c, 1) Jl '79
MOUNT McKINLEY NATIONAL
PARK, ALASKA
Travel 147:53-7 (c, 1) Ap '77
Natur Hist 86:74 (c, 1) Ag '77
Nat Wildlife 16:4-11 (c, 1) Ag '78
Nat Geog 156:66-79 (map, c, 1)
Jl '79
Natur Hist 90:46-7 (c, 1) Jl '81
MOUNT MITCHELL, NORTH
CAROLINA
Nat Geog 151:472-3 (c, 1) Ap '77
MOUNT RAINIER, WASHINGTON

Smithsonian 9:56-7 (c, 1) F '79
Ebony 34:40 (c, 4) My '79
Life 3:73 (c, 4) S '80
MOUNT RAINIER NATIONAL PARK,
WASHINGTON
Nat Wildlife 15:12 (c, 2) Ap '77
MOUNT RUSHMORE, SOUTH
DAKOTA
Travel 147:30 (4) Je '77
--Construction
Natur Hist 86:60-5 (c, 1) Ja '77
Am Heritage 28:cov., 18-27 (c, 1)
Je '77
MOUNT ST. HELENS, WASHINGTON
Nat Wildlife 18:36-7 (1) O '80
Life 4:77-82 (c, 1) Ja '81
Sports Illus 55:24-31 (c, 1) Jl 20
'81
Nat Geog 160:710-33 (c, 1) D '81
--1847 eruption
Smithsonian 11:60 (painting, c, 3)
Jl '80
Am Heritage 31:114 (painting, c, 4)
O '80
--1980 eruption
Life 3:111 (2) My '80
Life 3:98-101 (c, 1) Jl '80
Smithsonian 11:54-5, 62-3 (c, 1)
Jl '80
Life 4:73-6 (c, 1) Ja '81
Nat Geog 159:cov., 2-65 (c, 1)
Ja '81
Natur Hist 90:36 (c, 4) My '81
--Plants surviving 1980 eruption
Smithsonian 11:17-20 (c, 4) Ja '81
Natur Hist 90:cov., 36-47 (c, 1)
My '81
MOUNT SHASTA, CALIFORNIA
Am Heritage 30:70-1 (c, 3) F '79
Nat Wildlife 17:54-5 (c, 1) Ap
'79
Life 3:78 (c, 4) S '80
Nat Wildlife 18:42-3, 46-7 (c, 1)
O '80
Mount Vernon. See WASHINGTON,
GEORGE
MOUNT WASHINGTON, WHITE
MOUNTAINS, NEW HAMP-
SHIRE
Trav/Holiday 154:6, 30 (c, 4) O
'80
Nat Geog 159:368-9 (c, 1) Mr '81
MOUNTAIN CLIMBING
Sports Illus 49:44-7 (c, 2) D 25
'78
--Alaska
Nat Wildlife 15:60 (c, 4) Ja '77
Nat Wildlife 19:25-9 (c, 1) D '80

--Argentina
 Sports Illus 52:64-70 (c, 1) Ap
 14 '80
--Kenya
 Smithsonian 8:54 (c, 4) Ap '77
--Mt. Everest, Nepal
 Nat Geog 160:552-65 (c, 1) O '81
--Mt. McKinley, Alaska
 Nat Geog 156:68-79 (c, 1) Jl '79
--Nepal
 Nat Geog 155:294-313 (c, 1) Mr
 '79
--New Guinea
 Sports Illus 54:58-69 (c, 1) Mr
 9 '81
--Pakistan
 Sports Illus 46:92-5 (c, 1) My 2
 '77
 Nat Geog 155:622-49 (c, 1) My
 '79
--Shawangunk Mountains, New
 York
 Sports Illus 54:36 (c, 2) Je 15
 '81
--Washington
 Sports Illus 49:53 (c, 1) S 18 '78
--See also ROCK CLIMBING
MOUNTAIN LIONS
 Nat Wildlife 16:5 (c, 1) D '77
 Nat Wildlife 17:26-7 (paint-
 ing, c, 1) D '78
 Nat Wildlife 17:16 (4) F '79
 Nat Wildlife 18:48 (c, 4) Ap '80
 Nat Wildlife 19:30 (c, 4) O '81
MOUNTAINS
--Alaska
 Sports Illus 53:36-7 (c, 1) D 15
 '80
--Albania
 Nat Geog 158:540-1 (c, 1) O '80
--Baja California, Mexico
 Nat Geog 158:694-9 (c, 1) N '80
--Brooks Range, Alaska
 Nat Wildlife 15:54-5 (c, 1) Ja
 '77
 Nat Geog 156:744-5, 760
 (map, c, 1) D '79
--Camelback, Scottsdale, Arizona
 Trav/Holiday 148:62 (3) D '77
--Cantabrian, Spain
 Nat Geog 153:310-11 (c, 1) Mr
 '78
--Coast Range, Alaska
 Nat Wildlife 19:25-9 (c, 1) D '80
--Costa Rica
 Nat Geog 160:32-3 (c, 1) Jl '81
--Drakensberg Range, South Africa
 Nat Geog 151:794-5 (c, 1) Je '77

--Durmitor Range, Yugoslavia
 Nat Geog 152:664-5 (c, 1) N '77
--Fiftymile Mountain, Utah
 Nat Geog 158:786-7 (c, 1) D '80
--Harney Peak, South Dakota
 Travel 147:30 (3) Je '77
--Laurentian Mountains, Quebec
 Trav/Holiday 152:50-5 (c, 1) N
 '79
--Monadnock, New Hampshire
 Nat Wildlife 15:26-8 (c, 1) Ag '77
--Mt. Teide, Tenerife, Canary
 Islands
 Trav/Holiday 153:38-9 (c, 1) Je
 '80
--Mt. Yotei, Hokkaido, Japan
 Nat Geog 157:62-3 (c, 1) Ja '80
--New Guinea
 Sports Illus 54:64-5 (c, 1) Mr 2
 '81
 Sports Illus 54:58-69 (c, 1) Mr 9
 '81
--Ngauruhoe, New Zealand
 Trav/Holiday 155:41 (c, 3) Ja '81
--Santa Ana Mountains, California
 Nat Geog 160:774-5, 778-9 (c, 1)
 D '81
--Sugar Loaf, Rio de Janeiro,
 Brazil
 Travel 147:37 (c, 2) Je '77
 Nat Geog 153:247 (c, 1) F '78
--See also ACONCAGUA; ADIRON-
 DACKS; ALPS; ANDES; AP-
 PALACHIAN; ARARAT; BLUE
 RIDGE; CASCADE RANGE;
 HIMALAYAN; HINDU KUSH;
 MOUNT EVEREST; MOUNT
 HOOD; MOUNT KENYA;
 MOUNT LOGAN; MOUNT
 McKINLEY; MOUNT MITCHELL;
 MOUNT RAINIER; MOUNT ST.
 HELENS; MOUNT SHASTA;
 MOUNT WASHINGTON;
 OZARKS; ROCKY MOUNTAINS;
 ST. ELIAS; SIERRA NEVADAS;
 TETON RANGE; WASATCH
 RANGE; WHITE MOUNTAINS
Movies. See MOTION PICTURES
MUD
 Smithsonian 11:188-91 (c, 2) N
 '80
--Mud bath (California)
 Nat Geog 155:710-11 (c, 1) My
 '79
--Mud flats (Alaska)
 Smithsonian 8:45 (c, 4) D '77
--Mud slides (California)
 Nat Geog 155:32-3 (c, 1) Ja '79

MUD HENS
Natur Hist 86:58 (c, 2) Ag '77
MULE RIDING
--Hawaii
Trav/Holiday 150:37 (c, 2) D '78
MUMMIES
--Ancient Peru
Natur Hist 88:75-81 (c, 1) F '79
--Copper Man's hands (19th cent.
Chile)
Natur Hist 89:91 (3) Jl '80
MUNCH, EDVARD
Smithsonian 9:88, 91 (c, 4) D
'78
--Lovers in Waves
Smithsonian 8:116 (painting, 4)
Ja '78
--Paintings by him
Smithsonian 9:88-95 (c, 2) D
'78
MUNICH, WEST GERMANY
Trav/Holiday 148:53-7 (c, 1) D
'77
MURALS
--Atlanta city wall, Georgia
Trav/Holiday 153:56 (c, 1) F
'80
--Bronx, New York street
Smithsonian 9:68-9 (c, 2) Ja '79
--Decorated vans and motorcycles
Ebony 34:110-12 (painting, c, 4)
Jl '79
--Depicting black history (Chicago,
Illinois)
Ebony 36:38 (4) Je '81
--East Los Angeles streets, Cali-
fornia
Smithsonian 9:105-11 (c, 1) O
'79
--Hispanic culture (California)
Nat Geog 155:38-9 (c, 1) Ja '79
--Side of building (Los Angeles,
California)
Trav/Holiday 156:58 (c, 3) N '81
--Luxor, Egypt
Nat Geog 151:326-7 (c, 1) Mr
'77
--Memphis street, Tennessee
Ebony 36:121 (painting, c, 4) Je
'81
--Montreal, Quebec
Nat Geog 151:465 (c, 1) Ap '77
Trav/Holiday 151:54-5 (3) Ja
'79
--Wedding scene on building (Los
Angeles, California)
Life 3:9 (c, 2) O '80
MURRES (BIRDS)

Nat Wildlife 15:58 (c, 4) Ja '77
Natur Hist 87:47-9 (c, 1) F '78
MUSCAT, OMAN
Nat Geog 160:356-7, 372-3 (c, 1)
S '81
MUSEUM OF MODERN ART, NEW
YORK CITY, NEW YORK
--Pieces from its collection
Life 2:82-94 (c, 2) S '79
MUSEUMS
--19th cent. Egyptian Hall, London,
England
Smithsonian 9:68-77 (drawing, 1)
Ap '78
--African Art, Washington, D. C.
Smithsonian 8:55-6 (c, 3) Ag '77
--Albright-Knox, Buffalo, New York
Smithsonian 10:78-84 (c, 2) D '79
--Anthropology, British Columbia
Nat Geog 154:481 (c, 1) O '78
--Art (Los Angeles, California)
Nat Geog 155:45 (c, 3) Ja '79
--Art Institute of Chicago, Illinois
Trav/Holiday 155:56 (c, 1) Ap
'81
--Bardo, Tunis, Tunisia
Nat Geog 157:198-9 (c, 1) F '80
--Bay of Pigs exhibit (Cuba)
Nat Geog 151:64-5 (c, 2) Ja '77
--Black museums in the U. S.
Ebony 36:84-90 (4) F '81
--Boston Children's Museum, Mas-
sachusetts
Smithsonian 12:158-67 (c, 1) O
'81
--Brooklyn Museum, Brooklyn, New
York
Smithsonian 11:116-17 (c, 1) My
'80
--Budapest, Hungary
Smithsonian 10:170 (c, 3) N '79
--George Washington Carver Mu-
seum, Tuskegee, Alabama
Ebony 32:106 (4) Jl '77
--Chicago, Illinois
Trav/Holiday 153:12, 84 (2) Ap
'80
--Cooper-Hewitt, New York City,
New York
Smithsonian 7:129 (c, 4) Ja '77
Smithsonian 8:68-77 (c, 1) N '77
Smithsonian 10:132-8 (c, 2) N '79
--Corning Glass, Corning, New
York
Smithsonian 11:66-77 (c, 1) My
'80
--Denver, Colorado art museum
Smithsonian 10:115 (c, 4) Ap '79

Nat Wildlife 16:2 (c, 1) Ap '78
MUSIAL, STANLEY
Sports Illus 47:70 (4) O 10 '77
MUSIC
--History of jazz
Smithsonian 11:100-9 (c, 1) N
'80
--Listening to stereo
Ebony 33:159 (4) Ag '78
Ebony 34:152 (3) N '78
MUSIC STANDS
--Thomas Jefferson's stand for
quintet
Smithsonian 12:160 (4) Ap '81
MUSICAL INSTRUMENTS
--Home-made instruments
Smithsonian 11:112 (c, 4) Mr
'81
--Marimba
Ebony 37:78 (4) D '81
--Rare instruments (Washington,
D. C. museum)
Smithsonian 12:141 (c, 1) Ag '81
--Sarangi (India)
Nat Geog 160:120 (c, 3) Jl '81
--Tibet
Trav/Holiday 152:67 (c, 4) Jl '79
--Vibraphone
Ebony 37:145 (4) N '81
--See also ACCORDIONS; BAG-
PIPES; BANDS; BANDS,
MARCHING; BANJOS; BAS-
SOONS; CALLIOPES; CELLOS;
CLARINETS; CONCERTS;
CONDUCTORS, MUSIC;
CORONETS; DRUMS; DUL-
CIMERS; FIFES; FLUTES;
FRENCH HORNS; GUITARS;
HARPS; HORNS; JUKEBOXES;
LUTES; MANDOLINS; MUSI-
CIANS; OBOES; ORGANS;
PIANOS; SAXOPHONES;
TROMBONES; TRUMPETS;
TUBAS; VIOLINS
MUSICAL SCORES
Smithsonian 11:84-5 (c, 4) F '81
--19th cent. songs about mothers
Am Heritage 30:14-18 (c, 2) Ap
'79
--1907 "Roll Around" sheet music
cover
Am Heritage 31:22 (c, 4) Je '80
--Foster's "Old Folks at Home"
manuscript
Nat Geog 152:22 (4) Jl '77
--Hand-lettered vocal music
Smithsonian 8:77 (c, 1) Ja '78
--"O Tannenbaum"

Nat Wildlife 15:24 (c, 3) Ja '77
MUSICIANS
--Chamber musicians (New York)
Smithsonian 12:83 (c, 4) Je '81
--Country music stars
Am Heritage 30:97-8 (4) F '79
Smithsonian 12:146 (c, 4) Je '81
--Factory lunchtime concert (Wash-
ington)
Nat Geog 151:87 (c, 1) Ja '77
--Folk (Tunisia)
Trav/Holiday 149:30 (4) Ja '78
--Ireland
Nat Geog 154:666 (c, 3) N '78
--Jazz (Vermont)
Trav/Holiday 151:47 (c, 4) Ja '79
--New wave
Life 2:104-12 (c, 1) S '79
--Ozark Mountains
Am Heritage 29:104-5 (c, 1) D '77
--Pro football game
Sports Illus 51:26-7 (c, 2) S 17
'79
--Rock
Ebony 32:29 (c, 2) Ja '77
Travel 147:41 (c, 4) Ap '77
Ebony 34:130 (4) F '79
Ebony 34:62-3 (4) My '79
Nat Geog 157:467 (c, 2) Ap '80
Life 4:60-3 (c, 1) N '81
--Street musicians (Bavaria, West
Germany)
Trav/Holiday 153:69 (c, 4) Mr
'80
--Street musicians (Bolivia)
Trav/Holiday 150:57 (c, 1) Jl
'78
--Street musicians (New Orleans,
Louisiana)
Trav/Holiday 153:69 (c, 4) Mr '80
--Street musicians (New York)
Natur Hist 89:66-7 (2) Ag '80
--Street musicians (Tunisia)
Nat Geog 157:210-11 (c, 1) F '80
--Symphony orchestra (Washington,
D. C.)
Smithsonian 11:80-1 (c, 2) F '81
--West Indians at New York City
festival
Natur Hist 88:73-81 (c, 1) Ag '79
--See also ARMSTRONG, LOUIS;
BANDS; BANDS, MARCHING;
CHOPIN, FREDERIC; CON-
CERTS; CONDUCTORS, MUSIC
MUSK OXEN
Nat Geog 152:626-7 (c, 1) N '77
Nat Geog 155:376-7 (c, 1) Mr '79
Nat Geog 156:752-3 (c, 1) D '79

Nat Wildlife 18:3 (c, 4) Ap '80
MUSKRATS
Nat Wildlife 17:18 (4) O '79
Nat Wildlife 18:48 (c, 4) O '80
MUSSELS
Natur Hist 86:44-6 (c, 1) My
'77
Natur Hist 88:104 (4) Ap '79
MUSTACHES
Sports Illus 49:81 (c, 4) S 11 '78
Sports Illus 55:34 (c, 4) O 12
'81
--1880's (Great Britain)
Smithsonian 8:52 (drawing, 4)
D '77
--1894
Am Heritage 28:92-3 (4) Ag '77
--Curled
Sports Illus 54:cov. (c, 1) Mr
16 '81
--India
Nat Geog 151:218-19 (c, 1) F
'77
--See also BEARDS
Mustangs. See HORSES
MUSTARD PLANTS
Nat Geog 153:339 (c, 1) Mr '78
Mycenaean Civilization. See
GREECE, ANCIENT
MYSTIC, CONNECTICUT
--Mid 19th cent.
Am Heritage 31:24-33 (1) F '80
--Boat at seaport
Trav/Holiday 155:70 (c, 4) My
'81
Trav/Holiday 155:22-4 (4) Je
'81
MYTHOLOGY
--Celtic legends (Ireland)
Nat Geog 151:624-5 (painting, c, 2)
My '77
--See also DEITIES; DRAGONS;
KING ARTHUR; UNICORNS
MYTHOLOGY--GREEK AND
ROMAN
--Europa and Zeus (490 B. C.
Greek vase)
Smithsonian 8:56 (4) S '77
--Hades and Persephone (Greek
fresco)
Nat Geog 154:54 (c, 1) Jl '78
--Medusa (Ancient Roman sculp-
ture; Turkey)
Nat Geog 160:528 (c, 4) O '81
--Nike sculpture (5th cent. B. C.
Thrace)
Smithsonian 8:46 (c, 2) Je '77
--Orpheus mosaic (3rd cent.

Rome)
Smithsonian 8:54 (4) S '77
--Perseus and Andromeda (18th
cent. painting; Italy)
Smithsonian 12:74 (c, 2) D '81
--See also BACCHUS; DIANA; EROS;
HELEN OF TROY; HERCULES;
MINERVA; ULYSSES; VENUS
MYTHOLOGY--NORSE
--Death horse (Denmark)
Nat Geog 156:848-9 (c, 1) D '79
--Odin
Smithsonian 10:64 (drawing, 4)
Ja '80
--Thor
Nat Wildlife 18:14 (drawing, 4)
F '80

-N-

NAHANNI NATIONAL PARK,
NORTHWEST TERRITORIES
Nat Geog 160:396-419 (c, 1) S '81
NAIROBI, KENYA
Travel 148:52-4 (c, 1) Jl '77
--Parliament Square
Ebony 35:42 (c, 4) D '79
NAMIBIA
--Diamond mines
Nat Geog 155:90-1 (c, 1) Ja '79
Smithsonian 12:48-57 (c, 1) My
'81
NAMIBIA--COSTUME
--Bushmen
Smithsonian 11:86-95 (c, 1) Ap
'80
--Children in uniform
Nat Geog 159:268-9 (c, 1) F '81
NANTUCKET, MASSACHUSETTS
Travel 147:44-8 (c, 2) Ap '77
NAPOLEON
Smithsonian 9:118 (drawing, 4)
Ja '79
Smithsonian 11:204 (painting, c, 4)
N '80
--Carriage
Smithsonian 9:76-7 (painting, 1)
Ap '78
--Depicted in 1927 film "Napoleon"
Am Heritage 32:41 (4) Je '81
--Painting of wax Napoleon (London,
England)
Smithsonian 9:77 (painting, 1) Ap
'78
NARWHALS
Smithsonian 10:118-19, 122-5
(c, 2) F '80

Natur Hist 90:50-7 (c, 1) Ag '81
NASHVILLE, TENNESSEE
Nat Geog 153:693-711 (c, 1) My
'78
Trav/Holiday 155:50-5 (c, 1) Ap
'81
--Ryman Auditorium (Grand Ole
Opry House)
Am Heritage 30:94-103 (1) F
'79
NASSAU, BAHAMAS
Ebony 32:96 (c, 4) Ja '77
Trav/Holiday 151:55-62 (c, 3)
Ap '79
NAST, THOMAS
--1871 caricature of Boss Tweed
Am Heritage 28:66 (3) Je '77
--1874 painting of Santa Claus
Am Heritage 32:cov. (c, 2) D
'80
--Cartoon about evolution
Natur Hist 89:118 (4) Ap '80
--Cartoon of "Country going to
the dogs"
Smithsonian 10:16 (4) Ja '80
--Victoria Woodhull cartoon
Smithsonian 8:131 (3) O '77
NATCHEZ, MISSISSIPPI
--Late 19th cent.
Am Heritage 29:18-35 (1) Je
'78
NATIONAL BUREAU OF STAND-
ARDS
--Activities
Smithsonian 9:42-51 (c, 1) S '78
Smithsonian 9:88-96 (c, 1) O '78
NATIONAL GALLERY OF ART,
WASHINGTON, D. C.
Nat Geog 154:680-701 (c, 1) N
'78
--East Wing
Smithsonian 9:46-55 (c, 1) Je
'78
NATIONAL PARKS
Nat Geog 156:entire issue
(map, c, 1) Jl '79
--Fiordland, New Zealand
Nat Geog 153:116-29 (c, 1) Ja
'78
--See also ACADIA; ARCHES;
BADLANDS; BRYCE CANYON;
CANYONLANDS; EVER-
GLADES; GATEWAY;
GETTYSBURG; GLACIER;
GOLDEN GATE; GRAND
CANYON; GRAND TETON;
GREAT SMOKY MOUNTAINS;
GUADALOUPE; INDIANA

DUNES; KATMAI; KLUANE;
MESA VERDE; MOUNT Mc-
KINLEY; MOUNT RAINIER;
NAHANNI; NAVAJO; NORTH
CASCADES; OLYMPIC;
RAINBOW BRIDGE; RED-
WOOD; ROCKY MOUNTAIN;
SHILOH; WHITE SANDS;
WOLF TRAP FARM; YELLOW-
STONE; YOSEMITE
NATIONAL RIFLE ASSOCIATION
--Shooting events
Am Heritage 29:6-17, 116 (c, 1)
F '78
NATURALISTS
--Joseph Knowles in Maine woods
(1913)
Am Heritage 32:60-3 (c, 2) Ap
'81
--Aldo Leopold
Smithsonian 11:128, 131 (4) O
'80
--George Perkins Marsh
Nat Wildlife 18:28 (painting, c, 1)
Ag '80
--Statue of Theophrastus
Natur Hist 90:57 (c, 1) Mr '81
--See also AGASSIZ, LOUIS;
AUDUBON, JOHN JAMES;
BARTRAM, JOHN AND WIL-
LIAM; BURROUGHS, JOHN;
CUVIER, BARON GEORGES;
LINNAEUS, CAROLUS
NAURU
Life 2:70-1 (c, 1) Ag '79
NAUTILUSES (MOLLUSKS)
Smithsonian 8:76-81 (c, 1) Je '77
NAVAJO INDIANS (ARIZONA)
Nat Geog 156:80-5 (c, 1) Jl '79
--Woman on a horse
Nat Wildlife 17:52 (c, 1) Ap '79
NAVAJO INDIANS (ARIZONA)--ART
--Rugs
Trav/Holiday 154:61 (3) S '80
--Sand paintings
Trav/Holiday 151:63 (c, 4) Ja '79
Nat Geog 158:179 (c, 4) Ag '80
NAVAJO INDIANS (ARIZONA)--
COSTUME
Trav/Holiday 154:57-8 (c, 4) S
'80
NAVAJO NATIONAL MONUMENT,
ARIZONA
Nat Geog 156:81-5 (c, 1) Jl '79
NAVIGATION INSTRUMENTS
Sports Illus 54:33 (c, 4) F 23 '81
--18th cent.
Nat Geog 152:747 (c, 3) D '77

--Plotting a course
Nat Geog 154:820 (c, 4) D '78
--See also COMPASSES; RADAR
Navy, U. S. See MILITARY COS-
TUME; U. S. NAVY
NAZISM
--American Nazis
Ebony 34:160 (4) D '78
--American Nazis demonstrating
against blacks
Ebony 34:69 (4) Ag '79
--Adolf Eichmann's hands
Life 3:106-7 (1) N '80
--Dr. Josef Mengele
Life 4:44, 52 (4) Je '81
--Use of swastika through history
Natur Hist 89:68-75 (c, 1) Ja
'80
--See also CONCENTRATION
CAMPS; FRANK, ANNE;
HITLER, ADOLF; WORLD
WAR II
NEBRASKA
--1880's sod houses
Smithsonian 11:146 (4) Ap '80
Smithsonian 11:87 (3) N '80
--Barn
Trav/Holiday 153:37 (c, 2) Je
'80
--Chimney Rock
Nat Geog 158:65 (c, 4) Jl '80
--Farms
Nat Wildlife 16:6-7 (c, 3) Je '78
Nat Geog 158:54-5 (c, 1) Jl '80
--Northwestern area
Travel 148:50-5 (c, 1) Ag '77
--Sand Hills
Nat Geog 154:492-517 (c, 1) O
'78
--See also PLATTE RIVER
NEBULAE
--Great Nebula in Orion
Natur Hist 89:80 (4) My '80
--See also MILKY WAY; STARS
NECKLACES
--800 B. C. amber (Ireland)
Natur Hist 89:56 (4) N '80
--Ancient Celtic torque
Nat Geog 151:608 (c, 4) My '77
--Coral necklace
Nat Geog 155:731 (c, 1) My '79
--Neck coils (Burma)
Nat Geog 155:798-801 (c, 1) Je
'79
--Sapphire and diamond necklace
Smithsonian 9:144 (c, 4) F '79
NEEDLEWORK
--Crocheting (Ireland)

Trav/Holiday 153:57 (c, 2) My '80
--India
Trav/Holiday 153:58-60 (c, 2) Mr
'80
--See also EMBROIDERY; LACE
MAKING; SEWING; TAILORS;
TAPESTRIES
NELSON, HORATIO
Smithsonian 10:65 (drawing, 4)
Ja '80
--Fabric depicting his funeral
(1805)
Smithsonian 8:72 (c, 1) N '77
NENES (BIRDS)
Sports Illus 49:76 (c, 4) S 25 '78
Nat Wildlife 19:22 (c, 4) Je '81
Neon Signs. See SIGNS AND SIGN-
BOARDS
NEPAL
Nat Geog 151:500-17 (map, c, 1)
Ap '77
--Himalayan villages
Natur Hist 88:cov., 47-57 (c, 1)
Ja '79
--Katmandu region
Trav/Holiday 156:34-9 (map, c, 1)
Ag '81
--See also HIMALAYAN MOUN-
TAINS; KATMANDU; MOUNT
EVEREST
NEPAL--COSTUME
Nat Geog 151:500-17 (c, 1) Ap '77
Trav/Holiday 156:36 (c, 2) Ag '81
--Laborer
Natur Hist 88:50 (c, 3) O '79
--Newar people
Nat Geog 155:268-85 (c, 1) F '79
NEPAL--HOUSING
--Two-story houses
Natur Hist 88:49 (c, 4) Ja '79
NETHERLANDS
Trav/Holiday 153:cov., 44-9
(map, c, 1) F '80
Trav/Holiday 155:44-9 (c, 2) Ap
'81
--Tulip industry
Nat Geog 153:713-28 (c, 1) My
'78
Trav/Holiday 155:49 (c, 3) Ap '81
--Winter ice skating scenes
Life 2:106-13 (c, 1) Mr '79
--See also AMSTERDAM; DELFT
NETHERLANDS--COSTUME
Nat Geog 153:713-27 (c, 1) My
'78
Trav/Holiday 155:45-9 (c, 2) Ap
'81
--Royal family

Life 3:130-1 (c, 1) Ap '80
--Traditional
Trav/Holiday 153:48 (3) F '80
NETHERLANDS--HISTORY
--17th cent. tulip speculation
Smithsonian 8:70-5 (painting, c, 1)
Ap '77
NETHERLANDS--SOCIAL LIFE
AND CUSTOMS
--Dutch heritage in Holland,
Michigan
Trav/Holiday 149:47-9 (c, 1)
My '78
NETHERLANDS ANTILLES
--Bonaire
Trav/Holiday 151:57-61
(map, c, 1) Ja '79
Trav/Holiday 151:59 (c, 4) Ap
'79
--Curaçao
Ebony 32:94-5 (c, 3) Ja '77
Trav/Holiday 148:51 (2) N '77
--Curaçao rooftops
Trav/Holiday 153:68 (c, 4) Ap
'80
--See also ARUBA
NETTLES
--Rock nettles
Nat Wildlife 18:64 (c, 1) D '79
NEVADA
--Field
Nat Geog 158:50-1 (c, 1) Jl '80
--Rhyolite ghost town
Trav/Holiday 153:46-7, 66-8
(3) Je '80
--See also LAKE TAHOE; LAS
VEGAS; RENO
NEW BEDFORD, MASSACHUSETTS
Trav/Holiday 156:40-3 (c, 2) Jl
'81
NEW BRUNSWICK
Trav/Holiday 150:44-51 (c, 1)
Jl '78
--Madawaska area
Nat Geog 158:380-409 (map, c, 1)
S '80
--See also ST. ANDREWS; ST.
JOHN; ST. JOHN RIVER
NEW DELHI, INDIA
--Temple
Natur Hist 89:69 (c, 1) Ja '80
NEW ENGLAND
--Hydroelectric plants
Smithsonian 8:85-9 (c, 1) S '77
NEW ENGLAND--MAPS
Trav/Holiday 155:71 (4) My '81
NEW GUINEA
Nat Geog 152:124-46 (c, 1) Jl

'77
Sports Illus 54:64-74 (map, c, 1)
Mr 2 '81
Sports Illus 54:58-69 (c, 1) Mr
9 '81
NEW GUINEA--ART
--Iatmul works
Natur Hist 89:76-7 (c, 1) F '80
NEW GUINEA--COSTUME
Sports Illus 54:66-72 (c, 4) Mr
'81
--Actor with painted face
Smithsonian 12:218 (c, 4) O '81
--Gimi tribe
Nat Geog 152:124-46 (c, 1) Jl '77
NEW GUINEA--HOUSING
--Thatched-roof huts
Nat Geog 152:126-9 (c, 3) Jl '77
NEW GUINEA--SOCIAL LIFE AND
CUSTOMS
--Tribal dance
Smithsonian 8:58 (c, 3) N '77
NEW HAMPSHIRE
Trav/Holiday 150:41-3 (c, 1) Jl
'78
--Monadnock Mountain
Nat Wildlife 15:26-8 (c, 1) Ag '77
--See also CONCORD; CONNECTI-
CUT RIVER; MANCHESTER;
MOUNT WASHINGTON; PORTS-
MOUTH; WHITE MOUNTAINS
NEW JERSEY
Nat Geog 160:568-99 (map, c, 1)
N '81
--Cape May
Trav/Holiday 153:63-4 (c, 1) My
'80
--Cape May houses
Smithsonian 9:120-31 (c, 1) S '78
--Meadowlands sports complex
Sports Illus 47:74-7 (c, 1) S 12 '77
--Passaic River
Smithsonian 8:87 (c, 4) S '77
--See also ATLANTIC CITY;
GEORGE WASHINGTON
BRIDGE; JERSEY CITY;
NEWARK; PALISADES;
PRINCETON
NEW LONDON, CONNECTICUT
--Lighthouse
Trav/Holiday 149:22 (4) My '78
NEW MEXICO
Nat Geog 154:417-35 (map, c, 1)
S '78
--Acoma's Indian sites
Trav/Holiday 152:28-31 (map, c, 2)
D '79
--Angel Peak

Trav/Holiday 153:50 (c, 4) Ap
'80
--Copper mine
Nat Geog 156:486-7 (c, 1) O '79
--Hernandez
Life 2:18 (4) My '79
--National Radio Astronomy Ob-
servatory
Smithsonian 9:cov., 28-37 (c, 1)
Jl '78
--Pie Town (1940)
Am Heritage 31:74-81 (c, 1) F
'80
--Pueblo Indians village
Sports Illus 51:46-7 (c, 1) N 26
'79
--Ruidoso
Trav/Holiday 155:6 (4) Je '81
--Taos Valley
Smithsonian 10:100 (c, 4) Jl '79
--Tu-Tan Lake
Trav/Holiday 154:10 (c, 3) O '80
--See also ALBUQUERQUE; RIO
GRANDE RIVER; SANTA FE;
WHITE SANDS NATIONAL
MONUMENT
NEW ORLEANS, LOUISIANA
Nat Geog 153:214-15 (c, 1) F
'78
Sports Illus 49:94-5 (c, 1) D 4
'78
Ebony 34:33-5 (3) D '78
Sports Illus 54:48-52 (c, 3) Ja
19 '81
Trav/Holiday 155:52-7 (c, 1) F
'81
--19th cent. architecture
Am Heritage 30:cov., 66-79,
114 (painting, c, 1) Ag '79
--City Hall
Ebony 34:42 (4) Ja '79
--Restaurants
Trav/Holiday 150:53-4 (c, 1) Jl
'78
--Shotgun house
Natur Hist 86:50 (c, 1) F '77
NEW YEAR'S DAY
--Hong Kong celebration
Trav/Holiday 153:60-2 (c, 1)
Ja '80
--Mummer's parade (Philadelphia,
Pennsylvania)
Smithsonian 11:80-4 (c, 1) Ja
'81
--Tournament of Roses, Pasadena,
California
Am Heritage 29:2, 30-3 (c, 1)
D '77

NEW YORK
--1880's assemblymen
Am Heritage 30:34-42 (4) F '79
--Early 20th cent. Tuxedo
Am Heritage 29:69-75 (1) Ag '78
--Adirondack area
Smithsonian 10:42-51 (c, 1) F '80
--Ancram
Trav/Holiday 151:80-3 (map, c, 2)
My '79
--Beaverkill River, Roscoe
Sports Illus 46:19 (c, 3) Ja 31
'77
--Big Moose Lake
Sports Illus 55:68-9 (c, 1) S 21
'81
--Chautauqua
Smithsonian 12:80-91 (c, 1) Je
'81
--Finger Lakes region
Nat Geog 151:702-24 (map, c, 1)
My '77
Trav/Holiday 154:33-7 (map, c, 1)
Ag '80
--Jean Hasbrouck House, New
Paltz
Trav/Holiday 149:24 (4) My '78
--Hudson River Valley
Nat Geog 153:62-89 (map, c, 1)
Ja '78
--Lyndhurst Castle, Tarrytown
Trav/Holiday 150:51 (4) N '78
--Mountains
Smithsonian 9:59 (c, 3) D '78
--New Lebanon Shaker community
(1856)
Am Heritage 31:69-73 (paint-
ing, c, 1) Ap '80
--Saratoga
Trav/Holiday 149:33-5, 74 (c, 2)
My '78
Smithsonian 12:40-9 (c, 2) Ag '81
--Saratoga mansion
Smithsonian 8:49-51 (c, 1) Jl '77
--Sing Sing prison (1878)
Am Heritage 30:18-19 (drawing, 2)
O '79
--See also ADIRONDACK MOUN-
TAINS; ALBANY; BUFFALO;
FINGER LAKES; HARRIMAN,
W. AVERELL; HUDSON
RIVER; LAKE GEORGE;
LAKE PLACID; LONG ISLAND;
LONG ISLAND SOUND; NEW
YORK CITY; NIAGARA FALLS;
ROCKEFELLER, NELSON;
SYRACUSE; THOUSAND IS-
LANDS; WEST POINT

F '77
Am Heritage 29:111 (4) D '77
--See also AMERICAN MUSEUM
OF NATURAL HISTORY;
BRONX; BROOKLYN;
BROOKLYN BRIDGE; CONEY
ISLAND; EMPIRE STATE
BUILDING; GATEWAY NA-
TIONAL RECREATION AREA;
GEORGE WASHINGTON
BRIDGE; LA GUARDIA,
FIORELLO; LIBERTY,
STATUE OF; MADISON
SQUARE GARDEN; METRO-
POLITAN MUSEUM OF ART;
MUSEUM OF MODERN ART;
NEW YORK PUBLIC LI-
BRARY; ROCKEFELLER
CENTER; SUBWAYS; TWEED,
WILLIAM M. ; UNITED NA-
TIONS BUILDING; VERRA-
ZANO NARROWS BRIDGE;
WORLD TRADE CENTER
NEW YORK PUBLIC LIBRARY,
NEW YORK CITY, NEW
YORK
--Lion statue
Smithsonian 12:10 (4) My '81
--Reading room
Life 3:74 (c, 4) Ag '80
--Steps of library
Natur Hist 89:62-3 (c, 1) Ag '80
NEW ZEALAND
Trav/Holiday 155:37-41
(map, c, 2) Ja '81
Trav/Holiday 155:37-41 (4) Mr
'81
--Bay of Islands
Trav/Holiday 148:42-5
(map, c, 1) D '77
--Cuvier Island
Natur Hist 88:86 (map, c, 4) O
'79
--Milford Track, Fiordland Na-
tional Park
Nat Geog 153:116-29 (map, c, 1)
Ja '78
--South Island's high country
Nat Geog 154:246-65 (map, c, 1)
Ag '78
--Tasman Glacier
Trav/Holiday 156:32-3 (c, 1) D
'81
--See also MAORI PEOPLE
NEW ZEALAND--COSTUME
--South Island
Nat Geog 154:246-63 (c, 1) Ag
'78

NEWARK, NEW JERSEY
--Port Newark-Elizabeth
Nat Geog 160:574-5 (c, 1) N '81
--Slum
Nat Geog 160:586 (c, 1) N '81
NEWPORT, RHODE ISLAND
Trav/Holiday 149:38-41, 102
(c, 1) Ap '78
Sports Illus 53:72-80 (c, 1) Ag
18 '80
--1920 tennis casino
Am Heritage 32:66-7 (painting, c, 1)
Ag '81
--Colony House
Trav/Holiday 151:89 (4) Mr '79
--Mansion Christmas celebrations
Trav/Holiday 150:22-3 (4) N '78
--Mansions
Smithsonian 11:114-15 (c, 2) My
'80
--Stone Villa
Smithsonian 9:135 (4) N '78
NEWPORT BEACH, CALIFORNIA
Nat Geog 160:750-67 (c, 1) D '81
NEWSPAPER OFFICES
--Early 20th cent. (Kansas)
Am Heritage 30:88, 95, 97 (1)
O '79
--Denver, Colorado
Ebony 33:91 (4) O '78
--South Africa
Nat Geog 151:806 (c, 3) Je '77
--Yukon
Nat Geog 153:568-9 (c, 3) Ap '78
NEWSPAPERS
--1827 Freedom's Journal (New
York)
Ebony 32:113 (3) Ap '77
--1930 Indianapolis Star
Ebony 35:149 (4) Ap '80
--New York Amsterdam News
Ebony 33:130 (2) S '78
Newspapers--History. See BEN-
NETT, JAMES GORDON;
GREELEY, HORACE;
HEARST, WILLIAM RAN-
DOLPH
NEWSSTANDS
Ebony 36:40 (4) N '80
--Washington, D. C.
Smithsonian 12:63 (c, 4) Je '81
NEWTS
Nat Geog 157:130 (c, 1) Ja '80
NEZ PERCE INDIANS (NORTH-
WEST)
Nat Geog 151:408-33 (map, c, 1)
Mr '77
--See also JOSEPH, CHIEF

NEZ PERCE INDIANS (NORTH-
WEST)--COSTUME
Smithsonian 9:92-5 (2) My '78
NIAGARA FALLS, NEW YORK
--Winter Garden
Life 1:109-12 (c, 2) D '78
NIAGARA FALLS, NEW YORK/
ONTARIO
Nat Geog 154:760-1 (c, 1) D '78
--Depicted on 1830's wallpaper
Am Heritage 33:84-5 (c, 1) D
'81
NICARAGUA
Travel 148:40-4 (c, 2) Jl '77
--See also GRANADA; LEON
NICARAGUA--COSTUME
--Children's costume parade
Travel 148:42 (c, 2) Jl '77
--Maimed children
Life 2:104-5 (c, 1) Ag '79
NICARAGUA--HISTORY
--1850's regime of William Walker
Smithsonian 12:117-28 (3) Je
'81
NICARAGUA--MAPS
Nat Geog 160:60 (c, 2) Jl '81
NICARAGUA--POLITICS AND
GOVERNMENT
--Guerrilla warfare
Life 1:130-1 (1) O '78
NICHOLAS II (RUSSIA)
--1896 coronation
Smithsonian 9:94-5 (1) F '79
NICKEL MINES
--Ontario
Nat Geog 154:770-1 (c, 1) D '78
NICKEL MINING
--Cuba
Nat Geog 151:58-9 (c, 1) Ja '77
NIGER--ART
--Crafts of Inadan Tuaregs
Nat Geog 156:282-97 (c, 1) Ag
'79
NIGER--COSTUME
Ebony 33:88 (4) D '77
--Tuareg tribe
Nat Geog 156:282-97 (c, 1) Ag
'79
NIGER RIVER, NIGERIA
Nat Geog 155:420, 440-1 (c, 1)
Mr '79
NIGERIA
Nat Geog 155:412-43 (map, c, 1)
Mr '79
--Kano
Natur Hist 90:46 (c, 4) Je '81
--See also LAGOS; NIGER RIVER
NIGERIA--COSTUME

Nat Geog 155:412-43 (c, 1) Mr
'79
Ebony 35:34 (c, 4) D '79
--Arts and culture festival
Ebony 32:cov., 33-49 (c, 2) My
'77
Ebony 36:96 (3) N '80
--Dancer on stilts
Ebony 34:39 (4) Ja '79
--Hausa people
Natur Hist 90:44-53 (c, 1) Je '81
--Ibibio tribe mask
Smithsonian 9:50 (c, 4) O '78
--President
Ebony 35:33 (c, 4) D '79
Ebony 36:148-51 (c, 3) D '80
NIGERIA, ANCIENT--ART
Ebony 35:152-4 (c, 3) O '80
NIGHT CLUBS
--1952 (New York)
Ebony 33:132 (2) Je '78
--Cuba
Nat Geog 151:40-1 (c, 2) Ja '77
--Discos
Ebony 32:54-62 (c, 2) F '77
--Discos (Bahrain)
Nat Geog 166:313 (c, 4) S '79
--Discos (Beirut, Lebanon)
Life 3:34 (c, 2) S '80
--Discos (Chicago, Illinois)
Nat Geog 153:488 (c, 1) Ap '78
--Discos (New York, New York)
Ebony 34:41 (c, 4) My '79
Life 2:130-1 (c, 1) N '79
--Discos (Sydney, Australia)
Nat Geog 155:230-1 (c, 2) F '79
--Middle Eastern (Vancouver, Brit-
ish Columbia)
Nat Geog 154:484 (c, 1) O '78
--San Juan, Puerto Rico
Trav/Holiday 153:59 (c, 2) Ja '80
--Santo Domingo, Dominican Re-
public
Trav/Holiday 154:64 (c, 4) O '80
--See also DANCING; SINGERS
NIGHTSHADE
Smithsonian 8:53 (painting, c, 4)
My '77
--See also BITTERSWEETS; JIMSON
WEED
NILE RIVER, EGYPT
--Luxor
Smithsonian 10:60-1 (c, 1) My '79
NIXON, RICHARD MILHAUS
Am Heritage 28:54-5 (2) F '77
Life 2:25-30 (1) F '79
Ebony 34:185 (4) My '79
Life 2:44-5, 155 (1) D '79

Life 3:104-5 (c, 1) S '80
Life 3:138 (4) N '80
--During Alger Hiss affair
 Am Heritage 32:4-5, 13-14 (1)
 Ag '81
--See also WATERGATE
NOAH'S ARK
--16th cent. painting
 Smithsonian 8:60-1 (c, 1) S '77
NOISE POLLUTION
--Anti SST demonstrations
 Nat Geog 152:216-17 (c, 2) Ag
 '77
NOMADS
--Iran
 Natur Hist 86:48-9 (c, 2) Ag
 '77
--Kenya
 Life 2:66-7 (c, 1) Ag '79
--Kirgiz people (China)
 Nat Geog 159:177, 190 (c, 1)
 F '81
--Nepal
 Nat Geog 151:501-13 (c, 1) Ap
 '77
--See also BEDOUINS; BERBER
 PEOPLE
NORFOLK, VIRGINIA
 Travel 147:33-7 (c, 2) Ap '77
NORTH CAROLINA
 Nat Geog 157:332-59 (map, c, 1)
 Mr '80
--1800 house (Halifax)
 Life 3:114 (c, 4) D '80
--Beech Mountain ski area
 Trav/Holiday 148:47-51 (c, 1)
 D '77
--Blue Ridge Parkway
 Ebony 33:152 (4) My '78
--Dairy farm
 Ebony 32:47-52 (3) F '77
--Kitty Hawk beach front
 Smithsonian 11:58-9 (c, 1) S '80
--Old Salem
 Travel 147:48, 50 (c, 1) My
 '77
 Trav/Holiday 156:4-13 (c, 1) D
 '81
--Outer Banks
 Smithsonian 11:46-7, 51 (c, 1)
 S '80
--Piedmont
 Travel 147:48-53, 83 (c, 1) My
 '77
--Pisgah National Forest
 Natur Hist 90:38-9 (c, 1) Je '81
--Yanceyville courthouse
 Am Heritage 28:53 (4) O '77

--See also ASHEVILLE; CAPE
 HATTERAS; CHARLOTTE;
 GREAT SMOKY MOUNTAINS;
 GREAT SMOKY MOUNTAINS
 NATIONAL PARK; MOUNT
 MITCHELL; WINSTON-
 SALEM
NORTH CASCADES NATIONAL
 PARK, WASHINGTON
 Natur Hist 86:62-3 (c, 1) Ag '77
NORTH DAKOTA
--Red River floodplain
 Nat Geog 158:162-3 (c, 1) Ag '80
--See also RED RIVER OF THE
 NORTH
NORTH POLE
 Nat Geog 154:320-5 (c, 1) S '78
NORTH SEA, EUROPE
--Oil industry
 Nat Geog 151:518-49 (map, c, 1)
 Ap '77
NORTH YEMEN
 Nat Geog 156:244-69 (map, c, 1)
 Ag '79
--See also SANA
NORTH YEMEN--COSTUME
 Nat Geog 156:244-69 (c, 1) Ag
 '79
NORTHERN IRELAND
 Nat Geog 159:470-99 (map, c, 1)
 Ap '81
--Bomb blast
 Life 2:110-11 (1) Ag '79
--British patrol (1970)
 Life 2:186-7 (c, 1) D '79
--See also BELFAST
NORTHERN IRELAND--COSTUME
 Nat Geog 159:470-99 (c, 1) Ap
 '81
NORTHERN IRELAND--POLITICS
 AND GOVERNMENT
--IRA hunger strike victims
 Life 4:40-50 (c, 1) O '81
Northern Lights. See AURORA
 BOREALIS
NORTHWEST--MAPS
--Columbia River system
 Natur Hist 89:55 (c, 2) Jl '80
--Nez Percé lands
 Nat Geog 151:414-15 (c, 1) Mr
 '77
NORTHWEST TERRITORIES, CAN-
 ADA
--Prince Leopold Island
 Natur Hist 88:cov., 68-74
 (map, c, 1) Mr '79
--See also ARCTIC; BAFFIN IS-
 LAND; ELLESMERE ISLAND;

INUVIK; NAHANNI NATIONAL
PARK
NORWAY
Nat Geog 151:546-9 (c, 1) Ap '77
--Arctic islands
Nat Geog 154:266-83 (map, c, 1)
Ag '78
--Countryside
Travel 147:55 (c, 1) Mr '77
--Finnmark county
Nat Geog 152:364-79 (map, c, 1)
S '77
--Fjords
Trav/Holiday 150:41-3 (c, 1) N
'78
--Kirkenes
Life 4:34 (c, 4) Ag '81
--See also BERGEN; LAPLAND;
LAPP PEOPLE
NORWAY--COSTUME
Trav/Holiday 150:43-4 (c, 2) N
'78
--Arctic islands
Nat Geog 154:266-79 (c, 1) Ag
'78
--Nordic Fest (Iowa)
Trav/Holiday 151:61-2, 84-5
(c, 1) Je '79
Norway--History. See VIKINGS
NOUAKCHOTT, MAURITANIA
Nat Geog 156:614-15 (c, 1) N
'79
NOVA SCOTIA
--Fortresse de Louisbourg
Trav/Holiday 149:37-9 (c, 2)
My '78
Nuclear Energy. See ENERGY;
NUCLEAR POWER PLANTS;
NUCLEAR REACTORS
NUCLEAR POWER PLANTS
Life 2:cov., 22-30 (c, 1) My
'79
--Bordeaux, France
Nat Geog 158:258-9 (c, 1) Ag
'80
--Brazil
Nat Geog 153:260 (c, 3) F '78
--Browns Ferry, Alabama
Am Heritage 28:76 (c, 3) F '77
--First nuclear core (1957)
Am Heritage 32:71 (4) Je '81
--Ontario
Natur Hist 87:77-8 (c, 2) Ag '78
--Pakistan
Nat Geog 159:683 (c, 4) My '81
--Shippingport, Pennsylvania
Am Heritage 32:65 (3) Je '81
--Three Mile Island, Pennsylvania

Life 2:cov., 22-3 (c, 1) My '79
Life 2:166-7 (c, 1) D '79
NUCLEAR REACTORS
Nat Geog 155:458-93 (c, 1) Ap
'79
Smithsonian 11:107-12 (c, 2) Je
'80
--Construction of plant (Illinois)
Ebony 32:64-70 (2) Je '77
--Idaho Falls, Idaho
Ebony 35:89-92 (2) N '79
Nudibranches. See SLUGS
NUREMBERG, GERMANY
--Ruins (1945)
Am Heritage 32:74 (1) Ap '81
NURSES
Ebony 32:33 (3) Mr '77
Ebony 32:34 (4) S '77
Ebony 35:46-8 (2) F '80
Ebony 37:48-54 (3) D '81
--Late 19th cent.
Smithsonian 12:127-34 (c, 2) My
'81
--Civil War
Am Heritage 32:82 (4) F '81
--Japan
Nat Geog 152:852 (c, 4) D '77
--Nursing
Ebony 37:48-52 (3) D '81
--Training
Ebony 36:110 (4) Ap '81
--See also BARTON, CLARA;
KENNY, SISTER ELIZABETH
NUTHATCHES
Nat Wildlife 20:61 (c, 4) D '81
NUTMEG
Nat Geog 156:419 (c, 4) S '79
Nutrias. See COYPUS
Nuts. See ACORNS; CHESTNUTS;
PECANS; WALNUTS
NYMPHS (INSECTS)
Natur Hist 86:10 (3) D '77
Natur Hist 87:106 (2) Ag '78

-O-

OAK TREES. See also ACORNS
OAKLAND, CALIFORNIA
Ebony 35:52-60 (2) O '80
Nat Geog 159:822-3 (c, 1) Je '81
--Oak Center
Am Heritage 28:106-9 (c, 1) Je
'77
--See also SAN FRANCISCO-
OAKLAND BAY BRIDGE
OAKLEY, ANNIE
Nat Geog 160:84 (c, 4) Jl '81

OASES
--Siwa, Egypt
Nat Geog 151:330-1 (c, 2) Mr
'77
--Tenerhir, Morocco
Trav/Holiday 150:34 (c, 4) O
'78
OAXACA, MEXICO
Trav/Holiday 152:52-7 (c, 1) Jl
'79
OBESITY
Ebony 32:124-8 (3) O '77
Ebony 36:92-3 (2) S '81
--Singers
Ebony 36:102-6 (1) Je '81
OBOE PLAYING
--Oxford University, England
Travel 147:28 (4) Ap '77
OBREGON, ALVARO
Smithsonian 11:33 (4) Jl '80
OBSERVATORIES
Nat Geog 151:496-7 (c, 1) Ap
'77
Nat Wildlife 16:60 (c, 2) D '77
Nat Wildlife 16:46-7 (c, 1) Je
'78
Smithsonian 10:35 (c, 1) Jl '79
Natur Hist 90:69 (3) Jl '81
Smithsonian 12:132-3 (c, 1) O
'81
--Adirondack Mountains, New York
Sports Illus 52:64-5 (c, 2) Ja
28 '80
--Chile
Smithsonian 8:40-3 (c, 1) Ap '77
--Florence, Italy
Smithsonian 12:96 (c, 4) Ag '81
--Jaipur, India
Smithsonian 9:148 (c, 3) O '78
--Kitt Peak, Arizona
Nat Wildlife 18:12 (c, 1) F '80
--Monterey, California
Smithsonian 12:58-65 (c, 1) Jl
'81
--Mt. Hopkins, Arizona
Smithsonian 10:42-51 (c, 2) My
'79
--National Radio Astronomy Ob-
servatory, N. M.
Smithsonian 9:cov. , 28-37 (c, 1)
Jl '78
--Solar-powered
Smithsonian 8:42 (c, 4) O '77
--Vassar College, New York
(1880's)
Natur Hist 88:14 (3) My '79
O'CASEY, SEAN
Life 3:104 (c, 2) N '80

Occupations. See AIRPLANE FLY-
ING; AIRPLANE PILOTS;
ANIMAL TRAINERS; ARCHAE-
OLOGISTS; ARCHITECTS;
ARTISTS; ASTRONAUTS;
AUTOMOBILE MECHANICS;
BAKERS; BEGGARS; BLACK-
SMITHS; BOAT BUILDING;
BUSINESSMEN; CARPENTRY;
CHEERLEADERS; CHEFS;
CHIMNEY SWEEPS; CON-
DUCTORS, MUSIC; CONVICTS;
COWBOYS; CUSTOMS OFFI-
CIALS; DETECTIVES; DISC
JOCKEYS; DOCTORS; DOMES-
TIC WORKERS; DOORMEN;
ENGINEERS; ENTERTAINERS;
FACTORY WORKERS; FARM
WORKERS; FARMERS; FIRE
FIGHTERS; FISHERMEN;
FOREST RANGERS; FORTUNE
TELLERS; GUARDS; HUNTERS;
JANITORS; JOURNALISTS;
JUDGES; KNIGHTS; LABOR-
ERS; LAWYERS; LION TAM-
ING; LUMBERJACKS; MATA-
DORS; MESSENGERS; METAL-
WORK; MILITARY COSTUME;
MINERS; MODELING; NURSES;
OFFICE WORKERS; PAINT-
ERS; PHARMACISTS; PIRATES;
PLUMBERS; POLICEMEN;
PORTERS; POSTAL WORKERS;
PROSPECTING; PSYCHIA-
TRISTS; PSYCHOLOGISTS;
RAILROAD CONDUCTORS;
RAILROAD WORKERS; SAIL-
ORS; SCIENTISTS; SHAMANS;
SHEPHERDS; SHOE SHINING;
SPORTS ANNOUNCERS;
STREET VENDORS; TAILORS;
TAXICAB DRIVERS; TEACH-
ERS; TRANSIT WORKERS;
VETERINARIANS; WAITERS;
WAITRESSES; WINDOW WASH-
ING; WRITERS
OCEAN CRAFT
--1964 submersible
Smithsonian 11:174-5 (4) O '80
--Submersibles
Nat Geog 152:442-52 (c, 1) O '77
Trav/Holiday 149:58-9 (c, 4) F
'78
Nat Geog 153:530-1 (c, 1) Ap '78
Nat Geog 155:718-27 (c, 1) My
'79
Nat Geog 156:680-705 (c, 1) N
'79

--Woolworth Building, New York
 City, New York
 Am Heritage 28:2, 86-99 (c, 1)
 F '77
 Am Heritage 29:111 (4) D '77
--See also EMPIRE STATE BUILD-
 ING; SEARS TOWER; WORLD
 TRADE CENTER; and list
 under ARCHITECTURAL
 STRUCTURES
OFFICE BUILDINGS--CONSTRUC-
 TION
--Woolworth Building (1912-13)
 Am Heritage 28:92-3 (4) F '77
OFFICE MACHINES
--Census coding machines (1900)
 Am Heritage 31:17 (2) D '79
OFFICE WORKERS
--New Jersey
 Ebony 32:73-7 (4) F '77
--Stock room (New Jersey)
 Ebony 32:76 (4) F '77
OFFICES
 Ebony 32:102 (3) Mr '77
 Ebony 34:54-6 (4) Je '79
--California state assemblyman
 Ebony 33:147 (2) Je '78
--Mayor's office (East St. Louis,
 Illinois)
 Ebony 34:68 (2) O '79
--John D. Rockefeller, Jr.'s
 (New York)
 Smithsonian 8:91 (c, 3) S '77
--U. S. government official
 Ebony 34:33 (4) F '79
--See also DESKS; FILING
 CABINETS
OHIA TREES
 Nat Wildlife 19:22-3 (c, 1) Je
 '81
OHIO
--Bass Islands
 Travel 148:37-9 (c, 1) Jl '77
 Nat Geog 154:86-101 (map, c, 1)
 Jl '78
--Mingo Junction
 Nat Geog 151:251 (c, 1) F '77
--New Philadelphia courthouse
 Am Heritage 28:53 (4) O '77
--Southeastern area
 Trav/Holiday 152:50-5, 66-7
 (c, 2) S '79
--See also CINCINNATI; CLEVE-
 LAND; SANDUSKY; TOLEDO
OHIO RIVER, LOUISVILLE,
 KENTUCKY
 Trav/Holiday 151:53 (c, 1) Mr
 '79

OHIO RIVER, MIDWEST
 Nat Geog 151:244-73 (map, c, 1)
 F '77
 Smithsonian 8:76-7 (c, 1) Jl '77
OHM, GEORG SIMON
 Smithsonian 12:44 (4) N '81
OIL
 Nat Geog 153:640-1 (c, 2) My '78
 Nat Geog 159:2-3 (c, 1) F '81SR
OIL INDUSTRY
--Early 20th cent. (Los Angeles,
 California)
 Smithsonian 11:187-205 (2) O '80
--1918 shale mine (Colorado)
 Nat Geog 159:81 (3) F '81SR
--Backyard oil pumps (California)
 Nat Geog 160:758 (c, 4) D '81
--Decorated well (Bahrain)
 Trav/Holiday 151:76 (c, 4) My '79
--Family oil well (Louisiana)
 Ebony 36:67 (4) Jl '81
--Mexico
 Life 2:22-8 (c, 1) Mr '79
--Mining shale (Colorado)
 Nat Geog 159:76-80 (c, 1) F
 '81SR
--North Dakota
 Life 4:88-96 (1) S '81
--Producing synthetic crude oil
 (California)
 Ebony 35:25 (2) Mr '80
--Storage tanks (Japan)
 Nat Geog 154:110-12 (c, 1) Jl '78
--Storage tanks (Pennsylvania)
 Nat Geog 153:742-3 (c, 1) Je '78
--U. S. resources
 Nat Geog 159:68-9 (map, c, 1) F
 '81SR
OIL INDUSTRY--DRILLING
--Bahrain
 Nat Geog 156:306-7 (c, 1) S '79
--Capsized offshore oil rig (Norway)
 Life 3:116-17 (c, 1) My '80
--Louisiana
 Ebony 36:70 (2) Jl '81
--Nigeria
 Nat Geog 155:440-1 (c, 2) Mr '79
--North Sea
 Nat Geog 151:518-49 (map, c, 1)
 Ap '77
--Offshore
 Nat Geog 160:808 (c, 4) D '81
--Offshore (Louisiana)
 Nat Geog 156:394-5 (c, 1) S '79
--Offshore (Maryland)
 Smithsonian 10:cov., 43-51 (c, 1)
 D '79
--Offshore (Mexico)

Nat Geog 153:501 (c, 4) Ap '78
--Oil rigs
Smithsonian 12:82-9 (c, 1) My '81
OIL INDUSTRY--HISTORY
--Early 20th cent. (Texas)
Am Heritage 28:49-54 (1) Ap '77
OIL INDUSTRY--TRANSPORTATION
--Loading supertanker (Saudi
Arabia)
Nat Geog 158:302-3 (c, 1) S '80
--See also ALASKA PIPELINE;
TANKERS
OIL REFINERIES
--Montana
Nat Geog 160:270-1 (c, 1) Ag '81
--Norway
Nat Geog 151:548-9 (c, 1) Ap '77
--St. Croix, Virgin Islands
Nat Geog 159:240-1 (c, 1) F '81
OIL SPILLS
Nat Geog 154:108-9 (map, c, 1)
Jl '78
--1976
Nat Geog 153:510-17 (c, 1) Ap
'78
--Analyzing effects of oil spills
Smithsonian 10:68 75 (c, 2) O '79
--France (1978)
Nat Geog 154:125-35 (c, 1) Jl
'78
--Mexico (1979)
Life 2:140-1 (c, 1) S '79
Smithsonian 10:74-5 (c, 2) O '79
Nat Geog 160:810-11 (c, 1) D '81
--Nantucket, Massachusetts
Sports Illus 46:96-7 (c, 4) Ja
'77
--Santa Barbara, California (1969)
Nat Wildlife 17:17 (c, 4) F '79
--Texas coast (1979)
Nat Geog 159:170-1 (c, 2) F
'81
O'KEEFFE, GEORGIA
Life 1:10-12 (4) N '78
Smithsonian 11:102 (4) Ag '80
OKEFENOKEE SWAMP, FLORIDA/
GEORGIA
Trav/Holiday 149:58-61 (c, 1)
Je '78
Nat Geog 154:228-9 (c, 2) Ag
'78
Nat Wildlife 16:30 (c, 4) O '78
OKINAWA
Life 2:74 (4) My '79
OKLAHOMA
--1936 dust storm
Nat Geog 156:638 (4) N '79
--Anadarko

Trav/Holiday 150:37-8 (c, 2) Jl
'78
--See also OKLAHOMA CITY;
TULSA
OKLAHOMA CITY, OKLAHOMA
--Music Hall
Trav/Holiday 150:37 (c, 3) Jl '78
--Restaurant
Trav/Holiday 150:38 (c, 2) Jl '78
OLDFIELD, BARNEY
Am Heritage 28:66 (2) F '77
OLYMPIA, GREECE
Nat Geog 157:388-9 (c, 1) Mr '80
OLYMPIC NATIONAL PARK, WASH-
INGTON
Nat Wildlife 15:12, 16 (c, 1) Ja
'77
Nat Wildlife 17:48 (c, 1) Je '79
Natur Hist 90:58-66 (map, c, 1)
Ja '81
OLYMPICS
--Official symbol
Sports Illus 46:cov., 16 (c, 1) F
21 '77
OLYMPICS--1932 WINTER (LAKE
PLACID)
Sports Illus 52:35-96 (c, 2) Ja 14
'80
OLYMPICS--1936 SUMMER (BER-
LIN)
--Jesse Owens' feats
Ebony 35:07 (4) Je '80
OLYMPICS--1968 SUMMER (MEXICO
CITY)
Sports Illus 51:88 (c, 4) Ag 13
'79
--Black Power sign on victory
stand
Sports Illus 51:88 (c, 4) Ag 13 '79
OLYMPICS--1972 SUMMER (MUN-
ICH)
--Palestinian terrorists
Sports Illus 51:102 (c, 3) Ag 13
'79
Life 2:40-1 (1) D '79
--Swimming winners
Sports Illus 51:60-1 (c, 1) Ag 20
'79
OLYMPICS--1976 SUMMER
(MONTREAL)
Sports Illus 46:special issue F
'77
Sports Illus 51:114 (c, 3) Ag 13
'79
--Marathon
Sports Illus 47:34 (c, 3) O 24 '77
--Welterweights
Ebony 35:68 (4) Mr '80

OLYMPICS--1976 WINTER (INNS-
BRUCK)
 Sports Illus 46:special issue
 F '77
OLYMPICS--1980 SUMMER (MOS-
COW)
 Sports Illus 53:12-19 (c, 1) Ag
 4 '80
 Sports Illus 53:cov., 16-29
 (c, 1) Ag 11 '80
 Life 3:96-101 (c, 1) S '80
 Life 4:128-31 (c, 1) Ja '81
--Construction of buildings for
 Olympics
 Life 2:87-90 (c, 1) Jl '79
--Misha the Bear
 Trav/Holiday 153:8 (4) F '80
--Opening ceremonies
 Sports Illus 53:cov., 10-17
 (c, 1) Jl 28 '80
--U. S. athletes in practice
 Life 3:34-40 (c, 1) Mr '80
--U. S. track and field trials
 Sports Illus 53:cov., 12-17
 (c, 1) Jl 7 '80
OLYMPICS--1980 WINTER (LAKE
PLACID)
 Sports Illus 52:cov., 16-37
 (c, 1) F 25 '80
 Sports Illus 52:cov., 16-26
 (c, 1) Mr 3 '80
 Sports Illus 52:12-20 (c, 1) Mr
 10 '80
--Flag
 Sports Illus 49:45 (c, 4) D 11
 '78
--Hockey
 Life 3:133-5 (c, 1) Ap '80
 Sports Illus 53:cov., 31 (c, 1)
 D 22 '80
 Life 4:28-9 (c, 1) Ja '81
--Layout of the courses
 Sports Illus 52:84-8 (map, c, 1)
 F 11 '80
--Lake Placid Olympic site
 Sports Illus 50:20-3 (c, 1) Ap
 9 '79
 Smithsonian 10:43-5 (c, 3) F '80
--Opening ceremonies
 Sports Illus 52:18 (c, 4) F 25
 '80
--Signs
 Trav/Holiday 152:61-3 (c, 4) N
 '79
OMAN
 Nat Geog 160:344-77 (map, c, 1)
 S '81
--Ancient copper mine

Nat Geog 154:818-19 (c, 1) D '78
--Military bases
 Life 3:28-30 (c, 2) Mr '80
--See also MUSCAT
OMAN--COSTUME
 Nat Geog 160:344-75 (c, 1) S '81
--Military
 Life 3:30 (c, 2) Mr '80
ONTARIO, CANADA
 Nat Geog 154:760-95 (map, c, 1)
 D '78
--See also NIAGARA FALLS; OTTA-
 WA; THOUSAND ISLANDS;
 TORONTO
OPAL MINES
--Australia
 Trav/Holiday 150:29 (c, 4) Ag '78
OPALS
 Smithsonian 12:24 (c, 4) D '81
Opera. See THEATER
Opera Houses. See THEATERS
OPIUM INDUSTRY
--Farming (Pakistan)
 Nat Geog 151:123 (c, 2) Ja '77
--Farming (Turkey)
 Nat Geog 151:868-9 (c, 3) Je '77
 Nat Geog 152:112 (c, 1) Jl '77
OPIUM POPPIES
 Natur Hist 89:52-7 (c, 1) O '80
OPOSSUMS
 Nat Wildlife 18:54 (c, 4) O '80
 Nat Wildlife 19:37 (c, 2) Ag '81
 Nat Wildlife 19:53 (c, 4) O '81
 Trav/Holiday 156:54 (4) N '81
--Ringtail
 Sports Illus 55:82 (c, 4) O 5 '81
--See also CUSCUSES
OPPENHEIMER, J. ROBERT
 Am Heritage 28:72-83 (1) O '77
ORANGE GROVES
--California (1889)
 Am Heritage 28:84-5 (drawing, 2)
 Ap '77
ORANGE INDUSTRY--HARVESTING
--California
 Ebony 35:40 (c, 4) My '80
ORANGE INDUSTRY--HISTORY
--Early 20th cent. orange crate
 labels (California)
 Am Heritage 28:88-93 (c, 2) Ap
 '77
--California
 Am Heritage 28:84-94 (c, 2) Ap
 '77
ORANGES
 Natur Hist 86:88-9 (4) Je '77
 Life 4:138-9 (c, 1) My '81
ORANGUTANS

Nat Geog 151:639 (c, 1) My '77
Natur Hist 86:56-7 (c, 1) My
'77
Smithsonian 8:49 (c, 4) Mr '78
Natur Hist 87:110 (c, 2) Ag '78
Life 2:120 (2) F '79
Trav/Holiday 151:87 (4) Ap '79
Trav/Holiday 153:74 (c, 4) F
'80
Nat Geog 157:830-53 (c, 1) Je
'80
Natur Hist 89:38 (c, 4) Jl '80
Smithsonian 12:185 (c, 4) S '81
ORCHARDS
--Apple (Italy)
Life 3:60-1 (c, 1) O '80
--Midwest
Natur Hist 87:55 (c, 3) Ag '78
--Protecting them with smudge
pots (Washington)
Nat Geog 154:612-13 (c, 1) N
'78
--Washington
Nat Geog 154:609-13 (c, 1) N
'78
ORCHIDS
Travel 147:57 (c, 1) Ja '77
Natur Hist 86:65-71 (c, 1) D '77
Smithsonian 9:126-7 (c, 4) N '78
Smithsonian 9:64-5 (c, 1) Jl '78
Natur Hist 87:99 (c, 1) Ag '78
Nat Wildlife 17:58 (c, 4) D '78
Smithsonian 10:116-17 (c, 3) O
'79
Trav/Holiday 153:78 (c, 4) F
'80
--Disguised as a bee
Smithsonian 9:125 (c, 4) F '79
--See also LADY'S SLIPPERS
OREGON
--Coastal area
Nat Geog 156:798-823 (map, c, 1)
D '79
Trav/Holiday 154:33-7 (map, c, 1)
Jl '80
--Hells Canyon
Am Heritage 28:13-23 (map, c, 1)
Ap '77
--Lower Proxy Falls, Proxy
Creek
Nat Geog 152:4-5 (c, 1) Jl '77
--Mount Jefferson
Smithsonian 11:56-7 (c, 3) Jl '80
--Southwest region
Travel 147:38-9 (4) Mr '77
--See also CASCADE RANGE;
COLUMBIA RIVER; CRATER
LAKE; MCLOUGHLIN, JOHN;

MOUNT HOOD; MOUNT ST.
HELENS; SNAKE RIVER
ORGAN PLAYING
Ebony 34:100 (4) Jl '79
Ebony 34:110 (4) S '79
ORGANS
Life 4:91 (c, 2) My '81
--19th cent. automated fairground
organs
Smithsonian 8:78-83 (c, 1) Ja '78
--Street (Michigan)
Trav/Holiday 149:47 (c, 4) My
'78
ORKNEY ISLANDS, SCOTLAND
--Ring of Brogar
Nat Geog 152:622-3 (c, 1) N '77
ORLANDO, FLORIDA
--Walt Disney World
Ebony 34:44 (4) My '79
Nat Geog 158:158-9 (c, 2) Ag '80
Life 4:80-6 (c, 1) S '81
OSAGE INDIANS (OKLAHOMA)
--Scalp dance (1845)
Smithsonian 9:52-3 (painting, c, 3)
Jl '78
OSAGE INDIANS (OKLAHOMA)--
COSTUME
--Squaw
Smithsonian 8:102 (painting, c, 4)
Je '77
--Wedding dress
Smithsonian 9:62 (c, 3) Ag '78
OSAKA, JAPAN
Nat Geog 152:868-9 (c, 1) D '77
OSHKOSH, WISCONSIN
--Air show
Nat Geog 156:364-75 (c, 1) S '79
OSPREYS
Nat Wildlife 17:54 (c, 4) Ap '79
Natur Hist 89:4 (3) Mr '80
--Catching fish
Natur Hist 88:72-3 (c, 1) F '79
OSTRICHES
Sports Illus 48:36 (c, 4) My 29
'78
Trav/Holiday 155:22 (4) Ja '81
OTIS, ELISHA GRAVES
Am Heritage 29:42 (drawing, 4)
Ag '78
OTTAWA, ONTARIO
Nat Geog 154:766-7 (c, 1) D '78
--Winterlude Festival
Sports Illus 51:46-50 (c, 1) D 24
'79
OTTERS
Nat Wildlife 16:9 (c, 3) D '77
Nat Wildlife 17:46 (c, 4) O '79
Nat Wildlife 18:44 (4) D '79

Nat Geog 158:130-41 (c, 1) Jl
'80
Nat Wildlife 19:25-8 (c, 1) F
'81
Smithsonian 12:67 (c, 4) D '81
OUTHOUSES
--South
Ebony 34:60 (4) F '79
OVENBIRDS
Nat Wildlife 17:28C-28D (paint-
ing, c, 1) O '79
OWENS, JESSE
Life 3:118 (2) My '80
--1936 Olympics (Berlin, Ger-
many)
Ebony 35:67 (4) Je '80
--Funeral (Arizona)
Ebony 35:64-72 (3) Je '80
OWLS
Nat Geog 152:37 (c, 4) Jl '77
Nat Wildlife 16:cov. (c, 1) F
'78
Natur Hist 87:114 (c, 3) Ag '78
Smithsonian 10:38 (c, 4) Ag '79
Sports Illus 51:41 (c, 3) S 10
'79
Natur Hist 90:57 (woodcut, c, 4)
Je '81
Smithsonian 12:cov. (paint-
ing, c, 1) S '81
Nat Wildlife 19:5 (c, 1) O '81
Nat Wildlife 20:3 (c, 4) D '81
--Barn
Nat Wildlife 18:cov. (c, 1) Ap
'80
Smithsonian 11:20 (4) Mr '81
--Barred
Nat Wildlife 15:47 (c, 2) F '77
Nat Wildlife 19:51 (c, 4) O '81
--Burrowing
Natur Hist 87:64-5 (c, 2) O '78
Nat Wildlife 17:54-5 (c, 1) D
'78
Nat Wildlife 17:39 (drawing, 4)
Ap '79
--Depicted in medieval art
Natur Hist 87:100-7 (c, 1) O
'78
--Great gray
Nat Geog 151:150 (painting, c, 1)
F '77
--Great-horned
Nat Wildlife 16:8 (c, 4) Ag '78
Smithsonian 10:84-5 (c, 2) Jl '79
Nat Wildlife 19:10 (c, 4) Ap '81
--Long-eared
Nat Geog 157:30-5 (c, 1) Ja '80
--Screech owls

Nat Wildlife 19:28E-28H (paint-
ing, c, 1) O '81
--Short-eared
Nat Wildlife 17:9 (c, 3) Je '79
--Snowy
Nat Wildlife 15:cov. (painting, c, 1)
Ja '77
Smithsonian 8:45 (c, 4) S '77
Nat Wildlife 17:10 (c, 4) D '78
--Spotted
Nat Wildlife 16:28 (painting, c, 4)
Je '78
OXEN
Nat Geog 151:55 (c, 2) Ja '77
Nat Geog 154:552, 555 (c, 2) O
'78
Trav/Holiday 151:47 (c, 4) Ja '79
--Gaurs
Smithsonian 10:103 (c, 4) N '79
--Pulling plow (China)
Nat Geog 157:304-5 (c, 3) Mr '80
OXFORD, ENGLAND
--Oxford University
Travel 147:25-31 (c, 1) Ap '77
OYSTER INDUSTRY
--1882 engraving
Am Heritage 31:67 (c, 2) F '80
--Hawaii
Nat Geog 156:671 (c, 4) N '79
--Northern Ireland oyster farm
Nat Geog 159:494-5 (c, 2) Ap '81
OYSTER INDUSTRY--HARVESTING
--Philippines
Travel 148:39 (4) Ag '77
OYSTERS
Smithsonian 7:68-9 (c, 1) Ja '77
Am Heritage 31:64-73 (c, 1) F
'80
Nat Geog 157:812 (c, 4) Je '80
Natur Hist 90:92-6 (c, 1) My '81
Natur Hist 90:24 (drawing, 4) S
'81
OZARK MOUNTAINS, ARKANSAS/
MISSOURI
Travel 148:42-3 (c, 4) Ag '77
Am Heritage 29:97-109 (c, 1) D
'77

-P-

PACIFIC ISLANDS
--Bora Bora, Polynesia
Travel 148:30 (c, 3) S '77
Trav/Holiday 151:57-60 (map, c, 4)
Mr '79
--Performing arts
Trav/Holiday 155:cov., 77-9

(c, 1) F '81
--Polynesia's outer islands
Trav/Holiday 150:53-4 (c, 1) N
'78
--Sports and recreation
Trav/Holiday 153:69-98 (c, 2) F
'80
--See also FIJI; GUAM; HONG
KONG; INDONESIA; IWO
JIMA; MARQUESAS ISLANDS;
NAURU; NEW GUINEA; NEW
ZEALAND; OKINAWA; PAPUA
NEW GUINEA; PHILIPPINES;
SAMOA; SINGAPORE; SOCI-
ETY ISLANDS; SOLOMON
ISLANDS; TAHITI; TAIWAN;
TASMANIA
PACIFIC ISLANDS--COSTUME
--Bora Bora
Trav/Holiday 151:58-9 (c, 4) Mr
'79
--French Polynesia
Trav/Holiday 150:54, 68 (c, 4)
N '78
--Torres Strait Islanders
Natur Hist 90:55-63 (c, 1) My
'81
PACIFIC ISLANDS--MAPS
Natur Hist 86:12 (4) Mr '77
--French Polynesia
Trav/Holiday 151:51 (4) Mr '79
PACIFIC ISLANDS--SOCIAL LIFE
AND CUSTOMS
--Hawaii
Trav/Holiday 152:42-7 (c, 1) O
'79
PACIFIC OCEAN
Natur Hist 86:43 (c, 1) My '77
California's north coast
Trav/Holiday 153:53, 91 (c, 3)
Mr '80
--Continental Shelf
Nat Geog 153:524-6 (map, c, 1)
Ap '78
--Galapagos Rift
Nat Geog 152:440-53 (map, c, 1)
O '77
--Monterey coast, California
Trav/Holiday 149:40 (c, 1) Mr
'78
--Oregon shore
Trav/Holiday 154:37 (c, 2) Jl
'80
PACKAGING
--Early 20th cent. orange crate
labels (California)
Am Heritage 28:88-93 (c, 2) Ap
'77

PADDLEFISH
Natur Hist 86:64-5 (c, 1) F '77
PADUA, ITALY
Trav/Holiday 151:37-8 (c, 2) F
'79
--Botanical garden
Natur Hist 90:50-4 (c, 1) Mr '81
PAGODAS
--Burma
Trav/Holiday 153:44 (c, 3) Ap '80
--Katmandu, Nepal
Nat Geog 155:272-3 (c, 1) F '79
--Thailand
Trav/Holiday 154:46 (4) N '80
--Japan
Nat Geog 152:835 (c, 1) D '77
PAINTING
Smithsonian 8:46 (c, 4) Jl '77
Smithsonian 11:99 (c, 2) O '80
Smithsonian 11:119 (c, 4) D '80
Ebony 36:56 (4) Mr '81
--19th cent. France
Smithsonian 12:56 (4) Je '81
--Arizona
Sports Illus 51:64 (c, 4) Ag 20
'79
--Chinese finger painting (Singapore)
Trav/Holiday 148:34 (c, 3) N '77
--Modern work
Life 4:84-93 (c, 1) F '81
--Navajo sand painting (Arizona)
Trav/Holiday 151:63 (c, 4) Ja '79
--Pottery (Ecuador)
Trav/Holiday 151:73 (c, 2) My '79
--Pottery (Malaysia)
Trav/Holiday 151:37 (c, 4) Mr '79
--Seats at baseball stadium (Balti-
more, Maryland)
Sports Illus 55:19 (c, 4) Ag 10
'81
--Stages in painting a picture
Nat Wildlife 15:50-1 (painting, c, 1)
O '77
--Tree bark (Australia)
Nat Geog 158:646-7 (c, 2) N '80
PAINTINGS
--17th cent. Flemish
Nat Geog 155:746, 750 (paint-
ing, c, 4) Je '79
--Late 18th cent. portraits (U. S.)
Am Heritage 31:102-7 (paint-
ing, c, 4) Ap '80
--18th cent. U. S.
Smithsonian 8:115-24 (c, 2) F '78
--19th cent. American folk art
Am Heritage 31:2, 34-43 (c, 1)
F '80
--19th cent. U. S.

Am Heritage 32:2, 22-35 (c, 1)
Ag '81
--19th cent. U. S. still lifes
Am Heritage 32:2, 14-25 (c, 1)
O '81
--19th cent. Victorian artists
(Great Britain)
Smithsonian 9:48-57 (c, 2) D '78
--Early 19th cent. (U. S. S. R.)
Smithsonian 10:54-61 (c, 1) Ag
'79
--20th cent. American folk art
by Jean Lipman
Am Heritage 32:18-23 (c, 2) Ap
'81
--20th cent. California art
Smithsonian 8:56-61 (c, 2) My
'77
--Early 20th cent. France
Smithsonian 8:69-75 (c, 1) Jl '77
Smithsonian 10:cov., 94-101
(c, 1) F '80
--1930's Depression art
Smithsonian 10:cov., 44-53 (c, 1)
O '79
--Ancient silk paintings of Tun-
huang, China
Smithsonian 8:94-103 (c, 2) My
'77
--Black American art (1750-1950)
Ebony 32:33-8 (c, 4) F '77
--Frederic Church's works
Life 3:100-2 (c, 4) Ja '80
--Depictions of American workers
Am Heritage 31:8-21, 114 (c, 1)
Je '80
--Depictions of animals
Smithsonian 8:52-61 (c, 1) S '77
--Louis Eilshemius
Smithsonian 9:98-105 (c, 1) N
'78
--Freer collection of American
art
Smithsonian 7:50-6 (painting, c, 1)
Ja '77
--Ilia Glazunov
Smithsonian 8:101-6 (c, 1) D '77
--Armand Hammer's collection
Smithsonian 11:150-9 (c, 1) O
'80
--Marsden Hartley's works
Smithsonian 10:122-8 (c, 2) Mr
'80
--Italian
Smithsonian 9:50-5 (c, 1) Ja '79
--Japan
Smithsonian 8:84-91 (c, 1) Je '77
--Tella Kitchen's Midwest folk art

Nat Wildlife 16:28-35 (c, 1) D
'77
--Mexico (19th-20th cents.)
Smithsonian 9:53, 60-3 (c, 1) My
'78
--Modern
Nat Geog 153:750-1 (c, 1) Je '78
Smithsonian 9:82-5 (c, 2) F '79
Smithsonian 10:116-20 (c, 2) Ap
'79
Smithsonian 10:78-84 (c, 2) D '79
--Modern (North Carolina)
Smithsonian 9:91-5 (c, 2) Ja '79
--Modern (U. S. S. R.)
Nat Geog 153:11 (c, 3) Ja '78
--Modern art with human figures
Life 3:74-82 (c, 1) O '80
--National Collection of Fine Art
(D. C.)
Smithsonian 9:48-55 (c, 2) Jl '78
--New American realism
Smithsonian 12:68-77 (c, 1) O '81
--On glass (Poland)
Nat Geog 159:117 (c, 1) Ja '81
--Phillips Collection (Washington,
D. C.)
Smithsonian 10:68-77 (c, 1) My
'79
--Pompeii relics (79 A. D.)
Smithsonian 9:84-93 (c, 1) Ap '78
Natur Hist 88:cov., 37-75 (c, 1)
Ap '79
--Portraits
Nat Geog 152:653 (c, 2) N '77
--Post-Impressionism
Smithsonian 11:56-65 (c, 1) Je '80
--Stolen art works
Life 2:31-4 (c, 3) Mr '79
--Charles White's works
Ebony 35:69-73 (c, 1) F '80
--Yugoslavian folk art
Nat Geog 152:480 (c, 4) O '77
Nat Geog 152:678 (c, 2) N '77
PAKISTAN
Nat Geog 159:668-701 (map, c, 1)'
My '81
--Karakoram Mountains
Nat Geog 155:622-49 (c, 1) My '79
Trav/Holiday 153:96 (2) F '80
--North-West Frontier province
Nat Geog 151:110-39 (map, c, 1)
Ja '77
--Ruins of ancient Indus Valley
Smithsonian 8:56-65 (map, c, 1)
Jl '77
Nat Geog 154:822-3 (c, 1) D '78
--Tatta, Sind region
Natur Hist 89:70-1 (c, 1) N '80

--See also HYDERABAD; KHYBER
PASS; LAHORE
PAKISTAN--COSTUME
Nat Geog 155:628-9, 648-9 (c, 1)
My '79
Nat Geog 159:668-701 (c, 1) My
'81
--Kalash People
Nat Geog 160:458-73 (c, 1) O
'81
--North-West Frontier province
Nat Geog 151:111-39 (c, 1) Ja
'77
--Pakhtun tribe
Natur Hist 88:12-14 (3) O '79
PAKISTAN--RELICS
--Ancient Indus civilization
Smithsonian 8:56-65 (c, 1) Jl '77
PALACES
--1851 drawing room (St. Peters-
burg, Russia)
Smithsonian 10:56 (painting, c, 4)
Ag '79
--Alcazar, Santo Domingo, Domini-
can Republic
Trav/Holiday 154:64 (c, 4) O '80
--Chandra Mahal, Jaipur, India
Smithsonian 9:147-9 (c, 1) O
'78
--Courtyard of Torre Tagle Palace,
Lima, Peru
Travel 147:38 (c, 1) Ja '77
--Imperial, Peking, China
Trav/Holiday 150:cov. (c, 1) N
'78
--Iolani Palace, Honolulu, Hawaii
Trav/Holiday 152:44 (c, 4) O
'70
--Iolani Palace, Honolulu, Hawaii
(1865)
Am Heritage 32:85 (4) O '81
--Lallgarh, Rajasthan, India
Nat Geog 151:222-3 (c, 1) F '77
--Mexico City, Mexico
Trav/Holiday 155:67 (c, 2) Je
'81
--Peter the Great's winter palace
(U. S. S. R.)
Life 3:62 (4) S '80
--Port-au-Prince, Haiti
Nat Geog 159:248-9 (c, 3) F '81
--Potala, Lhasa, Tibet
Smithsonian 7:78-9, 84 (c, 3)
Ja '77
Nat Geog 157:218-19, 222-3,
235-9 (c, 1) F '80
Nat Geog 160:554-5 (c, 1) O '81
--Royal, Madrid, Spain

Travel 148:33 (c, 1) O '77
--Sigiriya, Sri Lanka
Nat Geog 155:144 (c, 1) Ja '79
--Toksu, Seoul, South Korea
Nat Geog 156:774-5 (c, 1) D '79
--Wadi Dahr, North Yemen
Nat Geog 156:266-7 (c, 1) Ag '79
--See also BUCKINGHAM; KNOSSOS;
LOUVRE; VERSAILLES
PALEONTOLOGISTS
Nat Geog 155:447-57 (c, 1) Ap
'79
Nat Geog 159:68-71 (c, 1) Ja '81
Life 4:120 (c, 4) D '81
PALERMO, ITALY
--Outdoor food market
Travel 148:47 (c, 4) Ag '77
PALISADES, NEW JERSEY
Nat Geog 153:68 (c, 4) Ja '78
PALMYRA, SYRIA
Nat Geog 154:350-1 (c, 1) S '78
PAMIR REGION, ASIA
Nat Geog 159:174-5, 194-9 (c, 1)
F '81
PANAMA
Trav/Holiday 149:42-7 (c, 2) Ap
'78
Ebony 33:44-54 (c, 3) Jl '78
--Barro Colorado Island
Smithsonian 10:8-10 (c, 4) N '79
--Canal area
Trav/Holiday 156:49-51, 58
(map, c, 1) Ag '81
--See also PANAMA CANAL;
PANAMA CITY
PANAMA--COSTUME
Nat Geog 153:278-91 (c, 1) F '78
Ebony 33:44-54 (c, 3) Jl '78
PANAMA--MAPS
Nat Geog 160:60-1 (c, 2) Jl '81
PANAMA CANAL, PANAMA
Ebony 32:36 (3) Je '77
Travel 147:37 (c, 2) Je '77
Nat Geog 153:278-93 (map, c, 1)
F '78
Ebony 33:48 (c, 4) Jl '78
Trav/Holiday 156:49-51, 58 (c, 1)
Ag '81
PANAMA CANAL, PANAMA--
CONSTRUCTION
--1910's
Smithsonian 8:94 (4) Ag '77
PANAMA CITY, PANAMA
Ebony 33:45-6 (c, 4) Jl '78
PANDAS
Life 1:30-2 (c, 1) N '78
Smithsonian 10:cov., 44-7 (c, 1)
S '79

Life 2:130 (c, 4) D '79
Life 4:57-62 (c, 1) Je '81
Nat Geog 160:cov., 734-46
(c, 1) D '81
--Drawing of paw
Natur Hist 87:24-8 (4) N '78
PANTHERS
Nat Wildlife 16:39 (c, 1) Je '78
Smithsonian 10:82-7 (c, 1) Je
'79
--Face
Nat Wildlife 18:14 (c, 4) D '79
Pantomime. See THEATER
PAPER INDUSTRY
--Brazil
Nat Geog 157:686-711 (c, 1) My
'80
--Maine/New Brunswick
Nat Geog 158:402-3 (c, 1) S '80
--Wood fuel for factory (Virginia)
Smithsonian 9:62-3 (c, 1) O '78
--See also MILLS
PAPUA NEW GUINEA
--Butterfly farm
Smithsonian 10:119-35 (c, 3) My
'79
PAPUA NEW GUINEA--ART
--Masks
Smithsonian 9:49 (c, 2) O '78
Natur Hist 90:104 (4) N '81
PAPUA NEW GUINEA--COSTUME
--Fore tribe lifestyle
Smithsonian 8:106-15 (c, 1) My
'77
--Manus Island
Natur Hist 88:87-90 (4) N '79
--Warriors
Smithsonian 11:96-8 (c, 3) Mr
'81
PAPYRUS PLANTS
Smithsonian 9:72 (c, 4) Jl '78
PARACHUTES
--For rockets
Nat Geog 159:336 (c, 2) Mr
'81
--Medieval design of parachute
Smithsonian 9:120 (drawing, 3)
O '78
PARACHUTING
Sports Illus 46:37-9 (c, 1) My
23 '77
PARADES
--1881 Garfield inauguration
Smithsonian 10:66 (2) D '79
--1918 Raisin Day (Fresno,
California)
Am Heritage 31:55 (2) O '80
--1930 Admiral Byrd parade

(New York City, New York)
Natur Hist 89:117 (4) Ap '80
--1930 ticker tape parade for Bobby
Jones (New York)
Am Heritage 31:81 (4) Ag '80
--1949 French boxcar gift to the
U. S. (New York)
Am Heritage 32:97 (1) O '81
--1976 Indianapolis 500
Sports Illus 46:36-7 (c, 1) My 16
'77
--1977 Presidential inauguration
(Washington, D. C.)
Ebony 32:142-3 (c, 4) Mr '77
--1981 Presidential inauguration
(Washington, D. C.)
Ebony 36:132-4 (c, 3) Mr '81
--Cuba
Nat Geog 151:32-3 (c, 1) Ja '77
--July 12 Orange Parade (Northern
Ireland)
Nat Geog 159:474 (c, 1) Ap '81
--Kennebunkport, Maine
Nat Geog 151:736 (c, 1) Je '77
--Macy's Thanksgiving Day Parade
(New York City, N. Y.)
Nat Geog 160:340 (c, 1) S '81
--May Day (Moscow, U. S. S. R.)
Nat Geog 153:22-3 (c, 1) Ja '78
--May Day (Portugal)
Nat Geog 158:812 (c, 1) D '80
--Mummer's New Year's parade
(Philadelphia, Pennsylvania)
Smithsonian 11:80-4 (c, 1) Ja '81
--Nikko feudal festival, Japan
Trav/Holiday 155:26 (3) Ap '81
--Political (Bulgaria)
Nat Geog 158:94-5 (c, 1) Jl '80
--Portland, Oregon
Sports Illus 47:36-7 (c, 2) O 31
'77
--St. Patrick's Day (Chicago, Illi-
nois)
Nat Geog 153:467 (c, 1) Ap '78
--Ticker tape for balloonists
(Arizona)
Nat Geog 154:882 (c, 3) D '78
--Ticker tape for Iranian hostages
(New York)
Life 4:32-3 (c, 1) Mr '81
--Tournament of Roses, Pasadena,
California
Am Heritage 29:30-3 (c, 4) D '77
--Tribute to poet (Mississippi)
Ebony 35:147 (3) S '80
--Trinidad
Ebony 32:97 (c, 4) Ja '77
--U. S. soldiers on Bastille Day

(1918; Paris, France)
Am Heritage 32:cov. (painting, c, 1) Ag '81
PARAGUAY--COSTUME
--Gauchos
Nat Geog 158:494-9 (c, 1) O '80
PARAKEETS
Nat Wildlife 18:40 (painting, c, 4) Ag '80
Smithsonian 12:55 (3) Jl '81
--Carolina
Nat Geog 151:152 (painting, c, 3) F '77
Natur Hist 87:cov., 10 (painting, c, 1) Ap '78
PARAMECIA
Smithsonian 8:90 (c, 3) Ja '78
PARIS, FRANCE
Nat Geog 158:468-77 (c, 1) O '80
--Late 19th cent. Pissarro painting
Smithsonian 12:54 (c, 2) Je '81
--Early 20th cent.
Life 4:9-16 (2) O '81
--Gare Saint-Lazare
Smithsonian 10:100-1 (painting, c, 2) S '79
--Humorous view of tourists
Sports Illus 51:50-3 (painting, c, 1) Ag 6 '79
--Les Halles
Life 2:84-5 (c, 4) Je '79
--Maxim's Restaurant
Life 2:90 (c, 2) My '79
--Père-Lachaise Cemetery
Smithsonian 9:cov., 108-17 (c, 1) N '78
--Pompidou Center
Smithsonian 8:cov., 20-9 (c, 1) Ag '77
Trav/Holiday 153:66 (c, 1) F '80
Nat Geog 158:468-77 (c, 1) O '80
--See also ARC DE TRIOMPHE; EIFFEL TOWER; LOUVRE
PARKING LOTS
Ebony 34:44 (4) Ag '79
--Mississippi college
Life 4:113 (3) Je '81
--Supermarket (Chicago, Illinois)
Ebony 33:25 (4) Ja '78
--Yugoslavian factory
Smithsonian 10:95 (c, 3) D '79
PARKS
--19th cent. Central Park bandstand (New York City)
Am Heritage 32:87 (4) Ap '81

--1920 bandstand (Twin Falls, Idaho)
Am Heritage 32:30-1 (1) Ap '81
--Baxter State Park, Maine
Am Heritage 29:49-53 (c, 1) Je '78
--Central Park, New York City, New York
Am Heritage 32:2-3, 81-97 (c, 1) Ap '81
--Chadron, Nebraska
Travel 148:53 (c, 1) Ag '77
--Costa Rica
Smithsonian 10:64-73 (c, 1) S '79
--Donana National Park, Spain
Smithsonian 9:72-9 (c, 2) Je '78
--Gas Works, Seattle, Washington
Smithsonian 8:116-20 (c, 2) N '77
--Grant, Chicago, Illinois
Nat Geog 153:476-7 (c, 1) Ap '78
--Harriman State, New York
Smithsonian 8:66-7 (c, 1) Ja '78
--Liberty, Jersey City, New Jersey
Smithsonian 9:151-2 (c, 3) O '78
--Lisbon, Portugal
Trav/Holiday 148:63 (c, 4) N '77
--Los Angeles, California
Smithsonian 10:26-35 (c, 1) Jl '79
--Louisville, Kentucky
Trav/Holiday 151:55 (4) Mr '79
--Madrid, Spain
Travel 148:31 (3) O '77
--Minneapolis, Minnesota
Nat Geog 158:674-5 (c, 2) N '80
--Moraine, Pennsylvania
Nat Geog 153:746-7 (c, 1) Je '78
--Munich, West Germany
Trav/Holiday 148:57 (c, 4) D '77
--Ohio
Nat Geog 254-5 (c, 1) F '77
--Paley Park, New York City, New York
Natur Hist 89:64, 68-9 (c, 1) Ag '80
--Peace Memorial, Hiroshima, Japan
Nat Geog 152:844-5 (c, 1) D '77
--Shanghai, China
Smithsonian 8:120 (c, 2) Ap '77
--Taipei, Taiwan
Trav/Holiday 148:34 (c, 2) D '77
--See also AMUSEMENT PARKS; PLAYGROUNDS; list under NATIONAL PARKS
PARLORS
--1898 (Yukon)
Am Heritage 31:89 (2) Ap '80
--1870's style (Cape May, New Jersey)

Smithsonian 9:129 (c, 4) S '78
--French chateau drawing room
Smithsonian 12:75 (c, 2) N '81
--Massachusetts mansion
Ebony 36:60 (c, 2) O '81
PARROTS
Natur Hist 86:63-5 (c, 2) My '77
Sports Illus 48:39 (c, 4) Ja 16
'78
Sports Illus 52:31 (painting, c, 1)
Je 16 '80
Nat Wildlife 18:40 (painting, c, 4)
Ag '80
--Lorikeets
Trav/Holiday 152:49 (c, 4) N '79
--See also COCKATOOS; KEAS;
MACAWS; PARAKEETS
PARSLEY
Natur Hist 90:37 (c, 1) My '81
PARTHENON, ATHENS, GREECE
Trav/Holiday 152:42 (c, 2) Ag
'79
Nat Geog 157:365-7 (c, 1) Mr
'80
PARTIES
--1918 50th anniversary dinner
(California)
Am Heritage 31:50-1 (1) O '80
--1981 Presidential inaugural balls
Ebony 36:140-2 (c, 4) Mr '81
--Charity benefit (Long Island,
New York)
Nat Geog 157:662-3 (c, 1) My
'80
--High society (Philadelphia,
Pennsylvania)
Ebony 32:72 (4) Ag '77
--See also BIRTHDAY PARTIES;
DANCES
PASADENA, CALIFORNIA
--Norton Simon Museum
Smithsonian 10:50-61 (c, 1) S
'79
PASQUEFLOWERS
Natur Hist 88:12-16 (c, 3) Ap
'79
Nat Geog 157:54-5 (c, 2) Ja '80
Natur Hist 90:75-6 (c, 3) O '81
Nat Geog 160:700 (c, 3) N '81
PASSENGER PIGEONS
Nat Geog 151:163 (painting, c, 1)
F '77
Sports Illus 47:102 (paint-
ing, c, 4) N 28 '77
Am Heritage 33:30-3 (c, 1) D '81
PASSPORTS
--1926 (U. S.)
Am Heritage 29:65, 67 (4) Je '78

PATENTS
--By Mark Twain
Am Heritage 29:36-7 (4) Je '78
Am Heritage 30:111 (4) F '79
PATTON, GEORGE S. , JR.
Am Heritage 29:94 (3) D '77
PAWNEE INDIANS--RITES AND
CEREMONIES
--Relics of Hako ritual
Am Heritage 30:78-9 (c, 2) F '79
PEACOCKS
Trav/Holiday 153:86 (c, 4) F '80
Life 3:9 (2) My '80
Smithsonian 12:78 (c, 4) N '81
PEALE, CHARLES WILLSON
Am Heritage 30:6 (painting, c, 4)
Ag '79
--Late 18th cent. portraits of women
Am Heritage 31:102-7 (paint-
ing, c, 4) Ap '80
--Paintings by Peale family (18th-
19th cents.)
Smithsonian 10:66-77 (c, 2) Ap '79
--Paintings of his family
Smithsonian 10:66-71 (painting, c, 2)
Ap '79
--Peale's Museum, Philadelphia,
Pa. (19th cent.)
Am Heritage 30:4-23 (painting, c, 1)
Ag '79
--Self-portrait
Natur Hist 89:84 (painting, c, 2)
Je '80
PEAR TREES
Natur Hist 88:62-3 (c, 1) My '79
Smithsonian 11:128-9, 138-40
(c, 2) Je '80
Smithsonian 12:92 (c, 1) My '81
--Blossoms
Nat Geog 154:608 (c, 1) N '78
--Infected with fire blight
Natur Hist 88:64-7 (c, 2) My '79
PEARL HARBOR, HAWAII
--Arizona Memorial
Nat Geog 156:664-5 (c, 1) N '79
--Artifacts from 1941 attack
Life 4:3, 42-52 (c, 1) D '81
--World War II memorial
Trav/Holiday 152:43 (c, 4) O '79
PEARS
Natur Hist 88:69 (painting, c, 1)
My '79
PEAT INDUSTRY
--Ireland
Natur Hist 89:50-7 (c, 1) N '80
Nat Geog 159:454-5 (c, 1) Ap '81
--Scotland
Nat Geog 151:540-1 (c, 1) Ap '77

PECANS
 Nat Geog 154:239 (c, 4) Ag '78
PECCARIES
 Natur Hist 88:86 (lithograph, c, 3)
 My '79
 Sports Illus 51:41 (c, 4) S 10 '79
 Sports Illus 52:112 (painting, c, 3)
 Ja 14 '80
 Nat Wildlife 19:18-19 (1) F '81
 Natur Hist 90:60-6 (c, 1) Je '81
 Nat Wildlife 19:45 (c, 1) Ag '81
PEKING, CHINA
 Trav/Holiday 150:cov., 34-7
 (c, 1) N '78
 Nat Geog 157:301, 330-1 (c, 2)
 Mr '80
PEKINGESE DOGS
 Sports Illus 46:28 (c, 2) Ja 10
 '77
PELICANS
 Nat Geog 151:172 (c, 3) F '77
 Nat Geog 151:688-9 (c, 1) My
 '77
 Nat Wildlife 15:46 (c, 4) Je '77
 Nat Geog 155:342-3, 354-5
 (c, 2) Mr '79
 Life 2:64-5 (c, 1) Ag '79
 Trav/Holiday 153:27 (c, 4) Ja
 '80
 Nat Wildlife 18:38 (painting, c, 1)
 Ag '80
 Nat Wildlife 19:10-11, 47
 (c, 1) F '81
 Nat Wildlife 19:48 (c, 1) Je '81
 Trav/Holiday 156:52 (c, 4) N '81
--Wooden
 Nat Wildlife 19:53 (c, 1) D '80
PENGUINS
 Nat Geog 152:236-55 (c, 1) Ag
 '77
 Life 1:100-1 (c, 1) O '78
 Trav/Holiday 152:61 (c, 4) S '79
 Smithsonian 10:56-65 (c, 1) O
 '79
 Natur Hist 89:68-9 (c, 2) Mr '80
 Nat Wildlife 18:29 (painting, c, 2)
 O '80
 Smithsonian 12:91 (c, 3) S '81
PENN, WILLIAM
 Nat Geog 153:730 (sculpture, c, 1)
 Je '78
PENNSYLVANIA
 Nat Geog 153:730-67 (map, c, 1)
 Je '78
--Effects of Johnstown flood
 Nat Geog 158:164-5 (c, 1) Ag '80
--Longwood Gardens
 Travel 147:54-7 (c, 1) Ja '77

--Pocono region
 Trav/Holiday 156:cov., 46-9
 (map, c, 1) S '81
--Schuylkill County almshouse
 (1881)
 Am Heritage 31:38-9 (painting, c, 1)
 F '80
--Three Mile Island nuclear power
 plant
 Life 2:cov., 22-3 (c, 1) My '79
 Life 2:166-7 (c, 1) D '79
--See also GETTYSBURG NATIONAL
 PARK; PENN, WILLIAM;
 PHILADELPHIA; PITTSBURGH;
 READING; SUSQUEHANNA
 RIVER; VALLEY FORGE
PENOBSCOT RIVER, MAINE
 Sports Illus 50:31-3 (c, 1) Je 25
 '79
People and civilizations. See
 ABORIGINES; AFRICAN
 TRIBES; AGED; AMISH;
 ASIAN TRIBES; AUDIENCES;
 AZTEC CIVILIZATION; BEDOU-
 INS; BERBERS; BOY SCOUTS;
 BRONZE AGE; BYZANTINE
 CIVILIZATION; CAVEMEN;
 CELTIC CIVILIZATION;
 DRUSES; ESKIMOS; FAMILY
 LIFE; GIRL SCOUTS; GREECE,
 ANCIENT; HANDICAPPED
 PEOPLE; HERMITS; HOBOES;
 HOMOSEXUALS; INDIANS OF
 LATIN AMERICA; INDIANS
 OF NORTH AMERICA; IN-
 JURED PEOPLE; KU KLUX
 KLAN; KURD PEOPLE; LAPP
 PEOPLE; MAYAN CIVILIZA-
 TION; MENNONITES; MIDDLE
 AGES; MIDGETS; NOMADS;
 PERSIAN EMPIRE; REFUGEES;
 ROMAN EMPIRE; SELEUCID
 CIVILIZATION; SHAKERS;
 SOUTH PACIFIC PEOPLE;
 STONE AGE; SUMERIAN
 CIVILIZATION; TARTAR EM-
 PIRE; VIKINGS; WITCHES;
 YOUTH
People's Republic of China. See
 CHINA
PEPPER INDUSTRY
--Albania
 Nat Geog 158:548-9 (c, 1) O '80
--Drying chili peppers (New Mexico)
 Nat Geog 154:426 (c, 4) S '78
Performers. See ENTERTAINERS
PERON, JUAN
--Eva Peron depicted in play "Evita"

Life 2:67-70 (c, 1) S '79
--Juan and Evita Peron
Life 2:67, 69-70 (4) S '79
PERSIAN EMPIRE--SCULPTURE
--Bronze bull head (1500-1300
B. C.)
Natur Hist 89:53 (c, 1) S '80
PERSIAN GULF--MAP
Nat Geog 156:308-9 (c, 1) S '79
PERU
--Amazon River tributaries
Smithsonian 8:100, 104 (c, 2)
O '77
--Farms
Natur Hist 86:32-8 (c, 1) My '77
--Mountainous countryside
Travel 147:44 (c, 3) Ja '77
Natur Hist 90:72-84 (c, 1) N '81
--See also LIMA; MACHU PICCHU
PERU--ART
--Silverwork
Nat Geog 160:302-5 (c, 1) S '81
PERU--COSTUME
--Farmers
Natur Hist 86:32-41 (c, 1) My
'77
--Sherpa tribe
Natur Hist 90:75, 78, 84 (c, 3)
N '81
--Quechua tribe
Natur Hist 90:cov., 72-7 (c, 1)
N '81
PERU, ANCIENT
--Mummies
Natur Hist 88:75-81 (c, 1) F '79
--See also INCA CIVILIZATION
PERU, ANCIENT--ART
--1st cent. Mochica gold nose
ornament
Smithsonian 9:46-7 (c, 1) O '78
--Golden gloves (Chimu culture)
Natur Hist 86:131 (4) O '77
--Pre-Hispanic gold sculpture
Smithsonian 8:84-91 (c, 1) D '77
PESTICIDES
Nat Geog 157:146-81 (map, c, 1)
F '80
--Effects of poisonous herbicides
(Arkansas)
Life 2:43-9 (2) O '79
--New ways of controlling insects
Life 4:129-34 (c, 1) O '81
--Research and applications
Smithsonian 9:78-85 (c, 1) Ja
'79
--See also CROP DUSTER PLANES
PETER THE GREAT
Life 3:57-68 (painting, c, 2) S

'80
PETRELS (BIRDS)
--Storm
Nat Geog 152:244 (c, 4) Ag '77
Petroglyphs. See CAVE DRAW-
INGS; ROCK CARVINGS;
ROCK PAINTINGS
PETS--HUMOR
--Famous people's unusual pets
Smithsonian 11:82-90 (painting, c, 2)
S '80
Pewees. See WOOD PEWEES
PHALAROPES (BIRDS)
Smithsonian 11:45 (c, 4) F '81
PHARAOHS
--2nd millennium B. C. glass head
(Egypt)
Smithsonian 11:68 (c, 4) My '80
PHARMACIES
--15th cent. (Beaune, France)
Trav/Holiday 149:36 (4) Ap '78
--Herbal pharmacy (India)
Smithsonian 12:92 (c, 4) N '81
--Puerto Rican botanicas (New York
City, New York)
Natur Hist 86:64-73 (c, 1) Ag '77
PHARMACISTS
--China
Nat Geog 158:31 (c, 4) Jl '80
--Filling prescriptions (Xavier Uni-
versity, Louisiana)
Ebony 35:54 (3) S '80
--Japan
Nat Geog 159:300 (c, 4) Mr '81
PHEASANTS
Nat Wildlife 15:52 (painting, c, 2)
O '77
Nat Geog 155:375 (c, 1) Mr '79
Trav/Holiday 153:96 (4) F '80
Nat Wildlife 19:32 (c, 4) D '80
Natur Hist 90:74 (woodcut, 4) My
'81
--Ring-necked
Nat Wildlife 17:cov. (c, 1) O '79
--Stuffed
Am Heritage 30:11 (c, 4) Ag '79
--See also PEACOCKS; TRAGO-
PANS
PHILADELPHIA, PENNSYLVANIA
Nat Geog 153:730-51 (c, 1) Je '78
Smithsonian 9:66-7, 72-5 (c, 1)
Ja '79
Trav/Holiday 152:46-9 (c, 1) Ag
'79
--19th cent. Fairmount Waterworks
Am Heritage 30:100-7 (c, 1) Ap
'79
--19th cent. properties of Stephen

Girard
 Am Heritage 29:42-3 (draw-
 ing, c, 3) Je '78
--Early 20th cent. Chestnut Hill
 mansion
 Am Heritage 30:31 (4) Ag '79
--Mummers' New Year's parade
 Smithsonian 11:80-4 (c, 1) Ja
 '81
--Renovated housing
 Ebony 33:78-80 (4) S '78
--See also INDEPENDENCE HALL;
 LIBERTY BELL
PHILIP II (MACEDONIA)
--Medallion depicting him
 Smithsonian 10:67 (4) Ja '80
--Treasures from his tomb
 Nat Geog 154:54-77 (c, 1) Jl '78
 Life 3:46-50 (c, 1) Jl '80
 Smithsonian 11:cov. , 126-38
 (c, 1) N '80
PHILIPPINES
 Nat Geog 151:360-90 (map, c, 1)
 Mr '77
--Lechon
 Trav/Holiday 151:37-8 (c, 2) Ja
 '79
--See also CEBU; DAVAO;
 MANILA; MANILA BAY
PHILIPPINES--COSTUME
 Nat Geog 151:360-90 (c, 1) Mr
 '77
 Life 2:29-36 (c, 1) Jl '79
--Davao
 Travel 148:37 (c, 1) Ag '77
--Farmer
 Nat Geog 152:87 (c, 3) Jl '77
--Manila
 Trav/Holiday 149:41-3 (c, 1) Ja
 '78
Philosophers. See WRITERS
PHOENIX, ARIZONA
 Nat Geog 152:493-7, 514-15
 (c, 1) O '77
PHONOGRAPHS
 Ebony 35:78-80 (4) D '79
--1916
 Smithsonian 12:78 (4) Ap '81
--Portable (Tibet)
 Nat Geog 157:238 (c, 4) F '80
PHONOGRAPHS--HISTORY
 Smithsonian 9:111-25 (c, 2) My
 '78
PHOTOGRAPHERS
--1870
 Natur Hist 89:71 (4) O '80
--Early 20th cent.
 Am Heritage 28:76 (4) Ag '77

--Alfred Eisenstaedt
 Life 4:10, 16 (2) F '81
--See also BRADY, MATHEW
PHOTOGRAPHY
--Mid 19th cent. daguerreotypes
 (Missouri)
 Am Heritage 31:76-93 (1) D '79
--Early 20th cent. postcards
 Smithsonian 12:96-103 (2) S '81
--Early 20th cent. snapshots
 Life 3:159-65 (4) D '80
--Early 20th cent. stereographs
 Smithsonian 9:cov. , 88-95 (1) F
 '79
--1914 studio (Utah)
 Am Heritage 30:31 (3) Je '79
--1920's-1930's nudes
 Life 3:9-12 (c, 2) My '80
--Aerial view photos
 Smithsonian 10:106-13 (c, 1) Ap
 '79
--Eugene Atget's works
 Life 4:9-16 (2) O '81
--Earliest daguerreotype portraits
 (1839)
 Am Heritage 32:92-3 (4) F '81
--Early color photos
 Life 3:85-93 (c, 1) Ap '80
--First color photos, made by Levi
 Hill (mid 19th cent.)
 Am Heritage 31:4-7 (c, 3) Je '80
--First color photos, made by James
 Maxwell (1861)
 Life 3:85 (c, 4) Ap '80
--High speed photography
 Smithsonian 10:84-7 (c, 2) Jl '79
--Kirlian photography
 Smithsonian 8:109-14 (c, 1) Ap '77
--Microscopy
 Natur Hist 86:47 (c, 1) Ag '77
 Smithsonian 9:66-71 (c, 2) Ag '78
 Natur Hist 89:36-7, 41 (c, 1) Jl
 '80
 Natur Hist 90:73 (c, 1) Jl '81
--Microscopy of plant cells
 Natur Hist 87:cov. , 74-8 (c, 1)
 Je '78
--Gjon Mili's works
 Life 3:98-110 (c, 1) N '80
--Photocopier art
 Life 3:9-12 (c, 2) Ja '80
--Photos by Mathew Brady
 Smithsonian 8:cov. , 24-35 (1)
 Jl '77
 Smithsonian 8:59-67 (1) Ag '77
--Photos made without cameras
 Nat Wildlife 17:17-19 (2) Ag '79
--Photos of the U. S. from the air

PICNICS
 Ebony 36:150 (3) Je '81
--British Columbia hikers
 Trav/Holiday 155:49 (c, 2) My
 '81
--California winery
 Nat Geog 155:704 (c, 4) My '79
--Elegant (Great Britain)
 Sports Illus 52:42 (c, 2) Je 23
 '80
--France
 Nat Geog 154:554-5 (c, 2) O '78
--Georgia backyard
 Sports Illus 53:35 (4) D 22 '80
--Lake Tahoe, Nevada/California
 Trav/Holiday 151:63 (c, 4) Mr
 '79
--Massachusetts
 Nat Wildlife 17:8 (c, 4) Ap '79
 Trav/Holiday 153:cov. (c, 1) Je
 '80
--Massachusetts beach
 Ebony 34:41 (c, 4) My '79
--Minnesota parking lot
 Nat Geog 158:670 (c, 2) N '80
--Pennsylvania
 Nat Geog 153:748-9 (c, 1) Je
 '78
--Picnic fare
 Ebony 35:80-6 (c, 2) Jl '80
--Tibet
 Nat Geog 157:241 (c, 4) F '80
--U. S. S. R.
 Nat Geog 152:258 (c, 4) Ag '77
--Virginia
 Natur Hist 89:101 (3) S '80
--Washington
 Nat Geog 154:610-11 (c, 1) N
 '70
--Zimbabwe
 Trav/Holiday 156:64 (c, 2) N '81
PICNICS--HUMOR
 Insect hazards
 Nat Wildlife 16:28-31 (paint-
 ing, c, 1) Ag '78
PIGEONS
 Am Heritage 28:92 (4) O '77
 Life 3:140 (c, 2) Mr '80
--Bred to battle (Brooklyn, N. Y.)
 Smithsonian 9:74-82 (c, 1) My
 '78
--Communicating with symbols
 Smithsonian 11:28 (4) My '80
--Feeding pigeons (Venice, Italy)
 Trav/Holiday 151:34 (c, 1) F
 '79
--Krakow, Poland square
 Trav/Holiday 155:66-7 (c, 1)

 Mr '81
--Race (Belgium)
 Nat Geog 155:322-3 (c, 1) Mr
 '79
--Studying homing skills
 Nat Geog 156:190-1 (c, 2) Ag '79
--Wearing cameras
 Smithsonian 10:107 (4) Ap '79
PIGS
 Nat Geog 154:398-415 (c, 1) S
 '78
 Nat Geog 155:782 (c, 4) Je '79
 Smithsonian 10:103 (c, 1) Je '79
 Natur Hist 89:38-9 (c, 1) Jl '80
 Nat Geog 160:200 (c, 3) Ag '81
--Piglet
 Nat Geog 159:622 (c, 3) My '81
--Tattooed winged pig
 Sports Illus 46:86-7 (c, 4) Ap 18
 '77
PIKAS
 Nat Wildlife 16:9 (c, 4) Ag '78
 Nat Geog 156:746 (c, 4) D '79
 Nat Wildlife 18:12-17 (c, 1) O
 '80
PIKE
 Sports Illus 51:96 (painting, c, 4)
 D 24 '79
PILTDOWN MAN
--1910 hoax (Great Britain)
 Smithsonian 9:32-3 (4) Mr '79
--Lower molars of jaw
 Natur Hist 88:86 (4) Mr '79
PINBALL MACHINES
 Sports Illus 47:33 (painting, c, 3)
 S 5 '77
 Sports Illus 50:23 (c, 2) Je 18
 '79
 Sports Illus 52:110 (c, 4) F 25 '80
 Sports Illus 54:106 (4) Ap 20 '81
--Arcades (Massachusetts)
 Smithsonian 12:50-1 (c, 1) S '81
--Australia
 Life 4:99 (c, 3) N '81
PINE TREES
 Nat Wildlife 15:2 (c, 1) Ja '77
 Nat Geog 152:714-15 (c, 1) N '77
 Nat Wildlife 16:44-5 (c, 3) Je '78
 Smithsonian 9:73 (c, 2) Je '78
 Smithsonian 9:50 (c, 3) Mr '79
 Smithsonian 11:136-7 (c, 1) O '80
--Bark
 Nat Geog 160:699 (c, 2) N '81
--Loblolly
 Life 3:76-7 (c, 1) Jl '80
--Pine cones
 Natur Hist 88:59 (c, 4) F '79
--See also BRISTLECONE PINE

TREES; DOUGLAS FIR
TREES; SPRUCE TREES
PINEAPPLE INDUSTRY
--Plantation (Hawaii)
 Nat Geog 160:200-1 (c, 2) Ag '81
 Trav/Holiday 156:56 (c, 4) O '81
Ping Pong. See TABLE TENNIS
PINKERTON, ALLAN
--Pinkerton and his sons
 Smithsonian 12:61-3 (3) Ag '81
PINKS (FLOWERS)
 Nat Wildlife 16:2 (c, 1) Ag '78
PIPE SMOKING
 Sports Illus 51:88 (4) O 8 '79
 Ebony 36:84 (4) My '81
 Sports Illus 54:19 (c, 4) Je 22
 '81
--17th cent.
 Natur Hist 86:26, 31 (drawing, 4)
 Ap '77
--Amish people
 Smithsonian 10:79 (c, 4) F '80
--Water pipe (Dubai)
 Travel 147:64 (4) Ja '77
--Water pipe (Turkey)
 Nat Geog 152:105 (c, 1) Jl '77
PIPEFISH
 Nat Geog 153:845 (c, 4) Je '78
PIPELINES
--Gas (Louisiana)
 Nat Geog 154:640 (c, 1) N '78
--Water (California)
 Smithsonian 11:43 (c, 4) F '81
--See also ALASKA PIPELINE
PIPES
--18th cent. (France)
 Nat Geog 152:765 (c, 1) D '77
--Oil industry (Texas)
 Ebony 35:70-1 (2) Jl '80
PIPES, TOBACCO
--17th cent. clay pipe (Great
 Britain)
 Nat Geog 155:762 (c, 4) Je '79
PIRANHAS
 Smithsonian 8:102 (c, 4) O '77
 Sports Illus 54:82 (c, 4) My 18
 '81
PIRATES
--17th cent.
 Nat Geog 152:748-9 (painting, c, 1)
 D '77
--19th cent. Barbary Coast
 Am Heritage 28:40-1 (painting, 2)
 Ag '77
--See also BARBAROSSA
PISA, ITALY
 Trav/Holiday 156:50-3 (map, c, 1)
 O '81

--See also LEANING TOWER OF
 PISA
PISSARRO, CAMILLE
 Smithsonian 12:51, 56 (4) Je '81
--Boulevard Montmartre, Mardi
 Gras (1897)
 Smithsonian 11:156-7 (painting, c, 2)
 O '80
--Paintings by him
 Smithsonian 12:48-57 (c, 1) Je '81
PITCHER PLANTS
 Nat Wildlife 15:9 (c, 4) Je '77
 Nat Wildlife 18:24 (c, 4) F '80
PITT, WILLIAM
--Wax sculpture
 Smithsonian 8:114 (c, 2) F '78
PITTSBURGH, PENNSYLVANIA
 Nat Geog 151:246-7 (c, 1) F '77
 Nat Geog 153:756-9 (c, 1) Je '78
 Sports Illus 51:100-1 (c, 1) D 10
 '79
--1873 destruction of railroad yards
 during strike
 Am Heritage 29:56-61 (1) F '78
--Early 20th cent.
 Am Heritage 30:7-8 (4) F '79
--Computer view of city
 Smithsonian 10:54-5 (c, 3) Mr '80
--St. Peter's Church
 Smithsonian 11:16 (4) Mr '81
PLANETARIUMS
 Nat Geog 156:162-3 (c, 1) Ag '79
PLANETS
 Life 4:cov., 75-90 (c, 1) Je '81
--Solar system
 Smithsonian 9:72 (drawing, c, 4)
 D '78
--See also EARTH; JUPITER;
 MOONS; SATURN; URANUS;
 VENUS
PLANKTON
 Nat Geog 157:538-9 (c, 1) Ap '80
 Nat Geog 159:638-9, 642-3 (c, 1)
 My '81
 Nat Geog 160:825 (c, 2) D '81
PLANTATIONS
--Early 19th cent. Baltimore, Mary-
 land
 Am Heritage 32:21 (painting, c, 3)
 F '81
--1828 plantation home (Louisiana)
 Trav/Holiday 149:39 (c, 2) Mr
 '78
--Antebellum plantation houses
 (Louisiana)
 Trav/Holiday 152:38, 41 (c, 2) O
 '79
--Antebellum plantations (South)

Travel 148:52-3 (c, 3) O '77
--1883 Louisiana
 Natur Hist 90:37 (painting, c, 4)
 Je '81
PLANTS
--Botanical garden conservatory
 (New York)
 Smithsonian 9:64-73 (c, 1) Jl
 '78
--Carnivorous
 Natur Hist 89:80 (c, 4) S '80
--Early plant handbooks
 Natur Hist 90:51-6 (c, 1) Mr
 '81
--Endangered species
 Smithsonian 9:122-9 (c, 1) N '78
--House plants (France)
 Nat Geog 154:550-1 (c, 1) O '78
--House plants (Hawaii)
 Nat Geog 156:676 (c, 1) N '79
--Jojoba
 Nat Geog 156:635 (c, 4) N '79
 Nat Geog 159:704-7 (c, 3) My '81
--Outdoor medicinal plant market
 (West Africa)
 Smithsonian 12:93-7 (c, 2) N '81
--Photomicrographs of cells
 Natur Hist 87:cov., 74-8 (c, 1)
 Je '78
--Poisonous
 Smithsonian 8:48-55 (paint-
 ing, c, 1) My '77
 Nat Wildlife 15:46-7 (paint-
 ing, c, 4) O '77
--Sea oats
 Travel 147:54 (c, 1) Je '77
--Tundra regions
 Smithsonian 8:50-1 (c, 2) S '77
--Used as medicine
 Smithsonian 12:86-97 (c, 1) N
 '81
--See also ALGAE; ANISE; BAM-
 BOO; CRESS; CYCADS;
 FENNEL; FERNS; FIGWORTS;
 FLOWERING PLANTS; FUNGI;
 GARDENS; GRASS; GREEN-
 HOUSES; GUAYULE; HERBS;
 HORSETAILS; HOUSE PLANTS;
 IVY; KELP; LICHENS;
 LICORICE; LINNAEUS,
 CAROLUS; MOLDS; MOSSES;
 MUSHROOMS; MUSTARD;
 NETTLES; PAPYRUS; POLLEN;
 RAGWEED; ROSEMARY;
 SEEDS; SKUNK CABBAGE;
 SLIME MOLDS; SUMAC; TOPI-
 ARY; VINES; WEEDS; WILD
 CARROTS; WILD RICE;

WITCH HAZEL
PLASTIC SURGERY
 Ebony 35:62-8 (3) S '80
--Before/after pictures
 Ebony 32:41-50 (4) Ja '77
PLATTE RIVER, NEBRASKA
 Nat Wildlife 16:4-7 (c, 1) Je '78
PLATYPUSES
 Smithsonian 11:62-9 (c, 1) Ja '81
PLAYGROUNDS
--1920 (New Hampshire)
 Am Heritage 29:20 (2) O '78
--Michigan
 Trav/Holiday 149:62 (c, 4) Mr '78
--Piedmont Park, Atlanta, Georgia
 Smithsonian 9:46-7 (c, 2) Ap '78
--Playtank (Indiana)
 Nat Geog 154:383 (c, 4) S '78
--Savannah, Georgia
 Trav/Holiday 151:53 (c, 4) F '79
--Slide
 Ebony 36:120 (4) My '81
--See also SWINGS
PLOVDIV, BULGARIA
 Nat Geog 158:105 (c, 3) Jl '80
PLOVERS (BIRDS)
 Nat Wildlife 15:60 (c, 4) Ja '77
--Snowy
 Nat Wildlife 19:44 (c, 4) F '81
--See also JACANAS
Plowing. See FARMING--PLOWING
PLUMBERS
 Sports Illus 55:27 (c, 3) Je 29 '81
PLYMOUTH, MASSACHUSETTS
--Statue of Chief Massasoit
 Ebony 34:41 (c, 4) My '79
POE, EDGAR ALLAN
 Am Heritage 29:48 (4) Ag '78
POLAND
--1944 aerial view of Auschwitz
 concentration camp
 Life 2:8-12 (1) Ap '79
--Church with salt carvings
 Nat Geog 152:392-3 (c, 1) S '77
--Malbork Castle
 Trav/Holiday 152:38-9 (4) N '79
--Southern mountain area
 Nat Geog 159:104-29 (map, c, 1)
 Ja '81
--See also KRAKOW; LUBLIN;
 WARSAW
POLAND--COSTUME
--Early 20th cent. emigrants to the
 U. S.
 Am Heritage 29:34-42 (1) Ap '78
--Mountain people
 Nat Geog 159:104-29 (c, 1) Ja '81
--Policemen

Life 4:14 (2) My '81
POLAND--HISTORY
--1944 resistance fighting (Warsaw)
Life 2:9, 12 (2) O '79
POLAND--POLITICS AND GOV-
ERNMENT
--Strikers
Life 3:122-3 (1) O '80
--Union demonstrators
Life 4:34-5 (c, 1) Ja '81
Life 4:10-18 (c, 1) My '81
POLAR BEARS
Smithsonian 8:cov. , 70-9 (c, 1)
F '78
Nat Geog 154:280-1 (c, 1) Ag
'78
Nat Geog 154:783 (c, 1) D '78
Nat Geog 156:578-9 (c, 2) O '79
Nat Geog 156:762-3 (c, 1) D '79
Nat Wildlife 18:14-15 (c, 4) D
'79
Nat Geog 160:786-7 (c, 1) D '81
POLE VAULTING
Sports Illus 47:18 (c, 4) S 12
'77
Sports Illus 48:31 (c, 1) My 1
'78
Sports Illus 49:26 (c, 4) Ag 21
'78
Sports Illus 50:118-19 (c, 1) F
15 '79
Sports Illus 50:54 (3) Mr 12 '79
Sports Illus 50:37-41 (1) Je 4
'79
Sports Illus 52:70 (c, 4) F 25 '80
Sports Illus 52:54 (c, 4) Mr 10
'80
Sports Illus 53:12-13 (c, 1) Jl 7
'80
--1980 Olympics (Moscow)
Sports Illus 53:18-19 (c, 3) Ag
11 '80
Life 3:98 (c, 3) S '80
POLICEMEN
--1890's (Hartford, Connecticut)
Smithsonian 8:150-1 (4) N '77
--1898 Northwest Mounted Police
(Yukon)
Am Heritage 31:93 (4) Ap '80
--Early 1900's
Am Heritage 29:111 (4) F '78
--1927 (New York City, New York)
Am Heritage 31:23 (4) O '80
--1955 (Alabama)
Ebony 32:54 (3) S '77
--Alabama state troopers
Ebony 35:55-60 (2) D '79
--Beefeater (London, England)

Trav/Holiday 149:60 (3) F '78
Nat Geog 156:452 (c, 1) O '79
--Buffalo, New York
Ebony 35:60-2 (3) Mr '80
Ebony 36:104 (4) F '81
--Changing of the Guard (Monte
Carlo)
Trav/Holiday 150:80 (4) Ag '78
--Chicago, Illinois
Ebony 36:104-6 (4) F '81
--Danish Royal Guard
Nat Geog 156:842-3 (c, 1) D '79
--Fingerprinting suspect
Ebony 32:54 (3) S '77
--Finland
Nat Geog 160:249 (c, 1) Ag '81
--Frisking thief
Ebony 34:84 (4) Ag '79
--Great Britain
Travel 147:62 (4) Mr '77
Sports Illus 51:12-13 (c, 1) Jl 30
'79
Life 3:66, 78 (2) Ap '80
Life 4:110-11 (1) Ag '81
--Grenadier Guards (London, Eng-
land)
Nat Geog 156:442-3 (c, 1) O '79
--Guardian Angels (New York City,
New York)
Ebony 37:42 (c, 4) N '81
--Hawaii
Sports Illus 51:105 (c, 4) O 8 '79
--Helicopter patrol (Washington,
D. C.)
Ebony 35:44-6 (3) O '80
--Houston, Texas
Sports Illus 46:25 (c, 4) My 2 '77
--Induction ceremony (Detroit, Mich-
igan)
Ebony 36:50 (4) Mr '81
--Miami, Florida
Ebony 36:47 (3) Mr '81
--Michigan
Nat Geog 155:824 (c, 4) Je '79
Ebony 35:88 (3) My '80
--Mounted (Richmond, Virginia)
Ebony 35:52 (4) Je '80
--New Jersey
Nat Geog 160:587, 597 (c, 3) N
'81
--New York
Nat Geog 151:194-5 (c, 1) F '77
Life 2:40-1 (1) Jl '79
Nat Geog 156:90-1 (c, 1) Jl '79
Ebony 34:75 (3) Ag '79
Nat Geog 160:332 (c, 4) S '81
--North Carolina
Ebony 36:106 (4) F '81

--Poland
 Life 4:14 (2) My '81
--Precinct (Buffalo, New York)
 Ebony 35:60-2 (3) Mr '80
--Rhode Island
 Life 3:10 (3) Ap '80
--Royal Canadian Mounted Police
 Nat Geog 153:574-5 (c, 1) Ap
 '78
 Nat Geog 155:672-3 (c, 2) My
 '79
--Scotland
 Nat Geog 151:766-7 (c, 1) Je '77
--South Korea
 Nat Geog 156:777 (c, 3) D '79
--Target practice
 Ebony 33:46 (4) Je '78
 Ebony 35:56 (2) D '79
--Traffic (Tel Aviv, Israel)
 Trav/Holiday 149:101 (4) Mr '78
--U. S. S. R.
 Life 3:45 (4) My '80
--Washington, D. C.
 Ebony 36:105 (4) F '81
--West Virginia
 Sports Illus 53:42 (3) S 22 '80
--See also DETECTIVES;
 HOOVER, J. EDGAR
POLISH AMERICANS
 Am Heritage 29:34-42 (1) Ap '78
POLITICAL CAMPAIGNS
--1847-1855 (Missouri)
 Am Heritage 31:cov. , 4-15
 (painting, c, 1) O '80
--1864 Lincoln kerchief
 Am Heritage 32:114 (c, 3) F '81
--1864 parade for candidate (Phila-
 delphia, Pa.)
 Am Heritage 31:2-3 (paint-
 ing, c, 1) O '80
--1884 presidential campaign of
 Belva Lockwood
 Smithsonian 11:138-50 (draw-
 ing, c, 4) Mr '81
--1896 presidential campaign
 Am Heritage 31:113 (2) F '80
 Am Heritage 31:4-11 (c, 1) Ap
 '80
--1900 lithograph of Bryan
 Am Heritage 31:110 (c, 4) Je '80
--1904 Roosevelt campaign relics
 Am Heritage 32:4-9 (c, 4) Je
 '81
--1972 Democratic National Con-
 vention
 Ebony 33:136 (3) O '78
--1980 presidential campaign
 Life 3:32-50 (c, 1) O '80

 Life 4:91-9, 134-5 (c, 1) Ja '81
--1980 Republican convention
 (Detroit, Michigan)
 Life 4:134-5 (c, 1) Ja '81
--Campaign artifacts and advertising
 gimmicks (1789-1840)
 Smithsonian 11:181-3 (c, 4) O '80
--Campaigning at county fair
 (Mississippi)
 Nat Geog 157:858-65 (c, 1) Je '80
--Election billboards (Cuba)
 Nat Geog 151:43 (c, 3) Ja '77
--Henry George for N. Y. C. mayor
 poster (1886)
 Am Heritage 29:12 (3) Ap '78
--Humphrey speaking at 1948 Demo-
 cratic convention
 Am Heritage 29:63 (4) D '77
--Rally (Spain)
 Nat Geog 153:324-5 (c, 1) Mr '78
--Shaking hands (Kentucky)
 Life 2:142-3 (1) S '79
--Voting at caucus (Iowa)
 Nat Geog 159:610 (c, 3) My '81
--See also ELECTIONS; GOVERN-
 MENT; SPEECHMAKING;
 U. S. --POLITICS AND GOVERN-
 MENT
POLITICAL CARTOONS
--Communism devouring Southeast
 Asia
 Nat Geog 157:633 (c, 4) My '80
--Lampooning William Jennings
 Bryan (1896)
 Am Heritage 31:11 (drawing, c, 3)
 Ap '80
--Teddy Roosevelt and the Panama
 Canal
 Nat Geog 153:279 (drawing, 4) F
 '78
Politicians. See STATESMEN
Politics and government. See
 DEMONSTRATIONS; ELEC-
 TIONS; GOVERNMENT;
 POLITICAL CAMPAIGNS;
 U. S. --POLITICS AND GOV-
 ERNMENT
POLK, JAMES KNOX
--Fan belonging to Mrs. Polk (1845)
 Smithsonian 7:106 (c, 4) Ja '77
POLLEN
 Nat Geog 151:290 (2) F '77
POLLUTION
--Chemical detoxification system
 Nat Geog 158:155 (c, 2) Ag '80
--Chemical wastes (New York)
 Nat Geog 158:154-5 (c, 1) Ag '80
--Political cartoons

Nat Wildlife 18:29-35 (draw-
ing, 4) F '80
--See also AIR POLLUTION; NOISE
POLLUTION; SMOG; WATER
POLLUTION
POLLUTION CONTROL EQUIP-
MENT
--Power plant (Pennsylvania)
Nat Geog 160:678-9 (c, 1) N '81
POLO
Sports Illus 46:68-71 (c, 1) My
9 '77
Life 3:102 (4) Ag '80
Polo, Water. See WATER POLO
Polynesia. See PACIFIC ISLANDS
POMPANO FISH
Nat Geog 160:834-5 (c, 1) D '81
POMPEII, ITALY
--1st cent. paintings and mosaics
Smithsonian 9:84-93 (c, 1) Ap
'78
Natur Hist 88:cov., 37-82 (c, 1)
Ap '79
Trav/Holiday 151:16-22 (c, 4)
My '79
--Remains of Temple of Jupiter
Smithsonian 8:43 (c, 1) Ag '77
--Ruins
Natur Hist 88:42-79 (1) Ap '79
POND LIFE
Smithsonian 8:84-91 (c, 2) Ja
'78
--See also MARINE LIFE
PONDS
Smithsonian 8:84 (c, 3) Ja '78
--Alaska
Nat Wildlife 16:10 (c, 4) Ag '78
--Walden Pond, Concord, Massa-
chusetts
Nat Geog 159:350-1 (c, 1) Mr
'81
Ponies. See HORSES
PONY EXPRESS
--History
Nat Geog 158:44-71 (c, 1) Jl '80
--Plaque marking Gothenburg
station, Nebraska
Trav/Holiday 153:62 (4) Je '80
POODLES
Ebony 32:51 (4) My '77
Ebony 32:119-22 (3) Jl '77
Smithsonian 9:92 (c, 4) N '78
Life 2:54 (2) S '79
Pool Playing. See BILLIARD
PLAYING
Pools. See SWIMMING POOLS
POORHOUSES
--1881 almshouse (Schuylkill

County, Pennsylvania)
Am Heritage 31:38-9 (painting, c, 1)
F '80
POPES
Ebony 35:110 (c, 4) Mr '80
Ebony 35:79 (4) O '80
--Clement XI
Smithsonian 8:71 (drawing, c, 4)
Ja '78
--John Paul I
Life 1:123-8 (c, 1) O '78
Life 1:103 (3) N '78
Life 2:195 (c, 4) D '79
--John Paul II
Life 1:8-14 (c, 1) D '78
Life 2:136-7 (c, 1) Mr '79
Life 2:98-9 (1) Jl '79
Life 2:cov., 45-54 (c, 1) S '79
Life 2:164-7 (c, 1) N '79
Life 2:54-5 (c, 1) D '79
Smithsonian 10:12 (4) D '79
Life 3:146-7 (1) Je '80
Ebony 35:33 (4) S '80
Life 4:140 (c, 2) Ja '81
--John Paul II assassination attempt
Life 4:102-3 (c, 1) Jl '81
--Paul V
Smithsonian 12:94 (mosaic, c, 4)
Ag '81
--Paul VI in death
Life 1:124-5 (c, 1) O '78
--Urban VIII
Smithsonian 12:95 (painting, c, 4)
Ag '81
POPLAR TREES
Natur Hist 87:112 (c, 3) Ag '78
--See also ASPEN TREES; COTTON-
WOOD TREES
POPOCATEPETL, MEXICO
Nat Geog 153:614-15 (c, 1) My
'78
POPPIES
Nat Wildlife 18:50-1 (c, 1) D '79
Nat Geog 157:208-9 (c, 1) F '80
Nat Geog 157:757-9 (c, 1) Je '80
Nat Wildlife 19:8 (c, 1) Ap '81
Natur Hist 90:76-7, 81 (c, 1) O
'81
--See also OPIUM POPPIES
Porcelain. See GLASSWARE;
POTTERY
PORCHES
--Late 19th cent. (Cape May, New
Jersey)
Smithsonian 9:120-9 (c, 1) S '78
--Maine
Nat Geog 151:726 (c, 1) Je '77
--New York

Nat Geog 151:722-3 (c, 1) My
'77
--Old hotel (New York)
Smithsonian 12:84, 86 (c, 4) Je
'81
--Sag Harbor, New York
Nat Geog 157:672-3 (c, 1) My '80
--Saranac, New York sanatorium
(1915)
Am Heritage 30:54-5 (1) F '79
--Washington, D. C. mansion
Smithsonian 8:66-7 (c, 4) S '77
PORCUPINE FISH
Nat Geog 153:684 (c, 4) My '78
PORCUPINES
Nat Geog 152:57 (c, 4) Jl '77
Nat Geog 153:552 (c, 4) Ap '78
Nat Wildlife 18:56 (c, 1) O '80
--Made of toothpicks
Nat Geog 158:392 (c, 1) S '80
PORPOISES
Natur Hist 88:60-7 (c, 1) Mr
'79
Nat Geog 155:cov., 507-40 (c, 1)
Ap '79
Smithsonian 11:72-81 (c, 1) O
'80
--Caught in tuna nets
Smithsonian 7:cov., 44-53
(c, 1) F '77
PORT-AU-PRINCE, HAITI
Trav/Holiday 151:56-8 (c, 3) F
'79
PORTERS
Sports Illus 55:29 (c, 4) Jl 27
'81
--Atlanta airport, Georgia
Smithsonian 11:94 (c, 3) F '81
--Clovelly, Great Britain
Nat Geog 156:481 (c, 1) O '79
--Dulles Airport, Washington,
D. C.
Ebony 35:120 (4) Ag '80
--Himalayan guides (Nepal)
Natur Hist 88:51 (c, 4) Ja '79
PORTLAND, MAINE
Nat Geog 151:750-1 (c, 1) Je
'77
--Lighthouse
Nat Wildlife 19:9 (c, 4) D '80
PORTO, PORTUGAL
Nat Geog 158:816-19 (c, 1) D
'80
--See also DOURO RIVER
Ports. See HARBORS
PORTSMOUTH, NEW HAMPSHIRE
--Lighthouse
Trav/Holiday 149:23 (4) Mr '78

PORTUGAL
Nat Geog 158:804-39 (map, c, 1)
D '80
--Nazare
Trav/Holiday 149:52-3 (2) F '78
--Southern coast
Trav/Holiday 151:42-7, 66 (c, 1)
F '79
--See also LISBON; MADEIRA;
PORTO
PORTUGAL--COSTUME
Nat Geog 158:808-39 (c, 1) D '80
--Nazare
Trav/Holiday 149:52-3 (2) F '78
PORTUGAL--HISTORY
--Relics from 17th cent. shipwreck
Smithsonian 8:92-7 (c, 1) F '78
POST, EMILY
Am Heritage 28:38 (2) Ap '77
POST OFFICES
--Arkansas
Nat Geog 151:357 (c, 4) Mr '77
--Bethlehem, Georgia
Nat Geog 154:233 (c, 3) Ag '78
--Los Angeles, California postal
facility
Ebony 33:48-54 (2) Mr '78
POSTAGE STAMPS
--Anti smallpox
Nat Geog 154:798 (c, 4) D '78
--George Washington Carver
Am Heritage 28:66 (2) Ag '77
--Christmas stamps
Smithsonian 10:76-7 (c, 4) Je '79
--Commemorating famous black
Americans
Ebony 34:136-44 (c, 4) My '79
--Commemorating U. S. Articles of
Confederation
Smithsonian 8:93 (c, 4) Ja '78
--Cut into mosaic works (Taiwan)
Life 2:51-3 (c, 1) F '79
--Duck stamps for hunters
Nat Wildlife 17:40-3 (c, 1) D '78
--Liechtenstein
Nat Geog 159:277 (c, 4) F '81
--Poland
Nat Geog 159:116 (c, 4) Ja '81
POSTAL CARDS
--Early 20th cent.
Smithsonian 12:96-102 (2) S '81
--1910 card to Mother
Am Heritage 30:114 (c, 4) Ap '79
Postal Service. See PONY EX-
PRESS; POSTAL WORKERS
POSTAL WORKERS
--Delivering mail by boat (New
York)

Nat Geog 151:706 (c, 4) My '77
--Los Angeles, California postal
facility
Ebony 33:48-54 (2) Mr '78
--Mailman (Mississippi)
Nat Geog 160:379 (c, 1) S '81
POSTERS
--1869 railroad poster
Natur Hist 87:74 (3) F '78
--1904 Binche Carnival, Belgium
Trav/Holiday 151:41 (c, 3) Ja
'79
--1940's save gas posters
Am Heritage 30:8-16 (c, 1) O
'79
--Entertainment (Hungary)
Nat Geog 152:473 (c, 4) O '77
--Political (Albania)
Nat Geog 158:530-1, 536 (c, 1)
O '80
--Siberia, U. S. S. R.
Trav/Holiday 149:28 (c, 4) My
'78
--See also TOULOUSE-LAUTREC,
HENRI DE
POTASH INDUSTRY
--Israel
Nat Geog 153:238-9 (c, 1) F '78
POTATO INDUSTRY
--Farm (Maine)
Nat Geog 158:382-3, 408-9 (c, 1)
S '80
POTATO INDUSTRY--FARMING
--Peru
Natur Hist 90:74-5 (c, 3) N '81
POTATO INDUSTRY--HARVESTING
--Georgia
Nat Geog 154:238 (c, 1) Ag '78
--Ireland
Nat Geog 154:658 (c, 4) N '78
POTATO INDUSTRY--TRANS-
PORTATION
--Maine
Nat Geog 151:743 (c, 1) Je '77
POTTER, BEATRIX
--Letter by her
Smithsonian 10:78 (4) S '79
POTTERY
Smithsonian 8:90 (c, 4) Mr '78
--14th cent. Chinese ceramics
Nat Geog 156:230-43 (c, 1) Ag
'79
--17th cent. British
Nat Geog 155:735-63 (c, 1) Je
'79
--17th cent. Chinese Ming porce-
lain
Nat Geog 154:562-75 (c, 1) O '78

--17th cent. German jug
Nat Geog 155:751 (c, 1) Je '79
--17th cent. Virginia
Nat Geog 155:754-5 (c, 1) Je '79
--18th cent. ship's pantry (Spain)
Nat Geog 156:864-5 (c, 2) D '79
--18th cent. shipwreck relics
Nat Geog 152:734-65 (c, 1) D '77
--19th cent. porcelain (China)
Natur Hist 89:65 (c, 1) S '80
--American porcelain
Smithsonian 11:113-16 (c, 2) F
'81
--Japan
Nat Geog 152:850 (c, 4) D '77
--Mexico
Nat Geog 153:651-9 (c, 1) My '78
--Minoan vessels (Crete)
Nat Geog 159:212-13, 220-1 (c, 2)
F '81
--Stone Age shards (Brazil)
Nat Geog 155:60-72 (c, 4) Ja '79
POTTERY INDUSTRY--TRANS-
PORTATION
--Egypt
Nat Geog 151:338-9 (c, 1) Mr '77
POTTERY MAKING
Smithsonian 8:87 (4) Mr '78
--Crete, Greece
Nat Geog 153:152 (c, 4) F '78
--Ecuador
Natur Hist 87:90-8 (c, 1) O '78
--Japan
Smithsonian 10:54 (c, 4) Ja '80
--Mexico
Nat Geog 153:651 (c, 3) My '78
--New Brunswick
Trav/Holiday 150:48 (4) Jl '78
--New Mexico
Am Heritage 29:36-7 (c, 2) O '78
--Painting ceramic tiles (Singapore)
Trav/Holiday 148:34 (c, 4) N '77
--Tunisia
Trav/Holiday 149:30-1 (3) Ja '78
--Wisconsin
Trav/Holiday 153:33 (c, 4) Je '80
POUND, EZRA
Smithsonian 9:76-7 (2) Jl '78
POUSSIN, NICOLAS
--The Realm of Flora
Smithsonian 9:60 (painting, c, 3)
Je '78
POVERTY
--1850's street urchins
Smithsonian 11:34 (painting, 4) D
'80
--1930's
Natur Hist 87:72-82 (1) F '78

Nat Geog 157:248 (c, 4) F '80
--Buddhists (Tibet)
Nat Geog 157:248-9 (c, 1) F '80
--Jimmy Carter
Am Heritage 28:cov. (c, 1) Ag
'77
--Hare Krishna devotees (West
Virginia)
Life 3:47 (4) Ap '80
--Indian sign language (New Mexico)
Nat Geog 154:431 (c, 3) S '78
--Ireland
Nat Geog 159:433 (c, 2) Ap '81
--Jews (Bronx, New York)
Natur Hist 89:28 (c, 3) D '80
--Jews (U. S. S. R.)
Life 4:92-3 (c, 1) D '81
--Muslims (Bahrain)
Nat Geog 156:322 (c, 1) S '79
--Muslims (Saudi Arabia)
Nat Geog 154:592-5 (c, 1) N '78
Life 2:91 (c, 2) D '79
Nat Geog 158:294-5 (c, 1) S '80
--Muslims (Somalia)
Nat Geog 159:749 (c, 1) Je '81
--Muslims (Washington)
Life 2:84-5 (1) Ag '79
--Nuns (Maryland)
Ebony 36:98 (4) N '80
--Saying grace before meal
Ebony 35:38 (4) Jl '80
Life 3:28 (3) Jl '80
--Seventh Day Adventists
Ebony 35:108 (4) N '79
--Tennis player
Sports Illus 52:21 (c, 3) Ja 21
'80
--See also MEDITATING
PREGNANCY
Sports Illus 46:71 (c, 4) Je 27
'77
Prehistory. See ANIMALS,
EXTINCT; BRONZE AGE;
FOSSILS; ICE AGE; MAN,
PREHISTORIC; STONE AGE
Presidents. See U. S. PRESI-
DENTS
Press conferences. See CON-
FERENCES
PRICKLY PEARS
Nat Wildlife 19:10 (c, 4) O '81
Primates. See APES; LEMURS;
MONKEYS
PRINCE EDWARD ISLAND,
CANADA
Trav/Holiday 151:cov. , 50-4
(c, 1) My '79
PRINCETON, NEW JERSEY

Trav/Holiday 156:65-9 (map, c, 2)
O '81
PRINCETON UNIVERSITY, NEW
JERSEY
--University Chapel
Trav/Holiday 156:65 (c, 2) O '81
PRINTING
--Fish printing
Smithsonian 12:151-3 (c, 3) Je '81
PRINTING INDUSTRY
--17th cent. type (Maryland)
Nat Geog 158:445 (c, 3) O '80
--18th cent. press room (France)
Smithsonian 10:128-9 (4) S '79
--1848 printer's shop (Philadelphia,
Pennsylvania)
Am Heritage 31:12 (painting, c, 2)
Je '80
--Typesetting
Ebony 32:48 (4) Ag '77
--See also BIBLES; GUTENBERG,
JOHANN
PRINTMAKING
--William Hayter
Smithsonian 9:89-92 (c, 3) S '78
PRISMS
Smithsonian 9:79 (c, 2) S '78
PRISON CAMPS
--1940's Japanese camp (Luzon,
Philippines)
Am Heritage 30:80-95 (paint-
ing, c, 3) Ap '79
--Andersonville, Georgia (1864)
Am Heritage 31:100-1 (2) Ap '80
--U. S. S. R.
Life 3:104-5 (1) Ap '80
--See also CONCENTRATION CAMPS
PRISONS
Sports Illus 48:62-3 (painting, c, 1)
F 6 '78
--1890's Virginia
Smithsonian 12:137 (4) D '81
--1971 Attica rebellion, New York
Life 2:183 (2) D '79
--Aftermath of protest (St. Louis,
Missouri)
Ebony 34:78-9 (3) Ag '79
--California
Ebony 36:56-62 (3) Je '81
--Cell block
Ebony 34:128 (3) Ag '79
--Cell block (New York)
Ebony 35:62, 103-5 (2) Mr '80
--Grant County Jail, Indiana
Ebony 35:149-50 (4) Ap '80
--Guards
Sports Illus 53:27 (c, 4) Jl 21 '80
--Hardwick, Georgia

Ebony 35:52 (4) S '80
--Marion, Ohio
Nat Geog 159:786-7 (c, 1) Je '81
--Northern Ireland
Life 4:46-7 (c, 1) O '81
--Port Arthur, Tasmania, Aus-
tralia
Travel 147:44 (4) Mr '77
--Scene of death in New York
prison cell
Life 3:148 (2) Mr '80
--Sing Sing, New York (1878)
Am Heritage 30:18-19 (draw-
ing, 2) O '79
--Toul Sleng, Cambodia
Life 3:44-5 (c, 1) Mr '80
--Virginia
Ebony 34:92-8 (1) Ag '79
--Walla Walla, Washington
Life 2:78-87 (1) Ag '79
--See also ALCATRAZ; CON-
VICTS; TOWER OF LONDON
PROHIBITION MOVEMENT
--1919 emptying of wine barrels
(California)
Am Heritage 31:58 (2) O '80
--1920's cartoons
Smithsonian 10:118 (4) Je '79
--Rum-running (Detroit, Michigan)
Smithsonian 10:113-25 (3) Je
'79
--Ben Shahn paintings
Am Heritage 30:85-92 (paint-
ing, c, 4) F '79
PRONGHORNS
Natur Hist 86:92 (painting, c, 4)
Ja '77
Nat Wildlife 10.cov. (c, 1) Je
'78
Nat Wildlife 16:cov., 5, 13
(map, c, 1) O '78
Nat Wildlife 17:8 (c, 3) Je '79
Nat Geog 159:528 (c, 4) Ap '81
PROSPECTING
--1898 (Klondike, Yukon)
Am Heritage 31:94-9 (1) Ap '80
--Brazil
Nat Geog 152:686 (c, 4) N '77
--California
Smithsonian 10:104-14 (c, 1) F
'80
--Dredging for gold
Sports Illus 47:63 (c, 2) Jl 11
'77
--Gold (Brazil)
Life 3:73 (c, 3) D '80
--Gold (Yukon, Canada)
Travel 148:59 (c, 3) Jl '77

Nat Geog 153:572-3 (c, 1) Ap '78
--Montana
Nat Geog 160:269 (c, 4) Ag '81
--Northwest Territories
Nat Geog 160:407 (c, 4) S '81
--Seeking metals for research
(California)
Smithsonian 9:48-9 (c, 3) Mr '79
--Sri Lanka
Nat Geog 155:135 (c, 1) Ja '79
PROSTITUTION
--1880's San Francisco madam
Ebony 34:52-62 (2) N '78
--Early 20th cent. (Texas)
Am Heritage 28:51 (2) Ap '77
--Ancient ad for brothel (Ephesus,
Turkey)
Nat Geog 152:114 (c, 4) Jl '77
Protest. See DEMONSTRATIONS
PROTOZOA
Smithsonian 8:88 (c, 4) Ja '78
PROUST, MARCEL
--Tomb (Paris, France)
Smithsonian 9:110 (c, 4) N '78
PROVIDENCE, RHODE ISLAND
Trav/Holiday 154:63-4 (c, 1) S
'80
PROVO, UTAH
--Brigham Young University
Sports Illus 53:84-7 (c, 1) D 8
'80
PSYCHIATRISTS
Sports Illus 48:60-1 (painting, c, 1)
Ja 23 '78
PSYCHOLOGISTS
Sports Illus 50:62 (c, 3) Je 18 '79
PTARMIGANS (BIRDS)
Smithsonian 8:44 (c, 2) S '77
Nat Wildlife 16:24 (c, 4) D '77
Nat Geog 156:750 (c, 4) D '79
Nat Wildlife 19:23 (c, 1) D '80
Public speaking. See SPEECHMAK-
ING
PUEBLO INDIANS
--1680 repulsion of Spanish con-
querors (New Mexico)
Smithsonian 11:86-95 (painting, c, 1)
O '80
--Acoma Pueblo Indians (New Mexi-
co)
Sports Illus 51:46-59 (c, 1) N 26
'79
--See also HOPI INDIANS; ZUNI
INDIANS
Pueblo Indians--Housing. See
ADOBE HOUSES
Puerto Rico. See SAN JUAN
PUFFINS

Nat Geog 151:541 (c, 4) Ap '77
Nat Wildlife 16:2 (c, 2) D '77
Natur Hist 87:cov. (c, 1) F '78
Nat Geog 155:cov., 357 (c, 1)
 Mr '79
Nat Geog 156:183 (c, 2) Ag '79
Smithsonian 11:125 (c, 4) Jl '80
Nat Wildlife 18:3 (painting, c, 4)
 O '80
--Ivory sculpture
 Natur Hist 90:57 (c, 4) F '81
--Wooden decoys
 Life 4:154 (c, 2) O '81
PUGET SOUND, WASHINGTON
 Nat Geog 151:70-95 (map, c, 1)
 Ja '77
PUGS (DOGS)
 Life 4:64 (c, 4) F '81
PUNISHMENT
--18th cent. slave whipping
 (Surinam)
 Natur Hist 90:58 (engraving, c, 3)
 S '81
--Inhumane treatment of research
 and farm animals
 Smithsonian 11:50-7 (c, 1) Ap
 '80
--Spanking child
 Ebony 36:51 (2) O '81
--Tools of torture (Tibet)
 Smithsonian 7:81 (c, 4) Ja '77
--Whipping black slave (1862 en-
 graving)
 Am Heritage 30:40-1 (1) O '79
--Yelling at child
 Ebony 33:68 (1) Ja '78
--See also CAPITAL PUNISH-
 MENT; LYNCHINGS; SLAVE
 CHAINS
PUPPETS
 Smithsonian 10:146 (c, 4) My
 '79
 Smithsonian 11:95-9 (c, 1) S '80
--Dummy Charlie McCarthy
 Life 1:118-19 (1) N '78
--Ice skating
 Smithsonian 12:200 (c, 4) D '81
--Japan
 Smithsonian 10:54-5 (c, 3) Ja
 '80
--Miss Piggy (Muppets)
 Nat Geog 154:400 (c, 4) S '78
 Life 2:130 (c, 4) D '79
--Muppets
 Life 1:144 (c, 2) D '78
 Life 3:cov., 54-60 (c, 1) Ag '80
--Puppet making (Indonesia)
 Trav/Holiday 148:36 (4) D '77

PURSES
--Crocodile purses (France)
 Nat Geog 159:313 (c, 4) Mr '81
PYLE, ERNIE
 Am Heritage 32:31-41 (1) F '81
PYRAMIDS
--Chichen Itza, Mexico
 Trav/Holiday 150:44, 46 (c, 4) O
 '78
 Smithsonian 9:16 (c, 4) D '78
--Giza, Egypt
 Nat Geog 151:312 (c, 4) Mr '77
 Smithsonian 10:56-7 (c, 1) My
 '79
 Smithsonian 12:116-19 (c, 3) Ap
 '81
--Meidum, Egypt
 Nat Geog 151:341 (c, 1) Mr '77
--Mexico
 Nat Geog 158:706-7, 712-13 (c, 1)
 D '80
--Teotihuacan, Mexico
 Trav/Holiday 155:66 (c, 4) Je '81
--Tikal, Guatemala
 Natur Hist 86:48 (c, 3) Ap '77
PYTHONS
 Nat Wildlife 17:3 (c, 4) O '79
 Nat Geog 159:310-11 (c, 1) Mr
 '81
--Eating rats
 Nat Geog 152:74 (c, 3) Jl '77

-Q-

QATAR
 Travel 147:63-5 (c, 2) Ja '77
QUAIL
 Nat Wildlife 16:21 (c, 4) D '77
 Nat Wildlife 18:26 (painting, c, 3)
 O '80
 Nat Wildlife 19:12-15 (c, 1) Ag
 '81
--Bobwhites
 Nat Wildlife 15:49 (painting, c, 2)
 O '77
--Partridges
 Natur Hist 90:76 (drawing, 4) My
 '81
--Wooden carving
 Nat Wildlife 19:50-1 (c, 1) D '80
Quakers. See PENN, WILLIAM
Quarrying. See GRANITE
QUARTZ
 Natur Hist 87:67 (c, 1) F '78
QUASARS
 Smithsonian 8:41, 47 (4) Ap '77
QUEBEC

Sports Illus 50:38-40 (c, 3)
Ap 30 '79
Sports Illus 50:59 (4) My 7 '79
Sports Illus 51:23 (c, 2) S 3 '79
Sports Illus 54:80-2 (c, 4) Je 1
'81
--Running
Sports Illus 55:12-15 (c, 1) Jl
20 '81
--Running (Massachusetts)
Sports Illus 49:72, 76 (c, 4)
S 4 '78
--Running (Nebraska)
Nat Geog 154:496-7 (c, 2) O '78
--Running (New York)
Sports Illus 49:26-7 (c, 3) O 2
'78
--See also BOAT RACES; CROSS
COUNTRY; DOG RACES;
HORSE RACING; MARA-
THONS; MOTORCYCLE RAC-
ING; SAILBOAT RACES;
TRUCK RACING
RACQUETBALL
Ebony 32:74 (4) S '77
Sports Illus 48:68 (4) Ap 10
'78
Sports Illus 49:49 (4) Jl 3 '78
Sports Illus 51:48-9 (1) N 19
'79
Sports Illus 52:47 (4) Ap 14 '80
Sports Illus 54:64 (c, 3) Je 15
'81
Ebony 36:78 (4) S '81
Ebony 37:93 (4) D '81
RADAR
--Airborne tracking disc
Ebony 35:50 (4) Mr '80
RADIO BROADCASTING
--1925
Am Heritage 30:97 (4) F '79
--1930
Am Heritage 31:41 (2) Ag '80
--See also DISC JOCKEYS
RADIO STATIONS
--Clark College, Pennsylvania
Ebony 35:54 (4) S '80
RADIOS
Life 3:81 (2) Ap '80
--1920's
Am Heritage 29:62-3 (c, 2) Je
'78
--1950's
Sports Illus 51:42 (painting, c, 4)
Ag 13 '79
--Ham radio set
Smithsonian 8:81 (c, 4) O '77
--Portable radio-cassette players

Ebony 35:134-8 (3) Je '80
--Portable transistor radio
Ebony 33:40 (4) Ag '78
--Two-way (Canada)
Nat Geog 154:310-11 (c, 1) S '78
--See also CITIZENS BAND
RADIOS
RADISHES
Nat Geog 160:592 (c, 3) N '81
RAFTING
--Caribbean
Trav/Holiday 152:37 (c, 4) O '79
--Colorado
Travel 147:40 (4) Ap '77
--Colorado River, Utah
Trav/Holiday 149:44 (c, 3) My '78
--Fiji
Trav/Holiday 155:60 (c, 3) Ja '81
--Inner tubes (Florida)
Nat Geog 152:28-9 (c, 1) Jl '77
--Jamaica
Trav/Holiday 153:68-9 (c, 4) Ap
'80
--New Guinea
Trav/Holiday 153:69 (c, 2) F '80
--Ocoee River, Tennessee
Trav/Holiday 155:75 (c, 3) Mr '81
--Pennsylvania
Nat Geog 153:762-3 (c, 1) Je '78
--Penobscot River, Maine
Sports Illus 50:31-3 (c, 1) Je 25
'79
--Rapids (Grand Canyon, Arizona)
Nat Geog 154:4-6 (c, 1) Jl '78
--Riding inner tube on rapids
(Colorado)
Nat Wildlife 16:28 (c, 3) Ap '78
--Salmon River, Idaho
Nat Wildlife 17:37-41 (c, 1) Je '79
--Shooting rapids (New York)
Nat Geog 153:65 (c, 1) Ja '78
RAGWEED
Natur Hist 89:42 (c, 3) D '80
RAILROAD CONDUCTORS
--Washington
Nat Geog 154:616 (c, 1) N '78
RAILROAD STATIONS
--19th cent. (Washington, D. C.)
Smithsonian 10:58 (4) D '79
--1874 (Sacramento, California)
Am Heritage 28:24-5 (paint-
ing, c, 2) F '77
--Austria
Travel 147:56-7 (c, 1) Mr '77
--Bayonne, New Jersey
Am Heritage 32:59 (c, 4) O '81
--Bombay, India
Nat Geog 160:107 (c, 4) Jl '81

Nat Geog 158:478-9 (c, 1) O '80
--Australia
Nat Geog 155:174-5 (c, 1) F '79
--California
Life 4:45-52 (c, 1) My '81
--Cattle (Nebraska)
Nat Geog 154:500-1 (c, 1) O '78
--Montana
Life 2:112 (c, 2) Ap '79
RANCHING
--19th cent. herding of animals
(Peru)
Smithsonian 9:94-5 (painting, c, 4)
Ag '78
--Argentina
Nat Geog 158:490-1, 496-7 (c, 2)
O '80
--Cattle (Dominican Republic)
Nat Geog 152:560-1 (c, 1) O '77
--Cattle (Mexico)
Nat Geog 153:626-7 (c, 1) My
'78
--Cattle (Nebraska)
Nat Geog 154:498-515 (c, 1) O
'78
--Cattle roundup (Wyoming)
Trav/Holiday 152:51 (c, 3) Jl
'79
--Herding cattle (Costa Rica)
Nat Geog 160:44-5 (c, 1) Jl '81
--Herding cattle (Hawaii)
Nat Geog 160:214 (c, 2) Ag '81
--Herding cattle (Texas)
Smithsonian 8:58-60 (c, 1) O
'77
--Horse roundup (Oregon)
Nat Geog 155:500-1 (c, 1) Ap
'79
--Idaho
Nat Geog 156:512-13 (c, 2) O
'79
--Lassoing calf
Sports Illus 55:33 (c, 3) Jl 20
'81
--Lassoing calf (Arizona)
Nat Geog 157:272-3 (c, 1) F '80
--Lassoing donkeys
Life 3:119 (c, 2) O '80
--Lassoing horse (Australia)
Nat Geog 155:166-7 (c, 1) F
'79
--Life on a roundup (Arizona)
Am Heritage 29:2, 101-7 (c, 1)
F '78
--Mexico
Nat Geog 158:226-7 (c, 1) Ag '80
--Montana
Nat Geog 160:268-9, 274-5

(c, 1) Ag '81
--Oregon
Nat Geog 156:808-9 (c, 1) D '79
--Paraguay
Nat Geog 158:498-9 (c, 1) O '80
--Ranching equipment
Smithsonian 11:28 (c, 4) N '80
--Texas
Nat Geog 157:442-3 (c, 1) Ap '80
--Utah
Nat Wildlife 17:4-11 (c, 1) Ag '79
Nat Geog 158:66 (c, 4) Jl '80
--Wyoming
Sports Illus 46:60-1 (c, 4) Ja 17
'77
--See also SHEEP RANCHING
RAPHAEL
--Lady with a Unicorn
Smithsonian 10:120 (painting, c, 4)
F '80
RATS
Nat Geog 152:61-87 (c, 1) Jl '77
--Being eaten by owl
Nat Geog 157:35 (c, 1) Ja '80
--Kangaroo
Nat Geog 156:630-1 (c, 4) N '79
--Pack
Natur Hist 89:41 (c, 1) S '80
RATTLESNAKES
Nat Geog 156:633 (c, 4) N '79
READING, PENNSYLVANIA
--Courthouse
Am Heritage 28:53 (4) O '77
READING
Ebony 33:160 (4) My '78
Ebony 34:100 (4) Ag '79
Ebony 35:148 (4) My '80
Sports Illus 55:65 (c, 4) Jl 13 '81
Sports Illus 55:57-9 (c, 4) Ag 31
'81
--Children (Maine)
Nat Geog 151:726 (c, 1) Je '77
--College students studying
Ebony 33:88 (4) My '78
--In tree (Oregon)
Travel 147:38 (4) Mr '77
--Library
Sports Illus 54:42 (c, 4) Je 8 '81
--Moscow, U. S. S. R.
Nat Geog 153:19, 42-3 (c, 1) Ja
'78
--Newspaper
Sports Illus 55:53 (c, 4) Jl 27 '81
--Newspaper (Albania)
Nat Geog 158:550-1 (c, 2) O '80
--Newspaper (China)
Nat Geog 158:14 (c, 1) Jl '80
REAGAN, RONALD

Life 2:29 (c, 2) O '79
Life 3:95 (4) Je '80
Ebony 36:105 (3) Ja '81
Life 4:24-5, 94-9 (c, 1) Ja '81
Life 4:cov., 31-40 (c, 1) My '81
Am Heritage 32:63 (c, 4) O '81
--Assassination attempt
Life 4:32-40 (c, 1) My '81
--California ranch
Life 4:45-52 (c, 2) My '81
--Childhood homes (Illinois)
Life 3:151-3 (c, 1) D '80
--Scenes from his early years
Life 3:151-6 (c, 1) D '80
RECORDING STUDIOS
Nat Geog 155:24 (c, 4) Ja '79
Life 2:82-3 (c, 2) N '79
Ebony 35:134-8 (3) Ap '80
Ebony 36:74, 76 (4) Ja '81
Ebony 36:81-2 (3) Mr '81
Ebony 36:56 (3) Jl '81
Ebony 37:41 (c, 3) N '81
--1910
Smithsonian 9:116 (4) My '78
--New York
Ebony 34:138 (4) F '79
RECORDS
--Home record collection
Ebony 35:75 (2) D '79
Recreation. See AMUSEMENTS;
SPORTS
RECREATIONAL VEHICLES
--Dune buggies
Smithsonian 9:70-1 (c, 2) S '78
--Off-road vehicle tracks
(California)
Smithsonian 9:66-75 (c, 1) S '78
--Tent on wheels
Trav/Holiday 151:80 (4) F '79
RECYCLING
--Collecting aluminum cans
(Florida)
Nat Geog 154:209 (c, 3) Ag '78
--Zurich, Switzerland
Smithsonian 11:143-9 (c, 1) N
'80
RED CROSS
--Activities
Nat Geog 159:776-91 (c, 1) Je
'81
--Beginnings and World War I
years
Am Heritage 32:81-91 (1) F
'81
--History
Smithsonian 12:126-42 (c, 2) My
'81
--Spain

Trav/Holiday 149:44 (c, 2) F '78
--See also BARTON, CLARA
RED RIVER OF THE NORTH, U.S.
Nat Geog 158:162-3 (c, 1) Ag '80
RED SEA, MIDDLE EAST
--Djibouti harbor
Nat Geog 154:521 (c, 2) O '78
REDSTARTS (BIRDS)
Nat Wildlife 19:42 (c, 4) Ag '81
REDWINGED BLACKBIRDS
Nat Geog 151:170-1 (c, 1) F '77
Nat Wildlife 18:32-4 (c, 1) Ap
'80
Nat Geog 159:364 (c, 4) Mr '81
--Chick
Nat Wildlife 17:40 (c, 4) Ag '79
REDWOOD NATIONAL PARK,
CALIFORNIA
Nat Geog 152:340-1, 360-1 (c, 1)
S '77
Smithsonian 9:41-5 (c, 1) Jl '78
Nat Geog 156:15-17, 28-9 (c, 1)
Jl '79
Nat Wildlife 17:48 (c, 1) Ag '79
REDWOOD TREES
Nat Geog 152:340-1 (c, 1) S '77
Smithsonian 9:38-45 (c, 1) Jl '78
Nat Geog 156:15-17 (c, 1) Jl '79
Nat Wildlife 19:44-7 (1) D '80
--Tunnel carved in tree (California)
Nat Wildlife 19:47 (4) D '80
REEDS
--Sumerian style reed ship
Nat Geog 154:807-27 (c, 1) D '78
Reefs. See CORAL REEFS
REFUGEE CAMPS
--Cuban (Arkansas)
Life 3:56-62 (c, 1) N '80
--Cuban (Florida)
Life 3:35 (c, 2) Jl '80
--Djibouti
Nat Geog 154:528-9 (c, 1) O '78
--Ethiopian (Somalia)
Life 4:36-46 (c, 1) Ap '81
--Haitian (Miami, Florida)
Ebony 35:140 (4) S '80
--Hong Kong
Nat Geog 156:706-31 (c, 1) N '79
--Laotians (Thailand)
Nat Geog 157:632-49 (c, 1) My
'80
--Nomads (Mauritania)
Nat Geog 156:615 (c, 1) N '79
--Somalia
Nat Geog 159:756-63 (c, 1) Je
'81
--Syria
Nat Geog 154:342-3 (c, 2) S '78

Am Heritage 28:5-7 (c, 4) Ag
'77
--See also BAPTISMS; COM-
MUNION; EXORCISM;
FUNERAL RITES AND CERE-
MONIES; MARRIAGE RITES
AND CUSTOMS; PRAYING;
specific religions--RITES
AND FESTIVALS
REMBRANDT
--The Blind Fiddler (1681)
Smithsonian 12:14 (drawing, 4)
S '81
--Figure of an old man
Smithsonian 11:45 (painting, c, 4)
Jl '80
--Juno
Smithsonian 11:153 (painting, c, 4)
O '80
--Portrait of the Artist's Son,
Titus
Smithsonian 10:51 (painting, c, 3)
S '79
--The Rabbi
Life 2:31 (painting, c, 3) Mr '79
REMINGTON, FREDERIC
--Paintings of football game (1893)
Am Heritage 32:98-100 (c, 1)
O '81
REMORAS
Nat Geog 159:202-3 (c, 1) F '81
RENO, NEVADA
Trav/Holiday 155:16 (4) F '81
RENOIR, PIERRE AUGUSTE
--Ambroise Vollard Dressed as
a Toreador
Smithsonian 8:74 (painting, c, 2)
Jl '77
--Painting of a woman (1900)
Smithsonian 10:98 (c, 4) F '80
REPRODUCTION
--Bat embryo
Natur Hist 88:61 (c, 3) Ag '79
--Cloning frogs
Life 2:165 (c, 1) D '79
--Fertilized hamster egg
Natur Hist 87:12 (4) O '78
--Fetus
Life 4:cov. (c, 4) N '81
--Germinating pollen grain of
tomato
Natur Hist 90:30 (c, 3) S '81
--Human spermatozoa
Natur Hist 87:14, 20-2 (3) O
'78
--Parthenogenesis in lizards
Natur Hist 87:58-60 (draw-
ing, c, 4) Ja '78

REPTILES
--Head of eaten lizard
Smithsonian 10:41 (c, 2) Ag '79
--Lizards
Natur Hist 87:73 (c, 1) My '78
Trav/Holiday 150:59 (c, 3) N '78
Trav/Holiday 154:59 (c, 4) Jl '80
--Spiny lizard
Nat Wildlife 16:46 (c, 4) F '78
--Texas horned lizard
Nat Geog 159:172-3 (c, 1) F '81
--Western swift lizard
Nat Wildlife 19:2 (c, 2) Ag '81
--Whiptail lizards
Natur Hist 87:57, 63 (c, 3) Ja
'78
--See also ALLIGATORS; CHAME-
LEONS; CHUCKWALLAS;
CROCODILES; GAVIALS;
GECKOS; IGUANAS; SNAKES
RESERVOIRS
--Cistern (Tunisian desert)
Smithsonian 10:35 (c, 4) Ag '79
--Los Padres, Carmel Valley,
California
Sports Illus 46:54 (3) Ap 4 '77
--Pardee (California)
Nat Geog 152:819 (c, 4) D '77
--Underground (Tucson, Arizona)
Nat Geog 152:500-1 (c, 2) O '77
RESORTS
--Early 20th cent. Saltair, Utah
Am Heritage 32:81-9 (1) Je '81
--Bay of Guaraguao, Venezuela
Trav/Holiday 156:52 (c, 4) S '81
--Cancun, Mexico
Trav/Holiday 150:42-7, 69 (c, 3)
O '78
Dominican Republic
Nat Geog 152:563 (c, 3) O '77
--Estoril, Portugal
Trav/Holiday 148:60-1 (4) N '77
--Golf and tennis resorts
Ebony 35:76-80 (3) My '80
--Las Hadas, Mexico
Trav/Holiday 153:55 (c, 3) F '80
--Maui, Hawaii
Sports Illus 46:44 (c, 3) Ja 24
'77
--Mexico
Nat Geog 153:644-5 (c, 1) My '78
Trav/Holiday 156:46-51 (c, 3) N
'81
--Palm Springs, California
Trav/Holiday 148:26-7 (c, 1) N '77
--South Carolina islands
Trav/Holiday 153:cov., 58-61, 63,
95 (c, 1) Ap '80

--Southern Pines, North Carolina
 Travel 147:50 (2) My '77
--Warm Springs, Oregon
 Nat Geog 155:496-7 (c, 1) Ap
 '79
--See also ACAPULCO, MEXICO;
 ATLANTIC CITY, NEW
 JERSEY; BEACH CLUBS;
 BEACHES, BATHING;
 HOTELS; MIAMI BEACH,
 FLORIDA; SKI RESORTS
RESTAURANTS
--1899 cafe (Cuba)
 Am Heritage 29:28 (painting, 3)
 O '78
--Early 20th cent. diners
 Am Heritage 28:68-71 (c, 3) Ap
 '77
 Am Heritage 28:33 (c, 1) Ag '77
--1917 oyster bar (New Orleans,
 Louisiana)
 Am Heritage 31:73 (painting, c, 4)
 F '80
--Adelaide, Australia
 Travel 147:45 (c, 4) Mr '77
--Atlanta, Georgia
 Ebony 35:64 (4) N '79
--Barbecue kitchen (Kansas City,
 Missouri)
 Ebony 36:80 (4) N '80
--Beer hall (Munich, West Ger-
 many)
 Nat Geog 152:166 (c, 4) Ag '77
--Cafe (St. Christophe en Brion-
 nais, France)
 Nat Geog 153:804-5 (c, 1) Je
 '78
--Cafe (Rethimnon, Crete)
 Nat Geog 157:392-3 (c, 1) Mr
 '80
--Coffee shop (Isle of Man)
 Trav/Holiday 151:56 (c, 4) Je
 '79
--Colonial Williamsburg, Virginia
 Trav/Holiday 156:30 (c, 2) Jl
 '81
--Colorado mountains
 Sports Illus 53:84 (c, 4) D 15
 '80
--Delmonico's, New York City
 (early 20th cent.)
 Am Heritage 31:96-101 (draw-
 ing, 4) Ag '80
--Diner (Little Ferry, New Jer-
 sey)
 Nat Geog 160:578-9 (c, 3) N
 '81
--Diner (Nebraska)

 Nat Geog 154:506 (c, 3) O '78
--Diner (Rutland, Vermont)
 Smithsonian 12:65 (c, 4) Ap '81
--Diner (St. Paul, Minnesota)
 Nat Geog 158:684 (c, 3) N '80
--Diners
 Smithsonian 10:160 (4) Mr '80
 Life 3:74-5 (painting, c, 1) O '80
--Elegant (Cuba)
 Nat Geog 151:40 (c, 4) Ja '77
--Elegant (Dallas, Texas)
 Smithsonian 9:66 (c, 4) N '78
--Elegant (Hawaii)
 Trav/Holiday 149:48 (c, 3) Ja '78
--Fast food hamburger restaurant
 Natur Hist 87:74-83 (1) Ja '78
--France
 Nat Geog 153:811 (c, 1) Je '78
--Greenwich Village, New York
 Ebony 33:122 (4) F '78
--Hawaii
 Trav/Holiday 152:47 (c, 4) O '79
--Hotel (Nairobi, Kenya)
 Travel 148:53 (c, 4) Jl '77
--Ice cream parlor (Indiana)
 Nat Geog 154:394 (c, 1) S '78
--Japan
 Trav/Holiday 152:56-9, 92 (2)
 N '79
--Kazan Station, Moscow, U. S. S. R.
 Smithsonian 10:99 (c, 2) S '79
--Kyoto, Japan
 Trav/Holiday 149:44 (c, 4) Je '78
--Lima, Peru
 Travel 147:41 (c, 1) Ja '77
--Los Angeles, California
 Trav/Holiday 152:46-9 (c, 2) S
 '79
--Maine
 Sports Illus 52:64-5 (c, 1) Je 16
 '80
--Maxim's, Paris, France
 Life 2:90 (c, 2) My '79
--Menu outside restaurant (New
 York)
 Trav/Holiday 152:29 (4) O '79
--Mexico
 Trav/Holiday 152:57 (c, 4) Jl '79
--Moscow, U. S. S. R.
 Nat Geog 153:8 (c, 1) Ja '78
--New Orleans, Louisiana
 Trav/Holiday 150:53-4 (c, 1) Jl
 '78
 Trav/Holiday 155:52 (c, 1) F '81
--Norfolk, Virginia
 Travel 147:37 (c, 3) Ap '77
--Oklahoma City, Oklahoma
 Trav/Holiday 150:38 (c, 2) Jl '78

--Oriental (Caribbean)
Trav/Holiday 155:71 (c, 4) Ap
'81
--Outdoor (Australia)
Trav/Holiday 150:31 (c, 4) Ag
'78
--Outdoor (Brussels, Belgium)
Travel 148:31 (1) Ag '77
Nat Geog 155:321 (c, 1) Mr '79
--Outdoor cafe (Geneva, Switzer-
land)
Trav/Holiday 150:63 (c, 4) Jl
'78
--Outdoor cafe (Hamburg, West
Germany)
Trav/Holiday 149:33 (4) Mr '78
--Outdoor cafe (Madrid, Spain)
Travel 148:49 (4) O '77
--Outdoor cafe (Mexico City,
Mexico)
Trav/Holiday 155:66 (c, 2) Je '81
--Outdoor cafe (Palm Beach,
Florida)
Trav/Holiday 151:42 (c, 4) Mr
'79
--Outdoor cafe (Singapore)
Trav/Holiday 148:28 (c, 3) D '77
Nat Geog 159:553 (c, 2) Ap '81
--Outdoor cafe (Venice, Italy)
Trav/Holiday 151:37 (c, 2) F
'79
--Outdoor cafe (Warsaw, Poland)
Smithsonian 9:115 (c, 2) S '78
--Oyster Bar, New York City,
New York
Am Heritage 31:71 (c, 3) F '80
--Pizza place entrance (London,
England)
Nat Geog 156:446 (c, 1) O '79
Polynesian (Florida)
Trav/Holiday 150:41 (c, 4) O '78
--Posh club (Houston, Texas)
Nat Geog 157:475 (c, 1) Ap '80
--Providence, Rhode Island
Trav/Holiday 154:64 (c, 4) S
'80
--Quebec
Nat Geog 157:605 (c, 1) My '80
--Rio de Janeiro, Brazil
Nat Geog 153:252-3 (c, 1) F '78
--San Antonio, Texas
Trav/Holiday 152:66 (c, 4) N
'79
--San Jose, Costa Rica
Trav/Holiday 150:58 (c, 4) N
'78
--Selecting wine at elegant restaur-
ant (Colorado)

Trav/Holiday 156:20 (c, 3) Jl '81
--Siberia, U. S. S. R.
Trav/Holiday 149:28, 31 (c, 3)
My '78
--Smithsonian Institution, Washing-
ton, D. C.
Smithsonian 8:79 (c, 3) Ag '77
--South Korea
Nat Geog 156:780-1 (c, 1) D '79
--Washington, D. C.
Ebony 33:48 (4) Je '78
--Wyoming
Trav/Holiday 153:88, 99 (4) Ap
'80
--See also CHEFS; COFFEE-
HOUSES; COOKING; DINNERS
AND DINING; KITCHENS;
TAVERNS; WAITERS
RESTORATION OF ART WORKS
--Ancient Roman sculpture (Turkey)
Nat Geog 160:540-1 (c, 1) O '81
--Fra Angelico fresco (Italy)
Life 4:110 (c, 3) Ap '81
--Cleaning 5th cent. B. C. Greek
bronze statues
Smithsonian 12:124-31 (c, 1) N
'81
--Prague, Czechoslovakia
Nat Geog 155:557 (c, 1) Ap '79
--Renovation of destroyed Warsaw
buildings
Smithsonian 9:106 17 (c, 1) S '78
--Restoring colonial Williamsburg,
Virginia
Am Heritage 32:84-95 (c, 1) Ag
'81
--Saving bronze statue (St. Louis,
Missouri)
Am Heritage 31.34 (2) Je '80
RETRIEVERS (DOGS)
Life 4:52 (c, 4) My '81
Nat Geog 160:267 (c, 1) Ag '81
REUNION
Nat Geog 160:424-6, 452-7
(map, c, 1) O '81
REVERE, PAUL
Am Heritage 28:2, 24-37 (paint-
ing, c, 1) Ap '77
--Statue (Boston, Massachusetts)
Ebony 34:41 (c, 4) My '79
REVOLUTIONARY WAR
Am Heritage 31:cov. , 49-63
(drawing, c, 1) Ap '80
--1776 Battle of Trenton
Nat Wildlife 15:5 (painting, c, 4)
Ja '77
--1779 battle between Serapis and
Bonhomme Richard

Smithsonian 11:150-4 (paint-
ing, c, 3) D '80
--1781 Battle of Yorktown
Am Heritage 32:65-7 (drawing, 2)
O '81
Smithsonian 12:cov., 92-9
(painting, c, 1) O '81
--Bill Mauldin's cartoons
Smithsonian 8:48-57 (drawing, 1)
F '78
--Monument to American inde-
pendence (Great Britain)
Am Heritage 29:47 (c, 3) D '77
--Monument to Washington
(Princeton, New Jersey)
Trav/Holiday 156:68 (4) O '81
--Paul Revere's ride
Am Heritage 28:2, 25-31 (paint-
ing, c, 1) Ap '77
--Rochambeau's French troops
Smithsonian 8:64-70 (painting, c, 1)
My '77
--Toppling King George III's
statue (1776; New York)
Am Heritage 30:110 (painting, 4)
Je '79
--See also ADAMS, JOHN; AR-
NOLD, BENEDICT; BOSTON
MASSACRE; BOSTON TEA
PARTY; CORNWALLIS,
CHARLES; FRANKLIN, BEN-
JAMIN; GEORGE III; GRASSE,
COMTE DE; GREENE,
NATHANAEL; HAMILTON,
ALEXANDER; JEFFERSON,
THOMAS; JONES, JOHN
PAUL; LAFAYETTE, MAR-
QUIS DE; LIBERTY BELL;
PITT, WILLIAM; REVERE,
PAUL; ROCHAMBEAU,
COMTE DE; RUSH, BEN-
JAMIN; WASHINGTON,
GEORGE
REYKJAVIK, ICELAND
Trav/Holiday 152:75-6 (4) O
'79
Trav/Holiday 155:52 (c, 3) Je '81
--Hothouse gardening
Nat Geog 152:573 (c, 4) O '77
RHINOCERI
Smithsonian 8:45, 50-1 (c, 1)
Mr '78
Life 3:56-60 (c, 1) Ap '80
Sports Illus 52:74-5 (c, 1) My
19 '80
Nat Wildlife 19:18 (c, 1) D '80
Nat Geog 159:298-9 (c, 1) Mr
'81

--Bronze Age Chinese sculpture
Smithsonian 11:70-1 (c, 1) Ap '80
--Horns
Nat Geog 158:598-9 (c, 1) N '80
Rhode Island. See NEWPORT;
PROVIDENCE
RHODES, CECIL
Trav/Holiday 152:57 (4) S '79
--1892 cartoon of his African am-
bitions
Smithsonian 12:50 (4) My '81
--Grave
Nat Geog 160:622 (c, 3) N '81
RHODES, GREECE
--Temple of Lindos
Smithsonian 9:132 (4) D '78
RHODESIA--COSTUME
Life 1:106-12 (1) N '78
--Children
Life 2:28-9 (1) Ap '79
RHODESIA--POLITICS AND GOV-
ERNMENT
--Defenses against terrorists
Life 1:106-12 (1) N '78
RHODODENDRONS
Nat Wildlife 17:48 (c, 1) Ag '79
RICE FIELDS
--Texas
Nat Geog 157:465 (c, 1) Ap '80
RICE INDUSTRY--HARVESTING
--Brazil
Nat Geog 157:710-11 (c, 1) My
'80
--Picking wild rice (Wisconsin)
Nat Geog 152:194-5 (c, 1) Ag '77
RICE INDUSTRY--PLANTING
--Japan
Nat Geog 157:66-7 (c, 1) Ja '80
RICE PADDIES
--Borneo
Trav/Holiday 151:cov. (c, 1) Mr
'79
--China
Trav/Holiday 152:32 (c, 2) O '79
--Indonesia
Travel 148:57 (c, 1) Ag '77
--Korea
Smithsonian 12:65 (c, 2) O '81
--Philippines
Trav/Holiday 151:38 (c, 2) Ja '79
RICHARDSON, HENRY HOBSON
Am Heritage 32:48-9 (1) O '81
--Architectural works by him
Am Heritage 32:50-9 (c, 1) O '81
RICHMOND, VIRGINIA
Ebony 35:44-50 (2) Je '80
--Railroad station
Am Heritage 32:59 (c, 4) O '81

--Old Crow, Alaska
Nat Geog 156:344-5 (c, 2) S '79
--Padernales, Texas
Nat Geog 157:468-9 (c, 1) Ap
'80
--Parched river bed
Nat Geog 152:50 (c, 3) Je '77
--Passaic, New Jersey
Smithsonian 8:87 (c, 4) S '77
--St. Croix, Minnesota/Wisconsin
Nat Geog 152:30-5 (c, 1) Jl '77
--Salmon River, Idaho
Nat Wildlife 17:37-41 (c, 1) Je
'79
--Semois, Bouillon, Belgium
Nat Geog 155:340-1 (c, 1) Mr
'79
--Shagit, Washington
Nat Geog 152:38-44 (map, c, 1)
Jl '77
--Sierra Leone
Smithsonian 12:34 (c, 4) D '81
--Soque, Georgia
Travel 147:38 (c, 1) F '77
--Stillwater, Montana
Life 4:132-3 (c, 1) Mr '81
--Stream in winter (Vermont)
Nat Wildlife 17:10 (c, 4) D '78
--Sui, China
Nat Geog 158:506-7 (c, 1) O '80
--Tajo, Toledo, Spain
Nat Geog 153:326-7 (c, 1) Mr
'78
--Tana, Kenya
Natur Hist 90:33 (map, c, 4) Ap
'81
--Vecht, Netherlands
Trav/Holiday 153:44 (c, 2) F '80
--Vijose, Albania
Nat Geog 158:540-1 (c, 1) O '80
--Wisconsin
Smithsonian 11:139 (c, 1) O '80
--Yakima, Washington
Nat Geog 154:628-9 (c, 1) N
'78
--See also AMAZON; ARKANSAS;
ARNO; CHAUDIERE; COLO-
RADO; COLUMBIA; CON-
NECTICUT; DAMS; DANUBE;
DETROIT; DOURO;
EUPHRATES; HUDSON;
KENNEBEC; KLAMATH;
LIFFEY; MACKENZIE;
MISSISSIPPI; MISSOURI;
MOSELLE; MONTMORENCY;
NIGER; NILE; OHIO; PENOB-
SCOT; PLATTE; RED RIVER
OF THE NORTH; RIO

GRANDE; ST. JOHN; ST.
LAWRENCE; SAONE; SHAN-
NON; SNAKE; SUSQUEHANNA;
SUWANEE; THAMES; WATER-
FALLS; YUKON
RIYADH, SAUDI ARABIA
Nat Geog 158:292-3 (c, 1) S '80
ROAD RUNNERS
Nat Wildlife 17:51 (c, 4) Ap '79
Sports Illus 52:114 (painting, c, 4)
Ja 14 '80
ROADS
--1st cent. (Syria)
Nat Geog 154:360-1 (c, 2) S '78
--Cobblestone street (Detroit,
Michigan)
Trav/Holiday 149:62-3 (4) Mr
'78
--Mexico City, Mexico
Trav/Holiday 155:66 (c, 4) Je '81
--Muddy dirt road (Colombia)
Sports Illus 53:98 (c, 4) N 24 '80
--Roman Appian Way, Italy
Nat Geog 159:714-46 (map, c, 1)
Je '81
--Route 66
Am Heritage 28:24-35 (c, 1) Ag
'77
--Texas country road
Nat Geog 156:194-5 (c, 1) Ag '79
--Through Australian outback
Nat Geog 155:164 (c, 1) F '79
--See also HIGHWAYS
ROADS--CONSTRUCTION
--Brazil
Nat Geog 152:688 (c, 3) N '77
--Repairing road (Georgia)
Nat Geog 155:110 (c, 3) Ja '79
--Repairing road (Itri, Italy)
Nat Geog 159:746 (c, 2) Je '81
--Roman Appian Way, Italy
Nat Geog 159:718-19 (painting, c, 1)
Je '81
--Tibet
Nat Geog 157:228-9 (c, 1) F '80
--Widening highway (New York)
Smithsonian 10:42-3 (c, 1) F '80
ROBINS
Natur Hist 88:62 (c, 2) Je '79
Nat Wildlife 19:32 (c, 4) D '80
--Chicks in nest
Natur Hist 86:51 (c, 1) Ag '77
Nat Wildlife 19:46 (c, 4) Ag '81
--Guarding nest
Nat Wildlife 18:2 (c, 2) Je '80
ROBINSON, JACKIE
Sports Illus 51:60 (c, 4) Ag 13
'79

Trav/Holiday 151:62 (c, 4) Ap
'79
--Swift River, New Hampshire
Trav/Holiday 150:42 (c, 1) Jl
'78
--Teapot Rock, Green River,
Wyoming
Life 2:10 (4) Mr '79
--Volcanic (Hawaii)
Natur Hist 87:34 (4) My '78
--Wisconsin gorge
Nat Geog 152:200-1 (c, 1) Ag
'77
--See also JEWELS; LIMESTONE;
MINERALS
ROCKWELL, NORMAN
Life 1:142 (2) D '78
ROCKY MOUNTAIN GOATS
Nat Wildlife 15:12-17 (c, 1) Ja
'77
Nat Geog 152:13 (c, 4) Jl '77
Nat Wildlife 16:cov. (c, 1) Ap
'78
Nat Geog 154:285-94 (c, 1) Ag
'78
Nat Geog 156:509 (c, 3) O '79
Nat Geog 157:777 (c, 4) Je '80
Nat Wildlife 18:cov. (c, 1) O
'80
Natur Hist 90:58-68 (c, 1) Ja
'81
Trav/Holiday 156:49 (c, 2) Jl '81
--Feeding on pine
Nat Wildlife 17:53 (c, 1) D '78
ROCKY MOUNTAIN NATIONAL
PARK, COLORADO
Nat Wildlife 16:33 (c, 4) Ap '78
Nat Geog 156:500-1, 505-9 (c, 1)
O '79
ROCKY MOUNTAINS, CANADA
Nat Geog 157:754-79 (c, 1) Je
'80
Trav/Holiday 155:cov., 43-6
(c, 1) My '81
ROCKY MOUNTAINS, U.S.
--Colorado
Travel 147:49 (c, 1) Mr '77
Sports Illus 47:54-5, 59 (c, 1)
D 5 '77
--Engineer Pass, Colorado
Nat Geog 156:216-17 (c, 1) Ag
'79
--Sawatch Range (Colorado)
Nat Geog 156:503 (c, 1) O '79
RODENTS
--Gerbils
Natur Hist 88:64-71 (c, 1) F '79
--See also BEAVERS; CAPY-

BARAS; CHIPMUNKS; COY-
PUS; GOPHERS; HEDGEHOGS;
JERBOAS; MARMOTS; MUSK-
RATS; PORCUPINES; PRAIRIE
DOGS; RATS; SQUIRRELS;
WOODCHUCKS
RODEOS
Sports Illus 48:134-5 (c, 1) F 9
'78
Sports Illus 48:76-9 (4) My 8 '78
Smithsonian 9:60-5 (c, 1) Mr '79
Sports Illus 55:43-9 (painting, c, 1)
D 28 '81
--Brazil
Nat Geog 152:712-13 (c, 2) N '77
Nat Geog 158:482-5 (c, 1) O '80
--California
Nat Geog 152:356 (c, 2) S '77
--Children's events
Smithsonian 9:60-1 (c, 4) Mr '79
--Louisiana
Nat Geog 153:205 (c, 1) F '78
--Mechanical bull
Life 3:70 (c, 4) Ja '80
Sports Illus 54:78 (c, 4) My 4 '81
--Mechanical bull (Arizona)
Nat Geog 157:275 (c, 3) F '80
--Mechanical bull (Wyoming)
Nat Geog 159:102-3 (1) F '81SR
--Mexico
Nat Geog 153:646-7 (c, 1) My '78
--Montana
Sports Illus 47:22-4 (c, 3) Ag 29
'77
--Riding buffalo through fire
Nat Geog 160:90-1 (c, 1) Jl '81
--Texas
Nat Geog 157:448-9 (c, 1) Ap '80
--Training
Smithsonian 9:56-63 (c, 1) Mr '79
--Washington
Nat Geog 151:421 (c, 1) Mr '77
RODIN, AUGUSTE
Smithsonian 12:37 (4) Jl '81
--The Cathedral (1908)
Smithsonian 12:45 (c, 2) Jl '81
Smithsonian 12:16 (sculpture, 4)
S '81
--Sculpture by him
Smithsonian 12:cov., 36-45 (c, 1)
Jl '81
ROGERS, WILL
--Statue of him (Claremore, Okla-
homa)
Trav/Holiday 156:55 (c, 4) Ag '81
ROLLER COASTERS
Travel 147:64-5, 74 (4) Je '77
Smithsonian 8:44-50 (c, 1) Ag '77

Life 2:43-51 (c, 1) Je '79
--California
 Trav/Holiday 155:80 (4) My '81
ROLLER SKATES
 Sports Illus 51:89 (c, 3) O 15 '79
ROLLER SKATING
 Sports Illus 49:44-6 (c, 2) O 30
 '78
 Life 1:36-7 (c, 3) N '78
 Ebony 34:90 (4) Jl '79
 Sports Illus 52:51, 55 (c, 3) F
 11 '80
 Ebony 35:116-18 (4) Ap '80
 Ebony 35:136 (4) Je '80
 Ebony 35:68 (4) Ag '80
 Sports Illus 54:109 (c, 4) Ja 19
 '81
 Ebony 36:68 (3) Mr '81
 Sports Illus 55:111 (c, 2) O 19
 '81
 Ebony 37:93 (4) D '81
--1876
 Am Heritage 33:111 (4) D '81
--1907 (New York City)
 Am Heritage 31:22-3 (c, 4) Je
 '80
--1940's gas shortage (New York
 City, N. Y.)
 Am Heritage 30:14 (1) O '79
--California
 Smithsonian 10:120-1 (c, 1) Mr
 '80
--New York City streets
 Nat Geog 160:341 (c, 2) S '81
--Pan-American Games 1979
 (Puerto Rico)
 Sports Illus 51:62 (c, 3) Jl 16
 '79
--Roller disco
 Sports Illus 52:62 (c, 3) Mr 31
 '80
--South Korea
 Nat Geog 156:770-1 (c, 1) D '79
ROMAN EMPIRE
--71 B. C. crucifixion of rebel
 slaves
 Nat Geog 159:726-7 (painting, c, 1)
 Je '81
--Harbor (Carthage)
 Smithsonian 9:49 (painting, c, 3)
 F '79
--See also CARTHAGE; MYTHOL-
 OGY--GREEK AND ROMAN;
 POMPEII
ROMAN EMPIRE--ARCHITECTURE
--1st cent. limestone road (Syria)
 Nat Geog 154:360-1 (c, 2) S '78
--2nd cent. aqueduct (Carthage)

Smithsonian 9:52-3 (c, 2) F '79
--Aphrodisias, Turkey
 Nat Geog 160:530-1 (c, 1) O '81
--Appian Way
 Nat Geog 159:714-46 (map, c, 1)
 Je '81
--Coliseum (Thysdrus, Tunisia)
 Nat Geog 157:186-7 (c, 1) F '80
--Column styles
 Natur Hist 88:70, 78 (drawing, 4)
 Ap '79
--Palmyra, Syria
 Nat Geog 154:350-1 (c, 1) S '78
--Ruins at Ephesus, Turkey
 Nat Geog 152:114-15 (c, 2) Jl '77
--Viaducts
 Nat Geog 159:732-3 (c, 1) Je '81
--See also COLOSSEUM; TEMPLES
 --ANCIENT; THEATERS--
 ANCIENT; TRAJAN'S COLUMN
ROMAN EMPIRE--ART
--2nd cent. greyhound sculpture
 Smithsonian 8:113 (c, 2) N '77
--3rd cent. mosaic of Ulysses
 (Tunisia)
 Nat Geog 157:198-9 (c, 1) F '80
--Catacomb painting of sky as ap-
 ples
 Smithsonian 11:158-9 (c, 2) Je '80
--Mosaic (Carthage)
 Trav/Holiday 149:30-1 (4) Ja '78
--Paintings from Pompeii
 Smithsonian 9:84-93 (c, 1) Ap '78
ROMAN EMPIRE--COSTUME
--Military
 Nat Geog 159:726-7 (painting, c, 1)
 Je '81
--Pompeii
 Smithsonian 9:84-88 (painting, c, 1)
 Ap '78
--See also GLADIATORS
ROMAN EMPIRE--RELICS
 Nat Geog 160:720-1 (c, 1) Je '81
--Early blown-glass objects
 Smithsonian 11:68-72 (c, 4) My
 '80
--Inscription on Trajan's Column
 Life 3:14 (4) Ag '80
--Pottery shard depicting Celt
 Nat Geog 151:588 (c, 4) My '77
ROMAN EMPIRE--RUINS
--Hierapolis Theater, Turkey
 Trav/Holiday 156:55 (c, 2) Jl '81
--See also POMPEII
Roman Empire--Sculpture. See
 SCULPTURE--ANCIENT
ROMANCE
--Couple holding hands

Ebony 36:29 (3) Ag '81
--Couples
 Ebony 33:107-8 (2) Ag '78
 Ebony 36:89-98 (2) D '80
--Couples cuddling
 Ebony 33:95 (4) D '77
--Couples walking together
 Ebony 32:141-6 (4) Jl '77
--Interracial couples
 Ebony 33:37-42 (2) Ja '78
 Ebony 33:64-70 (3) Je '78
--Kissing
 Ebony 36:121 (4) Ag '81
--Quiet romantic evening
 Ebony 36:110, 114 (2) Mr '81
--Teenagers flirting (Kansas)
 Life 2:98 (3) Je '79
ROMANIA
--Classroom
 Sports Illus 51:90 (c, 4) N 19
 '79
--See also BUCHAREST
ROMANIA--COSTUME
 Nat Geog 152:482-5 (c, 1) O '77
ROME, ITALY
 Smithsonian 8:38-41 (c, 2) Ag
 '77
 Smithsonian 8:104-5 (c, 2) Mr
 '78
 Trav/Holiday 154:18 (4) S '80
--19th cent. mosaic design of the
 city
 Smithsonian 8:90-1 (c, 2) My '77
--Restoration of monuments
 Life 3:61-4 (c, 2) Je '80
--Spanish Steps
 Life 3:64 (c, 4) Je '80
--See also COLOSSEUM; ST.
 PETER'S CHURCH; TRAJAN'S
 COLUMN
ROOSEVELT, ELEANOR
 Ebony 32:129-30 (4) F '77
 Ebony 35:48 (4) My '80
 Ebony 36:138 (4) Je '81
 Am Heritage 33:10-19 (1) D '81
ROOSEVELT, FRANKLIN DELANO
 Ebony 32:129 (4) F '77
 Am Heritage 28:11, 73 (4) Ag
 '77
 Am Heritage 30:38-9 (3) Ap '79
 Am Heritage 30:91 (4) O '79
 Sports Illus 52:64-8 (3) Ja 14
 '80
 Am Heritage 31:38-9 (4) Ag '80
 Nat Geog 158:322 (4) S '80
 Smithsonian 12:89 (4) Je '81
 Smithsonian 12:192 (4) N '81
 Am Heritage 33:113 (2) D '81

--1933 assassination attempt
 (Miami, Florida)
 Am Heritage 32:87-95 (4) D '80
--Dressed as hunter
 Am Heritage 29:11 (3) F '78
ROOSEVELT, THEODORE
 Ebony 32:76 (4) Je '77
 Smithsonian 9:165 (cartoon, 4) O
 '78
 Am Heritage 30:106 (4) D '78
 Am Heritage 30:23 (4) Je '79
 Natur Hist 89:15, 84-7 (2) Ap
 '80
 Smithsonian 11:172 (4) O '80
 Am Heritage 32:113 (2) Ap '81
 Am Heritage 32:cov., 4-15 (c, 1)
 Je '81
 Am Heritage 32:111 (3) Ag '81
--1883
 Am Heritage 30:34 (1) F '79
--1905 inauguration medal
 Smithsonian 11:26 (4) Ja '81
--Cartoon about Panama Canal
 Nat Geog 153:279 (drawing, 4) F
 '78
--Mount Rushmore sculpture
 Am Heritage 28:18, 27 (c, 4) Je
 '77
--Origin of "Teddy Bear" (1902)
 Smithsonian 9:144 (cartoon, 4)
 D '78
ROOSTERS
 Am Heritage 29:66 (4) Je '78
 Nat Geog 153:802 (c, 3) Je '78
 Nat Geog 156:679 (c, 2) N '79
 Nat Geog 158:390 (c, 1) S '80
ROPE JUMPING
 Ebony 33:120 (4) Ja '78
 Ebony 33:114 (4) S '78
 Ebony 34:114 (4) F '79
 Ebony 34:90 (4) Jl '79
 Ebony 35:104-5 (3) F '80
 Sports Illus 53:104 (c, 4) O 6 '80
 Sports Illus 53:88 (c, 4) O 20 '80
ROPES
--Ancient Egypt
 Nat Geog 151:296 (c, 4) Mr '77
ROSEMARY
 Am Heritage 28:101 (drawing, c, 4)
 Je '77
ROSES
 Smithsonian 10:cov., 44-52 (c, 1)
 Ap '79
 Nat Geog 158:102-3 (c, 2) Jl '80
--Wild
 Nat Wildlife 19:62 (c, 4) D '80
ROTHSCHILD, NATHAN MAYER
--Driving zebras

Smithsonian 9:42 (cartoon, c, 4)
Je '78
ROTIFERS
Nat Geog 155:286-92 (c, 1) F
'79
ROTTWEILER DOGS
Ebony 32:120 (4) Jl '77
ROUALT, GEORGES
--Bride and Groom
Smithsonian 8:73 (painting, 4)
Jl '77
ROUEN, FRANCE
--The Great Clock
Trav/Holiday 150:15 (4) O '78
ROUSSEAU, HENRI
--Sleeping Gypsy
Smithsonian 9:81 (painting, c, 3)
Jl '78
ROWBOATS
Nat Geog 154:46-7 (c, 3) Jl '78
--19th cent. collapsible boat
(Connecticut)
Am Heritage 31:29 (4) F '80
ROWING
Life 4:33 (c, 4) F '81
--Hawaii
Trav/Holiday 150:41 (c, 2) D '78
--Lifeguard team (New Jersey)
Nat Geog 160:583 (c, 1) N '81
--Nebraska park
Travel 148:53 (c, 1) Ag '77
--Reed ship
Nat Geog 154:820-1 (c, 1) D '78
--Transatlantic boat trip
Smithsonian 12:192-215 (c, 1)
O '81
--U. S. S. R.
Nat Geog 155:786-7 (c, 1) Je '79
--See also BOAT RACES
ROWING--COLLEGE
Sports Illus 46:54-5 (c, 4) My
30 '77
Sports Illus 47:18-19 (c, 2) Jl
11 '77
Sports Illus 48:87 (c, 4) Ap 10
'78
Sports Illus 48:105 (4) My 29
'78
Sports Illus 49:71 (c, 3) Jl 10
'78
Sports Illus 50:62 (c, 3) Ap 16
'79
Sports Illus 52:80-5 (4) My 26
'80
Sports Illus 54:86 (4) Ap 13 '81
--Celebrating
Sports Illus 50:88 (4) My 28 '79
--Women

Nat Geog 158:454 (c, 4) O '80
ROYCE, JOSIAH
Am Heritage 31:18-19 (c, 2) O
'80
RUBBER INDUSTRY
--Malaysia
Nat Geog 151:634-5 (c, 1) My '77
--Tapping latex (Indonesia)
Nat Geog 159:418 (c, 3) Mr '81
--See also GOODYEAR, CHARLES
RUBENS, PETER PAUL
--Home (Antwerp, Belgium)
Smithsonian 8:48-54 (c, 1) O '77
--Paintings
Smithsonian 8:46-55 (c, 1) O '77
--Portrait of Helena Fourment
Smithsonian 11:45 (painting, c, 3)
Jl '80
--Toilette of Venus
Smithsonian 10:76 (painting, c, 2)
N '79
--Tomb (Antwerp, Belgium)
Smithsonian 8:55 (c, 1) O '77
RUG MAKING
--China
Trav/Holiday 150:37 (c, 4) N '78
--Latch hook rug (Louisiana)
Sports Illus 54:96 (c, 4) Je 8 '81
--Weaving (Pakistan)
Nat Geog 159:674-5 (c, 1) My '81
RUGBY
Sports Illus 47:26-8 (c, 2) O 24
'77
Sports Illus 52:29-32 (c, 1) Mr 17
'80
Sports Illus 53:67-8 (4) O 20 '80
Sports Illus 55:36-7 (c, 3) S 28
'81
--Australia
Nat Geog 155:228-9 (c, 3) F '79
--Colorado
Nat Geog 155:398-9 (c, 1) Mr '79
--Great Britain
Sports Illus 51:97-8 (c, 4) O 15
'79
RUGS
--Navajo rugs (Arizona)
Trav/Holiday 154:61 (3) S '80
--Tunisia
Trav/Holiday 149:26-7 (c, 1) Ja
'78
RULERS AND MONARCHS
--Late 19th cent. Great Britain
Smithsonian 12:171-90 (2) O '81
--1896 coronation of Czar Nicholas
II (Russia)
Smithsonian 9:94-5 (1) F '79
--1903 Malaysia

Natur Hist 87:36-7 (3) My '78
--African countries
Ebony 35:32-3 (c, 4) D '79
--Bahrain
Sports Illus 53:92 (c, 3) N 17
'80
--Canada
Life 3:144 (c, 2) Ap '80
--Ethiopian emperor (1954)
Ebony 36:94 (3) N '80
--Great Britain
Life 3:9-12 (2) Mr '80
Life 4:58-66 (1) Jl '81
--Iran
Life 1:24-8 (c, 1) O '78
Life 3:cov., 22 (c, 1) Ja '80
--Japan
Life 3:138-9 (c, 1) Ap '80
--Kamehameha V (1865; Hawaii)
Am Heritage 32:84-5 (2) O '81
--Libya
Life 3:102-8 (c, 1) F '80
--Liechtenstein
Nat Geog 159:280 (c, 4) F '81
--Mayor (British Columbia)
Nat Geog 154:482 (c, 4) O '78
--Netherlands
Life 3:130-1 (c, 1) Ap '80
--Nigeria
Ebony 32:35 (c, 4) My '77
Ebony 36:148-51 (c, 3) D '80
--Prince Rudolph (Austria)
Smithsonian 10:156 (4) F '80
--Saudi Arabia
Nat Geog 158:324-5 (c, 1) S '80
Life 4:92-3 (c, 1) Jl '81
Life 4:125-32 (c, 4) D '81
--Saudi Arabia (1945)
Nat Geog 158:322 (4) S '80
--Shah of Iran (1967)
Nat Geog 155:102 (c, 3) Ja '79
--Sheikh (Bahrain)
Nat Geog 156:320-1 (c, 1) S '79
--Spain
Nat Geog 153:328-9 (c, 1) Mr
'78
--Sultan (Oman)
Nat Geog 160:351 (painting, c, 1)
S '81
--U. S. S. R.
Life 1:89-92 (3) D '78
--U. S. representation at 1955
coronation (Nepal)
Am Heritage 31:43 (2) Ag '80
--U. S. Vice President's house
(Wash. , D. C.)
Smithsonian 8:62-9 (c, 1) S '77
--Upper Volta

Ebony 33:165 (c, 4) O '78
--Wedding of Prince Charles and
Diana (Great Britain)
Life 4:110-15 (c, 1) S '81
--See also ALEXANDER THE
GREAT; BREZHNEV, LEONID;
CASTRO, FIDEL; CHIANG
KAI-SHEK; CHURCHILL,
WINSTON; CLEMENCEAU,
GEORGES; CLEOPATRA;
CROWNS; EDWARD IV; ED-
WARD VII; ELIZABETH I;
ELIZABETH II; FRANCO,
FRANCISCO; GEORGE III;
GEORGE V; GEORGE VI;
HENRY VIII; HITLER, ADOLF;
KHRUSHCHEV, NIKITA; KING
ARTHUR; KUBLAI KHAN;
LENIN, NIKOLAI; LOUIS IX;
LOUIS XIV; MAO TSE-TUNG;
NAPOLEON; PERON, JUAN;
PETER THE GREAT; PHAR-
AOHS; PHILIP II; STALIN,
JOSEPH; TALLEYRAND,
CHARLES MAURICE; TAMER-
LANE; THRONES; TITO,
MARSHAL: U. S. PRESIDENTS;
VICTORIA

RUNNING
Sports Illus 46:68-9 (c, 1) Je 27
'77
Sports Illus 47:26-7 (c, 1) Ag 29
'77
Sports Illus 48:45 (drawing, c, 4)
Ap 3 '78
Sports Illus 48:78-88 (c, 2) Ap 17
'78
Sports Illus 48:78-9 (c, 1) My 1
'78
Sports Illus 49:56 (c, 4) S 18 '78
Life 1:34-5 (c, 1) N '78
Sports Illus 49:79 (3) N 20 '78
Sports Illus 50:32 (c, 2) F 26 '79
Sports Illus 50:64-5 (c, 1) Je 25
'79
Sports Illus 51:75 (c, 3) Ag 13
'79
Sports Illus 51:44 (c, 3) O 22 '79
Sports Illus 53:36-7, 50 (2) S 29
'80
Sports Illus 54:32-3 (c, 1) Je 22
'81
Life 4:70 (c, 2) N '81
--California beach
Sports Illus 51:77 (4) N 19 '79
--Hawaii beach
Sports Illus 46:34-5 (c, 2) F 14
'77

--See also CROSS COUNTRY;
 JOGGING; MARATHONS;
 RACES; TRACK
RUNNING--HUMOR
 Sports Illus 48:40-5 (draw-
 ing, c, 2) Ap 24 '78
RUSH, BENJAMIN
 Am Heritage 28:102 (4) F '77
RUSH PLANTS
 Natur Hist 87:66 (c, 4) Ag '78
RUSSELL, CHARLES
--1924 painting
 Am Heritage 28:27 (painting, c, 3)
 O '77
RUSSELL, LILLIAN
 Smithsonian 12:47 (4) Ag '81
RUSSO-JAPANESE WAR (1904-
 1905)
 Am Heritage 28:76-7 (2) Ag '77
RUTH, BABE
 Sports Illus 47:84-6 (2) O 10
 '77
 Sports Illus 49:72, 86 (3) O 9
 '78

-S-

SACRAMENTO, CALIFORNIA
 Nat Geog 158:68-9 (c, 1) Jl '80
--Railroad station (1874)
 Am Heritage 28:24-5 (paint-
 ing, c, 2) F '77
Sacrifices. See RELIGIOUS
 RITES AND FESTIVALS
SADDLES
 Life 4:49 (c, 4) My '81
SAFETY CAMPAIGNS
--Improving aviation safety
 Nat Geog 152:cov., 206-35 (c, 1)
 Ag '77
SAFETY EQUIPMENT
--Life jackets
 Sports Illus 50:34 (c, 4) Je 25
 '79
SAHARA DESERT, AFRICA
 Nat Geog 156:598-9, 612-13
 (c, 1) N '79
 Nat Geog 157:214-15 (c, 1) F '80
--Algeria
 Natur Hist 88:65-8 (c, 1) F '79
--Tunisia
 Smithsonian 10:cov., 32-41 (c, 1)
 Ag '79
SAILBOAT RACES
--1880's schooners (San Francisco,
 California)
 Am Heritage 29:56-7 (1) O '78

--America Cup (early 20th cent.)
 Smithsonian 11:38-9, 46-7 (c, 1)
 Ag '80
--America Cup 1903
 Am Heritage 31:86-95 (1) Ag '80
--America Cup 1977 (Newport,
 Rhode Island)
 Sports Illus 47:26-7 (c, 2) S 26
 '77
 Sports Illus 48:140-4 (c, 1) F 9
 '78
--America Cup 1980
 Sports Illus 53:24-7 (c, 2) S 15
 '80
 Sports Illus 53:98 (c, 4) O 6 '80
--British Columbia
 Sports Illus 48:41-8 (c, 1) My 22
 '78
--California
 Sports Illus 46:48 (c, 3) Mr 28
 '77
--Caribbean
 Sports Illus 52:55 (c, 4) Mr 3
 '80
--Cross-Atlantic
 Sports Illus 53:24-9 (c, 1) Jl 7
 '80
--Florida
 Sports Illus 54:70, 73 (c, 4) Je 1
 '81
--Georgia
 Trav/Holiday 155:76 (c, 2) Mr
 '81
--Great Britain
 Sports Illus 51:16-23 (c, 1) Ag
 27 '79
--Hobie cats (California)
 Life 2:96-7 (c, 1) Ja '79
--Maryland
 Sports Illus 47:24-5 (c, 1) N 28
 '77
 Nat Geog 158:432-3 (c, 2) O '80
--New York
 Sports Illus 46:55 (4) Je 6 '77
--Newport, Rhode Island
 Sports Illus 46:31-4 (c, 1) Je 20
 '77
 Sports Illus 47:cov., 18-19 (c, 1)
 Jl 4 '77
 Sports Illus 47:23 (c, 2) Ag 8 '77
 Sports Illus 47:48 (c, 4) Ag 15
 '77
 Sports Illus 47:24-6 (c, 1) S 12
 '77
 Sports Illus 53:28-30 (c, 2) Je
 30 '80
--Portugal
 Nat Geog 158:806-7 (c, 2) D '80

Smithsonian 10:80-1 (c, 2) Je
'79
--St. Andrew's seal (Scotland)
Sports Illus 49:44 (c, 4) Jl 10
'78
SALAMANDERS
Nat Wildlife 15:42-5 (c, 1) O '77
Natur Hist 86:84-8 (c, 1) O '77
Natur Hist 89:46-52 (c, 1) D '80
--Embryo developing
Nat Wildlife 18:40 (c, 4) D '79
--Embryos stunted by pollution
Nat Geog 160:672-3 (c, 4) N '81
SALEM, MASSACHUSETTS
Nat Geog 155:578-9 (c, 1) Ap
'79
SALISBURY, ZIMBABWE
Nat Geog 160:634-5 (c, 2) N '81
Trav/Holiday 156:62-3 (c, 1) N
'81
SALMON
Nat Geog 151:779 (c, 2) Je '77
Nat Geog 154:675 (c, 3) N '78
Natur Hist 87:38-45 (c, 1) D '78
Life 2:109 (c, 4) F '79
Smithsonian 9:58 (c, 4) F '79
Sports Illus 51:73 (painting, c, 3)
Jl 16 '79
Nat Wildlife 19:9 (c, 4) O '81
Nat Geog 160:601-15 (c, 1) N
'81
--Atlantic
Smithsonian 12:170-9 (c, 1) N
'81
--Caught in net
Sports Illus 50:31 (c, 2) Je 4
'79
--Chinook
Nat Geog 155:814 (c, 4) Je '79
--Drying sockeye salmon (Alaska)
Nat Geog 156:38-9 (c, 1) Jl '79
--Location of Atlantic salmon
Nat Geog 160:610 (map, c, 3) N
'81
--Sockeye
Nat Geog 156:65 (c, 2) Jl '79
Salonika, Greece. See THESSA-
LONIKI
Saloons. See TAVERNS
SALT
Nat Geog 152:380-400 (c, 1) S
'77
SALT INDUSTRY
--Ethiopia
Nat Geog 152:382-97 (c, 1) S '77
--Evaporation
Nat Geog 152:394-400 (c, 1) S
'77

--Mali
Nat Geog 152:384-5 (c, 2) S '77
--Salt pans (San Francisco, Califor-
nia)
Nat Geog 159:821 (c, 2) Je '81
SALT LAKE CITY, UTAH
--1891 aerial map
Am Heritage 30:14-15 (c, 1) F
'79
--Library
Smithsonian 12:86-94 (c, 1) D '81
--Mormon temple (1897)
Am Heritage 28:74-5 (1) Je '77
SALT MINING
--17th cent. (Austria)
Nat Geog 152:391 (painting, c, 3)
S '77
--1890's (Syracuse, New York)
Nat Geog 152:389 (4) S '77
--Louisiana
Nat Geog 152:388-9 (c, 1) S '77
SALVATION ARMY
--History and activities
Smithsonian 11:78-88 (c, 1) D '80
SALZBURG, AUSTRIA
Trav/Holiday 153:16 (drawing, 4)
Je '80
SAMARKAND, U. S. S. R.
Smithsonian 10:90-7 (c, 1) S '79
SAMOA--COSTUME
--1920's
Natur Hist 89:103-5 (2) Ap '80
SAMOYED DOGS
Sports Illus 53:36, 40 (c, 1) D
15 '80
SAMPANS
--China
Nat Geog 156:544-5 (c, 1) O '79
San Andreas. See CALIFORNIA
SAN ANTONIO, TEXAS
Trav/Holiday 152:65-8 (c, 1) N
'79
--18th cent. missions (1840's
paintings)
Am Heritage 30:50-3 (c, 3) O '79
SAN DIEGO, CALIFORNIA
--Aerial view
Life 3:80 (c, 2) D '80
--Chicano Park
Nat Geog 157:782-3 (c, 1) Je '80
--Harbor (1880's)
Am Heritage 29:54 (4) O '78
--Humorous view of sports in the
city
Sports Illus 49:48, 58 (draw-
ing, c, 1) D 25 '78
--San Diego de Alcala Mission
Trav/Holiday 149:34 (c, 1) F '78

--Zoo
 Trav/Holiday 151:85-7 (c, 2) Ap
 '79
SAN FRANCISCO, CALIFORNIA
 Ebony 32:69, 74 (3) Ap '77
 Smithsonian 8:80 (c, 4) Jl '77
 Sports Illus 49:41 (c, 1) D 25
 '78
 Life 2:60 (4) Mr '79
 Smithsonian 9:106-7 (c, 3) Mr
 '79
 Nat Geog 156:12-14, 23-5 (c, 1)
 Jl '79
 Trav/Holiday 152:58 (c, 4) Jl
 '79
 Nat Geog 159:814-43 (c, 1) Je
 '81
--19th cent. house
 Smithsonian 9:136 (4) My '78
--1840's
 Am Heritage 30:75 (lithograph, 4)
 Je '79
--1850
 Am Heritage 29:112 (4) Ag '78
--1880's mansion
 Ebony 34:52, 56-60 (2) N '78
 Ebony 34:72 (4) My '79
--Broadway Wharf (1890's)
 Am Heritage 29:52-9 (1) O '78
--Palace of Fine Arts
 Am Heritage 32:42-3 (c, 1) Ag
 '81
--Mary Ellen Pleasant (19th cent.)
 Ebony 34:90-2 (2) Ap '79
 Ebony 34:71-86 (4) My '70
--Vigil for murdered mayor
 Life 2:82 (c, 2) D '79
--See also ALCATRAZ; CHINA-
 TOWN; GOLDEN GATE
 BRIDGE; SAN FRANCISCO-
 OAKLAND BAY BRIDGE
SAN FRANCISCO-OAKLAND BAY
 BRIDGE, CALIFORNIA
 Nat Geog 159:30-1 (c, 1) F
 '81SR
 Nat Geog 159:836-7 (c, 1) Je '81
SAN JOSE, CALIFORNIA
--Run-down street
 Nat Geog 157:804-5 (c, 1) Je
 '80
SAN JOSE, COSTA RICA
 Nat Geog 160:36-9 (c, 1) Jl '81
SAN JUAN, PUERTO RICO
 Trav/Holiday 153:56-9 (c, 2) Ja
 '80
 Nat Geog 159:263 (c, 1) F '81
SAN JUAN ISLANDS, WASHINGTON
 Travel 148:cov., 26-31

 (map, c, 1) Jl '77
SANA, NORTH YEMEN
 Nat Geog 156:246-7 (c, 1) Ag '79
SAND
 Nat Wildlife 17:49 (c, 1) Ap '79
--Coral Pink Sand Dunes, Utah
 Natur Hist 88:60 (c, 1) Ag '79
--Magnified grains of sand
 Nat Wildlife 16:42-3 (c, 3) Je '78
SAND DUNES
 Nat Geog 156:586-623 (c, 1) N '79
--African deserts
 Smithsonian 8:38-9 (c, 3) Je '77
--China
 Nat Geog 159:188-9 (c, 1) F '81
--Mexico
 Nat Geog 153:638-9 (c, 1) My '78
--Nebraska
 Nat Geog 154:494-5 (c, 1) O '78
--New Mexico
 Nat Wildlife 15:32 (c, 2) Ap '77
--Oregon
 Nat Geog 156:813 (c, 4) D '79
--Saskatchewan
 Nat Geog 155:674-5 (c, 1) My '79
--Saudi Arabia
 Nat Geog 158:288-9 (c, 1) S '80
--Somalia
 Nat Geog 159:764-5 (c, 1) Je '81
SAND PAINTING
--Navajo Indians (Arizona)
 Nat Geog 158:179 (c, 4) Ag '80
SANDBURG, CARL
 Am Heritage 32:73 (4) F '81
SANDPIPERS
 Nat Geog 156:176-9 (c, 1) Ag '79
 Nat Geog 156:749 (c, 4) D '79
 Natur Hist 90:30 (drawing, 4) N
 '81
SANDSTONE
 Nat Geog 160:404 (c, 4) S '81
SANDUSKY, OHIO
--Block plan
 Am Heritage 32:111 (4) Ap '81
SANGER, MARGARET
 Am Heritage 29:84 (4) Ag '78
SANITATION WORK
--Cleaning horse manure from
 street (Michigan)
 Natur Hist 89:35 (c, 1) My '80
--Cleaning New York harbor
 Nat Geog 153:72 (c, 4) Ja '78
--Dropping sludge in New York
 water
 Nat Geog 153:520-1 (c, 2) Ap '78
--New York sewage plant
 Nat Geog 153:87 (c, 1) Ja '78
--Switzerland

Smithsonian 11:143 (c, 3) N '80
SANTA BARBARA, CALIFORNIA
--Mission cemetery
 Trav/Holiday 149:33 (c, 1) F
 '78
SANTA CLAUS
--1874 Thomas Nast painting
 Am Heritage 32:cov. (c, 2) D
 '80
--Antique Santa figures
 Smithsonian 12:177-82 (c, 2) D
 '81
--New York City street Santas
 Nat Geog 160:338 (c, 3) S '81
--Santa and reindeer
 Nat Wildlife 16:51 (painting, c, 3)
 D '77
SANTA FE, NEW MEXICO
--Outdoor theater
 Smithsonian 12:100 (c, 1) Ag '81
--San Miguel Mission
 Nat Geog 154:433 (c, 1) S '78
 Trav/Holiday 154:16 (4) O '80
SANTAYANA, GEORGE
 Am Heritage 31:18 (drawing, 4)
 O '80
SANTO DOMINGO, DOMINICAN
 REPUBLIC
 Nat Geog 152:554-5 (c, 1) O '77
 Trav/Holiday 149:54-7 (c, 1) Ja
 '78
 Trav/Holiday 154:63-5 (c, 1) O
 '80
SÃO PAULO, BRAZIL
 Nat Geog 153:266-77 (c, 1) F
 '78
SAONE RIVER, FRANCE
 Nat Geog 153:808-9 (c, 1) Je
 '78
SAPPHIRES
 Smithsonian 11:68-74 (c, 1) Je
 '80
--Necklace
 Smithsonian 9:144 (c, 4) F '79
SAPPORO, JAPAN
 Trav/Holiday 154:53-5, 69-70
 (map, c, 2) N '80
--Snow Festival
 Life 4:106-7 (c, 1) F '81
SAPSUCKERS
--Yellow-bellied
 Nat Geog 160:693 (c, 2) N '81
SARASOTA, FLORIDA
 Trav/Holiday 153:48-50 (map, c, 2)
 Mr '80
--John Ringling's home
 Smithsonian 12:62-71 (c, 1) S '81
SARDINE INDUSTRY

--Drying racks (Zimbabwe)
 Nat Geog 160:640-1 (c, 2) N '81
SARDINIA, ITALY
 Trav/Holiday 150:42-7 (c, 2) D
 '78
SARGENT, JOHN SINGER
 Smithsonian 10:102-3 (3) O '79
--Dr. Pozzi at Home
 Smithsonian 11:156 (painting, c, 3)
 O '80
--Paintings by him
 Smithsonian 10:100-9 (c, 1) O '79
--Portrait of Isabella Stewart
 Gardner
 Am Heritage 29:46 (c, 4) O '78
--Portrait of Endicott Peabody
 (1906)
 Am Heritage 31:99 (painting, c, 1)
 O '80
SAROYAN, WILLIAM
 Am Heritage 31:49 (4) O '80
SASKATCHEWAN
 Nat Geog 155:650-79 (map, c, 1)
 My '79
--See also REGINA
Satellites. See SPACE PROGRAM;
 SPACECRAFT
SATIE, ERIK
 Smithsonian 9:77 (4) Jl '78
SATURN
 Life 2:136-7 (c, 1) O '79
 Life 4:cov., 10-12 (c, 1) Ja '81
 Natur Hist 90:44-51 (c, 1) S '81
--Moons
 Smithsonian 10:46-7 (c, 1) Ja '80
--Photos from Voyager I
 Nat Geog 160:cov., 2-31 (c, 1)
 Jl '81
--Rings
 Natur Hist 90:104 (4) Mr '81
 Life 4:148-52 (c, 1) O '81
SAUDI ARABIA
 Nat Geog 158:cov., 287-333
 (c, 1) S '80
--Jidda Airport
 Nat Geog 154:582-3 (c, 1) N '78
 Nat Geog 158:298 (c, 4) S '80
 Life 4:91-4 (c, 1) Jl '81
--Mina
 Nat Geog 154:598-9 (c, 1) N '78
--Model of King Khalid Military
 City
 Life 2:92-3 (c, 1) D '79
--See also MECCA; RIYADH
SAUDI ARABIA--COSTUME
 Nat Geog 154:578-607 (c, 1) N
 '78
 Life 2:91-6 (c, 1) D '79

Nat Geog 158:287-333 (c, 1) S
'80
Life 4:92-3 (c, 1) Jl '81
--Royal family
Life 4:125-32 (c, 4) D '81
SAUDI ARABIA--MAPS
--Mecca area
Nat Geog 154:584-5 (c, 2) N
'78
SAUNAS
--Apache Indians (Arizona)
Nat Geog 157:284-5 (c, 1) F '80
SAVANNAH, GEORGIA
Trav/Holiday 151:53-4, 64 (c, 4)
F '79
--Harbor
Nat Geog 154:242 (c, 3) Ag '78
Life 2:60 (4) Mr '79
--Old Cotton Exchange
Trav/Holiday 154:48 (c, 2) O
'80
SAWMILLS
--19th cent. Mississippi
Natur Hist 90:34-5, 82 (4) Je
'81
--Oregon
Nat Geog 156:810-11 (c, 1) D
'79
--Vermont
Smithsonian 8:85 (c, 4) S '77
SAXOPHONE PLAYING
Ebony 33:148 (4) Ag '78
Trav/Holiday 155:53 (c, 4) F '81
Smithsonian 11:117 (c, 1) Mr '81
--1920's
Smithsonian 11:44 (4) Ag '80
SCALES
Ashanti gold weights (Ghana)
Natur Hist 89:71 (c, 4) Ja '00
--Doctor's scale
Ebony 34:110 (4) My '79
--Standing scale
Ebony 30:122 (c, 3) D '80
--Weighing baby (New Guinea)
Nat Geog 152:126 (c, 4) Jl '77
--Weighing child from hanging
scale (Somalia)
Life 4:40 (c, 3) Ap '81
SCALLOPS
Nat Geog 157:535 (c, 4) Ap '80
Life 3:10 (c, 4) Je '80
Nat Wildlife 19:37 (c, 4) D '80
SCARECROWS
Nat Wildlife 17:4 (c, 4) O '79
Trav/Holiday 154:cov. (c, 1) S
'80
--Keeping birds from polluted
water (Alberta)

Nat Geog 159:95 (c, 1) F '81SR
SCHLIEMANN, HEINRICH
Nat Geog 153:148 (painting, c, 4)
F '78
SCHOOLS
--19th cent. Groton
Am Heritage 31:98-105 (4) O '80
--Canal Zone High School, Panama
Ebony 33:48 (c, 4) Jl '78
--Chicago high school, Illinois
Ebony 34:52 (4) D '78
Life 4:102-12 (1) Mr '81
--Cleveland, Ohio
Ebony 36:106-15 (2) Ap '81
--Columbus, Indiana
Nat Geog 154:388-9 (c, 1) S '78
--Little Rock, Arkansas high school
(1957)
Ebony 36:106 (4) N '80
--One-room schoolhouse (Colorado)
Am Heritage 32:30-1 (c, 4) O '81
--One-room schoolhouse (Georgia)
Am Heritage 32:30 (c, 4) O '81
--One-room schoolhouse (Montana)
Sports Illus 53:39 (4) S 15 '80
--One-room schoolhouse (Nebraska)
Nat Geog 154:494-7 (c, 1) O '78
--One-room schoolhouse (Oregon)
Am Heritage 32:30 (c, 4) O '81
--Performing arts (North Carolina)
Smithsonian 11:cov., 54-65 (c, 1)
Mr '81
--Topeka, Kansas
Ebony 34:188 (4) My '79
--Underground, solar-heated school
(Virginia)
Smithsonian 9:104 (c, 2) F '79
Nat Geog 159:37 (c, 1) F '81SR
--See also CLASSROOMS; COLLEGES
AND UNIVERSITIES; DORMI-
TORIES
SCHWEITZER, ALBERT
Life 1:53 (4) D '78
Science. See ASTRONOMY; BIOL-
OGY; MEDICINE--PRACTICE;
OCEANOGRAPHY; PHRENOL-
OGY; SCIENTIFIC EXPERI-
MENTS; SCIENTISTS
SCIENCE FICTION
--Fanciful depictions of aliens
Smithsonian 9:48-50 (drawing, c, 2)
My '78
--Paranormal phenomena
Smithsonian 8:54-61 (c, 1) Mr
'78
SCIENTIFIC EXPERIMENTS
Ebony 32:36 (4) Mr '77
Ebony 34:109-12 (2) Ap '79

--Activities of National Bureau
of Standards
Smithsonian 9:42-51 (c, 1) S '78
--Analyzing effects of oil spills
Smithsonian 10:68-75 (c, 2) O
'79
--Bird migration research
Smithsonian 10:52-61 (c, 1) Je
'79
--Cloning research
Ebony 33:95-100 (4) Jl '78
--Cold and ice research
Smithsonian 11:102-11 (c, 1) F
'81
--Developing synthetic fuels
Nat Geog 159:75-93 (c, 1) F
'81SR
--Dissecting frog (Kansas high
school)
Life 2:91 (3) Je '79
--Evaluating perfumes for deodor-
ants
Sports Illus 55:76-7 (c, 2) O 26
'81
--Fusion
Smithsonian 11:128-36 (c, 1) D
'80
--High school (Houston, Texas)
Ebony 35:74-8 (3) Je '80
--Inhumane treatment of research
animals
Smithsonian 11:50-7 (c, 1) Ap
'80
--Interferon research
Life 2:55-62 (c, 3) Jl '79
--Investigating house heat loss
Nat Geog 159:48-9 (c, 3) F
'81SR
--National Institute of Health
activities
Smithsonian 10:42-51 (c, 1) Ag
'79
--Pesticide research
Life 4:129-34 (c, 1) O '81
--Pigeons communicating with sym-
bols
Smithsonian 11:28 (4) My '80
--Polygraph testing of sleepers
Smithsonian 9:84-95 (c, 1) N
'78
--Research on rats
Nat Geog 152:64-9 (c, 1) Jl '77
--Studying athletes' neuromuscular
functions
Smithsonian 11:66-75 (c, 1) Jl
'80
--Studying goldfish retina (Califor-
nia)

Nat Geog 160:763 (c, 4) D '81
--Testing Einstein's theory of rela-
tivity
Smithsonian 11:74-83 (c, 1) Ap
'80
--U. S. Geological Survey activities
Smithsonian 9:40-53 (c, 1) Mr '79
--Use of photography in research
Nat Geog 153:361-88 (c, 1) Mr
'78
--See also GENETICS; LABORA-
TORIES; MEDICAL RESEARCH
SCIENTIFIC INSTRUMENTS
--Aircraft control equipment
Nat Geog 152:212-33 (c, 1) Ag
'77
--Anti-gravity mass launcher
Smithsonian 12:36 (4) Ap '81
--Contact lens-making equipment
Ebony 36:54-6 (4) F '81
--Device for accelerating electrons
Ebony 35:27 (4) Mr '80
--Items from Burndy Library
Smithsonian 10:128-35 (c, 2) O
'79
--Linear accelerator
Smithsonian 12:83 (c, 3) O '81
--Linear accelerator (Maryland)
Smithsonian 9:91 (c, 3) O '78
--Neutron accelerator (Washington,
D. C.)
Ebony 35:60 (4) S '80
--Weather research tools
Smithsonian 10:84-7 (c, 4) Ap '79
--See also MEDICAL INSTRU-
MENTS; MICROSCOPES;
TELESCOPES
Scientists. See ARCHAEOLOGISTS;
CARVER, GEORGE WASHING-
TON; CUVIER, BARON
GEORGES; DARWIN, CHARLES;
EINSTEIN, ALBERT; GALI-
LEO; GODDARD, ROBERT
HUTCHINGS; LINNAEUS,
CAROLUS; MEAD, MAR-
GARET; OHM, GEORG SIMON;
OPPENHEIMER, J. ROBERT;
PALEONTOLOGISTS
SCOREBOARDS
--Baseball
Sports Illus 48:26 (c, 2) My 15
'78
Sports Illus 48:83 (c, 4) Je 19 '78
Sports Illus 51:39 (4) Jl 9 '79
Sports Illus 51:10-11 (c, 1) Ag 27
'79
Sports Illus 53:25 (c, 1) O 27 '80
Sports Illus 54:40-1 (c, 1) My 25

'81
--Football
Sports Illus 53:38-9 (4) S 8 '80
--Horse race
Sports Illus 53:26 (c, 4) O 20 '80
--Swimming competiton
Sports Illus 53:32 (c, 4) Ag 11
'80
SCORPION FLIES
Nat Wildlife 15:37 (c, 1) Ag '77
SCORPIONS
Nat Geog 156:630 (c, 4) N '79
Nat Geog 158:699 (c, 4) N '80
SCOTLAND, GREAT BRITAIN
Nat Geog 151:528-45 (c, 1) Ap
'77
Trav/Holiday 149:53-7 (c, 1) My
'78
Trav/Holiday 152:cov., 41-5,
79 (c, 1) S '79
--Isle of Bute golf course
Trav/Holiday 151:41 (c, 1) F '79
--John Paul Jones' birthplace
(Kirkbean)
Smithsonian 11:140 (c, 4) D '80
--St. Andrews
Sports Illus 49:44-53 (c, 1) Jl
10 '78
Sports Illus 50:80-1 (c, 1) F 15
'79
--See also EDINBURGH; GLAS-
GOW; HEBRIDES; LOCH
NESS; ORKNEY ISLANDS
SCOTLAND--COSTUME
Trav/Holiday 152:cov., 42-5,
79 (c, 1) S '79
--1890
Life 3:86-7 (c, 1) Ap '80
--Edinburgh guard
Trav/Holiday 155:47 (c, 1) Ja '81
--Gentleman fisherman
Nat Geog 160:602-3 (c, 1) N '81
--Golfers
Sports Illus 49:50-1 (c, 4) Jl 10
'78
--Kilt
Life 1:61 (c, 2) D '78
--St. Kildans, Hebrides
Smithsonian 11:143-56 (c, 2) Je
'80
--Traditional
Smithsonian 11:45 (4) Ag '80
SCOTLAND--SOCIAL LIFE AND
CUSTOMS
--Lifting the Dinnie and Inver
Stones
Sports Illus 51:44-6 (c, 2) N 5
'79

SCOTT, WINFIELD
Smithsonian 8:60-1 (1) Ag '77
SCRIMSHAW
Smithsonian 9:154 (c, 4) N '78
Nat Wildlife 19:12-17 (c, 1) F
'81
--Carving scrimshaw
Nat Wildlife 19:12 (c, 1) F '80
--Walrus tusks (Hawaii)
Nat Geog 159:291 (c, 4) Mr '81
Scuba diving. See SKIN DIVING
SCULPIN FISH
Nat Geog 151:580 (c, 4) Ap '77
Life 3:10 (c, 4) Je '80
SCULPTING
Smithsonian 8:48 (c, 4) Jl '77
--India
Trav/Holiday 153:60 (c, 4) Mr
'80
--Italy
Nat Geog 152:305 (c, 4) S '77
--Massachusetts
Nat Geog 155:576-7 (c, 2) Ap '79
SCULPTURE
--13th cent. sandstone (Africa)
Smithsonian 11:176 (c, 4) S '80
--14th cent. silver candelabrum
(Great Britain)
Nat Geog 160:294 (c, 1) S '81
--18th cent. Germany
Nat Geog 154:708 (c, 1) N '78
--19th cent. tombstones (Northeast)
Am Heritage 30:2, 42-55 (1) Ag
'79
--19th cent. U. S.
Am Heritage 31:26-7 (2) Ap '80
--Late 19th cent. U. S.
Smithsonian 11:108, 112 (c, 3)
My '80
--1882 jeweled St. George and
dragon (U. S. S. R.)
Smithsonian 9:10 (c, 2) Mr '79
--20th cent. tombstone adornments
by William Edmondson
Smithsonian 12:50-5 (c, 1) Ag '81
--Early 20th cent. life casts
Natur Hist 90:84-6 (3) Je '81
--Aztec (Mexico)
Nat Geog 158:705-70 (c, 1) D '80
--Black American works
Ebony 32:36 (4) F '77
--Corroded by acid rain (Kentucky)
Nat Geog 158:160 (c, 3) Ag '80
--Cow made of butter
Life 3:132 (c, 2) O '80
--Heiau idol, Kona, Hawaii
Travel 147:43 (c, 4) F '77
--Ivory carving (Japan)

Natur Hist 89:46-7, 69 (c, 1) S
'80
--Jade
Smithsonian 8:80-5 (c, 1) Ap '77
--Les Lannes fanciful practical
objects
Smithsonian 7:74-81 (c, 1) F '77
--Made of machinery (Indiana)
Nat Geog 154:382 (c, 1) S '78
--Modern
Nat Geog 154:693-9 (c, 1) N '78
Smithsonian 10:114-17 (c, 2)
Ap '79
Smithsonian 10:62-9 (c, 1) Je
'79
--Modern (California)
Smithsonian 10:86-91 (c, 1) Ja
'80
--Modern (North Carolina)
Smithsonian 9:89-95 (c, 2) Ja '79
--Modern (Yugoslavia)
Nat Geog 152:678 (c, 4) N '77
--Modern works on Chicago streets
Nat Geog 153:474-5 (c, 1) Ap
'78
--Mythical lions (Burma)
Trav/Holiday 153:44 (c, 2) Ap
'80
--New York City buildings, New
York
Smithsonian 11:103-7 (c, 1) Mr
'81
--Nigeria
Nat Geog 155:436-7 (c, 2) Mr
'79
--Isamu Noguchi
Smithsonian 9:cov. , 46-55 (c, 1)
Ap '78
--Office building plazas
Smithsonian 9:cov. , 54-5 (c, 1)
Ap '78
--Office building plazas (Philadel-
phia, Pennsylvania)
Ebony 34:44 (4) My '79
--Office building plazas (Los
Angeles, California)
Trav/Holiday 156:57 (c, 1) N '81
--Office plaza globe
Smithsonian 8:cov. (c, 1) Ja '78
--Oil roustabout (Tulsa, Oklahoma)
Trav/Holiday 156:52 (c, 1) Ag
'81
--Outdoor (Chicago, Illinois)
Ebony 33:154-6 (c, 3) O '78
--Pre-Columbian Mexico
Smithsonian 9:cov. , 52-9 (c, 1)
My '78
--Pre-Hispanic gold works

(Colombia)
Natur Hist 88:cov. , 36-52 (c, 1)
N '79
--Primitive (Rockefeller collection)
Smithsonian 9:cov. , 42-53 (c, 1)
O '78
--Prussian notable (Germany)
Life 4:11 (2) F '81
--Rainbow sculpture
Life 2:95-100 (c, 1) O '79
--Running Fence (California)
Life 2:195 (c, 2) D '79
--Salt (Poland)
Nat Geog 152:392-3 (c, 1) S '77
--Scrap iron (Washington, D. C.)
Smithsonian 9:26 (c, 4) Ja '79
--Michael Singer's nature art
Smithsonian 8:62-9 (c, 1) Ja '78
--David Smith
Smithsonian 7:68-75 (c, 1) Mr
'77
--Snow building (Japan)
Life 4:106-7 (c, 1) F '81
--Robert Tatin (France)
Smithsonian 9:110-17 (c, 1) F '79
--Peter Voulkos
Smithsonian 8:86-93 (c, 1) Mr '78
--See also HOUDON, JEAN AN-
TOINE; MONUMENTS; MOORE,
HENRY; RODIN, AUGUSTE;
SCRIMSHAW; WOOD CARVINGS
SCULPTURE--ANCIENT
--3100 B. C. stone sculpture (Malta)
Nat Geog 152:614 (c, 1) N '77
--3rd millennium, B. C. (Ebla,
Syria)
Nat Geog 154:735-56 (c, 1) D '78
--11th cent. B. C. bronze elephant
(China)
Smithsonian 9:111 (c, 4) Je '78
--7th cent. B. C. Boeotian figurine
Natur Hist 89:68, 98 (4) Ja '80
--5th cent. B. C. Greek bronzes
(Calabria, Italy)
Life 4:146-50 (c, 1) N '81
Smithsonian 12:124-31 (c, 1) N
'81
--4th cent. B. C. (Macedon, Greece)
Nat Geog 154:56-7, 62 (c, 1) Jl
'78
--2nd cent. B. C. Chinese clay
guards
Smithsonian 10:cov. , 38-51 (c, 1)
N '79
--2nd cent. greyhounds (Rome)
Smithsonian 8:113 (c, 2) N '77
--Aphrodisias, Turkey
Nat Geog 160:526-51 (c, 1) O '81

--Baluchistan
 Natur Hist 89:48 (c, 1) S '80
--Carthage
 Smithsonian 9:42-3 (c, 1) F '79
--Cave Buddhas (Yun-king, China)
 Smithsonian 10:54-63 (c, 1) Ap
 '79
--Celtic works
 Nat Geog 151:582-631 (c, 1) My
 '77
--China
 Nat Geog 153:cov. , 441-59 (c, 1)
 Ap '78
--Crete
 Nat Geog 153:146 (c, 4) F '78
--Cycladic figures (Crete)
 Nat Geog 159:214-15 (c, 1) F
 '81
--Egypt
 Nat Geog 151:292-309 (c, 1) Mr
 '77
--Gold (Peru)
 Smithsonian 8:84-91 (c, 1) D '77
--Nigerian bronzes
 Ebony 35:152-4 (c, 3) O '80
--Oldest known sculpture, of mam-
 moth ivory
 Trav/Holiday 149:8 (4) Ap '78
--Polyphemus & Ulysses (Rome)
 Nat Geog 159:730-1 (c, 1) Je
 '81
--Pompeii
 Natur Hist 88:51, 63 (c, 4) Ap
 '79
SEA ANEMONES
 Nat Geog 152:446 (c, 4) O '77
 Nat Geog 154:377 (c, 4) S '78
 Nat Geog 157:cov. , 529-31,
 544-7 (c, 1) Ap '80
 Nat Wildlife 18:10-11 (c, 1) Ap
 '80
 Life 3:9, 12 (c, 2) Je '80
 Nat Wildlife 19:34-5 (c, 1) D '80
SEA BATS
 Natur Hist 87:75 (c, 4) My '78
 Nat Geog 154:372 (c, 3) S '78
SEA COWS
 Natur Hist 87:9-17 (drawing, 3)
 N '78
 Natur Hist 88:cov. , 44-53 (c, 1)
 F '79
 Nat Wildlife 18:28-35 (c, 1) D
 '79
 Life 3:97-100 (c, 2) My '80
SEA CUCUMBERS
 Nat Geog 152:448 (c, 4) O '77
 Life 3:12 (c, 3) Je '80
 Nat Wildlife 19:13-15 (c, 1) Ap

'81
 Nat Geog 159:640 (c, 4) My '81
SEA HORSES
 Nat Geog 151:682 (c, 3) My '77
 Nat Geog 153:844 (c, 1) Je '78
 Nat Geog 157:408 (c, 4) Mr '80
 Nat Geog 158:30 (c, 4) Jl '80
SEA LILIES
 Smithsonian 8:116 (c, 4) O '77
 Smithsonian 9:86-9 (c, 1) My '78
 Natur Hist 88:58-69 (c, 1) Ja '79
 Nat Geog 159:658-9 (c, 1) My '81
Sea Lions. See SEALS
Sea Shells. See SHELLS
SEA URCHINS
 Nat Geog 157:526-8, 537 (c, 1)
 Ap '80
 Nat Geog 158:411 (c, 4) S '80
 Smithsonian 11:40-1 (c, 4) Ja '81
 Smithsonian 12:125 (c, 4) S '81
SEALS
 Nat Wildlife 15:62 (c, 4) Ja '77
 Nat Geog 152:245-53 (c, 1) Ag '77
 Smithsonian 8:46-7 (c, 4) D '77
 Nat Wildlife 16:54-5 (c, 1) Ap '78
 Nat Geog 153:682-3 (c, 1) My '78
 Nat Geog 154:367-9, 378-9 (c, 1)
 S '78
 Life 1:99 (c, 2) O '78
 Nat Geog 155:250-1 (c, 3) F '79
 Trav/Holiday 152:46 (c, 2) N '79
 Nat Geog 156:816-17 (c, 1) D '79
 Natur Hist 89:69 (c, 4) Mr '80
 Trav/Holiday 154:cov. (c, 1) Jl
 '80
 Nat Wildlife 20:53 (c, 3) D '81
--Balancing ball on its nose
 Trav/Holiday 150:48 (c, 2) N '78
--Elephant
 Nat Wildlife 15:2 (c, 2) Je '77
 Nat Wildlife 16:6-7 (c, 1) D '77
 Smithsonian 9:94-8 (c, 2) Ap '78
 Nat Wildlife 16:21-7 (c, 1) Je '78
 Trav/Holiday 152:61 (c, 4) S '79
--Elephant seal sunning on beach
 Nat Wildlife 18:8 (c, 3) Ap '80
--Fur seals
 Nat Wildlife 18:4-11 (c, 1) Je '80
 Trav/Holiday 154:22 (4) S '80
--Harbor
 Smithsonian 11:125 (c, 4) Jl '80
--Harp
 Sports Illus 46:80 (c, 4) Ap 18 '77
 Smithsonian 10:44-53 (c, 1) Jl '79
--Monk seals
 Natur Hist 86:78-83 (c, 1) O '77
SEALS AND EMBLEMS
--Ancient Indus Valley, Pakistan

Nat Geog 154:823 (c, 4) D '78
--C. I. A.
 Am Heritage 28:4-12 (c, 2) F
 '77
--National Wildlife Federation
 emblem
 Nat Wildlife 17:25 (drawing, c, 4)
 Ap '79
--Seals of government agencies
 (1880's)
 Am Heritage 30:62 (4) F '79
--Sumerian seal
 Nat Geog 154:806 (c, 4) D '78
--U. S. Army
 Ebony 35:45 (4) F '80
--U. S. Presidential seal
 Sports Illus 49:114 (drawing, c, 4)
 O 23 '78
--West Point coat of arms
 Am Heritage 29:6 (4) Je '78
SEANCES
--Puerto Rican (New York City)
 Natur Hist 86:71 (c, 4) Ag '77
SEARS TOWER, CHICAGO, ILLI-
 NOIS
 Ebony 32:76 (4) Ap '77
 Ebony 34:64 (2) N '78
SEASONS
--Louisiana swamp
 Nat Geog 156:390-1 (c, 2) S '79
--See also AUTUMN; SPRING;
 SUMMER; WINTER
SEATTLE, WASHINGTON
 Nat Geog 151:74-5, 80-1 (c, 1)
 Ja '77
 Nat Wildlife 16:5 (c, 1) F '78
 Smithsonian 9:108-9 (c, 4) Mr
 '79
 Ebony 34:40 (c, 4) My '79
 Trav/Holiday 153:51-2, 115
 (c, 2) F '80
 Smithsonian 12:85 (c, 2) My '81
 Ebony 36:58-9 (2) S '81
--1891 aerial map
 Am Heritage 30:cov., 114 (c, 1)
 F '79
--1932
 Smithsonian 8:116 (2) N '77
--Gas Works Park
 Smithsonian 8:116-20 (c, 2) N
 '77
--Harbor area
 Life 2:60 (4) Mr '79
--Space Needle
 Ebony 34:44 (4) My '79
 Trav/Holiday 153:52 (c, 4) F '80
--Yesler Way
 Smithsonian 10:14 (4) My '79

Seaweed. See KELP
SECURITY SYSTEMS
--Casino monitoring equipment
 (New Jersey)
 Life 2:34-5 (1) Ja '79
 Nat Geog 160:580 (c, 3) N '81
--Monitoring closed circuit TV
 system (Botswana)
 Nat Geog 155:92 (c, 4) Ja '79
SEEDS
 Natur Hist 87:57-69 (painting, c, 1)
 Ap '78
 Natur Hist 88:54-60 (c, 1) F '79
 Natur Hist 89:cov., 44 (c, 1) D
 '80
 Natur Hist 90:42-7 (painting, c, 2)
 D '81
SELEUCID CIVILIZATION (SYRIA)
--Dura Europus, Syria (300 B. C. -
 256 A. D.)
 Nat Geog 156:588-9 (c, 1) N '79
SEMINOLE INDIANS (FLORIDA)--
 COSTUME
--Councilor's costume
 Smithsonian 9:63 (c, 3) Ag '78
SENEGAL
 Trav/Holiday 148:38-43 (c, 1) N
 '77
 Ebony 33:168-9 (c, 4) O '78
SENEGAL--COSTUME
 Trav/Holiday 148:38-43 (c, 1) N
 '77
SEOUL, SOUTH KOREA
 Nat Geog 156:770-97 (map, c, 1)
 D '79
SEQUOIA TREES
 Nat Geog 156:18, 20-2 (1) Jl '79
 Life 4:134-5 (c, 1) Mr '81
SETTERS (DOGS)
 Sports Illus 49:85-6 (c, 4) N 20
 '78
 Sports Illus 51:85 (c, 4) D 10 '79
SEURAT, GEORGES
--The Models
 Smithsonian 11:155 (drawing, c, 4)
 O '80
--Paintings by him
 Smithsonian 11:59 (painting, c, 4)
 Je '80
SEVILLA, SPAIN
--April fair
 Trav/Holiday 149:42-7 (c, 1) F
 '78
--Holy Week ceremonies
 Natur Hist 87:44-55 (c, 1) Ap '78
Sewage Disposal. See SANITATION
 WORK
SEWARD, WILLIAM H.

Smithsonian 8:60-1 (1) Ag '77
Am Heritage 33:78 (painting, 4)
 D '81
SEWERS
--Manhole (Germany)
 Nat Geog 152:62 (c, 3) Jl '77
SEWING
 Nat Geog 152:178-9 (c, 1) Ag
 '77
--Ice Age needle
 Nat Geog 156:333 (c, 4) S '79
--See also GARMENT INDUSTRY;
 TAILORS
SEWING MACHINES
 Ebony 32:94 (4) Ap '77
 Ebony 32:120 (4) My '77
 Ebony 34:72 (4) Ap '79
 Ebony 35:68 (4) Ag '80
--1910's (Utah)
 Am Heritage 30:46-7 (1) Je '79
--China
 Nat Geog 159:180 (c, 4) F '81
--France
 Nat Geog 154:550-1 (c, 1) O '78
--Oman
 Nat Geog 160:358-9 (c, 1) S '81
--Senegal
 Trav/Holiday 148:40 (4) N '77
SEYCHELLES ISLANDS
 Sports Illus 50:58-64 (map, c, 1)
 F 5 '79
 Nat Geog 160:422-6, 438-9
 (map, c, 1) O '81
SEYCHELLES ISLANDS--COSTUME
 Nat Geog 160:422-3 (c, 1) O '81
SHAHN, BEN
--1920's paintings of prohibition
 Am Heritage 30:86-93 (c, 4) F
 '79
SHAKERS
--19th cent.
 Am Heritage 31:65-73 (c, 1) Ap
 '80
--Maine
 Nat Geog 151:744 (c, 1) Je '77
--Weaving (Kentucky)
 Trav/Holiday 155:61 (c, 4) Je
 '81
SHAKESPEARE, WILLIAM
--Birthplace (Stratford-on-Avon,
 England)
 Natur Hist 90:54-5 (painting, c, 1)
 Je '81
SHAMANS
--19th cent. shaman's rattle
 (Tlingits; Alaska)
 Smithsonian 8:112 (c, 3) N '77
--Huichol Indians (Mexico)

Nat Geog 151:837 (c, 3) Je '77
--Mexican (California)
 Nat Geog 157:795 (c, 2) Je '80
--Mexico
 Nat Geog 158:746-7 (c, 1) D '80
--Nepal
 Nat Geog 151:501, 510 (c, 1) Ap
 '77
SHANGHAI, CHINA
 Trav/Holiday 150:38 (c, 4) N '78
 Nat Geog 158:2-42 (map, c, 1)
 Jl '80
 Trav/Holiday 156:35-6 (c, 2) Jl
 '81
SHANNON RIVER, IRELAND
 Nat Geog 154:653-7, 676-7 (c, 1)
 N '78
SHARKS
 Sports Illus 46:76-9 (painting, c, 1)
 Ap 25 '77
 Natur Hist 87:76-81 (c, 1) Mr '78
 Nat Geog 158:422 (c, 3) S '80
 Life 3:124-5 (c, 1) O '80
 Nat Geog 160:138-87 (c, 1) Ag '81
--Antishark cage
 Nat Geog 160:149, 182-3 (c, 1)
 Ag '81
--Blue
 Nat Geog 159:cov., 664-7 (c, 1)
 My '81
--Reef
 Nat Geog 159:640 (c, 4) My '81
--Wrestling shark (Mexico)
 Travel 148:57 (4) S '77
SHAVING
 Life 1:87 (c, 4) O '78
 Life 1:14 (2) D '78
--Outdoors (1918)
 Smithsonian 9:94 (1) Je '78
SHEEP
 Natur Hist 86:34 (c, 1) My '77
 Natur Hist 86:52 (c, 1) O '77
 Sports Illus 49:100-1 (painting, c, 1)
 O 23 '78
 Nat Geog 154:631 (c, 4) N '78
 Life 1:98 (c, 4) D '78
 Life 2:46-8 (c, 2) Ag '79
 Nat Geog 156:245 (c, 1) Ag '79
 Natur Hist 88:62 (c, 4) Ag '79
 Smithsonian 11:87 (c, 4) Ag '80
 Natur Hist 89:96-7 (2) O '80
 Natur Hist 90:68-9 (c, 2) F '81
 Nat Wildlife 19:6-7 (c, 1) Ap '81
 Smithsonian 12:64 (c, 4) Je '81
 Nat Wildlife 20:60 (c, 4) D '81
--1740's sculpture (Scotland)
 Smithsonian 8:109 (c, 4) N '77
--Bighorn

--18th cent. shipwreck relics
Nat Geog 152:724-66 (c, 1) D
'77
--18th cent. Spanish
Nat Geog 156:850-76 (c, 1) D
'79
Am Heritage 31:35-46 (draw-
ing, c, 2) O '80
--19th cent. wrecks at Cape
Horn
Am Heritage 32:2, 102-7 (c, 1)
Je '81
--Late 19th cent. (Cornwall, Eng-
land)
Smithsonian 9:134-41 (2) O '78
--1904 fire on excursion steamer
"Slocum" (New York City)
Am Heritage 30:62-75 (1) O '79
--1913 (Oregon)
Am Heritage 29:64-5 (1) O '78
--1915 capsized steamer (Chicago,
Illinois)
Am Heritage 31:105 (3) D '79
--1940's attacks on U. S. ships
by German U-boats
Smithsonian 12:100-9 (paint-
ing, c, 2) N '81
--1942
Am Heritage 30:58 (drawing, 4)
Je '79
--1942 British shipwreck relics
Life 4:136-40 (c, 1) D '81
--1978 oil tanker (France)
Nat Geog 154:128-9 (c, 1) Jl '78
SHOE SHINING
--Georgia
Ebony 36:58 (4) D '80
--Yugoslavia
Smithsonian 10:93 (c, 4) D '79
Shoes. See FOOTWEAR
SHOOTING
--Clay pigeons (Texas)
Life 2:39 (4) O '79
--Glass-ball targets (Wyoming)
Nat Geog 160:82-3 (c, 1) Jl '81
--Revolver practice
Nat Geog 156:44-5 (c, 1) Jl '79
--Riflery practice and shooting
events
Am Heritage 29:4-17, 116 (c, 1)
F '78
--Rifles
Sports Illus 50:39 (drawing, c, 2)
Je 11 '79
--Trapshooting
Sports Illus 47:34 (c, 2) Ag 8 '77
--See also DUELS; GUNS
SHOPPING CENTERS

--1937
Smithsonian 11:112 (4) Ag '80
--Baltimore, Maryland
Life 3:91 (c, 4) S '80
--Chicago, Illinois
Trav/Holiday 155:59 (c, 4) Ap '81
--Houston, Texas
Travel 147:38 (c, 3) My '77
Nat Geog 157:471 (c, 1) Ap '80
--Kiawah Island, South Carolina
Trav/Holiday 153:60 (c, 4) Ap
'80
--Louisville, Kentucky
Trav/Holiday 151:54-5 (c, 4) Mr
'79
--Minneapolis, Minnesota
Nat Geog 158:673 (c, 3) N '80
--New Market, Philadelphia,
Pennsylvania
Trav/Holiday 152:49 (c, 4) Ag '79
--Pedestrian mall (Belfast, North-
ern Ireland)
Nat Geog 159:476 (c, 3) Ap '81
--Philadelphia, Pennsylvania
Smithsonian 9:75 (c, 1) Ja '79
--Saudi Arabia
Nat Geog 158:330-1 (c, 1) S '80
--Singapore
Nat Geog 159:559 (c, 3) Ap '81
--Sydney, Australia
Nat Geog 155:221 (c, 2) F '79
--Toronto, Ontario
Trav/Holiday 151:87 (4) Je '79
--Underground (Montreal, Quebec)
Trav/Holiday 151:54-5 (4) Ja '79
--Underground atrium (Toronto,
Ontario)
Smithsonian 11:34 (c, 4) Mr '81
SHOT-PUTTING
Sports Illus 46:14-15 (c, 1) Ja 24
'77
Sports Illus 47:56 (c, 4) Ag 22 '77
Sports Illus 50:33 (c, 1) Mr 26
'79
Sports Illus 50:23-4 (c, 2) My 7
'79
Sports Illus 51:58 (c, 4) Jl 2 '79
Sports Illus 52:48 (c, 4) Mr 3 '80
Sports Illus 53:22 (c, 4) Je 30 '80
Shoveling. See SNOW SHOVELING
SHREWS
Natur Hist 89:46-53 (c, 1) Ja '80
SHRIKES (BIRDS)
Smithsonian 10:39 (c, 4) Ag '79
SHRIMP INDUSTRY
--Belgium
Nat Geog 155:330-1 (c, 1) Mr '79
--Brine shrimp (California)

Smithsonian 11:46 (c, 4) F '81
--Georgia
 Nat Geog 154:240 (c, 4) Ag '78
--Mississippi
 Nat Geog 160:388-9 (c, 2) S
 '81
SHRIMPS
 Nat Geog 151:402-3 (c, 1) Mr
 '77
 Nat Geog 151:681 (c, 4) My '77
 Nat Geog 153:501 (c, 4) Ap '78
 Nat Geog 157:408-9 (c, 2) Mr
 '80
 Nat Geog 157:544-5 (c, 1) Ap
 '80
 Nat Geog 158:424-5 (c, 1) S '80
 Smithsonian 11:38-9 (c, 4) Ja
 '81
 Sports Illus 54:62-3 (c, 2) Mr
 23 '81
 Natur Hist 90:36-43 (c, 1) Jl '81
 Nat Geog 160:509 (c, 4) O '81
--Larvae
 Nat Geog 160:844 (c, 4) D '81
SIBERIA, U. S. S. R.
 Trav/Holiday 149:cov., 26-31
 (c, 1) My '78
--Constructing railroad
 Smithsonian 8:36-47 (map, c, 1)
 F '78
--See also LAKE BAYKAL
SIBERIAN HUSKIES
 Nat Geog 154:298-324 (c, 1) S
 '78
 Nat Geog 156:812-13 (c, 1) D
 '79
SICILY, ITALY
--Taormina
 Travel 148:46-9 (c, 1) Ag '77
--See also MT. ETNA; PALERMO
SIERRA LEONE
--Little Scarcies River
 Smithsonian 12:34 (c, 4) D '81
SIERRA LEONE--COSTUME
 Smithsonian 8:103 (c, 4) S '77
SIERRA NEVADA MOUNTAINS,
 CALIFORNIA
 Smithsonian 9:47-9 (c, 3) Mr '79
 Nat Geog 158:268-9 (c, 1) Ag
 '80
--Jawbone Creek
 Smithsonian 9:48-9 (c, 3) Mr '79
SIGN LANGUAGE
 Life 2:40 (4) F '79
--Teaching Ameslan to a gorilla
 Nat Geog 154:441-61 (c, 1) O
 '78
SIGNS AND SIGNBOARDS

--1980 winter Olympics (Lake
 Placid, New York)
 Trav/Holiday 152:61-3 (c, 4) N
 '79
--Anti-litter (Scotland)
 Nat Geog 151:765 (c, 4) Je '77
--Atlanta airport, Georgia
 Smithsonian 11:92-3 (c, 2) F '81
--Boone, North Carolina city limit
 sign
 Sports Illus 53:77 (c, 4) N 10 '80
--Bumper sticker (Arkansas)
 Nat Geog 153:398 (c, 4) Mr '78
--Directional post (Maine)
 Trav/Holiday 151:89 (4) F '79
--Florida golf course
 Sports Illus 53:70 (4) O 20 '80
--"For Sale" sign
 Natur Hist 86:52-3 (c, 4) Ag '77
 Ebony 34:69 (4) S '79
--Hanging shop sign (Bern, Switzer-
 land)
 Trav/Holiday 154:cov. (c, 1) O
 '80
--Historic plaque (New Orleans,
 Louisiana)
 Trav/Holiday 155:57 (c, 4) F '81
--"Hollywood" sign (California)
 Am Heritage 29:111 (4) O '78
 Ebony 33:33 (4) O '78
--Humorous signs
 Smithsonian 8:138-9 (4) N '77
--Malaysian border sign
 Nat Geog 151:637 (c, 4) My '77
--Mud sign (Utah)
 Sports Illus 55:54 (c, 4) O 5 '81
--Neon
 Am Heritage 30:94-105 (c, 1) Je
 '79
--Neon (Las Vegas, Nevada)
 Trav/Holiday 153:cov. (c, 1) Ja
 '80
--Neon (Osaka, Japan)
 Nat Geog 152:858-9 (c, 1) D '77
--Neon (U. S. S. R.)
 Smithsonian 10:150-3 (c, 2) O '79
--Neon sculpture (Atlanta, Georgia)
 Smithsonian 11:91 (c, 1) F '81
--New York City bus stop, New
 York
 Travel 148:38-9 (1) S '77
--Shellfish warning (Quebec)
 Nat Geog 157:620 (c, 4) My '80
--Shopping center (Nashville, Ten-
 nessee)
 Trav/Holiday 155:53 (4) Ap '81
--"Stop killing rhinos" (Kenya)
 Nat Geog 159:298 (c, 4) Mr '81

--Stop sign (Quebec)
 Nat Geog 151:439 (c, 1) Ap '77
--Stop signs
 Nat Geog 153:707 (c, 2) My '78
 Sports Illus 51:40-1 (c, 1) D 3
 '79
--Symbols used for clarity
 Smithsonian 8:108-17 (c, 3) D
 '77
--Tavern (Savannah, Georgia)
 Trav/Holiday 151:53 (c, 4) F '79
--Walking path signs (Luxembourg)
 Trav/Holiday 154:51 (c, 1) S '80
--See also BILLBOARDS; POSTERS;
 STREET SIGNS
SIGNS AND SYMBOLS
--Bald eagle as U.S. symbol
 Nat Wildlife 20:27-32 (c, 4) D
 '81
--Beehive as Utah's state symbol
 Smithsonian 12:165 (c, 4) Ap '81
--"Black" salute
 Ebony 35:160 (4) My '80
--Eagle emblem of Apollo moon
 mission
 Nat Wildlife 17:17 (4) D '78
--Freemasonry symbols
 Am Heritage 31:91-7 (c, 1) O
 '80
--Great seal of the U.S.
 Smithsonian 10:66 (drawing, 4)
 Ja '80
--Hand and arm gestures
 Natur Hist 88:114-21 (3) O '79
--Harmonious duality symbol
 (South Korea)
 Nat Geog 156:797 (c, 1) D '79
--Indian medicine wheels
 Nat Geog 151:140-5 (c, 1) Ja
 '77
--Infinity symbol
 Smithsonian 7:104-5 (drawing, c, 3)
 Mr '77
--Lexigram communication for the
 retarded
 Smithsonian 10:92 (c, 4) Ap '79
--Marks identifying silver pieces
 (Great Britain)
 Nat Geog 160:295 (c, 4) S '81
--Olympic symbols
 Sports Illus 46:cov., 16 (c, 1)
 F 21 '77
 Trav/Holiday 152:63 (4) N '79
--Pan-American Games 1979 (Puerto
 Rico)
 Sports Illus 51:18 (c, 4) Jl 23
 '79
--Rude arm gesture (Polish athlete)

Sports Illus 53:19 (c, 4) Ag 11
 '80
--Silver helmet (Orchid Island)
 Nat Geog 151:108-9 (c, 1) Ja '77
--Soviet hammer and sickle
 Nat Geog 154:271 (c, 4) Ag '78
--Symbols used for clarity
 Smithsonian 8:108-17 (c, 3) D '77
--Universal symbol of man
 Smithsonian 9:41 (drawing, c, 3)
 My '78
--Use of swastika through history
 Natur Hist 89:68-75 (c, 1) Ja
 '80
--Victory symbol
 Ebony 33:134 (3) O '78
--Waving arms (Florida)
 Smithsonian 7:70 (c, 4) Ja '77
--"We're number 1" signal
 Sports Illus 52:19 (c, 1) Ja 28 '80
SILHOUETTES
--Revolutionary War era
 Am Heritage 30:78-9 (3) Je '79
--19th cent. U.S.
 Smithsonian 9:160 (4) N '78
SILK INDUSTRY
--Factory (China)
 Life 2:48 (3) Mr '79
--Silkworms
 Trav/Holiday 156:39 (c, 3) Jl '81
--Sorting cocoons (China)
 Nat Geog 159:180 (c, 4) F '81
SILOS
--India
 Nat Geog 151:238-9 (c, 1) F '77
SILVER
 Nat Geog 160:280-312 (c, 1) S
 '81
SILVER MINES
--Peru
 Nat Geog 160:293 (c, 4) S '81
--World map of silver mines
 Nat Geog 160:286-7 (c, 3) S '81
SILVERWARE
 Nat Geog 160:280-1, 295-7, 312
 (c, 1) S '81
--17th cent. (Spain)
 Nat Geog 152:740-1 (c, 1) D '77
--19th cent. silver service
 Smithsonian 11:85 (c, 4) Mr '81
--1810 sauceboat (Philadelphia,
 Pennsylvania)
 Am Heritage 31:22-3 (c, 4) Ap
 '80
--Armenia
 Natur Hist 89:57 (c, 1) S '80
--Paul Revere's work
 Am Heritage 28:26-7 (4) Ap '77

SINGAPORE
Trav/Holiday 148:28, 31 (c, 2)
D '77
Trav/Holiday 154:42-7, 94
(map, c, 1) O '80
Nat Geog 159:540-61 (map, c, 1)
Ap '81
--Handicraft Centre
Trav/Holiday 148:35 (4) N '77
SINGAPORE--ART
--Handicraft Centre
Trav/Holiday 148:33-5 (c, 1) N
'77
SINGAPORE--COSTUME
Trav/Holiday 154:44 (c, 4) O '80
Nat Geog 159:542-61 (c, 1) Ap
'81
SINGAPORE--HOUSING
--Apartment building
Life 2:68-9 (c, 1) Ag '79
SINGERS
Ebony 32:149, 156-7 (c, 2) Mr
'77
Ebony 32:143 (3) My '77
Ebony 32:83-6 (4) Jl '77
Ebony 32:90-1 (1) S '77
Ebony 33:32-3, 165 (c, 2) My
'78
Ebony 33:cov. (c, 4) Jl '78
Ebony 33:90 (4) O '78
Trav/Holiday 151:80 (c, 2) My
'79
Ebony 34:103-5 (2) Je '79
Ebony 34:cov., 84-6, 140-2
(c, 1) Jl '79
Ebony 34:47-57 (c, 2) O '79
Ebony 35:131, 164 (c, 2) N '79
Ebony 35:107-8 (3) Ap '80
Ebony 35:42 (c, 3) My '80
Ebony 35:64 (3) O '80
Ebony 36:69-78 (2) Ja '81
Ebony 36:59-60 (4) Ap '81
Ebony 36:89, 94 (3) Jl '81
--Black celebrities
Ebony 35:74-90 (3) F '80
--Country music (Tennessee)
Nat Geog 153:693, 698 (c, 1) My
'78
Trav/Holiday 155:50 (c, 1) Ap
'81
--Disco group
Ebony 33:55 (4) Ap '78
--Female group
Ebony 33:170 (4) S '78
Ebony 35:70 (2) S '80
--Gospel
Ebony 32:98-100 (2) S '77
Ebony 33:55 (3) O '78

--Jazz festival (Rhode Island)
Ebony 35:94-8 (2) S '80
--Minstrel
Ebony 35:159, 162 (4) My '80
--Groups
Ebony 32:29, 36 (c, 2) Ja '77
Ebony 34:137 (3) F '79
Ebony 35:58 (3) Je '80
Ebony 36:45-6 (3) N '80
Ebony 36:144-6 (2) O '81
--See also ANDERSON, MARIAN;
CARUSO, ENRICO; CHOIRS;
CONCERTS; JACKSON,
MAHALIA; JOLSON, AL;
LIND, JENNY; PIAF, EDITH
SIOUX INDIANS
Am Heritage 28:27 (c, 4) Je '77
Ebony 33:45 (3) O '78
Smithsonian 9:111-28 (c, 2) D '78
--1860
Nat Geog 158:62 (3) Jl '80
--Oglala medicine man (South
Dakota)
Nat Geog 159:532 (c, 1) Ap '81
--See also SITTING BULL
SIOUX INDIANS--COSTUME
--19th cent.
Nat Geog 160:94-5 (2) Jl '81
--1905
Smithsonian 12:72-3 (2) Ap '81
SITKA, ALASKA
--19th and 20th cents.
Smithsonian 10:129, 134-6 (c, 4)
D '79
SITTING BULL
Smithsonian 9:26 (4) O '78
SKATEBOARDING
Sports Illus 46:30-1 (1) F 7 '77
Sports Illus 47.60-70 (4) N 21
'77
Sports Illus 48:35-8 (c, 1) Ap 24
'78
Ebony 34:73 (1) Mr '79
Ebony 35:66 (4) F '80
--California
Smithsonian 10:112-14 (c, 2) Mr
'80
--Minnesota
Nat Geog 158:668-9 (c, 1) N '80
SKATES (FISH)
Nat Geog 152:449 (c, 4) O '77
SKATING
Ebony 32:122-3, 126 (c, 4) F '77
--1878 (New York City, New York)
Am Heritage 32:94-5 (painting, c, 1)
Ap '81
--Shopping mall rink (Houston,
Texas)

'78
SKIING--CROSS-COUNTRY
 Trav/Holiday 150:48-51, 65
 (c, 1) D '78
 Sports Illus 49:44 (c, 3) D 11 '78
 Sports Illus 50:42-3 (c, 3) Ja 8
 '79
 Sports Illus 50:17 (c, 4) F 19
 '79
 Nat Wildlife 17:44-5 (c, 2) Je
 '79
 Nat Wildlife 18:4 (c, 1) D '79
--Aerial view (Switzerland)
 Smithsonian 10:108 (c, 2) Ap '79
--Alaska
 Sports Illus 48:22-3 (c, 3) Ja 16
 '78
--On roller skates
 Sports Illus 49:46 (c, 4) D 25
 '78
--Practicing cross-country on
 wheels (Alberta)
 Nat Geog 157:774 (c, 4) Je '80
--Wisconsin
 Sports Illus 46:44 (c, 4) Ja 3
 '77
SKIING--EDUCATION
--Japan
 Nat Geog 157:86-7 (c, 1) Ja '80
--Vermont
 Sports Illus 48:23-5 (c, 2) Ja
 2 '78
SKIING--HUMOR
--Olympics
 Sports Illus 52:32-7 (drawing, c, 1)
 Ja 28 '80
SKIING COMPETITIONS
 Sports Illus 50:22-3 (c, 3) Mr
 12 '79
--1980 Olympics (Lake Placid)
 Sports Illus 52:22-3 (c, 2) F 25
 '80
SKIMMERS (BIRDS)
 Nat Geog 159:168-9 (c, 1) F '81
SKIN DIVING
 Nat Geog 151:404 (c, 1) Mr '77
 Nat Geog 153:494, 522 (c, 1)
 Ap '78
 Nat Geog 153:768-92 (c, 1) Je
 '78
 Trav/Holiday 151:60 (c, 2) Ja
 '79
 Nat Geog 155:512-13 (c, 1) Ap
 '79
 Trav/Holiday 151:62, 65 (c, 2)
 Ap '79
 Smithsonian 10:54 (c, 1) Jl '79
 Nat Geog 156:411 (c, 2) S '79

 Trav/Holiday 153:71 (c, 3) F '80
 Trav/Holiday 154:44 (c, 2) Jl '80
 Nat Geog 159:200-3 (c, 1) F '81
 Trav/Holiday 156:46 (c, 4) N '81
--Chain-mail suit
 Nat Geog 159:cov., 664-7 (c, 1)
 My '81
--Diving suit
 Nat Geog 157:624-30 (c, 1) My
 '80
--Exploring 17th cent. shipwreck
 (St. Helena)
 Nat Geog 154:562-9 (c, 1) O '78
--Exploring 18th cent. Spanish
 shipwreck
 Am Heritage 31:35-46 (draw-
 ing, c, 2) O '80
--Exploring shipwrecks
 Nat Geog 152:724-66 (c, 1) D '77
 Smithsonian 8:92-9 (c, 1) F '78
--Searching for Loch Ness monster
 Nat Geog 151:758-77 (c, 1) Je
 '77
--Snorkeling (Haiti)
 Trav/Holiday 151:68 (4) F '79
--Underwater scuba trails (Virgin
 Islands)
 Trav/Holiday 149:30 (4) F '78
SKULLS
 Smithsonian 7:117 (c, 4) F '77
--Bones of massacred Cambodians
 Life 3:108-9 (1) Ja '80
--Camel ancestor
 Smithsonian 9:8 (4) Jl '78
--Headhunter's trophy (Malaysia)
 Nat Geog 151:654-5 (c, 1) My '77
--Neanderthal man
 Natur Hist 87:59 (c, 1) D '78
--Whale
 Smithsonian 10:148 (4) My '79
--See also MAN, PREHISTORIC;
 SKELETONS
SKUNK CABBAGE
 Nat Wildlife 17:2 (c, 1) F '79
 Natur Hist 88:43-7 (c, 1) Mr '79
SKUNKS
 Nat Wildlife 16:3, 18-21 (c, 1) O
 '78
SKYDIVING
 Life 2:9-14 (c, 1) S '79
 Sports Illus 52:30-1 (c, 2) My 12
 '80
Skyscrapers. See OFFICE BUILD-
 INGS
SLAVE CHAINS
--Manacles
 Smithsonian 9:145 (4) F '79
SLAVERY

--71 B. C. crucifixion of rebel
 slaves (Rome)
 Nat Geog 159:726-7 (paint-
 ing, c, 1) Je '81
--18th cent. barter beads and
 manillas
 Nat Geog 152:725-7 (c, 1) D '77
--18th cent. slave ship
 Nat Geog 152:730-1 (c, 2) D '77
--18th cent. slave whipping
 (Surinam)
 Natur Hist 90:58 (engraving, c, 3)
 S '81
SLAVERY--U. S.
 Am Heritage 30:40-9 (drawing, 1)
 O '79
--1773 tombstone of slave
 Natur Hist 86:36 (2) Je '77
--1850 daguerreotypes of slaves
 Am Heritage 28:5-11 (1) Je '77
--1862 Emancipation
 Am Heritage 32:74-83 (draw-
 ing, 3) D '80
--Black slave drivers
 Am Heritage 30:40-9 (drawing, 1)
 O '79
--Blacks serving Confederacy
 Smithsonian 9:95-101 (paint-
 ing, c, 1) Mr '79
--Blacks waiting for moment of
 emancipation
 Am Heritage 33:44 (painting, c, 2)
 D '81
--Engraving of kneeling slave
 Ebony 32:42 (4) F '77
--Slave cabins (Georgia)
 Natur Hist 88:8-30 (2) Ja '79
--Slave shack (Virginia)
 Ebony 32:58 (4) Je '77
--Tubman leading slaves to free-
 dom in Canada
 Ebony 32:164-5 (drawing, 2) Ag
 '77
SLEDS
--1926 baby sleigh
 Life 3:80 (4) Je '80
--Sleigh ride (Japan)
 Trav/Holiday 154:54-5 (c, 3)
 N '80
--Sleigh ride (Montreal, Quebec)
 Trav/Holiday 151:53 (c, 3) Ja
 '79
--Troikas (U. S. S. R.)
 Nat Geog 153:15 (c, 1) Ja '78
--See also DOG SLEDS
SLEEP
 Ebony 33:105 (2) Mr '78
--Child with teddy bear

Ebony 36:102 (4) Mr '81
--Napping on couch
 Life 3:30-1 (1) Jl '80
--Polygraph tests of sleepers
 Smithsonian 9:84-95 (c, 1) N '78
SLEEPING BAGS
 Nat Geog 155:386 (c, 1) Mr '79
 Nat Geog 156:30-1 (c, 1) Jl '79
Sleighs. See SLEDS
SLIME MOLDS
 Natur Hist 87:70-9, 100 (1) D
 '78
 Nat Geog 160:130-6 (c, 1) Jl '81
SLINGSHOTS
 Natur Hist 86:62 (c, 2) Mr '77
 Sports Illus 46:81 (c, 4) Je 13
 '77
SLOTHS
 Natur Hist 86:66-7, 72-3 (c, 1)
 Ja '77
 Smithsonian 8:103 (c, 4) O '77
 Smithsonian 10:71 (c, 4) S '79
 Smithsonian 11:46 (c, 4) Je '80
SLUGS (MOLLUSKS)
 Natur Hist 86:47-50 (c, 1) N '77
 Smithsonian 9:25 (c, 4) S '78
 Nat Geog 157:538-9 (c, 1) Ap '80
 Smithsonian 11:128 (drawing, 4)
 Ap '80
 Natur Hist 89:34-5 (c, 4) Jl '80
 Nat Geog 158:284 (c, 4) Ag '80
 Nat Geog 159:660-1 (c, 1) My '81
 Nat Wildlife 20:52 (c, 2) D '81
SLUMS
--Late 19th cent. Natchez, Mis-
 sissippi
 Am Heritage 29:20 (1) Je '78
--Early 20th cent. Pittsburgh,
 Pennsylvania
 Am Heritage 30:7-8 (4) F '79
--Abandoned and vandalized buildings
 Ebony 34:40, 49-54, 132 (3) Ag
 '79
--Boarded up storefronts (Chicago,
 Illinois)
 Ebony 33:86 (3) Ag '78
--Bombay, India
 Nat Geog 160:116-19, 128 (c, 1)
 Jl '81
--Brazil
 Natur Hist 87:66-7 (c, 2) Je '78
--Cape Town, South Africa
 Nat Geog 151:802-3 (c, 1) Je '77
--Dallas, Texas
 Smithsonian 9:60-9 (c, 1) N '78
--Mexico City, Mexico
 Nat Geog 153:637 (c, 1) My '78
--New York City, New York

Nat Geog 151:178-206 (c, 1) F
'77
Smithsonian 9:69 (c, 3) Ja '79
Ebony 36:36 (4) F '81
--New York City tenement fire
escapes
Nat Geog 160:320-1 (c, 1) S '81
--Newark, New Jersey
Nat Geog 160:586 (c, 1) N '81
--Panama
Ebony 33:46 (c, 4) Jl '78
--Street corner scene in ghetto
Ebony 33:97 (3) Ap '78
--Sugar camp (Hawaii)
Nat Geog 152:610-11 (c, 1) N
'77
--Venice, Italy
Smithsonian 8:46-7 (c, 2) N '77
SMALLPOX
Nat Geog 154:796-805 (c, 1) D
'78
--Viruses
Natur Hist 89:6 (4) My '80
SMITHSONIAN INSTITUTION,
WASHINGTON, D. C.
Smithsonian 7:123-30 (c, 1) Ja
'77
Trav/Holiday 150:24 (4) O '78
Smithsonian 9:31 (c, 2) D '78
--Air & Space exhibits
Nat Geog 153:818-37 (c, 1) Je
'78
--Hirshhorn sculpture garden
Smithsonian 12:241 (c, 4) O '81
--Maritime Hall
Smithsonian 9:152-7 (c, 1) N
'78
SMOG
--Los Angeles, California
Nat Geog 155:31 (c, 2) Ja '79
--Utah
Nat Geog 158:794-5 (c, 2) D '80
Smoking. See CIGAR SMOKING;
CIGARETTE SMOKING; PIPE
SMOKING
SNAILS
Nat Geog 151:569 (c, 4) Ap '77
Natur Hist 86:105-7 (c, 2) Ag
'77
Natur Hist 87:cov., 47-57 (c, 1)
D '78
Nat Geog 158:425 (c, 3) S '80
Nat Geog 158:564 (c, 4) O '80
Nat Wildlife 19:42-3 (c, 1) Ag
'81
--Cooked (France)
Nat Geog 153:810 (c, 4) Je '78
--Eating goby fish

Natur Hist 88:58-9 (c, 2) Ag '79
--Eating sea cucumber
Natur Hist 86:56 (c, 4) Ag '77
--Reproduction process
Natur Hist 86:105-7 (c, 2) Ag '77
SNAKE RIVER, PACIFIC NORTH-
WEST
Nat Geog 151:412 (c, 1) Mr '77
Am Heritage 28:13-23 (c, 1) Ap
'77
Nat Wildlife 15:42-3 (c, 1) Ag
'77
Trav/Holiday 152:51 (c, 3) Jl '79
Trav/Holiday 152:56-61 (c, 1) Ag
'79
SNAKES
Natur Hist 87:56-61 (c, 1) N '78
Nat Wildlife 19:50-5 (c, 1) Ap
'81
--Bull
Am Heritage 28:17 (c, 4) Ap '77
--Bullsnake eating bird's egg
Nat Wildlife 17:8 (c, 4) Je '79
--Coachwhips
Nat Wildlife 19:52 (c, 3) Ap '81
--Desert brown
Smithsonian 10:38 (c, 4) Ag '79
--Dried coin snakes
Nat Geog 158:30-1 (c, 2) Jl '80
--Model of ring-necked snake
Natur Hist 86:98-9 (c, 1) N '77
--Rat
Nat Geog 151:687 (c, 4) My '77
Smithsonian 8:111 (c, 1) O '77
Nat Wildlife 16:61 (c, 1) D '77
Smithsonian 10:124-7 (c, 1) O
'79
--Shedding skin
Natur Hist 89:64-70 (c, 1) F '80
--Shieldtails
Natur Hist 88:70-2 (c, 1) My '79
--Snake charmer (India)
Smithsonian 10:120-7 (c, 1) O '79
--Snake charmer (Morocco)
Trav/Holiday 150:34 (c, 4) O '78
--Snake trainer (Georgia)
Trav/Holiday 149:58 (c, 4) Je '78
--Water
Nat Geog 156:386-7 (c, 3) S '79
--See also ANACONDAS; BOA CON-
STRICTORS; COBRAS; CORAL
SNAKES; GARTER SNAKES;
KING SNAKES; PYTHONS;
RATTLESNAKES; VIPERS
SNAPDRAGONS
Natur Hist 90:63 (c, 4) Ag '81
SNAPPERS
--Red (dead)

Sports Illus 49:110 (4) O 9 '78
Ebony 34:55-60 (2) D '78
Sports Illus 49:18 (c, 3) D 18
 '78
Sports Illus 50:cov., 76-80
 (c, 1) My 21 '79
Sports Illus 51:18-19 (c, 3) Jl
 9 '79
Sports Illus 51:47 (c, 4) Ag 6
 '79
Sports Illus 51:28-30 (c, 2) S
 10 '79
Sports Illus 52:22-4 (c, 3) F
 18 '80
Sports Illus 52:36, 43 (2) Je
 9 '80
Sports Illus 52:63 (4) Je 23
 '80
Life 4:56-62 (c, 1) Ap '81
Sports Illus 55:70-3 (c, 4) O 5
 '81
--Celebrating
Sports Illus 51:28 (c, 4) S 10
 '79
Sports Illus 51:35 (c, 2) S 17
 '79
--Goal-tending
Sports Illus 52:86 (4) My 26
 '80
--Indoor
Sports Illus 54:40-1 (1) F 2
 '81
--Soccer Bowl 1977
Sports Illus 47:14-16 (c, 1) S
 5 '77
--Soccer Bowl 1980
Sports Illus 53:14-19 (c, 1) S
 29 '80
--World Cup 1978
Sports Illus 48:20-3 (c, 2) Je
 12 '78
Sports Illus 48:24-6 (c, 2) Je
 19 '78
Sports Illus 49:cov., 10-13 (c, 1)
 Jl 3 '78
SOCCER BALLS
Sports Illus 47:66 (4) O 24 '77
Sports Illus 50:71 (c, 4) Ap 30
 '79
SOCCER PLAYERS
Sports Illus 46:66 (4) Mr 14
 '77
SOCIAL SECURITY ADMINISTRA-
 TION
--1930's office
Am Heritage 30:41 (4) Ap '79
--History
Am Heritage 30:38-49 (3) Ap

 '79
SOCIETY ISLANDS
Nat Geog 155:844-69 (map, c, 1)
 Je '79
--See also TAHITI
SOD HOUSES
--19th cent. Kansas
Smithsonian 9:98 (drawing, 4) F
 '79
--19th cent. plains states
Natur Hist 86:48-53 (2) My '77
--1880's Nebraska
Smithsonian 11:146 (4) Ap '80
Smithsonian 11:87 (3) N '80
--Midwest
Natur Hist 87:75 (4) F '78
--Nebraska
Travel 148:50-1, 54 (1) Ag '77
SOFIA, BULGARIA
Nat Geog 158:94-101 (c, 1) Jl '80
SOFTBALL--AMATEUR
--Hitting
Sports Illus 50:98 (c, 4) My 28
 '79
--Running
Sports Illus 53:64 (c, 4) S 1 '80
--Pitching
Sports Illus 50:92-4 (c, 1) My 28
 '79
SOFTBALL--PROFESSIONAL
Sports Illus 46:66 (4) Je 13 '77
SOFTBALL PLAYERS
Sports Illus 53:66-8 (c, 4) S 1
 '80
Solar eclipses. See ECLIPSES
SOLAR ENERGY
--Arizona
Smithsonian 10:158-67 (c, 4) N '79
--Arizona hospital
Nat Geog 157:278-9 (c, 3) F '80
--California
Ebony 35:104-6 (3) My '80
--Cleaning solar panel (California)
Nat Wildlife 18:12 (c, 3) Je '80
--House (California)
Nat Geog 152:358 (c, 4) S '77
--Potential in U.S.
Nat Geog 159:68-9 (map, c, 1) F
 '81SR
--Solar collectors (underground
 Virginia school)
Smithsonian 9:104 (c, 2) F '79
Nat Geog 159:37 (c, 1) F '81SR
--Solar-heated houses
Life 3:48-54 (c, 1) Ja '80
--Solar panels
Nat Wildlife 17:21 (c, 4) F '79
Life 2:120-3 (c, 1) S '79

--Solar panels on houses
Nat Wildlife 16:41-3 (4) Ap '78
--Solar-powered plane
Smithsonian 11:74-6 (c, 3) F '81
--Solar-powered plane (California)
Nat Geog 159:41 (c, 3) F '81SR
--Use of silver
Nat Geog 160:290-1 (c, 1) S
'81
--Use of solar cells
Smithsonian 8:38-45 (c, 1) O '77
--Used on underground dwellings
Smithsonian 9:96-105 (c, 2) F
'79
Soldiers. See MILITARY COS-
TUME
SOLOMON ISLANDS
--Vella Lavella
Am Heritage 28:34-5 (3) Je '77
SOLOMON ISLANDS--MAPS
Am Heritage 28:34-5 (3) Je
'77
SOLZHENITSYN, ALEKSANDR
Life 2:39-48 (c, 1) N '79
SOMALIA
--Costume, lifestyle
Nat Geog 159:cov., 749-75
(map, c, 1) Je '81
--Ethiopian refugee camp
Life 4:36-46 (c, 1) Ap '81
SOMALIA--COSTUME
Nat Geog 159:749-75 (c, 1) Je
'81
SOMALIA--MAPS
Life 4:44 (c, 4) Ap '81
SORGHUM INDUSTRY
--Boiling cane (Ozarks)
Travel 148:43 (c, 4) Ag '77
SORREL
Smithsonian 8:95 (painting, c, 4)
Ap '77
Natur Hist 90:84 (c, 4) O '81
--Wood
Natur Hist 90:62-3 (c, 1) Ag '81
SOUTH
--Natchez Trace Parkway sites
Travel 148:52-7 (c, 1) O '77
--Outdoor activities
Trav/Holiday 155:75-6, 91
(c, 2) Mr '81
--Scenes of southern states
Trav/Holiday 154:54, 57 (c, 3)
Ag '80
--Summer festivals
Trav/Holiday 153:67-9 (c, 1) Mr
'80
SOUTH--MAPS
--1850's map of lower Mississippi

River
Natur Hist 90:36 (c, 2) Je '81
SOUTH AFRICA
Nat Geog 151:780-819 (map, c, 1)
Je '77
--1830's Zulu lands
Am Heritage 29:67-75 (drawing, 3)
F '78
--Coal liquefaction plant
Nat Geog 159:84-5 (c, 1) F '81SR
--Diamond mines
Nat Geog 155:88-9 (c, 2) Ja '79
--See also CAPE TOWN; JOHANNES-
BURG; KIMBERLEY
SOUTH AFRICA--COSTUME
Nat Geog 151:780-819 (c, 1) Je
'77
--Swazis
Nat Geog 153:46-61 (c, 1) Ja '78
--Zulus
Nat Geog 153:46-61 (c, 1) Ja '78
SOUTH AFRICA--HISTORY
--1838 Zulu-Boer War
Am Heritage 29:75-6 (paint-
ing, c, 2) F '78
--See also RHODES, CECIL
SOUTH AMERICA
--Amazon area wildlife
Smithsonian 8:100-11 (c, 1) O '77
SOUTH CAROLINA
--Coastal areas
Life 3:70-6 (c, 1) Jl '80
--Grand Strand coastal area
Travel 147:54-7 (c, 1) Je '77
--Island resort areas
Trav/Holiday 153:cov., 58-63,
95 (map, c, 1) Ap '80
--Oyotunji (West African village)
Ebony 33.86-94 (c, 2) Ja '78
--See also CHARLESTON
SOUTH DAKOTA
--Badlands
Travel 147:30-3 (4) Je '77
Nat Geog 159:524-39 (map, c, 1)
Ap '81
--Black Hills
Travel 147:30-3 (3) Je '77
Travel 148:76 (3) S '77
--Prairie land
Smithsonian 9:81 (c, 3) D '78
--See also BADLANDS NATIONAL
PARK; MOUNT RUSHMORE
South Korea. See KOREA (SOUTH)
SOUTH PACIFIC PEOPLES
--Fore tribe (Papua New Guinea)
Smithsonian 8:106-15 (c, 1) My
'77
--Gimi tribe (New Guinea)

--Golf
 Sports Illus 49:29 (c, 2) D 25
 '78
 Sports Illus 50:21 (c, 1) Je 25
 '79
--Hurling (Ireland)
 Nat Geog 159:452-3 (c, 1) Ap '81
--Soccer
 Sports Illus 47:48 (4) Ag 8 '77
 Sports Illus 52:24 (c, 4) F 18
 '80
 Sports Illus 54:68 (c, 4) Je 15
 '81
--Soccer (Albania)
 Nat Geog 158:534-5 (c, 1) O '80
--Soccer (Brazil)
 Nat Geog 153:250-1 (c, 2) F '78
--Swimming competition
 Sports Illus 51:23 (c, 2) Jl 16
 '79
SPECTATORS--HUMOR
--Baseball
 Sports Illus 52:62-70 (draw-
 ing, c, 1) Ap 28 '80
SPEECHMAKING
 Ebony 32:104 (3) F '77
 Ebony 33:78 (2) Ap '78
 Smithsonian 9:16 (c, 3) S '78
 Ebony 34:80 (4) N '78
 Ebony 34:105, 113 (2) Ag '79
 Ebony 35:53 (2) N '79
 Ebony 35:94-6 (2) F '80
 Ebony 35:152-4 (4) My '80
 Ebony 36:102 (4) Ap '81
 Nat Geog 159:475 (c, 4) Ap '81
--Evangelist preacher (New York)
 Nat Geog 151:198-9 (c, 1) F
 '77
--High school auditorium
 Sports Illus 47:44 (c, 4) S 26
 '77
--Jamaica political campaign
 Nat Geog 159:256 (c, 4) F '81
--Quebec
 Nat Geog 151:441 (c, 3) Ap '77
--Sydney, Australia park
 Nat Geog 155:218-9 (c, 2) F '79
SPERM WHALES
 Nat Wildlife 17:12-15 (paint-
 ing, c, 1) Ag '79
--Beached (Mexico)
 Life 2:138-9 (c, 1) Mr '79
SPHINX, EGYPT
 Am Heritage 28:49 (3) O '77
 Smithsonian 12:116 (c, 3) Ap '81
SPICES
 Trav/Holiday 156:61 (c, 4) S '81
SPIDERS

Smithsonian 9:66-75 (c, 1) O '78
Natur Hist 89:cov. , 56-61 (c, 1)
 Ja '80
Nat Geog 157:396-7 (c, 1) Mr '80
Nat Geog 158:564 (c, 4) O '80
Nat Geog 159:155 (c, 4) F '81
Natur Hist 90:68 (c, 1) Jl '81
--Crab
 Nat Wildlife 17:56 (c, 1) Ap '79
--Fisher spiders
 Smithsonian 11:78-83 (c, 1) Jl
 '80
--Jumping
 Nat Wildlife 18:21-4 (c, 1) F '80
--Webs
 Smithsonian 9:68-75 (c, 1) O '78
 Natur Hist 89:cov. , 56-60 (c, 1)
 Ja '80
--Wolf
 Nat Wildlife 15:32 (c, 4) O '77
 Nat Wildlife 16:43 (c, 4) Je '78
 Nat Wildlife 19:40 (c, 1) Ag '81
--See also TARANTULAS
SPIDERWORT PLANTS
 Nat Wildlife 17:8 (c, 4) Je '79
SPIES
--John Scobell and Carrie Lawton
 (Civil War)
 Ebony 33:73-81 (drawing, 2) O
 '78
--World War II German coding
 machine "Enigma"
 Am Heritage 32:110 (4) Ag '81
--See also BOYD, BELLE
SPINNING WHEELS
--Louisiana
 Natur Hist 87:100-1 (1) Mr '78
SPONGE INDUSTRY
--Florida
 Nat Geog 151:404-5 (c, 1) Mr '77
--Greece
 Smithsonian 8:51 (c, 4) Ap '77
SPONGES
 Nat Geog 151:392-407 (c, 1) Mr
 '77
 Smithsonian 9:97-102 (c, 1) D '78
SPOONBILLS
 Nat Geog 153:218-19 (c, 1) F '78
 Nat Geog 156:7-8 (c, 1) Jl '79
--Baby roseate
 Smithsonian 11:178 (c, 4) S '80
--Roseate
 Sports Illus 47:21 (painting, c, 3)
 Jl 11 '77
 Sports Illus 49:37 (c, 4) N 27 '78
 Sports Illus 53:92 (drawing, c, 2)
 N 10 '80
SPORTS

--Early 20th cent. winter sports
 (Lake Placid, N. Y.)
 Life 3:8-9 (1) F '80
--1954-1979
 Sports Illus 51:58-127 (c, 1)
 Ag 13 '79
--1976 events
 Sports Illus 46:special issue
 F '77
--1978 review
 Sports Illus 50:entire issue
 (c, 1) F 15 '79
--1979 review
 Sports Illus 52:entire issue
 (c, 1) Mr 10 '80
--Bull dancing (Ancient Crete)
 Nat Geog 153:168-9 (painting, c, 1)
 F '78
--Buzkashi (Afghanistan)
 Natur Hist 87:55-62 (c, 1) F
 '78
--Computer analysis of athletes'
 movements
 Sports Illus 47:53-7 (c, 1) Ag
 22 '77
--Floating in inner tubes (Califor-
 nia)
 Life 1:140-1 (c, 1) D '78
--Handsprinting
 Ebony 35:72-6 (3) N '79
--Hocker
 Sports Illus 47:40 (4) Ag 22 '77
--Human-powered speed champion-
 ships
 Sports Illus 48:31-3 (c, 1) My
 22 '78
--National Sports Festival 1978
 (Colorado)
 Sports Illus 49:20-3 (c, 3) Ag 7
 '78
--Nunchaku
 Sports Illus 54:47 (c, 4) Je 8 '81
--Recreational activities (Asia)
 Trav/Holiday 153:69 98 (o, 2) F
 '80
--Spartakiade festival (U. S. S. R.)
 Sports Illus 51:18-22 (c, 2) Ag
 6 '79
--Studying athletes' neuromuscular
 functions
 Smithsonian 11:66-75 (c, 1) Jl
 '80
--Summer athletic activities
 Travel 147:38-43 (c, 1) Ap '77
 Life 1:34-9 (c, 1) N '78
--Tractor pulling
 Sports Illus 47:29-32 (c, 1) Jl
 11 '77

--War game (New Hampshire)
 Sports Illus 55:64-8 (c, 2) O 19
 '81
--See also AIRPLANE FLYING;
 ARCHERY; ATHLETIC
 STUNTS; AUTOMOBILE RAC-
 ING; BALLOONING; BASE-
 BALL; BASKETBALL; BATON
 TWIRLING; BICYCLING; BIRD
 WATCHING; BOAT RACES;
 BOATING; BOBSLEDDING;
 BODYBUILDING; BOWLING;
 BOWLING, LAWN; BOXING;
 BULLFIGHTING; CALISTHEN-
 ICS; CAMPING; CANOEING;
 CHEERLEADERS; CLIFF
 DIVING; CRICKET PLAYING;
 CROQUET; CROSS-COUNTRY;
 CURLING; DISCUS THROW-
 ING; DIVING; EXERCISING;
 FENCING; FISHING; FOOT-
 BALL; GOLF; GYMNASIUMS;
 GYMNASTICS; HANDBALL;
 HANG GLIDING; HIGH JUMP-
 ING; HIKING; HOCKEY; HORSE
 JUMPING EVENTS; HORSE
 RACING; HORSEBACK RIDING;
 HUNTING; HURDLING; HURL
 ING; ICE CLIMBING; ICE
 FISHING; JAI ALAI; JOUST-
 ING; JUDO; JUMPING; KARATE;
 LACROSSE; LOGROLLING;
 MOUNTAIN CLIMBING; PARA-
 CHUTING; POLE VAULTING;
 RACQUETBALL; ROCK CLIMB-
 ING; ROLLER SKATING;
 ROWING; RUGBY; RUNNING;
 SHOOTING; SKATEBOARDING;
 SKATING; SKATING, FIGURE;
 SKATING, SPEED; SKIING;
 SKIING--CROSS COUNTRY;
 SKIN DIVING; SKYDIVING;
 SNOWMOBILING; SOAP BOX
 DERBIES; SOCCER, SOFT-
 BALL; SPECTATORS; SPORTS
 ARENAS; SQUASH; STADIUMS;
 SURFING; SWIMMING; TABLE
 TENNIS; TENNIS; TOBAGGAN-
 ING; TRACK; TRACK AND
 FIELD--MEETS; TROPHIES;
 VOLLEYBALL; WALKING;
 WATER POLO; WATER SKI-
 ING; WEIGHT LIFTING;
 WRESTLING; YOGA
SPORTS ANNOUNCERS
 Sports Illus 49:37-9 (c, 1) S 18
 '78
 Sports Illus 50:53 (4) Je 11 '79

Nat Wildlife 19:32 (c, 4) D '80
Nat Wildlife 19:56 (c, 1) Ap '81
Smithsonian 12:111 (paint-
ing, c, 4) S '81
--Fox
Nat Wildlife 17:64 (c, 1) D '78
Nat Wildlife 19:54 (c, 4) O '81
--In tree trunk
Nat Geog 159:370 (c, 2) Mr '81
--See also FLYING SQUIRRELS
SRI LANKA
Nat Geog 155:122-49 (map, c, 1)
Ja '79
--See also COLOMBO
SRI LANKA--COSTUME
Nat Geog 155:124-46 (c, 1) Ja
'79
--Miners
Smithsonian 11:69, 72 (c, 4) Je
'80
--Tovil performers
Natur Hist 87:cov., 43-9 (c, 1)
Ja '78
STABLES
Sports Illus 52:24-6 (c, 2) My
5 '80
--Arkansas
Nat Geog 151:354 (c, 1) Mr '77
--Kentucky
Ebony 33:46 (4) S '78
STADIUMS
--Air Force Academy, Colorado
Springs, Colorado
Trav/Holiday 150:64 (c, 3) N
'78
--Arlington, Texas
Sports Illus 52:66-7 (c, 1) Ap
7 '80
Astrodome, Houston, Texas
Ebony 33:142 (4) Jl '78
Life 3:66-7 (c, 1) Ja '80
--Atlanta, Georgia
Sports Illus 46:74-5 (c, 2) Mr
21 '77
Ebony 32:52-3 (1) Jl '77
--Baltimore, Maryland (1897)
Smithsonian 10:156 (4) O '79
--Baseball field (Massachusetts)
Sports Illus 55:12-13 (c, 1)
Jl 6 '81
--Bleachers
Sports Illus 50:34 (c, 2) Mr 26
'79
--Busch, St. Louis, Missouri
Sports Illus 51:10-11 (c, 1) Ag
27 '79
--Checkerdome, St. Louis, Mis-
souri

Sports Illus 52:22-3 (c, 3) F 18
'80
--Comiskey Park, Chicago, Illinois
Sports Illus 53:49 (painting, c, 3)
Jl 7 '80
--County, Milwaukee, Wisconsin
Sports Illus 52:60-1 (c, 1) Ap 7
'80
--Dodger, Los Angeles, California
Sports Illus 47:37 (c, 1) S 26 '77
--Fenway Park, Boston, Massachu-
setts
Sports Illus 53:50-1 (painting, c, 1)
Jl 7 '80
--Fenway Park seats, Boston, Mas-
sachusetts
Sports Illus 52:58-9 (c, 1) Ap 7
'80
--Football
Sports Illus 55:62-9 (c, 1) S 7 '81
--Football (Alabama)
Sports Illus 55:94-8 (c, 1) N 23
'81
--Football (University of Colorado)
Sports Illus 53:30 (c, 3) O 6 '80
--Harvard University, Cambridge,
Massachusetts
Sports Illus 55:84-8 (painting, c, 1)
N 16 '81
--Robert F. Kennedy Stadium, Wash-
ington, D. C.
Sports Illus 51:68 (c, 4) Jl 2 '79
--Lenin, Moscow, U. S. S. R.
Life 2:90 (c, 4) Jl '79
Sports Illus 51:18-19 (c, 2) Ag 6
'79
--Liberty Bowl Memorial, Memphis,
Tennessee
Trav/Holiday 149:46 (4) Ja '78
--Maracana, Rio de Janeiro, Brazil
Nat Geog 153:251 (c, 3) F '78
--Municipal, Cleveland, Ohio
Sports Illus 53:48-9 (painting, c, 1)
Jl 7 '80
--Olympic Stadium, Montreal, Que-
bec
Sports Illus 51:20-1 (c, 4) Jl 16
'79
--Pinar del Rio, Cuba
Sports Illus 46:71 (c, 4) Je 6 '77
--Riverfront vendor (Cincinnati,
Ohio)
Nat Geog 151:253 (c, 3) F '77
--Schaefer, Foxboro, Massachusetts
Sports Illus 51:48 (c, 4) Ag 6 '79
--Seats (Detroit, Michigan)
Sports Illus 48:26 (c, 4) Ap 24 '78
--Shea, Queens, New York

Sports Illus 52:25 (c, 3) Je 2
'80
Sports Illus 54:20-1 (c, 2) Je 22
'81
--Souvenir stand
Sports Illus 54:18 (c, 4) Je 22
'81
--Souvenir stand (Fenway Park,
Boston, Massachusetts)
Trav/Holiday 150:58 (c, 4) O
'78
--Souvenir stand (Metropolitan,
Bloomington, Minnesota)
Sports Illus 52:62-3 (c, 1) Ap
7 '80
--Superdome, New Orleans,
Louisiana
Sports Illus 48:16-17 (c, 1) Ja
23 '78
Nat Geog 153:214 (c, 3) F '78
Sports Illus 54:52 (c, 4) Ja 19
'81
--Superdome interior, New Or-
leans, Louisiana
Ebony 34:104 (2) Ag '79
--Tiger, Detroit, Michigan
Sports Illus 53:47 (painting, c, 1)
Jl 7 '80
--Wrigley Field, Chicago, Illinois
Sports Illus 51:8-12 (c, 1) Ag
20 '79
Sports Illus 53:52 (painting, c, 1)
Jl 7 '80
--Yankee, Bronx, New York
Sports Illus 47:122-4 (c, 1) O
10 '77
Sports Illus 52:56-7 (c, 1) Mr
3 '80
--See also SCOREBOARDS; SPORTS
ARENAS; TENNIS STADIUMS
STAGECOACHES
Travel 147:80 (4) My '77
Travel 147:33 (4) Je '77
Am Heritage 28:27 (painting, c, 3)
O '77
--Drivers
Am Heritage 29:cov. (painting, c, 1)
F '78
STAINED GLASS
--19th cent. (Arkansas)
Nat Geog 153:406 (c, 1) Mr '78
--Late 19th cent. U. S.
Smithsonian 11:109 (c, 3) My '80
--1905 Tiffany scene
Am Heritage 31:29 (c, 4) Ap '80
--Australian museum
Trav/Holiday 155:79 (c, 4) F '81
--Canterbury Cathedral, England

Life 4:172 (c, 1) D '81
--Chartres Cathedral, France
Smithsonian 10:78-9 (c, 2) Je '79
--Dallas chapel, Texas
Trav/Holiday 149:60 (c, 4) Ap '78
--St. Patrick's Church, Toledo,
Ohio
Am Heritage 32:31 (c, 4) D '80
--Washington Cathedral, D. C.
Nat Geog 157:553, 568-9 (c, 1)
Ap '80
--Window
Smithsonian 8:82-9 (c, 1) F '78
STAIRCASES
Natur Hist 90:76-7 (c, 4) Jl '81
--18th cent. house (Massachusetts)
Life 3:160 (c, 1) N '80
--19th cent. (Arkansas)
Nat Geog 153:406 (c, 1) Mr '78
--Leading to church (Macau)
Travel 147:34 (c, 2) F '77
--Lowell, Massachusetts mill
Life 3:90 (c, 4) Jl '80
--Massachusetts mansion
Ebony 36:61 (c, 3) O '81
--Whitney Museum, New York City,
New York
Smithsonian 11:93 (4) Ag '80
STALIN, JOSEPH
Am Heritage 28:11 (4) Ag '77
Am Heritage 31:47 (3) Je '80
--Funeral (1953)
Am Heritage 28:15 (4) Ag '77
Stamps. See POSTAGE STAMPS
STANLEY, HENRY M.
Am Heritage 29:66 (4) O '78
STARFISH
Natur Hist 86:44-5 (c, 1) My '77
Nat Wildlife 15:16 (c, 4) O '77
Natur Hist 88:66 (c, 3) Ag '79
Nat Geog 157:546-51 (c, 1) Ap
'80
Smithsonian 11:36-7 (c, 1) Ja '81
Smithsonian 12:124 (c, 4) S '81
STARS
--Ancient Roman catacomb painting
Smithsonian 11:158-9 (c, 2) Je
'80
--Black hole
Life 2:168 (c, 4) D '79
--Computer photograph
Nat Geog 153:361-2 (c, 1) Mr '78
--SS433
Smithsonian 11:30 (c, 4) S '80
--Supernova
Smithsonian 11:110-14 (c, 2) S
'80
--See also CONSTELLATIONS

Starvation. See MALNUTRITION
Statesmen. See ACHESON, DEAN;
BRYAN, WILLIAM JEN-
NINGS; BRYCE, JAMES;
CALHOUN, JOHN; CHAND-
LER, ZACHARIAH; CHURCH-
ILL, WINSTON; CLAY,
HENRY; CLEMENCEAU,
GEORGES; DAVIS, JEFFER-
SON; DOUGLAS, STEPHEN;
DULLES, JOHN FOSTER;
FISH, HAMILTON; FOR-
RESTAL, JAMES V. ;
FRANKLIN, BENJAMIN;
FREMONT, JOHN C. ; GOR-
HAM, NATHANIEL; HAMIL-
TON, ALEXANDER; HAMP-
TON, WADE; HANCOCK,
JOHN; HANSON, JOHN;
HARRIMAN, W. AVERELL;
HAY, JOHN; HISS, ALGER;
HUGHES, CHARLES EVANS;
HUMPHREY, HUBERT;
HUNTINGTON, SAMUEL;
JAY, JOHN; KENNAN,
GEORGE; LA GUARDIA,
FIORELLO; LEE, RICHARD
HENRY; LONG, HUEY;
MARSHALL, GEORGE C.;
McCARTHY, JOSEPH;
McKEAN, THOMAS; MIF-
FLIN, THOMAS; REVERE,
PAUL; RHODES, CECIL;
ROCKEFELLER, NELSON;
ROTHSCHILD, NATHAN
MAYER; RUSH, BENJAMIN;
ST. CLAIR, ARTHUR;
SEWARD, WILLIAM H. ;
STEVENSON, ADLAI; SUM-
NER, CHARLES; TALLEY-
RAND, CHARLES MAURICE;
TWEED, WILLIAM M. ;
WEBSTER, DANIEL
Statue of Liberty. See LIBERTY,
STATUE OF
Statues. See MONUMENTS;
SCULPTURE
STEAMBOATS
Nat Geog 151:269 (c, 4) F '77
--1853 (Missouri)
Am Heritage 31:111 (3) Je '80
--1870 (Mississippi)
Am Heritage 29:18-19 (1) Je
'78
--1870 Mississippi River race
Am Heritage 31:96-103 (c, 1)
F '80
--1893 excursion steamer (New

York City)
Am Heritage 30:62-3 (1) O '79
--1908
Trav/Holiday 155:24 (4) Je '81
--Kentucky
Trav/Holiday 151:53, 68 (c, 1)
Mr '79
--Louisiana
Trav/Holiday 154:14 (4) Jl '80
--Louisville, Kentucky
Trav/Holiday 155:76 (c, 4) Mr '81
--Ohio
Trav/Holiday 152:52 (c, 2) S '79
--Sternwheeler (New York)
Smithsonian 12:80 (c, 3) Je '81
STEEL INDUSTRY
--Early 20th cent. steel workers
Am Heritage 30:34-7 (1) Ag '79
--Filling ingot molds (West Ger-
many)
Nat Geog 152:152-3 (c, 1) Ag '77
--Pennsylvania
Nat Geog 153:744-5 (c, 1) Je '78
--See also MILLS
STEIN, GERTRUDE
--Tomb (Paris, France)
Smithsonian 9:110 (c, 4) N '78
STEVENSON, ADLAI
Am Heritage 28:89 (4) Ag '77
Am Heritage 33:14 (4) D '81
STEVENSON, ROBERT LOUIS
Nat Geog 154:535, 561 (paint-
ing, c, 4) O '78
--Illustrations from "Travel with a
Donkey"
Nat Geog 154:534-53 (drawing, 1)
O '78
--Plaque on his house (Adirondacks,
New York)
Sports Illus 52:66 (c, 4) Ja 28
'80
STICKLEBACK FISH
Natur Hist 88:cov., 33-5 (c, 1)
D '79
STILTS (BIRDS)
Nat Wildlife 15:44-5 (c, 4) Je '77
Nat Geog 159:820 (c, 3) Je '81
Natur Hist 90:46-9 (c, 1) Ag '81
STINKBUGS
Smithsonian 8:85 (c, 4) N '77
STOCK EXCHANGES
--Brazil futures trading
Nat Geog 153:27 (c, 2) F '78
--Commodities exchanges (Chicago,
Illinois)
Ebony 36:98 (2) Jl '81
--Commodities exchanges (New York
City, N.Y.)

Life 2:33-4 (c, 2) F '79
--Shirts (British Columbia)
 Nat Geog 154:485 (c, 1) O '78
--Shoes
 Sports Illus 54:82 (c, 4) Ap 6
 '81
--Shoes (Chicago, Illinois)
 Ebony 34:72-8 (2) D '78
--Shopping street (Aalborg, Den-
 mark)
 Trav/Holiday 154:47 (c, 3) Ag
 '80
--South Korea
 Trav/Holiday 156:45 (c, 2) S '81
--Sporting goods (Denver, Colo-
 rado)
 Nat Geog 155:386-7 (c, 1) Mr
 '79
--Tobacco shop (North Carolina)
 Travel 147:48 (c, 1) My '77
--Underground bookstore (Minne-
 sota)
 Smithsonian 9:105 (c, 2) F '79
--Variety store
 Ebony 34:98 (3) My '79
--Women's clothing (Bombay, In-
 dia)
 Nat Geog 160:112-13 (c, 3) Jl
 '81
--See also FLEA MARKETS; FOOD
 MARKETS; MARKETS; PHAR-
 MACIES; RESTAURANTS;
 SHOPPING CENTERS; STREET
 VENDORS
STORKS
 Natur Hist 90:cov. (painting, c, 1)
 Je '81
 Smithsonian 12:60 (c, 4) O '81
STORMS
 At sea (Alaska)
 Nat Geog 155:266-7 (c, 2) F '79
--At sea (California)
 Nat Geog 152:338-9 (c, 2) S '77
--Midwestern Plains
 Natur Hist 90:54-5 (c, 1) N '81
--Ship hit by wave (1942)
 Smithsonian 9:18 (4) My '78
--Threatening sky (Texas)
 Nat Geog 156:208-9 (c, 1) Ag
 '79
--Thunder and lightning storms
 Smithsonian 10:74-81 (c, 1)
 Ag '79
--Waves threatening ships
 Smithsonian 8:60-7 (c, 1) F '78
--See also DUST STORMS; SNOW
 STORMS
STORMS--DAMAGE

--Malibu, California cottages
 Life 3:136-7 (c, 1) Ap '80
Stoves. See KITCHENS
STOWE, HARRIET BEECHER
 Smithsonian 8:65 (4) Ag '77
--19th cent. statue of Uncle Tom
 and Little Eva
 Nat Geog 159:355 (c, 3) Mr '81
STRATFORD-ON-AVON, ENGLAND
--Shakespeare's birthplace
 Natur Hist 90:54-5 (painting, c, 1)
 Je '81
STRAUSS, JOHANN
--Monument (Vienna, Austria)
 Trav/Holiday 151:47 (c, 4) Mr
 '79
STRAWBERRIES
 Travel 147:10 (drawing, c, 4) F
 '77
 Travel 147:66 (c, 1) Ap '77
 Ebony 34:125-35 (c, 2) My '79
STRAWBERRY INDUSTRY--
 HARVESTING
--Bulgaria
 Nat Geog 158:111 (c, 4) Jl '80
--California
 Nat Geog 160:768 (c, 4) D '81
--Children picking strawberries
 (Prince Edward Island)
 Trav/Holiday 151:53 (c, 4) My
 '79
STREAKING
--1975 (Great Britain)
 Life 2:198 (2) D '79
STREAMS
--Adirondack Mountains, New York
 Natur Hist 90:58-9 (c, 1) F '81
STREET LIGHTS
--British Columbia
 Nat Geog 154:477 (c, 1) O '78
--Franklin, Louisiana
 Nat Geog 153:208 (c, 3) F '78
--Gas lamp (Rhode Island)
 Trav/Holiday 149:39 (4) Ap '78
--Gas lamps (Prague, Czecho-
 slovakia)
 Nat Geog 155:548 (c, 4) Ap '79
--Gas-fired (New Jersey)
 Smithsonian 9:130-1 (c, 1) S '78
--Gaslight post (Massachusetts)
 Smithsonian 12:69 (c, 1) Ap '81
--Lamppost (New Orleans, Louisi-
 ana)
 Natur Hist 86:50 (c, 1) F '77
Street musicians. See MUSICIANS
STREET SIGNS
--Kangaroo crossing (Australia)
 Nat Geog 155:200 (c, 4) F '79

--Stenciled backwards (Virgin
Islands)
Nat Geog 159:238-9 (c, 2) F
'81
--"Walk" light (California)
Ebony 33:120 (4) D '77
STREET VENDORS
--1895 oyster cart (New York
City, New York)
Am Heritage 31:72 (4) F '80
--Black market toiletries (Le-
banon)
Life 3:32 (c, 4) S '80
--Doughnuts (Colombia)
Trav/Holiday 152:65 (c, 4) Ag
'79
--Fish (Japan)
Nat Geog 152:838-9 (c, 1) D
'77
--Football game
Sports Illus 55:68 (c, 1) S 7
'81
--Hand-carved miniature vendor
carts (Venezuela)
Trav/Holiday 156:52 (c, 2) S
'81
--Lemonade stand (Ohio)
Nat Geog 154:89 (c, 4) Jl '78
--New York City festival, New
York
Natur Hist 88:83 (c, 4) Ag '79
--Silversmith (Morocco)
Trav/Holiday 150:37 (c, 3) O
'78
--Sports stadium (U. S. S. R.)
Sports Illus 51:20 (c, 4) Ag 6
'79
Streetcars. See TROLLEY CARS
STROKES
--Diagram of blood clot
Sports Illus 53:14 (c, 4) Ag 18
'80
--Photograph of aneurysm rup-
turing
Life 2:61-2 (c, 2) My '79
--Treatment
Ebony 34:106-20 (2) My '79
STUART, GILBERT
--Portraits of George and Martha
Washington
Am Heritage 31:cov. , 3, 114
(painting, c, 1) F '80
Studying. See COLLEGE LIFE;
READING
STURGEONS
Sports Illus 51:52, 55 (c, 4)
Jl 30 '79
--Dead

Nat Geog 153:71 (c, 1) Ja '78
SUBMARINES
Nat Geog 151:81 (c, 4) Ja '77
Trav/Holiday 150:48 (c, 4) N '78
Natur Hist 89:6 (3) Ja '80
--1776 model
Am Heritage 32:33-7 (4) D '80
--19th cent.
Am Heritage 32:39-40 (4) D '80
--1940's German U-boats
Smithsonian 12:100-9 (painting, c, 2)
N '81
--Nuclear
Life 2:120-1 (1) My '79
--Research (Hawaii)
Nat Geog 157:626-9 (c, 1) My '80
--World War II Pacific Theater
Am Heritage 32:32, 45-55 (c, 1)
D '80
Submersibles. See OCEAN CRAFT
Suburbia. See HOUSING DEVELOP-
MENTS
SUBWAYS
--Atlanta, Georgia
Trav/Holiday 153:59 (c, 4) F '80
Smithsonian 11:93 (c, 4) F '81
--Elevated (Chicago, Illinois)
Nat Geog 153:482 (c, 1) Ap '78
--Montreal, Quebec
Trav/Holiday 151:54-5 (3) Ja
'79
--Moscow, U. S. S. R.
Nat Geog 153:43 (c, 1) Ja '78
--New York City, New York
Life 2:38-44 (1) Jl '79
Nat Geog 160:324-5 (c, 1) S '81
--Prague, Czechoslovakia
Trav/Holiday 150:28-9 (4) O '78
--Washington, D. C.
Trav/Holiday 151:66-7 (3) My
'79
SUBWAYS--CONSTRUCTION
--Seoul, South Korea
Nat Geog 156:790-1 (c, 1) D '79
SUDAN--COSTUME
--Murle hunters
Life 2:65-8 (c, 1) Je '79
SUEZ CANAL, EGYPT
Nat Geog 151:320-1 (c, 2) Mr '77
SUGAR BEET INDUSTRY--
HARVESTING
--West Germany
Nat Geog 152:170 (c, 3) Ag '77
SUGAR CANE INDUSTRY
--Crushed in oxen-powered mills
(Peru)
Natur Hist 86:35 (c, 3) My '77
--Hawaii farm

--Windsurfing (California)
 Nat Geog 160:774 (c, 4) D '81
--Windsurfing (Hawaii)
 Nat Geog 156:660-1 (c, 1) N
 '79
--Windsurfing (Mexico)
 Trav/Holiday 153:101 (4) F '80
--Windsurfing (Virgin Islands)
 Trav/Holiday 156:49 (c, 4) O
 '81
--Windsurfing (West Germany)
 Nat Geog 152:168 (c, 4) Ag '77
--Windsurfing Championships
 1980 (Massachusetts)
 Sports Illus 53:14-17 (c, 1) Ag
 25 '80
SURGERY
 Ebony 32:40 (3) Ja '77
 Ebony 36:68 (4) N '80
 Ebony 36:67, 91 (2) O '81
--1840's
 Life 3:10 (4) S '80
--1875
 Am Heritage 32:23 (painting, c, 1)
 Je '81
--Brain surgery
 Life 2:62-75 (1) Ap '79
--Civil War
 Am Heritage 31:61 (drawing, 3)
 Ag '80
--First surgery under anesthesia
 (1846; Massachusetts)
 Am Heritage 30:80 (painting, c, 2)
 Ag '79
--Foot
 Ebony 33:105 (2) S '78
--Kidney transplant
 Ebony 32:60-5 (2) Ap '77
 Open heart surgery
 Life 4:28-31 (c, 1) S '81
--Ophthalmic surgery
 Life 4:92-8 (c, 1) Ag '81
--Removing breast tumor
 Ebony 33:75-82 (2) Jl '78
--Replanting severed limbs
 Life 2:22-7 (1) Ag '79
--Uganda
 Nat Geog 158:80 (c, 4) Jl '80
--Vasectomy
 Ebony 34:136 (4) N '78
--See also PLASTIC SURGERY
SURINAM
 Smithsonian 7:78-85 (c, 1) Mr
 '77
SURINAM--ART
--Maroons
 Natur Hist 90:54-63 (c, 1) S '81
SURINAM--COSTUME

Smithsonian 7:78-85 (c, 1) Mr '77
SURINAM--HISTORY
--18th cent. escape of Maroon
 slaves
 Natur Hist 90:56, 58 (engrav-
 ing, c, 1) S '81
SURINAM--MAPS
--Tribal map
 Natur Hist 90:57 (c, 3) S '81
SURINAM TOADS
 Smithsonian 8:108 (c, 4) O '77
SURVEYING
 Am Heritage 30:63-6 (1) F '79
 Ebony 34:88 (4) Je '79
SURVEYING EQUIPMENT
 Ebony 35:74 (4) Je '80
--Early 19th cent.
 Nat Geog 159:353 (c, 4) Mr '81
--Ancient Roman groma
 Nat Geog 159:718-19 (painting, c, 1)
 Je '81
SUSQUEHANNA RIVER, PENN-
 SYLVANIA
 Nat Geog 153:732-3 (c, 1) Je '78
SUWANNEE RIVER, GEORGIA/
 FLORIDA
 Nat Geog 152:20-9 (map, c, 1) Jl
 '77
SWALLOWS
 Nat Geog 151:175 (c, 4) F '77
 Nat Geog 155:349 (c, 2) Mr '79
--Barn
 Nat Wildlife 17:24 (c, 4) Je '79
Swamps. See MARSHES; OKE-
 FENOKEE SWAMP
SWANS
 Trav/Holiday 148:61 (3) D '77
 Nat Geog 154:840-1 (c, 1) D '78
 Nat Geog 156:825 (c, 4) D '79
 Nat Wildlife 18:2 (c, 1) D '79
 Trav/Holiday 154:64 (4) Jl '80
 Smithsonian 12:60 (c, 4) O '81
 Nat Geog 160:706-7 (c, 1) N '81
--Trumpeter
 Nat Wildlife 15:27 (c, 4) Ap '77
 Nat Wildlife 16:10 (c, 4) D '77
 Natur Hist 87:72-7 (c, 1) N '78
--Whistling
 Nat Wildlife 17:45 (c, 4) Je '79
 Nat Wildlife 18:50-1 (c, 1) Ap '80
Sweden. See STOCKHOLM
SWIMMERS
 Sports Illus 52:67-8 (4) Ap 21 '80
--Covered with Vasoline
 Sports Illus 51:28 (c, 2) S 24 '79
SWIMMING
 Sports Illus 46:60 (c, 4) F 28 '77
 Sports Illus 48:72 (4) My 15 '78

Sports Illus 49:33-6 (c, 1) Jl
 10 '78
Sports Illus 49:24 (c, 3) Ag 28
 '78
Ebony 34:47, 50 (3) F '79
Sports Illus 50:128-9 (c, 1) F
 15 '79
Sports Illus 51:62 (c, 3) Ag 20
 '79
Sports Illus 54:28 (4) Ja 12 '81
Sports Illus 54:73 (4) Ap 13 '81
Sports Illus 54:86 (c, 4) Ap 20
 '81
Sports Illus 55:24-5, 28 (c, 2)
 Ag 3 '81
Sports Illus 55:30-1, 35 (c, 1)
 Ag 10 '81
--1920's (Utah)
 Am Heritage 32:81, 87 (2) Je
 '81
--Butterfly stroke
 Sports Illus 47:19 (c, 3) S 5 '77
 Sports Illus 52:18-19 (c, 1) Ap
 7 '80
--Children playing (Canada)
 Nat Geog 152:634 (c, 4) N '77
--Children playing (Malaysia)
 Nat Geog 151:661 (c, 1) My '77
--English Channel
 Sports Illus 51:28-30 (c, 2) S
 24 '79
--Iran
 Life 1:26 (c, 4) O '78
--Playing in pool (Pennsylvania)
 Sports Illus 54:37 (c, 4) Mr 2
 '81
--Raft in pool
 Ebony 34:35 (c, 4) S '79
--Small pond
 Trav/Holiday 153:49 (c, 3) Je
 '80
--Special swimming cage
 Sports Illus 49:22-3 (c, 3) Ag
 28 '78
--Swimming holes
 Life 4:cov., 100-8 (c, 1) Ag '81
--Training
 Sports Illus 52:56-62 (c, 3) Mr
 10 '80
--U. S. S. R.
 Nat Geog 153:41 (c, 1) Ja '78
--Yosemite National Park,
 California
 Nat Geog 156:33 (c, 1) Jl '79
--See also BEACHES, BATHING;
 DIVING
SWIMMING--COLLEGE
 Sports Illus 46:26-7 (c, 3) Ap

4 '77
Sports Illus 48:18-19 (c, 3) F 13
 '78
Sports Illus 48:26-8 (c, 2) Ap 3
 '78
--NCAA competition
 Sports Illus 52:18-21 (c, 1) Ap 7
 '80
SWIMMING--COMPETITONS
 Sports Illus 48:22-3 (c, 3) Ap 17
 '78
 Sports Illus 49:26-8 (c, 3) S 4
 '78
 Sports Illus 50:33-5 (c, 2) Ap 2
 '79
 Sports Illus 50:90 (c, 4) Ap 23
 '79
 Life 3:36-7 (c, 2) Mr '80
 Sports Illus 52:110-14 (c, 1) Mr
 10 '80
 Sports Illus 54:63 (c, 4) F 2 '81
 Sports Illus 55:24-6 (c, 2) Ag 24
 '81
--1972 Olympic winners
 Sports Illus 51:60-1 (c, 1) Ag 20
 '79
--Pan-American Games 1979 (Puerto
 Rico)
 Sports Illus 51:22-4 (c, 2) Jl 16
 '79
--U. S. Long Course (California)
 Sports Illus 53:32-4 (c, 2) Ag 11
 '80
--Victors
 Sports Illus 51:28 (c, 2) Ag 27
 '79
SWIMMING--EDUCATION
--1900 land instruction
 Nat Geog 159:782 (4) Je '81
SWIMMING--HUMOR
--Polar Bear Club
 Sports Illus 53:80-8 (drawing, c, 1)
 D 22 '80
SWIMMING POOLS
--Boot-shaped (Texas)
 Nat Geog 157:482 (c, 1) Ap '80
--California
 Sports Illus 49:33 (c, 1) Jl 10
 '78
 Ebony 33:145-6 (3) O '78
 Life 3:94-5 (c, 1) Jl '80
--Cancun, Mexico
 Trav/Holiday 150:43 (c, 3) O '78
--Cuba
 Nat Geog 151:49 (c, 4) Ja '77
--Florida
 Ebony 34:88-92 (c, 2) N '78
 Nat Geog 158:158-9 (c, 2) Ag '80

Sports Illus 55:26 (c, 3) S 21
'81
--France
Sports Illus 51:35 (c, 4) O 1
'79
--Guam hotel
Trav/Holiday 154:43 (c, 4) Jl
'80
--Guitar-shaped (Tennessee)
Nat Geog 153:696-7 (c, 2) My
'78
--Haiti hotel
Trav/Holiday 151:59 (c, 2) Ap
'79
--Hawaiian hotel
Sports Illus 46:44 (c, 4) Ja 24
'77
--Indoor (California mansion)
Ebony 35:144-5 (c, 1) My '80
--Italy
Life 3:64 (c, 3) O '80
--Kenyon College, Ohio
Sports Illus 50:32-3 (2) F 19
'79
--Mexican hotel
Trav/Holiday 153:39 (c, 2) Ja
'80
Trav/Holiday 153:55 (c, 4) F
'80
--Missouri
Trav/Holiday 156:31 (4) S '81
--Montana ranch
Travel 147:57 (c, 4) My '77
--New Mexico
Smithsonian 12:103 (c, 4) Ag '81
--Palm Springs, California
Trav/Holiday 148:26-8 (c, 1) N
'77
--Pepperdine University, California
Sports Illus 46:101 (c, 4) My
23 '77
--Pool bar at Mexican resort
Nat Geog 153:644 (c, 3) My '78
--Poolside (Florida)
Sports Illus 52:32 (c, 3) Je 16
'80
--St. Petersburg condominium,
Florida
Smithsonian 11:52-3 (c, 1) S '80
--Saratoga, New York
Trav/Holiday 149:34 (c, 4) My
'78
--Scottsdale, Arizona
Trav/Holiday 148:60 (c, 2) D
'77
--Seabrook, South Carolina
Trav/Holiday 153:60 (c, 2) Ap
'80

--Shipboard
Travel 147:34 (c, 1) Je '77
Travel 148:68 (4) S '77
Trav/Holiday 156:26 (c, 3) O '81
--Texas
Ebony 33:132 (4) Ag '78
Life 3:66 (c, 4) Ja '80
--Virgin Islands
Nat Geog 159:228-9 (c, 1) F '81
Trav/Holiday 156:cov. (c, 1) O
'81
--Washington
Smithsonian 9:65 (c, 1) F '79
Swimsuits. See BATHING SUITS
SWINGS
Sports Illus 54:48 (c, 4) Je 8 '81
Life 4:90-1 (1) Ag '81
--Porch (Texas)
Nat Geog 156:140 (c, 1) Jl '79
--Tire swing (Bahrain)
Nat Geog 156:329 (c, 2) S '79
--Tire swing (Mississippi)
Nat Geog 160:395 (c, 1) S '81
SWITZERLAND
--Alpine villages
Natur Hist 88:48-56 (c, 1) Ja '79
--See also ALPS; BERN, GENEVA;
ZURICH
SWITZERLAND--COSTUME
Trav/Holiday 155:61-2 (c, 3) My
'81
SWITZERLAND--HOUSING
--Alpine house
Natur Hist 88:48-9 (c, 1) Ja '79
SWORDS
--18th cent. silver handguard
(Spain)
Nat Geog 152:766 (c, 1) D '77
--Celtic
Nat Geog 151:593 (c, 1) My '77
--Silver Viking sword hilt
Smithsonian 11:65 (c, 4) S '80
SYDNEY, AUSTRALIA
Nat Geog 155:210-35 (map, c, 1)
F '79
--Harbor
Trav/Holiday 148:38 (c, 2) D '77
--Hotel's "Marble Bar"
Trav/Holiday 150:24 (4) D '78
--Opera House
Life 4:108 (c, 3) N '81
Synagogues. See TEMPLES
SYRACUSE, NEW YORK
--Canal Museum
Travel 148:65 (4) Jl '77
SYRIA
Nat Geog 154:327-61 (map, c, 1)
S '78

--Ancient Ebla
 Nat Geog 154:730-58 (map, c, 1)
 D '78
--Ruins of Dura Europus
 Nat Geog 156:588-9 (c, 1) N
 '79
--See also ALEPPO; DAMASCUS;
 EUPHRATES RIVER;
 PALMYRA
SYRIA--COSTUME
 Nat Geog 154:327-56 (c, 1) S
 '78

-T-

TABLE TENNIS
 Sports Illus 46:73-4 (4) Ap 18
 '77
 Sports Illus 47:82-6 (c, 1) N 21
 '77
 Ebony 33:55 (4) D '77
 Sports Illus 48:39 (c, 4) Ja 2
 '78
 Sports Illus 55:58-60 (c, 4) Je
 29 '81
--China
 Nat Geog 158:34-5 (c, 1) Jl '80
--Chinese children
 Nat Geog 159:794-5 (c, 1) Je '81
TABLES
--17th cent. Plymouth
 Am Heritage 31:18-19 (3) Ap
 '80
--1720 Dutch table depicting
 Mississippi Bubble scandal
 Am Heritage 29:29 (c, 1) F '78
TAFT, WILLIAM HOWARD
 Am Heritage 29:34-5 (1) Ag
 '78
 Am Heritage 30:22 (4) Je '79
--Birthplace (Cincinnati, Ohio)
 Am Heritage 29:33 (4) Ap '78
TAHITI
 Nat Geog 155:844-57 (c, 1) Je
 '79
--Bali Hai, Raiatea
 Trav/Holiday 148:28 (c, 3) D '77
TAHITI--COSTUME
--Fishermen
 Trav/Holiday 153:98 (3) F '80
TAILORS
--China
 Nat Geog 156:554-5 (c, 1) O
 '79
--Kashmir, India
 Trav/Holiday 149:37 (c, 2) Je
 '78

--Mali
 Natur Hist 86:69 (c, 4) My '77
TAIPEI, TAIWAN
 Trav/Holiday 148:cov., 34 (c, 2)
 D '77
TAIWAN
--Bamboo industry
 Nat Geog 158:518-19 (c, 1) O '80
--Orchid Island
 Nat Geog 151:98-109 (map, c, 1)
 Ja '77
--See also TAIPEI
TAIWAN--ART
--Mosaics made from postage
 stamps
 Life 2:51-3 (c, 1) F '79
TAIWAN--COSTUME
--Yamis people (Orchid Island)
 Nat Geog 151:98-109 (c, 1) Ja
 '77
TAJ MAHAL, AGRA, INDIA
 Travel 148:60 (c, 1) O '77
 Trav/Holiday 151:100 (4) My '79
TALLEYRAND, CHARLES MAURICE
 Smithsonian 12:74 (painting, c, 4)
 N '81
--Home and artifacts (Valencay,
 France)
 Smithsonian 12:73-83 (c, 1) N
 '81
TALLINN, ESTONIA
 Nat Geog 157:484-7, 505-11 (c, 1)
 Ap '80
TAMERLANE
 Smithsonian 10:88-92 (c, 4) S '79
--Sites associated with him
 Smithsonian 10:88-97 (c, 1) S '79
--Tomb (Samarkand)
 Smithsonian 10:97 (c, 1) S '79
TAMPA, FLORIDA
--Homes on Tampa Bay sandspits
 Nat Geog 158:374-5 (c, 1) S '80
--Lightning storm
 Nat Geog 151:870 (c, 2) Je '77
TANAGERS
 Nat Wildlife 18:39 (painting, c, 4)
 Ag '80
--Scarlet
 Nat Wildlife 19:3 (c, 4) Ap '81
TANKERS
--Oil
 Nat Geog 154:102-23 (c, 1) Jl '78
--Supertankers
 Life 2:46-54 (c, 1) Ap '79
 Nat Geog 158:302-3 (c, 1) S '80
 Nat Geog 160:427-9 (c, 1) O '81
TANKS, ARMORED
 Nat Geog 151:65 (c, 4) Ja '77

Life 3:32-3 (c, 1) Ap '80
--1956 (U. S. S. R.)
 Life 4:38 (4) N '81
--Bolivia
 Life 3:85 (c, 2) O '80
--German (World War II)
 Am Heritage 29:56 (4) Ap '78
--Rusting after World War II battle
 (Germany)
 Am Heritage 31:32-3 (paint-
 ing, c, 1) D '79
TANZANIA
--Gombe Stream National Park
 Nat Geog 155:592-621 (c, 1)
 My '79
--Laetoli archaeological site
 Nat Geog 155:447-57 (map, c, 1)
 Ap '79
--See also LAKE VICTORIA
TANZANIA--COSTUME
 Nat Geog 156:431 (c, 2) S '79
--Soldier
 Nat Geog 158:77 (c, 4) Jl '80
TAPESTRIES
--15th cent. Flemish
 Life 2:33 (4) Mr '79
--Bayeux Tapestry
 Natur Hist 89:56 (3) D '80
 Smithsonian 12:174-5 (c, 4) S
 '81
TARANTULAS
 Natur Hist 89:48-53 (c, 1) Mr
 '80
TARASCAN INDIANS (MEXICO)
 ART
 Nat Geog 153:648-52 (c, 1) My
 '78
TARBELL, IDA
 Am Heritage 32:72 (4) F '81
TARTAR EMPIRE (14TH CENT.)
 Smithsonian 10:88-97 (c, 1) S
 '79
--See also TAMERLANE
TARZAN
--1930's movies
 Am Heritage 31:17 (4) F '80
TASMANIA, AUSTRALIA
 Travel 147:42-7 (map, c, 1)
 Mr '77
 Sports Illus 55:76-85 (map, c, 2)
 O 5 '81
TASMANIAN DEVILS
 Sports Illus 55:74-86 (c, 1)
 O 5 '81
TASMANIAN TIGERS
 Sports Illus 55:88 (4) O 5 '81
TATTOOS
 Smithsonian 9:154-5 (c, 4) N '78

--Japan
 Smithsonian 11:101 (c, 4) Jl '80
--Stalin tattooed on man's chest
 (U. S. S. R.)
 Life 3:42 (4) My '80
--Star of David
 Sports Illus 49:28 (c, 4) D 18 '78
--Tattooing (Rhode Island)
 Sports Illus 53:76 (c, 4) Ag 18 '80
--Tattooing Cuban refugees (Arkan-
 sas)
 Life 3:56-7 (c, 1) N '80
--Virginia
 Nat Geog 157:824 (c, 4) Je '80
TAVERNS
 Sports Illus 46:37 (drawing, c, 1)
 Je 6 '77
 Sports Illus 47:34-6 (painting, c, 1)
 S 5 '77
 Sports Illus 49:100 (c, 4) D 4 '78
 Sports Illus 52:64-5 (painting, c, 2)
 My 12 '80
--1798 Newcom Tavern, Dayton,
 Ohio
 Trav/Holiday 153:38 (4) F '80
--19th cent. Alabama
 Travel 148:55 (4) O '77
--19th cent. Arkansas
 Travel 147:51 (c, 3) Ja '77
--Late 19th cent. (Dodge City,
 Kansas)
 Smithsonian 10:140 (4) F '80
--1920's speakeasies
 Am Heritage 30:87 (painting, c, 4)
 F '79
--Beergarden (Osaka, Japan)
 Nat Geog 152:858-9 (c, 1) D '77
--Chicago, Illinois
 Nat Geog 153:489 (c, 2) Ap '78
--Dublin, Ireland
 Trav/Holiday 153:60 (c, 2) My
 '80
 Nat Geog 159:448-9 (c, 2) Ap '81
--Hotel bar (Indianapolis, Indiana)
 Trav/Holiday 151:48 (c, 2) Ja '79
--"Marble Bar, " Sydney, Australia
 Trav/Holiday 150:24 (4) D '78
--Milwaukee, Wisconsin
 Nat Geog 158:198-9 (c, 2) Ag '80
--Minnesota
 Sports Illus 53:35 (c, 3) D 22 '80
--Old West saloon
 Smithsonian 10:156 (drawing, c, 4)
 D '79
--Old West style saloon (West Ger-
 many)
 Nat Geog 152:176-7 (c, 1) Ag '77
--Rhodes Tavern, Washington, D. C.

(1817)
Am Heritage 31:106-7 (paint-
ing, c, 1) F '80
--St. Thomas, Virgin Islands
Ebony 33:114 (4) Ja '78
--South Dakota
Nat Geog 159:531 (c, 1) Ap '81
--Whitehaven, England
Smithsonian 11:146 (c, 4) D '80
--Wine bars (London, England)
Trav/Holiday 153:16-18, 24 (4)
F '80
--Wyoming
Nat Geog 159:102-3 (1) F '81SR
--York, England
Trav/Holiday 153:91 (4) Ap '80
TAXICAB DRIVERS
--South Korea
Nat Geog 156:776 (c, 3) D '79
TAXICABS
--Man-powered taxi (Macao)
Trav/Holiday 153:89 (4) F '80
--Pakistan
Nat Geog 159:676 (c, 2) My '81
TAYLOR, MAXWELL
Am Heritage 32:4-16 (1) Ap
'81
Tea drinking. See DRINKING
CUSTOMS
TEA INDUSTRY
--1890 advertisement (Great
Britain)
Smithsonian 11:41 (3) Ag '80
TEA INDUSTRY--HARVESTING
--Sri Lanka
Nat Geog 155:124-5 (c, 1) Ja
'79
TEACHERS
Smithsonian 11:59 (c, 1) Ja '81
--1870's
Am Heritage 32:26 (painting, c, 1)
Ag '81
TEAKETTLES
--18th cent. Great Britain
Smithsonian 11:144 (c, 4) D '80
--1930's Bauhaus design
Life 2:84-5 (c, 2) S '79
--Ancient tea samovar (Kashmir)
Trav/Holiday 149:95 (4) Ap '78
TEALS
Nat Geog 153:672 (c, 4) My '78
Nat Wildlife 19:44-5 (c, 2) F
'81
--Green-winged
Nat Wildlife 15:cov. (paint-
ing, c, 1) O '77
TEETH
--Artificial

Nat Geog 159:282 (c, 4) F '81
--Boxer's missing front teeth
Ebony 33:131 (c, 4) My '78
--Branded with Texas star
Nat Geog 157:483 (c, 4) Ap '80
--Donkeys
Life 3:119 (c, 4) O '80
--Ice Age human
Nat Geog 156:331, 343 (c, 1) S
'79
--Magnified scenes of bacteria on
teeth
Life 1:54-8 (1) N '78
TEHERAN, IRAN
--U. S. Embassy area
Life 3:24-5 (1) Ja '80
TEL AVIV, ISRAEL
Trav/Holiday 149:50-5, 101 (c, 1)
Mr '78
TELEPHONE BOOTHS
Smithsonian 9:125 (painting, c, 4)
Ja '79
TELEPHONES
Sports Illus 54:43 (3) Ap 27 '81
--Businessman speaking on phone
Sports Illus 49:32 (c, 4) N 20 '78
--Phone conversation
Ebony 34:61 (3) Jl '79
Life 2:78 (c, 4) Jl '79
Ebony 35:36 (4) Ap '80
Ebony 35:93 (2) My '80
Ebony 35:62 (3) Jl '80
Ebony 35:102 (3) S '80
Sports Illus 54:21, 61 (c, 3) Ja
26 '81
Ebony 36:22, 88-90 (4) Mr '81
--Portable
Nat Geog 159:311 (c, 1) Mr '81
--Solar-powered radiophone (Saudi
Arabia)
Nat Geog 158:333 (c, 1) S '80
TELESCOPES
Life 3:84 (3) F '80
Life 3:3, 96-102 (c, 1) O '80
Nat Wildlife 19:27 (c, 4) Ag '81
--17th cent. telescope belonging to
Galileo
Smithsonian 12:92-3 (4) Ag '81
--1880's
Natur Hist 88:14 (3) My '79
--Arizona observatory
Smithsonian 10:42-51 (c, 2) My
'79
--Mobile radio telescope
Life 2:84 (c, 2) Ja '79
--Multiple Mirror Telescope
(Arizona)
Smithsonian 12:9 (c, 4) My '81

--Radio telescopes (New Mexico
 observatory)
 Smithsonian 9:cov., 28-37 (c, 1)
 Jl '78
--Space telescope
 Nat Geog 159:340-1 (c, 1) Mr
 '81
--Zeiss Mark VI
 Trav/Holiday 156:4 (3) N '81
Television cameras. See
 CAMERAS
TELEVISION NEWSCASTERS
 Ebony 34:110-15 (1) Ja '79
 Life 3:138-40 (3) N '80
 Ebony 36:34 (4) Ap '81
 Ebony 37:52-3 (3) N '81
TELEVISION PROGRAMS
--"Beulah" (1950's)
 Ebony 35:104 (4) Ja '80
--Black-oriented shows
 Ebony 35:104-8 (4) Ja '80
 Ebony 35:33-6 (4) Mr '80
 Ebony 36:115 (4) S '81
--"Dallas"
 Life 4:115 (c, 2) Ja '81
--"Diff'rent Strokes"
 Ebony 34:104-6 (c, 2) F '79
--"Good Times"
 Ebony 33:80 (4) Ag '78
--"The Jeffersons"
 Ebony 33:80 (4) Ag '78
 Ebony 35:104 (4) Ja '80
 Ebony 35:60 (4) S '80
--"The Love Boat"
 Ebony 36:66-7 (3) Mr '81
--"One in a Million"
 Ebony 35:93-4 (2) My '80
--"One Life to Live"
 Ebony 34:cov., 148-50 (c, 1)
 O '79
--"Real People"
 Ebony 35:84-5 (2) Ap '80
--"The Righteous Apples"
 Ebony 35:71 (3) O '80
--Scenes of blacks in soap operas
 Ebony 33:32-6 (2) Mr '78
--Sports on television
 Sports Illus 55:48-9 (c, 4) Ag
 10 '81
--"Up & Coming"
 Ebony 36:74-6 (4) F '81
--Wax depiction of Fonzie from
 "Happy Days"
 Trav/Holiday 155:81 (4) My '81
--"What's Happening!!"
 Ebony 33:cov., 74-5 (c, 1) Je
 '78
--"White Shadow"

Ebony 35:33 (4) Mr '80
TELEVISION STUDIOS
--Control and monitoring rooms
 Sports Illus 55:50-1 (c, 4) Ag 10
 '81
TELEVISION WATCHING
 Sports Illus 47:38 (c, 4) D 5 '77
 Ebony 34:83 (3) Ap '79
 Ebony 34:86 (4) Ag '79
 Sports Illus 54:34 (c, 4) Je 22
 '81
--Airport waiting rooms (Colorado)
 Natur Hist 87:111 (3) Ag '78
--Apache Indians (Arizona)
 Nat Geog 157:288-9 (c, 1) F '80
--China
 Life 4:102-3 (c, 1) F '81
--Large-screen television
 Ebony 35:32 (4) Ja '80
--Nez Percé Indians (Washington)
 Nat Geog 151:426-7 (c, 1) Mr '77
--North Carolina
 Ebony 32:53 (4) F '77
--Norway
 Nat Geog 152:376 (c, 3) S '77
--Poland
 Life 1:8-9 (c, 1) D '78
--Sports fans
 Sports Illus 55:50 (c, 4) Ag 10 '81
TELEVISIONS
--Cable channel selector
 Sports Illus 55:62 (c, 4) Ag 10
 '81
--Installing cable television
 Sports Illus 55:26-31 (c, 1) Ag
 17 '81
--Monitoring closed circuit system
 (Saudi Arabia)
 Nat Geog 154:599 (c, 4) N '78
--Video-tape equipment
 Ebony 36:67 (2) F '81
TEMPLES
--1420 Temple of Heaven (China)
 Trav/Holiday 150:37 (c, 1) N '78
--Buddhist (Chiangmai, Thailand)
 Trav/Holiday 151:34 (c, 1) Ja '79
--Dohany Street Synagogue, Buda-
 pest, Hungary
 Smithsonian 10:64 (c, 2) Ag '79
 Smithsonian 10:12-13 (c, 4) O '79
--Hindu (Java, Indonesia)
 Travel 148:58 (c, 2) Ag '77
--Hindu (New Delhi, India)
 Natur Hist 89:69 (c, 1) Ja '80
--Hindu (Pashupatinath, Nepal)
 Trav/Holiday 156:39 (c, 4) Ag '81
--Hindu (Tirukalikundram, India)
 Trav/Holiday 156:44-5 (c, 1) Jl

'81
--Jokhang, Tibet
Nat Geog 157:242-51 (c, 1) F
'80
--Kinkaku-Ji, Kyoto, Japan
Trav/Holiday 149:47 (c, 1) Je
'78
--Kyongju, South Korea
Trav/Holiday 156:40-5 (c, 1) S
'81
--Mormon (1886; Manti, Utah)
Am Heritage 30:28-9 (1) Je
'79
--Mormon (Salt Lake City, Utah)
Trav/Holiday 152:20 (4) N '79
--Penang, Malaysia
Trav/Holiday 151:34, 38 (c, 2)
Mr '79
--Rajasthan, India
Nat Geog 152:70-1 (c, 1) Jl '77
--Risinji, Japan
Travel 147:65 (4) F '77
--Statuary (Pening, Malaysia)
Trav/Holiday 148:41 (c, 2) D '77
--Synagogues
Smithsonian 9:34-5 (c, 4) Je '78
--Synagogues (U. S. S. R.)
Life 4:94 (c, 4) D '81
--Tampaksiring, Bali, Indonesia
Trav/Holiday 155:66 (c, 4) My
'81
TEMPLES--ANCIENT
--3500 B. C. (Malta)
Nat Geog 152:618-19 (c, 1) N '77
--Egyptian Dendur Temple (New
York City, New York)
Life 1:116-17 (c, 1) N '78
--Giunone, Sicily
Trav/Holiday 153:24 (4) Ap '80
--Olympia, Greece
Nat Geog 157:388-9 (c, 1) Mr
'80
--Paestum, Italy (1800 mosaic)
Smithsonian 8:90-1 (c, 2) My
'77
--Pompeii, Italy
Natur Hist 88:53 (c, 2) Ap '79
--Remains of ancient temple
(North Yemen)
Nat Geog 156:258 (c, 1) Ag '79
--El Tajin, Mexico
Nat Geog 158:cov. , 210-11
(c, 1) Ag '80
--Temple of Apollo, Kos, Greece
Trav/Holiday 151:14 (4) F '79
--Temple of Lindos, Rhodes,
Greece
Smithsonian 9:132 (4) D '78

--Tenochtitlan, Mexico
Nat Geog 158:768-75 (c, 1) D '80
--See also PARTHENON
TEN COMMANDMENTS
--Inscribed on mountain (North
Carolina)
Nat Geog 157:350-1 (c, 1) Mr '80
TENNESSEE
--Dayton
Natur Hist 90:12-22 (2) O '81
--Farms
Life 4:80-2 (c, 2) D '81
--Gatlinburg
Smithsonian 9:27 (c, 4) F '79
--See also GREAT SMOKY MOUN-
TAINS; GREAT SMOKY
MOUNTAINS NATIONAL PARK;
MEMPHIS; NASHVILLE;
SHILOH NATIONAL PARK
TENNESSEE VALLEY AUTHORITY
--Activities
Am Heritage 28:68-76 (c, 1) F
'77
Smithsonian 10:94-103 (c, 1) Ja
'80
TENNIS
Ebony 35:74 (2) My '80
--Late 19th cent.
Smithsonian 9:137 (4) N '78
--China
Sports Illus 47:99-100 (c, 4) D
5 '77
Sports Illus 53:42-7 (c, 2) N 17
'80
--Platform tennis
Sports Illus 46:74 (c, 4) Ap 11
'77
--Practice
Ebony 32:134-8 (3) O '77
TENNIS--EDUCATION
Sports Illus 50:36-7 (c, 3) Mr 12
'79
--Florida tennis camp
Sports Illus 52:26-30 (c, 1) Je 9
'80
TENNIS--HUMOR
Sports Illus 48:60-5 (painting, c, 1)
Ja 23 '78
TENNIS--PROFESSIONAL
Sports Illus 46:21 (c, 2) F 7 '77
Sports Illus 46:30-1 (c, 2) Mr 14
'77
Sports Illus 46:20-1 (c, 3) My 9
'77
Sports Illus 48:16-19 (c, 2) Ja 16
'78
Sports Illus 48:20-1 (c, 2) F 6
'78

Nat Wildlife 15:14-15 (c, 1) Ap
'77
Nat Geog 154:304-23 (c, 1) S
'78
Sports Illus 49:54-5 (c, 2) S
18 '78
--Aesthetic tents for desert use
Sports Illus 53:25-9 (c, 1) Ag
25 '80
--Camping
Travel 147:49 (c, 1) Mr '77
Nat Wildlife 17:36-7 (c, 3) D
'78
Trav/Holiday 155:38 (c, 4) Ja
'81
Nat Geog 159:191, 199 (c, 4)
F '81
Trav/Holiday 155:46 (c, 2) My
'81
Nat Geog 160:562-3 (c, 1) O
'81
--Camping (China)
Nat Geog 160:740-1 (c, 1) D '81
--Camping trip (Pennsylvania)
Nat Geog 153:746-7 (c, 1) Je
'78
--Caribou skin (Canada)
Natur Hist 90:46 (c, 3) O '81
--Egypt
Smithsonian 12:121 (c, 4) Ap
'81
--Felt gers (Mongolia)
Travel 147:28 (c, 4) Je '77
--Fiberglass (Saudi Arabia)
Nat Geog 158:299 (c, 1) S '80
--Mountain climbing camps
Nat Geog 155:634-9 (c, 1) My
'79
--Yak-hair (Nepal)
Nat Geog 151:506 (c, 4) Ap '77
TEPEES
Smithsonian 11:104 (c, 4) S '80
--Model
Smithsonian 9:122 (c, 4) D '78
--Plains Indians (Oklahoma)
Trav/Holiday 150:38 (o, 2) Jl
'78
TERMITES
Nat Geog 153:532-47 (c, 1) Ap
'78
TERNS
Nat Wildlife 15:44-5 (c, 1) Je
'77
Nat Geog 153:680-1, 686-9
(c, 1) My '78
Natur Hist 87:54-61 (c, 1) Je
'78
Nat Geog 156:184-5 (c, 1) Ag '79

Nat Wildlife 18:37-9 (c, 1) F '80
Smithsonian 11:cov. , 28-37 (c, 1)
Ag '80
Nat Geog 159:46-7 (c, 2) F '81
Natur Hist 90:62-71, 90-1 (c, 1)
N '81
TERRAPINS
Natur Hist 87:43 (c, 1) My '78
TERRIERS
Smithsonian 8:60 (4) Ap '77
Ebony 32:50-1 (2) My '77
Ebony 34:cov. (c, 1) N '78
Life 2:44-5 (c, 1) Ja '79
--Jack Russell
Sports Illus 55:90-101 (c, 1) N 2
'81
TESLA, NIKOLA
Am Heritage 28:45 (1) Ag '77
TETON RANGE, WYOMING
Ebony 33:150 (4) My '78
Nat Wildlife 17:28 (c, 4) Ap '79
Nat Geog 156:150-1 (c, 1) Jl '79
Trav/Holiday 152:47-51 (c, 1) Jl
'79
Sports Illus 52:58-9, 71 (c, 1)
Je 16 '80
TEXAS
Nat Geog 157:440-83 (map, c, 1)
Ap '80
--Early 20th cent.
Am Heritage 28:48-55 (1) Ap '77
--1979 Wichita Falls tornado damage
Nat Wildlife 18:31 (2) Je '80
--Big Thicket forest
Nat Wildlife 15:4-11 (map, c, 1)
Je '77
Am Heritage 28:45-51 (c, 1) Je
'77
Natur Hist 87:108-10 (c, 1) N '78
--Burkburnett (1930's)
Am Heritage 28:54 (2) Ap '77
--Charro Days Fest, Brownsville
Trav/Holiday 151:22 (4) F '79
--Chihuahua Desert
Nat Wildlife 18:50 3 (c, 1) D '79
--Countryside
Nat Geog 156:194-5 (c, 1) Ag '79
--Gulf of Mexico area
Nat Geog 153:200-3, 216-23
(map, c, 1) F '78
Nat Geog 159:144-73 (map, c, 1)
F '81
--See also ALAMO; DALLAS; EL
PASO; FORT WORTH; GAL-
VESTON; GUADALOUPE
MOUNTAINS NATIONAL PARK;
HOUSTON, SAM; HOUSTON;
RIO GRANDE RIVER; SAN

ANTONIO
TEXTILE INDUSTRY
--Early 20th cent. mill (New
 Hampshire)
 Am Heritage 29:14-25 (c, 1) O
 '78
--Dyed textiles (Japan)
 Smithsonian 10:53 (c, 3) Ja '80
--Georgia
 Nat Geog 154:224 (c, 3) Ag '78
--Making cloth from marijuana
 (Japan)
 Smithsonian 10:59 (c, 1) Ja '80
--North Yemen
 Nat Geog 156:256 (c, 4) Ag '79
--See also COTTON INDUSTRY;
 GARMENT INDUSTRY;
 SILK INDUSTRY; WOOL IN-
 DUSTRY
TEXTILES
--Dyed cloth (India)
 Natur Hist 88:cov. (c, 1) Ag
 '79
--Samoa
 Natur Hist 90:106-7 (c, 3) N
 '81
THAILAND
 Trav/Holiday 154:43-7 (map, c, 3)
 N '80
--See also CHIANGMAI
THAILAND--COSTUME
 Trav/Holiday 154:43-6 (c, 2) N
 '80
--Hills tribe woman (Chiangmai)
 Trav/Holiday 148:33 (c, 1) D
 '77
THAMES RIVER, LONDON, ENG-
 LAND
 Nat Geog 156:454-5 (c, 1) O '79
--Revival activities
 Smithsonian 9:102-8 (c, 2) My
 '78
THANKSGIVING
--Macy's parade (New York City,
 New York)
 Nat Geog 160:340 (c, 1) S '81
THEATER
--19th cent. minstrel shows
 Am Heritage 29:cov., 93-105
 (c, 1) Ap '78
--Acting class (California)
 Ebony 32:80 (2) S '77
--Backstage activities (Great
 Britain)
 Smithsonian 8:70-1 (c, 4) Je '77
--Barnum
 Life 3:67 (4) Jl '80
--Black theater festival

Ebony 34:108-12 (3) O '79
--Bohemian Club "Grove Plays"
 (1900-1949; California)
 Am Heritage 31:81-91 (c, 1) Je
 '80
--"Camelot"
 Life 4:86 (c, 4) Ja '81
--"Carmen"
 Ebony 36:59 (4) Ap '81
--"Evita"
 Life 2:67-70 (c, 1) S '79
--Kathakali performers (India)
 Smithsonian 9:cov., 68-75 (c, 1)
 Mr '79
--Korean masked dance drama
 Natur Hist 86:cov., 43-6 (c, 1)
 Mr '77
--"The Magic Flute"
 Ebony 34:48-51 (c, 2) My '79
--Magic show (Massachusetts)
 Smithsonian 12:110-19 (c, 1) N
 '81
--Menotti's opera "The Consul"
 (South Carolina)
 Trav/Holiday 149:28 (c, 4) Ap
 '78
--"Mikado" (1912; Idaho)
 Am Heritage 32:34 (4) Ap '81
--Mimes (Tivoli Park, Copenhagen,
 Denmark)
 Nat Geog 156:837 (c, 1) D '79
--Mystery play (York, England)
 Trav/Holiday 153:55 (1) Ap '80
--"Nicholas Nickleby"
 Life 4:84 (c, 2) O '81
--Opera
 Ebony 37:32-6 (c, 2) N '81
--Opera (New Mexico)
 Smithsonian 12:cov., 104-7 (c, 1)
 Ag '81
--Pacific area
 Trav/Holiday 155:cov., 77-9 (c, 1)
 F '81
--Passion Play (South Dakota)
 Travel 147:33 (4) Je '77
--Performance art
 Life 3:83-7 (c, 1) Ja '80
--Shadow play (Indonesia)
 Travel 148:58 (c, 2) Ag '77
--Street players (Singapore)
 Nat Geog 159:548-9 (c, 1) Ap '81
--"Sugar Babies"
 Life 3:68-71 (c, 1) Mr '80
--Verdi's "A Masked Ball" (1955;
 New York)
 Am Heritage 28:53 (4) F '77
--"Your Arms Too Short to Box
 with God"

Ebony 35:122 (4) O '80
--Yugoslavia
Smithsonian 10:99 (c, 3) D '79
--See also AUDIENCES; DANCING;
ENTERTAINERS; KABUKI
THEATER--COSTUME
--19th cent. (U. S.)
Smithsonian 8:61-3 (3) Ag '77
--Applying makeup
Ebony 32:158 (c, 4) Mr '77
Ebony 36:104 (4) Je '81
Smithsonian 12:83 (c, 4) Je '81
Smithsonian 12:101-2 (c, 4) Ag
'81
--Caribbean carnival
Trav/Holiday 151:61 (c, 4) Ap
'79
--Chinese opera (China)
Trav/Holiday 156:36 (c, 4) Jl
'81
--Costume designing
Ebony 32:66-72 (c, 2) My '77
--Costumes from Bermans (Great
Britain)
Smithsonian 12:156-67 (c, 1)
N '81
--Designed by Erte
Smithsonian 10:148-52 (c, 2) D
'79
--Marlowe's "Tamburlaine" (Great
Britain)
Smithsonian 8:66-7 (c, 1) Je '77
--Opera (Taiwan)
Trav/Holiday 148:cov. (c, 1) D
'77
--Shakespearean play (Oregon)
Travel 147:41 (c, 1) Mr '77
--Thai classical dancer
Trav/Holiday 155:79 (c, 4) F
'81
--Werewolf makeup
Life 4:61-4 (c, 1) S '81
THEATERS
--1917 curtain covered with ads
(California)
Am Heritage 31:56-7 (1) O
'80
--Adelaide, Australia
Trav/Holiday 150:29, 89 (c, 4)
Ag '78
--Ancient Pompeii
Natur Hist 88:58 (3) Ap '79
--Boettcher Concert Hall, Denver,
Colorado
Nat Geog 155:406-7 (c, 2) Mr
'79
--Carnegie Hall, New York City,
New York

Life 4:84-91 (c, 1) My '81
--Castle Garden, New York City,
New York (1850)
Am Heritage 28:103 (litho-
graph, c, 4) O '77
--Civic Center, Des Moines, Iowa
Nat Geog 159:607 (c, 3) My '81
--Concert hall (Byelorussia,
U. S. S. R.)
Nat Geog 155:792-3 (c, 2) Je '79
--Concert hall (Minneapolis, Min-
nesota)
Nat Geog 158:672 (c, 2) N '80
--Concert hall (Sydney, Australia)
Nat Geog 155:214-5 (c, 2) F '79
--Concert hall (Tivoli, Copenhagen,
Denmark)
Trav/Holiday 153:30 (4) Ap '80
--Dawson City, Yukon, Canada
Travel 148:57 (c, 2) Jl '77
--Dressing rooms
Ebony 35:138, 140 (c, 4) F '80
--42nd Street, New York City, New
York
Life 3:74-7 (c, 1) Ag '80
--Goodspeed Opera House, East
Haddam, Connecticut
Travel 147:47 (c, 4) Ap '77
Trav/Holiday 150:35 (c, 4) Ag '78
Trav/Holiday 154:6 (4) Ag '80
--Hollywood Bowl, Los Angeles,
California
Nat Geog 155:53 (c, 1) Ja '79
--Kennedy Center, Washington,
D. C.
Ebony 32:106 (3) Ja '77
Smithsonian 9:56, 63 (c, 2) Ja
'79
--Lagos, Nigeria
Ebony 32:36 (c, 4) My '77
--London, England
Trav/Holiday 151:97 (4) Mr '79
--Manila, Philippines cultural
center
Nat Geog 151:372-3 (c, 2) Mr '77
--Market Square Arena, Indianap-
olis, Indiana
Trav/Holiday 151:51 (4) Ja '79
--Motion picture tent (Brazil)
Nat Geog 152:706 (c, 2) N '77
--National Theater, London, Eng-
land
Smithsonian 8:66-71 (c, 1) Je '77
--New Grand Ole Opry House (Nash-
ville, Tennessee)
Nat Geog 153:700-1 (c, 2) My '78
--Oklahoma City Music Hall, Okla-
homa

Trav/Holiday 150:37 (c, 3) Jl
'78
--Opera House (Manaus, Brazil)
Trav/Holiday 149:46 (c, 4) Mr
'78
--Outdoor (Cornwall, Great Britain)
Nat Geog 156:476 (c, 1) O '79
--Prince Edward Island
Trav/Holiday 151:53 (c, 3) My
'79
--Royal, Copenhagen, Denmark
Nat Geog 156:840 (drawing, c, 1)
D '79
--San José, Costa Rica
Trav/Holiday 150:58 (c, 4) N
'78
--Santa Fe, New Mexico
Smithsonian 12:100 (c, 1) Ag '81
--Saratoga Performing Arts Cen-
ter, New York
Trav/Holiday 149:33, 74 (c, 2)
My '78
--La Scala Opera House, Milan,
Italy
Travel 148:44-8 (c, 1) O '77
--Shakespearean Theater, Ash-
land, Oregon
Travel 147:72 (4) Mr '77
--Sydney Opera House, Australia
Trav/Holiday 148:38 (c, 2) D
'77
Life 4:108 (c, 3) N '81
--Ulan Bator, Mongolia
Travel 147:28 (c, 4) Je '77
--See also DRESSING ROOMS
THEATERS--ANCIENT
--Aphrodisias, Turkey
Nat Geog 160:530-1 (c, 1) O '81
--Roman Odeum (Aphrodisias,
Turkey)
Nat Geog 160:546-7 (c, 1) O '81
--Segesta, Italy
Travel 148:48 (2) Ag '77
Therapy. See MEDICINE--
PRACTICE; PSYCHIATRISTS;
PSYCHOLOGISTS
THESSALY, GREECE
--Meteora
Nat Geog 157:362-4 (c, 1) Mr '80
--Thessaloniki
Nat Geog 157:384 (c, 1) Mr '80
THISTLES
Smithsonian 8:94 (painting, c, 4)
Ap '77
Nat Wildlife 17:62-3 (c, 1) D
'78
Nat Wildlife 17:25 (c, 4) Ag '79
--See also CALENDULAS

THOMAS, LOWELL
Am Heritage 31:32-45 (1) Ag
'80
THOREAU, HENRY DAVID
Natur Hist 87:7 (3) Mr '78
Smithsonian 9:159-61 (paint-
ing, c, 3) N '78
Nat Wildlife 18:18 (drawing, 4) O
'80
Nat Geog 159:348 (2) Mr '81
--Home and effects (Concord, Mas-
sachusetts)
Nat Geog 159:352-3 (c, 2) Mr '81
--Tombstone (Concord, Massachu-
setts)
Nat Geog 159:382 (c, 4) Mr '81
THOUSAND ISLANDS, NEW YORK/
ONTARIO
Nat Geog 157:592-5 (c, 1) My '80
--Boldt Castle
Trav/Holiday 150:50-1 (3) N '78
Thrace. See GREECE, ANCIENT
THRONES
--16th cent. Russia
Nat Geog 153:28 (c, 3) Ja '78
--17th cent. Denmark
Smithsonian 10:119 (c, 4) F '80
--Knossos, Crete
Nat Geog 153:170 (c, 1) F '78
THRUSHES
Nat Wildlife 16:28C-28F (paint-
ing, c, 1) O '78
--Feeding young
Nat Wildlife 17:20-1 (3) D '78
THURBER, JAMES
Smithsonian 7:86 (4) Ja '77
--Cartoons about sailing
Travel 147:32-3 (2) Mr '77
--Cartoons by him
Smithsonian 7:87-92 (c, 1) Ja '77
--Home in Bermuda
Travel 147:37 (4) Mr '77
TIBET
Smithsonian 7:78-85 (c, 2) Ja '77
Nat Geog 157:cov., 218-59
(map, c, 1) F '80
Smithsonian 11:96-105 (c, 1) Ja
'81
--Lahaul Valley
Trav/Holiday 152:63-7 (c, 2) Jl
'79
--Transhimalaya Mountains
Natur Hist 90:67 (c, 3) S '81
--See also HIMALAYAN MOUN-
TAINS; LHASA
TIBET--COSTUME
Smithsonian 7:80-5 (c, 2) Ja '77
Trav/Holiday 152:63-7, 72 (c, 2)

Jl '79
Nat Geog 157:cov. , 218-59
(c, 1) F '80
Natur Hist 90:71 (c, 1) S '81
--Buddhist festivals
Life 2:134-42 (c, 1) N '79
TICKETS
--1851 concert tickets
Am Heritage 28:102 (c, 4) O '77
TICKS
--Cattle fever ticks
Smithsonian 8:62-5 (c, 1) O '77
TIFFANY, LOUIS COMFORT
--Paintings by him
Am Heritage 30:cov. , 54-61,
114 (c, 4) O '79
TIGER LILIES
Natur Hist 86:80 (painting, c, 2)
Mr '77
TIGERS
Travel 148:61 (drawing, 4) O
'77
Smithsonian 10:26 (4) S '79
Nat Wildlife 18:62-3 (paint-
ing, c, 1) D '79
Trav/Holiday 153:86 (c, 4) F
'80
Trav/Holiday 153:104 (4) Mr
'80
Smithsonian 11:107-17 (c, 3) Jl
'80
Smithsonian 12:67 (c, 4) D '81
--1796 painting
Smithsonian 8:108-9 (1) N '77
--Bengal tigers
Smithsonian 9:cov. , 29-32, 114
(c, 1) Ag '70
--Symbol of Canadian football team
Sports Illus 55:56 (painting, c, 4)
Je 29 '81
TILDEN, WILLIAM
Sports Illus 51:44 (4) Ag 20 '79
Am Heritage 32:69 (4) Ag '81
TIMBUKTU, MALI
Natur Hist 86:68-75 (c, 1) My
'77
TIME CLOCKS
--Card slots (Indiana)
Life 3:34-5 (c, 1) Ag '80
TIN MINING
--Malaysia
Nat Geog 151:667 (c, 1) My '77
TIRES
--Chains
Nat Geog 158:390-1 (c, 1) S '80
TITIAN
--Portrait of Doge Francesco
Venier

Smithsonian 10:80 (painting, c, 4)
N '79
TITMICE
Nat Wildlife 16:42 (painting, c, 4)
D '77
Natur Hist 88:70 (c, 3) Ag '79
TITO, MARSHAL
Smithsonian 10:102 (c, 2) D '79
Life 3:135-40 (2) Je '80
Life 4:106 (4) Ja '81
TLINGIT INDIANS (ALASKA)--ART
--19th cent. shaman's rattle
Smithsonian 8:112 (c, 3) N '77
TLINGIT INDIANS (ALASKA)--
COSTUME
Smithsonian 10:150 (painting, c, 4)
Ap '79
TOADFISH
Sports Illus 53:82-3 (drawing, c, 1)
N 10 '80
TOADFLAX
Travel 147:51 (c, 4) Mr '77
TOADS
Nat Wildlife 15:32 (c, 4) Ap '77
Nat Wildlife 16:2 (c, 1) Ap '78
Smithsonian 10:68-9 (c, 3) S '79
Nat Geog 156:632-3 (c, 1) N '79
Nat Wildlife 18:14 (c, 4) D '79
Natur Hist 89:48-53 (c, 1) Mr
'80
Nat Wildlife 18:48 (c, 1) Ag '80
Nat Geog 160:48 (c, 4) Jl '81
Natur Hist 90:80 (c, 3) Jl '81
--See also SURINAM TOADS
TOBACCO CHEWING
--Baseball players
Sports Illus 47:54-7 (c, 4) Jl 4
'77
Sports Illus 47:21 (c, 4) O 3 '77
TOBACCO INDUSTRY
--Curing (Cuba)
Nat Geog 151:52-3 (c, 1) Ja '77
--Curing (Maryland)
Nat Geog 158:494 (c, 1) O '80
--Drying leaves (North Carolina)
Ebony 32:50 (4) F '77
--North Carolina
Nat Geog 157:356-7 (c, 1) Mr '80
--Tobacco leaves
Natur Hist 86:22 (drawing, 4) Ap
'77
TOBAGO
Trav/Holiday 153:68-9 (c, 4) Ap
'80
--Beach
Trav/Holiday 151:62 (c, 4) Ap '79
TOBOGGANING
Nat Wildlife 18:5 (c, 4) D '79

--Early 20th cent. (New York)
 Life 3:10 (2) F '80
--Into water (Wyoming)
 Smithsonian 8:93 (c, 4) N '77
--Quebec
 Trav/Holiday 151:54 (c, 4) Ja
 '79
--See also BOBSLEDDING
TOILETRIES
--1926 deodorant advertisement
 Sports Illus 55:88 (4) O 26 '81
TOKYO, JAPAN
 Trav/Holiday 152:56-9, 92 (2)
 N '79
TOLEDO, OHIO
--St. Patrick's Church
 Am Heritage 32:30-1 (c, 4) D
 '80
TOLEDO, SPAIN
 Nat Geog 153:326-7 (c, 1) Mr
 '78
TOLSTOY, LEO
 Smithsonian 12:132 (4) Je '81
TOMATOES
 Nat Geog 156:626-7 (c, 1) N
 '79
TOMBS
--6th cent. B. C. Celtic (Ger-
 many)
 Nat Geog 157:430-1 (c, 1) Mr
 '80
--3rd cent. B. C. (China)
 Nat Geog 153:cov., 441-59
 (c, 1) Ap '78
--Ancient Egypt
 Nat Geog 151:298-302 (c, 1) Mr
 '77
--Barrow (South Korea)
 Trav/Holiday 156:45 (c, 4) S
 '81
--Bronze Age (Jordan)
 Smithsonian 9:82-7 (c, 1) Ag
 '78
--Contents of Philip II of Mace-
 don's tomb
 Life 3:46-50 (c, 1) Jl '80
--Marcus Garvey (Jamaica)
 Ebony 32:97 (c, 4) Ja '77
--Philip II (4th cent. B. C.;
 Macedon, Greece)
 Nat Geog 154:54-77 (c, 1) Jl
 '78
 Life 3:46-50 (c, 1) Jl '80
 Smithsonian 11:cov., 126-38
 (c, 1) N '80
--Race horse's grave (California)
 Sports Illus 54:77 (c, 4) My
 18 '81

--Reliquary (Tibet)
 Smithsonian 11:102 (c, 4) Ja '81
--Peter Paul Rubens (Belgium)
 Smithsonian 8:55 (c, 1) O '77
--James Smithson (Washington,
 D. C.)
 Smithsonian 7:130 (c, 3) Ja '77
--Tamerlane's mausoleum (Samar-
 kand)
 Smithsonian 10:97 (c, 1) S '79
--Walt Whitman's mausoleum (New
 Jersey)
 Life 3:174 (4) D '80
--World War II memorial (Philip-
 pines)
 Nat Geog 151:381 (c, 4) Mr '77
--Elihu Yale (Wales)
 Smithsonian 8:96 (c, 4) O '77
--See also CEMETERIES; TAJ
 MAHAL
TOMBSTONES
--18th cent. B. C. Mycenaean stele
 Nat Geog 152:619 (c, 4) N '77
--17th cent. U. S.
 Natur Hist 86:32-7 (c, 1) Je '77
--19th cent.
 Natur Hist 86:34-7 (c, 1) Je '77
--19th cent. Alabama
 Travel 147:28 (c, 4) Ja '77
--19th cent. Northeast
 Am Heritage 30:2, 42-55 (1) Ag
 '79
--Late 19th cent. (Cascade, Mon-
 tana)
 Ebony 32:96-7 (2) O '77
--20th cent. sculptures by William
 Edmondson
 Smithsonian 12:50-5 (c, 1) Ag '81
--Early 20th cent. granite funerary
 sculpture
 Am Heritage 32:70-1 (1) D '80
--American sailors (Japan)
 Travel 147:65 (4) F '77
--John Brown (New York)
 Sports Illus 52:74 (4) Ja 28 '80
--Child (South Africa)
 Nat Geog 151:801 (c, 4) Je '77
--Choctaw chief (Washington, D. C.)
 Smithsonian 12:77 (c, 4) Ap '81
--Cowboy (Wyoming)
 Nat Geog 159:113 (2) F '81SR
--Dostoevsky (Leningrad, U. S. S. R.)
 Smithsonian 9:12 (4) Ja '79
--Famous blacks
 Ebony 34:75-80 (2) F '79
--France
 Smithsonian 8:120 (c, 4) Mr '78
--Graveyard effigies (Kalash people;

--Supreme Court, Washington,
D. C.
Smithsonian 7:90-1 (c, 3) F
'77
TOURISTS--HUMOR
--Paris, France
Sports Illus 51:50-3 (paint-
ing, c, 1) Ag 6 '79
TOURMALINE
Natur Hist 87:66 (c, 2) F '78
TOWER OF LONDON, LONDON,
ENGLAND
Trav/Holiday 151:97 (4) Mr '79
TOWHEES (BIRDS)
Nat Wildlife 18:37 (painting, c, 4)
Ag '80
Town Halls. See CITY HALLS
TOYS
Ebony 35:99-104 (2) N '79
Ebony 36:135-40 (3) N '80
Ebony 37:59-64 (2) N '81
--18th cent. bilbouquet
Trav/Holiday 156:11 (4) D '81
--19th cent.
Am Heritage 32:18-29, 114
(c, 1) D '80
--19th cent. rattle (France)
Nat Geog 154:199 (c, 1) Ag '78
--1840 Haida Indian rattle (British
Columbia)
Natur Hist 87:91 (c, 1) My '78
--1900 toy boats
Am Heritage 32:28-9 (c, 1) D
'80
--Antique mechanical toys
Smithsonian 11:157-63 (c, 2) D
'80
--Boats
Smithsonian 8:12 (4) N '77
--Dogs playing frisbee
Life 1:111-12 (c, 2) O '78
--Frisbee playing
Smithsonian 8:15 (4) Ja '78
Sports Illus 54:16 (c, 2) Ap 13
'81
--Frisbees (Maryland)
Smithsonian 8:82 (c, 1) O '77
--Racing cars (Canada)
Nat Geog 152:645 (c, 1) N '77
--Science fiction toys
Ebony 34:99-102 (3) N '78
--Stuffed panda
Trav/Holiday 156:34 (c, 4) Jl
'81
--Testing subtlety of toy pro-
jectiles
Smithsonian 9:49 (c, 3) S '78
--Tops (Malaysia)

Nat Geog 151:660 (c, 4) My '77
--Toy soldiers
Smithsonian 11:68-75 (c, 2) Ag
'80
--Victorian
Smithsonian 12:188 (c, 1) D '81
--Water walkers
Nat Geog 152:320 (c, 4) S '77
--See also BALLOONS, TOY; CARD
PLAYING; CHESS PLAYING;
DOLL HOUSES; DOLLS;
GAMES; KITES; PLAY-
GROUNDS; PUPPETS; ROLLER
SKATING; SWINGS
TRACK
Sports Illus 46:16 (c, 4) Ja 24 '77
Sports Illus 46:14-15 (c, 1) F 7
'77
Sports Illus 46:24-6 (c, 2) F 28
'77
Sports Illus 46:66 (c, 3) Je 27
'77
Sports Illus 47:cov. , 16-21 (c, 1)
S 12 '77
Sports Illus 48:54 (4) Ja 23 '78
Sports Illus 48:22-3 (c, 2) Ja 30
'78
Sports Illus 48:cov. , 18-19 (c, 1)
F 6 '78
Sports Illus 50:86 (c, 4) Ja 15
'79
Sports Illus 50:18 (c, 4) Ja 29
'79
Sports Illus 50:10-13 (c, 2) F 19
'79
Sports Illus 50:cov. , 16 (c, 1) F
26 '79
Sports Illus 50:37-9 (4) My 14
'79
Sports Illus 51:cov. , 12-15 (c, 1)
Jl 9 '79
Sports Illus 51:cov. , 16-19 (c, 1)
Jl 30 '79
Sports Illus 52:cov. , 14-15 (c, 1)
F 18 '80
Sports Illus 52:58 (1) Ap 28 '80
Sports Illus 52:74 (c, 3) Je 23 '80
Sports Illus 53:25 (c, 3) Jl 14 '80
Sports Illus 54:30-2 (c, 3) F 9
'81
Sports Illus 54:22-4 (c, 3) F 16
'81
Sports Illus 54:18-23 (c, 1) Mr 2
'81
Sports Illus 54:26-8 (c, 2) Je 15
'81
Sports Illus 54:40, 43, 63 (c, 4)
Je 22 '81

Sports Illus 50:20-1 (c, 3) Je
11 '79
--NCAA Meet 1981
Sports Illus 55:22-5 (c, 2) Je
29 '81
--New York
Sports Illus 48:cov. , 16-19
(c, 1) F 6 '78
--Olympic trials
Sports Illus 53:22-3 (c, 3) Je
30 '80
--Pan-American Games 1979
(Puerto Rico)
Sports Illus 51:22-4, 62 (c, 2)
Jl 16 '79
Sports Illus 51:18-31 (c, 2) Jl
23 '79
--Scotland
Nat Geog 151:764 (c, 1) Je '77
--U. S. S. R.
Sports Illus 52:84-90 (c, 1) Mr
13 '80
--World Cup 1977
Sports Illus 47:cov. , 16-21
(c, 1) S 12 '77
--World Cup 1979 (Montreal)
Sports Illus 51:18-23 (c, 1) S 3
'79
--World Cup 1981 (Rome, Italy)
Sports Illus 55:22-5 (c, 2) S
14 '81
Track Stars. See OWENS, JESSE
TRACTORS
Nat Wildlife 17:11 (c, 4) Je '79
Ebony 35:38-9 (1) Ag '80
--New York winery
Trav/Holiday 154:33 (c, 2) Ag
'80
--Weight pulling contests
Sports Illus 47:29-32 (c, 1) Jl
11 '77
TRADE SHOWS
--Offshore drilling (Texas)
Life 3:66-7 (c, 1) Ja '80
TRADEMARKS
Am Heritage 28:64-9 (c, 3) O
'77
Traffic. See AUTOMOBILES--
TRAFFIC
TRAFFIC LIGHTS
--Housing bird nest
Natur Hist 86:51 (c, 1) Ag '77
--New York City, New York
Natur Hist 90:68-9 (c, 2) My
'81
--Texas
Nat Geog 153:216-17 (c, 2) F
'78

TRAGOPANS (BIRDS)
Natur Hist 86:79 (painting, c, 2)
Mr '77
TRAILER CAMPS
--Michigan
Trav/Holiday 154:54 (c, 4) Jl '80
--New York
Sports Illus 47:32 (c, 1) O 3 '77
--Wyoming
Smithsonian 8:34-5 (c, 2) Ag '77
Nat Geog 159:104-7 (1) F '81SR
TRAILERS
Nat Geog 158:790-1 (c, 3) D '80
TRAINS
Nat Geog 151:256-7 (c, 1) F '77
Trav/Holiday 149:38 (c, 4) F '78
Nat Geog 159:96-7 (1) F '81SR
Smithsonian 12:86 (c, 2) My '81
--19th cent. caboose
Trav/Holiday 154:48 (c, 2) S '80
--1840 hogshead train (South Caro-
lina)
Smithsonian 9:174 (drawing, 4) O
'78
--1860's Confederate train
Am Heritage 29:34-45 (paint-
ing, c, 2) D '77
--1871 woodcut
Smithsonian 12:76 (c, 4) My '81
--1874 toy locomotive
Am Heritage 32:26 (c, 2) D '80
--1885 Timber train (California)
Trav/Holiday 153:57 (c, 3) Mr
'80
--1886 lounge library of Orient Ex-
press
Smithsonian 9:136-7 (drawing, 4)
Mr '79
--1896 train (Utah)
Am Heritage 30:42-3 (1) Je '79
--Early 20th cent. electric train
(Idaho)
Am Heritage 32:36-7 (1) Ap '81
--1901 (Kenya)
Trav/Holiday 151:64-5 (1) Je '79
--1928 (Kenya)
Trav/Holiday 151:66 (3) Je '79
--Antique (British Columbia)
Nat Geog 154:469 (c, 2) O '78
--Antique steam train (Essex,
Connecticut)
Trav/Holiday 150:32-3 (c, 1) Ag
'78
--Australia
Nat Geog 155:181 (c, 1) F '79
--Bolivia
Trav/Holiday 150:59 (c, 4) Jl '78
--Car interiors

Trav/Holiday 151:32 (4) Ap '79
--Car interiors (China)
 Nat Geog 157:302-3 (c, 4) Mr
 '80
--Design for monorail
 Smithsonian 10:89 (c, 4) N '79
--Djibouti
 Nat Geog 154:524-5 (c, 1) O '78
--Europe
 Travel 147:56-9 (c, 1) Mr '77
 Trav/Holiday 151:26-34 (4) My
 '79
--Experimental Transrapid Train
 (West Germany)
 Nat Geog 152:154 (c, 4) Ag '77
--French trains used in World
 War II
 Am Heritage 32:94 (2) O '81
--Ireland
 Nat Geog 159:456-7 (c, 1) Ap
 '81
--Ontario
 Nat Geog 154:787, 790-1 (c, 1)
 D '78
--Modern trains (France)
 Life 4:198 (c, 2) D '81
--Old railroad car (Florida)
 Trav/Holiday 151:81 (4) Mr '79
--Peru
 Travel 147:47 (4) Ja '77
--Sightseeing train at movie studio
 (California)
 Trav/Holiday 155:59 (c, 3) My
 '81
--Steam (Blue Ridge, North Caro-
 lina)
 Trav/Holiday 156:1 (4) Ag '81
--Steam-powered shuttle train
 (Hawaii)
 Trav/Holiday 153:52 (3) Ja '80
--West Germany
 Trav/Holiday 153:14 (4) Mr '80
--See also LOCOMOTIVES; RAIL-
 ROADS; SUBWAYS
TRAJAN'S COLUMN, ROME,
 ITALY (113 A. D.)
 Life 3:61-4 (c, 2) Je '80
TRANSIT WORKERS
--Chicago, Illinois
 Ebony 32:104 (3) Je '77
TRANSPORTATION
--400 B. C. wooden block wheel
 (Ireland)
 Natur Hist 89:53 (4) N '80
--Motorized scooter (New York)
 Ebony 35:120-2 (3) Jl '80
--Three-wheeled racing vehicle
 Sports Illus 46:28-9 (c, 2) Ja

17 '77
--See also AIRPLANES; AIRSHIPS;
 AMBULANCES; BABY CAR-
 RIAGES; BABY STROLLERS;
 BALLOONING; BICYCLES;
 BOATS; BUSES; CABLE CARS
 (GONDOLAS); CARAVANS;
 CARRIAGES AND CARTS;
 CHARIOTS; COVERED WAGONS;
 CROP DUSTER PLANES; DOG
 SLEDS; ELEVATORS; ESCA-
 LATORS; FIRETRUCKS; GLID-
 ERS; HELICOPTERS; JEEPS;
 LOCOMOTIVES; MASS
 TRANSIT; MOPEDS; MOTOR-
 CYCLES; OCEAN CRAFT;
 RAILROADS; RECREATIONAL
 VEHICLES; RICKSHAWS;
 SHIPS; SLEDS; SNOWMOBILES;
 SPACECRAFT; STAGE-
 COACHES; SUBWAYS; TAXI-
 CABS; TRAILERS; TRAINS;
 TROLLEY CARS; TRUCKS;
 WAGONS; WHEELBARROWS
TRAWLERS
 Smithsonian 8:95 (c, 4) F '78
TREASURE HUNTS
--Virginia
 Smithsonian 12:126-44 (c, 2) Ap
 '81
TREE CLIMBING
 Ebony 34:34 (c, 3) S '79
TREE FROGS
 Nat Wildlife 15:46 (c, 3) F '77
 Nat Wildlife 15:8 (c, 4) Je '77
 Smithsonian 9:134 (drawing, 4)
 F '79
 Nat Wildlife 18:21-3 (c, 1) Je '80
 Nat Geog 159:155 (c, 4) F '81
TREE HOUSES
--California
 Nat Geog 152:350 (c, 1) S '77
--Costa Rican rain forest
 Smithsonian 11:53 (c, 1) Je '80
--Hawaii
 Nat Geog 152:608-9 (c, 2) N '77
TREE PLANTING
--Redwood National Park, California
 Nat Geog 156:28 (c, 4) Jl '79
TREES
 Smithsonian 11:160 (c, 4) My '80
 Nat Wildlife 19:18-19 (1) Je '81
--Autumn
 Travel 148:58-60, 76-7 (c, 1) S
 '77
 Trav/Holiday 154:43 (c, 1) S '80
 Natur Hist 90:82 (c, 1) Mr '81
--Chicago, Illinois park

Ebony 36:144 (c, 4) My '81
--Climbing trees (New York)
 Smithsonian 9:115 (c, 4) Ja '79
--Franklin
 Smithsonian 8:122 (painting, c, 1)
 O '77
--Gnawed by beavers
 Smithsonian 10:99 (c, 4) My '79
--Koa
 Nat Wildlife 19:24 (c, 3) Je '81
--Radiocarbon dating
 Nat Geog 152:616 (graph, c, 4)
 N '77
--Use of dying tree by birds
 Nat Wildlife 30:1 (drawing, 4)
 Je '78
--Winter
 Trav/Holiday 154:cov. (c, 1) N
 '80
--See also ACACIAS; APPLE;
 ASPEN; BANYAN; BAOBAB;
 BEECH; BIRCH; BRISTLE-
 CONE PINE; CEDAR; CHERRY;
 CHESTNUT; CHRISTMAS;
 CINCHONA; COCONUT PALMS;
 COTTONWOOD; CRAB APPLE;
 CYPRESS; DATE PALMS;
 DOGWOOD; DOUGLAS FIRS;
 ELM; EUCALYPTUS; FIG;
 FIR TREES; HEMLOCK;
 HOLLY; LAUREL; LEAVES;
 MADRONA; MANGROVE;
 MAPLE; OAK; OHIA; PEAR;
 PINE; POPLAR; REDWOOD;
 SEQUOIA; SPRUCE; SUMAC;
 TREE PLANTING; TULIP
Trials. See COURTROOMS; JUS-
 TICE, ADMINISTRATION OF
TRILLIUM
 Nat Wildlife 19:62 (c, 3) D '80
 Natur Hist 90:79 (c, 4) O '81
TRILOBITES
--Fossils
 Natur Hist 89:46-51 (drawing, 3)
 Jl '80
TRINIDAD--COSTUME
 Ebony 32:97-8 (c, 4) Ja '77
TROLLEY CARS
--19th cent. Washington, D. C.
 Smithsonian 10:58, 62-3 (2) D
 '79
--Early 20th cent. (Washington)
 Nat Geog 154:616-17 (c, 1) N
 '78
--1906 cable car (San Francisco,
 California)
 Trav/Holiday 148:37 (4) N '77
--1910 (Chicago, Illinois)

Am Heritage 30:4-5 (1) F '79
--Amsterdam, Netherlands
 Trav/Holiday 151:46 (c, 2) Je '79
--Cable cars (San Francisco, Cali-
 fornia)
 Sports Illus 46:26 (c, 1) Ja 31 '77
 Trav/Holiday 152:58 (c, 4) Jl '79
--Detroit, Michigan
 Trav/Holiday 149:61 (c, 4) Mr '78
 Ebony 33:38 (4) Ap '78
--Horsetram (Isle of Man)
 Trav/Holiday 151:56 (c, 4) Je '79
--Porto, Portugal
 Nat Geog 158:818-19 (c, 1) D '80
--St. Louis, Missouri
 Trav/Holiday 150:24 (c, 1) Ag '78
--Sofia, Bulgaria
 Nat Geog 158:98-9 (c, 1) Jl '80
--Zagreb, Yugoslavia
 Travel 148:34 (c, 2) Jl '77
TROMBONE PLAYING
--Louisiana
 Nat Geog 153:214-15 (c, 1) F '78
TROPHIES
 Nat Geog 153:704 (c, 3) My '78
 Sports Illus 54:74 (c, 4) My 11
 '81
 Nat Geog 160:215 (c, 1) Ag '81
--Auto racing
 Ebony 34:34 (3) Mr '79
 Ebony 35:110 (4) Ja '80
--Basketball
 Sports Illus 46:21 (c, 4) Ja 10
 '77
 Sports Illus 47:26 (c, 3) D 12 '77
 Sports Illus 48:72 (4) Ja 9 '78
 Sports Illus 52:cov. (c, 1) My 26
 '80
 Sports Illus 54:34-5 (c, 2) Je 8
 '81
--Belmont Stakes
 Sports Illus 46:40 (c, 1) Je 13 '77
--Bodybuilding
 Ebony 35:130 (c, 3) Ap '80
--Bowling
 Sports Illus 46:72 (c, 4) Mr 7 '77
--Boxing
 Sports Illus 53:94 (c, 4) N 24 '80
--Chess championship
 Ebony 36:103, 106 (4) O '81
--Figure skating
 Ebony 32:45 (3) Je '77
--Football
 Sports Illus 47:36-7 (c, 2) D 5 '77
 Sports Illus 55:46-7 (c, 1) Ag 3
 '81
--Golf
 Sports Illus 47:88 (c, 4) S 5 '77

TRUMAN, HARRY S
 Am Heritage 28:8, 54-5 (2) F
 '77
 Am Heritage 28:4 (4) Ap '77
 Smithsonian 9:51 (4) Ja '79
 Am Heritage 30:48 (4) F '79
 Am Heritage 30:23 (2) Je '79
 Life 2:146 (4) D '79
 Am Heritage 31:44-5 (1) F '80
 Am Heritage 31:113 (2) Ap '80
 Am Heritage 31:37-47 (2) Je
 '80
 Life 3:138 (4) N '80
 Am Heritage 32:7, 110 (3) Ag
 '81
--1949 inaugural button
 Smithsonian 7:111 (4) Ja '77
TRUMBULL, JOHN
--Portrait of Jefferson
 Am Heritage 29:112 (4) Ap '78
--Self-portrait
 Am Heritage 29:112 (4) Ap '78
TRUMPET PLAYING
 Ebony 33:58 (4) S '78
 Smithsonian 9:69 (c, 1) N '78
 Life 2:145 (c, 2) D '79
 Ebony 35:73 (4) F '80
 Sports Illus 53:29 (c, 4) S 8 '80
 Ebony 36:94-5 (2) O '81
 Sports Illus 55:112 (c, 4) O 19
 '81
--Heralds (Wales)
 Trav/Holiday 153:110 (3) Ap
 '80
--New Orleans, Louisiana
 Trav/Holiday 150:54 (c, 4) Jl
 '78
--See also ARMSTRONG, LOUIS
TRUMPETS
--Owned by W. C. Handy
 Travel 148:57 (c, 4) O '77
TRUTH, SOJOURNER
 Ebony 32:164 (drawing, 4) Ag
 '77
--Depiction in theater
 Ebony 33:94 (4) My '78
--Tombstone (Battle Creek, Michi-
 gan)
 Ebony 34:76 (3) F '79
TSETSE FLIES
 Natur Hist 86:76-7 (painting, c, 1)
 F '77
Tuareg Tribe. See BERBER
 PEOPLE
TUBA PLAYING
 Sports Illus 51:23 (c, 4) Jl 2
 '79
 Smithsonian 12:91 (c, 1) Je '81

--Spain
 Natur Hist 87:53 (c, 3) Ap '78
--Wisconsin
 Nat Geog 152:190 (c, 1) Ag '77
TUBERCULOSIS
--1915 sanatorium (Adirondacks,
 New York)
 Am Heritage 30:54-5 (1) F '79
TUBMAN, HARRIET
 Ebony 32:164 (4) Ag '77
--Depiction in drama
 Ebony 34:29 (c, 3) Ja '78
TUCSON, ARIZONA
 Nat Geog 152:500 (c, 3) O '77
--Seven Falls
 Life 4:108 (c, 2) Ag '81
--Suburban housing
 Nat Geog 158:178 (c, 1) Ag '80
Tufa. See LIMESTONE
TUGBOATS
 Nat Geog 153:202-3 (c, 1) F '78
TULIP TREES
 Nat Wildlife 19:25 (c, 3) Je '81
TULIPS
 Smithsonian 8:cov. , 70-7 (c, 1)
 Ap '77
 Nat Geog 153:713-28 (c, 1) My
 '78
 Smithsonian 12:cov. (c, 1) My
 '81
--17th cent. Netherlands
 Smithsonian 8:70-5 (painting, c, 1)
 Ap '77
--Tulip field (Netherlands)
 Trav/Holiday 151:45 (c, 2) Je '79
 Trav/Holiday 155:49 (c, 3) Ap '81
TULSA, OKLAHOMA
 Trav/Holiday 156:52-5 (c, 1) Ag
 '81
TUNA
 Nat Geog 160:784-5 (c, 1) D '81
--Bluefin
 Sports Illus 47:103 (c, 4) O 10
 '77
 Nat Geog 153:528-9 (c, 1) Ap '78
TUNDRA
--Alaska
 Nat Geog 152:54-5 (c, 1) Jl '77
 Nat Geog 156:734-69 (c, 1) D '79
--Wyoming
 Natur Hist 90:82-4 (c, 1) O '81
TUNIS, TUNISIA
 Trav/Holiday 149:33 (c, 2) Ja '78
 Nat Geog 157:195-203 (c, 1) F
 '80
TUNISIA
 Trav/Holiday 149:cov. , 26-33
 (c, 1) Ja '78

Natur Hist 89:cov., 42-9 (c, 1)
My '80
Trav/Holiday 154:23-4 (4) S
'80
Nat Wildlife 18:2 (c, 3) O '80
Trav/Holiday 155:60 (drawing, 4)
Ap '81
Smithsonian 12:110 (painting, c, 4)
S '81
--Butchering green turtles
(Nicaragua)
Natur Hist 89:8 (3) F '80
--Green
Natur Hist 87:28 (3) D '78
Nat Geog 159:648-51 (c, 1) My
'81
Nat Wildlife 19:4-11 (c, 1) Je
'81
--Illinois mud turtles
Natur Hist 86:52-7 (c, 1) Ap '77
--Loggerhead
Sports Illus 54:60-8 (c, 1) Mr
23 '81
--Sea
Life 2:77-80 (c, 2) S '79
--Sea turtles without shells
Nat Geog 159:294-5 (c, 1) Mr
'81
--Snapping
Nat Geog 157:136-7 (c, 1) Ja '80
Nat Wildlife 18:42-5 (c, 1) Ap
'80
--Tuntong
Natur Hist 87:39-42 (c, 2) My
'78
--Underwater
Trav/Holiday 156:79 (c, 2) O
'81
--See also TERRAPINS
TWAIN, MARK
Smithsonian 8:64 (4) Ag '77
Smithsonian 9:130 (4) My '78
Am Heritage 29:46 (4) Je '78
Am Heritage 30:73 (2) Ap '79
Sports Illus 52:73 (4) Ja 28 '80
Am Heritage 31:101 (4) Ag '80
Am Heritage 32:81 (4) O '81
--Boyhood home (Hannibal, Mis-
souri)
Smithsonian 9:156 (4) O '78
--Home (Hartford, Connecticut)
Travel 147:67 (c, 3) Mr '77
--Patents by him
Am Heritage 29:36-7 (4) Je '78
Am Heritage 30:111 (4) F '79
--Sites connected with Tom Sawyer
(Hannibal, Missouri)
Smithsonian 9:155-63 (c, 4) O

'78
TWEED, WILLIAM MARCY (BOSS)
--Caricature by Thomas Nast (1871)
Am Heritage 28:66 (3) Je '77
TWILIGHT
--Minnesota farm
Nat Geog 160:704-5 (c, 1) N '81
TWINS
Nat Geog 153:397 (c, 1) Mr '78
Ebony 34:cov., 134-42 (c, 2) D
'78
Ebony 34:95-8 (2) Je '79
Smithsonian 11:48-57 (1) O '80
Ebony 36:80-4 (3) D '80
--Siamese twins
Ebony 33:123-6 (3) D '77
Ebony 34:95 (4) Je '79
Life 2:100-1 (1) Jl '79
TYPEWRITERS
Smithsonian 8:60 (sculpture, c, 4)
My '77
--1927
Am Heritage 31:27 (4) O '80
TYPING
Ebony 32:77 (4) F '77
Smithsonian 8:49 (c, 4) Jl '77
Ebony 33:124 (2) N '77
Ebony 33:156 (3) My '78
Sports Illus 50:72 (c, 4) Je 4 '79
--Gorilla
Nat Geog 154:454-5 (c, 1) O '78
--New Zealand
Nat Geog 154:259 (c, 4) Ag '78
TYPING--EDUCATION
Ebony 32:82 (4) Ap '77
Ebony 34:48 (4) D '78

-U-

UFO's. See UNIDENTIFIED FLY-
ING OBJECTS
UGANDA
Nat Geog 158:72-89 (map, c, 1)
Jl '80
--Fishing industry
Life 2:64-5 (c, 1) Ag '79
--See also LAKE VICTORIA
UGANDA--COSTUME
Nat Geog 158:72-89 (c, 1) Jl '80
--Military
Life 2:132-3 (1) Je '79
ULAN BATOR, MONGOLIA
Travel 147:28, 66 (c, 4) Je '77
ULYSSES
--3rd cent. mosaic (Tunisia)
Nat Geog 157:198-9 (c, 1) F '80
--Blinding cyclops Polyphemus

Smithsonian 8:52-3 (painting, c, 1)
Jl '77
--Treasures of the czars
Nat Geog 153:25-33 (c, 1) Ja
'78
--See also BREZHNEV, LEONID;
KHRUSHCHEV, NIKITA;
LENIN, NIKOLAI; NICHOLAS
II; PETER THE GREAT;
RUSSO-JAPANESE WAR;
STALIN, JOSEPH; WORLD
WAR I; WORLD WAR II
U. S. S. R. --MAPS
--Railroad lines
Smithsonian 8:38 (4) F '78
U. S. S. R. --POLITICS AND GOV-
ERNMENT
--Police repressing protester
(Moscow)
Life 3:32-3 (2) My '80
Unions. See LABOR UNIONS
United Arab Emirates. See
ABU DHABI; DUBAI
UNITED NATIONS
--General Assembly
Ebony 33:111-14 (c, 4) Ap '78
Ebony 34:41 (c, 4) My '79
Ebony 36:150 (3) D '80
--Security Council
Ebony 35:116-17, 120 (3) Ja
'80
Ebony 35:74 (2) Mr '80
--Security Council (1962)
Am Heritage 28:14 (4) O '77
--U. S. Mission to the U. N.
Ebony 35:76 (2) Mr '80
UNITED NATIONS BUILDING,
NEW YORK CITY, NEW
YORK
Travel 148:40 (4) S '77
Ebony 36:88 (2) Jl '81
U. S. See EASTERN U. S.; MID-
WEST; NEW ENGLAND;
NORTHWEST; SOUTH; UNCLE
SAM; WESTERN U. S.; in-
dividual states
U. S. --COSTUME--17TH CENT.
--Recreation of 1642 Boston cos-
tume
Smithsonian 9:86-93 (c, 1) Mr
'79
--Virginia settlers
Nat Geog 155:736-67 (paint-
ing, c, 1) Je '79
U. S. --COSTUME--18TH CENT.
Smithsonian 8:114-24 (paint-
ing, c, 2) F '78
--Late 18th cent. wealthy women

Am Heritage 31:102-7 (paint-
ing, c, 4) Ap '80
--Revolutionary War fife & drum
style
Sports Illus 53:cov. (c, 1) D 1
'80
--Revolutionary War period (Boston)
Am Heritage 28:30-1 (painting, c, 1)
Ap '77
U. S. --COSTUME--19TH CENT.
Smithsonian 8:59-67 (1) Ag '77
Smithsonian 9:96-7 (4) My '78
--Early 19th cent. frontier costume
Smithsonian 10:99-104 (draw-
ing, c, 1) Ap '79
--1830's
Smithsonian 9:135 (painting, 4) N
'78
--Mid 1800's
Am Heritage 29:8-9 (4) Ap '78
--1850 painting
Am Heritage 31:6-7 (painting, c, 1)
D '79
--1850's
Am Heritage 28:2, 98-107 (c, 1)
O '77
Smithsonian 11:48 (4) Ja '81
Smithsonian 12:117 (3) Je '81
--Antebellum costume
Ebony 32:153 (c, 4) Mr '77
--1860's
Natur Hist 89:55 (3) My '80
--1860's elderly women
Am Heritage 30:105 (4) F '79
--1863 women
Am Heritage 30:17 (painting, c, 2)
Ap '79
--1865
Smithsonian 8:82-3 (drawing, 2)
Jl '77
--1866 woman
Am Heritage 32:2 (painting, c, 1)
Ag '81
--Post-Civil War blacks
Ebony 34:102-6 (3) O '79
--1869 woman
Smithsonian 8:66 (4) Ap '77
--1870's
Smithsonian 7:52 (painting, c, 4)
Ja '77
--1870's fashionable attire
Smithsonian 9:132-3 (c, 2) N '78
--1873
Smithsonian 8:60-1 (3) Ap '77
--Late 19th cent. (Mississippi)
Am Heritage 29:26-35 (1) Je '78
--Late 19th cent. (Utah)
Am Heritage 30:34-44 (1) Je '79

--Late 19th cent. corseted woman
 dressing
 Am Heritage 32:59 (4) Je '81
--Late 19th cent. walking attire
 Smithsonian 10:89-98 (4) Jl '79
--1879 men's wear
 Smithsonian 10:98 (4) Ag '79
--1880
 Am Heritage 32:24-5 (paint-
 ing, c, 1) Ag '81
--1880's (West)
 Smithsonian 10:130-42 (3) F '80
--1880's men's wear
 Smithsonian 12:75 (2) Ap '81
--1880's woman
 Smithsonian 11:136 (4) Mr '81
--1881 inaugural gown of Lucretia
 Garfield
 Smithsonian 11:26 (4) Ja '81
--1885
 Am Heritage 28:100 (3) F '77
--1888
 Am Heritage 29:30-1 (1) Ag
 '78
--1889
 Smithsonian 10:116 (drawing, 4)
 Ja '80
--1890's hoboes
 Smithsonian 8:141-51 (3) N '77
--1893
 Am Heritage 29:52-3 (3) F '78
--1898
 Am Heritage 31:88 (4) Ap '80
 Smithsonian 12:130 (4) My '81
--1899 farm workers (Oregon)
 Smithsonian 7:55 (1) Mr '77
--1900 Chinatown, San Francisco,
 California
 Am Heritage 30:cov., 36-46 (1)
 D '78
--1900 men
 Am Heritage 30:30-1 (1) Ap '79
--Folk art portraits (Pennsylvania)
 Am Heritage 31:36-7 (paint-
 ing, c, 4) F '80
--Midwest settlers
 Natur Hist 89:76-7 (1) N '80
--Old Salem, North Carolina
 Trav/Holiday 156:4-13 (c, 1) D
 '81
--Paintings of American workers
 Am Heritage 31:8-21, 114
 (painting, c, 1) Je '80
--Plains homesteaders
 Natur Hist 86:48-53 (2) My '77
--Tom Sawyer costumes
 Smithsonian 9:158 (4) O '78
U. S. --COSTUME--20TH CENT.

--Early 20th cent.
 Smithsonian 9:98-100 (4) S '78
 Smithsonian 12:96-102 (2) S '81
--Early 20th cent. (New York)
 Life 3:8-10 (1) F '80
--Early 20th cent. (Texas)
 Am Heritage 28:50-5 (1) Ap '77
--Early 20th cent. farm life (Ohio)
 Am Heritage 32:74-81 (2) Ag '81
--Early 20th cent. gentleman sailor
 Smithsonian 11:39 (1) Ag '80
--Early 20th cent. girls' gym
 bloomers
 Am Heritage 29:7 (2) O '78
--Early 20th cent. sailors (Wash-
 ington)
 Smithsonian 9:98-100 (4) S '78
--Early 20th cent. siren
 Life 4:10-18 (1) Je '81
--Early 20th cent. woman's driving
 attire
 Smithsonian 11:138 (4) S '80
--1902 woman
 Am Heritage 29:33 (1) Ag '78
--1903
 Nat Geog 156:220 (4) Ag '79
--1904
 Am Heritage 33:68-9 (1) D '81
--1904 (Utah)
 Am Heritage 30:32-3 (1) Je '79
--1906 factory workers (New Hamp-
 shire)
 Smithsonian 9:140-1 (4) Mr '79
--1910's
 Am Heritage 30:68-75 (2) Ap '79
--1910's (California)
 Am Heritage 31:50-60 (1) O '80
--1910's (Lake Placid, New York)
 Am Heritage 33:66-7 (4) D '81
--1912
 Am Heritage 29:37 (3) Ag '78
--1913 well-dressed man
 Am Heritage 28:91 (3) F '77
--1916 men's wear
 Smithsonian 7:57 (2) Ja '77
--1916 wealthy woman
 Smithsonian 11:92-5 (painting, c, 2)
 Ag '80
--1918 industrialists on camping
 trip
 Smithsonian 9:88-95 (1) Je '78
--1919 women
 Am Heritage 30:17-29 (2) D '78
--1920's
 Nat Geog 151:180-1 (1) F '77
--1920's female booze smuggler
 Smithsonian 10:113 (3) Je '79
--1926 woman's dinner jacket

Smithsonian 10:140 (drawing, 4)
My '79
--1927
Am Heritage 31:20-9 (2) O '80
--1929 woman
Smithsonian 7:57 (4) Ja '77
--1930's (Alabama)
Life 4:10-12 (2) Mr '81
--1930's elegant dress
Smithsonian 12:165 (c, 4) N '81
--1930's laborers
Smithsonian 10:94-5 (2) Ja '80
--1934 child
Life 3:79, 92 (4) Je '80
--1936 woman
Life 2:6 (2) Jl '79
--1938 (Harlem, New York)
Am Heritage 29:91 (2) O '78
--1940 (New Mexico)
Am Heritage 31:74-81 (c, 1) F
'80
--1940's woman factory worker
Am Heritage 32:93 (3) O '81
--1945 (New York)
Life 3:7, 10 (2) Ag '80
--1951 man in overcoat
Am Heritage 32:21 (1) Ag '81
--1955 Alabama blacks
Ebony 32:55 (3) S '77
--1956 women's wear
Ebony 33:94-101 (c, 2) Mr '78
--1960-1980 fashions as seen on
Barbie dolls
Life 2:108-12 (c, 1) N '79
--Late 1960's flower children
Life 2:40-1 (c, 1) Mr '79
--1970's fashions
Life 2:66-8 (c, 4) D '79
--1980's preppy and punk styles
Life 4:65 (c, 2) Ja '81
--Brooklyn, New York working
class
Smithsonian 9:74-9 (2) My '78
--Mexican Americans
Nat Geog 157:780-809 (c, 1) Je
'80
--New Wave styles
Life 3:102-8 (c, 1) Je '80
--Street dwellers (New York City,
New York)
Natur Hist 86:79-85 (1) N '77
--See also MILITARY COSTUME;
list under OCCUPATIONS
U. S. -- HISTORY
--Early 19th cent. depiction of
U. S. as Indian maiden
(France)
Am Heritage 33:cov. (paint-

ing, c, 2) D '81
--1911 center of population (Indiana)
Am Heritage 31:14 (4) D '79
--As depicted on cigar labels
Am Heritage 30:82-91 (paint-
ing, c, 1) D '78
--Depicted on 1884 clock
Am Heritage 33:4-9 (c, 1) D '81
--Depicted on wallpaper
Am Heritage 33:81-9 (c, 1) D '81
--History of U. S. foreign aid pro-
grams
Am Heritage 29:64-81 (c, 1) Ap
'78
--Taking of the Census through his-
tory
Am Heritage 31:6-17 (c, 1) D '79
U. S. -- HISTORY -- COLONIAL
PERIOD
--1693 anti-French document (New
York)
Am Heritage 28:84-5 (2) O '77
--1776 life
Nat Wildlife 15:5-11 (painting, c, 1)
Ja '77
--Bill for payment in tobacco
(Maryland)
Nat Geog 158:445 (c, 3) O '80
--Paintings by British officer
Am Heritage 29:98-107 (c, 2) Je
'78
--Pocahontas on 19th cent. cigar
label
Am Heritage 30:82 (painting, c, 3)
D '78
--Recreation of 1642 Boston houses
Smithsonian 9:89 (c, 3) Mr '79
--Reenactment of Roanoke settlement
story
Trav/Holiday 153:69 (c, 4) Mr '80
--Relics from 17th cent. Virginia
settlement
Nat Geog 155:734-67 (c, 1) Je '79
--See also FRENCH AND INDIAN
WAR; PENN, WILLIAM;
WILLIAMSBURG, VIRGINIA
U. S. --History--Revolutionary War.
See REVOLUTIONARY WAR
U. S. -- HISTORY -- 1783-1861
--19th cent. life depicted in paint-
ings
Am Heritage 32:2, 22-35 (paint-
ing, c, 1) Ag '81
--19th cent. war with Barbary
pirates
Am Heritage 28:2, 36-43 (paint-
ing, c, 1) Ag '77
--Congressional leaders (1774-1889)

Smithsonian 8:92-105 (paint-
ing, c, 4) Ja '78
--Moravian sect life in Old Salem,
North Carolina
Trav/Holiday 156:4-13 (c, 1) D
'81
--See also INDIAN WARS; LEWIS
AND CLARK EXPEDITION;
MEXICAN WAR; PONY EX-
PRESS; WAR OF 1812
U. S. --History--Civil War. See
CIVIL WAR
U. S. --HISTORY--1865-1898
--Late 19th cent. Louisiana lot-
tery scandal
Smithsonian 10:113-25 (draw-
ing, 3) Ja '80
--1870's trip on transcontinental
railroad
Am Heritage 28:14-25 (paint-
ing, c, 2) F '77
--Collecting manure for fuel (Mid-
west)
Natur Hist 89:76-9 (1) N '80
--See also GOLD RUSH; INDIAN
WARS; MOLLY MAGUIRES;
SPANISH-AMERICAN WAR;
WESTERN FRONTIER LIFE
U. S. --HISTORY--1898-1919
--Early 20th cent. cartoons about
exploitation of West
Am Heritage 29:6-9 (4) Ag '78
--Early 20th cent. West Coast
shipping industry
Am Heritage 29:50-65 (1) O
'78
--See also PROHIBITION MOVE-
MENT; WOMEN'S SUFFRAGE
MOVEMENT; WORLD WAR I
U. S. --HISTORY--1919-1933
--1925 Scopes trial (Tennessee)
Natur Hist 90:12-22 (2) O '81
--1930 breadline (Chicago, Illinois)
Am Heritage 30:91 (4) F '79
--See also PROHIBITION MOVE-
MENT
U. S. --HISTORY--1933-1945
--1940's efforts to conserve gas
Am Heritage 30:4-16 (c, 1) O
'79
--Family fleeing dust storm (Okla-
homa)
Nat Geog 156:638 (4) N '79
--Founding of Social Security Ad-
ministration
Am Heritage 30:38-49 (3) Ap
'79
--Paintings of the 1930's Depres-

sion
Smithsonian 10:cov., 44-53 (c, 1)
O '79
--See also WORLD WAR II
U. S. --HISTORY--1945-1953
--1948 Alger Hiss case
Am Heritage 32:4-21 (1) Ag '81
U. S. --HISTORY--1961-
--1962 Cuban missile crisis
Am Heritage 28:6-15 (c, 1) O '77
--1970 Kent State shooting, Ohio
Life 2:37 (1) D '79
--1970's events
Life 2:entire issue (c, 1) D '79
--Failed attempt to rescue Iranian
hostages
Life 3:143-5 (c, 1) Je '80
--Hostages in Iran (1979-81)
Life 4:32-3, 42-51 (c, 1) Ja '81
Life 4:cov., 3, 26-40 (c, 1) Mr
'81
--See also CIVIL RIGHTS; WATER-
GATE; WOMEN'S LIBERATION
MOVEMENT
U. S. --MAPS
--Energy resources
Nat Geog 159:58-69 (c, 1) F
'81SR
--Outline of U. S.
Am Heritage 28:6 (drawing, 4) O
'77
--Tallgrass prairie land
Nat Geog 157:43 (c, 1) Ja '80
--Water resources
Nat Geog 158:150-1 (c, 1) Ag '80
--Wildlife refuges
Nat Geog 155:363-7 (c, 1) Mr '79
U. S. --POLITICS AND GOVERN-
MENT
--Cabinet meeting
Ebony 34:33 (4) F '79
--Cabinet members
Life 3:11-14 (c, 2) N '80
--City Council meeting (Birming-
ham, Alabama)
Ebony 35:36 (3) F '80
--Congressional leaders (1776-1789)
Smithsonian 8:92-105 (painting, c, 4)
Ja '78
--FCC meeting
Ebony 35:115 (3) Je '80
--House celebration at passing of
13th Amendment (1865)
Ebony 36:32 (engraving, 3) O '81
--House committee in session
Ebony 33:134 (2) O '78
--Lincoln's cabinet (1860's)
Smithsonian 8:60-1 (1) Ag '77

--New England town meeting
(Concord, Mass.)
Nat Geog 159:356 (c, 4) Mr '81
--Senate committee hearing
Ebony 33:107 (3) My '78
--Speaker of the House Joseph
Gurney Cannon (20th cent.)
Am Heritage 28:cov. , 29 (1)
F '77
--Speakers of the House
Am Heritage 28:cov. , 26-31
(c, 2) F '77
--Swearing in mayor (Birmingham,
Alabama)
Ebony 35:34-5 (1) F '80
--Swearing in mayor (New Or-
leans, Louisiana)
Ebony 34:34 (4) D '78
--See also CENTRAL INTELLI-
GENCE AGENCY; CAPITOL
BUILDINGS; ELECTIONS;
GOVERNMENT--LEGISLA-
TURES; POLITICAL CAM-
PAIGNS; U. S. PRESIDENTS;
WATERGATE
U. S. --RITES AND CEREMONIES
--Observing National Anthem at
ballpark
Sports Illus 52:56-7 (c, 1) Ap
7 '80
Ebony 36:81 (3) Jl '81
--Pledging allegiance to the flag
(Iowa)
Nat Geog 159:602 (c, 1) My '81
U. S. --SIGNS AND SYMBOLS
--Portraits made up of men
Am Heritage 28:93 (4) Je '77
--See also LIBERTY, STATUE
OF; LIBERTY BELL; UNCLE
SAM
U. S. --SOCIAL LIFE AND CUS-
TOMS
--Early 20th cent. society life
(New York)
Am Heritage 29:69-75 (1) Ag
'78
--Early 20th cent. working class
city life
Am Heritage 30:7-12 (4) F '79
--20th cent. variety store products
Life 2:54-5 (c, 1) Je '79
--1970's artifacts
Life 2:65-8 (c, 4) D '79
--American heroes
Life 2:92-4 (c, 1) Mr '79
--Flag raising ceremony at Indian
festival (New York)
Travel 147:52 (4) F '77

--Paintings by Diego Rivera
Am Heritage 29:16-29 (paint-
ing, c, 1) D '77
--See also FARM LIFE; WESTERN
FRONTIER LIFE
U. S. ARMY
--Pinning on general's stars
Ebony 35:45 (4) Ja '80
Ebony 35:48 (4) F '80
--See also MILITARY COSTUME;
WEST POINT
U. S. COAST GUARD
--Tracking dope smuggling ships
Sports Illus 50:28-30 (c, 3) Ap
9 '79
--Tracking ships in Puget Sound,
Washington
Nat Geog 151:76 (c, 3) Ja '77
U. S. NATIONAL ARCHIVES,
WASHINGTON, D. C.
Ebony 32:52-60 (4) Je '77
U. S. NAVAL ACADEMY, ANNAPO-
LIS, MARYLAND
Travel 147:44-5 (3) Je '77
U. S. NAVY
--Guantanamo Bay naval base (1927)
Am Heritage 29:31 (3) O '78
--See also MILITARY COSTUME;
SAILORS; U. S. NAVAL
ACADEMY
U. S. PRESIDENTS
--1881 inaugural gown of Lucretia
Garfield
Smithsonian 11:26 (4) Ja '81
--1961 Kennedy inauguration
Am Heritage 28:54-5 (2) F '77
--1977 Carter inauguration
Ebony 32:139-49 (c, 2) Mr '77
--1981 Reagan inaugural parade
Trav/Holiday 155:111 (4) Ap '81
--1981 Reagan inauguration
Ebony 36:130-3 (c, 3) Mr '81
--Inaugural relics
Smithsonian 7:101-11 (painting, c, 2)
Ja '77
--Oval Office desk
Am Heritage 32:63-4 (c, 4) O '81
--Painting of presidents (1789-1931)
by Carlos Coyle
Am Heritage 29:60-1 (painting, c, 1)
Ag '78
--Recent presidents at interviews
Life 3:138 (4) N '80
--See also WASHINGTON, GEORGE;
ADAMS, JOHN; JEFFERSON,
THOMAS; MADISON, JAMES;
ADAMS, JOHN QUINCY; JACK-
SON, ANDREW; VAN BUREN,

MARTIN; HARRISON, WIL-
LIAM HENRY; POLK, JAMES
KNOX; FILLMORE, MIL-
LARD; LINCOLN, ABRAHAM;
GRANT, ULYSSES S.;
HAYES, RUTHERFORD B.;
GARFIELD, JAMES; CLEVE-
LAND, GROVER; HARRISON,
BENJAMIN; McKINLEY,
WILLIAM; ROOSEVELT,
THEODORE; TAFT, WIL-
LIAM HOWARD; WILSON,
WOODROW; HARDING, WAR-
REN G.; COOLIDGE, CAL-
VIN; HOOVER, HERBERT;
ROOSEVELT, FRANKLIN
DELANO; TRUMAN, HARRY
S; EISENHOWER, DWIGHT
D.; KENNEDY, JOHN FITZ-
GERALD; JOHNSON, LYN-
DON BAINES; NIXON,
RICHARD MILHAUS; FORD,
GERALD; CARTER, JIMMY;
REAGAN, RONALD; WHITE
HOUSE
UNIVERSE
--Black and white holes
Smithsonian 8:100-7 (c, 1) N
'77
--See also COMETS; CONSTEL-
LATIONS; EARTH; ECLIPSES;
GALAXIES; JUPITER;
METEORITES; MILKY WAY;
MOONS; NEBULAE; PLANETS;
QUASARS; SATURN; SPACE
PROGRAM; SPACECRAFT;
STARS; SUN; URANUS; VENUS
UPPER VOLTA
--Oursi village
Nat Geog 157:512-25 (c, 1) Ap
'80
UPPER VOLTA--COSTUME
Nat Geog 156:cov., 612-13
(c, 1) N '79
--Oursi village tribes
Nat Geog 157:513-25 (c, 1) Ap
'80
--Rulers
Ebony 33:165, 170 (c, 4) O '78
URANUS
Smithsonian 9:66-73 (drawing, c, 1)
D '78
URBAN RENEWAL
--Baltimore, Maryland
Life 3:94 (c, 3) S '80
--Renovating old houses
Ebony 33:72-81 (2) S '78
UTAH

Nat Geog 158:776-802 (map, c, 1)
D '80
--Early 20th cent. Saltair resort
Am Heritage 32:81-9 (1) Je '81
--Bear River Delta
Nat Geog 155:346-7 (c, 1) Mr
'79
--Bonneville Salt Flats
Sports Illus 55:50-7 (c, 1) O 5
'81
--Calf Creek Falls, Escalante
Life 4:106-7 (c, 1) Ag '81
--Coral Pink Sand Dunes State Re-
serve
Natur Hist 88:60 (c, 1) Ag '79
--Countryside
Trav/Holiday 149:42-4 (c, 1) My
'78
--Echo Canyon Pony Express station
(1868)
Nat Geog 158:52-3 (2) Jl '80
--Goblin Valley
Trav/Holiday 151:63-5 (c, 1) My
'79
--Green River
Nat Geog 156:218-19 (c, 1) Ag
'79
--Kaiparowits Plateau
Smithsonian 8:33 (c, 4) Ag '77
--Lake Powell
Trav/Holiday 156:cov., 45, 57
(c, 1) Ag '81
--Manti (1886)
Am Heritage 30:28-9 (1) Je '79
--Monument Valley
Life 1:36-7 (c, 1) O '78
--Rock art
Nat Geog 157:94-117 (c, 1) Ja '80
--Snowbird avalanche control
Smithsonian 11:56-65 (c, 1) D '80
--Use of beehive as state symbol
Smithsonian 12:165 (c, 4) Ap '81
--See also ARCHES NATIONAL
PARK; BRYCE CANYON NA-
TIONAL PARK; CANYONLANDS
NATIONAL PARK; COLORADO
RIVER; GREAT SALT LAKE;
PROVO; RAINBOW BRIDGE
NATIONAL MONUMENT; SALT
LAKE CITY; WASATCH
RANGE; ZION NATIONAL
PARK
UTAH--HISTORY
--Late 19th cent.
Am Heritage 30:cov., 28-47, 114
(1) Je '79
--1896 statehood queen
Am Heritage 30:44 (1) Je '79

UTAH--MAPS
--Southern region
 Nat Geog 158:778-9 (c, 1) D
 '80
UTE INDIANS (WEST)
--1873
 Natur Hist 89:70-1 (2) O '80

-V-

VACCINATIONS
 Nat Geog 154:802-3 (c, 1) D
 '78
--Chad
 Ebony 33:92 (4) D '77
VACUUM CLEANERS
--Great Britain
 Trav/Holiday 151:48 (c, 1) Mr
 '79
VACUUMING
 Sports Illus 52:62 (c, 4) Mr 17
 '80
 Ebony 35:50 (4) Ag '80
VALENTINE'S DAY
--Early 20th cent. cards
 Smithsonian 11:153 (c, 4) F '81
VALLEY FORGE, PENNSYL-
 VANIA
 Trav/Holiday 155:32, 105 (4)
 Ap '81
VAN BUREN, MARTIN
--1840 campaign souvenirs
 Smithsonian 11:181-2 (c, 4) O
 '80
VANCOUVER, BRITISH COLUM-
 BIA
 Travel 147:30, 33 (c, 1) My
 '77
 Nat Geog 154:466-91 (map, c, 1)
 O '78
--Aquarium
 Nat Wildlife 16:8 (c, 4) F '78
--Totem poles (Stanley Park)
 Trav/Holiday 155:66 (c, 4) Ap
 '81
--See also VICTORIA
VANDERBILT, CORNELIUS
 Smithsonian 8:135 (drawing, 4)
 O '77
 Smithsonian 12:122 (4) Je '81
--Early 20th cent. Vanderbilt
 properties and heirs
 Life 3:79-92 (1) Je '80
VAN DER WEYDEN, ROGER
--Last Judgment
 Smithsonian 10:80-1 (paint-
 ing, c, 2) Je '79

VAN EYCK, JAN
--The Arnolfini Marriage
 Nat Geog 155:338 (painting, c, 2)
 Mr '79
VAN GOGH, VINCENT
--The Novel Reader (1888)
 Smithsonian 11:56-7 (painting, c, 1)
 Je '80
--Sunflowers
 Life 2:84 (painting, c, 4) S '79
Vatican City, Italy. See POPES;
 ST. PETER'S CHURCH
VEGETABLES
--19th cent. American still lifes
 Am Heritage 32:2, 14-25 (paint-
 ing, c, 1) O '81
--Winged bean
 Life 3:59 (c, 2) Ja '80
--See also ARTICHOKES; ASPARA-
 GUS; CORN; CRESS; GARLIC;
 KOHLRABI; MUSTARD
 PLANTS; PARSLEY; PEPPER;
 POTATOES; RADISHES; SOR-
 REL; SOYBEANS
VENDING MACHINES
--Japan
 Nat Geog 157:78-9 (c, 2) Ja '80
--Selling water (California)
 Nat Geog 155:34 (c, 4) Ja '79
VENEZUELA
--Caracas region
 Trav/Holiday 156:51-5 (c, 1) S
 '81
--Llanos area
 Life 4:181-91 (c, 2) D '81
--See also CARACAS
VENEZUELA--COSTUME
--Miners
 Natur Hist 88:66-71 (1) D '79
VENICE, ITALY
 Smithsonian 8:40-53 (map, c, 2)
 N '77
 Trav/Holiday 151:cov. , 34-9
 (c, 1) F '79
 Life 2:93-5 (c, 1) Jl '79
 Sports Illus 52:28-9 (c, 2) Ja 28
 '80
--1890
 Nat Geog 160:96-7 (painting, c, 1)
 Jl '81
--Armenian seminary
 Nat Geog 153:858-9 (c, 2) Je '78
--See also ST. MARK'S CATHE-
 DRAL
VENTRILOQUISTS
 Ebony 36:77-82 (2) O '81
VENUS
--4th cent. B. C. terra cotta

figures (Greece)
Smithsonian 11:134 (c, 4) N '80
--17th cent. Rubens painting
Smithsonian 8:50-1 (c, 2) O
'77
--Ancient Roman sculpture
Nat Geog 159:734 (c, 1) Je '81
--Ancient Roman sculpture
(Pompeii)
Natur Hist 88:51 (c, 4) Ap '79
--Ancient Roman sculpture (Tur-
key)
Nat Geog 160:529, 535 (c, 1)
O '81
VENUS (PLANET)
Natur Hist 87:84-5 (4) Ja '78
Life 2:48 (c, 2) My '79
Natur Hist 88:94-7 (c, 3) O '79
Life 3:163 (c, 2) N '80
--Temperature map
Natur Hist 87:92-3 (c, 3) D '78
VERACRUZ, MEXICO
Nat Geog 158:cov., 202-31
(map, c, 1) Ag '80
VERBENAS
Nat Wildlife 15:50 (c, 4) Ja '77
VERMEER
--Girl at a Window Reading a
Letter
Smithsonian 9:61 (painting, c, 2)
Je '78
Nat Geog 154:715 (c, 2) N '78
VERMONT
Natur Hist 90:cov., 72-82 (c, 1)
Mr '81
--Autumn scenes
Nat Wildlife 16:42-7 (c, 1) Ag
'78
Bonnington
Trav/Holiday 149:54-7 (c, 1) Je
'78
--Bennington's Park-McCullough
House
Trav/Holiday 155:70 (c, 4) My
'81
--Countryside
Smithsonian 10:124-9 (c, 2) N
'79
--Forests
Nat Wildlife 17:42-7 (c, 1) F
'79
--Passumpsic River
Smithsonian 8:88-9 (c, 1) S '77
--Ryegate area
Natur Hist 87:42 (c, 4) D '78
--Scenes of spring
Nat Wildlife 19:cov., 4-11 (c, 1)
Ap '81

--See also BARRE
VERRAZANO NARROWS BRIDGE,
NEW YORK
Sports Illus 47:24-5 (c, 1) O 31
'77
--Crossed by marathoners
Life 2:78-9 (c, 1) D '79
Sports Illus 53:16-17 (c, 1) N 3
'80
VERSAILLES PALACE, FRANCE
Smithsonian 7:38-47 (c, 1) Mr
'77
VESUVIUS, ITALY
--79 A. D. eruption (1813 painting)
Natur Hist 88:39 (c, 3) Ap '79
--1760 eruption
Natur Hist 88:46 (painting, c, 4)
Ap '79
--1771 painting of eruption
Smithsonian 12:82-3 (c, 1) D '81
VETERINARIANS
Ebony 32:122 (4) Jl '77
Smithsonian 9:126-30 (c, 3) O '78
--Horse operation (Pennsylvania)
Nat Geog 153:761 (c, 1) Je '78
--Treating injured animals
Nat Wildlife 19:4-11 (c, 1) F '81
VIADUCTS
--Ancient Rome
Nat Geog 159:732-3 (c, 1) Je '81
VICHY, FRANCE
Trav/Holiday 153:69 (c, 3) My '80
VICKSBURG, MISSISSIPPI
--Antebellum plantation
Travel 148:53 (c, 4) O '77
--Courthouse museum
Travel 148:54 (c, 1) O '77
VICTORIA (GREAT BRITAIN)
Natur Hist 90:77 (painting, 3) My
'81
Smithsonian 12:171-5 (2) O '81
--1842 painting by Edwin Landseer
Smithsonian 12:68 (c, 2) N '81
VICTORIA, BRITISH COLUMBIA
Travel 147:31, 34 (c, 1) My '77
Sports Illus 48:48 (c, 1) My 22
'78
VICTORIA FALLS, ZAMBEZI
RIVER, ZIMBABWE
Nat Geog 160:620-1, 650-1 (c, 1)
N '81
Trav/Holiday 156:64 (c, 4) N '81
VICUNAS
Smithsonian 7:60-4 (c, 2) Ja '77
Nat Geog 159:307 (c, 4) Mr '81
Life 4:73-6 (c, 2) Mr '81
VIENNA, AUSTRIA
Trav/Holiday 151:44-7, 84-5

(c, 1) Mr '79
Smithsonian 10:78-87 (c, 1) O
'79
--Schonbrunn Palace greenhouse
Smithsonian 10:112-13 (c, 3) O
'79
VIETNAM--COSTUME
--Boat people
Life 1:22-8 (c, 2) D '78
--Boat people (Mississippi)
Nat Geog 160:379-95 (c, 1) S '81
--Refugees in Hong Kong
Nat Geog 156:706-31 (c, 1) N
'79
--Refugees in Malaysia
Life 2:30-7 (c, 1) S '79
VIETNAM WAR
Life 2:104-12 (c, 1) O '79
--1966 injured soldiers
Am Heritage 29:30-1 (c, 1) Ap
'78
--1967 anti-war protest (New
York)
Am Heritage 29:22-3 (1) Ap '78
--1975 rescue of Americans by
helicopter
Life 2:46-7 (1) D '79
--Aiding wounded in helicopter
Life 2:104 (1) O '79
--American POW in Hanoi
Am Heritage 29:24 (1) Ag '78
--Napalmed child
Life 2:185 (2) D '79
--U. S. troops
Ebony 34:38 (3) Ag '79
VIKINGS
--Reconstruction of house interior
Smithsonian 11:62 (c, 4) S '80
VIKINGS--RELICS
Smithsonian 11:cov., 60-9
(c, 1) S '80
--Boat
Trav/Holiday 153:10, 13 (2)
My '80
--Ellesmere Island, Arctic region,
Canada
Nat Geog 159:575-601 (c, 1) My
'81
VILLA, PANCHO
Am Heritage 28:78-9 (1) Ag '77
Smithsonian 11:30, 40 (1) Jl
'80
VILLAGES
--19th cent. Pontoise, France
Smithsonian 12:48-9 (paint-
ing, c, 1) Je '81
--1930's southwestern town
Sports Illus 55:78 (drawing, c, 3)

Ag 31 '81
--Kirkenes, Norway
Life 4:34 (c, 4) Ag '81
--Le Barroux, France
Smithsonian 12:158 (c, 4) D '81
--Montaillou, France
Smithsonian 8:114-29 (c, 2) Mr
'78
--Nimkhera, India
Nat Geog 152:273 (c, 2) Ag '77
--Palmyra, New York
Nat Geog 151:720-1 (c, 1) My '77
--Queros, Peru
Natur Hist 90:72-3 (c, 1) N '81
--Somalia
Nat Geog 159:774 (c, 1) Je '81
VINES
--Rain forest (Costa Rica)
Smithsonian 9:121-30 (c, 3) Mr
'79
--Yam
Nat Geog 152:596-7 (c, 1) N '77
--See also IVY
VINEYARDS
--Bordeaux, France
Nat Geog 158:244-5 (c, 1) Ag '80
--Finger Lakes region, New York
Trav/Holiday 154:33 (c, 2) Ag '80
--Napa Valley, California
Nat Geog 155:694, 702-3 (c, 1)
My '79
--Ohio
Travel 148:39 (3) Jl '77
Nat Geog 154:94-5 (c, 2) Jl '78
--Portugal
Nat Geog 158:820-1 (c, 1) D '80
--Rioja, Spain
Trav/Holiday 155:58 (c, 1) F '81
--See also GRAPE INDUSTRY;
WINE
VIOLETS
Smithsonian 8:cov., 64-71 (c, 1)
Mr '78
Nat Wildlife 19:62 (c, 3) D '80
Natur Hist 90:66 (c, 4) Ja '81
VIOLIN MAKING
Smithsonian 8:106-10 (c, 1) S '77
Ebony 34:72-6 (3) N '78
--Poland
Nat Geog 159:116 (c, 4) Ja '81
VIOLIN PLAYING
Nat Geog 151:260-1 (c, 1) F '77
Sports Illus 53:72 (c, 4) S 15 '80
Natur Hist 90:84 (2) Jl '81
Sports Illus 55:46-7 (c, 1) Ag 3
'81
--Arkansas
Trav/Holiday 153:40 (4) Ap '80

--Child (U. S. S. R.)
Nat Geog 153:20 (c, 4) Ja '78
--China
Nat Geog 158:27 (c, 2) Jl '80
--Class (Cleveland, Ohio)
Ebony 36:108 (2) Ap '81
--Illinois street
Nat Geog 153:478-9 (c, 1) Ap
'78
--Louisville, Kentucky restaurant
Trav/Holiday 151:54 (c, 4) Mr
'79
--Nebraska
Nat Geog 154:509 (c, 1) O '78
--New Mexico
Nat Geog 154:417 (c, 2) S '78
--Northern Ireland
Nat Geog 159:489 (c, 1) Ap '81
--Under water (California)
Sports Illus 51:56-7 (c, 1) Jl
30 '79
VIOLINS
Smithsonian 8:106-10 (c, 1) S
'77
--Aluminum
Nat Geog 154:200 (c, 3) Ag '78
VIPERS
Natur Hist 87:61 (c, 1) N '78
Natur Hist 88:68 (c, 4) F '79
Natur Hist 89:64-5 (c, 1) F '80
VIREOS (BIRDS)
Nat Wildlife 15:cov. (c, 1) Je
'77
VIRGIN ISLANDS, GREAT BRITAIN
Sports Illus 52:52-6 (map, c, 2)
F 4 '80
Sports Illus 52:134-6 (c, 1) Mr
13 '80
VIRGIN ISLANDS, U. S.
Trav/Holiday 149:cov., 26-30
(c, 1) F '78
Trav/Holiday 153:68-9 (c, 3)
Ap '80
Nat Geog 159:224-43 (map, c, 1)
F '81
Trav/Holiday 156:44-9 (c, 1) O
'81
--St. Croix
Trav/Holiday 149:cov. (c, 1) F
'78
--St. John
Ebony 32:94-5 (c, 2) Ja '77
Trav/Holiday 149:28 (c, 2) F
'78
--St. Thomas
Ebony 33:110-14 (c, 2) Ja '78
Trav/Holiday 149:26-7, 30
(c, 1) F '78

Trav/Holiday 151:60 (c, 4) Ap
'79
Trav/Holiday 156:cov., 44-5
(c, 1) O '81
--St. Thomas Mahogan Run Golf
Course
Trav/Holiday 156:51 (c, 2) Ag '81
VIRGIN ISLANDS, U. S.--COSTUME
Nat Geog 159:224-39 (c, 1) F '81
VIRGINIA
--1916 German sailor community
Am Heritage 33:108-9 (3) D '81
--Chincoteague Island
Trav/Holiday 151:49 (c, 4) Je '79
Nat Geog 157:810-28 (map, c, 1)
Je '80
--Civil War camp recreations
Trav/Holiday 150:30-5, 55-7
(c, 1) Jl '78
--Estate grounds
Life 2:14-15 (c, 2) Ja '79
Life 4:61 (c, 2) F '81
--Highlands
Trav/Holiday 154:cov., 43-5
(map, c, 1) S '80
--Hogcamp Branch River
Nat Geog 152:10 (c, 1) Jl '77
--King William courthouse
Am Heritage 28:53 (4) O '77
--Parramore Island
Smithsonian 9:80 (c, 4) D '78
--Petersburg (1865)
Smithsonian 8:34-5 (1) Jl '77
--Saltville
Nat Geog 151:470-1 (c, 2) Ap '77
--Solar-heated, underground school
(Reston)
Smithsonian 9:104 (c, 2) F '79
Nat Geog 159:37 (c, 1) F '81ER
--Virginia Beach
Travel 147:33, 72 (c, 1) Ap '77
--See also ARLINGTON NATIONAL
CEMETERY; CHARLOTTES-
VILLE; HAMPTON ROADS;
LURAY CAVERNS; NORFOLK;
RICHMOND; WILLIAMSBURG;
WOLF TRAP FARM PARK
VIRGINIA--MAPS
--1651
Nat Geog 155:744-5 (c, 1) Je '79
VIRUSES
Nat Geog 151:288 (2) F '77
Natur Hist 89:6 (4) My '80
--Injected into insect
Nat Geog 157:162-3 (c, 2) F '80
VOLCANIC ERUPTIONS
Natur Hist 86:36-45 (c, 1) Ap '77
--Jolnir, Iceland (1965)

Natur Hist 88:44-5 (4) O '79
--Jupiter
 Nat Geog 157:cov., 4-5, 16-
 19 (c, 1) Ja '80
--Krakatoa (1883)
 Natur Hist 86:8 (painting, 4) Ja
 '77
--Mauna Ulu, Hawaii
 Nat Geog 156:43 (c, 1) Jl '79
--Mount Agung, Bali, Indonesia
 (1963)
 Natur Hist 86:14 (3) Ja '77
--Mount Katmai, Alaska (1912)
 Am Heritage 31:85-7 (4) O '80
--Mt. Soufriere, St. Vincent
 (1979)
 Nat Geog 156:404-7 (c, 1) S '79
--Prehistoric Nebraska
 Nat Geog 159:66-73 (painting, c, 1)
 Ja '81
--Vestmannaeyjar, Iceland (1973)
 Nat Geog 151:691 (c, 4) My '77
VOLCANOES
 Life 3:58-61 (c, 1) Mr '80
--Cascade Range, Northwest
 Smithsonian 11:56 (map, c, 3)
 Jl '80
 Life 3:70-9 (c, 1) S '80
--Earth plates
 Nat Geog 159:30-1 (map, c, 1)
 Ja '81
--Ethiopia
 Nat Geog 152:396-7 (c, 1) S '77
--Fernandina, Galapagos, Ecuador
 Life 2:58-9 (c, 1) Ag '79
--Haleakala, Maui, Hawaii
 Trav/Holiday 153:55 (c, 2) Ja
 '80
 Nat Wildlife 19:21, 26-7 (c, 1)
 Je '81
--Molokai, Hawaii
 Nat Geog 160:190-1 (c, 1) Ag '81
--Mt. Ngauruhoe, New Zealand
 Trav/Holiday 155:41 (c, 3) Ja
 '81
--Mt. Redoubt, Alaska
 Smithsonian 8:48 (c, 4) D '77
--Mt. Singgalang, Sumatra, Indo-
 nesia
 Nat Geog 159:414-15 (c, 1) Mr
 '81
--Pacaya, Guatemala
 Natur Hist 90:38 (c, 3) Ag '81
--Piton de la Fournaise, Reunion
 Nat Geog 160:452-3 (c, 1) O '81
--Poas, Costa Rica
 Smithsonian 10:67 (c, 4) S '79
--Thera, Greece

Natur Hist 87:70-6 (c, 1) Ap '78
--Volcan Arenal, Costa Rica
 Nat Geog 160:48-9 (c, 1) Jl '81
--Waialeale, Kauai, Hawaii
 Nat Geog 152:597 (c, 1) N '77
--See also ANIAKCHAK; DIAMOND
 HEAD; KATMAI; KILAUEA;
 KRAKATOA; LAVA; MAUNA
 LOA; MOUNT ETNA; MOUNT
 ST. HELENS; VESUVIUS
VOLCANOES--DAMAGE
--Morton, Washington covered with
 ash
 Life 3:102-3 (c, 1) Jl '80
--Mount St. Helens, Washington
 (1980)
 Smithsonian 11:59-61 (c, 3) Jl
 '80
 Nat Geog 159:cov., 2-65 (c, 1)
 Ja '81
 Nat Geog 160:718-29 (c, 1) D '81
--Villages covered with volcanic
 ash (Iceland)
 Natur Hist 86:cov., 41-3 (c, 1)
 Ap '77
VOLCANOES--MAPS
--West coast eruptions
 Nat Geog 160:731 (c, 4) D '81
VOLCANOES NATIONAL PARK,
 HAWAII
 Nat Geog 156:43 (c, 1) Jl '79
VOLLEYBALL
 Sports Illus 49:73 (3) N 6 '78
--Colorado
 Nat Geog 155:398 (c, 4) Mr '79
--Mexico
 Nat Geog 151:853 (c, 4) Je '77
--Played in mud
 Sports Illus 48:41 (c, 4) My 15
 '78
VULTURES
 Smithsonian 7:72 (c, 4) Ja '77
 Trav/Holiday 149:66 (4) Ap '78
 Natur Hist 88:65 (c, 2) Je '79
 Natur Hist 89:43 (c, 3) S '80
 Nat Geog 158:850 (c, 3) D '80
 Life 4:185 (c, 4) D '81

-W-

WAGONS
--Carrying oil (1920's; California)
 Smithsonian 11:196-7 (4) O '80
--Old mining wagon (Montana)
 Trav/Holiday 156:50 (c, 4) Jl '81
--Sheep wagon (Nevada)
 Life 3:36-7 (c, 1) Je '80

--See also CARRIAGES AND CARTS;
 COVERED WAGONS
WAITERS
--1902 (New York City, New York)
 Am Heritage 31:98-9 (4) Ag
 '80
--California
 Nat Geog 155:697 (c, 2) My '79
WAITRESSES
--Playboy bunny
 Ebony 33:134 (3) Ag '78
WALES
 Sports Illus 51:96-9 (paint-
 ing, c, 1) D 24 '79
--Eisteddfod Festival
 Trav/Holiday 153:110, 120 (3)
 Ap '80
--North Wales
 Trav/Holiday 151:76-8, 94 (c, 1)
 Ap '79
--Portmeirion
 Trav/Holiday 153:4, 46-8 (4)
 My '80
WALES--ARCHITECTURE
--17th cent. house
 Smithsonian 8:92 (drawing, c, 3)
 O '77
--Caernarvon Castle
 Life 4:58 (c, 2) D '81
WALKER, WILLIAM
 Smithsonian 12:117 (3) Je '81
WALKING
--19th cent. walking competitions
 Smithsonian 10:89-98 (4) Jl
 '79
 Race walking
 Sports Illus 48:34 (c, 1) My 8
 '78
 Sports Illus 53:56 (4) Ag 4 '80
--Stroll through woods
 Smithsonian 11:57 (c, 1) Ag '80
WALKING STICKS
 Sports Illus 46:34 (c, 2) Mr 14
 '77
WALLA WALLA, WASHINGTON
--Prison
 Life 2:78-87 (1) Ag '79
WALLS
--Great Wall of India
 Nat Geog 151:221 (c, 1) F '77
--See also GREAT WALL OF
 CHINA
WALNUTS
 Natur Hist 88:130 (4) O '79
WALPOLE, HORACE
 Smithsonian 10:103 (painting, c, 4)
 My '79
--Home and effects

Smithsonian 10:104-8 (c, 4) My
 '79
WALRUSES
 Natur Hist 86:cov., 52-61 (c, 1)
 N '77
 Nat Geog 156:564-79 (c, 1) O '79
 Nat Wildlife 17:25-31 (c, 1) O '79
 Nat Geog 159:586 (c, 4) My '81
--Durer drawing (1521)
 Smithsonian 8:59 (4) S '77
WAR OF 1812
--Perry memorial (Ohio)
 Nat Geog 154:90-1, 98-9 (c, 1)
 Jl '78
--See also HAMPTON, WADE;
 SCOTT, WINFIELD
WARBLERS
 Nat Geog 151:176-7 (c, 2) F '77
 Nat Wildlife 15:25 (c, 2) Ap '77
 Nat Wildlife 16:9, 44, 47 (c, 4)
 D '77
 Nat Wildlife 16:28 (painting, c, 4)
 Je '78
 Nat Wildlife 17:25 (c, 1) Je '79
 Nat Geog 156:157, 168-9 (c, 1)
 Ag '79
 Nat Wildlife 17:28E-28F (paint-
 ing, c, 1) O '79
 Nat Wildlife 18:16 (c, 4) D '79
 Nat Wildlife 18:40 (painting, c, 4)
 Ag '80
 Nat Wildlife 19:48 (c, 1) Ag '81
--See also OVENBIRDS; REDSTARTS
WARFARE
--13th cent. battles between Mongols
 and Japan
 Smithsonian 12:118-29 (c, 1) D '81
--14th cent. Indians (South Dakota)
 Smithsonian 11:108 (painting, c, 2)
 S '80
--Alexander vs. Darius (Pompeii
 painting)
 Natur Hist 88:66-7 (c, 1) Ap '79
--Ancient Mycenaean civilization,
 Greece
 Nat Geog 153:182-3 (c, 2) F '78
--Aztec Indians (Mexico)
 Nat Geog 158:740-3 (painting, c, 1)
 D '80
--Celtic Europe
 Nat Geog 151:594-9 (painting, c, 1)
 My '77
--Iran-Iraq war
 Life 3:164-7 (c, 1) N '80
--Oriental naval battles through
 history
 Natur Hist 86:48-51 (c, 1) D '77
--Simulated combat

OCEAN; LAKES; LONG
ISLAND SOUND; MANILA
BAY; MARINE LIFE; NORTH
SEA; OASES; OCEANS;
PACIFIC OCEAN; PERSIAN
GULF; POND LIFE; PONDS;
PUGET SOUND; RED SEA;
RIVERS; STREAMS; WAVES;
WELLS; lists under LAKES;
RIVERS

WATER FOUNTAINS
--1870
　Am Heritage 31:16 (painting, c, 2)
　　Je '80
--1899 (Galveston, Texas)
　Am Heritage 31:92-5 (painting, c, 1)
　　Je '80
WATER LILIES
　Am Heritage 28:100 (drawing, c, 4)
　　Je '77
　Sports Illus 48:40-1 (c, 1) Ja
　　16 '78
　Smithsonian 9:78-83 (c, 1) Ap
　　'78
　Trav/Holiday 149:58 (c, 4) Je
　　'78
　Natur Hist 87:66 (c, 4) Ag '78
　Nat Geog 157:131 (c, 4) Ja '80
　Nat Wildlife 18:48 (c, 1) Ag '80
　Trav/Holiday 154:47 (c, 2) O '80
　Trav/Holiday 154:59 (c, 4) N '80
--Lily pads
　Nat Geog 159:364-5 (c, 1) Mr
　　'81
WATER OUZELS
　Nat Wildlife 17:23 (c, 4) Je '79
WATER POLLUTION
--Acid rain
　Nat Geog 160:652-81 (c, 1) N
　　'81
--Acid rain victims
　Sports Illus 55:68-82 (c, 1) S
　　21 '81
--Acid rain's effects on water
　　bodies
　Natur Hist 90:58-65 (c, 1) F
　　'81
--Illinois River, Illinois
　Natur Hist 89:44-5 (c, 3) My
　　'80
--Oil spills
　Nat Geog 153:516-17 (c, 1) Ap
　　'78
--Reviving the Thames River,
　　London, England
　Smithsonian 9:102-8 (c, 2) My
　　'78
--Testing

Nat Geog 153:502-3, 520-3 (c, 1)
　　Ap '78
--Treating lake with lime (Sweden)
　Nat Geog 160:658-9 (c, 1) N '81
WATER POLO
　Sports Illus 54:55-6 (c, 4) My 11
　　'81
WATER SKIING
　Nat Geog 153:408-9 (c, 1) Mr
　　'78
--California
　Sports Illus 52:33 (c, 2) Je 2 '80
--Florida
　Trav/Holiday 149:67 (4) My '78
--Lebanon
　Life 3:30-1 (c, 1) S '80
--Mexico
　Trav/Holiday 156:47 (c, 4) N '81
--Riding on people's backs
　Life 4:112 (c, 2) Jl '81
--St. Maarten
　Trav/Holiday 151:55 (c, 3) Ap '79
--Squirrel water skiing (Florida)
　Life 3:112 (2) Ja '80
--Utah
　Trav/Holiday 156:45 (c, 1) Ag '81
WATER WHEELS
--Maryland
　Travel 148:62 (4) Jl '77
WATERFALLS
--Ashley, Massachusetts
　Smithsonian 8:cov. (c, 1) S '77
--Australia
　Trav/Holiday 152:49 (c, 4) N '79
--Berkshires, Massachusetts
　Trav/Holiday 153:43 (c, 1) Je '80
--Brook in forest
　Natur Hist 86:62-3 (c, 1) N '77
--Calf Creek, Escalante, Utah
　Life 4:106-7 (c, 1) Ag '81
--Caribbean
　Trav/Holiday 155:69 (c, 2) Ap '81
--Chaudière River Falls, Quebec
　　(1787)
　Am Heritage 29:98-9 (painting, c, 2)
　　Je '78
--Costa Rica
　Smithsonian 10:64 (c, 1) S '79
--Fern Grotto, Kauai, Hawaii
　Nat Geog 152:606-7 (c, 1) N '77
--Grand Canyon, Arizona
　Nat Geog 154:14-15 (c, 1) Jl '78
--Havasu, Arizona
　Trav/Holiday 154:57 (c, 3) S '80
　Life 4:102-3 (c, 1) Ag '81
--Isle of Man
　Smithsonian 10:77 (c, 2) Jl '79
--Kauai, Hawaii

Ebony 36:118 (c, 3) Ja '81
--Lowell, Massachusetts
Life 3:89 (c, 3) Jl '80
--Lower Proxy, Oregon
Nat Geog 152:4-5 (c, 1) Jl '77
--Mackay, New Zealand
Nat Geog 153:125 (c, 1) Ja '78
--Milford Sound, New Zealand
Trav/Holiday 155:39 (4) Mr '81
--Molokai, Hawaii
Nat Geog 160:192-3 (c, 1) Ag
'81
--Montmorency, Quebec
Nat Geog 157:611 (c, 1) My '80
--Nahanni National Park, North-
west Territories
Nat Geog 160:396-7 (c, 1) S '81
--Quebec
Nat Geog 159:384-5 (c, 1) Mr
'81
--Rainbow Falls, Hawaii
Am Heritage 32:83 (4) O '81
--Seven Falls, Colorado Springs,
Colorado
Trav/Holiday 150:63 (c, 1) N
'78
--Sunwapta, Jasper National Park,
Alberta
Nat Geog 157:761 (c, 1) Je '80
--Tannery, Savoy, Massachusetts
Smithsonian 8:82 (c, 1) S '77
--Tanzania
Nat Geog 155:601 (c, 1) My '79
--Waimea Falls Park, Hawaii
Trav/Holiday 152:47 (c, 4) O
'79
--Yellowstone, Wyoming
Nat Geog 152:cov. , 3 (c, 1) Jl
'77
Life 1:94-5 (c, 1) D '78
Nat Geog 160:258-9 (c, 1) Ag
'81
--Zarqa Main, Jordan
Nat Geog 153:244-5 (c, 1) F '78
--See also BRIDALVEIL FALLS;
NIAGARA FALLS; VICTORIA
FALLS
WATERGATE
--John Dean taking oath at hear-
ings (1973)
Life 2:42-3 (c, 1) D '79
WATERMELONS
--1860's festival aftermath (Iowa)
Am Heritage 29:7 (4) D '77
WATTEAU, ANTOINE
--Couple Seated on a Bank
Smithsonian 11:154 (drawing, c, 4)
O '80

WATTS, GEORGE FEDERIC
Smithsonian 9:50 (4) D '78
--Peasants of the Roman Campagne
(1845)
Smithsonian 9:54-5 (painting, c, 2)
D '78
WAVES
Nat Geog 160:780-1, 790 (c, 1) D
'81
--Large, ship-threatening ocean
waves
Smithsonian 8:60-7 (c, 1) F '78
WEASELS
Smithsonian 8:46 (c, 4) S '77
Nat Wildlife 16:21 (c, 4) D '77
Nat Wildlife 18:52 (c, 3) Ap '80
Nat Wildlife 19:56 (c, 1) O '81
--See also BADGERS; ERMINES;
FERRETS; SKUNKS
WEATHER
Nat Geog 152:798-829 (maps, c, 1)
D '77
--Colorful rays in the skies
Smithsonian 11:72-9 (c, 1) Ja '81
--Effects of summer heat
Life 3:22-9 (c, 1) S '80
--Jet streams
Natur Hist 90:66 (drawing, c, 4)
S '81
--Oceanic research on weather
Smithsonian 10:80-9 (c, 1) Ap '79
--See also AIR POLLUTION; AU-
RORA BOREALIS; AURORAS;
CLOUDS; CYCLONES;
DROUGHT; DUST STORMS;
FLOODS; FOG; HAILSTONES;
HURRICANES; ICE; LIGHT-
NING; RAIN; RAINBOWS;
SEASONS; SMOG; SNOW
SCENES; SNOW STORMS;
STORMS; TORNADOES;
WEATHERVANES
WEATHERVANES
--Newport, Rhode Island
Trav/Holiday 149:40 (4) Ap '78
WEAVING
--Aztec Indians (Mexico)
Nat Geog 158:722-3 (c, 3) D '80
--Bora Bora, Polynesia
Trav/Holiday 150:54 (c, 4) N '78
--Ecuador
Natur Hist 86:49-53 (c, 1) O '77
Trav/Holiday 151:70 (c, 2) My
'79
--Egypt
Nat Geog 151:335 (c, 4) Mr '77
--Huichol Indians (Mexico)
Nat Geog 151:844 (c, 1) Je '77

--Mayan Indians (Mexico)
 Nat Geog 153:654-5 (c, 1) My
 '78
--Navajos (Arizona)
 Nat Geog 156:83 (c, 4) Jl '79
 Trav/Holiday 154:58 (c, 4) S
 '80
--Oman
 Nat Geog 160:370 (c, 1) S '81
--Ozarks, Arkansas
 Trav/Holiday 153:36 (4) Ap '80
--Peru
 Natur Hist 86:38 (c, 2) My '77
 Natur Hist 89:92 (2) My '80
--Shakers (Kentucky)
 Trav/Holiday 155:61 (c, 4) Je
 '81
--Silk (Japan)
 Trav/Holiday 149:44 (c, 4) Je
 '78
--See also BASKET WEAVING;
 RUG MAKING
WEBSTER, DANIEL
 Smithsonian 8:26 (4) Jl '77
 Am Heritage 29:43 (painting, 4)
 Je '78
 Am Heritage 33:79 (painting, 4)
 D '81
Weddings. See MARRIAGE RITES
 AND CUSTOMS
WEEDS
 Natur Hist 89:cov. , 36-45 (c, 1)
 D '80
WEEVILS
 Natur Hist 88:36-43 (c, 1) D '79
 Nat Wildlife 18:53 (c, 4) O '80
 Natur Hist 90:86 (drawing, 4)
 Mr '81
--See also BOLL WEEVILS
WEIGHT LIFTERS
 Sports Illus 51:27 (c, 1) Ag 6
 '79
WEIGHT LIFTING
 Sports Illus 47:16-19 (c, 2) D
 12 '77
 Ebony 33:56 (4) Ap '78
 Sports Illus 49:57 (4) Ag 14
 '78
 Sports Illus 49:58 (4) O 9 '78
 Sports Illus 49:90, 95 (4) O
 16 '78
 Sports Illus 49:44 (c, 4) D 4
 '78
 Sports Illus 50:38-49 (1) Ap
 16 '79
 Sports Illus 51:28-9 (c, 3) Ag
 6 '79
 Sports Illus 51:74 (4) N 26 '79

Ebony 35:132-3 (4) Ap '80
 Sports Illus 52:40 (4) My 26 '80
 Sports Illus 53:21 (c, 4) Ag 18
 '80
 Sports Illus 53:38 (c, 4) O 6 '80
 Sports Illus 53:62 (4) N 17 '80
 Life 4:88 (c, 3) Ap '81
 Sports Illus 54:92-3 (c, 1) Je 8
 '81
--Early 20th cent. girls
 Am Heritage 29:7 (2) O '78
--1980 Olympics (Moscow)
 Sports Illus 53:25-6 (c, 2) Ag 11
 '80
--Bench pressing
 Sports Illus 55:20-1 (c, 3) Ag 3
 '81
--Lifting famous Scottish stones
 Sports Illus 51:44-6 (c, 2) N 5
 '79
--Tunisia
 Nat Geog 157:206 (c, 4) F '80
--Women
 Sports Illus 47:60, 64 (c, 1) N
 14 '77
WEIMARANERS (DOGS)
 Smithsonian 8:38-9 (c, 2) Ag '77
WELLS
--Drawing water from well (Georgia)
 Ebony 35:54 (4) Ag '80
--Louisiana museum
 Trav/Holiday 152:41 (c, 4) O '79
--Upper Volta
 Nat Geog 156:612 (c, 2) N '79
--Water wells
 Ebony 34:60 (4) F '79
 Nat Geog 158:170-1 (c, 1) Ag '80
WELLS--CONSTRUCTION
--California
 Nat Geog 152:828 (c, 3) D '77
WEST, BENJAMIN
 Smithsonian 10:136 (painting, c, 4)
 My '79
 Am Heritage 31:16-17 (paint-
 ing, c, 1) Ap '80
West Germany. See GERMANY,
 WEST
West Indies. See BAHAMAS; BAR-
 BADOS; BERMUDA; CUBA;
 DOMINICAN REPUBLIC;
 GUADELOUPE; HAITI;
 JAMAICA; LEEWARD ISLANDS;
 NETHERLANDS ANTILLES;
 PUERTO RICO; TRINIDAD;
 TOBAGO; VIRGIN ISLANDS;
 WINDWARD ISLANDS
WEST INDIES--COSTUME
--New York festival

Natur Hist 88:72-85 (c, 1) Ag
'79
WEST POINT, NEW YORK
Am Heritage 29:6-17 (c, 1) Je
'78
Life 3:70-9 (c, 1) My '80
--Site of the fort (1778)
Am Heritage 30:100-1 (paint-
ing, c, 2) Ag '79
WEST VIRGINIA
--Hopeville
Nat Geog 153:436-7 (c, 1) Mr
'78
--Potomac area
Travel 148:34-7 (c, 3) O '77
WESTERN FRONTIER LIFE
--1880's Dodge City, Kansas
saloon
Smithsonian 10:140 (4) F '80
--1880's lawmen and criminals
Smithsonian 10:130-42 (3) F
'80
--Criminals
Am Heritage 30:22-31 (1) Ap
'79
--Depicted on 19th cent. cigar
labels
Am Heritage 30:86-7 (paint-
ing, c, 3) D '78
--Wyatt Earp
Smithsonian 10:132 (4) F '80
--Expedition into Canadian Rockies
Trav/Holiday 155:43-6 (c, 1)
My '81
--Mike Fink, Mississippi River
legend
Smithsonian 10:99-104 (draw-
ing, c, 1) Ap '79
--Dat Maaturoon
Smithsonian 10:116 (4) Ag '79
Smithsonian 10:134-5 (4) F
'80
--Migrating pioneers
Smithsonian 10:132 (4) Je '79
--Pioneers
Am Heritage 32:58-61 (paint-
ing, c, 1) F '81
--Pioneers traveling west (1853
painting)
Am Heritage 30:56-7 (c, 1) D
'78
--See also BOONE, DANIEL;
CODY, WILLIAM F.;
COVERED WAGONS; COW-
BOYS; FORTS; GHOST
TOWNS; INDIAN WARS;
OAKLEY, ANNIE; PONY
EXPRESS; RANCHING;

STAGECOACHES
WESTERN FRONTIER LIFE--
COSTUME
--Texas
Trav/Holiday 152:65 (c, 1) N '79
WESTERN U. S.
Am Heritage 29:cov. , 4-13 (c, 1)
Ag '78
--Early 20th cent. shipping industry
Am Heritage 29:50-65 (1) O '78
--West German reconstruction of
saloon
Nat Geog 152:176-7 (c, 1) Ag '77
WHALES
Smithsonian 8:54-5 (c, 2) Ja '78
Life 2:cov. , 18-26 (c, 1) Jl '79
--Beached (Oregon)
Life 3:10 (3) Ap '80
--Blue
Smithsonian 8:54-5 (4) Ja '78
--Bowhead
Nat Wildlife 16:5-11 (c, 1) Ap
'78
--Finback
Smithsonian 8:22 (4) Mr '78
--Grey
Trav/Holiday 153:28-9 (c, 4) Ja
'80
--Humpback
Nat Wildlife 16:25 (c, 2) Ap '78
Nat Geog 155:3-25 (c, 1) Ja '79
Natur Hist 88:47-9 (c, 1) Je '79
Nat Wildlife 18:38 (c, 4) D '79
Natur Hist 90:31-5 (c, 1) D '81
--Humpback tail
Natur Hist 87:100-1 (c, 1) Ag '78
Life 2:cov. (c, 1) Jl '79
--Model
Smithsonian 8:52-9 (c, 1) Ja '78
--Right
Nat Wildlife 18:32-5 (painting, c, 1)
O '80
--See also BELUGAS; KILLER
WHALES; NARWHALS;
SCRIMSHAW; SPERM WHALES
WHALING INDUSTRY
--19th cent. New England
Am Heritage 28:46-65 (paint-
ing, c, 1) Ag '77
WHALING SHIPS
Trav/Holiday 155:22 (4) Je '81
--19th cent.
Am Heritage 29:110 (painting, c, 4)
Ap '79
Natur Hist 89:54-5 (painting, c, 3)
My '80
--19th cent. New England
Am Heritage 28:46-65 (paint-

ing, c, 1) Ag '77
WHEAT
 Nat Wildlife 17:25 (c, 4) F '79
WHEAT FIELDS
--Illinois
 Nat Geog 157:169 (c, 1) F '80
--Midwest
 Natur Hist 90:60-1 (c, 1) N '81
--Oklahoma
 Nat Geog 156:638-9 (c, 1) N
 '79
--Saskatchewan
 Nat Geog 155:658-9 (c, 1) My
 '79
--Washington
 Nat Geog 151:424-5 (c, 1) Mr
 '77
WHEAT INDUSTRY
--Grain elevators (Washington)
 Life 4:74-5 (c, 1) D '81
WHEAT INDUSTRY--HARVESTING
--1875 (California)
 Am Heritage 29:22-3 (paint-
 ing, c, 2) F '78
--By hand (Egypt)
 Smithsonian 10:58-9 (c, 1) My
 '79
--India
 Nat Geog 152:284-5 (c, 1) Ag
 '77
--Saskatchewan
 Nat Geog 155:658-9 (c, 1) My
 '79
--Tibet
 Nat Geog 157:231 (c, 3) F '80
WHEAT INDUSTRY--TRANSPORT-
 ATION
--Shipment arriving in Pakistan
 Nat Geog 159:692-3 (c, 1) My
 '81
WHEELBARROWS
--Tunisia
 Nat Geog 157:204-5 (c, 2) F '80
WHEELCHAIRS
 Nat Wildlife 15:39 (c, 4) Je '77
 Trav/Holiday 149:62 (4) F '78
 Nat Geog 156:88 (c, 3) Jl '79
 Smithsonian 11:52 (c, 4) Ag '80
 Nat Geog 158:362 (c, 4) S '80
 Ebony 36:33 (4) D '80
 Ebony 36:154 (4) My '81
 Life 4:78-9 (1) Jl '81
 Ebony 36:92 (3) O '81
--China
 Nat Geog 158:7 (c, 3) Jl '80
WHISTLER, JAMES M.
--Paintings from Freer collection
 Smithsonian 7:50-6 (painting, c, 1)

Ja '77
WHISTLES
 Sports Illus 46:59 (c, 4) F 28 '77
 Smithsonian 10:86 (c, 3) Ap '79
--17th cent. Dutch
 Nat Geog 154:568 (c, 4) O '78
WHISTLING
--Through acorns
 Nat Wildlife 18:12 (c, 2) Ap '80
WHITE, STANFORD
 Life 4:11 (4) Je '81
--Herald Building, New York
 Smithsonian 9:134 (4) N '78
--Evelyn Nesbit and Harry K. Thaw
 Life 4:10-18 (1) Je '81
WHITE, WILLIAM ALLEN
 Am Heritage 30:80-97 (3) O '79
WHITE-FOOTED MICE
 Nat Wildlife 18:53 (c, 4) O '80
WHITE HOUSE, WASHINGTON,
 D. C.
 Life 4:58 (c, 3) F '81
 Life 4:26-7 (c, 1) Mr '81
--1960's Red Room model
 Smithsonian 10:186 (c, 4) O '79
--Thermogram of escaping heat
 Life 3:144-5 (c, 3) Mr '80
WHITE MOUNTAINS, NEW HAMP-
 SHIRE
 Nat Geog 159:368-9 (c, 1) Mr '81
 Trav/Holiday 155:28-9 (c, 3) Ap
 '81
WHITE SANDS NATIONAL MONU-
 MENT, NEW MEXICO
 Travel 148:58-9 (c, 1) O '77
WHITEFISH
 Natur Hist 90:92 (c, 4) D '81
WHITMAN, WALT
 Am Heritage 31:62, 67 (2) O '80
 Life 3:168-72 (1) D '80
 Smithsonian 11:154 (4) Mr '81
--Mausoleum (New Jersey)
 Life 3:174 (4) D '80
WHOOPING CRANES
 Nat Geog 151:172-3 (c, 1) F '77
 Nat Geog 152:202 (c, 3) Ag '77
 Nat Wildlife 16:8 (c, 3) D '77
 Smithsonian 9:cov., 52-63 (c, 1)
 S '78
 Nat Geog 155:680-93 (c, 1) My
 '79
 Life 3:100-1 (c, 1) Ag '80
 Nat Geog 159:cov., 150 (c, 1) F
 '81
--Map of range in U. S.
 Natur Hist 86:23-4 (3) Mr '77
WIGS
 Life 4:70 (c, 4) Jl '81

--Carved frame (Switzerland)
Natur Hist 88:50 (c, 3) Ja '79
--Installing storm windows
Natur Hist 90:112, 115 (c, 3)
O '81
--Modern abstract design (Hungary)
Nat Geog 152:477 (c, 1) O '77
WINDSOR CASTLE, ENGLAND
Nat Geog 158:cov. , 604-31
(map, c, 1) N '80
--Doll house
Nat Geog 158:632-43 (c, 1) N
'80
WINDWARD ISLANDS
--Dominica
Ebony 36:116-22 (c, 2) Jl '81
--Grenada
Ebony 32:98 (c, 4) Ja '77
Nat Geog 159:252-7 (c, 2) F '81
Trav/Holiday 156:61-2 (c, 2) S
'81
--Grenadines
Nat Geog 156:398-425 (map, c, 1)
S '79
--Mustique, Grenada
Trav/Holiday 152:37 (c, 2) O
'79
--St. George's, Grenada
Trav/Holiday 148:47 (c, 1) N '77
Trav/Holiday 156:61-2 (c, 2) S
'81
--St. Lucia food market
Ebony 32:98 (c, 4) Ja '77
Ebony 34:122 (3) Ja '79
WINE
Trav/Holiday 151:81-2 (c, 1) Ap
'79
--1947 Chateau Lafite-Rothschild
label
Trav/Holiday 154:34 (4) S '80
--Bottles
Ebony 32:116-20 (c, 4) F '77
Travel 147:43 (c, 1) My '77
Trav/Holiday 150:31 (c, 4) Ag
'78
--Chateau Mouton Rothschild labels
Trav/Holiday 153:100, 102 (4)
Mr '80
--Corkscrews
Ebony 32:118 (c, 4) F '77
--Madeira bottles
Trav/Holiday 153:62 (c, 2) F
'80
--New Zealand wine labels
Trav/Holiday 156:4, 6 (c, 4) S
'81
--Sherry

Trav/Holiday 149:58 (c, 1) My
'78
--Spanish wine labels
Trav/Holiday 155:59-61 (4) F
'81
--Wine racks
Ebony 32:118 (c, 4) F '77
WINE INDUSTRY
--Aging casks
Ebony 32:116 (c, 4) F '77
--Aging casks (California)
Trav/Holiday 153:108 (4) F '80
--Aging casks (Michigan)
Trav/Holiday 156:43 (4) Ag '81
--Bordeaux region, France
Nat Geog 158:238-51 (map, c, 1)
Ag '80
--California
Life 4:135-44 (c, 1) N '81
--Crushing grapes (Italy)
Nat Geog 159:741 (c, 1) Je '81
--Crushing grapes (Yugoslavia)
Nat Geog 152:683 (c, 2) N '77
--France
Trav/Holiday 153:26, 30, 100-2
(c, 3) Mr '80
--Michigan
Trav/Holiday 156:40-3 (c, 1) Ag
'81
--Napa Valley, California
Nat Geog 155:694-717 (map, c, 1)
My '79
--Oak vat storage (California)
Trav/Holiday 153:9 (c, 3) Je '80
--Stomping grapes (Portugal)
Nat Geog 158:808-9 (c, 1) D '80
--West Germany
Nat Geog 152:167 (c, 1) Ag '77
--Wine cellar (Beaune, France)
Trav/Holiday 149:100 (4) Ap '78
--Wine cellar (Bordeaux, France)
Nat Geog 158:250 (c, 4) Ag '80
--See also GRAPE INDUSTRY;
VINEYARDS; WINERIES
Wine Tasting. See DRINKING
CUSTOMS
WINERIES
--Napa Valley, California
Nat Geog 155:714-15 (c, 1) My '79
--Wine tasting (Australia)
Trav/Holiday 150:29 (c, 4) Ag '78
WINNEBAGO INDIANS (WISCONSIN)
--COSTUME
--Chief
Smithsonian 8:100-1 (painting, c, 4)
Je '77
WINNIPEG, MANITOBA
Life 2:114-15 (c, 1) Ap '79

ing, c, 1) Mr '78
--See also ANDERSON, MARIAN;
AUSTEN, JANE; BARTON,
CLARA; BOYD, BELLE;
CASSATT, MARY; CHRISTIE,
AGATHA; CLEOPATRA;
DUNCAN, ISADORA; EAR-
HART, AMELIA; EDDY, MARY
BAKER; FRANK, ANNE;
FULLER, MARGARET; HOWE,
JULIA WARD; JACKSON,
MAHALIA; KENNY, SISTER
ELIZABETH; LIND, JENNY;
LOCKWOOD, BELVA; MADI-
SON, DOLLEY; MEAD, MAR-
GARET; OAKLEY, ANNIE;
O'KEEFFE, GEORGIA; PIAF,
EDITH; POST, EMILY;
POTTER, BEATRIX; ROOSE-
VELT, ELEANOR; RUSSELL,
LILLIAN; SANGER, MAR-
GARET; STOWE, HARRIET
BEECHER; TARBELL, IDA;
TRUTH, SOJOURNER; TUB-
MAN, HARRIET; WOODHULL,
VICTORIA
WOMEN'S LIBERATION MOVE-
MENT
--1884 presidential campaign of
Belva Lockwood
Smithsonian 11:138-50 (draw-
ing, c, 4) Mr '81
--1970 march (New York City,
New York)
Life 2:134-5 (1) D '79
--Abortion issue
Life 4:45-54 (3) N '81
--Dr. Mary Walker's male dress
(19th cent.)
Smithsonian 7:113-19 (3) Mr
'77
Am Heritage 29:111 (4) D '77
--Women in traditionally men's
jobs
Life 2:136-7 (2) D '79
--See also WOODHULL, VICTORIA
WOMEN'S SUFFRAGE MOVEMENT
Am Heritage 30:12-35 (c, 2)
D '78
--Alice Paul
Am Heritage 30:30 (4) D '78
WOOD, GRANT
--American Gothic (1930)
Smithsonian 11:85 (painting, c, 2)
N '80
--Painting of George Washington
and the cherry tree
Am Heritage 32:cov. (c, 1) F '81

--Paintings by him
Smithsonian 11:84-97 (c, 1) N '80
--Parodies of American Gothic
Smithsonian 11:88-9 (c, 4) N '80
--Self-portrait (1930's)
Smithsonian 11:84 (painting, c, 4)
N '80
WOOD
--Collecting firewood (India)
Natur Hist 88:12 (2) Je '79
--Cutting firewood (New England)
Natur Hist 89:14-28 (3) F '80
--Stockpiling wood for fuel (Ver-
mont)
Nat Geog 159:34-5 (c, 1) F '81SR
--Woodpile
Nat Wildlife 17:12 (c, 4) O '79
--Woodpile (Vermont)
Nat Wildlife 17:9 (c, 1) D '78
WOOD CARVING
--Carving totem poles (Washington)
Travel 148:31 (4) Jl '77
--Making bamboo fly rod
Nat Geog 158:524-5 (c, 1) O '80
--Nepal
Nat Geog 155:282 (c, 1) F '79
WOOD CARVINGS
--Bali, Indonesia
Trav/Holiday 155:66, 82 (c, 4)
My '81
--Maine
Nat Geog 158:392-3 (c, 1) S '80
--Quebec
Nat Geog 157:617 (c, 2) My '80
WOOD DUCKS
Nat Wildlife 15:8 (painting, c, 4)
Ja '77
Nat Wildlife 16:28 (painting, c, 4)
Je '78
Nat Wildlife 17:37 (c, 1) Ag '79
WOOD PEWEES
Nat Wildlife 18:28 (painting, c, 4)
O '80
WOODCHUCKS
Natur Hist 87:112-13 (drawing, 3)
My '78
Nat Wildlife 18:25-8 (c, 1) F '80
WOODCOCKS (BIRDS)
Nat Wildlife 16:36-40 (c, 1) Ag
'78
WOODHULL, VICTORIA
Smithsonian 8:131-41 (3) O '77
WOODPECKERS
Nat Wildlife 16:44 (c, 4) D '77
Nat Wildlife 16:28 (painting, c, 4)
Je '78
Nat Wildlife 17:24 (c, 4) Je '79
Nat Wildlife 18:39 (painting, c, 4)

Ag '80
Nat Wildlife 18:52 (c, 4) O '80
Smithsonian 11:101 (painting, c, 4)
O '80
--Ivory-billed
Nat Geog 151:162 (painting, c, 3)
F '77
--Nuts hidden in fence
Nat Wildlife 18:52 (c, 4) O '80
--Redheaded
Nat Wildlife 16:44 (c, 4) D '77
WOOL INDUSTRY
--Shearing sheep (New Zealand)
Nat Geog 154:251 (c, 4) Ag '78
--Yarn colored by natural plant
dyes
Nat Wildlife 15:50-5 (c, 1) Ap
'77
WOOL SPINNING
--Albania
Nat Geog 158:554-5 (c, 1) O '80
--India
Nat Geog 153:340 (c, 4) Mr '78
--Nepal
Nat Geog 151:506-7 (c, 1) Ap
'77
WOOLWORTH, FRANK W.
Am Heritage 28:89, 91 (3) F
'77
Life 2:56 (4) Je '79
WORCESTER, MASSACHUSETTS
--High school
Am Heritage 32:50 (4) O '81
WORLD TRADE CENTER, NEW
YORK CITY, NEW YORK
Ebony 32:68 (4) Ap '77
Smithsonian 8:42-9 (c, 1) Ja '78
Nat Geog 153:88 (c, 1) Ja '78
Nat Geog 154:200 (c, 1) Ag '78
Nat Geog 160:336 (c, 1) S '81
WORLD WAR I
Am Heritage 28:80-1 (2) Ag
'77
Life 3:92-3 (c, 1) Ap '80
--1916 German sailor community
(Virginia)
Am Heritage 33:108-9 (3) D
'81
--1918 battle for Belleau Wood
Am Heritage 31:49-63 (draw-
ing, c, 2) F '80
--German soldiers
Life 4:10 (2) F '81
--Journalist in Palestine (1918)
Smithsonian 11:178-9 (3) O '80
--The Lost Battalion
Am Heritage 28:86-95 (c, 1) O
'77

--Relics
Nat Geog 153:826-7 (c, 1) Je '78
--Role of Red Cross
Am Heritage 32:84-91 (1) F '81
--U. S. soldiers on Bastille Day
(1918; Paris, France)
Am Heritage 32:cov. (painting, c, 1)
Ag '81
--See also WILSON, WOODROW;
YORK, ALVIN C.
WORLD WAR II
Life 1:49-51 (1) D '78
--1941 shooting of Jews by Nazis
(Latvia)
Life 3:24-5 (2) F '80
--1942 Bataan death march
Am Heritage 33:96-103 (c, 2) D
'81
--1943 invasion of Sicily by U. S.
Am Heritage 29:46-60 (c, 1) Ap
'78
--1943 rescue of U. S. S. Helena
survivors (Vella Lavella)
Am Heritage 28:34-44 (1) Je '77
--1944 Battle of the Huertgen
Forest
Am Heritage 31:32-43 (c, 1) D
'79
--1944 Normandy invasion
Am Heritage 29:81-91 (drawing, 3)
F '78
--1944 Polish resistance fighting
(Warsaw)
Life 2:9, 12 (2) O '79
--1945 attack on Okinawa by U. S.
Life 2:72-85 (1) My '79
--1945 Potsdam Conference
Am Heritage 31:37-47 (2) Je '80
1945 ruins of Berlin
Am Heritage 31:43 (2) Je '80
--1945 V-J Day celebration (New
York)
Life 3:7, 10 (2) Ag '80
--Allied air raids over Germany
Am Heritage 32:cov. , 65-77 (1)
Ap '81
--American soldiers on trains to
French front
Am Heritage 32:94 (2) O '81
--American troops on the Queen
Mary
Am Heritage 30:88-9 (2) Je '79
--Cassino, Italy campaign
Am Heritage 32:32-45 (1) O '81
--Corregidor Memorial (Philippines)
Trav/Holiday 149:42-3 (4) Ja '78
--German coding machine "Enigma"
Am Heritage 32:110 (4) Ag '81

--Iwo Jima (1945)
 Am Heritage 32:92-101 (c, 2) Je
 '81
--Japanese prison camp (Luzon,
 Philippines)
 Am Heritage 30:80-95 (paint-
 ing, c, 3) Ap '79
--Bill Mauldin's cartoons
 Smithsonian 8:49, 56 (drawing, 4)
 F '78
--Memorial statues (Czechoslovakia)
 Nat Geog 152:468-9 (c, 1) O '77
--Memorial statues (Hungary)
 Nat Geog 152:469 (c, 3) O '77
--Memorial to Ghetto Heroes
 (Warsaw, Poland)
 Smithsonian 9:20 (4) N '78
--Pre-war attacks on U. S. ships
 by German U-boats
 Smithsonian 12:100-9 (paint-
 ing, c, 2) N '81
--Submarines in the Pacific Theater
 Am Heritage 32:32, 45-55 (c, 1)
 D '80
--U. S. monoplanes
 Am Heritage 32:32-6 (1) O '81
--U. S. troops
 Am Heritage 32:35 (4) F '81
--See also CHURCHILL, WINSTON;
 CONCENTRATION CAMPS;
 EISENHOWER, DWIGHT D.;
 FRANK, ANNE; HITLER,
 ADOLF; IWO JIMA; Mac-
 ARTHUR, DOUGLAS; PEARL
 HARBOR; ROOSEVELT,
 FRANKLIN DELANO; STALIN,
 JOSEPH
WORMS
 Natur Hist 90:41 (c, 3) Jl '81
 Nat Geog 160:843 (c, 4) D '81
--Annelid
 Smithsonian 8:88 (c, 4) Ja '78
--Feather-duster
 Nat Geog 152:449 (c, 4) O '77
--Giant red underwater worms
 Nat Geog 156:681, 689-91 (c, 1)
 N '79
--Samoan palolo worms
 Natur Hist 87:64-5 (c, 2) D '78
--Tube
 Nat Geog 152:440-1 (c, 1) O '77
 Life 3:66 (c, 2) Ag '80
 Smithsonian 11:cov. (c, 1) Ja
 '81
 Nat Geog 159:636 (c, 4) My '81
 Nat Geog 160:805 (c, 4) D '81
--See also EARTHWORMS; FLAT-
 WORMS; LEECHES

WORRY BEADS
--Syria
 Nat Geog 154:327 (c, 3) S '78
WRENS
 Smithsonian 11:12 (c, 4) Ag '80
 Nat Wildlife 18:30 (painting, c, 3)
 O '80
--Marsh
 Nat Wildlife 17:22-3 (c, 1) Je '79
WRESTLERS
--College team
 Sports Illus 46:56 (c, 3) Mr 28
 '77
WRESTLING
 Sports Illus 51:48 (3) O 22 '79
--Arm wrestling
 Sports Illus 49:56-61 (1) O 9 '78
--Arm wrestling (Iowa fair)
 Nat Geog 159:614 (c, 4) My '81
--Arm wrestling (U. S. S. R.)
 Nat Geog 155:770-1 (c, 1) Je '79
WRESTLING--AMATEUR
 Sports Illus 48:22-3 (c, 2) Ap 24
 '78
WRESTLING--COLLEGE
 Sports Illus 46:29-30 (c, 2) F 21
 '77
 Sports Illus 48:76 (4) Mr 27 '78
 Sports Illus 50:30-1 (c, 3) Mr 5
 '79
 Sports Illus 50:62 (c, 4) Mr 19
 '79
 Sports Illus 54:50 (4) Mr 23 '81
WRESTLING--HIGH SCHOOL
 Sports Illus 52:46 (4) Mr 17 '80
WRESTLING--PROFESSIONAL
 Sports Illus 55:78-9, 90 (c, 3) D
 21 '81
WRIGHT, FRANK LLOYD
--Chair designed by him
 Smithsonian 12:26 (c, 4) My '81
WRIGHT, WILBUR AND ORVILLE
 Life 1:62-3 (1) N '78
 Am Heritage 31:45-59 (1) D '79
--1903 flight
 Natur Hist 90:64-5 (2) Mr '81
--Depiction of their 1903 flight
 Smithsonian 9:40-6 (drawing, c, 2)
 D '78
Writers. See ADAMS, HENRY;
 ALBEE, EDWARD; ALGER,
 HORATIO; ANDERSEN, HANS
 CHRISTIAN; AUSTEN, JANE;
 BALZAC, HONORE DE;
 BENCHLEY, ROBERT; BIERCE,
 AMBROSE; CARROLL, LEWIS;
 CATTON, BRUCE; CHATEAU-
 BRIAND; CHRISTIE, AGATHA;

COWARD, NOEL; DANTE;
DOSTOEVSKY, FYODOR;
EMERSON, RALPH WALDO;
FITZGERALD, F. SCOTT;
FORD, FORD MADOX;
FROST, ROBERT; FULLER,
MARGARET; GALBRAITH,
JOHN KENNETH; GEORGE,
HENRY; HAWTHORNE,
NATHANIEL; HEMINGWAY,
ERNEST; HEYERDAHL,
THOR; HOLMES, OLIVER
WENDELL; HOWE, JULIA
WARD; HOWELLS, WILLIAM
DEAN; IRVING, WASHING-
TON; JAMES, HENRY;
JAMES, WILLIAM; JOYCE,
JAMES; KAFKA, FRANZ;
LEAR, EDWARD; LONDON,
JACK; LOWELL, JAMES
RUSSELL; MAIMONIDES;
MENCKEN, H. L.; MORI-
SON, SAMUEL ELIOT;
O'CASEY, SEAN; POE,
EDGAR ALLAN; POTTER,
BEATRIX; POUND, EZRA;
PROUST, MARCEL; ROYCE,
JOSIAH; SANDBURG, CARL;
SANTAYANA, GEORGE;
SAROYAN, WILLIAM;
SCHWEITZER, ALBERT;
SHAKESPEARE, WILLIAM;
SOLZHENITSYN, ALEKSANDR;
STEIN, GERTRUDE; STEVEN-
SON, ROBERT LOUIS;
STOWE, HARRIET BEECHER;
TARBELL, IDA; THOREAU,
HENRY DAVID; THURBER,
JAMES; TOLSTOY, LEO;
TURGENEV, IVAN; TWAIN,
MARK; WALPOLE, HORACE;
WHITMAN, WALT; WILDE,
OSCAR; WISTER, OWEN
Writing. See ALPHABETS;
CUNEIFORM; HIEROGLYPHICS
WYOMING
--Cody
Nat Geog 160:86-7, 98-9 (c,1)
Jl '81
--Countryside
Smithsonian 11:119 (c,2) N '80
--Fort Laramie
Nat Geog 158:62-3 (c,1) Jl '80
--Great Divide Basin
Nat Geog 156:510-11 (c,1) O
'79
--Powder River Basin
Nat Geog 159:96-113 (1) F

'81SR
--Statue of Buffalo Bill Cody
Smithsonian 11:94 (3) Ag '80
--Wilderness lands
Nat Geog 160:82-3, 100-1 (c,1)
Jl '81
--See also CHEYENNE; GRAND
TETON NATIONAL PARK;
TETON RANGE; YELLOW-
STONE NATIONAL PARK

-X-

X-RAY EQUIPMENT
--X-ray cancer therapy
Ebony 32:127, 130 (2) Ap '78
Ebony 34:95 (2) N '78
X-RAYS
Ebony 33:128 (4) Ap '78
Ebony 33:106 (4) S '78
Natur Hist 88:81 (3) F '79
Ebony 34:52 (4) Je '79
Ebony 35:64 (4) S '80
Ebony 36:66, 114 (2) N '80
Sports Illus 55:26 (c,2) Je 29
'81
--Pigeons
Smithsonian 9:127 (c,3) O '78

-Y-

YACHTS
Trav/Holiday 150:41 (c,4) O '78
Nat Geog 159:236-7 (c,1) F '81
Sports Illus 54:31-5 (c,1) F 23
'81
Trav/Holiday 156:46 (c,1) O '81
Nat Geog 160:750-1 (c,1) D '81
--1890's
Smithsonian 9:141 (painting,c,2)
N '78
--Designer
Sports Illus 51:38-9 (c,2) D 17
'79
--Owned by celebrities
Sports Illus 55:52-66 (c,1) Jl 20
'81
--Sand yacht (Great Britain)
Nat Geog 156:478-9 (c,1) O '79
YAKIMA, WASHINGTON
--Covered with volcanic ash (1980)
Nat Geog 159:50-9 (c,1) Ja '81
YAKS
Sports Illus 46:86 (c,4) Ap 18
'77
Nat Geog 153:346-7 (c,1) Mr '78

Nat Geog 160:552-3 (c, 1) O
'81
YALE UNIVERSITY, NEW HAVEN,
CONNECTICUT
--Elihu Yale
Smithsonian 8:91-7 (c, 2) O '77
--Sterling Library
Sports Illus 54:35 (c, 4) Mr 30
'81
YELLOW JACKETS
Natur Hist 88:56-65 (c, 1) O '79
YELLOWLEGS (BIRDS)
Nat Wildlife 15:45 (c, 4) Je '77
YELLOWSTONE NATIONAL PARK,
WYOMING
Nat Geog 152:cov., 3 (c, 1) Jl
'77
Ebony 33:152 (3) My '78
Nat Geog 154:828-57 (c, 1) D
'78
Nat Geog 156:27, 48-9 (3) Jl
'79
Nat Geog 160:256-77 (c, 1) Ag
'81
--Lone Star Geyser (1883)
Smithsonian 9:46 (4) Mr '79
--Lower Falls
Life 1:94-5 (c, 1) D '78
--Winter scenes
Trav/Holiday 155:53-4 (c, 1) Ja
'81
--Yellowstone River
Nat Wildlife 15:42-7 (c, 1) Ag
'77
Life 1:94-104 (c, 1) D '78
Nat Geog 160:256-77 (c, 1) Ag
'81
--See also SNAKE RIVER
Yemen. See NORTH YEMEN
YEMEN--COSTUME
Nat Geog 159:301 (c, 1) Mr '81
--Woman
Natur Hist 87:115 (c, 1) Ag '78
YOGA
Ebony 34:28 (c, 4) Ja '79
--Football players in relaxation
pose
Smithsonian 10:114 (c, 3) D '79
YORK, ALVIN C.
Am Heritage 32:56-63 (1) Ag
'81
YORK, ENGLAND
Trav/Holiday 153:54-7, 91-3
(c, 1) Ap '80
YORKSHIRE, GREAT BRITAIN
--Countryside
Smithsonian 11:84 (c, 1) Ag '80
YOSEMITE NATIONAL PARK,

CALIFORNIA
Nat Wildlife 15:34-7 (4) O '77
Nat Geog 156:cov., 18, 30-3
(c, 1) Jl '79
--Country hotel
Sports Illus 52:68, 74 (c, 3) Je
16 '80
--See also BRIDALVEIL FALLS
YOUNG, BRIGHAM
--Statue (Provo, Utah)
Sports Illus 53:87 (c, 4) D 8 '80
YOUTH
Ebony 33:77 (4) Ag '78
--High school life (Kansas)
Life 2:90-100 (1) Je '79
--Lifestyle (Illinois)
Sports Illus 51:54-5 (c, 4) Jl 9
'79
--Mexican American gang (Califor-
nia)
Nat Geog 157:800-1, 806-7 (c, 1)
Je '80
--See also COLLEGE LIFE
YOUTH--HUMOR
Ebony 33:44-54 (drawing, 2) Ag
'78
YUCCA PLANTS
Nat Wildlife 18:52 (c, 3) D '79
Natur Hist 89:44-5 (c, 1) Jl '80
Nat Geog 160:688-9 (c, 1) N '81
YUGOSLAVIA
Nat Geog 152:478-81 (c, 1) O '77
Smithsonian 10:93-102 (c, 2) D
'79
--Countryside
Life 2:57-8 (c, 3) Ap '79
--Kranjska Gora
Trav/Holiday 152:cov., 8-10, 75
(c, 1) D '79
--See also BELGRADE; MONTE-
NEGRO; TITO, MARSHAL;
ZAGREB
YUGOSLAVIA--COSTUME
Nat Geog 152:480-1 (c, 1) O '77
Smithsonian 10:93-102 (c, 2) D
'79
--1940's
Smithsonian 10:93-102 (c, 2) D
'79
--Montenegro
Nat Geog 152:662-87 (c, 1) N '77
--Zagreb
Travel 148:33 (c, 2) Jl '77
YUGOSLAVIA--HISTORY
--During World War II
Smithsonian 10:93-102 (2) D '79
YUKON RIVER, YUKON
--Klondike area